THE
LOUVRE

A graduate of the École Nationale des Chartres and an art historian, Geneviève Bresc-Bautier was general curator and director of the Department of Sculptures of the Musée du Louvre. Initiator at the museum of the History of the Louvre section, she has written several publications on the subject, including *Mémoires du Louvre* (Gallimard, 1989) and *Le Louvre, une histoire de palais* (Musée du Louvre Éditions/Somogy, 2008), and directed *L'Histoire du Louvre* (Musée du Louvre Éditions/Fayard, 2014).

Author of numerous books on travel, the scars of war, French and European heritage, and the world of contemporary painters, Gérard Rondeau (1963-2016) was a unique photographer. His works include *Le Maroc: hommage à Delacroix* (Presses du Languedoc, 1999), *Rebeyrolle, ou le journal d'un peintre*, with Paul Rebeyrolle (Ides et Calendes, 2001), Hors Cadre (Réunion des Musées Nationaux, 2005), *La Cathédrale de Reims, texte d'Auguste Rodin* (RMN, 2011), *Quai Branly: là où soufflent les esprits* (Quai Branly/La Martinière, 2012).

First published in the United States of America in 2020 by Rizzoli Electa, A Division of Rizzoli International Publications 300 Park Avenue South New York, NY 10010 www.rizzoliusa.com

Originally published in French in 2013 by Citadelles & Mazenod and Musée du Louvre © 2013, 2019, Citadelles & Mazenod © 2013, Musée du Louvre, Paris

Printed in Italy

Second printing, 2022 2022 2023 2024 2025 / 10 9 8 7 6 5 4 3 2

ISBN: 978-0-8478-6893-3

Library of Congress Control Number: 2019949313

Visit us online: Facebook.com/RizzoliNewYork Twitter: @Rizzoli_Books Instagram.com/RizzoliBooks Pinterest.com/RizzoliBooks Youtube.com/user/RizzoliNY Issuu.com/Rizzoli

Front of Jacket:
Jean Auguste Dominique Ingres (1780–1867)
Une Odalisque, also known as *La Grande Odalisque* (detail), 1814
Oil on canvas, 91 × 162 cm (35 7/8 x 63 3/4 in.)
Department of Paintings, acquired in 1899 (see pp. 306–7)

Back of Jacket:
Sleeping Hermaphrodite
Roman copy, 2nd century A.D., of a Greek original
Marble, L. 169 cm (66 1/2 in.)
Department of Greek, Etruscan, and Roman Antiquities (see pp. 334–35)

Above
Christ Surrounded by Cherubs Bearing the Soul of His Mother (detail), ca. 1400–20
Marble, H. 57 cm (22 1/2 in.)
Department of Sculptures, acquired in 1894

This relief, attributed to a workshop commissioned by Jean, Duke of Berry, comes from Bourges.

THE
LOUVRE

Geneviève Bresc-Bautier

with photographs by Gérard Rondeau

Rizzoli **Electa**

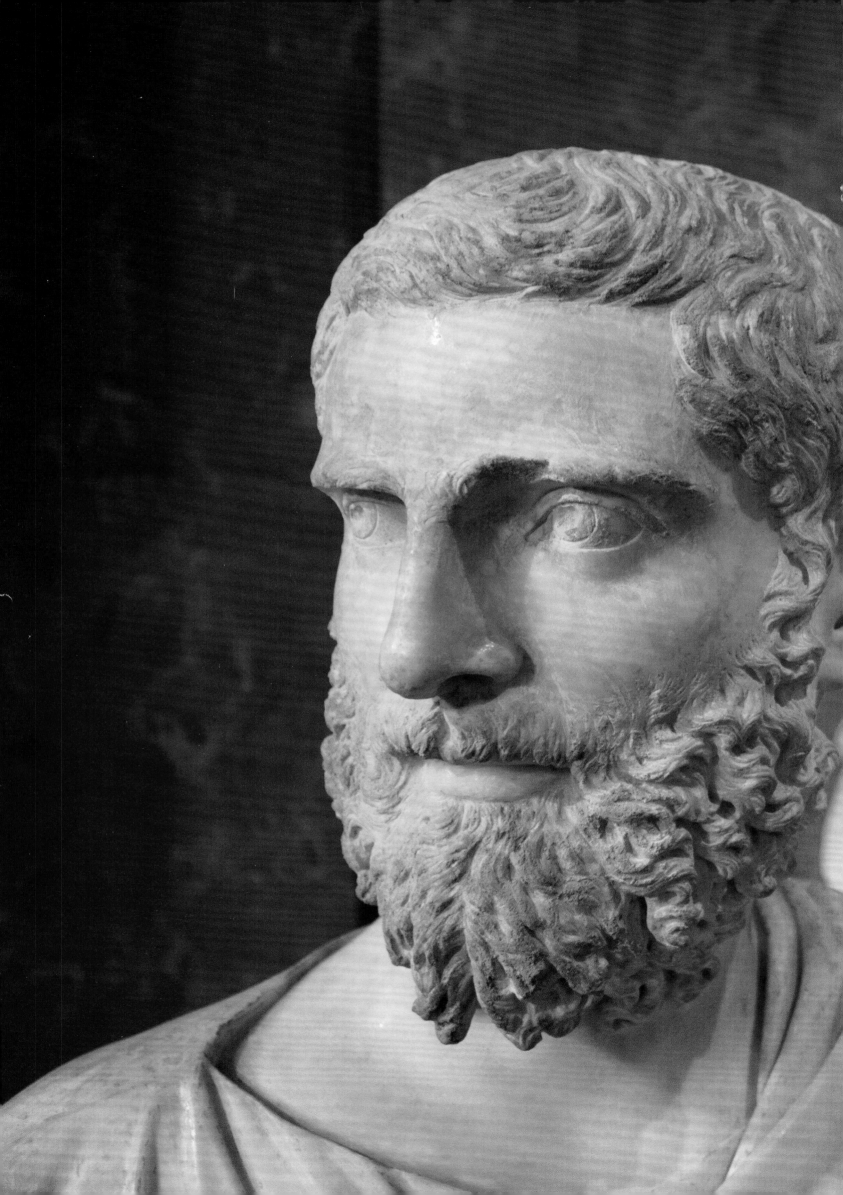

Foreword

A Castle, a Palace, a Museum, a World

Every year, millions of visitors from all over the world visit the Louvre's sixty-eight thousand square meters (731,945 sq ft.) of galleries that offer more than thirty-five thousand works of art to the public. The Musée du Louvre fascinates, surprises, and moves.

What is the history of this important heritage site, and how did its prestigious collections develop? This is what this book proposes to retrace, by way of a rich iconography.

A fortified castle in the Middle Ages and then home to the kings of France, the Louvre is the setting for eight centuries of history. Its origins date back to the twelfth century, when King Philip Augustus decided to protect Paris, his new capital, by providing it with a fortress on the right bank of the Seine. With Charles V, the Louvre became a royal residence, which the Valois and Bourbon kings continued to expand, develop, and embellish, as did Napoleon I, Napoleon III, and then the elected representatives of the Republic. The most brilliant architects, sculptors, and painters were called upon to work there (including Pierre Lescot, Jean Goujon, Jacques Lemercier, Louis Le Vau, Nicolas Poussin, Charles Le Brun, Claude Perrault, Eugène Delacroix, Jean-Baptiste Carpeaux). Hosting the Royal Academy of Painting and Sculpture, the Salon's headquarters, and the residence of many artists in the eighteenth century, the Louvre confirmed its vocation as a temple of the arts with the opening in 1793 of the Muséum des Arts, the first national museum to welcome the public.

From then on, its collections, which come from the royal collections, would be enriched as acquisitions, archaeological discoveries, donations, and legacies were made. In addition to the paintings and antiquities presented by the museum in its early days, there are also works from distant worlds, such as Egypt or the Far East, or more recently, Africa and America, where all the artistic techniques are now represented. In 1989, the "Grand Louvre" project, symbolized by I. M. Pei's famous Pyramid, put the finishing touches to these centuries of transformation. Later museographic interventions have brought modernity to this temple of the arts.

It is this fascinating story that I want to recount here, accompanied by the eye of Gérard Rondeau, a penetrating photographer and author of several books on French heritage, who, thanks to his talent, was able to capture this Louvre, which he explored for months.

Geneviève Bresc-Bautier

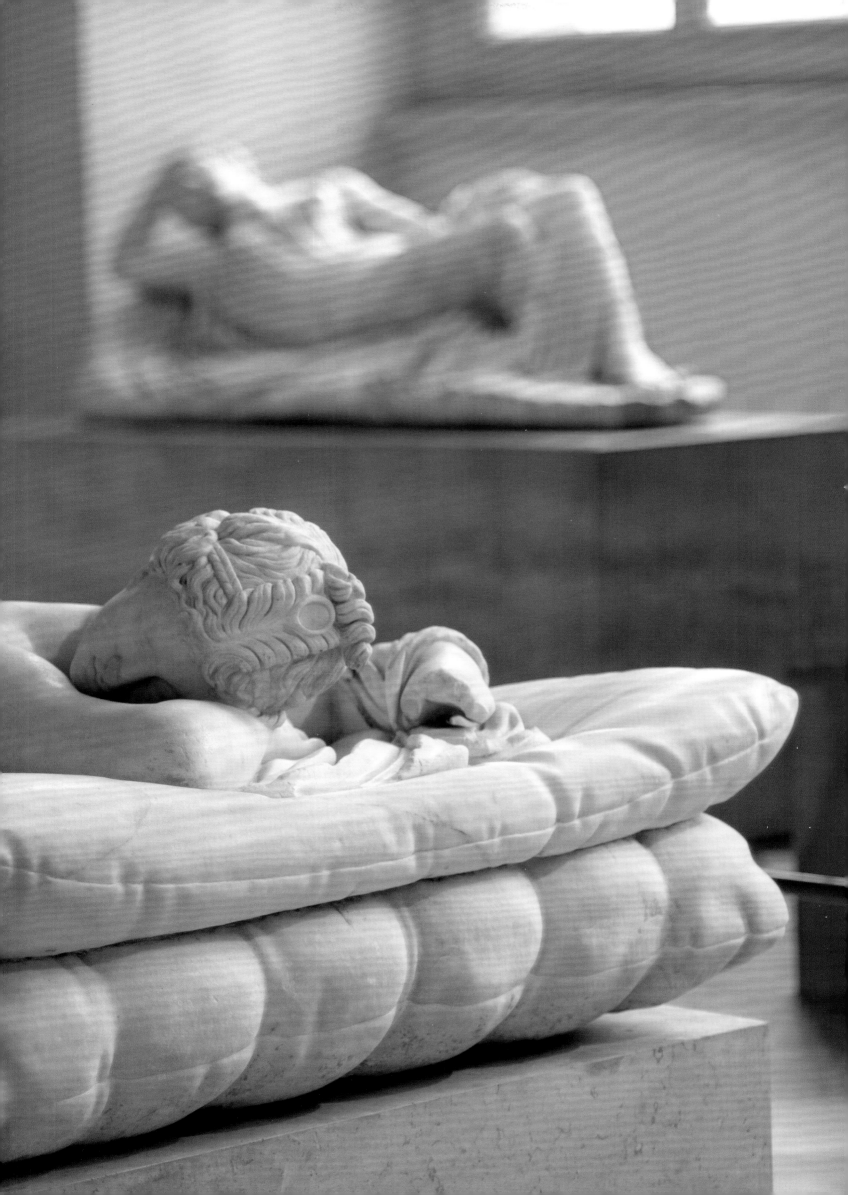

Contents

Jacques-Louis David (1748–1825)
*Madame Pierre Sériziat, née Émilie Pécoul
and her son, Emile* (detail), Salon of 1795
Oil on canvas, 131 × 96 cm (51 5/8 × 37 7/8 in.)
Department of Paintings, acquired in 1902

Previous spread
Sleeping Hermaphrodite
Roman copy, 2nd century A.D.,
of a Greek original
Marble, L. 169 cm (66 1/2 in.)
Department of Greek, Etruscan,
and Roman Antiquities
(see pp. 334–35)

Background, left:
Unknown figure, ca. 250 A.D.
Marble, H. 67 cm (26 3/8 in.)
Attributed to a Greek sculptor working
in Rome
Department of Greek, Etruscan, and Roman
Antiquities, Borghese collection, acquired
in 1807

Background, right:
Municipal figure, ca. 235–245 A.D.
Marble, H. 61 cm (24 in.)
Albani collection, inventoried in 1798,
exchanged in 1816

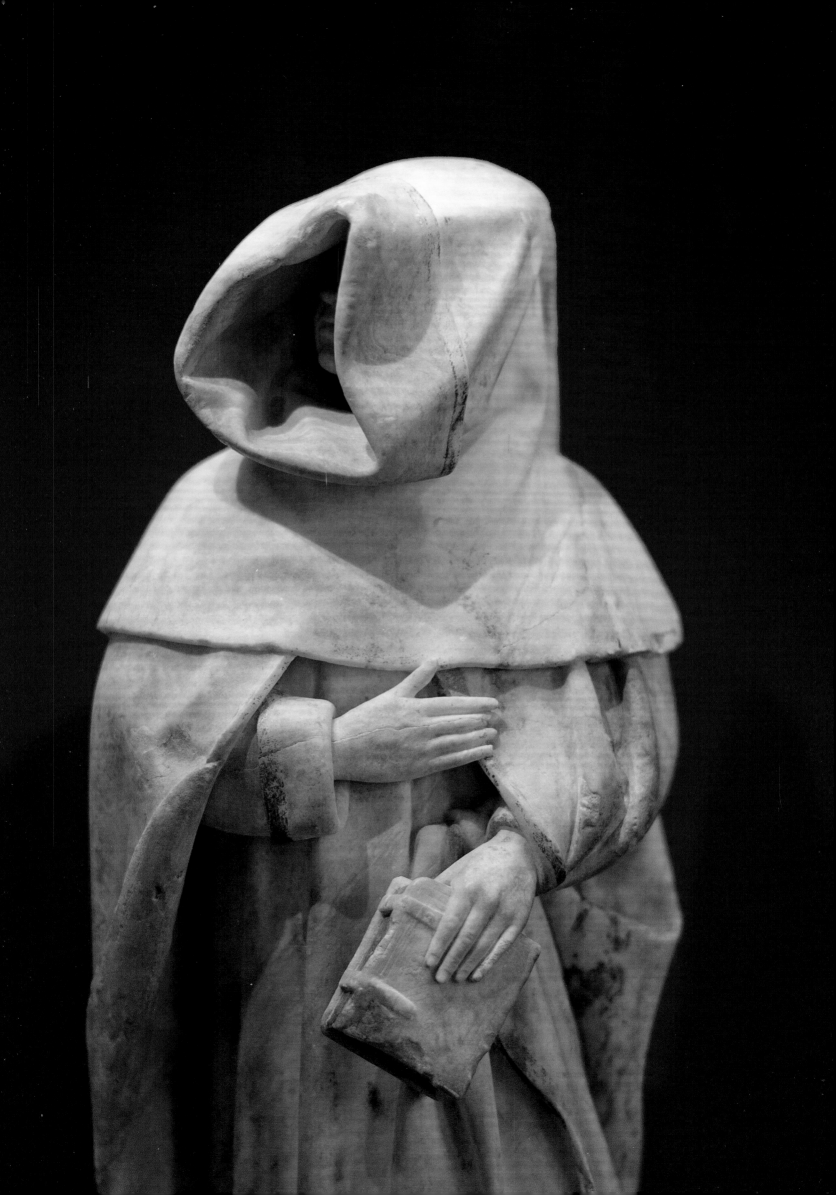

A Medieval Fortress

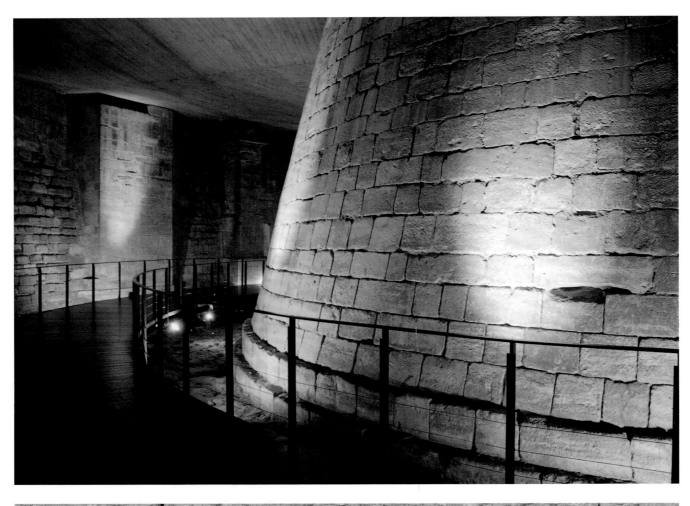

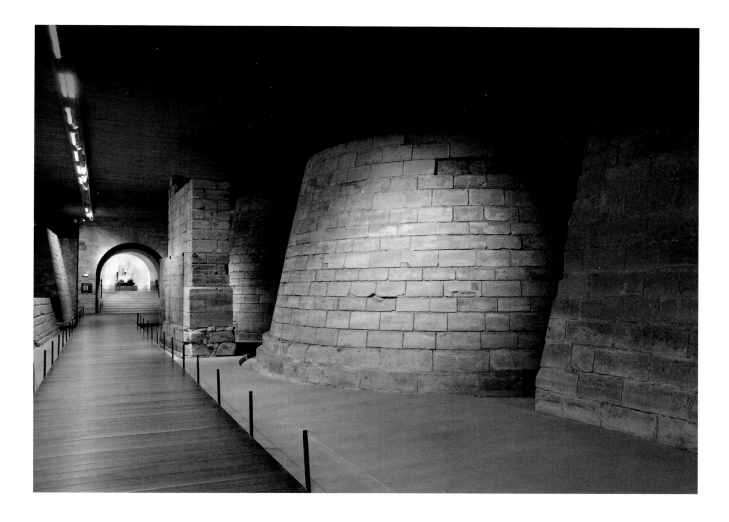

You probably have in mind an image of the Louvre as a temple of art, therefore of painting: its Leonardos, its Raphaels, its Rembrandts, its Poussins, its Rubens hung here and there, with the Venus de Milo looking down from above and the towering *Winged Victory of Samothrace* at the top of a grand staircase. But no! The Louvre is much richer than all that: a palace that is still mysterious, with centuries of civilizations that overlap and intersect, mazes populated by ceramics and enamels, vast courtyards where the sun shines on immense marbles. A world built by human hands, superhuman efforts, sweat and tears, enthusiasm and regret. Works hidden under the apparent cover of beauty that seem so simple and yet are the result of a long journey.

You can enter under a pyramid of glass and metal, the mark of twentieth-century modernity, through the jostling crowds, while up there against the Parisian sky you see the silhouettes of the luxuriant shapes of the nineteenth-century facades. Or take a long stone corridor and reach the Middle Ages, the first stage in the discovery of the City of the Louvre.

Philip Augustus and the Beginnings of a Capital City

The medieval castles encompassed a hidden world until the works of the Grand Louvre and its inauguration in 1989. In 1866, under Napoleon III, excavations carried out by Adolphe Berty had already uncovered the upper part of the original fortress in the southwestern part of the Cour Carrée ("square courtyard"), but it was the archaeological research of Michel Fleury and Venceslas Kruta in 1984 and 1985 that made it possible to clear the entire base. Now the medieval trench circuit is part of the museum spaces.

Above
Base of the twin towers and the drawbridge pier of the eastern gate of Philip Augustus's fortress, late 12th–early 13th century

Opposite
The base of Philip Augustus's keep and the circular moat; limestone blocks of the fortress wall, end of the 12th to early 13th century

Previous spread
Étienne Bobillet (documented 1453) and Paul Mosselmann (active 1441–d. 1467) *Mourner Holding a Book*, after 1450 Alabaster and traces of gilding, H. 39 cm (15 3/8 in.) Element from the funeral procession commissioned by King Charles VII for the foundation of the tomb of Jean de France, Duke of Berry Sainte-Chapelle de Bourges (dismembered during the Revolution) Department of Sculptures, acquired in 1953

The circular moat of the fortress of Philip Augustus

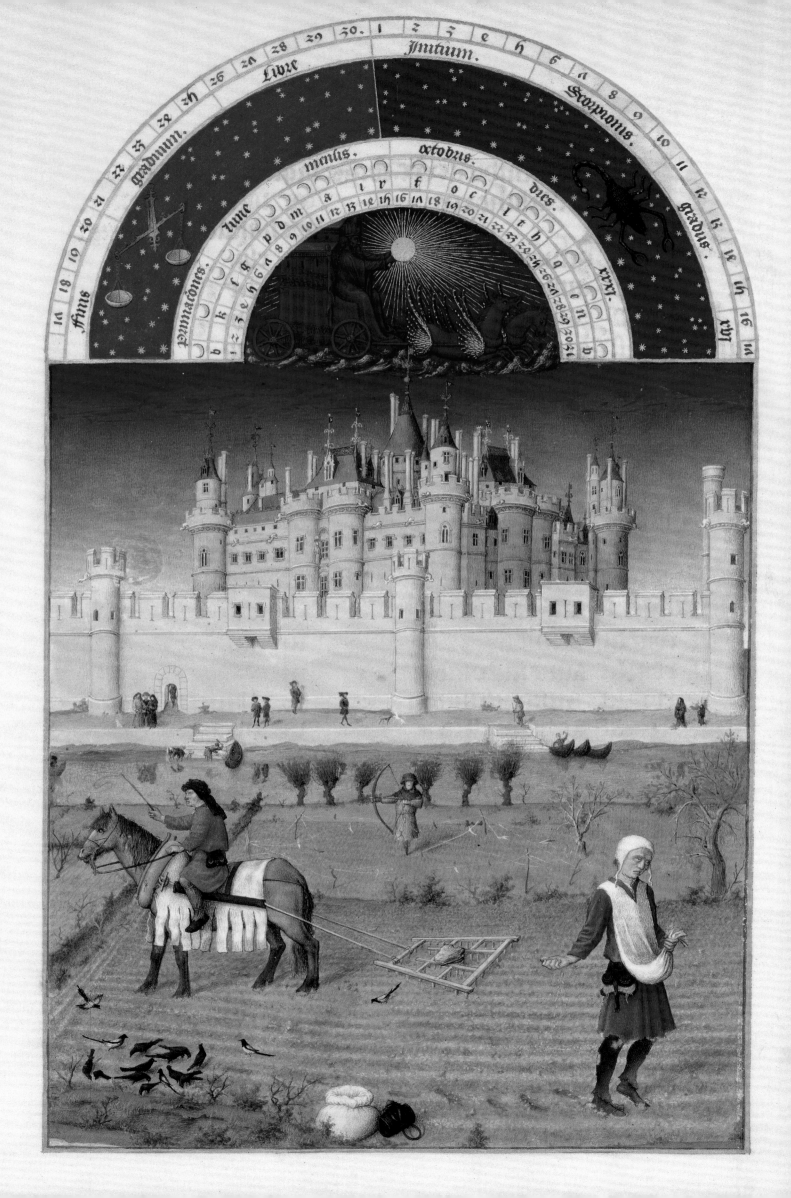

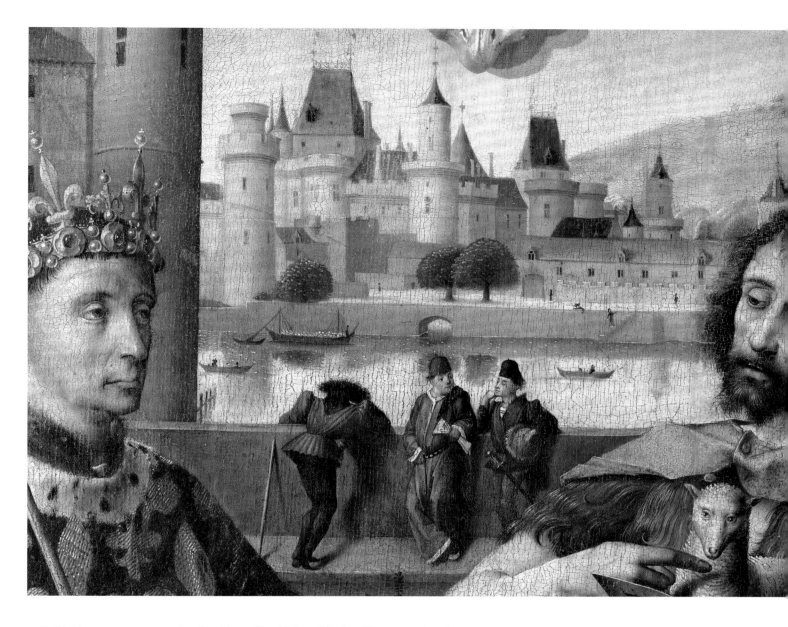

Suddenly you enter a moat, bordered by walls with huge blocks of limestone that the light cuts with a mysterious halo. On the carefully crafted walls of yellowish limestone, the stonemasons—"drudgers"—incised their marks of squares and hearts that remain enigmatic to this day. An exercise of the imagination is necessary to picture the work of the quarry, the handling of the pick, the size of the blocks, their transport and installation using the craft techniques of the time; the clackety scaffolding, the strength of the barrow men, the precision of the mason adjusting the stereotomy with his square and plumb line.

And yet, you only see the lower part of a medieval fortress, the sloping base that supported the walls and towers. It takes a leap of imagination to truly grasp the height of the building, and close observation to spot the few images of the castle that painters proudly inserted into works such as the *Altarpiece of the Parliament of Paris* and the *Pietà of Saint-Germain-des-Prés*. In the background of the *Altarpiece* is the silhouette of a square-planned castle, flanked by a tower at each corner. On two sides, one facing the Seine and the other the city of Paris, an entrance door opens in the center of the wall, which is protected by two half-towers. With the drawbridge raised, the castle was protected from incursions. In the center, the silhouette of a high circular keep—the Grosse Tour (Large Tower) of the Louvre—dominates the enclosure. About 30 meters (98 ft.) high, it forms the heart of the system. You can access its base via a corridor recently built through the wall. Here, too, the structure is impressive—a symbol of power and an impregnable redoubt.

King Philip Augustus ordered the construction of this fortress on the outskirts of his city, by then the real capital of the kingdom. In 1190, he went on a crusade with his brother-in-law, King Richard the Lionheart of England, leaving Paris in a vulnerable situation. These English allies had often been enemies—and would be again for a long time to come.

Above
Detail of the *Altarpiece of the Parliament of Paris*: the Louvre castle seen from the southeast, on the left bank of the Seine (see the following spread)

Opposite
Jean, Paul, and Herman de Limbourg (active 1399–1416)
The Very Rich Hours of the Duke of Berry: October, illustrated with a view of the Louvre castle seen from the south, from the left bank of the Seine Paint on vellum, 29 × 21 cm (11 3/8 × 8 1/4 in.)
Musée Condé, Chantilly

The illuminated manuscript, commissioned by Jean, Duke of Berry, in 1410–11, was not completed when the Limbourg brothers died in 1416. The characters' costumes suggest a date for this illumination in the 1440s.

From the Duchy of Normandy, which the English held, they could quickly attack Paris by the Seine. However, the royal palace, which had always been located on the Île de la Cité, was at the forefront of an attack. The Louvre would be its downstream defense. According to Rigord, the royal biographer, the king had ordered his citizens to build an enclosure to defend Paris. The fortress's tower was installed at the point where the city met the river. It was a defensive barrier, but also a well-protected, simple lodging, from which it was easy to escape by river. Alternate prison, arsenal, safe house, and residence, the Louvre, although perhaps only one of the domiciles of an itinerant monarchy, also signified authority. In 1202, Philip Augustus recommended the keep as a prototype for another castle, that of Dun-le-Roi (Berry), and the Louvre tower became the emblematic place on which the fiefdoms of the kingdom supposedly depended. While the kingdom established itself as a spiritual reference, and Paris assumed its function as capital, the Louvre became a visual symbol of its ascendancy.

We don't yet know when the work began, but it was clearly before 1202. Similarly, the origin of the name remains a mystery: *Lovre* or *Louvre* in French, *Lupara* in Latin; a first occurrence (*Louvrea*) appears in 1189. This toponym thus antedates the first mention of the fortress and is clearly applicable to the suburban district where a hospital dedicated to Thomas Becket—the archbishop of Canterbury murdered in his cathedral by King Henry II of England (1170)—was built in 1175–80.

A fortress erected on a plain, the castle was a robust square measuring 72 meters (236 ft.) east to west and 78 meters (255 ft.) north to south, bordered by water-filled trenches. Although the towers were habitable, only the south and west wings had dwellings, since they were the only ones spacious enough for apartments, as well as a chapel and ceremonial rooms. There is still a lower room, whose walls date back to the buildings of Philip Augustus and which was vaulted with ribs in the middle of the thirteenth century, probably under Saint Louis. For the sake of convenience, it was called the Salle Saint-Louis (Saint Louis Hall). Fortuitously discovered during work in 1882—and refurbished in 1989 with theatrical lighting by Richard Peduzzi—with its round columns, sculpted capitals, and consoles of grotesque masks, it evokes the decoration of a royal palace, even if it was only a secondary-use lower room. The excavations also revealed thirteenth-century embellishments: paving tiles lining one of the corner towers, which hold evidence of a royal occupation.

The central keep, perfectly circular and 15 meters (49 ft.) in diameter, was surrounded by a dry ditch, 6 meters (19 ft.) deep and 10 meters (32 ft.) wide. It was accessible only through a single narrow door, which made it totally secure: you could neither enter nor leave without being seen. A well supplied it with water, and probably cisterns. Although it was not precisely in the center of the courtyard, it wasn't part of the defensive system as some keeps were, but was considered a fortified redoubt. Thanks to its height and centrality, it would become the emblem of royal power.

The dramas of war also played out within its walls, since functions other than defense had been found for the fortress: Ferdinand of Portugal, count of Flanders, was

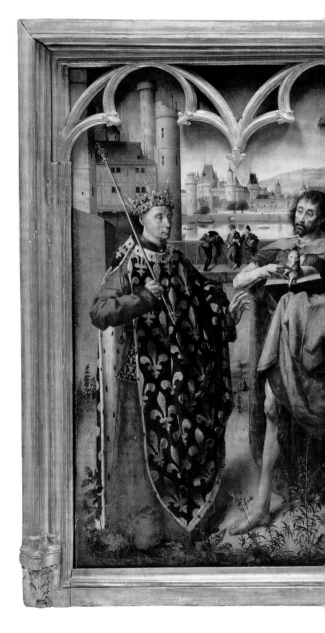

Altarpiece of the Parliament of Paris, ca. 1449
Oil on oak panel, 145 × 270 cm (57 ⅛ × 106 ¼ in.)
(central gable, H. 226 cm/89 in.)
Around the Crucifixion group: Saint Louis,
John the Baptist, Saint Denis, and Charlemagne;
in the left background, view of the Louvre Castle
Department of Paintings, transferred to
the Louvre in 1904
This altarpiece, recently attributed to André d'Ypres,
an Amiens painter active in Paris, was executed
for the Parlement of Paris at the Palais de l'Île
de la Cité.

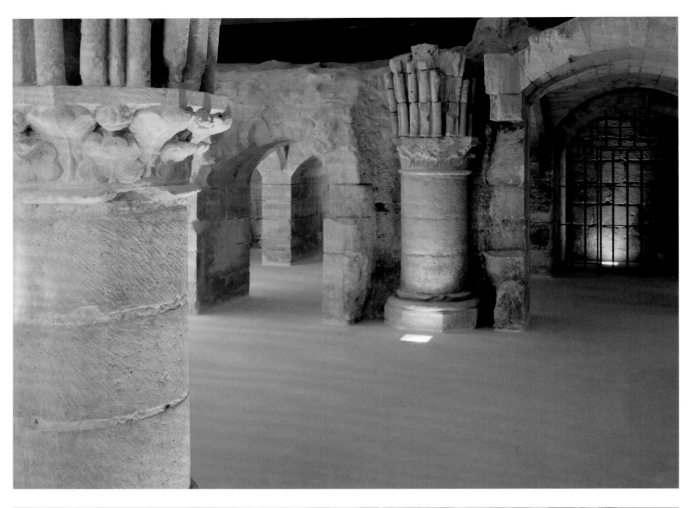

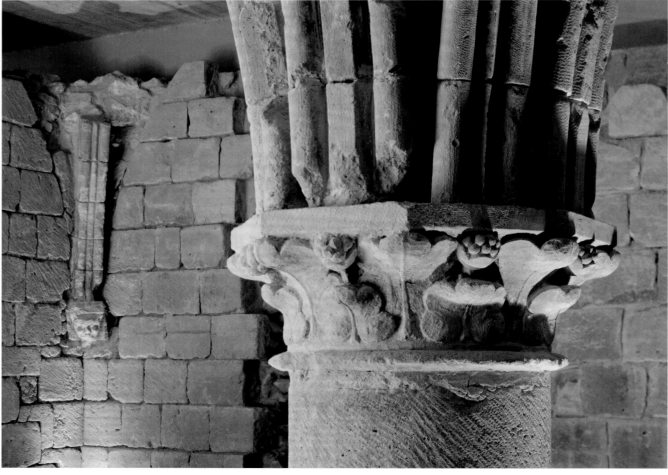

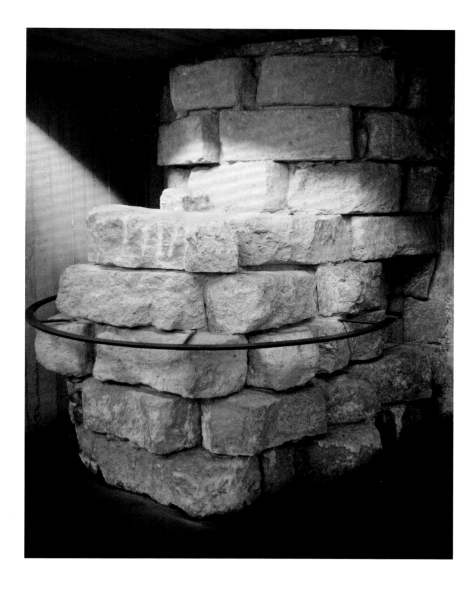

taken prisoner at the Battle of Bouvines (1214) and locked up there for thirteen years. The Parisians' taunts of "*Ferran te voilà ferré*" ("Ferdinand, here you are in irons"—an alliterative play on the French word *fer*, meaning "iron") accompanied his transfer to Paris.

The king would sometimes come to the castle's main living area. He held assemblies there, such as the one in which Philip the Fair, in an outrageous act, decided to attack Pope Boniface VIII. The tower housed the royal treasury from 1295 onward, when Philip the Fair withdrew it from the custody of the Order of the Temple before having the Knights Templar arrested.

But little by little, the Louvre Castle lost its key position in the defense of the city. An urban district had developed at its feet. In fact, when the fortress was constructed, there was already a Saint-Thomas du Louvre church, and soon after, its affiliate Saint-Nicolas was built a little to the west. To the northwest, Saint Louis founded the hospice for the blind in 1254, the Quinze-Vingts (it literally means "Three Hundred," after the number of beds it housed for blind patients), and a vast enclosure with a chapel and small houses. The high nobility put up some manors, such as that of the duke of Brittany, which were, in fact, small-town castles more than private mansions.

Parisian Art in the Twelfth Century

As a museum, the Louvre cannot evoke the splendors of the architecture of the cathedrals, with their high vaults, sculpted portals, and colorful stained glass, despite the window featuring the story of Saint Nicasius, originally from Soissons Cathedral, which is housed in the museum and bears witness to the cathedrals' brilliance. However, one room is

Detail of the masonry of the keep's well

Opposite
Salle Saint-Louis, ca. 1220–30: lower room of the west residence of the Louvre Castle, later vaulted at construction

Capital of a column in the Salle Saint-Louis

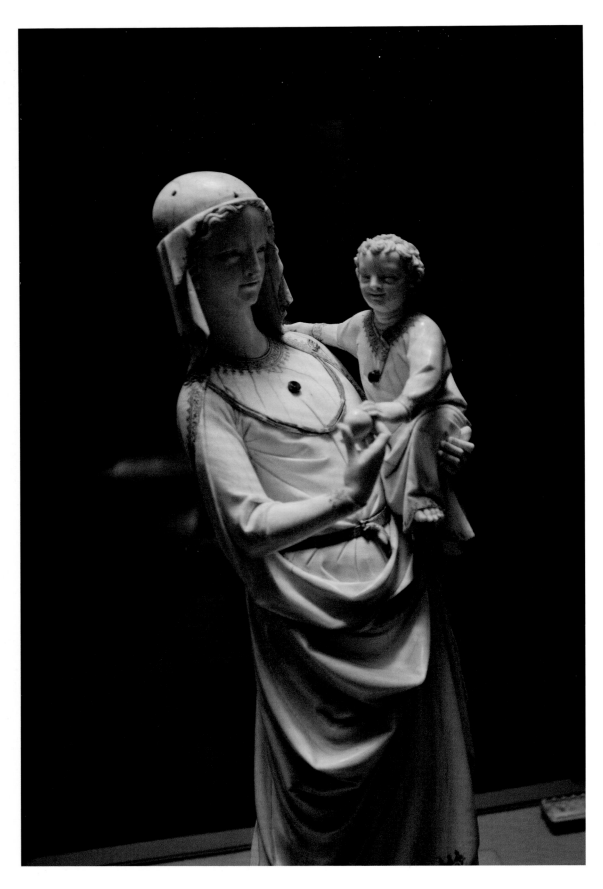

Virgin and Child (detail), ca. 1260–70
Ivory, traces of polychrome, H. 41 cm (16 ⅛ in.)
Department of Decorative Arts, confiscated
during the Revolution, collection of Alexandre
Lenoir (1797–1837), acquired at the Soltykoff
sale in 1861

This statuette, with its slender proportions,
comes from the treasury of Sainte-Chapelle
in Paris, where it was discovered in 1279.

Opposite

King Childebert I (died 558), ca. 1239–44
Limestone, remains of polychrome and gilding,
H. 191 cm (75 ¼ in.)
Doorway mullion, refectory door, Benedictine
abbey of Saint-Germain-des-Prés, Paris
Department of Sculptures, confiscated during
the Revolution, former Musée des Monuments
Français, transferred to the Louvre by the École
nationale supérieure des Beaux-Arts in 1851

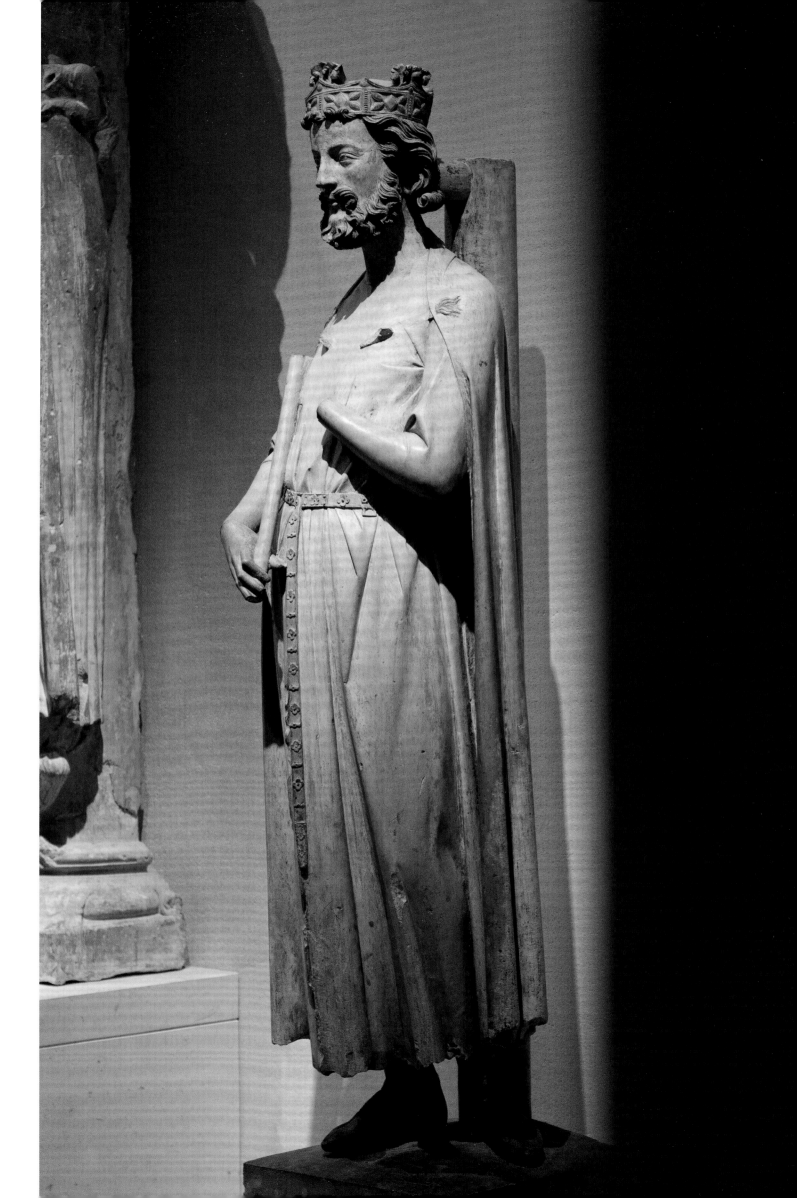

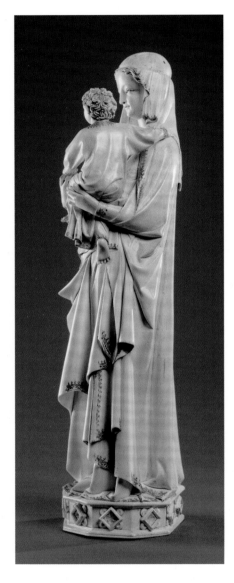

Virgin and Child, ca. 1260–70
Ivory, traces of polychrome, H. 41 cm (16 ⅛ in.)
From the treasury of the Sainte-Chapelle
in Paris Department of Decorative Arts,
confiscated during the Revolution, entered into
the collection of Alexandre Lenoir (1797–1837)

Opposite
Saint Genevieve, first quarter of the 13th century
Limestone, traces of polychrome,
H. 230 cm (90 ½ in.)
Doorway mullion, central portal, west
facade of the church of the Canons Regular
of Sainte-Geneviève, Paris
Department of Sculptures, transferred to
the Louvre by the Lycée Henri IV in 1896

dedicated to the sculpture of the cathedrals. This room is lined with stone remains, such as the reliefs on the rood screens from Chartres and Amiens cathedrals, interspersed with wood figures, angels or a great Madonna with a charming smile, sometimes described as a "Reims's smile" in reference to the major work of medieval statuary.

In the museum's sculpture and decorative arts rooms, we find the great art of the city of Paris, epitomizing the Gothic style and the antithesis of the castle's robustness. The many Parisian trades of the thirteenth century required regulation, and the provost of merchants, Étienne Boileau, was ordered by the king to provide a legal definition for each in his *Book of Trades*. Image makers carved Parisian limestone; ivory makers transformed Paris into the capital of Gothic ivory production in the thirteenth and fourteenth centuries; and goldsmiths, miniaturists, and embroiderers were in high demand.

In the medieval sculpture rooms, two large statues attest to the visual force that the sculptors achieved and to the historical authority of the great Parisian abbeys. The statue of Saint Genevieve, patron saint of Paris, comes from the church of Sainte-Geneviève, built on the Montagne Sainte-Geneviève on the left bank of the Seine, while a sculpture of the Merovingian king Childebert was chosen by the monks of Saint-Germain-des-Prés to preside over the entrance to the refectory, thereby honoring their founding sovereign. This retrospective effigy, with a slightly melancholic smile, does not seek to convey a realistic likeness but, rather, the natural authority of the abbey's founder. The soft drape shows an exceptional plastic density that was once reinforced by a now faded polychrome.

The Louvre, although lacking in the art of miniature, is the great treasury of the decorative arts. Ivories are displayed in the rooms of the Richelieu Wing: statuettes, diptychs, and portable tabernacles served as a medium for private devotion; while domestic objects—such as boxes, writing tablets and stamps, and mirror cases—abound. Among the great masterpieces of ivory, the *Virgin and Child* from Sainte-Chapelle expresses an ideal of beauty: the slight sway of the hip and the refinement of the drape and the face together form a delicate harmony. Probably donated by King Louis IX, this Virgin, which is mentioned for the first time in the inventory of the chapel of the Palais de la Cité in 1279, belongs to the treasury housed in the Louvre. Another ensemble is composed of multiple statuettes representing the descent from the Cross. Christ is carried and venerated by Nicodemus and Joseph of Arimathea. On either side, the Virgin and John the Evangelist express intense emotion, while the allegorical figures of the Church and the Synagogue represent the New and Old Law. The statuettes of Saint John and the Synagogue were identified and acquired by the Louvre in 2013, thanks to a public subscription and the Société des Amis du Louvre, completing one of the most prestigious collections of ivory art, with that of the Abbey of Saint-Denis.

Charles V, the Wise King

The Valois dynasty was established in the early fourteenth century, when the kings of England challenged its legitimacy. A fratricidal war would bloody the kingdom for a hundred years. In 1356, after the defeat at Poitiers, King John the Good was taken prisoner. His eldest son, Charles, who was the first to be named dauphin, ensured a difficult regency. He found himself in the midst of the Parisian revolt by the provost of merchants, Étienne Marcel. At the Palais de la Cité, where the dauphin resided, he saw his marshals killed in front of him and was forced to escape covering his head with a hood featuring the colors of Paris.

In the mid-fourteenth century, as the Hundred Years' War raged and a peasant revolt was brewing, Marcel built a new enclosure in the city of Paris, made of ditches and earthen embankments, to encompass the outlying districts. Having become king, Charles continued to fortify this large protective space. Dubbed the Wall of Charles V, the great defensive trench is now situated in the Carrousel Garden. However, the wall does not date from the

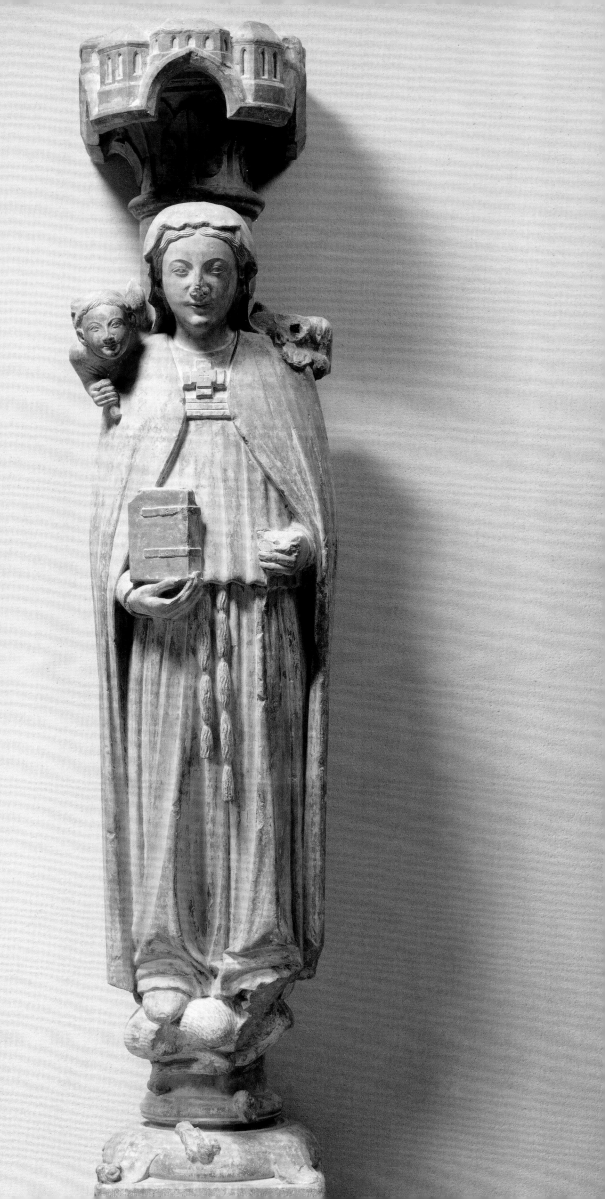

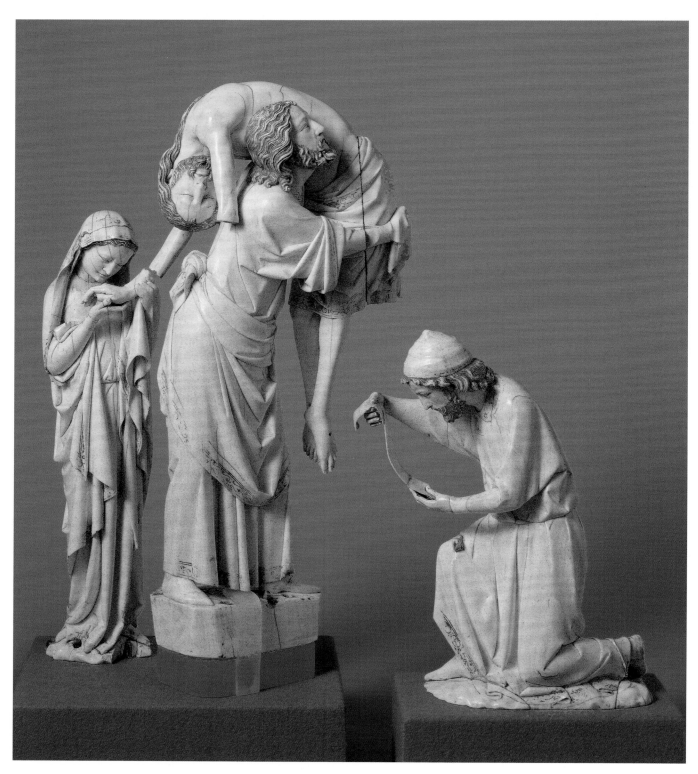

Descent from the Cross, Paris, ca. 1260–80
Ivory, traces of gilding and polychrome,
H. 30 cm (11 ¾ in.)
Department of Decorative Arts, central group
acquired in 1896, Nicodemus (right), gift of
the children of Robert de Rothschild in 1947
(John the Evangelist and the Synagogue,
not visible, acquired in 2013)

Opposite
Detail of the central group: the face
of Joseph of Arimathea

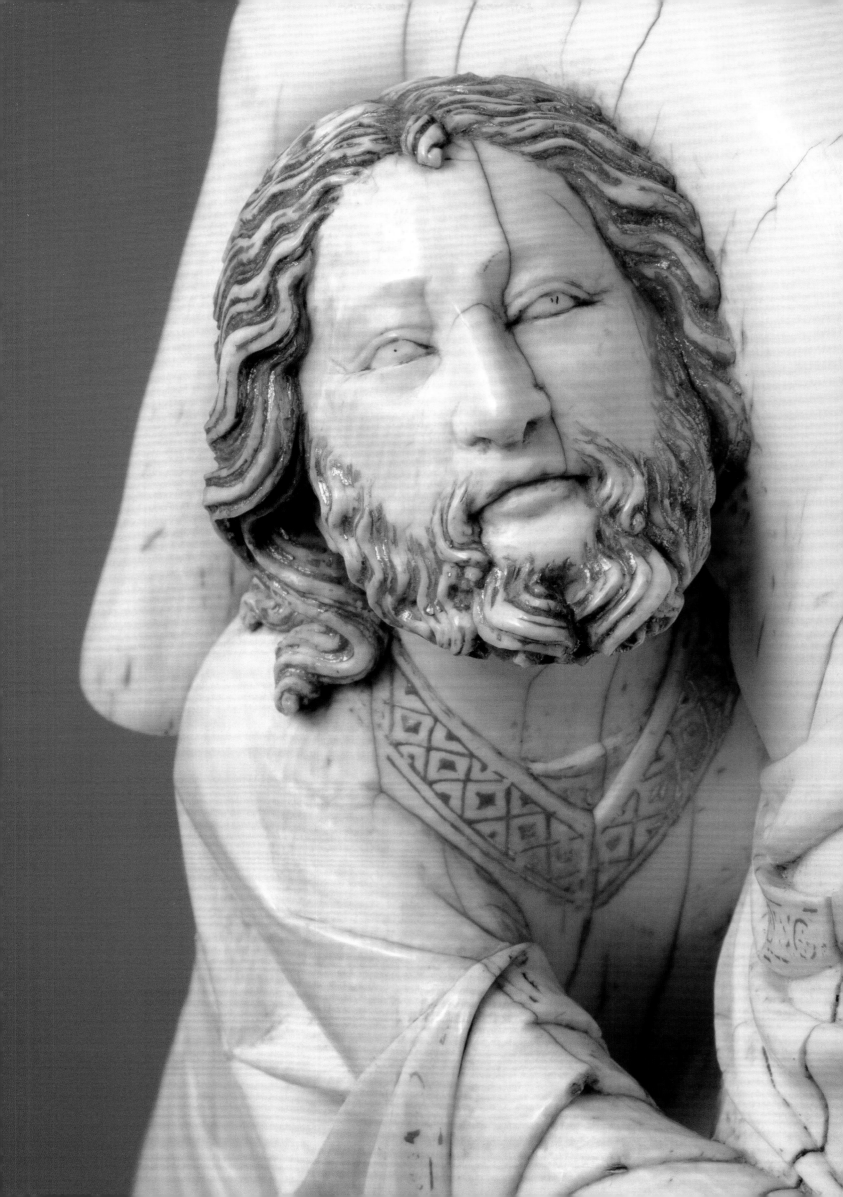

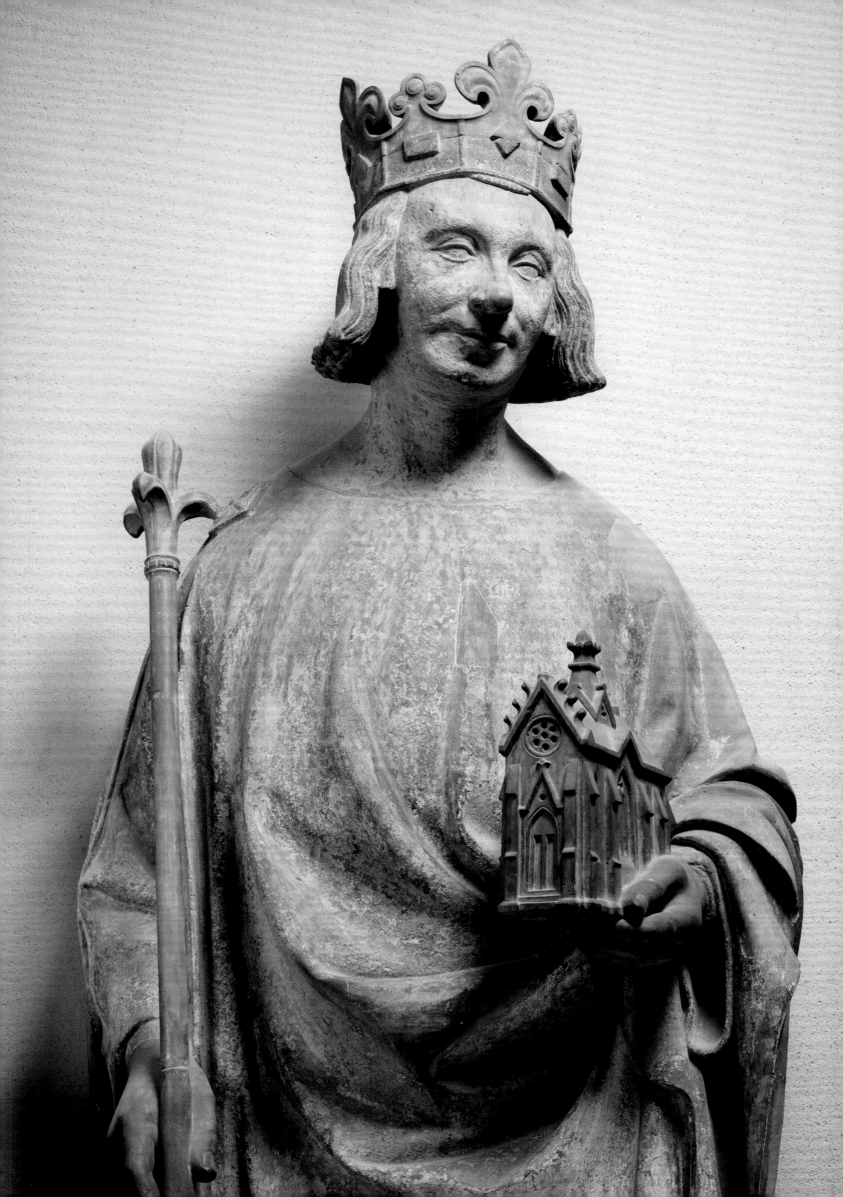

Middle Ages, but from the early sixteenth century, when another king, Louis XII, sought to strengthen the protection of his capital.

Now in the center of an urban district, the Louvre Castle retained one of its original functions: defending the king and his treasury and weapons, and ensuring his safety, while militarily holding the rebel city. Between 1360 and 1380, Charles V transformed the Louvre into a residence that was well protected from the city and the river by a system of walls and baileys.

At the beginning of his reign, Charles V ordered his architect, Raymond du Temple, to carry out modifications necessary to make the fortress habitable: new private chambers were built, alternating rooms and halls to accommodate the king and queen; large windows were opened; and a chapel was set up. A staircase of eighty-three steps leading to the piano nobile was added in 1364–69. Raymond du Temple's masterpiece, this monumental staircase known as the Grande Vis (Great Spiral), was punctuated by statues of the Virgin Mary, John the Baptist, the king and the queen, the king's brothers, and two sergeants at arms—one of which may be a portrait of the architect, who bore this title. When you walk along the trench around the keep, you notice the bases or corbels placed on the outside flank: these were the supports of the Grande Vis, built in a spiral form.

On the facades, other statues display the royal effigy, as Charles V had also ordered for the new fortress of the Bastille. The Louvre's Department of Sculptures preserves the sculptures of Charles V and Queen Jeanne de Bourbon from the royal collections, which were probably removed from a facade during the expansion of the château in the eighteenth century.

Outside, toward the north and the Seine, were two pleasure gardens, decorated with porticoes, wood pavilions, and even a menagerie—which, together with the art collections, constituted one of the manifestations of royal power. In addition, Charles V, called the Wise, friend of the arts and letters, transformed the Falconry Tower to the northwest into the Library Tower, where he stored part of the large royal collection of books. In 1373, the librarian Gilles Malet inventoried 973 works.

A superb and isolated white construction facing the city, bristling with towers and turrets, weather vanes and banners—this was the appearance of the Louvre of Charles V, represented in a rare number of works, such as the two famous altarpieces preserved in the Louvre, the *Pietà of Saint-Germain-des-Prés* and the *Altarpiece of the Parliament of Paris*.

The castle's treasury and royal stable also held valuable objects. It seems that during the reign of Charles VI, thieves stole many precious pieces, scraped the gold from them, and then threw the fragments into a castle well. Archaeologists found the fragments in 1984: tin plates displaying the heraldic arms of the dauphin, saddlery elements, and a parade helmet gilded and embellished with enamels, broken into a thousand pieces. In the royal inventory of 1411, this helmet corresponds to a "golden hat" decorated with winged deer, the motto "En bien," enamels bearing the lilies of France, and a crown formed out of fleur-de-lis. This refined emblem was that of King Charles VI and the future Charles VII, to whom the helmet probably belonged.

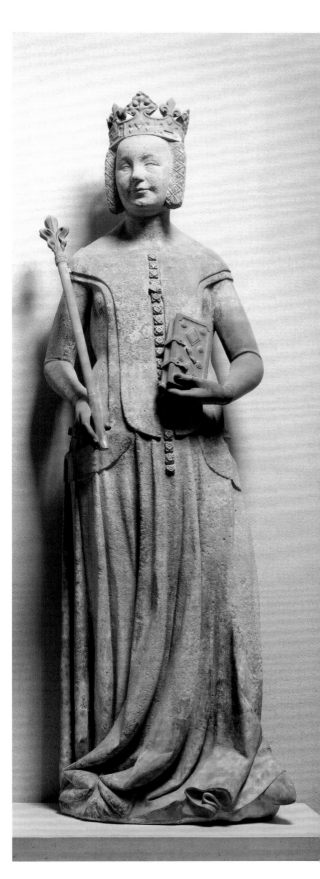

Opposite and right
Charles V, King of France (1364–1380)
and *Jeanne de Bourbon (1365–1380)*
Stone, H. 195 cm (76 ¾ in.)
From the exterior decoration of the Château
du Louvre, attested in the Salle des Antiques
of the Louvre from 1692 to the Revolution
Department of Sculptures, former Musée des
Monuments Français, Basilica of Saint-Denis,
transferred to the Louvre in 1904

Master of Saint-Germain-des-Prés
Lamentation of Christ, known as the *Pietà
of Saint-Germain-des-Prés*, 15th century
Oil on wood panel, 97 × 198 cm (38 ¼ × 78 in.)
Department of Paintings, confiscated during
the Revolution

In the background is the Louvre Castle,
seen from the south.

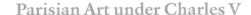

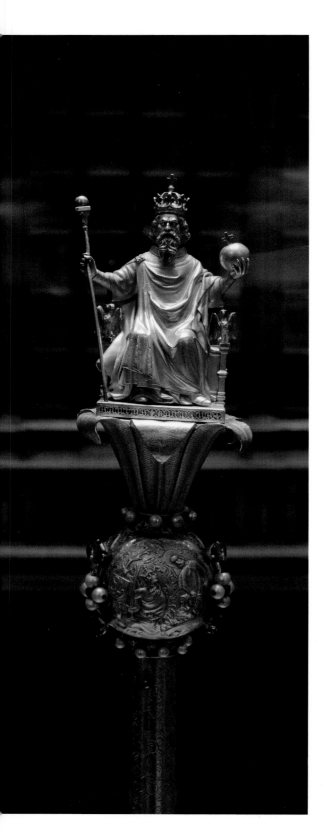

In the sculpture rooms, the statues of Charles V and Jeanne de Bourbon, from the Château du Louvre, introduced a renewal of the arts that animated the royal court. The patronage of princes, collectors and sponsors of works of art, and the beginnings of philosophical and literary humanism revolutionized the styles of the time. The genre of the portrait moved closer to reality, more present, more naturalistic, more sensitive to the expressions of actual life. The portrait of John the Good, which reproduced the king's features on a painted panel, was already a first in France. However, this work, the oldest easel painting representing an individual in profile, may reflect a lost prototype of the great masters of Sienese art, then working in Avignon.

The likeness of Charles V (p. 28), so recognizable by his large nose, comes to life with a gentle smile. The king is obviously rendered in a more austere way in his recumbent effigy from the "tomb of entrails" executed for the royal abbey of Maubuisson. In the French Painting rooms, he is shown kneeling in prayer in *The Narbonne Altarcloth*, a large grisaille on white silk, probably intended to decorate an altar during Lent. Here again, his sly grin animates the more stylized face.

But art was not limited to portraiture under Charles V. It was a time that saw a flowering of all techniques. The goldsmith's trade reached a peak before 1379 with the commission of the royal insignia, ordered by the king for his son's coronation. The scepter, which would later be used for other coronations, bears the statuette of the crowned emperor Charlemagne at the top, holding the scepter and the orb of the world and seated on a naturalistic lily—the traditional heraldic symbol of the kings of France—once adorned with white enamel. Beneath the lily, the globular node depicts legendary episodes of Charlemagne's life, in reference to the prestigious Emperor of the West. Charles V (and his son, the future Charles VI) was thus associated with an illustrious ancestor, whose first name he bore and whose glory he could boast of, thereby strengthening the legitimacy of dynastic continuity.

The linear elegance and expressive power of these characterizations revitalized the royal arts, whether it was that of sculptors, such as Jean de Liège—creator of the tomb of Charles V, whose elements are preserved in the Louvre—or painters, such as the master of *The Narbonne Altarcloth*, or even silversmiths.

Scepter of Charles V, known as Charlemagne
1364 (?)–1380
Gold (top), gilded silver (wadding), ruby,
colored glass, beads, H. 60 cm (23 ⅝ in.)
Department of Decorative Arts, returned
by Charles V to the treasury of Saint-Denis
on 7 May 1380, entered the museum in 1793

Opposite
John II the Good, King of France (1319–1364),
Paris, ca. 1350
Egg tempera on plaster coating applied to a fine
canvas glued on oak panel, stamped guilloché
on edge of gold background, original frame
carved from mass of panel, 60 × 44.5 cm
(23 ⅝ × 17 ½ in.)
From the Château d'Oiron, Poitou, given to
the scholar Roger de Gaignières and taken
from the sale of the latter in 1717 for the Royal
Library, Department of Paintings, deposit from
the National Library of France, 1925

Following spread
The Narbonne Altarcloth, ca. 1375
Gray wash on fluted silk imitating samite,
78 × 208 cm (30 ¾ × 81 ⅞ in.)
Altar cloth for Lent, Department
of Paintings, collection of Jules Boilly,
acquired for the Musée des Souverains
in the Louvre in 1852

Jehan rcy de fauc

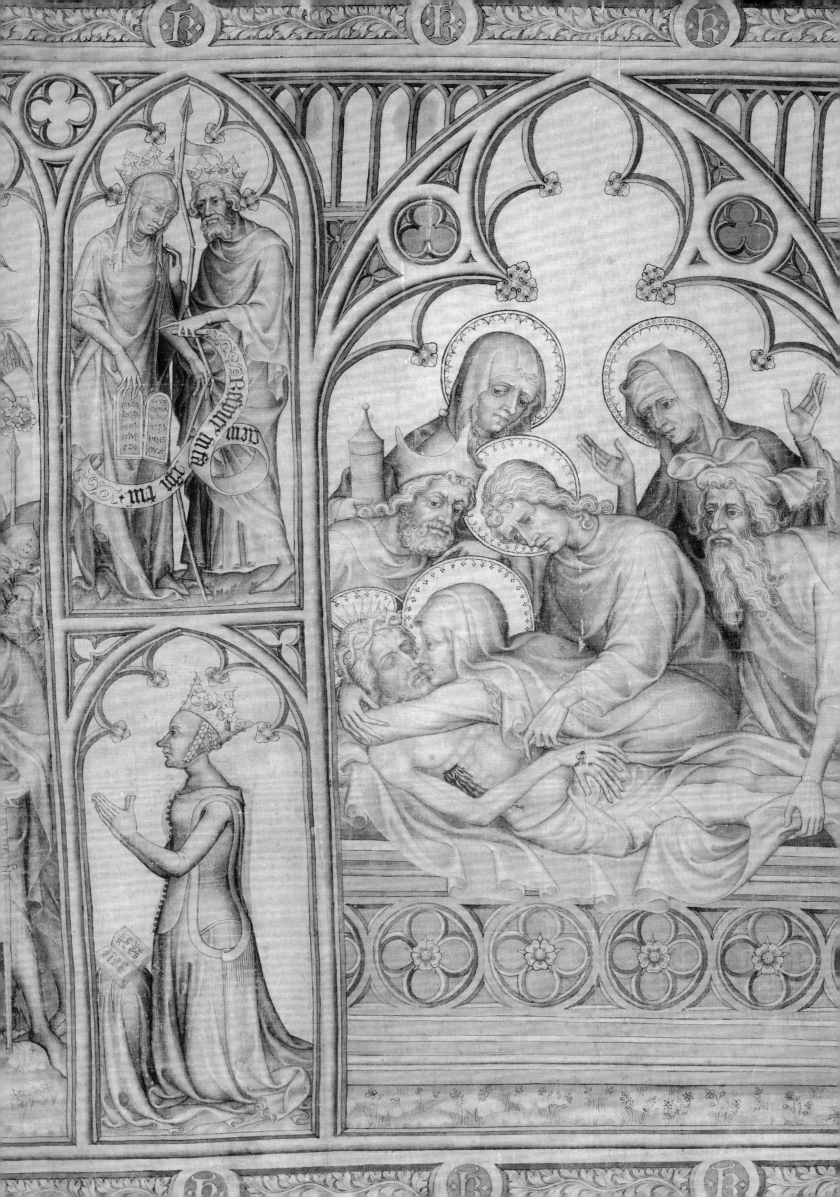

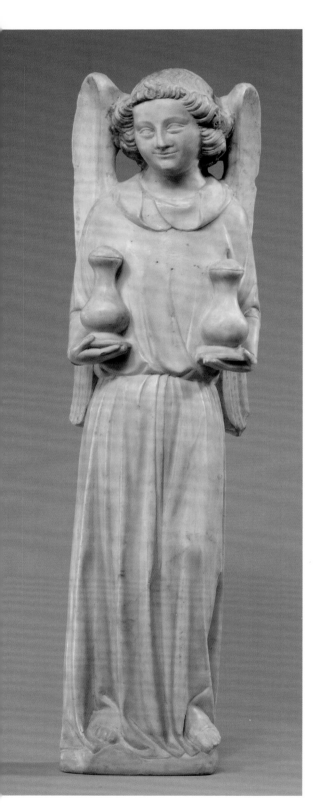

The French Primitives:
An Art-Historical Rediscovery

We should look not only at the works themselves or their authors, but also at those who discovered, acquired, studied, and showcased them in the museum. The masterpieces of the Middle Ages discussed here entered the Louvre relatively late in its history. The art of the French Middle Ages was long neglected at the Louvre, and although the first medieval sculpture was acquired in 1850, it was not until the 1880s that art historians succeeded in raising awareness about the importance of the various movements of that period and introducing them into the museum. Around 1880–95, the curator Louis Courajod traveled through France in search of the most significant examples of Romanesque and Gothic art—capitals, cornices, and statues—for the Department of Sculptures. In 1904, an exhibition devoted to the "French Primitives" established a new vision of painting, which since then has occasionally been accused of nationalistic chauvinism.

Thanks to this proactive initiative, in the nineteenth century the Louvre acquired the most outstanding examples of French art from the late Middle Ages. In the Department of Sculptures, an entire room was dedicated to medieval Virgins, which curator André Michel had been looking to collect. The Société des Amis du Louvre, founded in 1897, offered a large group from the Carmelites, who, following the law of separation of church and state in 1905, sold their heritage artifacts. *An Angel Carrying Two Cruets*, a delicate marble relief from the altar of the Maubuisson abbey, then entered the Louvre, along with the small recumbent effigies of King Charles IV the Fair and Jeanne d'Évreux, who decorated the tomb with their entrails in the same abbey.

If the works of the fourteenth century were then widely sought after, those of the fifteenth century would later become the object of all the museum's desires. The major regions then explored were Burgundy of the Grand Dukes of the West; the Loire Valley, which was the court's residence; Avignon, at the center of artistic crosscurrents from Italy and Flanders; and Bourbonnais, or Champagne.

Obviously, the Louvre cannot compete with these regions, which are custodians of their own heritage. However, the museum houses the great tomb of Philippe Pot, the heroic seneschal of Burgundy. This ensemble of statues featuring a recumbent effigy carried by eight hooded mourners is a fine demonstration of the power of Burgundian sculpture. In the same way, Jean Malouel's *Large Round Pietà*, also in the museum, shows the delicate expression of the court painters, informed by Flemish art. In 2012, this Pietà was joined by another one, larger in size but in the same style, which may have been commissioned by Philip the Bold's brother, Jean, Duke of Berry.

The Loire Valley experienced unprecedented development in the fifteenth century. Painting was dominated by the personality of Jean Fouquet, author of the great portrait of Charles VII, whose small enamel self-portrait from the frame of the diptych of Melun (ca. 1450), captures

Attributed to Évrard d'Orléans
(active 1292–d. 1357)
An Angel Carrying Two Cruets, ca. 1340
Marble, faint traces of polychrome and gilding,
H. 52.7 cm (20 ¾ in.)
Element of an altarpiece donated by Queen
Jeanne d'Évreux for the high altar of the
Cistercian abbey church of Maubuisson
(Val-d'Oise)
Department of Sculptures, acquired from the
Carmelites of the rue de Saxe, gift from the
Société des Amis du Louvre, 1907

Opposite
Jean de Liège (active 1357–d. 1381)
Jeanne d'Évreux (died 1371) and *Charles IV the Fair
(died 1328)*, 1372
Marble, L. 135 cm (53 ⅛ in.), D. 16 cm (6 ¼ in.)
Recumbent effigies from the abbey church
of Maubuisson
Department of Sculptures, acquired from the
Carmelites of the rue de Saxe, gift from the Société
des Amis du Louvre, 1907

Following spread
*Tomb of Philippe Pot, Grand Seneschal of Burgundy
(died 1493)*, 1477–83
Limestone, polychrome, H. 181 cm (71 ¼ in.),
L. 260 cm (102 ⅜ in.)
From the abbey of Cîteaux (Côte-d'Or)
Department of Sculptures, acquired in 1889

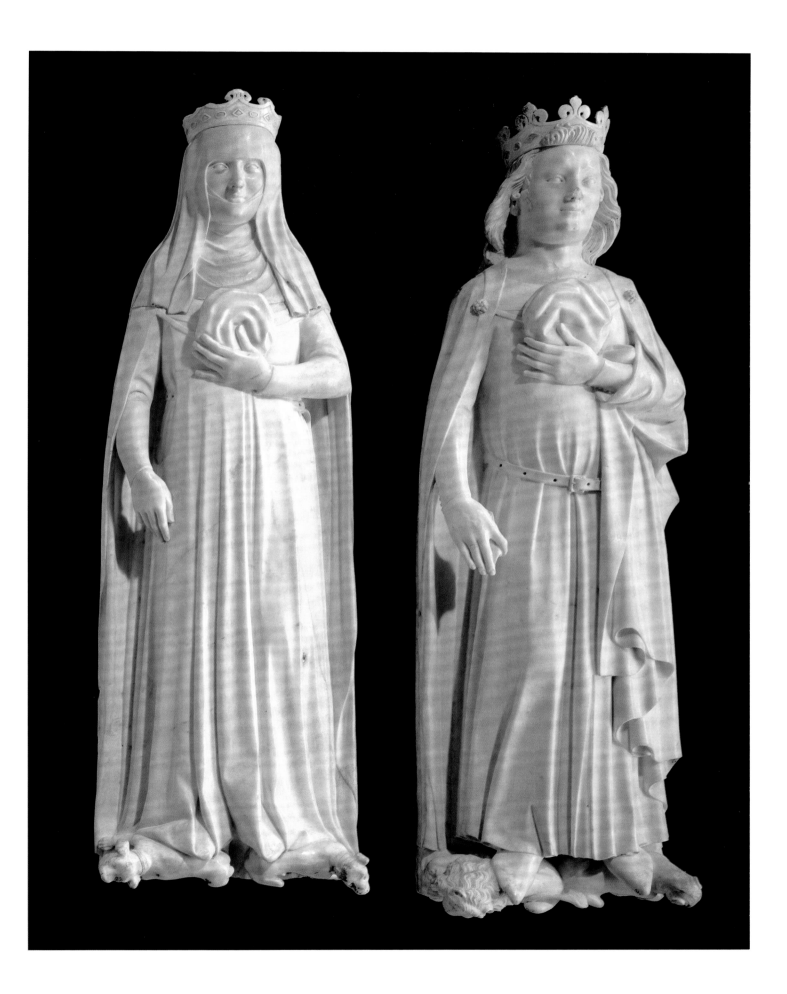

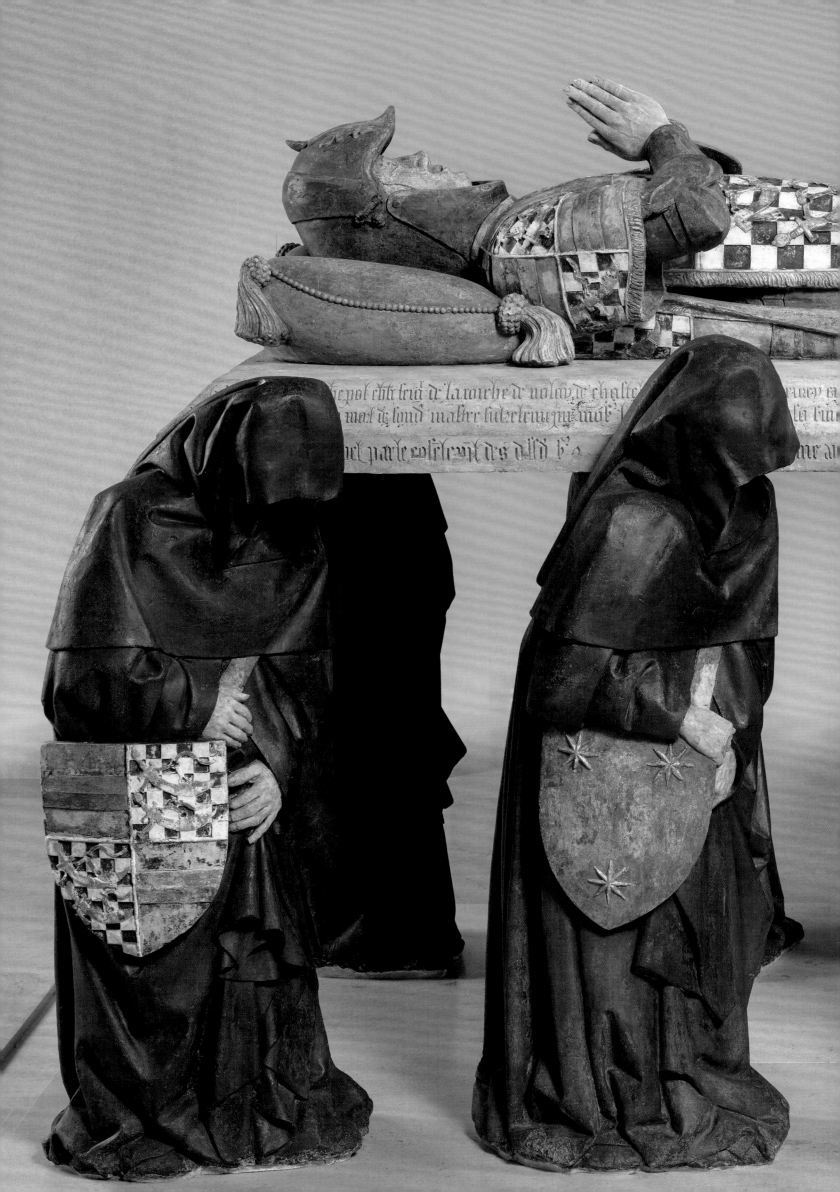

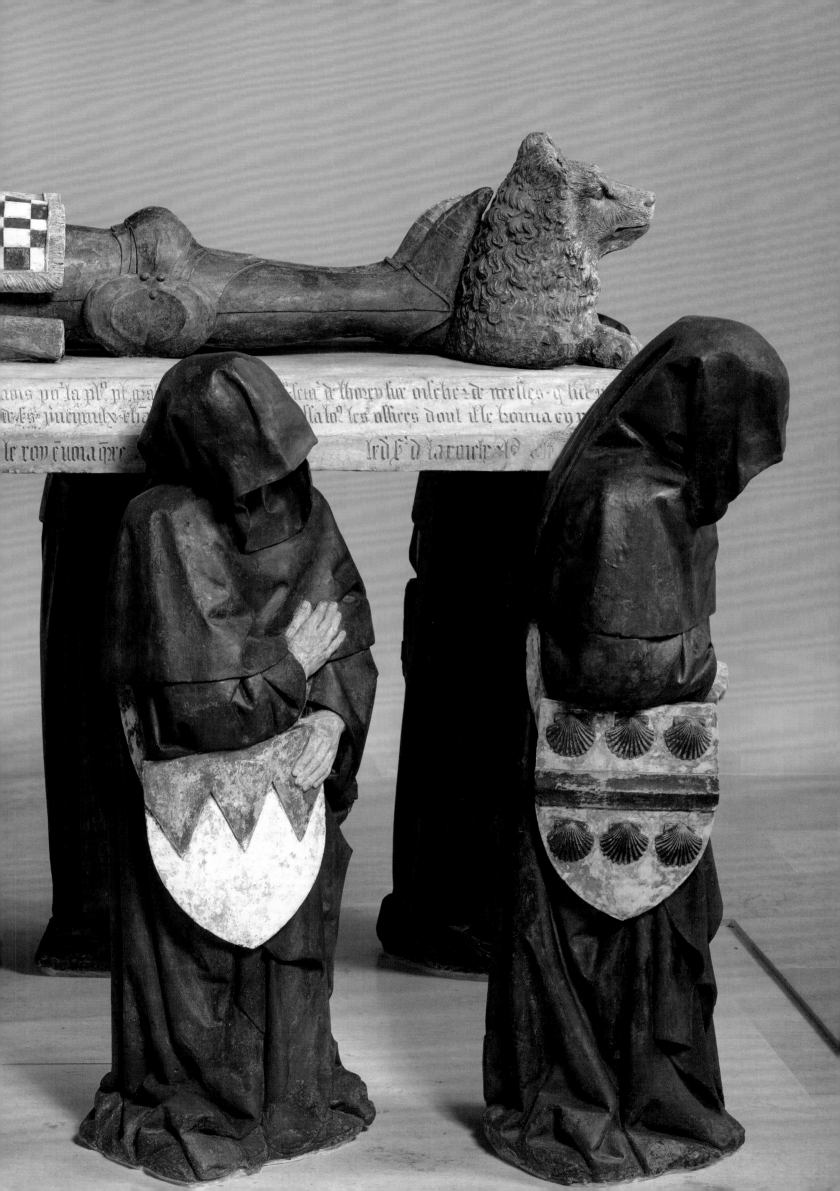

LE · TRESVETORIEVX · ROY · LE · FRANCE ·

CHARLES · SEPTIESME · TE · LE · NOM ·

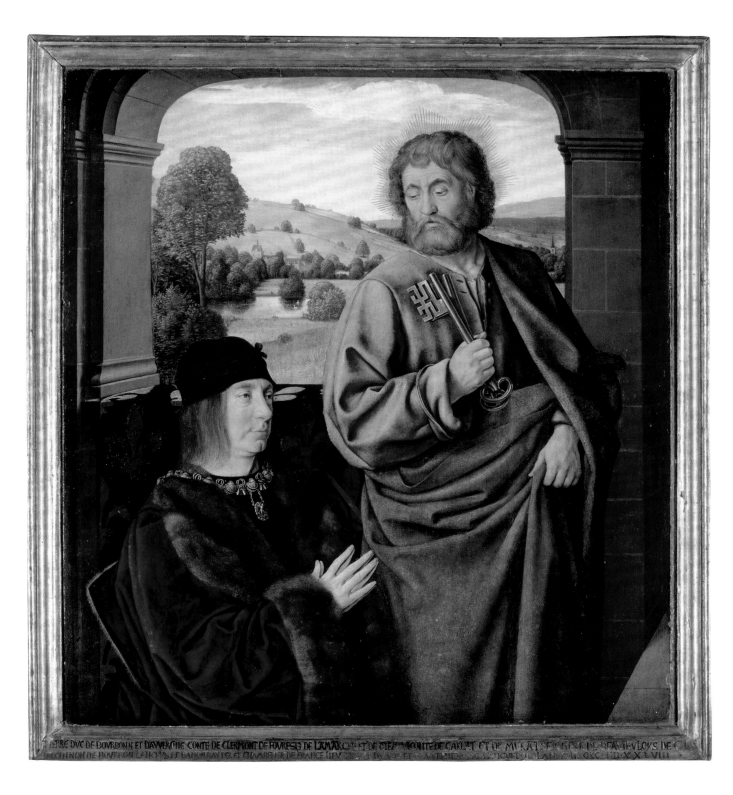

Opposite
Jean Fouquet (1420–78/81)
Charles VII (1403–1461), King of France, ca. 1450–55
Oil on panel, 85 × 70 cm (33 ½ × 27 ½ in.)
Department of Paintings, acquired in 1838

The painting, which was kept at Sainte-
Chapelle de Bourges, exalts the sovereign
with the inscription "Le très victorieux roy
de France Charles septiesme de ce nom"
("The greatly victorious King of France,
Charles the seventh of this name"), in reference
to his victory at Formigny, a major battle of the
Hundred Years' War (1450).

Jean Hey, originally from Brussels, identified
with the Master of Moulins (active 1480–1505)
*Pierre II, Sire of Beaujeu, Duke of Bourbon,
Presented by Saint Peter*, ca. 1492–93
Oil on wood panel, 73 × 65 cm (28 ¾ × 25 ⅝ in.)
Element of a triptych whose central part is now
lost and whose side panels represented the
donors, Pierre and Anne de Bourbon, and their
daughter, accompanied by the patron saints.
Department of Paintings, acquired by the
Musée de Versailles in 1842

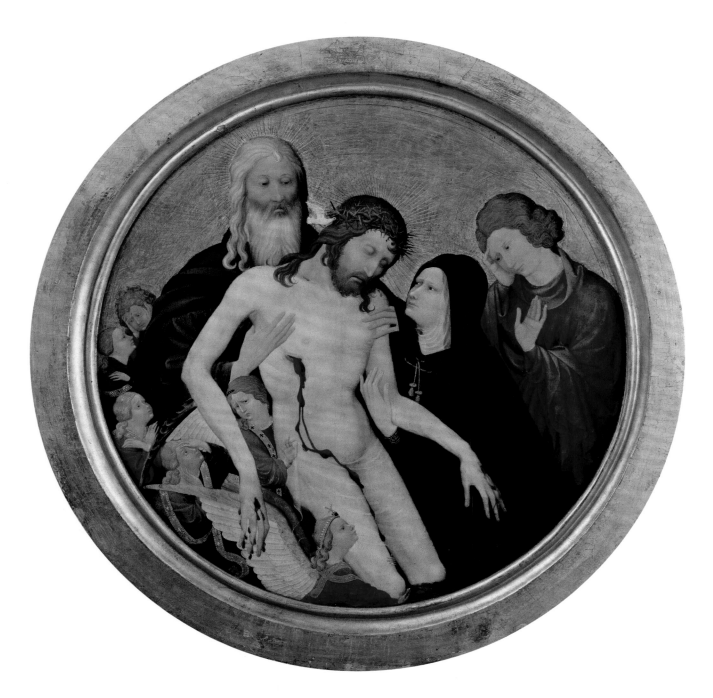

Attributed to Jean Malouel (ca. 1370/75–1415)
The Pietà of God the Father, called *Large Round
Pietà*, ca. 1400
Paint on oak panel, frame carved from mass
of panel, D. 64.5 cm (25 ⅜ in.)
Department of Paintings, J. Pujol collection,
Toulouse, acquired at the Pujol sale in 1864

Opposite
Jean Guilhomet, known as Jean de Chartres
(documented ca. 1465–d. ca. 1515/16)
Saint Suzanne, Patron Saint of Suzanne
de Bourbon, ca. 1501–3
Stone, H. 183 cm (72 in.)
From the castle of the dukes of Bourbon in
Chantelle (Allier)
Department of Sculptures, acquired in 1897

his extraordinary presence in the few centimeters of a locket. Its influence can be seen in the sculptures of the Loire Valley, for example, the moving *Saint John at Calvary* from Loché. Farther south, at the Bourbon court, we find a Flemish man, the Master of Moulins (Jean Hey), who delineates his figures in a pure light that sculpts their volumes. The patronage of Duke Pierre de Bourbon and Duchess Anne, daughter of King Louis XI, extended to the large statues of *Saint Pierre*, *Saint Anne Educating the Virgin*, and *Saint Suzanne*, which came from their castle in Chantelle into the museum collection. These works by the sculptor Jean Guilhomet, who was probably from Chartres, show the links that unite the various building sites of the kingdom, created by major sponsors and orchestrated by artists from diverse backgrounds.

This variety of origins is also characteristic of artists working in the Comtat Venaissin, the region surrounding Avignon. A holiday spot for popes in the fourteenth century, the city was visited by many Italian artists, creators of what is known as the Avignon School. This crucible in which the skills of painters, sculptors, and goldsmiths mixed would last until the fifteenth century. Enguerrand Quarton, who painted *The Pietà of Villeneuve-lès-Avignon*, was its leader. Originally from the Laon region, he imbued his figures with an austere drama that was both poignant and powerful. This theme of the Virgin of Mercy, or Pietà, cradling the body of the dead Christ on her knees, conceived as a medium for prayer and devotion, was born in the Germanic world in the fourteenth century and developed in France in the fifteenth. Each artist lent his own sensibility to the vision of the unfolding story. Thus, another Virgin of Mercy from Avignon, executed in stone at the same time as the *Avignon Pietà*, shows a more compact composition and a bloodier Christ, and the Virgin's face is just as marked by tears.

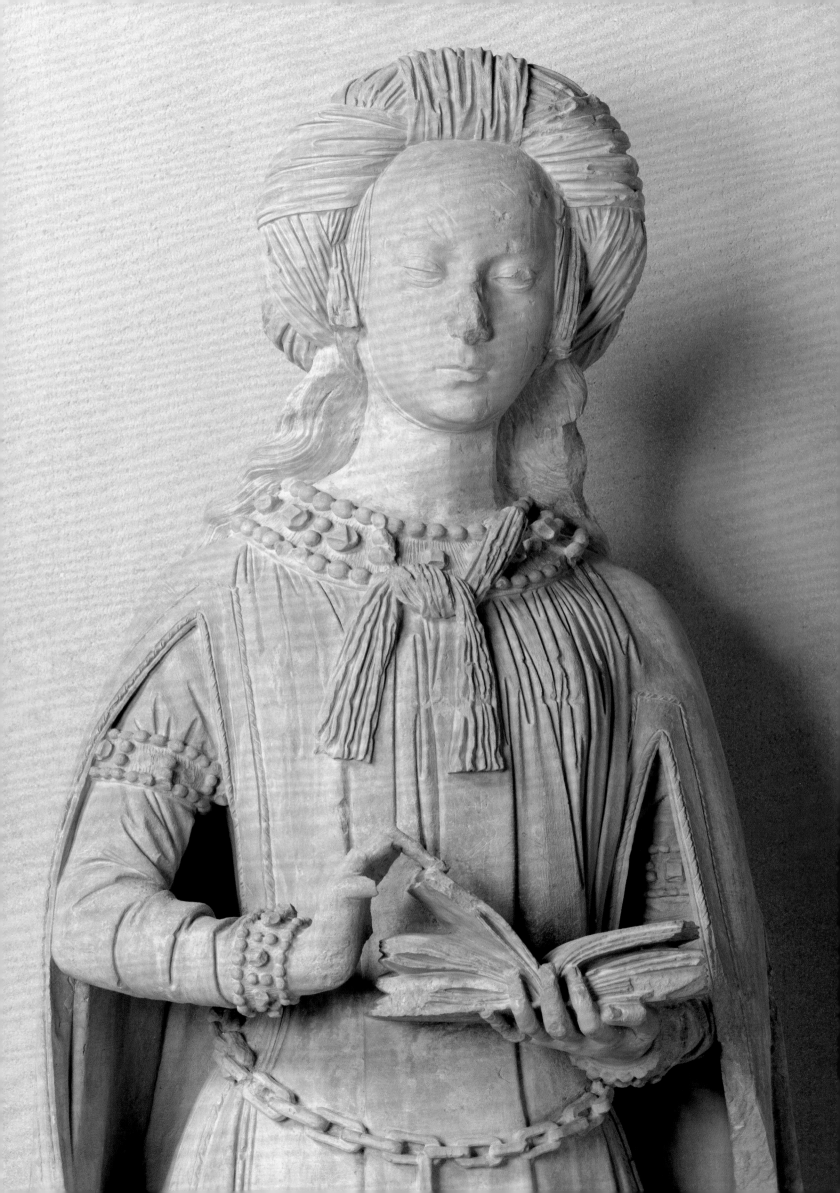

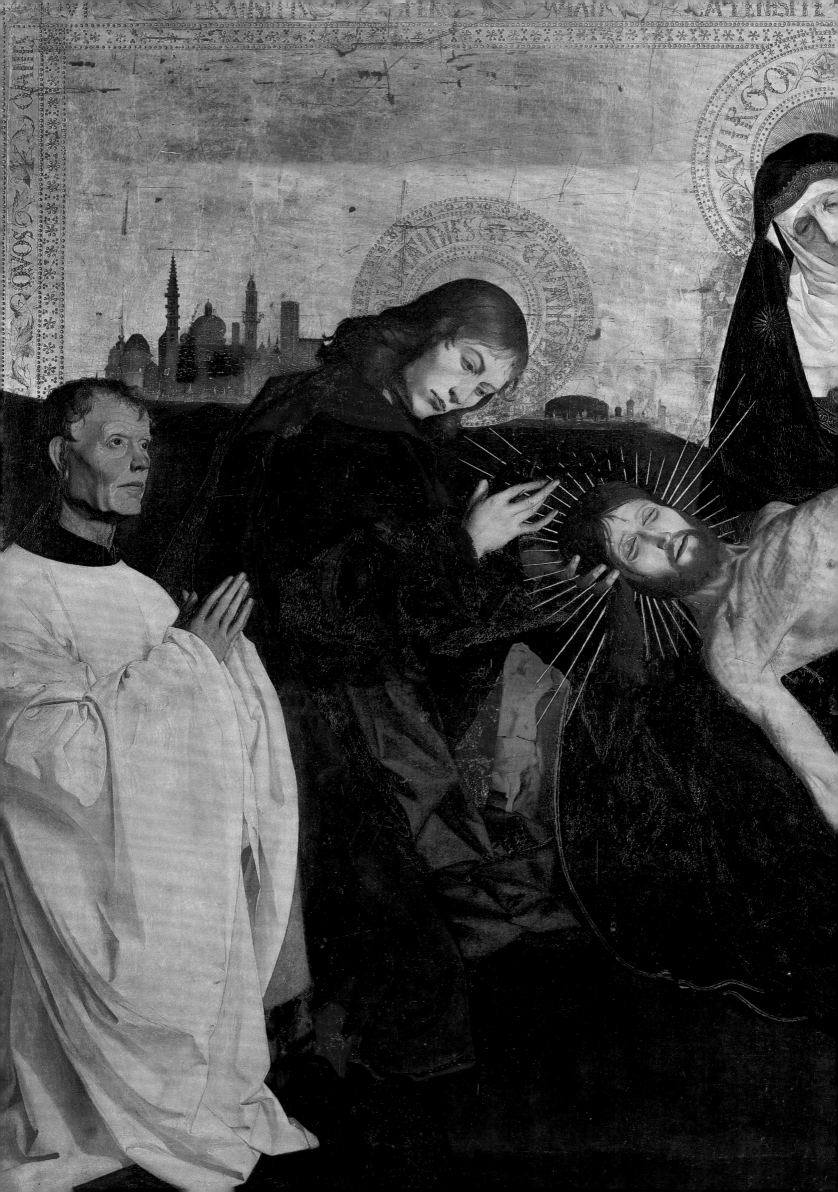

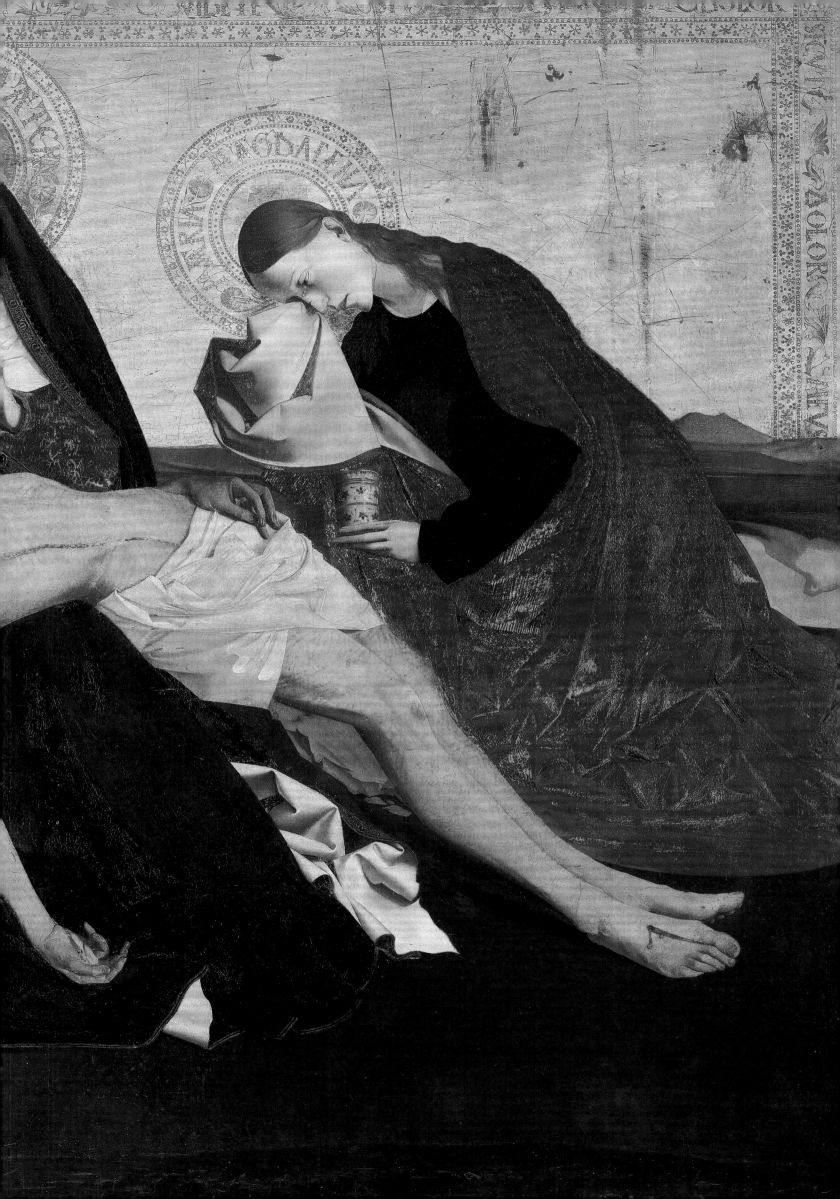

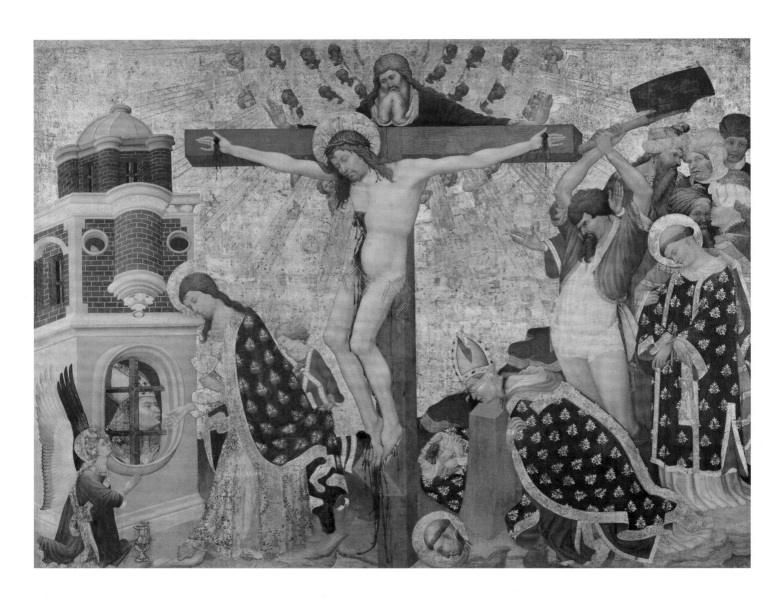

Previous spread
Attributed to Enguerrand Quarton
(documented in Provence 1444–66)
The Pietà of Villeneuve-lès-Avignon, known as
the *Avignon Pietà*, ca. 1455
Oil on three walnut panels, 163 × 218 cm
(64 ⅛ × 85 ⅞ in.)
Department of Paintings, acquired from the
town of Villeneuve-lès-Avignon, gift from
the Société des Amis du Louvre, 1905

Henri Bellechose (documented in Dijon
1415–44)
Altarpiece: The Martyrdom of Saint Denis,
Crucifixion, Christ giving Communion
to the saint in his jail and (detail on the right):
the beheading of the saint, 1416
Tempera on panel transferred to canvas,
162 × 211 cm (63 ¾ × 83 ⅛ in.)
Executed for the duke of Burgundy, John the
Fearless, for the Carthusian monastery of
Champmol in Dijon, placed under the name
of the Trinity Department of Paintings, gift of
Frédéric Reiset, Curator of Paintings
at the Louvre, 1863

Virgin and Child (detail), Lorraine, ca. 1330
Limestone, polychrome, H. 92 cm (36 ¼ in.)
Department of Sculptures, former Georges
Ryaux collection, acquired with the
participation of the Société des Amis du Louvre
in 1979

Opposite
Saint Valerie Cephalophore, Accompanied by Two
Angels (detail), Nivernais, late 15th century
Stone, traces of polychrome and gilding,
H. 110 cm (43 ¼ in.)
Department of Sculptures, acquired in 1911

The *Education of the Child* (detail),
late 15th century
Limestone, traces of polychrome and gilding,
H. 85 cm (33 ½ in.)
From the Longvé chapel (Bressolles, Allier)
Department of Sculptures, acquired in 1955

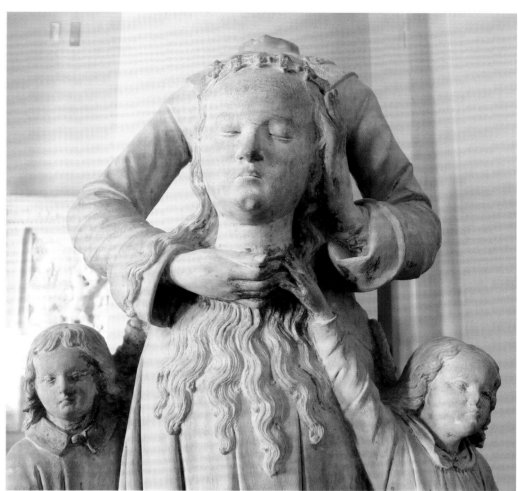

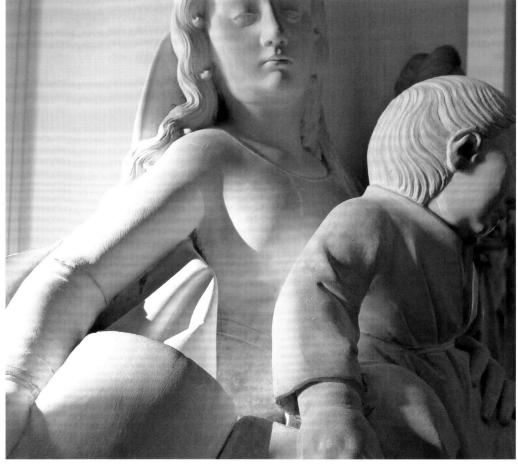

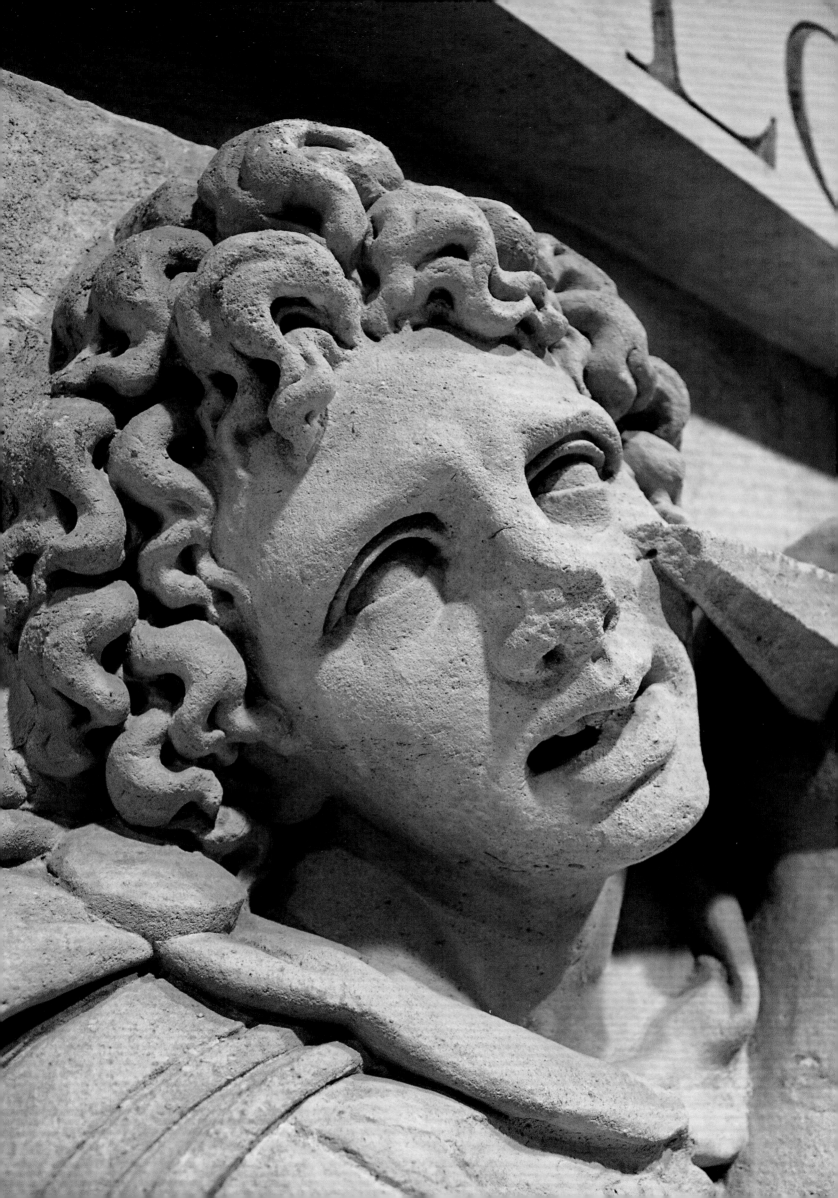

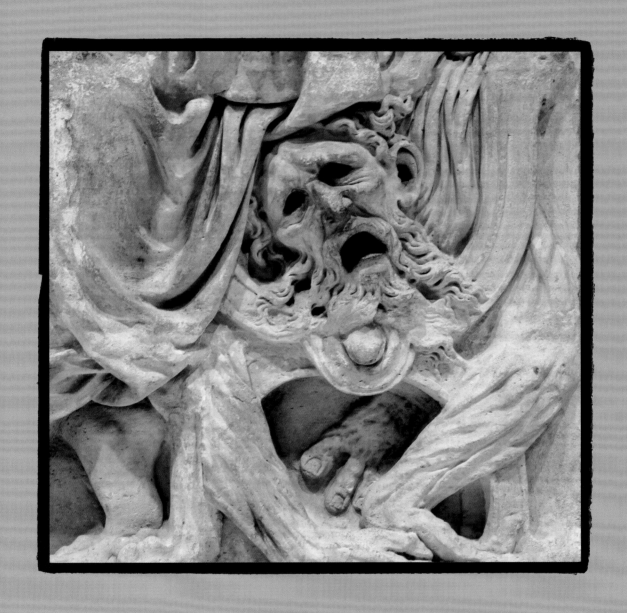

The Renaissance
Palace

Alexandre-Marie Colin (1798–1873)
*Charles V Received at the Louvre
by Francis I*
Commissioned for the Apollo
Gallery, 1843
Oil on canvas, 175 × 135 cm
(68 ⅞ × 53 ⅛ in.)
Paris, National Assembly, deposit
of the Louvre

Previous spread
Workshop of Jean Goujon
(active 1540–68)
The Son of Zaleucus Gouging His Eye
and *The Judgment of Cambyses* (details;
see pp. 66 and 65)

Opposite
Jean Clouet (1480?–1540/41)
Portrait of Francis I, King of France
(1494–1547), ca. 1530
Oil on wood panel, 96 × 74 cm
(37 ¾ × 29 ⅛ in.)
Department of Paintings, collection
of Francis I

This court portrait of the king, wearing the
necklace of the Order of Saint Michael,
follows the composition of the portrait of
Charles VII by Fouquet and is at the heart
of the dialogue between the art of the
North and that of Leonardo da Vinci.

N
ow let us leave behind the austere fortress of the kings of the Middle Ages and
turn to the splendors of the Renaissance rulers, who transformed the castle
into a residence in line with its times. The facade of the Cour Carrée, built by
Pierre Lescot; the great Salle des Caryatides; and the neighboring staircase,
today encompassed in a vast palace (and which only formed the modern wing of the medieval
château at the time of their creation), testify to the elegance of this French Renaissance. The
construction rested on the wish of one man: King Francis I, a refined aesthete and a great
lover of art. Work was actually conducted under the rule of his son Henri II, since it was only
at the end of Francis I's reign that, after having devoted himself to beautifying his castles
—Blois; Chambord; Villers-Cotterêts; Madrid and above all Fontainebleau—the monarch
finally decided, in 1546, to entrust the architect Pierre Lescot with the construction of a new
building in place of the western wing of the old Château du Louvre.

As early as 1518, Francis I had acquired for his mother, Louise de Savoie, a small estate
to the west of the castle, which would later form the nucleus of the palace of his widowed
daughter-in-law, Catherine de Médicis, who planned the future Tuileries Palace. On 15
March 1528, on his return from captivity in Spain, Francis I announced to the aldermen of
Paris that he intended to settle in the capital, and mainly in the Louvre, "recognizing that our
castle of the Louvre is the most convenient and proper place for us to reside." He had decided
to "have said castle repaired and put in order." Thus, the city redeveloped the quay in front
of the Louvre. Built in 1519, it was used as a commercial supply port for the city and allowed
unloading the stones necessary for the reconstruction of the castle. It was also an alternative
route, a faster way than Faubourg of Saint-Honoré for leaving Paris toward the west.

The king took little care of his castle, preferring to hunt in the game parks of his other
residences. To give the private chambers air and light, he had the Grosse Tour keep razed
in February 1528; the trenches were filled and the courtyard was paved. New apartments
were built, some of them painted with frescoes. To the west, the kitchens were grouped
around a vast courtyard (ca. 1530), keeping dangers and odors away from royal residents.
For his pleasure, an early racquets court was built on the other side, to the east. And for
the sound management of a kingdom heavily indebted by the war, he deposited the Trésor
de l'Épargne (central treasury) at the Louvre in 1532, as well as the war treasury and the
finance administration. The presence of the central treasury, then recently created (1523)
to bring together the management of the kingdom's income and expenditure, made the
Louvre the royal safe, the keys to which were in the hands of the presidents of the Court
of Auditors. From then on, the palace would become the residence of the until-then itin-
erant court. Francis I settled in the Louvre in 1534. He held celebrations there, such as the
wedding of the Duke of Guise and Mademoiselle de Longueville, and the reception of the
king of Scotland. The most sumptuous of these was organized in honor of Emperor
Charles V, on 1 January 1540. In the center of the courtyard, now cleared of the keep, there
was a gigantic statue of the god Vulcan holding a torch.

The king then considered transforming his castle from top to bottom. Around 1540,
the Italian architect Sebastiano Serlio, called to France by the king, drew in his *Sixth Book
on Architecture* a "casa del Re in città" (house for the king in the city), which was probably a

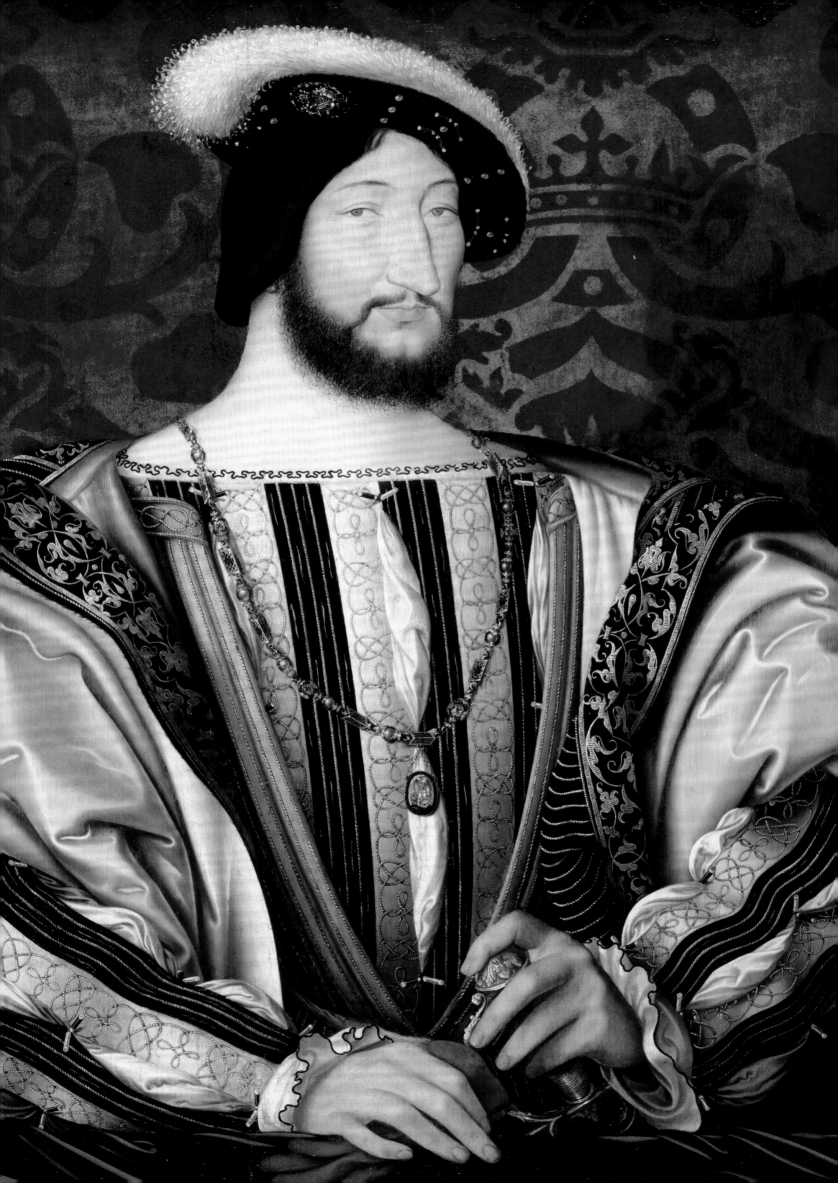

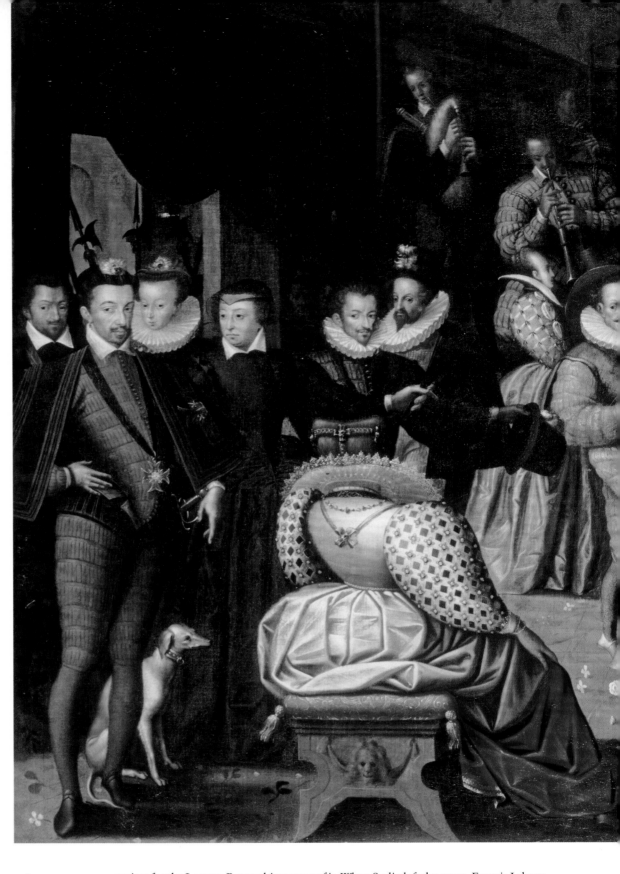

Ball at the Court of Henri III, ca. 1575–85
Oil on canvas, 120 × 183 cm (47 ¼ × 72 in.)
Department of Paintings, collection
of Louis XV

project for the Louvre. But nothing came of it. When Serlio left the court, Francis I chose a French architect: Pierre Lescot, Sieur de Clagny, a Parisian cleric who was the king's ordinary chaplain and abbot commendatory of Clermont, near Laval. On 2 August 1546, the king decided to commission Lescot with the building of "a large group of apartments in the place where the great hall was presently." On the site of the western residence, which was that of the great hall and certainly the widest, the architect built a new building, placing it in a very symbolic way within the narrow limits of the royal residence. Lescot would be in charge of the Louvre building site until his death (1570). But Francis I died shortly after having made his decision, and did not see the new palace that his son, Henri II, would order built through several construction campaigns and changes of program. It was then that the new generation of French architects emerged, who, following the Italian model, were no longer just master masons, but men of culture. They would forge the new

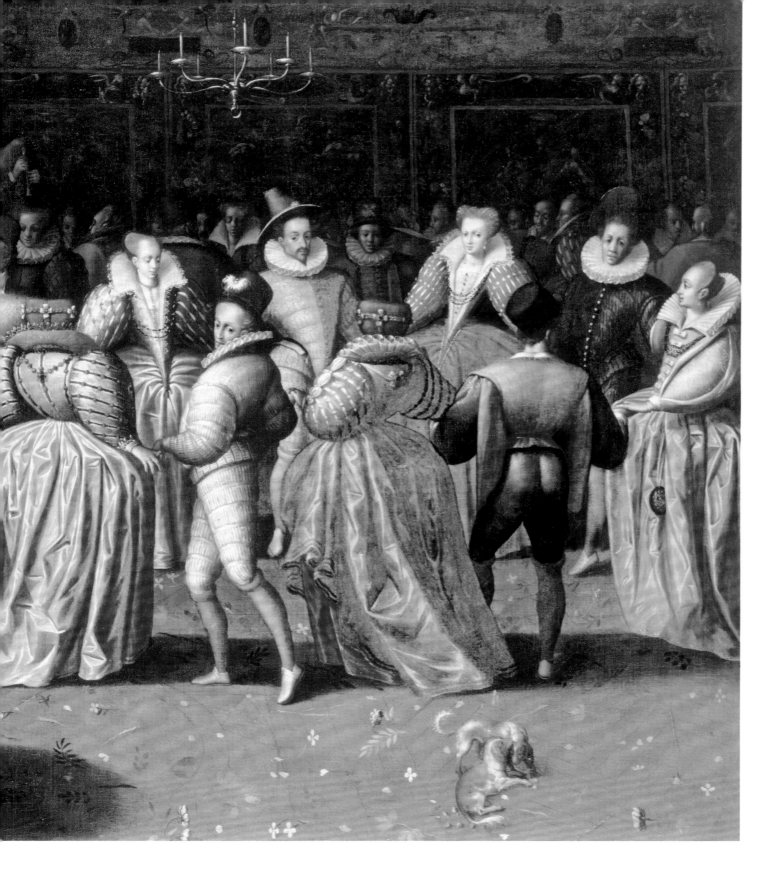

vocabulary of architecture, the heir to ancient art. The Louvre project appears to be a turning point in the assimilation of the language of Renaissance architecture and the great laboratory of its origin.

Pierre Lescot's Facade

The gilded Renaissance facade is distinguished from those of the other wings around the Cour Carrée by the abundance of its decoration. After the construction campaigns of the seventeenth to nineteenth centuries, the facade of this wing built by Pierre Lescot occupied only a quarter of the courtyard. While its plan seems coherent, it is actually the result

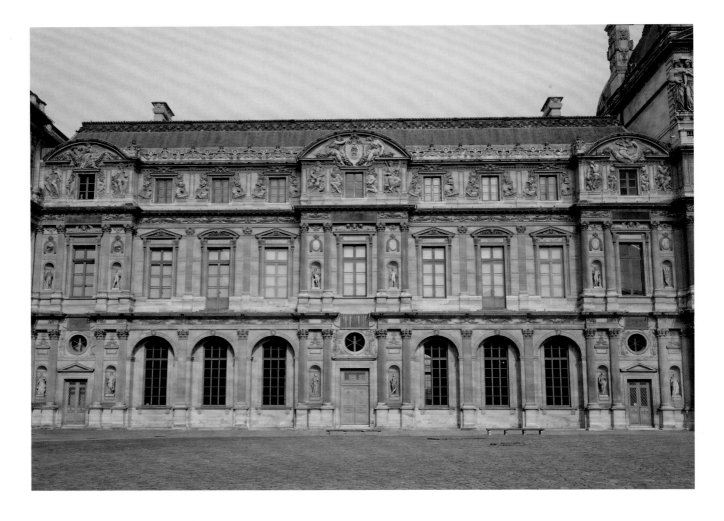

of twenty years of multiple rethinkings and experimentation, carried out between 1546 and 1566. Its structure was meant to reflect the original layout. Initially, Lescot had designed a clearly symmetrical distribution of elements, with a central staircase leading to a vestibule opening on to the avant-corps of the middle building, surrounded by two small rooms. The door, topped by an oculus that dated from 1548, would have given access to this main entrance. But according to letters dated 10 July 1549, the king decided to move the staircase northward, to make way for a single huge room rather than two small ones.

This relocation led to a radical change in the structure of the facade: two newer, slightly narrower lateral avant-corps were built at both ends, the one on the right giving access to the stairs. Lescot therefore conceived a facade with a highly punctuated rhythm: three column-shaped avant-corps that alternated with the two slightly recessed intermediate wings, and that presented a dynamic succession of arcades on the ground floor, like a false peristyle, and a procession of large windows on the first floor. On the ground floor of the avant-corps, the doors are surmounted by large oculi framed by allegories executed in 1548–50 by Jean Goujon, architect and sculptor, author of the woodcuts illustrating the translation of the treatise of Vitruvius (1547), and a theorist of ancient architecture. On the first floor, in May 1552, Goujon produced the lintels of the windows: in the avant-corps, he depicted a Diana's head "interlaced with crescents" between two dogs; and in the wings, horned heads of male and female satyrs. A few months later, he executed the frieze featuring chubby cherubs holding garlands, the royal monogram ("H"), and the symbol of Diana—the crescent—with birds pecking at it.

In 1553, at the moment when construction was in full swing, the architectural design changed again—the wing had to be topped with a second floor in the style of an Italian attic. The high French-style roof was replaced by a mansard roof, the lower part of which was covered with stone lacework. This attic maintained the system of the three avant-corps, with alternating wings and rectangular windows. For the avant-corps, in May 1554, Goujon undertook to "enrich three large pediments over the top floor of the basement with figures of medium size." The windows were confined by military trophies that exuded an almost brutal force. Their large size, true to the precepts of Vitruvius, was intended to bring the

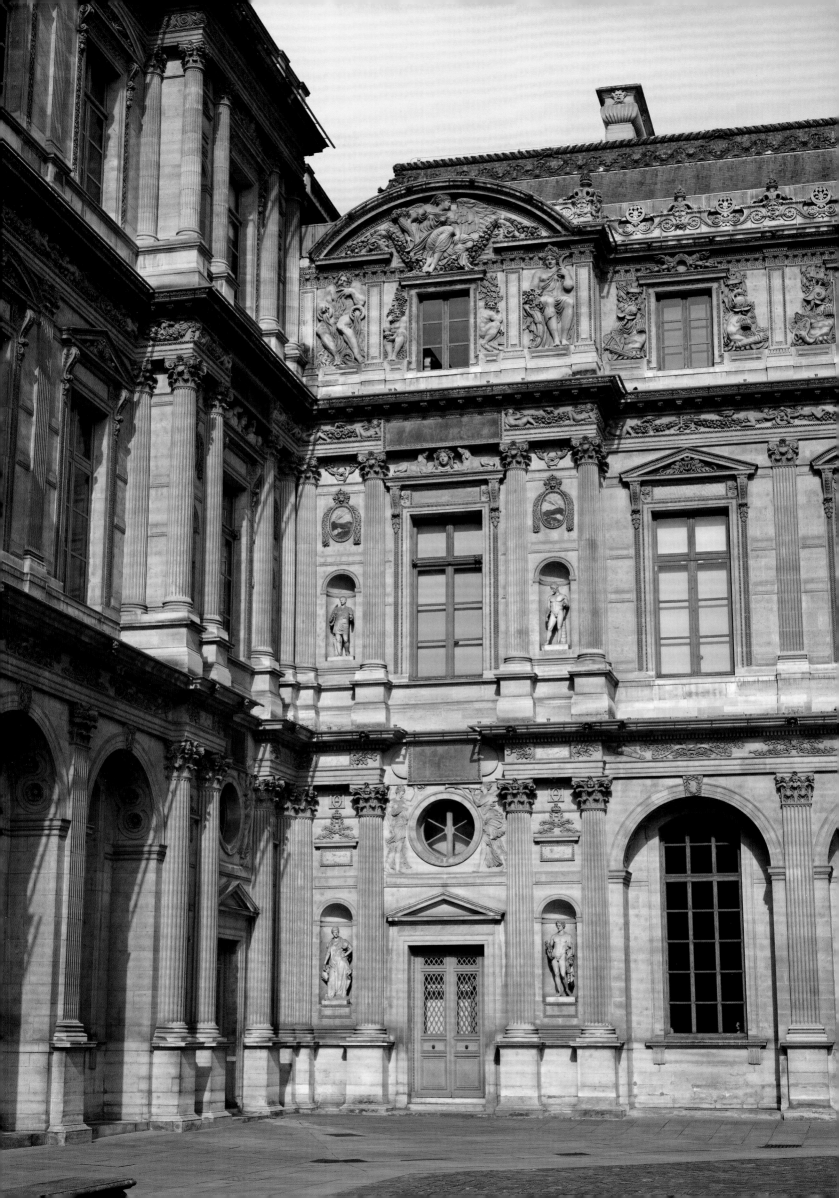

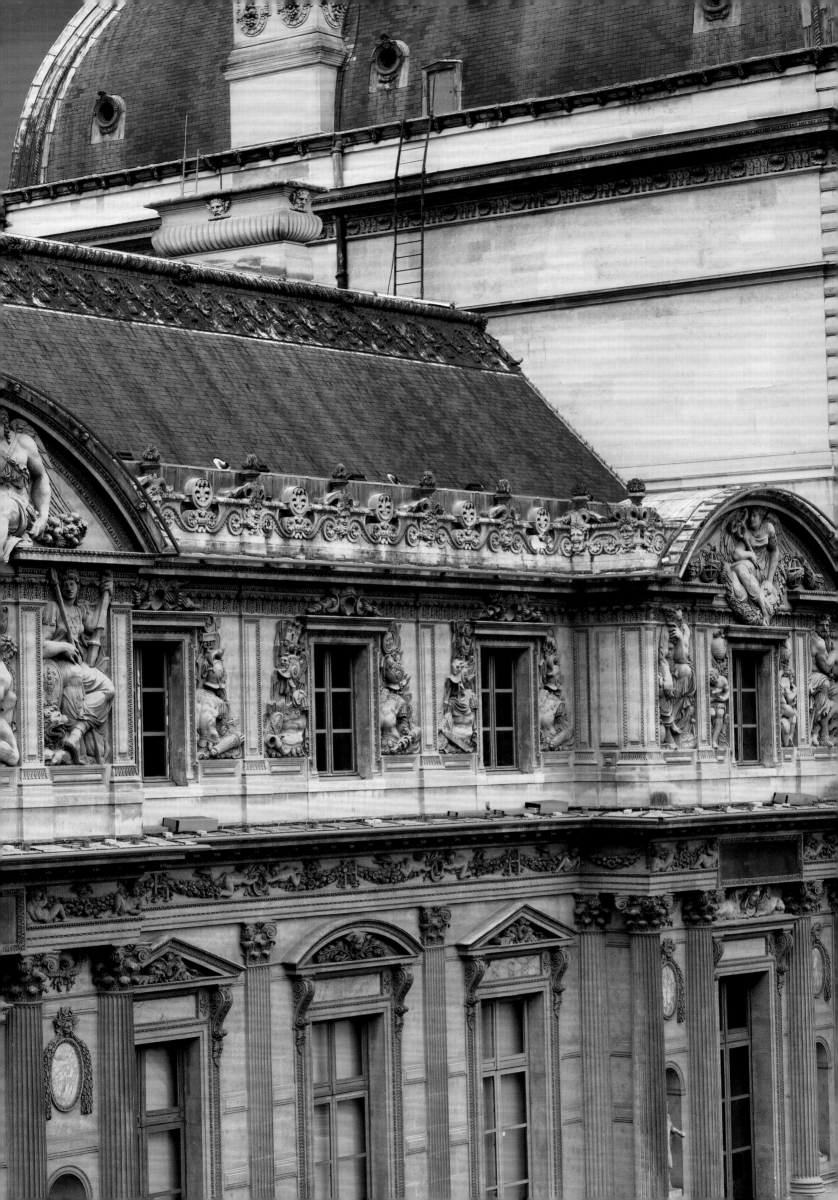

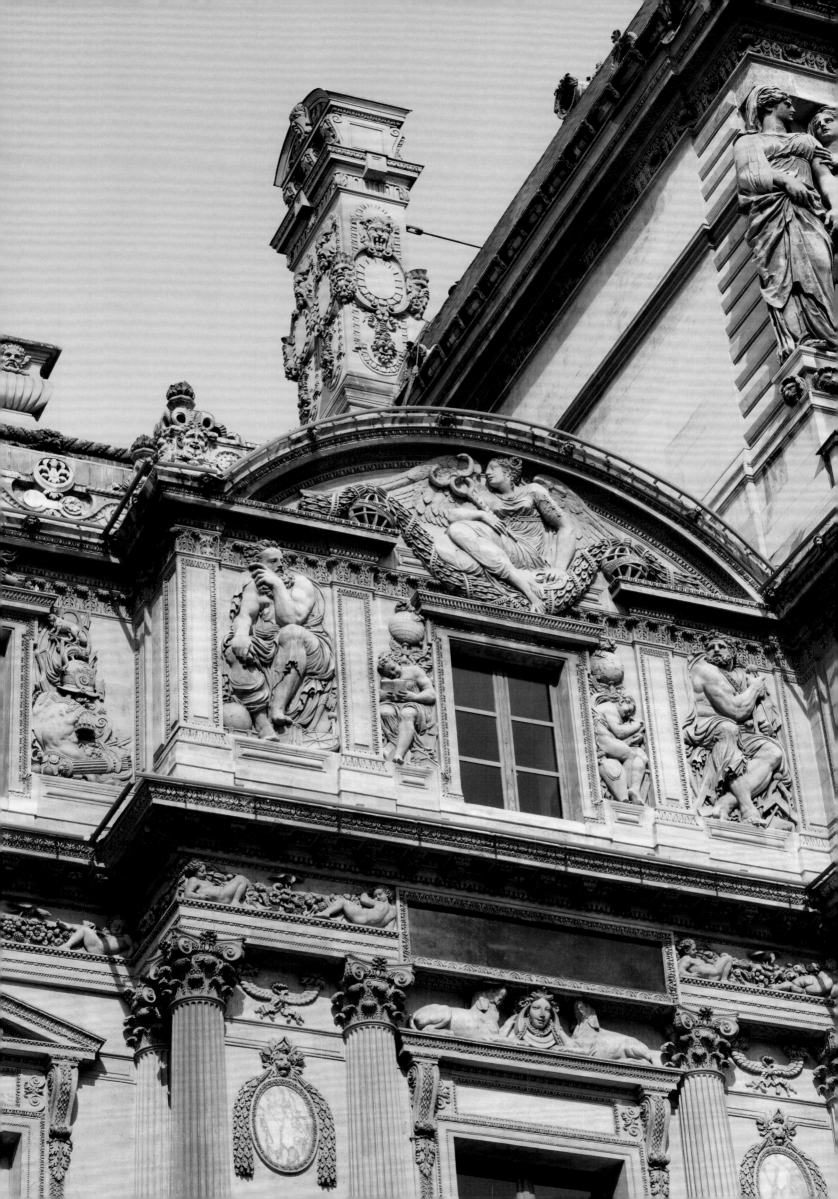

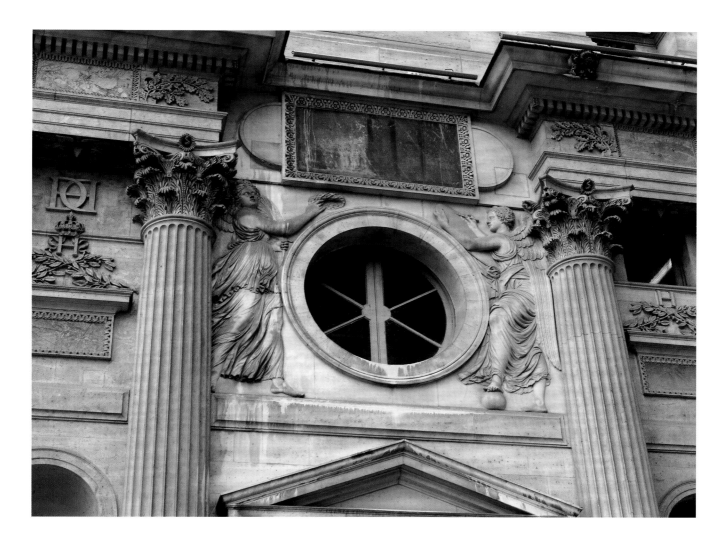

sculptures closer to the viewer, otherwise far from their reach. The plastic density, an expression of restrained power, also owes much to familiarity with Michelangelo's work.

Lescot's facade was totally innovative, with its strikingly punctuated structure, which clearly echoes an ancient triumphal arch; its mansard roof, which launched a long French tradition; and the play of colors. The subtle polychrome enhances the stone's blond features. This is the coarse-grained limestone from Saint-Leu-d'Esserent, in the Oise region, into which the oculi, carved by Goujon in very fine, hard, and white binder stone were inlaid, and on which the colored marble slabs from the Pyrenees, that formed ovals, cartouches, and lintels, were applied.

Jean Goujon's presence on the site from 1548 to 1562 was a novelty that gave sculpture an unequaled place in French architecture. To analyze his style, you have to visit the room dedicated to him in the Department of Sculptures. The reliefs of the parapet of the Saint-Germain-l'Auxerrois rood screen—another collaboration of Goujon and Lescot—are also on display there. The central image of the reliefs, Our Lady of Mercy, is actually a Lamentation of Christ, and is inspired by the composition of the *Pietà* from Château d'Écouen, executed by the painter Rosso Fiorentino for Constable Anne de Montmorency, which is also kept in the Louvre. The influence of Michelangelo and engravings after Raphael can also be seen in the four small reliefs depicting the Evangelists that adorned the rood screen. But the resulting style represents not only an amalgamation of certain forms: it is the fruit of a light and subtle manner of sculpting, featuring delicate relief work and fine wet-drapery. The allegorical figures decorating the oculi on the ground floor are akin to the nymphs that Goujon had created for the Fountain of the Innocents (1549), built for Henri II's royal entry into Paris. After the fountain's transformation at the end of the eighteenth century, the standing figures were recovered in the new temple-like monument, but the horizontal reliefs were sheltered in the Louvre. As on the Louvre facade, the reliefs show reclining nymphs surrounded by small aquatic spirits are ringed by a fine line that defines the undulation of the bodies, while draperies in very low relief reveal the sensual amplitude of the shapes.

Detail of a facade of the Louvre on the Cour Carrée, west wing built by Pierre Lescot, oculus of the northern avant-corps sculpted by Jean Goujon in 1549; the allegorical figure of Victory extends a crown to History as she writes

Opposite
Detail of a facade of the Louvre on the Cour Carrée, west wing built by Pierre Lescot, attic floor sculpted by Jean Goujon in 1553, part of the northern avant-corps: the figure of Science surmounting two ancient scientists, and two cherubs writing and reading

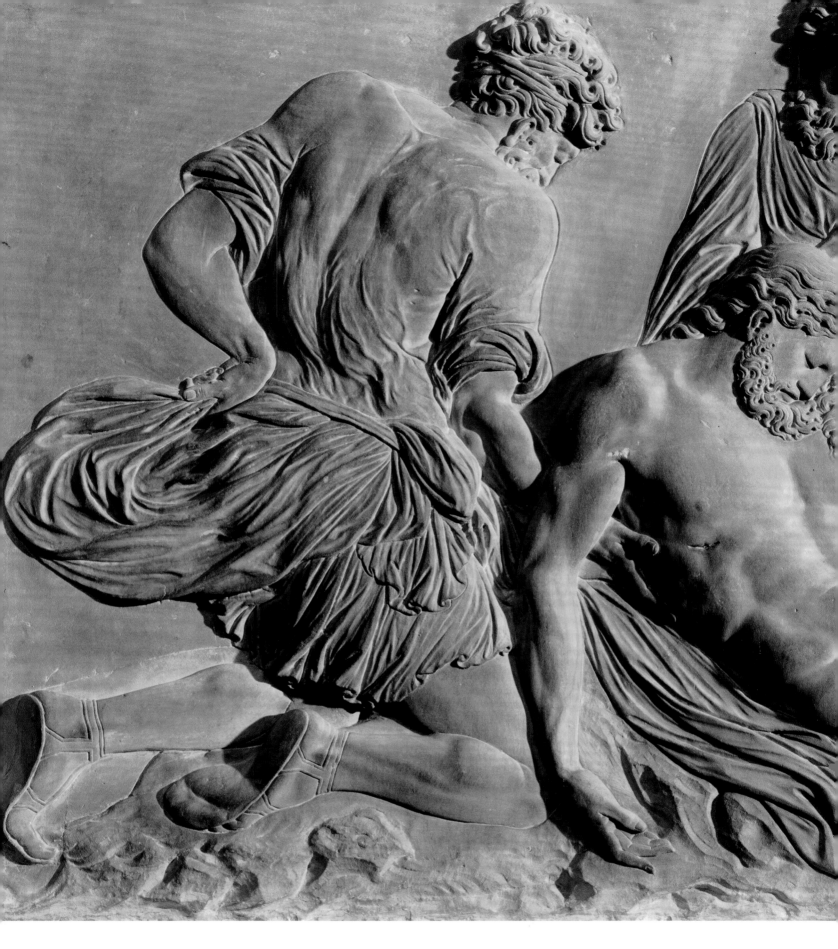

Was Goujon more than a sculptor at this Louvre building site? In the introduction to the collection of illustrations of Henri II's ceremonial entry, he boasted of being the architect to the constable of Montmorency, a lavish patron and friend of the king. In this capacity, Goujon had participated in the construction of the Château d'Écouen, embellished with famed figures—probably made by his own chisel—similar to those on the Louvre. It is not impossible that his collaboration with Lescot was more than that of a simple executor and workshop manager. However, Goujon's life remains an enigma to this day. We

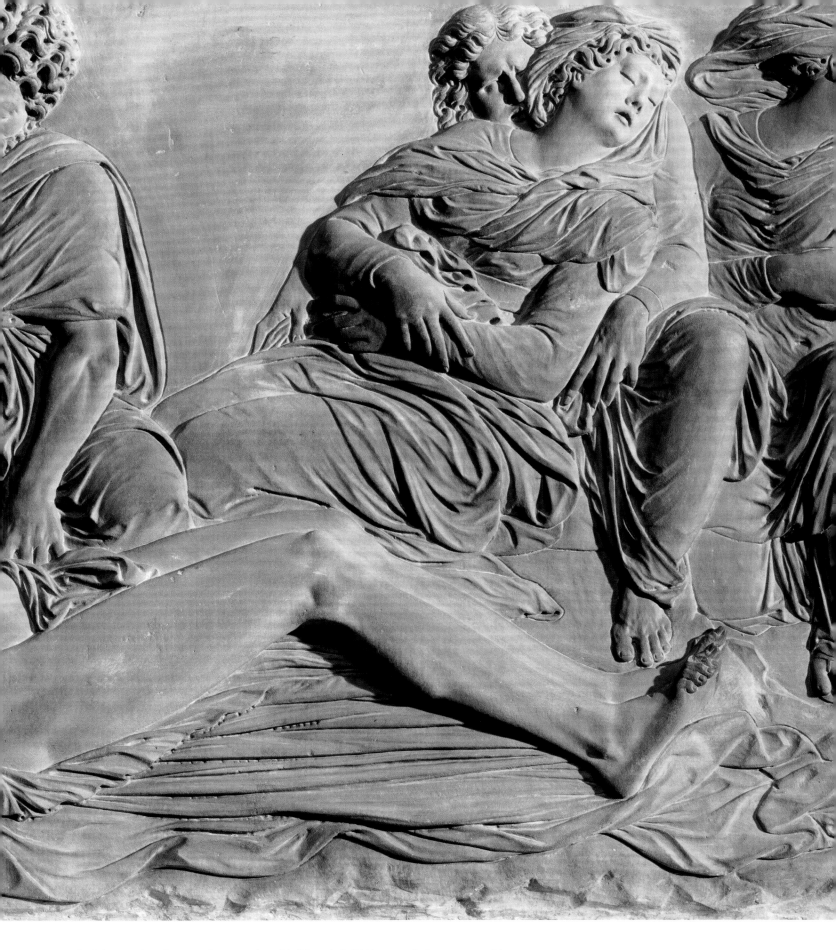

don't know where he came from or where his life ended. Did he go to Italy to return with the knowledge of the ancient world? His name is first mentioned in documents in Rouen: he produced the first beautiful isolated column of the French Renaissance, done in the antique style, for the organ loft of Saint-Maclou. After a commission for the tomb of Louis de Brézé, husband of Diane de Poitiers, was erected in the axial chapel of Rouen cathedral, he finally appeared in Paris in 1544 in the orbit of Lescot, in Saint-Germain-l'Auxerrois, at the Fountain of the Innocents and then at the Louvre. But while his work at the Louvre

Jean Goujon (active 1540–68)
Our Lady of Mercy, or *Lamentation of Christ*, 1544–45
Stone, 67 × 182 cm (26 3/8 × 71 5/8 in.)
Bas-relief executed for the parapet of the rood screen at the church of Saint-Germain-l'Auxerrois, built under the direction of Pierre Lescot
Department of Sculptures, former Musée des Monuments Français, transferred to the Louvre in 1818

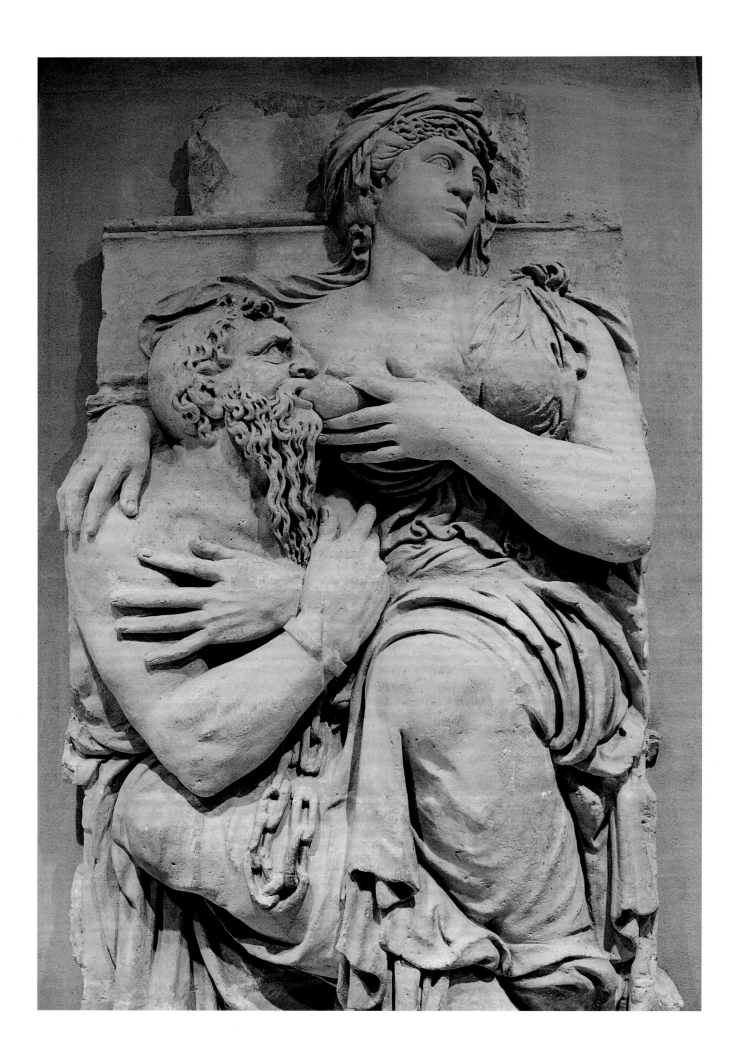

site is attested by numerous documents, contracts, and accounts, in 1562 he mysteriously disappeared. A late testimony in a trial indicates his presence in Bologna. Did he leave France for religious reasons (he was a Protestant, as were many artists and writers) or to pursue other projects? Or perhaps to escape the law (he had been imprisoned for debts in 1552)? We do not know.

The themes represented on Lescot's facade express the ambitions of Henri II and a highly philosophical, almost mystical, conception of royal power. The "very Christian" king, crowned in Reims, aspired to the empire, but also to dominate his kingdom as the guarantor of the divine order. The iconographic program of the facade supports and demonstrates these aspirations but remains difficult to interpret. The allegories of the oculi are probably there to illustrate the engraved motto: "Virtuti regis invictissimi" ("To the virtue of the totally undefeated king"). They surely represent History and Fame, and probably themes of victory. In the attic, the symbolic themes are distributed according to the three avant-corps. In the center, framing the royal arms held by the figures of Fame, and two warrior deities, Mars and Bellona, embody the victorious power with two chained captives by their sides. On the right avant-corps, two ancient scientists, accompanied by cherubs reading and writing, frame a figure of Science or Knowledge, who holds a caduceus. On the left avant-corps, Nature, with her cornucopia, is surrounded by the deities of Nature: Ceres and the harvests, Bacchus and the vine, Pan and the woods, Neptune and water. Thus, around the power of war, Nature and Science express the divine order, of which the divine and monarchical Concord is the authorizing figure.

After the construction of the new wing, Lescot undertook a pavilion following the wing southward. This large, higher pavilion, which was to house the king's apartment, resembled a keep, but one that was symbolic and not actually defensive. The king's chamber still communicated with the medieval wing, which had to be partially demolished to provide the queen a prestigious apartment. From then on, it became possible to envisage a new château, with a square or rectangular courtyard surrounded by Renaissance facades.

Workshop of Jean Goujon (active 1540–68)
The Judgment of Cambyses, detail: the remains of the corrupt judge, ca. 1560–64
Stone, H. 269 cm (105 ⅞ in.)
Illustration of a story reported by Herodotus; King Cambyses ordered the son of a corrupt judge to sit on his father's flayed remains
Relief from the attic of the south wing of the Cour Carrée, removed in 1807
Department of Sculptures, former Musée des Monuments Français, École nationale supérieure des Beaux-Arts, transferred to the Louvre in 1988

Opposite
Workshop of Jean Goujon (active 1540–68)
Roman Charity, or *Cimon and Pero*, ca. 1560–64
Stone, H. 269 cm (105 ⅞ in.)
Illustration of a Roman story reported by Valerius Maximus: the young Pero breastfeeding her father in prison
Relief from the attic of the southern wing of the Cour Carrée, removed in 1807
Department of Sculptures, former Musée des Monuments Français, École nationale supérieure des Beaux-Arts, transferred to the Louvre in 1988

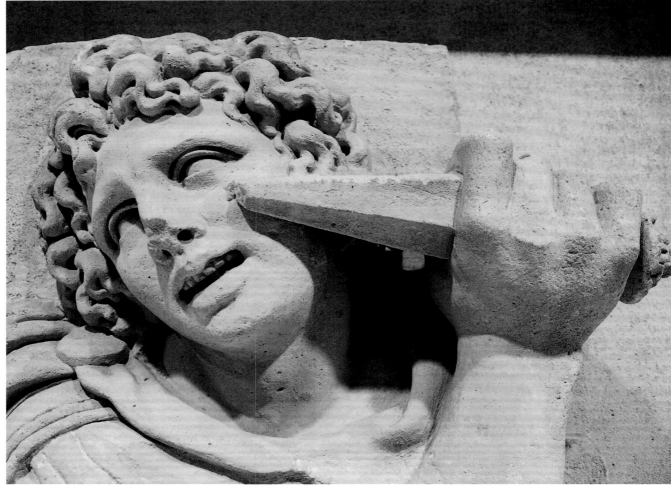

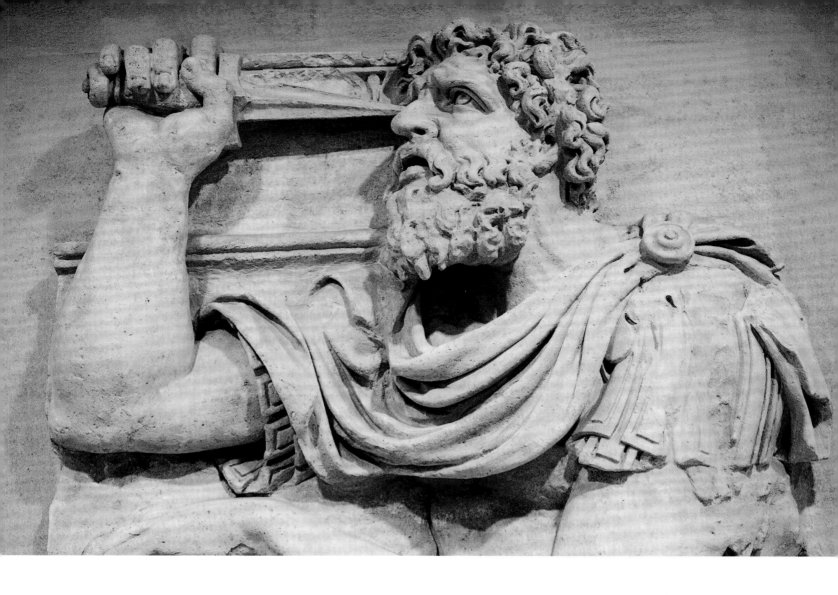

In fact, according to Jacques Androuet du Cerceau, Henri II, "being so greatly satisfied with the sight of such a perfect work, he decided to have it continued by three other sides, to make this courtyard unique."

Now let's turn south, to the wing dedicated to the queen, which attracts less attention. While it had the same elevation as the Lescot Wing, with two pedimented avant-corps, it was transformed under Napoleon I by the architects Percier and Fontaine, who destroyed the attic to accommodate the same structure as the rest of the Cour Carrée.

Here, again, Lescot changed his program. He began with the first span, flanked by two avant-corps. The decoration continued after the death of Henri II. Although an "H" had begun to be carved for the king's initial, soon there was need for a "K," denoting his son Charles ("Karolus") IX. Goujon departed, and other sculptors—the Lheureux brothers, Martin Lefort, and Étienne Carmoy—executed the decorative sculptures in 1562–65. Then the last span was erected, which would carry the acronym "HDB," for "Henri de Bourbon," in other words, Henri IV.

The destroyed attic floor illustrated Justice and Charity, the two virtues that formed the heraldic motto of Charles IX. Its decoration was removed in 1806 by Percier and Fontaine, great admirers of the Renaissance, and is now spread over several parts of the Louvre. The pediments, with the allegorical figures of Piety and Justice, were reinstalled under the passage of Saint-Germain-l'Auxerrois. The reliefs that accompanied them are now embedded in the access corridor to the Sully Wing, under the Pyramid, and in the History of the Louvre room. They echo dramatic ancient episodes, related to the theme of the pediments. Representing Justice is King Cambyses, meting out punishments from a seat draped with the flayed skin of a corrupt judge, as well as Zaleucus, philosopher and legislator, accompanied by his son, each one gouging his own eye to carry out the sentence reserved for adulterers (the father, resolving that his son not be totally blinded, shared the punishment with him). The stories that evoke Piety are less bloody: on the one hand, *Roman Charity* illustrates filial piety (a woman nursing her father in prison); on the other hand, a character who is probably the Roman priest-king Numa Pompilius offers a sacrifice to the gods. Piety and Justice, depicted according to episodes taken from Valerius Maximus, are thus

Workshop of Jean Goujon (active 1540–68)
Zaleucus, ca. 1560–64
Stone, H. 269 cm (105 ⅞ in.)
Zaleucus, whose son was condemned to be blinded, assumed half of his punishment by gouging his own eye out
Relief from the attic of the south wing of the Cour Carrée, removed in 1807
Department of Sculptures, former Musée des Monuments Français, École nationale supérieure des Beaux-Arts, transferred to the Louvre in 1988

Opposite
Workshop of Jean Goujon (active 1540–68)
The Sacrificer's Assistant, ca. 1560–64
Stone, H. 190 cm (74 ¾ in.)
Relief from the attic of the southern wing of the Cour Carrée, removed in 1807
Department of Sculptures, former Musée des Monuments Français, École nationale supérieure des Beaux-Arts, transferred to the Louvre in 1988

Workshop of Jean Goujon (active 1540–68)
The Son of Zaleucus, ca. 1560–64
Stone, H. 190 cm (74 ¾ in.)
Relief from the attic of the southern wing of the Cour Carrée, removed in 1807
Department of Sculptures, former Musée des Monuments Français, École nationale supérieure des Beaux-Arts, transferred to the Louvre in 1988

added to the coded image of the main facade, which highlights the universal power of the warrior king between the blessings of Nature and Knowledge. This forms the image of a triumphant monarchy, one that refers to a philosophical unity around the king, and is followed by a monarchy buttressed by the two virtues that will justify the Wars of Religion.

Henri II's Staircase

Inside the new building, Lescot built a magnificent flight of stairs with straight ramps, the "grand degré" ("great staircase"). Its vestibule, which features a vault decorated with a trophy of arms with a large armor, gives access to the great hall intended for celebrations and official ceremonies. On the first floor, it leads to the king's apartment: a guard room, an anteroom, and, in the king's pavilion, the audience chamber—which was also used by the council—and the privy bedroom. The staircase is sumptuously decorated. Its stone vault and the ceiling over the stair landings are carved with allegorical motifs and themes illustrating power, such as a lion's head and lightning, but also nature and hunting: a hound, a stag's head, a satyr, the figure of Diana with a Turkish bow. The ceiling allegories are convoluted, and their meaning is now lost. Here, two naked cherubs, surrounded by a garland of fruit and one with his foot placed on a globe, raise the royal crescent. Love therefore seems to dominate the globe of the world. The same idea can be found on the ceiling over the next landing, where a figure of Love wields Jupiter's lightning bolt and shoots flaming arrows. The scene seems to illustrate a passage from Pliny's book describing a figure of Love with lightning painted on Octavia's portico, which he called "Eros pandamator" ("Love dominating all things").

On the upper floor, the door is decorated with a large relief depicting six childlike cherubs. These Italian-style *putti* with full shapes lift the draperies as they play. Another curious set of figures is that of the old satyrs, seated and languid, occupying the entire tympanum at the end of the last vault.

Although these works are very close to Goujon's style, the execution contracts of 1553 record the names of other sculptors. It is obvious that different hands worked on them: the chubby flesh of the children owes nothing to the art of Goujon. But the grotesque

Above and opposite
Details of the staircase's ceilings built
by Pierre Lescot in the west wing of the
Cour Carrée, sculpted in 1553 in Trossy stone:
the goddess Diana, the monogram of Henri II,
and reclining satyrs

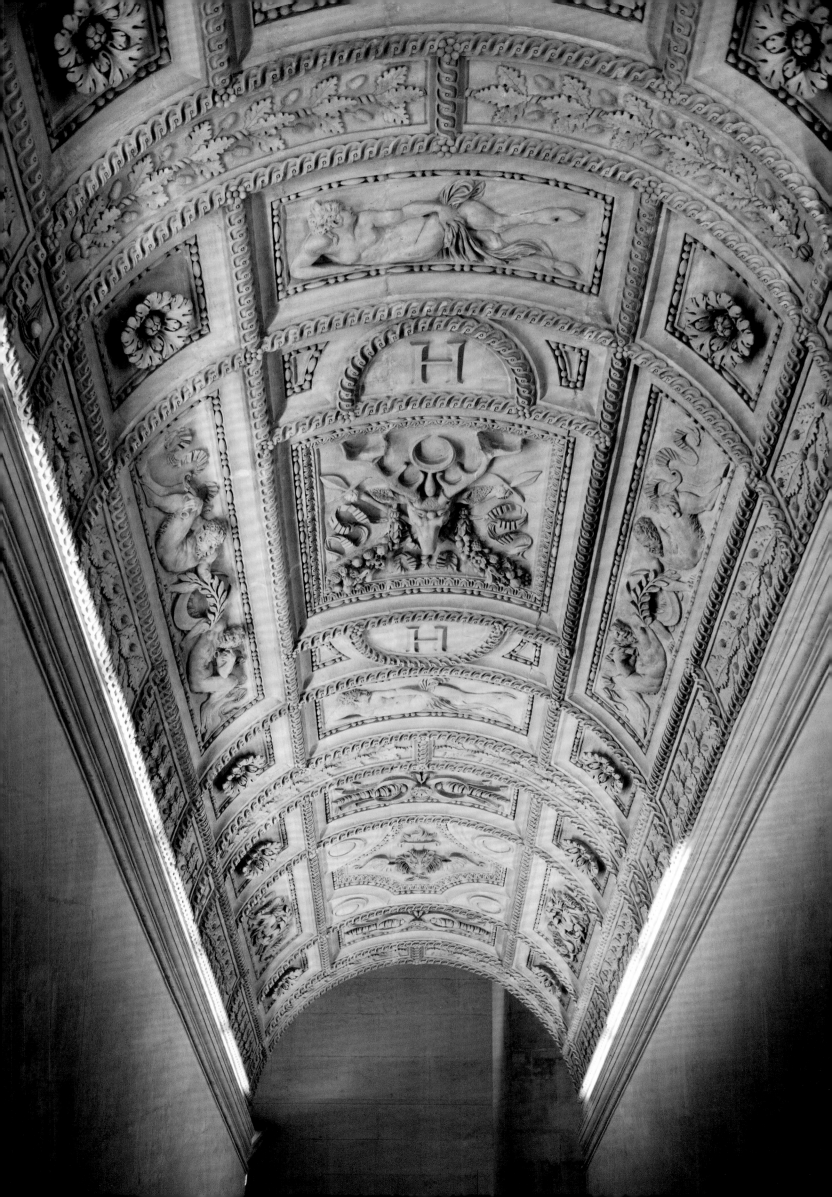

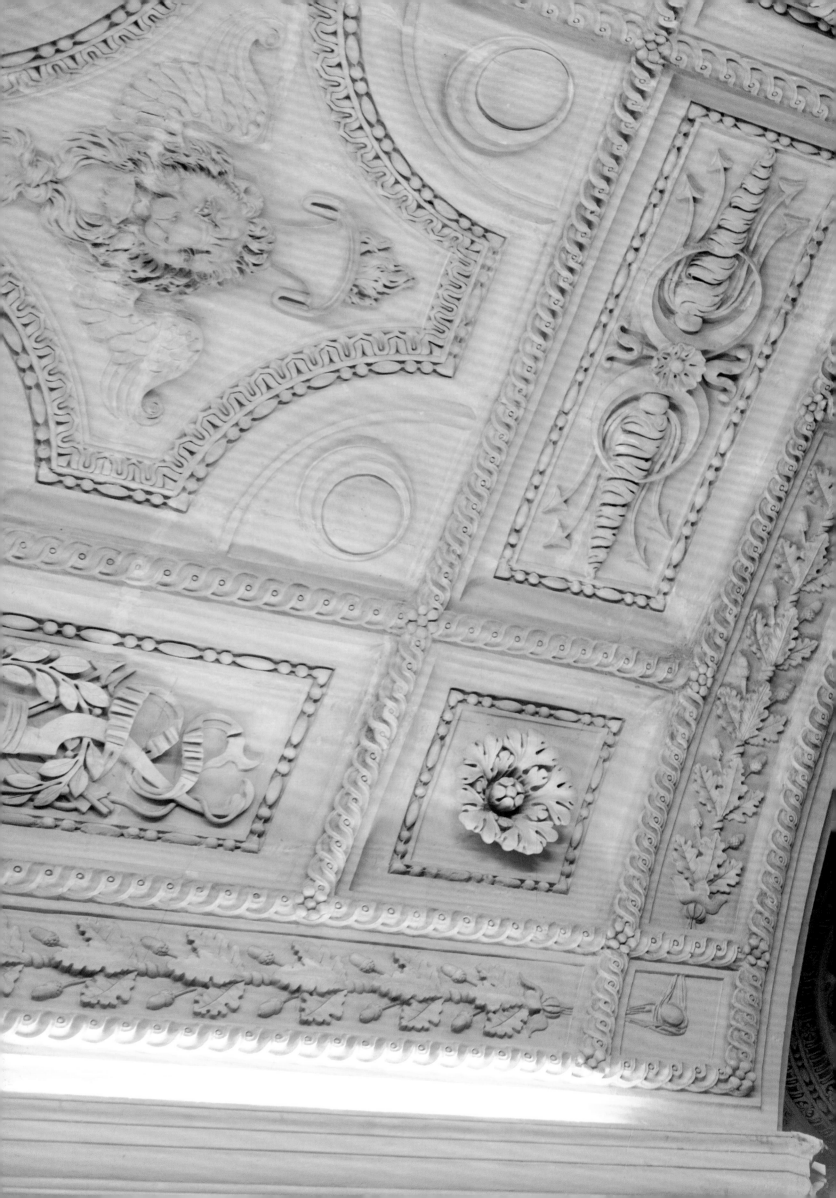

masks of satyrs and laughing female fauns, placed at each arch's keystone, recall Diana's heads on the facade and the details of the Salle des Caryatides.

The sculptors used Trossy stone, from one of the best quarries in Saint-Maximin, the great production center of the Oise Valley. Just imagine the large blocks transported to the river bank, brought downriver from the Oise, then up the Seine to Paris. It must have been a long and complicated undertaking, especially since the ceilings were large monoliths made of binding stone, the installation of which would have entailed a delicate job of cladding.

The Ballroom, or the Salle des Caryatides

The entire ground floor is occupied by this large room. To the south is the tribunal (court), where the king stands: the elevated structure is separated from the rest of the room by groups of four columns, according to the architectural arrangement invented by Sebastiano Serlio and Palladio. At the other end, above the front door and forming a portico, the musicians' gallery is supported by four great figures of caryatids or, as in the execution contract from 1550, "figures used as columns." Their large white shapes, made of Trossy stone—like the decoration of the staircase—were designed to surprise visitors. These ambitious sculptures, created by Jean Goujon, demonstrate a very classic desire to suit their setting. Strictly frontal, caryatids are like women turned to stone. However, these sketch a slight *contrapposto* movement: they advance a leg forward, which disrupts the orderly flow of the drapes. Their bodies can be seen under the fine drapery, revealing very carnal shapes, with prominent breasts and marked navels.

On either side of the door, two marble plaques add a cheerful note of decoration to this otherwise austere ensemble. At the bottom, a smiling female mask, with an open mouth and clearly visible teeth, contrasts with the severe gravity of the caryatids; at the top is a young musician cherub who blows a trumpet.

Goujon had also sculpted huge figures for the fireplace (2.60 meters), which were reused by Napoleon's architects, Percier and Fontaine, in the large neoclassical fireplace that has been a feature of the room since 1811. Drastically "restored" at that time, they have lost some of their original force, and no attribute identifies them, even if some historians have seen in them Ceres and Mars because the male figure wears a laurel wreath and the female figure a wreath of flowers. Their lines and the soft, wet drapery of the female figure, which reveals a round belly with a pronounced navel, are in harmony with the style of the caryatids.

The room as we see it today is not, however, that of Lescot and Goujon. Originally, it was covered with a wood ceiling. It was vaulted under Louis XIII by the king's architect, Jacques Lemercier. While it probably did not suffer great changes when it became the gallery of the king's collection of ancient statues in 1692, it was redesigned in 1795 to become the French Institute's meeting room, which undoubtedly led to the destruction of the old chimney. The Salle des Caryatides, which was assigned to the museum, was considerably remodeled by Percier and Fontaine: they transformed the balustrade of the gallery, added the fireplace, and had vaults carved in a style echoing the staircase decoration. It is in this neoclassical state that we now experience this space.

It is very difficult to imagine today the lavish and dramatic events that took place here: the balls of the Valois court, or the hanging of four leaders of the Ligue in 1591. It is easier to imagine it as the king's "Antique Sculptures Room," when large marble sculptures, plaster figures modeled on classical prototypes, emperors' busts, and small reliefs were piled up there in 1692. Apart from inventories, there is no single image that allows us to appreciate the richness of this assemblage, which is the basis of the Louvre's collection. Classical pieces are mixed with royal commissions going back to the effigy of Charles V through the statues of the great men that must have decorated the great gallery of the museum under Louis XVI.

Above and opposite
Salle des Caryatides: detail of the caryatids of Jean Goujon (active 1540–68), 1550, Trossy stone, 260 cm (102 3/8 in.)

Previous spread
Details of the staircase's ceilings built by Pierre Lescot, sculpted in 1553: winged lion's head surmounted by a torch; Turkish bow, lightning with a double-crescent moon; *Love Hurling Jupiter's Bolt of Lightning*

Following spread
Salle des Caryatides
Foreground: *Artemis with a Doe*, known as the *Versailles Diana* or *Diana of Versailles* (royal collection); right: *Three Graces* (acquired with the Borghese collection in 1807); left: *Suppliant Psyche* (from the same collection) Department of Greek, Etruscan, and Roman Antiquities

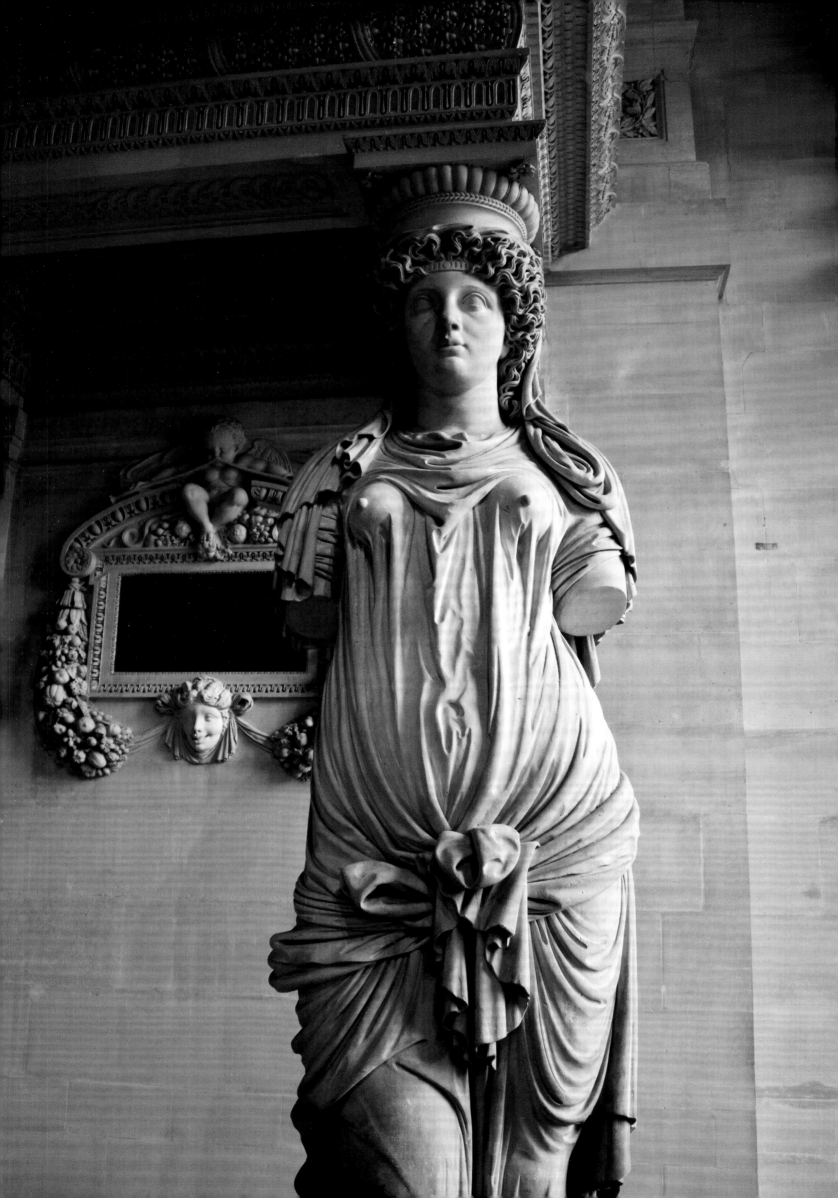

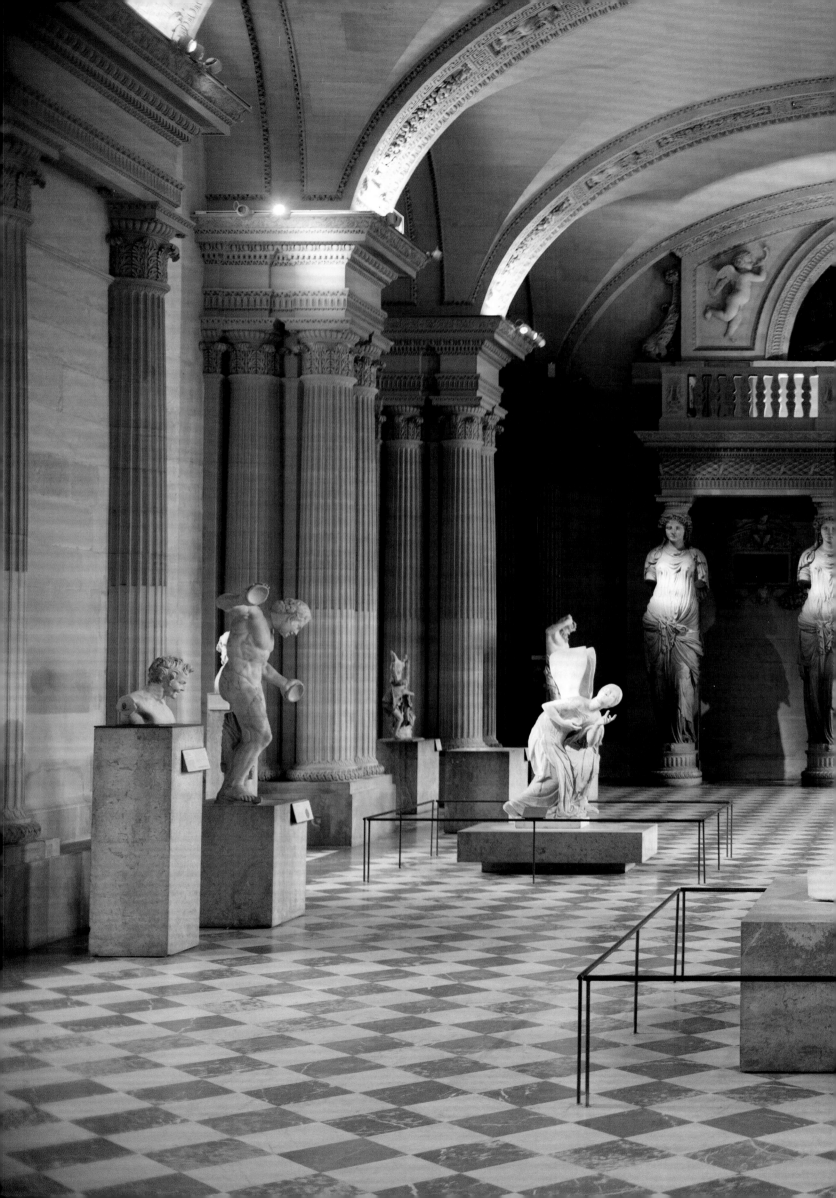

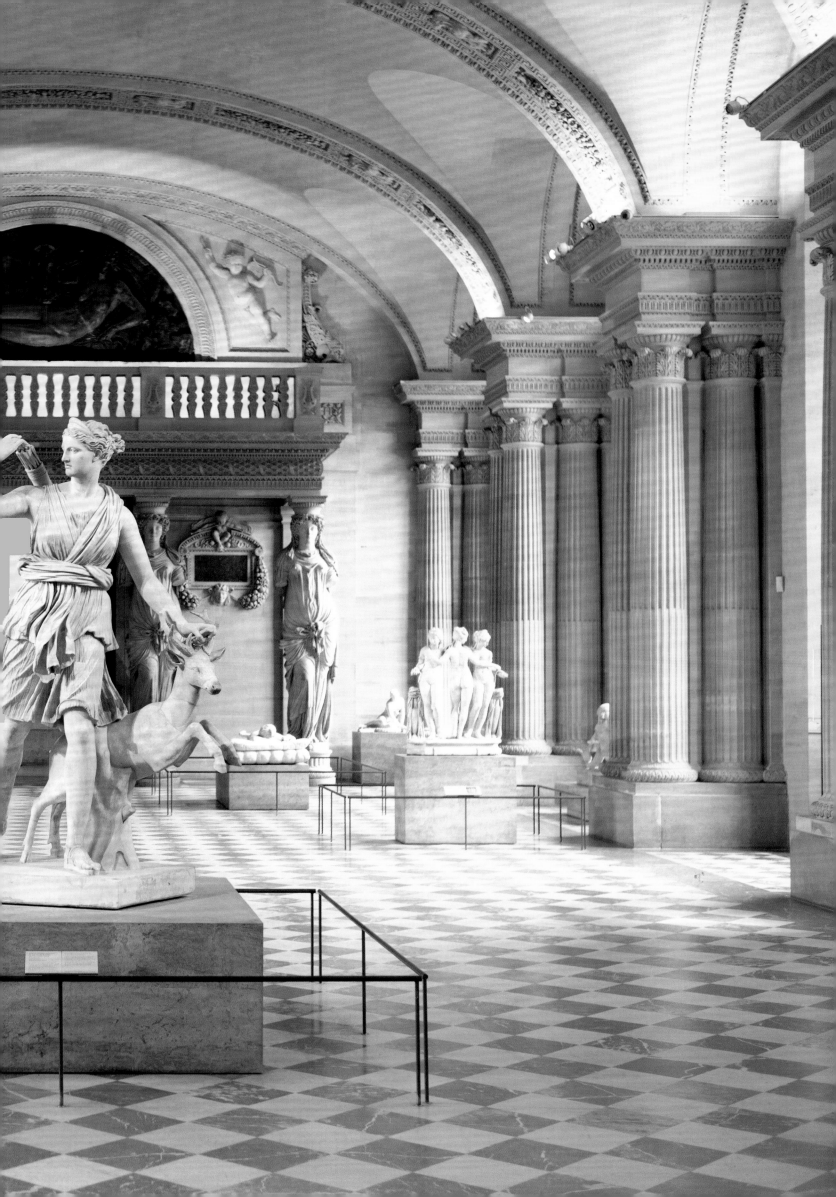

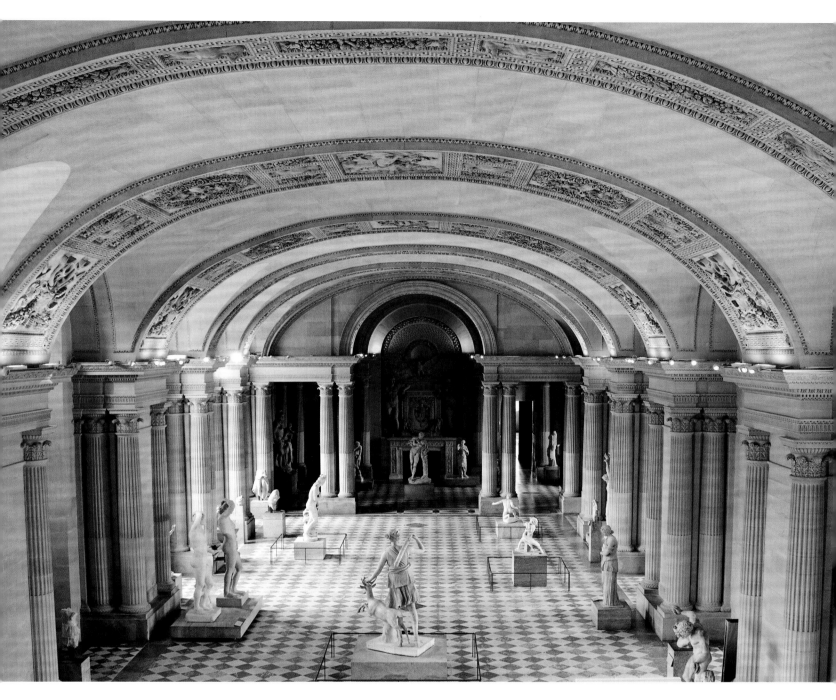

Opposite
Antoine-Louis Barye (1795–1875)
Molding of *The Nymph of Fontainebleau*
Copy of the bronze relief by Benvenuto Cellini,
kept in the Department of Sculptures, inserted
in 1849 into the tympanum of the musicians'
gallery in the Salle des Caryatides, replacing the
original that Percier and Fontaine had installed
there in 1811

Salle des Caryatides, built by Pierre Lescot
in 1550, vaulted by Jacques Lemercier,
refurbished by Percier and Fontaine in 1811:
view from the musicians' gallery
Department of Greek, Etruscan, and Roman
Antiquities
The "Tribunal" archway essentially follows the
style of the Italian architect Andrea Palladio

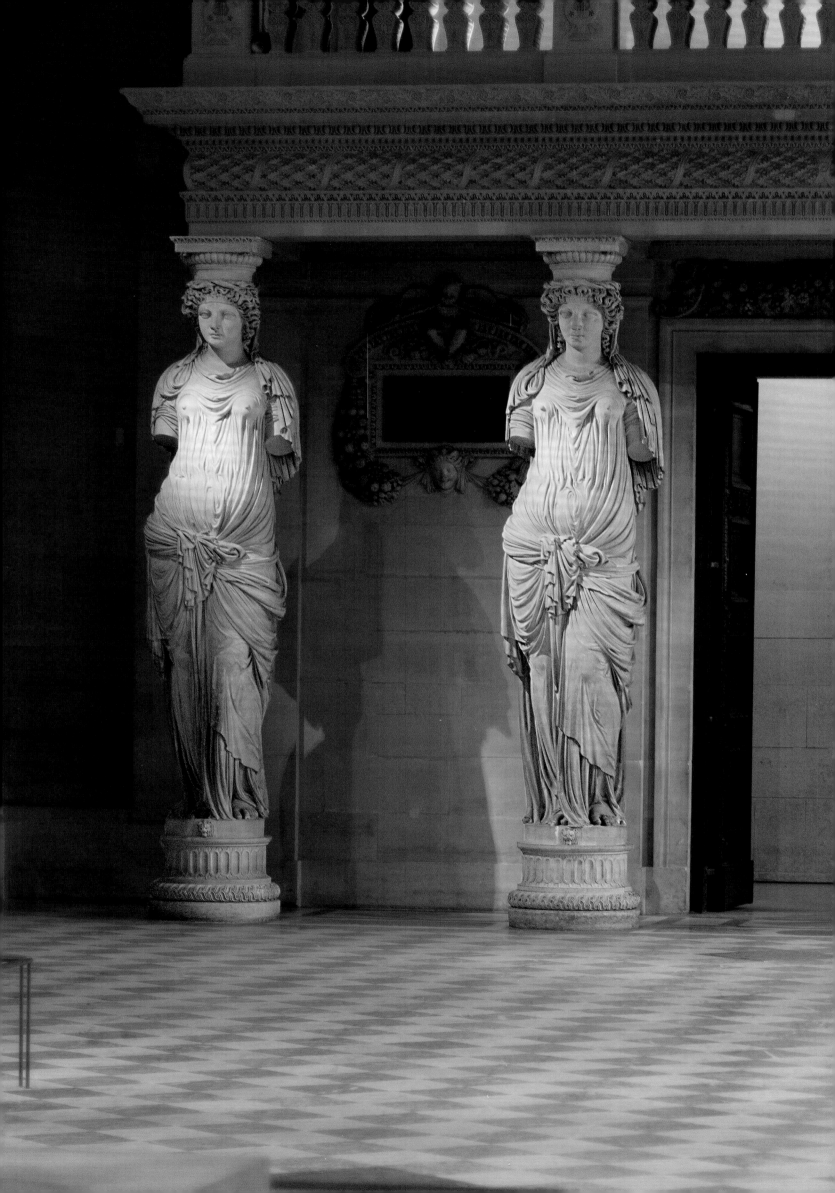

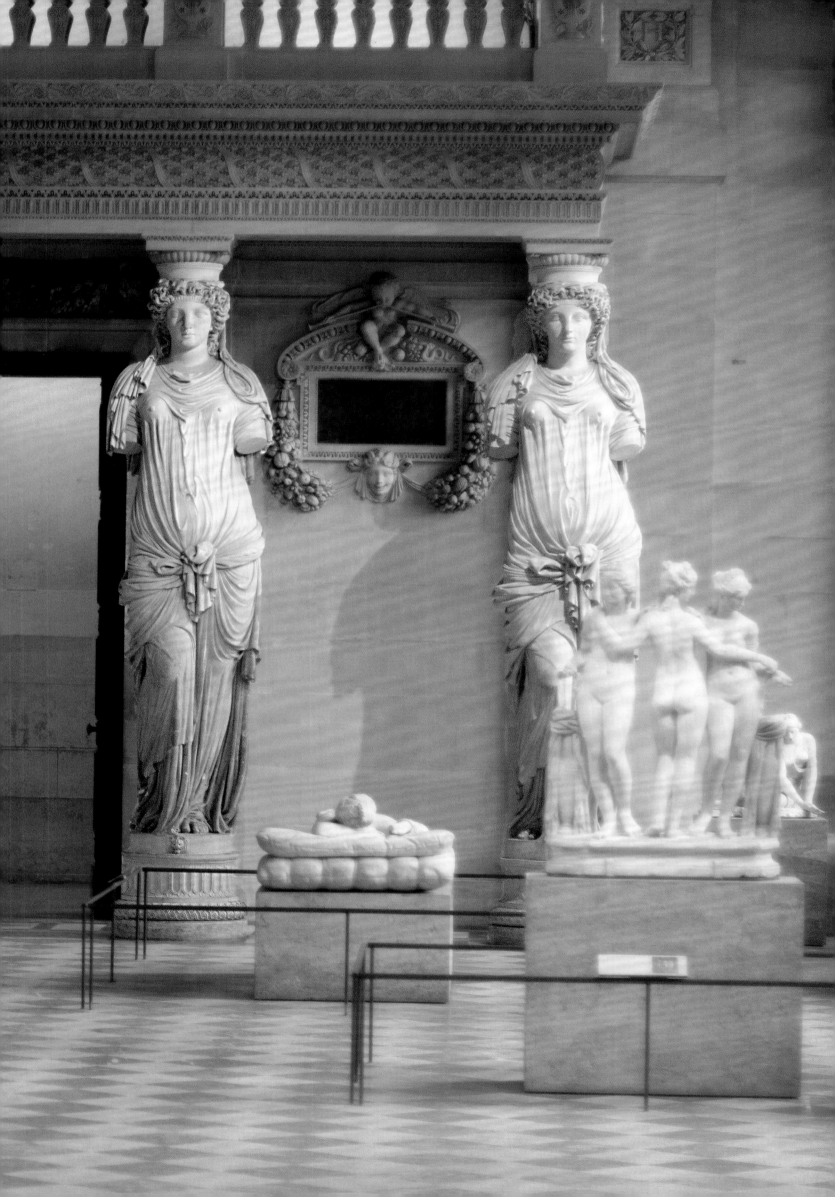

Ceilings and Woodwork in the King's Apartment

Henri II's apartment was sumptuously decorated. On the main floor of the king's pavilion were the two royal rooms, both offering magnificent views. The most beautiful, the square audience chamber, had an ornate wood ceiling. Designed by Lescot, it was executed in 1556 under the direction of Francisque Scibecq de Carpi, a Lombard woodworker who had already distinguished himself in the Gallery of Francis I at Fontainebleau, as well as in the Sainte-Chapelle and the Anet, Vincennes, and Beauregard castles.

The ceiling in the Aile de la Colonnade was rebuilt by the architect Fontaine in 1819, like the doors and the low paneling, which featured astonishing allegorical compositions. During the 1990 restoration, the graffiti of the carpenters who had installed the woodwork was discovered, well hidden under the wood. They had evidently amused themselves by inscribing proclamations in favor of Napoleon.

The king's room is now dedicated to the galleries of Egyptian antiquities. The sacred center of royal power, reserved for family members and members of the council, is now entered after a rather long walk. The visitor is first struck by the vision of the superb Egyptian sculptures, and it takes a certain effort to loosen their grip on your attention and to understand that the place was once the epicenter of a staging of power. Lescot expressed this through the sumptuous woodwork decor.

The large antechamber also underwent a major reworking. It was originally a relatively small room, made twice as large and extended to the depth of the building by a small office. Under Louis XIV, the decision was made to unify the space. In its center, the ceiling —sculpted in 1557 and 1558 by Scibecq de Carpi—based on the models of the sculptor François Carmoy, was retained and still features the monogram of Henri II and his motto. But two side compartments were added to the space, whose style is quite in line with that of the Renaissance, except for the royal monogram in extravagant italic letters.

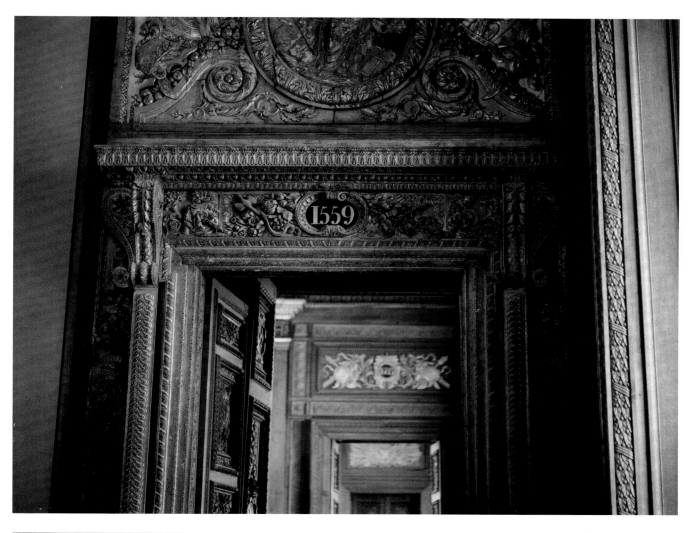

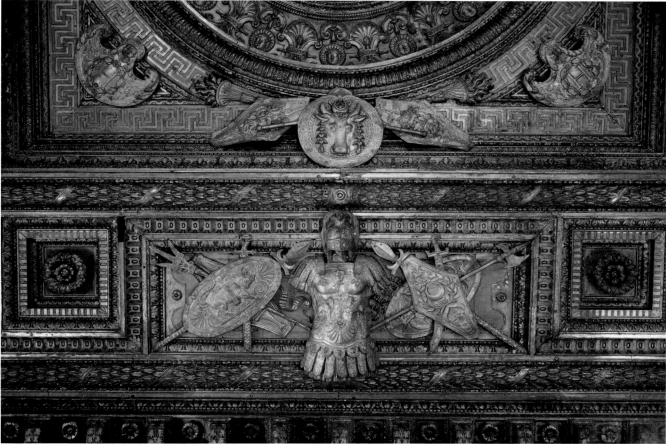

Francisque Scibecq de Carpi
(active 1537–60)
Three panels of low wainscoting decorated
with trophies from the Salle Henri II,
reassembled in 1819, in the Aile de la
Colonnade

The transformation did not stop there. Under the Restoration, Merry-François Blondel introduced compositions painted in honor of the monarchy. This neoclassical style —highly official and formal—was unpopular in the mid-twentieth century. In 1953, the director of French museums, Georges Salles, who was a great lover of contemporary art, commissioned three new paintings from Georges Braque, *The Birds*. This was the first insertion of contemporary art into a historical setting, which prefigured André Malraux's approach to the ceilings of the Paris Opera or the Odéon Theatre.

Francisque Scibecq de Carpi
(active 1537–60)
Ceiling of the Salle Henri II, executed
in 1556, reassembled in 1819, in the Aile de la
Colonnade, wood painted in bronze and gold

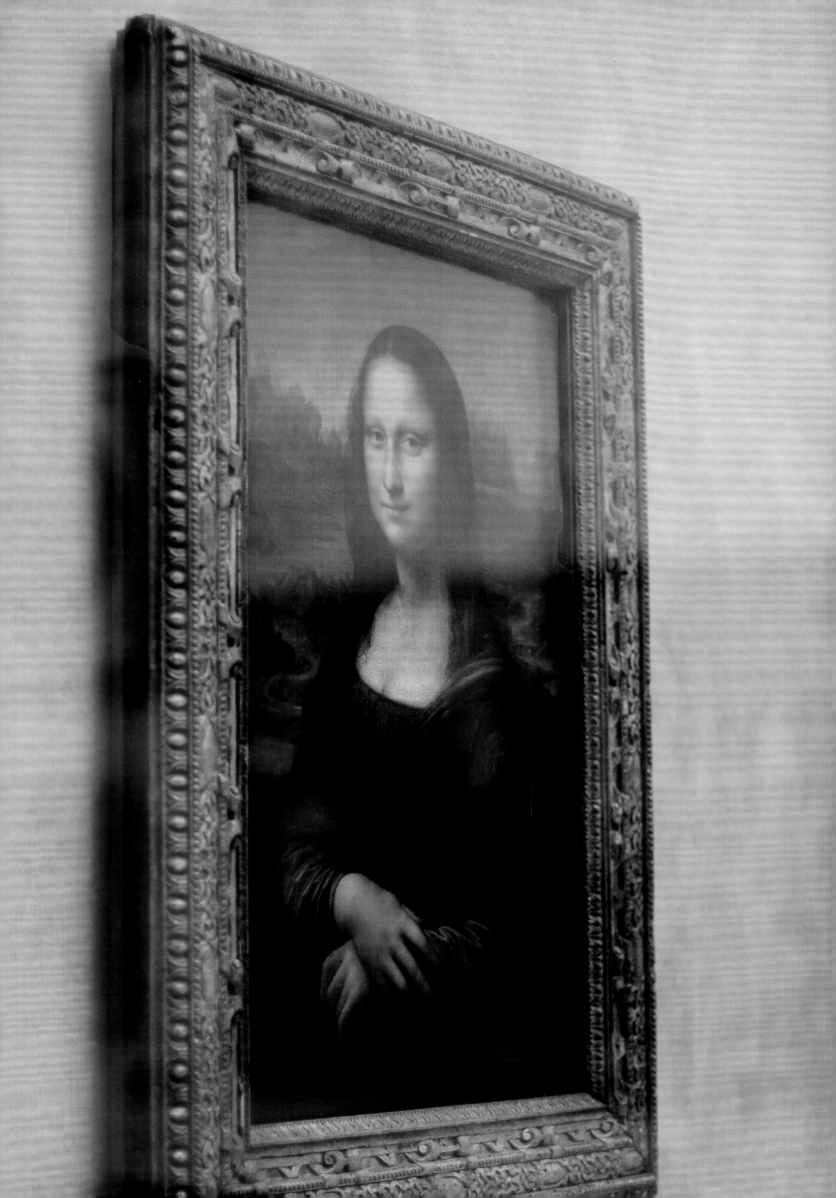

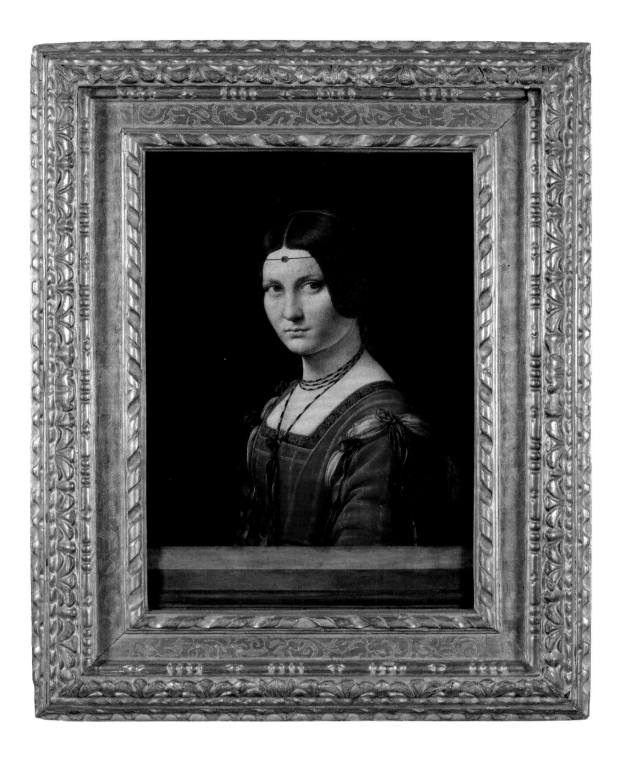

The Collections of the Renaissance Rulers:
The Origins of the Louvre

The commitment to the architectural remodelings of the Louvre under different kings hardly found a parallel in the configuration of the art collections. Charles V's library had disappeared. From the Treasury of the Royal Stables, we saw the case of the parade helmet, stolen and miraculously reappearing in the hands of archaeologists. Then there is the case of the crown jewels: the Treasury of the Crown Jewels, instituted in 1530 by Francis I and declared inalienable, was likely housed with the royal treasury. At that time, it contained eight precious stones, one of which, having escaped the Revolution and the sales of the nineteenth century together with other pieces, remains one of the glories of the Louvre to this day: the Côte de Bretagne red spinel. However, it was cut into the shape of a dragon during the reign of Louis XV.

Leonardo da Vinci (1452–1519)
Presumed Portrait of Lucrezia Crivelli,
known as *La Belle Ferronnière*, ca. 1495–97
Oil on wood panel, 63 × 45 cm (24 ¾ × 17 ¾ in.)
Department of Paintings, brought from Milan
to Amboise by order of Louis XII, ca. 1499

Opposite
Leonardo da Vinci (1452–1519)
Mona Lisa, know as *La Gioconda*, ca. 1503–5
Oil on wood panel, 77 × 53 cm (30 ¼ × 20 ⅞ in.)
Department of Paintings, acquired by Francis I
in 1518

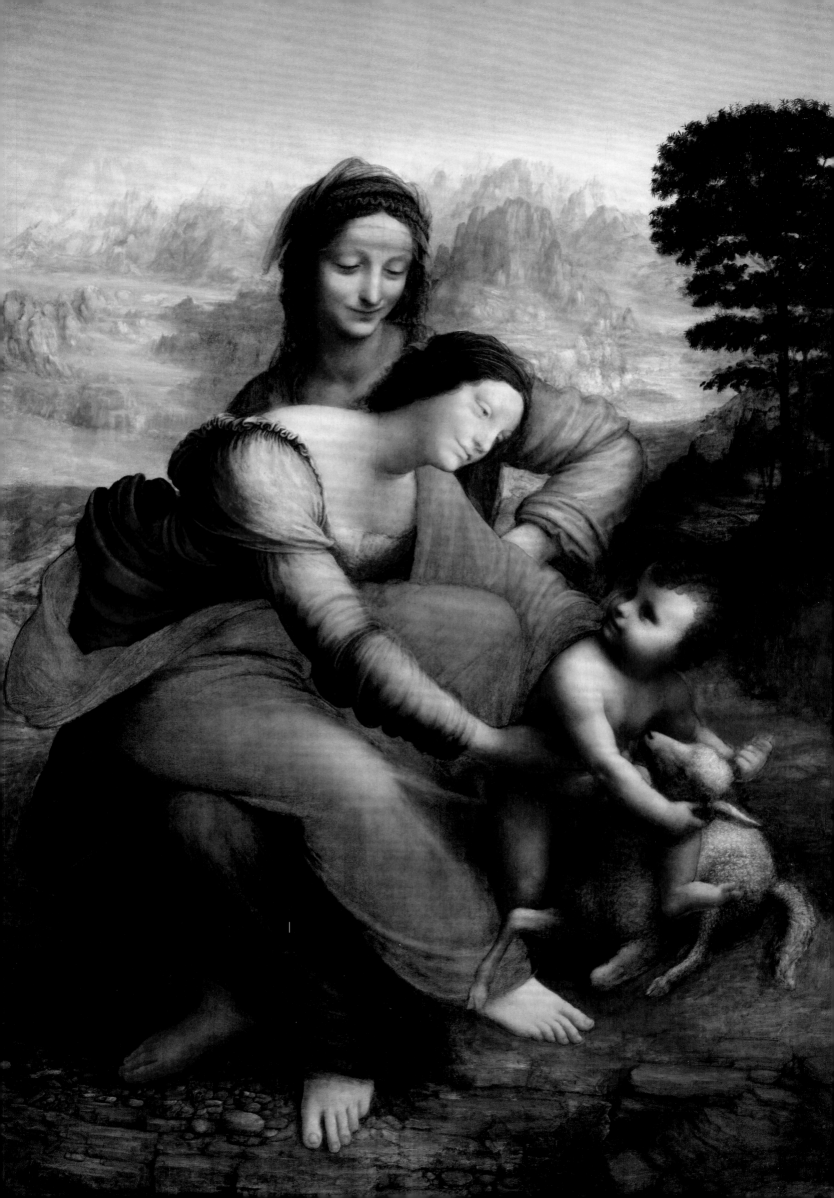

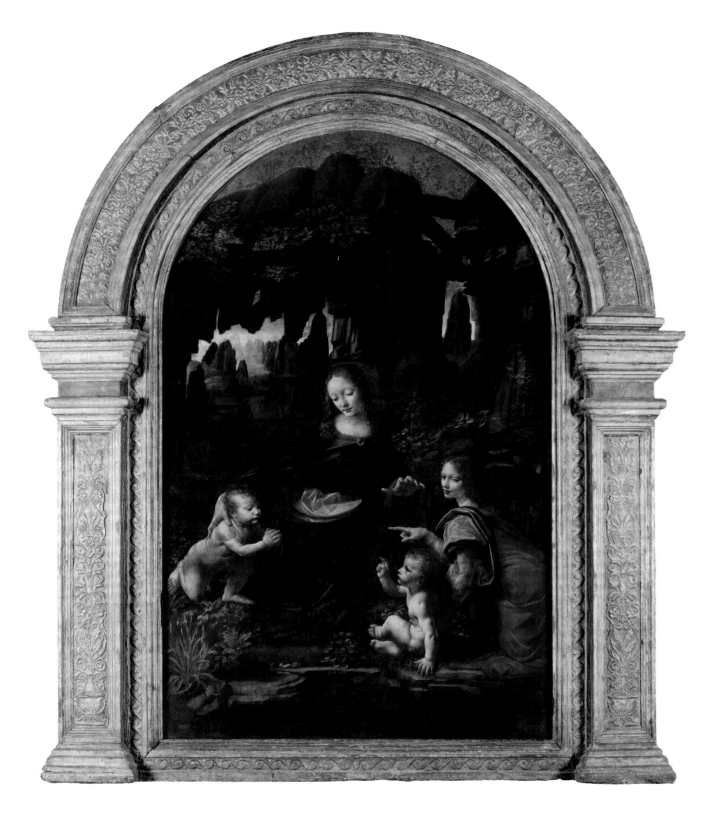

The first nucleus of a collection at the Louvre was a royal furniture repository of tapestries, which was established in 1537 and inventoried in 1542. Then a cabinet of curiosities probably developed under Charles IX, of which nothing is known. It was not until a 1602 inventory that the existence of a small, highly mixed collection was discovered.

Although the Louvre's painting rooms show the extent of the Renaissance rulers' interest in collecting works of the great masters, it was in other residences that these rulers cultivated their taste for the arts: Charles VIII and Louis XII favored Blois and Amboise, and Francis I preferred Fontainebleau, the château that he loved above all. Through confiscations made during the Revolution, the Louvre found itself the heir to royal property accumulated elsewhere, including great royal portraits such as *Francis I* by Jean Clouet (p. 53), a painter from Valenciennes who settled in Tours and later in Paris. This effigy of the ruler, presented with magnificent sobriety in a black-and-silver doublet, was donated by the artist

Leonardo da Vinci (1452–1519)
The Virgin of the Rocks, ca. 1483–86
Oil on wood panel transferred to canvas
in 1751, 199 × 122 cm (78 ⅜ × 48 in.)
Department of Paintings, collection of
Louis XII (?), attested in the royal collection
in 1627

Opposite
Leonardo da Vinci (1452–1519)
*Saint Anne, the Virgin, and the Child Playing
with a Lamb*, known as *Saint Anne*, ca. 1501–19
Oil on canvas, 168 × 130 cm (66 ⅛ × 51 ⅛ in.)
Department of Paintings, collection of
Francis I

in 1527. His meticulous vision contrasts with the style of the profile portrait of Francis I that Titian executed after a medal made by Benvenuto Cellini and at the request of the writer Pietro Aretino, who wanted to present the painting to the king as a genuine expression of a cultural and artistic Italianism. The French kings' appetite for Italian art grew out of their expeditions to the peninsula and the rule of the Duchy of Milan beginning in 1499.

The rooms of Italian painting still display the most exquisite jewels from this inspired collecting. Louis XII, who had probably commissioned Leonardo da Vinci's *Saint Anne*, brought back from Milan the artist's *La Belle Ferronnière* and *The Virgin of the Rocks*. Of all the Renaissance rulers, however, none loved Italian culture more than Francis I. A lavish patron, he sought to attract the best artists from mainland Italy to his court. Upon his accession in 1515, he invited Fra Bartolomeo, and although the artist declined, Francis nevertheless was able to acquire his *Incarnation of Christ* that same year. He was no more successful in bringing Michelangelo to the court, and the statue of Hercules he obtained from the sculptor has unfortunately disappeared. On the other hand, Leonardo da Vinci accepted his hospitality in 1516 and settled in Amboise, where he would spend the last three years of his life in the Cloux Manor (Clos Lucé). There he completed his last composition, *Saint John the Baptist*, and likely continued to work on the *Mona Lisa*, both of which Francis acquired in 1518. The latter, also known as *La Gioconda*, is now the star of the museum. Other artists answered the king's call. Andrea del Sarto, whose stay in 1518–19 was admittedly brief, delivered the great *Charity*. Rosso Fiorentino settled at the court, making the Gallery of Francis I at the Château de Fontainebleau the most imaginative manifesto of Mannerism yet seen. He was followed by Francesco Primaticcio, who would spearhead the Fontainebleau School that revolutionized French art.

Somewhat less fortunate, because faced with Primaticcio's enmity, the goldsmith Benvenuto Cellini visited the court twice. While he executed works in his particular discipline—the medal with the effigy of the king and the famous salt cellar (kept in the Vienna Museum)—he received from the king a commission for an exceptional piece that would convert him to the production of large-scale sculpture: *The Nymph of Fontainebleau*. Cast in Paris in his workshop at the Hôtel de Nesle, the bronze relief was meant to have stood in the tympanum of the golden door at Fontainebleau. Relations between Francis and Cellini soured, however, and the work languished until Henri II offered it to his mistress Diane de Poitiers. The architect Philibert Delorme installed it on the triumphal arch at the entrance to her château at Anet, from which the revolutionaries pulled it down and delivered it to the Louvre.

At the same time, Francis sent agents to procure works of art in Italy: true antiquities, copies of antiquities, or paintings. Some he acquired directly from the artist; others he obtained through diplomatic channels. Pope Leo X refused to give Francis the classical *Laocoön*, but he did grant permission to make casts of the main Vatican sculptures. While Raphael and his team, including Giulio Romano, were busy with the papal apartments in the Vatican, the pope commissioned from them paintings for the French court on themes well suited to royalty: a large *Saint Michael* for the king, the *Holy Family* for the queen, and *Saint Margaret* for Marguerite de Valois (the king's sister); Cardinal Bibbiena added the *Portrait of Doña Isabel de Requesens*, wife of the viceroy of Naples. The Republic of Venice offered the *Visitation* by Sebastiano del Piombo to the queen, who had just given birth to the dauphin.

These diplomatic gifts continued under Henri II, even though French enchantment with Italian art had waned. It is assumed that Michelangelo's two unfinished *Slaves* were gifts from the pope, through Pietro Strozzi, to Henri II, who himself would give them to his favorite, Anne of Montmorency for the Château d'Écouen. After a detour to the Château de Richelieu in Poitou, and then to the garden of the Hôtel de Richelieu in Paris, they entered the Louvre during the Revolution. In the Michelangelo gallery, they now attract crowds that are captivated by the contrast between the fiery and rebellious colossus and the youth who seems lost in reverie, moved by their coiled strength and intrigued by the hidden meaning of these captives, who are perhaps symbols of shackled passions.

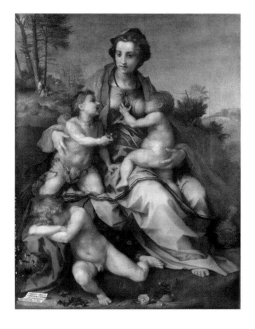

Above and opposite
Andrea del Sarto (1486–1530)
Charity, 1518
Oil on wood panel, transferred to canvas,
185 × 137 cm (72 ⅞ × 54 in.)
Department of Paintings, collection of Francis I

Painted during Andrea del Sarto's stay in France in 1518–19, the composition shows Virtue surrounded by children, and refers to the royal family at the time of the birth of the dauphin. If Virtue recalls the features of the queen, the figure in the foreground alludes to "happy France reposing in Peace."

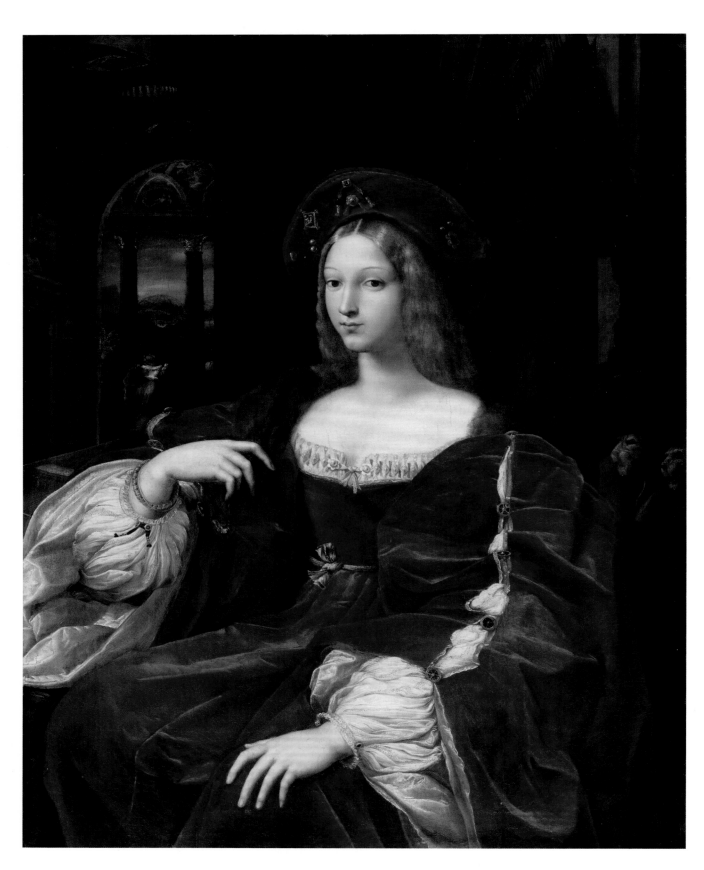

Raphael (1483–1520) and Giulio Romano
(1499–1546)
*Portrait of Doña Isabel de Requesens y Enriquez
de Cardona-Anglesola (1498–1534),
Wife of the Viceroy of Naples*, 1518
Oil on wood panel, transferred to canvas,
120 × 95 cm (47 ¼ × 37 ⅜ in.)
Department of Paintings, collection of Francis I

Opposite
Raphael (1483–1520)
Saint Michael Overwhelming the Demon,
known as the *Large Saint Michael*, 1518
Oil on wood panel, transferred to canvas,
268 × 160 cm (105 ½ × 63 in.)
Department of Paintings, collection of Francis I

This is the largest and most important of the three
paintings commissioned by Pope Leo X to be
donated to Francis I, with the large *Holy Family*.

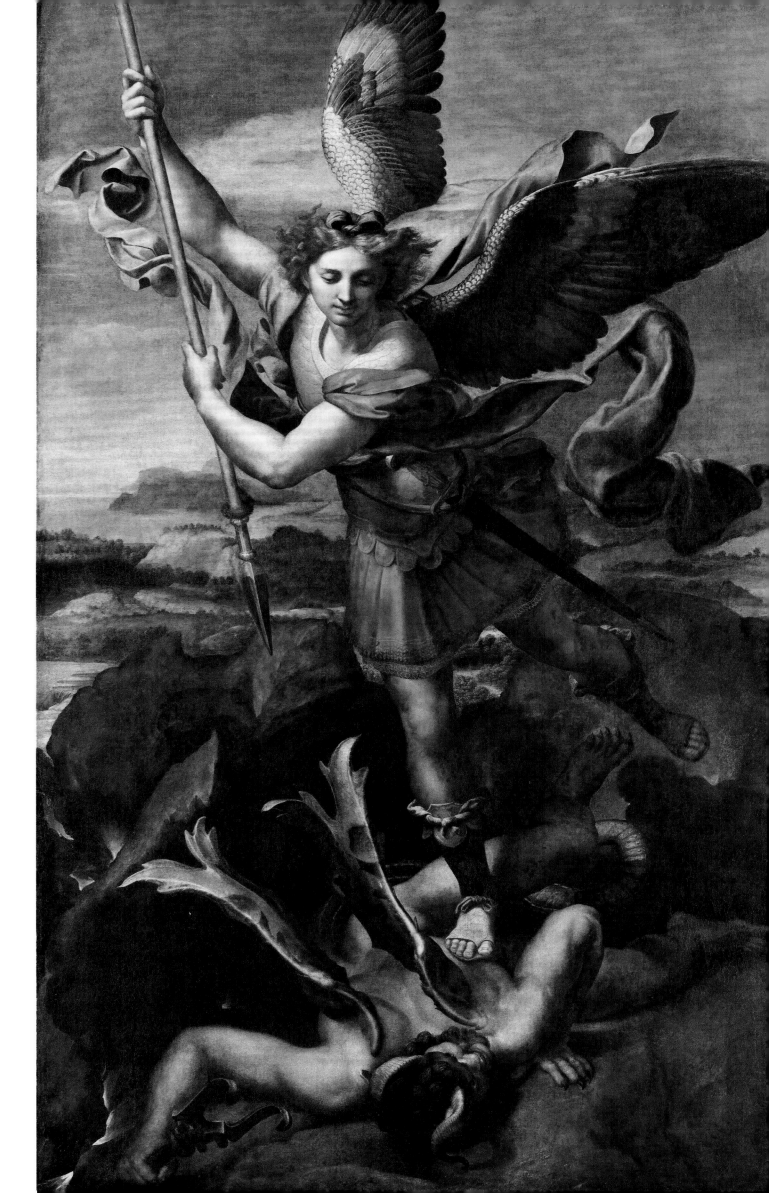

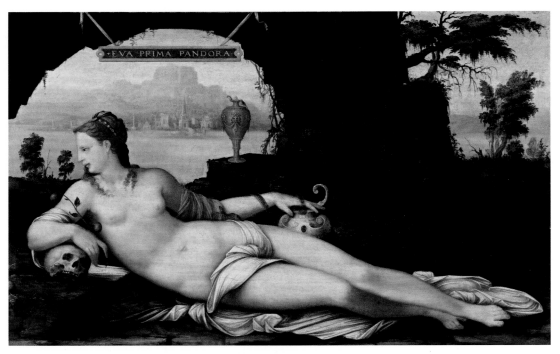

Another diplomatic gift forms the heart of the Salle des Caryatides: the classical *Artemis with a Doe*, after a model by Leocharès. Offered by Pope Paul IV, it first appeared at Château de Meudon and then at the Park of Fontainebleau. Exhibited under Henri IV in the Louvre's Hall of Antiquities, it was known as the *Louvre Diana* before becoming *Versailles Diana*, or *Diana of Versailles*, when Louis XIV placed it in the center of the Galerie des Glaces. Since the creation of the Musée des Antiques in the Louvre, it has led a procession of large marble statues, carved in Roman times after the Greek model.

Traces of the Last Valois Kings

In the Louvre Palace, traces of the last Valois kings are present less in their collections than the architecture itself. Shadowed by the Wars of Religion, their reigns were characterized by continued strife between Catholics and Huguenots, often erupting into mob violence. As a result, the monarchy was considerably weakened. The terrible St. Bartholomew's Day Massacre turned the marriage celebrations of Henri of Navarre—the future Henri IV— and Marguerite, "Queen Margot," into a bloodbath. After the Day of the Barricades, the Catholic League forced Henri III and the Calvinists to flee the city. Antoine Caron's *Massacres of the Triumvirate*, painted in 1566, alludes to the atrocities committed under the banner of religion during this time through a depiction of the destruction wrought by the civil wars in ancient Rome.

Yet court life continued and art flourished. Fêtes, balls, and weddings were recorded in paintings. Parisian art of the period reached a high point, as the style developed at Fontainebleau spread throughout France. In *Eva Prima Pandora*, Jean Cousin, originally from Sens, created an enigmatic and sensual nude reclining in a landscape. His poetry blends with a refined aesthetic, which combines the most imaginative motifs of Mannerism. Cousin also provided designs for large tombs like that of Admiral Chabot: a melancholy figure flanked by torch-bearing genii.

To experience the luxury of the late Valois court, you must visit the Louvre's Department of Decorative Arts. The art of Limoges enamelers was then at its peak, and Léonard Limosin was their greatest master. In his enamel altarpieces for Sainte-Chapelle, he depicts the kings and queens worshipping at the Crucifixion and the Resurrection of Christ. Enamelers and goldsmiths made Paris a center of decorative Mannerism, which, combined with highly ornamental compositions designed by the very active sphere of

Under the direction of Jean Cousin the Elder (ca. 1490–ca. 1560)
Alabaster elements from the tomb of Philippe Chabot, count of Brion, admiral of France (ca. 1490–1543), from the church of the Celestines, Paris: recumbent effigy and lion (L. 158 cm/62 ¼ in.); two spirits holding inverted torches; allegory of Misfortune
Department of Sculptures, former Musée des Monuments Français, entered in 1818, 1821, 1851, and 1898

Opposite
Jean Cousin the Elder (ca. 1490–ca. 1560)
Eva Prima Pandora, ca. 1550
Oil on wood panel, 97 × 150 cm (38 ¼ × 59 in.)
Department of Paintings, gift of the Société des Amis du Louvre, 1922

In this major work of the French Renaissance, Eve, by whom man was condemned to sin, is likened to Pandora, who, out of curiosity, opened the bottle from which evils escaped. This clever composition places the large sensual nude before a landscape in which wild nature on one side contrasts with nature shaped by man on the other.

Opposite
Workshop of François Clouet (ca. 1515–72)
Henri II, King of France, 1559
Oil on wood panel, 35 × 20 cm (13 ¾ × 7 ⅞ in.)
Reduction of the full-length portrait in the
Uffizi Museum, Florence
Department of Paintings, entered the Imperial
Gallery of Vienna in 1809

Views of the portrait room of 16th-century French
painting, with, at the top, *Wedding Ball of the Duc
de Joyeuse* (French School), partly visible, and
Portrait of Charles IX (workshop of François
Clouet); at the bottom, *Portrait of Jean Babou,
Lord of La Bourdaisière* and, in the foreground,
Portrait of Henri III (attributed to François
Quesnel)
Department of Paintings

Léonard Limosin (ca. 1505–76/77)
Altarpiece of the Crucifixion
Rood screen, 1553
Enamel painted on copper, 106 × 74 cm
(41 ¾ × 29 ⅛ in.)
Department of Decorative Arts, confiscated
during the Revolution, 1794

Two painted enamel altarpieces adorned
the two altars of the Sainte-Chapelle rood
screen, executed in 1553 by Francisque Scibecq
de Carpi. In the lower medallions are the
kneeling figures of Francis I and Claude of
France. (The other altarpiece presents the
Resurrection and the figures of Henri II
and Catherine de Médicis.)

Opposite
Léonard Limosin (ca. 1505–76/77)
*Portrait of Constable Anne de Montmorency
(1493–1567)*, 1556
Enamel painted on copper with gold
highlights, gilded wood frame, 72 × 54 cm
(28 ⅜ × 21 ¼ in.)
Department of Decorative Arts, confiscated
during the Revolution from the duke of
Montmorency in 1794

On either side, the large satyrs reproduce
figures sculpted in stucco by Rosso Fiorentino
in the Gallery of Francis I, Château de
Fontainebleau.

painters, resulted in works like the shield and helmet of Charles IX or the mace of the
Order of the Holy Spirit. Not to mention the ceramists, so closely linked to the court, such
as Bernard Palissy, who created a fantastic grotto for the queen in her garden of the
Tuileries and whose workshop was discovered there during archaeological excavations.
The garden was named for the artisan tile workers—*tuiliers*—who worked in the manu-
factories that formerly blanketed the area. The site yielded test specimens, casts, and mod-
els from Palissy's kilns—now in the rooms dedicated to the history of the Louvre—that
were used by Palissy before he fled Paris, driven out by the Catholic League for being a
Protestant. These finds—the mold of a female torso, columns decorated with foliage and
shells, a lizard, a frog, a terra-cotta snake—are familiar elements in Palissy's eccentric,
enameled landscapes applied in raised relief to large platters and other ceramic objects.
The brilliantly colored "rustiques figulines," as he called them, which include all manner
of flora and fauna, along with nude figures, were extremely popular, and Palissy had many
followers; for instance, a school of potters in Avon. Just as popular with royal clientele was
a pottery type known as Saint-Porchaire, originating, like Palissy, in Poitou, characterized
by intricate designs of colored clays inlaid into kaolin-rich white clay.

Unassuming as a queen, Catherine de Médicis was nevertheless a formidable regent.
The palace she had built a stone's throw from the Louvre was demolished in 1883, but her
garden remains, especially its name: the Tuileries. She had imagined a beautiful suburban
residence, such as it would have looked in her native Florence. Her architects, Philibert
Delorme and Jean Bullant, designed a palace that could rival that of Henri II, rich in dec-
orated columns, antique cornices, and a discreet polychrome derived from hard stone, red
marble, and limestone. After the destruction of the palace, some parts were selected as
evidence of the architectural quality. A nine-meter-high portico, built by Delorme, was
reassembled in the Louvre, framed by columns bearing the emblems of widowhood—
feathers and tears—and broken chains.

Deprived of its architectural context, the portico opens next to a room in the
Department of Sculptures showcasing the monuments that the queen had dedicated to
her husband, Henri II. There you will find the central monument that Germain Pilon and
Domenico del Barbiere Fiorentino have erected in the church of the Celestines in Paris;
the sketches for the recumbent effigy of the king and his funeral mask; and the unfinished
recumbent effigy that the Florentine Girolamo della Robbia had planned for the queen
mother and which presents her in the frightening attitude of death. Most of the works in
this room are by the sculptor Germain Pilon, who imbued Mannerism's elongated forms
with naturalism. These include the model for the marble *Virgin of Sorrows*, which was to be
installed in the funeral chapel of Henri II in Saint-Denis, like *The Resurrection*, whose
Christ stands between two slaughtered Roman soldiers.

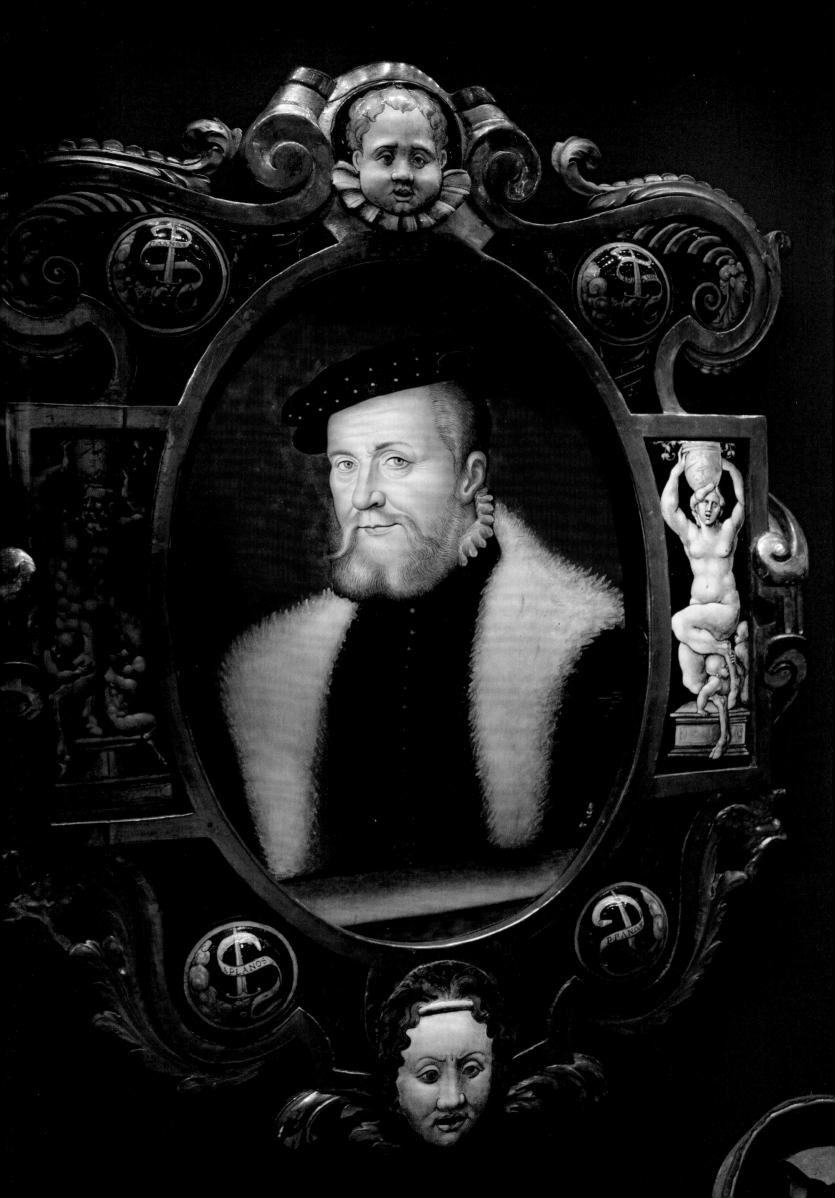

Opposite
"Rustic" pool decorated with snakes,
shells, and fish
France, late 16th–early 18th century
Clay, lead glaze, 55 × 40 cm (21 5/8 × 15 3/4 in.)
Department of Decorative Arts, former
collection of the Lyon painter Pierre Révoil,
acquired in 1828

"Rustic" pool decorated with snakes, shells,
and fish
France, late 16th–early 18th century
Clay, lead glaze, 52 × 40 cm (20 1/2 × 15 3/4 in.)
Department of Decorative Arts, former
collection of Edme Durand, acquired in 1825

Above
Fontainebleau workshop, known as
the Avon (?) workshop
Gondolas decorated with a figure
of Venus and figures of Bacchus and Ceres,
early 18th century
Clay, lead glaze, H. 15 cm and 14 cm
(5 7/8 × 5 1/2 in.)
Department of Decorative Arts, donation by
the violinist Charles Sauvageot, 1856

Following spread (left)
Germain Pilon (active 1540–d. 1590)
and Domenico del Barbiere, known as
Dominique Florentin (d. ca. 1570/71)
Monument to the Heart of Henri II: Three Graces
(Pilon) and pedestal (Florentin)
Marble, H. 150 cm and 105 cm (59 × 41 3/8 in.)
Commissioned by Catherine de Médicis for the
church of the Celestines, Paris, 1561
Department of Sculptures, confiscated during
the Revolution, former Musée des Monuments
Français, transferred to the Louvre in 1817

Following spread (right)
Germain Pilon (active 1540–d. 1590)
Virgin of Sorrows
Terra-cotta with polychrome and gypsum rock,
H. 159 cm (62 5/8 in.)
Large-scale model of the marble *Virgin of Sorrows*
commissioned by Catherine de Médicis for the
rotunda of the Valois in Saint-Denis, 1586
Department of Sculptures, confiscated during
the Revolution, former Musée des Monuments
Français, then chapel of the Saint-Cyr military
school, transferred to the Louvre in 1890

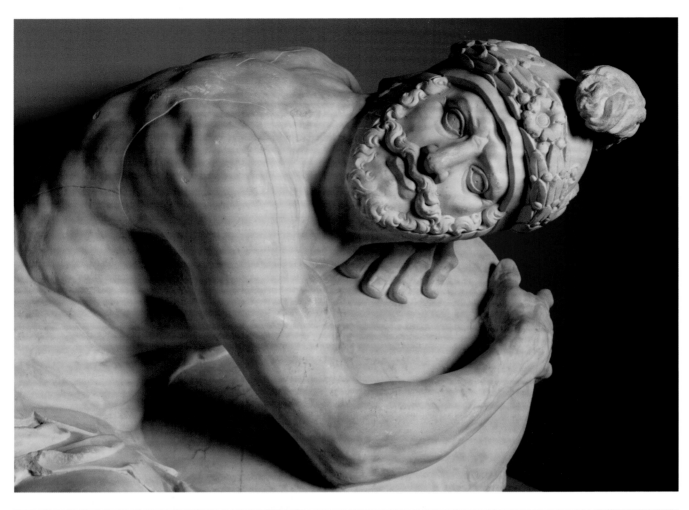

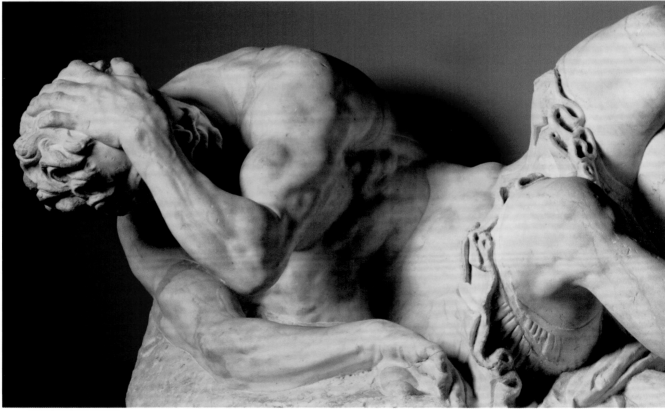

Germain Pilon (active 1540–d. 1590)
The Resurrection, details: the Roman soldier on the right, the
Roman soldier on the left, Christ (H. 215 cm/84 ⅝ in.)
Marble statue commissioned by Catherine de Médicis
for the rotunda of the Valois in Saint-Denis, inventoried
in the sculptor's workshop in 1572; kept in the Salle des

Antiques in the Louvre from 1609 to the Revolution
Department of Sculptures, former Musée des
Monuments Français, soldiers transferred to the Louvre
in 1821, Christ transferred to the Louvre from the
church of Saint-Paul-Saint-Louis in 1933

The "Grand Design"
of the Bourbons

Previous spread (left)
Middle terrace of the Marly courtyard with two sculptures by Antoine Coysevox (1640–1720), from Marly Park: *Neptune* (foregound), and *The Seine* (1705)
Department of Sculptures

Previous spread (right)
Guillaume I Coustou (1677–1746)
Horse Restrained by a Groom, called *The Marly Horse*
Carrara marble, H. 355 cm (139 ¾ in.),
L. 284 cm (111 ¾ in.)
Commissioned in 1739, installed in 1745 in Marly Park, transferred in 1794 to the entrance of the Avenue des Champs-Élysées
Department of Sculptures, transferred to the Louvre in 1985

Facade of the Louvre facing the Seine:
from left to right, the Pavillon de Flore,
the Grande Galerie, and the Petite Galerie

Opposite
Jean-Baptiste Nicolas Raguenet (1715–93)
The Seine from the Pont-Royal (detail), 1754
Oil on canvas, 46 × 85 cm (18 ⅛ × 33 ½ in.)
Department of Paintings, gift of Générale
Durosoy, born Simone David-Weill, 1971

From the Petite Galerie to the Pavillon de Flore: Traces of Henri IV

L et's take a stroll along the Seine. The Grande Galerie's facade extends along the river. Conceived by Henri IV, the building was transformed, half destroyed, and then rebuilt: the very image of a Louvre in perpetual renewal. What we see now is only a reflection of what it was, but it is also a kind of geological cross-section revealing the depth of the Louvre's history. Since car traffic now separates the palace from the river, let's close our eyes and imagine a port city, a castle overlooking a quay, with gate-keepers everywhere, and a paved road along which carriages sway and horses' hooves clatter. Moored boats unload their goods, while others arrive to dock. The quay isn't only used by the palace, even if the food and materials needed for its construction arrive there. It's also connected to the city through the "guichets du Louvre"—narrow passages that connect it to the streets of the surrounding district. You could even describe it as the Port of Saint Nicolas, at the outlet of the street that comes from the church of the same name.

In the Middle Ages, on the river side, only a low protection extended from the ancient fortress to Charles V's surrounding moat. There, a door opening onto the quay gave access to the suburb. Under Francis I, the quay was reinforced and bordered by a road for commercial and administrative traffic.

When she built her Palace of the Tuileries on the outskirts of Paris, Catherine de Médicis wanted to connect it to the castle of her son, the king, a bit like the Uffizi communicated with the Pitti Palace via a long corridor spanning the Arno River in her native Florence. In 1566, Charles IX laid the foundations for a "Petite Galerie" between the Pavillon du Roi and the quay. He also ensured his mother's safety by starting a new fortification west of the great Tuileries Garden, and probably built a traffic corridor between the end of the new gallery (Petite Galerie) and the palace under construction. But the civil war raged; the Parisians rebelled; and Henri III, who was forced to flee, was murdered. The successor he chose for himself was his brother-in-law and distant cousin Henri, King of Navarre. A heretic and the leader of the Protestant clan, he besieged Paris, initially in vain.

Paris being "worth a mass," the Navarrese monarch—native of Béarn—converted and, once crowned king as Henri IV, he entered his new capital on 22 March 1594 by the Quai de Seine, alongside the castle, then under construction. Did he then understand the urgency of carrying out the Valois project, of creating a vast palatial complex in the heart of the city? The will of this Bourbon king was quickly expressed with the resumption of work (architecture

*Portrait of Henri IV as Hercules Slaying
the Lernaean Hydra*, ca. 1600
Oil on canvas, 91 × 74 cm (35 ⅞ × 29 ⅛ in.)
Department of Paintings, acquired in 1997

Henri IV, as Hercules, vanquishes the hydra,
which represented the king's Catholic League
foes.

and decoration), whose administrative direction he entrusted shortly afterwards to his friend
Sully. This proved that it was a top-priority undertaking that only the great financier could
direct while he was trying to turn the country's finances around. Intended to revive the econ-
omy through major works, the project is a distant forerunner of Keynesian dynamics. But it
was also a political manifesto. A converted king, from a foreign kingdom, a remote descen-
dant of Saint Louis through the Bourbon branch, Henri IV had to assert his legitimacy at the
same time as his power. Did he dream of turning the Louvre into a kind of royal city, where
both the arts and administration could flourish? A fresco from the Château de Fontainebleau
preserves the traces of an ambitious expansion project. He planned to quadruple the small
courtyard of the Louvre and to connect the Louvre and Tuileries Palaces with a series of wings
and courtyards to replace the religious, aristocratic, and industrial districts that separated
them. Called the Grand Design (Grand Dessein), this urban planning program, which aimed
to unite the two castles, remained—until 1857, under Napoleon III—an ideal never achieved,
but an ambition pursued by successive sovereigns and the Republics.

Henri IV first ordered the Tuileries to be completed, then the southern wing of the Old
Louvre, then the elevation of the Petite Galerie, and finally, in 1595, the construction of
the Grande Galerie to connect the Petite Galerie to the Tuileries. In short order, the royal
construction site was concentrated at three points that we must nowadays read like a
palimpsest of the Grand Design—so much did the subsequent transformations alter it:
the Petite Galerie, the Grande Galerie, and a large pavilion linking it to the Château des
Tuileries (later called the Pavillon de Flore). As for the Château des Tuileries, largely trans-
formed under Louis XIV and half rebuilt by Napoleon III, the Pavilion went up in flames
during the Paris Commune before being demolished by the Republic in 1883.

Consequently, we must simply imagine what the palace of Henri IV was like. First a Petite
Galerie, housing a space similar to that of Fontainebleau, on the piano nobile where sculp-
ture and painting were at the service of dynastic affirmation. Although the descriptions
contradict each other, it seems that it was Toussaint Dubreuil who provided the overall
design of the vault, animated by various stories: the Gigantomachy, episodes from Ovid's
Metamorphoses, Pan and Syrinx, Jupiter and Danae, and Perseus and Andromeda. Dubreuil
put his collaborators to work, including Jacob Bunel, who decorated the walls with portraits
of the kings and queens of France or illustrious men, while sculptors created coats of arms
in stucco. A woman appeared on the site, Marguerite Bahuche—Bunel's wife—a rare exam-
ple for her times of a female painter recognized for her talent. The ambition of the decoration
approached the dreams of the royal patron, but only written accounts of it remain. In 1661,
a fire completely destroyed the gallery, which was fully refurbished by Le Brun for Louis XIV
and would be reborn under the name Galerie d'Apollon (Apollo Gallery).

Outside, the Petite Galerie had an arcaded facade on the ground floor, spandrels with
allegories, and bossed pilasters where black marble played with yellow stone. The entire
upper section had been redone by Louis Le Vau after the fire. But in the nineteenth century,
"restoration" standards imposed a return to origins—at least presumed origins—and thus
prohibited this mixture of styles. In 1850, the architect Duban, faced with a building that
had partially collapsed on the river side, therefore intended to return to the original proj-
ect, known from a print. The Henri IV style was restored, and on the pediment, a kind of
republican allegory, sculpted by Cavelier, replaced the "Royal Majesty" style of the
Bourbon implemented around 1601.

Back on the quay, the Grande Galerie that was built to connect the Louvre to the
Tuileries had several uses. On the piano nobile, after a first pavilion, there was an immense
space with windows wide open to the river, where the king liked to stroll and look at
the landscape—more pleasant than on the side facing north, where the narrow rue des
Orties ran alongside the palace.

On the ground floor of the pavilion, closest to the Petite Galerie, the king had his architect,
Louis Métezeau, build a sumptuously marble-lined Salle des Antiques (Hall of Antiquities).
In it, he displayed the most beautiful statues from the royal, antique, and modern collections,

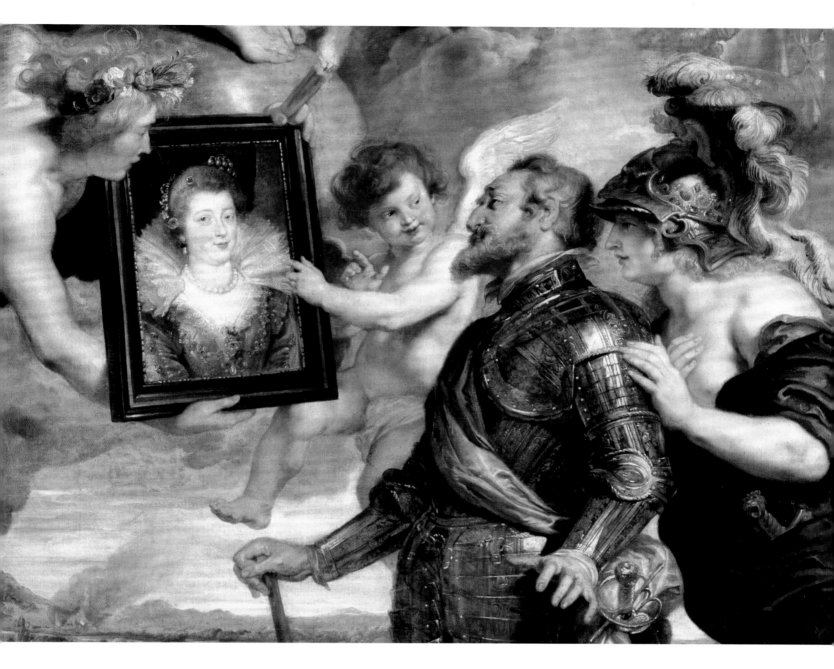

denoting a dominion over the arts comparable to that of the popes at the Cortile del Belvedere. A keeper of the king's antiquities was in charge of the room's maintenance. We have a description of it from the Parisian historian Henri Sauval. The *Diana of Versailles*, also known as *Artemis with a Doe* or *Diane Chasseresse* (Diana the Huntress), was installed there around 1654. It was the first classical statue owned by a king. The room also housed antique copies, referred to as "false antiquities," and contemporary works by Baccio Bandinelli, Pierre Francqueville, and Germain Pilon, which were often commissions that had not been completed or had not reached their intended destinations. But the room disappeared, and the collections were scattered, first to the Palais-Royal, then to Versailles, and in 1692 to the Salle des Caryatides. Nonetheless, this luxurious installation of the royal antiquities was in a way the first steps toward a museum at the Louvre. As for the architecture, it was also transformed by Le Vau, under Louis XIV, to enlarge the queen mother's apartment and give the piano nobile the necessary height for the vast Salon Carré, which would be the heart of Parisian artistic life in the eighteenth century before becoming the museum's most prestigious room.

The Grande Galerie itself forms a long tunnel on the first floor that did not originally have a prestigious function: Henri IV received his subjects there who were sick from scrofula, upon whom he bestowed the "royal touch," which was supposed to heal those who suffered from tubercular adenitis—a miracle that attests to the divine character of the sovereign. Henri IV, who was coronated in Chartres Cathedral instead of at Reims at the time of his conquest of the kingdom, adopted and successfully wielded this supernatural persona.

Peter Paul Rubens (1577–1640)
Henri IV Receives the Portrait of Marie de Médicis and Is Disarmed by Love (detail), ca. 1622–25
Oil on canvas, 394 × 295 cm (155 × 116 in.)
From the *Life of Marie de Médicis* cycle, produced for the gallery of the Luxembourg Palace
Department of Paintings, cycle of 24 paintings transferred in 1790

View of the Petite Galerie and the Pont des Arts

On the ground and mezzanine floors of the gallery, according to letters dated 22 December 1608, the king moved his artists into their quarters. This was the first manifestation of a residence of artists in the Louvre, where the king and those who served him lived. They thereby enjoyed royal protection, escaping the jurisdiction of the city and the rules and competition of the guilds, the bodies that then governed the trades. Artists, architects, painters, sculptors, goldsmiths, perfumers, and mathematical-instrument makers resided in the first part of the gallery, which opened onto the rue des Orties through a wide arcade. The second

part of the gallery provided space for enormous workshops housing the tapestry looms that would emigrate to the royal Gobelins Manufactory in 1671. From this point on, artists were at home in the Louvre. Little by little, they would colonize other areas of the palace, such as the Tuileries Garden and abandoned areas, including houses in the neighborhood bought by the king. Expelled in 1806, they later returned; some remained until the Second Republic.

The structure of the facade of the Grande Galerie reflects these uses. It pits the two parts —the eastern part, near the Tuileries, and western part, near the Louvre—against each

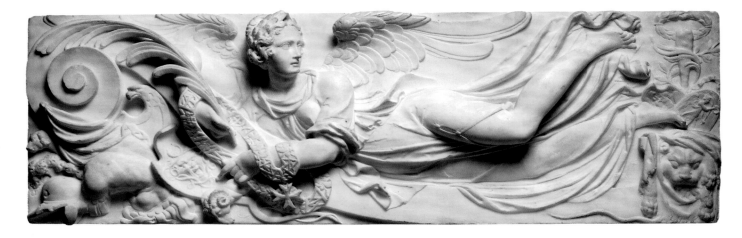

Matthieu Jacquet (ca. 1545–1611)
*Victory Holding the Necklace of the Order
of the Holy Spirit*, 1597–1601
Marble, 26.7 × 83.4 cm (10 ½ × 32 ⅞ in.)
Department of Sculptures, entered in 1851

The most talented disciple of Germain Pilon
executed this work for the Belle Cheminée
(beautiful chimney) of the Château de
Fontainebleau. The room with the fireplace
was dismembered in 1725, and Jacquet's reliefs
eventually made their way to the Louvre.

other, with the break occurring in the area of what was then still the moat of the medieval city wall. In the eastern part, there was first a complex elevation on the Seine side: low, narrow windows that cast light onto several floors under the large openings of the royal gallery. Here we see a continuous frieze of plump children at play; decoration lining the pilasters and capitals, exalting royal power and its bounties—cornucopias, scales of justice, a scepter, a royal monogram, necklaces of the royal orders, and dolphins celebrating the birth of the king's heir in 1600. This facade remained unfinished after the death of Henri IV. The pediments were only undertaken under Louis XIV. On the courtyard side, the elevation is quite different: large arches with arcades whose keystones bear trophies of arms, and friezes that are crowned by nearly square windows. All these facades were profoundly redesigned, like the Petite Galerie, by the architect Duban in 1850. On the Seine, an unfinished frieze was sculpted and the high niches covered by reliefs. It wasn't until the Second Empire that the niches were populated with figures.

No traces of the times of Henri IV remain on the western part: it was completely rebuilt by the architect Lefuel under Napoleon III, along with the majestic Grands Guichets (Great Wicket Gates) which now form a transition between the two parts of the gallery. Originally, the structure was the one seen—ironically—on the north wing built by Percier and Fontaine during the Empire: a colossal order, punctuated by double composite pilasters, bearing large pediments. Napoleon's architects appreciated the monumental order adopted in an innovative way under Henri IV. For his ambitious and proud reconstruction, Lefuel therefore composed a sophisticated copy of the eastern Grande Galerie, undoubtedly to ensure coherence, to the detriment of the diversity taken up by Henri IV and historical accuracy.

Attached to the end, the "large pavilion on the side of the river" (Pavillon de Flore) was already part of the Château des Tuileries, of which it forms an extension. Built under Henri IV, it was also destroyed by Lefuel and replaced by a very ornate pastiche, where the smiling figure of a naked and laughing Flore, surrounded by children, appears almost at the top of the floors, attributed to Carpeaux, Napoleon III's favorite sculptor.

The works would be important under Henri IV, but for a short duration. Struck down by Ravaillac on rue de la Ferronnerie and brought back to the Louvre dying, the king passed away on 14 May 1610. His body was exposed for twelve days in the Salle des Caryatides before his funeral in Saint-Denis. The great construction site fell silent.

Royal Art under Henri IV

The interior decoration of Henri IV's Louvre has disappeared. To evoke the king, we need to look for his image in the different departments of the museum—an image that the first Bourbon widely disseminated through engravings, medals, small bronzes, and even ceramic plates. All types of representations coexist: allegorical or mythological, as a man or as a conqueror. In the Department of Sculptures, in the Salle Francqueville, there is a portrait of the smiling and friendly king next to a relief that shows him as a Roman emperor, protected by Jupiter, emerging from clouds to brandish lightning against his enemies. This figuration of the Victory of Ivry (1590), sculpted by Matthieu Jacquet after a drawing by Antoine Caron, had been installed at the Château de Fontainebleau on a marble fireplace that was so magnificent it had been given the name of Belle Cheminée. Around the central relief, we see the

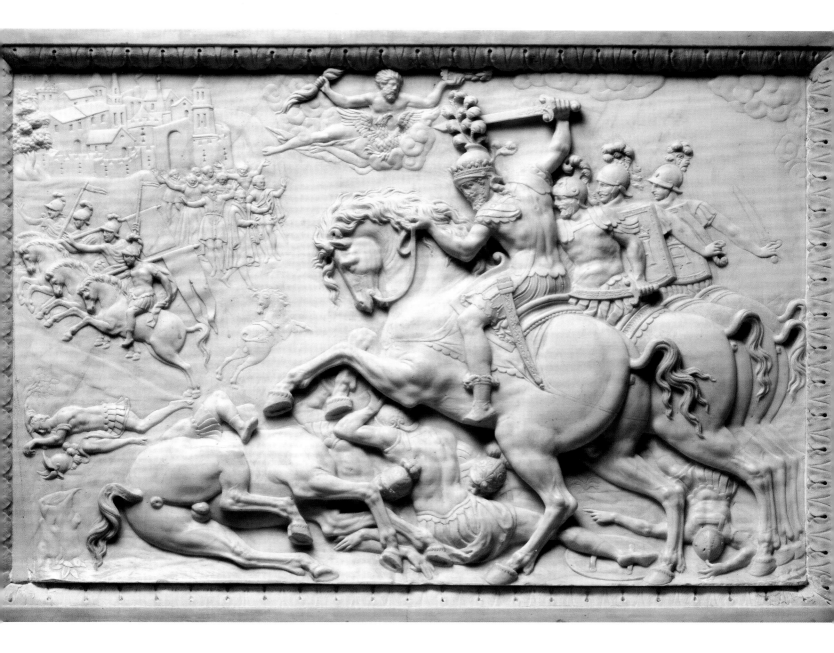

Renommées (figures of Fama) carrying palms and the orders of France—cherubs carrying flags, the scepter, and crown—and all in praise of the triumphant king. Our hero appears again in the Department of Paintings, where the conqueror of the Catholic League is portrayed as Hercules vanquishing the hydra. He can also be found in the Department of Decorative Arts, where his statuette shows him as Jupiter, and the pendant of the queen, Marie de Médicis, as Juno. Here, the sculptor Barthélemy Prieur exalted the king in Olympus with a mythological and allegorical portrait. Francis I had already used this device, and so did Henri IV on this occasion, foreshadowing Louis XIV's plans. It is worth mentioning that before his marriage to Marie de Médicis in 1600, Henri IV was a well-known lover. The Vert Galant, as he was warmly dubbed, had many mistresses, not to mention his first wife, Queen Margot, who he repudiated. Above all, he adored the beautiful Gabrielle d'Estrées, who died during childbirth near the Louvre in 1599. The Louvre holds a mysterious painting in which one of the figures is believed to be a portrait of her.

We have just seen the royal commission for the Belle Cheminée of Fontainebleau (1597), which was a sign that court art was being revived with verve under the new King Henri. A whole host of painters, such as Toussaint Dubreuil and Ambroise Dubois, would constitute a "second School of Fontainebleau." This indicated not only that they were actively working on the project, but also that they were returning to the aesthetic of the first school and its strong attachment to Mannerism. The Louvre holds the remains of Henri IV's great commission for his château in Saint-Germain-en-Laye, where Dubreuil illustrated *La Franciade*, Ronsard's epic poem celebrating the French dynasty as the heir to the heroes of Troy. Less

Matthieu Jacquet (ca. 1545–1611)
The Battle of Ivry and the Surrender of Mantes (14 March 1590), 1597–1601
Marble, 46.6 × 66.7 cm (18 ³⁄₈ × 26 ¹⁄₄ in.)
Central relief of the lintel of the Belle Cheminée at the Château de Fontainebleau, representing the conquest of the kingdom by Henri IV, based on a drawing by Antoine Caron
Department of Sculptures, former Musée des Monuments Français, transferred in 1818

School of Fontainebleau
Presumed Portrait of Gabrielle d'Estrées
and Her Sister the Duchess of Villars, ca. 1594
Oil on canvas, 96 × 125 cm (37 ¾ × 49 ¼ in.)
Department of Paintings, acquired in 1937

This enigmatic, sensual painting may allude
to the upcoming birth of a child of Henri IV
and his mistress, Gabrielle d'Estrées. She died
in 1599 giving birth to her fourth child, just as
the king was on the point of marrying her.

Opposite
Pierre Francqueville (1548–1615)
David, Conqueror of Goliath, ca. 1605–10
Marble, H. 179 cm (70 ½ in.)
Commissioned by Henri IV; kept in the
Salle des Antiques in the Louvre up to the
Revolution
Department of Sculptures, former Musée
des Monuments Français, transferred in 1818

specifically linked to Fontainebleau—even if he decorated its chapel—Martin Fréminet was the most Italian of the royal artists; the influence of Michelangelo, with whose work the artist had direct contact, is palpable. Returning from Italy in 1603, and immediately named Valet of the King's Chamber, Fréminet brought a great colorful and dynamic style that can be seen in *The Charity of Saint Martin*, which entered the Louvre in 2007.

The artistic tradition of Fontainebleau is less strong in sculpture, as can be seen in the Salle Francqueville. The king hired Matthieu Jacquet, a pupil of Germain Pilon, who also extended his master's art into the great fireplace of the destroyed Château de Villeroy and into the medallion of the poet Desportes. More durably marked by Italian art, which he experienced in Rome and Turin, Barthélemy Prieur—protected by the king perhaps because he was a Protestant—continued an activity he had already carried out for large tombs during the civil wars. But the king's favorite sculptor was a quasi-Italian: Pierre Francqueville, whom the Florentines called Pietro Francavilla. To change his style, or to tame the great Tuscan artist, the king brought him to the French court. Henri was undoubtedly fascinated by Francqueville's large statue *Orpheus Charming the Animals* that he saw in the Parisian garden of the Florentine Jérôme de Gondi (preserved in the Louvre after decorating the gardens of Versailles), and he commissioned major works from the sculptor. Thus, *David, Conqueror of Goliath*, dreaming and melancholically leaning on the great sword of the decapitated giant, took its place in the Salle des Antiques of the Louvre. Francqueville was to be the intermediary between Queen Marie de Médicis and her uncle, the grand duke of Tuscany, when she inquired about the possibility of erecting an equestrian statue of her husband in bronze. Although the work, commissioned by Giambologna, arrived after the king's death, Francqueville prepared the portrait of the king and models of the four captive figures

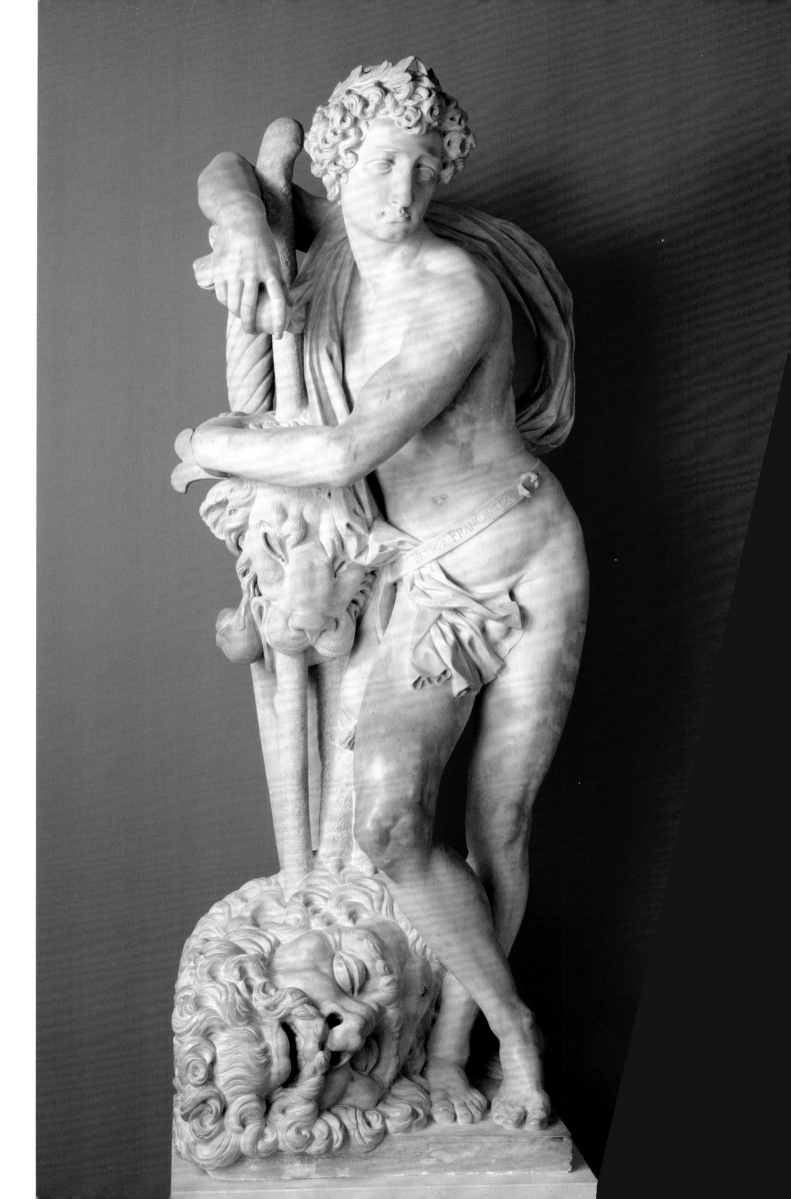

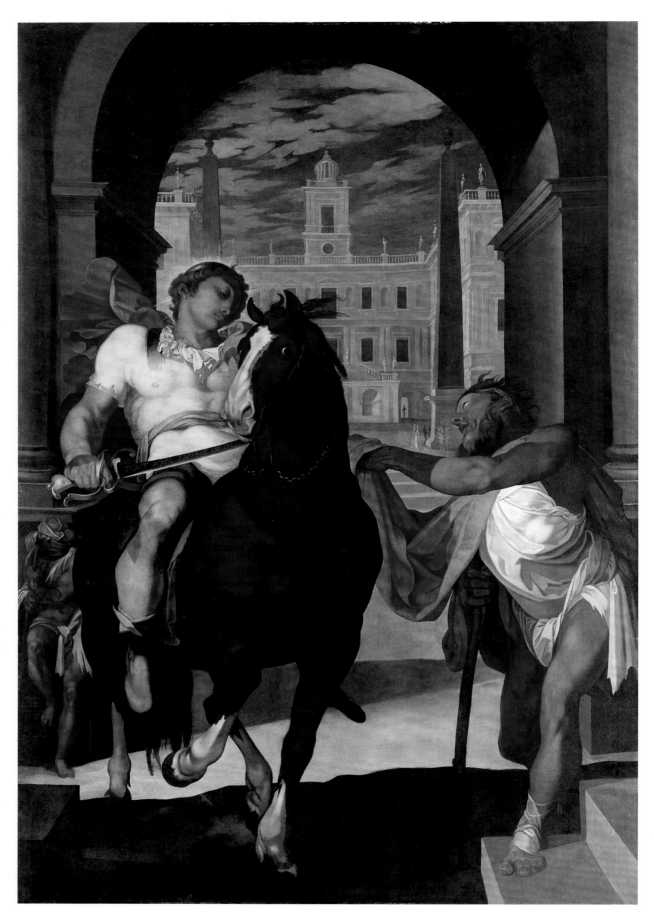

Martin Fréminet (1567–1619)
The Charity of Saint Martin, ca. 1610–19
Oil on canvas, 347 × 237 cm (136 ½ × 93 ¼ in.)
In the background: view of the Capitoline, Rome
Paintings Department, acquired by dation
in 2007

Opposite
Pierre Francqueville (1548–1615) and Francesco Bordoni
(1580–1654)
Captive in the Prime of Life and *Young Captive*
Bronze, H. 160 cm (63 in.)
Commissioned from Francqueville in 1614, finished by
Bordoni in 1618
Department of Sculptures, seized during the Revolution,
former Musée des Monuments Français, transferred
in 1817

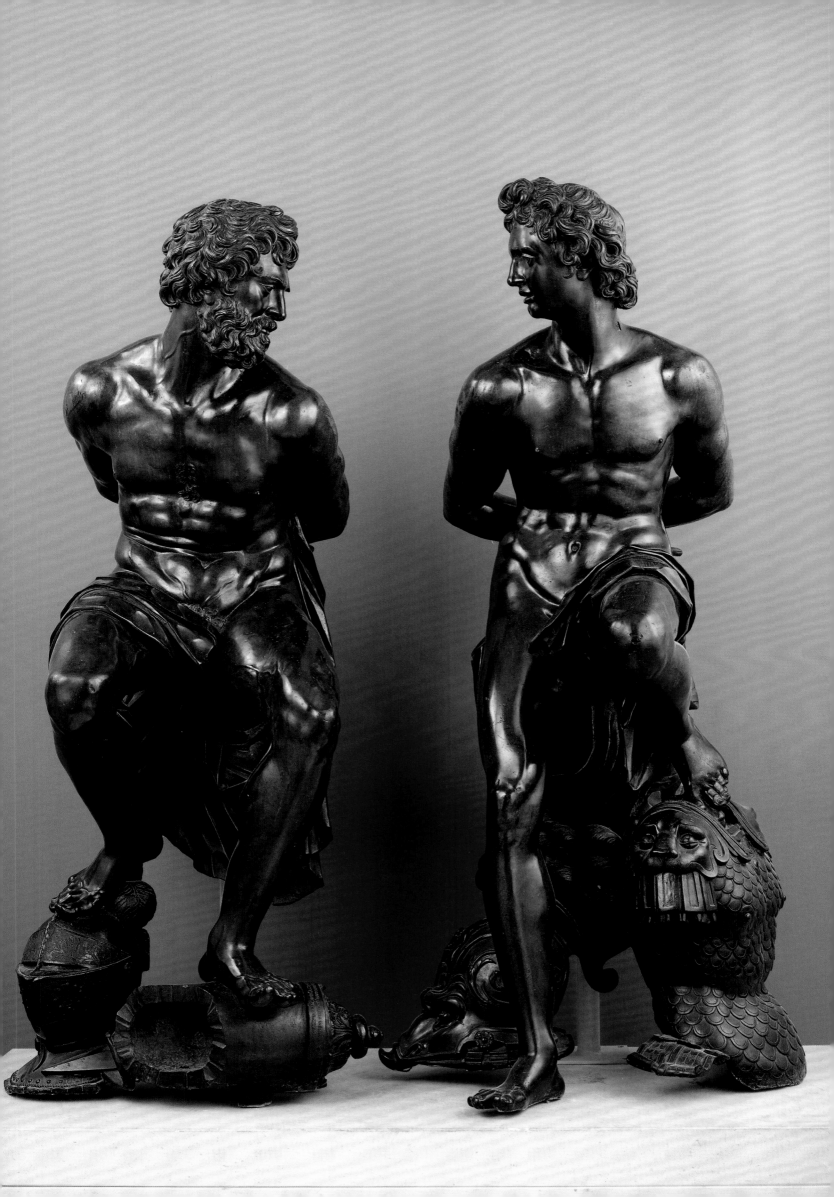

intended for the pedestal. Completed in 1618 by Francqueville's son-in-law, Francesco Bordoni, a Florentine sculptor of the king, these *Captives*, who seem to be in dialogue, express through their twisting bodies the drama of slavery.

The Louvre of Louis XIII: Abandoned Projects

Let us place ourselves in the center of the large wing of the Cour Carrée, the Pavillon de l'Horloge (Clock Pavilion) dominating its two symmetrical wings and proudly raised dome. It relates another episode in the history of the Louvre. The intertwined royal monograms, Louis's Greek lambda and Anne of Austria's "A," tell us that the patron was Louis XIII. What they don't reveal is that the construction was the result of the long political conflicts that followed the death of Henri IV.

In 1610, the new king, Louis XIII, was ten years old. His late father did not really entrust the regency to the queen mother, Marie de Médicis, who had seized authority. She would later have her story of love and power "rewritten" by Peter Paul Rubens for her Luxembourg palace. This cycle of monumental paintings is one of the glories of the Louvre.

At the time, the Louvre was an almost abandoned construction site. In the Grande Galerie, the little king practiced fox hunting, a very proper, princely activity that shows how vast and sparsely occupied the space was. Although the main courtyard, which was still very small, was rebuilt on one side, where the royal apartments were located, the other two wings—north and east—were still those from the Middle Ages, with their towers and foul-smelling moats. Marie de Médicis gave up on the Grand Design, simply refurbishing her own apartment and creating a small garden along the Seine, the current Infanta's Garden, which extends in front of the Petite Galerie. It communicated with her apartment and, according to rumors, allowed Concino Concini, her Florentine adviser who had a small mansion built near the château in 1612, to visit her discreetly. But the affair went awry: Louis XIII plotted against Marie's favorite and had him murdered in 1617, right at the door of the Louvre. This was the prelude to long disputes between the queen mother and her son, which led to Marie de Médicis's exile.

The queen mother probably didn't like the Louvre very much. Like Catherine de Médicis, she had a palace outside the city, the Luxembourg, built in 1615 and completed around 1629. It was there that she brought Rubens, in 1621, to paint the most extraordinary mythical story of a queen blessed by the gods. The Antwerp painter was then at the height of his artistic powers. He tackled the gigantic task that involved the skills of both a diplomat, careful to show the twists and turns of the European court, and an extraordinary decorator, capable of animating twenty-four immense canvases (4 meters/13 feet high, some 7 meters/23 feet wide) with a lush mix of fantasy and realism. "Rubens, a river of oblivion . . . where life flows and whirls incessantly," Baudelaire wrote. This very official art, so praiseworthy, still reveals a real pleasure in painting, abundant and warm, with its generous, allegorical humor; its playful and teasing children; its skies that open wide; its flowers and fruits; its misty distances; and its golden silks. The Musée du Louvre appropriated the cycle in 1790, when it had to furnish its gallery walls. Today, the paintings dominate a room specially designed for them in the Richelieu Wing.

The king allowed this to be done and belatedly took up his father's plans for the Louvre. With his power now asserted, and while the great classical art was developing in his kingdom, his thoughts turned to creating an exceptional and immense palace. Undoubtedly pushed by the new all-powerful minister Cardinal de Richelieu, Louis XIII promulgated the edict of the Grand Design in 1624, thenceforth prohibiting construction in the area of the future Louvre and Tuileries Palaces. The ancient fortress was doomed. The medieval wings fell under the picks of the demolition workers. It is probably at this time that the statues of Charles V and Jeanne de Bourbon, taken from the medieval facade, entered into the royal collection.

Pavillon de l'Horloge (known as the Sully Pavillon under Napoleon III), built by Jacques Lemercier in 1639–40: Cour Carrée, west wing

Several rooms are dedicated to the history of the Louvre in this pavilion.

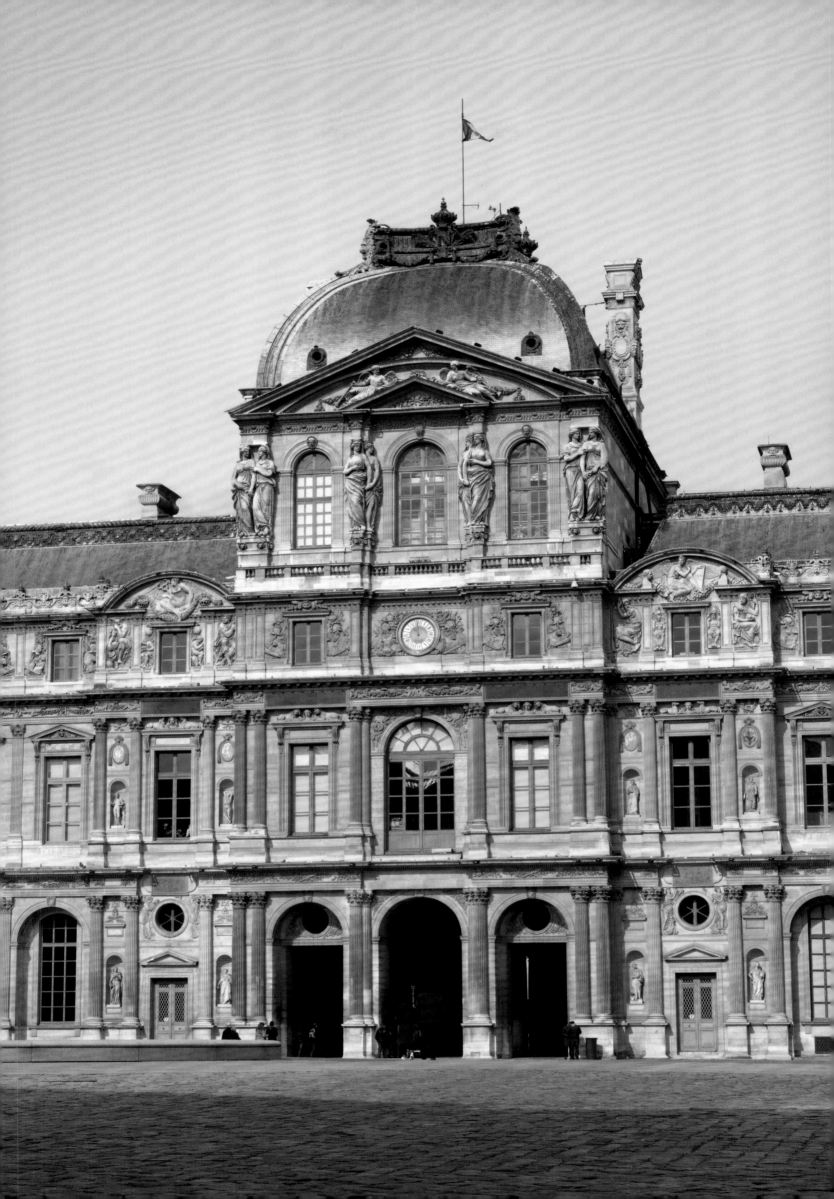

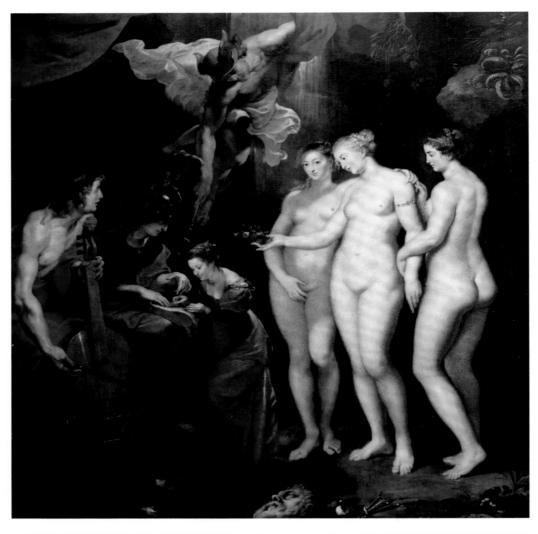

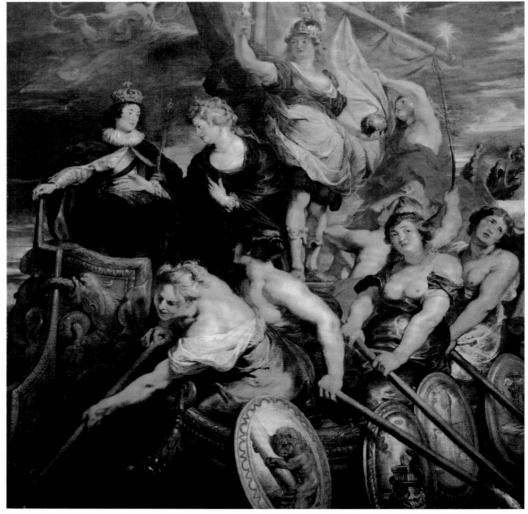

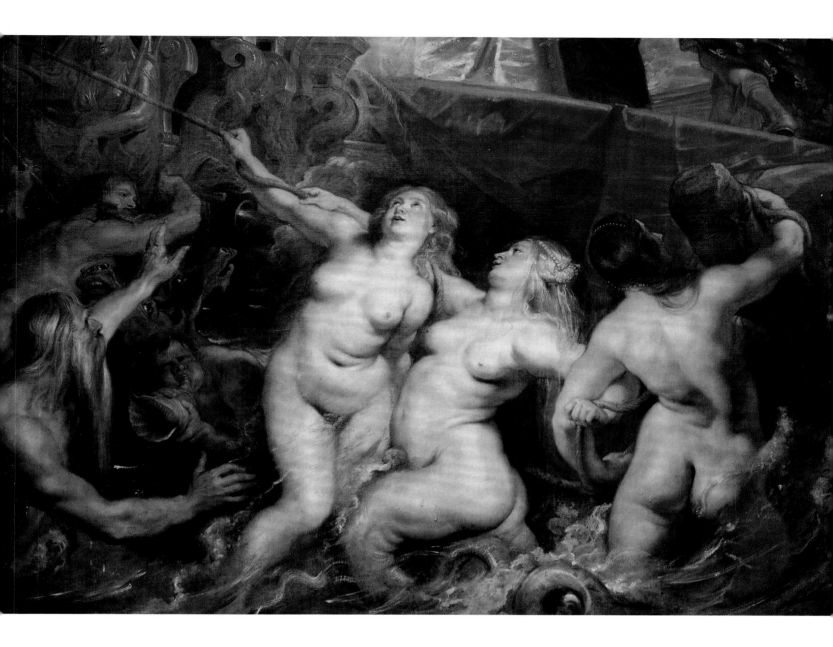

In July 1624, the king laid the foundation stone for a new pavilion at the end of the Henri II Wing, the Pavillon du Milieu or Gros Pavillon du Louvre, later called Pavillon de l'Horloge (Clock Pavilion), and later, the anachronistic Pavillon Sully. To the north, a new wing, following the model of the Lescot Wing, made it possible to quadruple the size of the courtyard. At that time, the architect was Clément II Métezeau. But it was a false start, and work once again stalled.

In 1638, the birth of a long-awaited heir (the future Louis XIV) awakened the impulse that the king previously lacked to resume the Grand Design. Three artists trained in Rome, the laboratory of European art, were to work there: the architect Jacques Lemercier; the sculptor Jacques Sarazin; and the great Nicolas Poussin, whom the king brought back from Rome. Lemercier, the new architect, came from the Luxembourg site, and he was a protégé of Richelieu, for whom he was building a superb château on the border of Poitou and Touraine. He was "a little slow . . . heavy, but on the other hand, foresighted, judicious, profound, solid —in a word, the premier architect of our century," said Henri Sauval, one of the first historians of the Louvre and a witness to the construction works. Heir to the master masons of Pontoise, Lemercier combined contemporary Roman forms with French building traditions.

The architect directed the construction of the Central Pavilion in 1639 and 1640. He applied the order of Pierre Lescot's facade to the ground floor, the first floor, and the attic. But at the top of the pavilion, he introduced a spectacular new feature: three cantoned bays were opened featuring four groups of two caryatids each—supple, voluptuously modeled female figures. In the center, Lemercier placed a monumental sculpture. Higher up, he encased a triangular pediment with reclining allegorical figures, under a second pediment, this time curvilinear,

Peter Paul Rubens (1577–1640)
Three details of compositions from the *Life of Marie de Médicis* cycle, 1622–25, painted for the gallery of the Luxembourg Palace:
Education of the Princess (opposite, top)
Louis XIII Comes of Age, The Queen Transfers Her Powers to the King on 20 October 1614 (opposite, bottom)
The Disembarkation at Marseilles, 3 November 1600 (above)
Oil on canvas, 394 × 295 cm (155 × 116 in.)
Department of Paintings, cycle of 24 paintings transferred in 1790

After Simon Vouet (1590–1649)
Moses Saved from the Waters, ca. 1630
Tapestry, wool and silk, 495 × 588 cm
(194 ¾ × 231 ½ in.)
Third piece of the *Old Testament* wall hanging,
woven at the Louvre by Maurice Dubout and
Girard Laurent, based on Vouet's full-sized
sketches
Department of Decorative Arts, former
Crown collection, transferred from the
Mobilier National in 1906

Opposite
Simon Vouet (1590–1649)
Wealth, ca. 1640
Oil on canvas, 170 × 124 cm (66 ⅞ × 48 ⅞ in.)
Department of Paintings, collection of
Louis XIII

This light-filled composition has been compared
to the paintings made for the Château de
Saint-Germain-en-Laye. Here, material wealth,
represented by jewelry, is dominated by the
spiritual wealth to which the child refers by
pointing to the sky.

inscribed inside another pediment, which was also triangular. Above it stood an elegant dome, the prototype of all the future domes of the Louvre. But the one we see today is the result of the radical transformation brought about by Hector Lefuel under Napoleon III. Wider, higher, heavier, it has taken on the appearance of a huge coiffure.

The sculpture work was directed by Jacques Sarazin, a sculptor to the king who was housed at the Louvre, who had Philippe de Buyster (housed at Les Tuileries) and Gilles Guérin in his workshop. These two created the caryatids of the facade: immense classical figures with ample, dynamic bodies in dialogue: arms entwined, embracing, turned toward each other. They are only a distant memory of the figures that Goujon had sculpted in the Salle des Caryatides, because here, they are real women and no longer columns. This sense of life is reflected in the friezes, where plump and smiling children play between garlands of foliage.

Louis XIII also undertook to reform the interior of the palace. The Salle des Caryatides, until then simply covered by a ceiling with joists, was vaulted with stone by Lemercier in 1639, and the Grande Galerie was finally to be decorated with a painted vault.

The King's Artists and the Royal Commission

We must imagine the great hive of artists who were living at the palace, in the Grande Galerie, as well as in the Tuileries. In the latter, with Philippe de Buyster, we find the Florentine Francesco Bordoni, the king's sculptor, who was already active under Henri IV. He modeled an incisive portrait of an ill Louis XIII, with marked features and swollen lips, which the finely chased bronze work makes even more dramatic, despite the pomp of the garment.

There were also painters living on site, such as Sébastien Bourdon (at the Louvre) in 1641, as well as Simon Vouet and Nicolas Poussin. The king brought Vouet back from Rome in 1627 and assigned to him the decoration of the Château de Saint-Germain-en-Laye, his favorite residence. The painter displayed all his virtuosity, nourished by memories of Fontainebleau's art and Roman colors; for example in the allegory of *Wealth*, with the subtle monumental sinuosity animated by the glances exchanged between a woman in profile and the playing children. Largely housed in the Louvre's galleries and benefiting from two

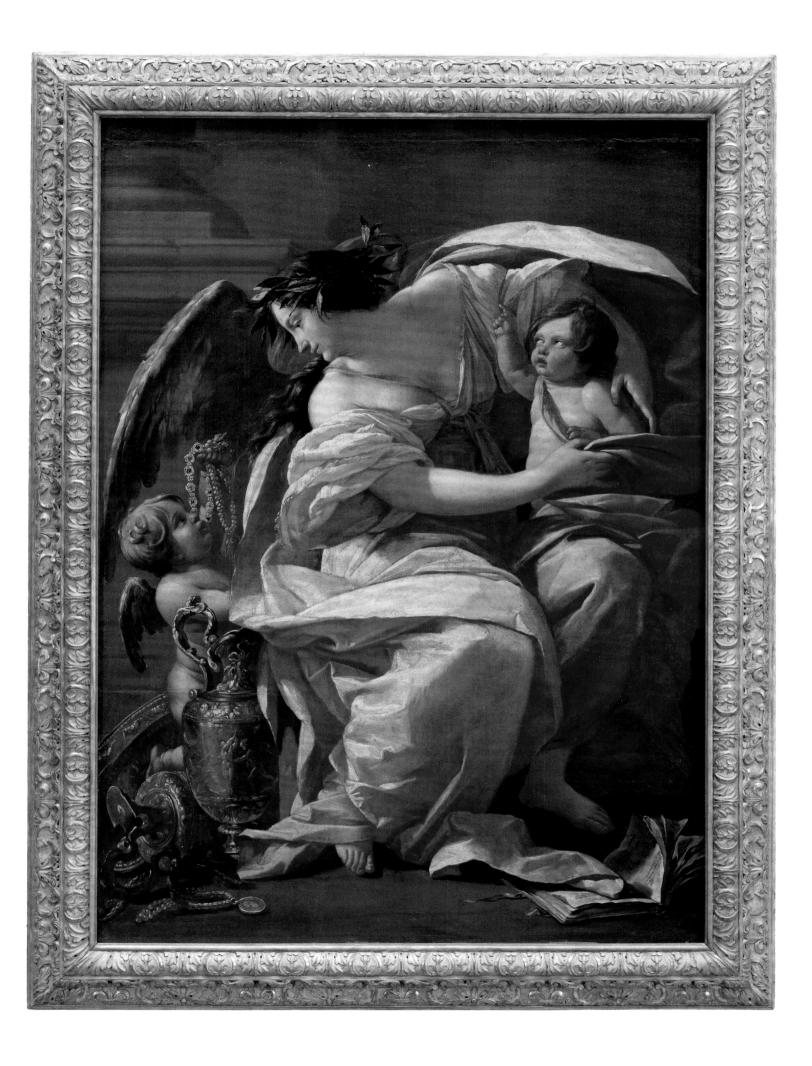

Above and opposite
Pierre Delabarre
(appointed master in 1625–ca. 1654)
Ewer, ca. 1630–35
Mountings of two sardonyx ewers from
the 1st century B.C.–1st century A.D.
Enameled gold, rubies, diamonds, emeralds,
opals, figure of a nude woman, and terminal
figures, H. 26.1 cm (10 ¼ in.) (work stolen
from the Louvre in 1830, acquired in 1971 on
the arrears of the James H. Hyde bequest)
Enameled gold and ruby bust of Minerva
on the lid, fantastic dragons and masks,
H. 27.5 cm (10 ⅞ in.)
Department of Decorative Arts

workshops, he became a mentor for his closest friends, the painter Michel Corneille and the sculptor Jacques Sarazin. However, he was almost eclipsed by the arrival of Poussin, who came to decorate the Grande Galerie ("Here Vouet met his match," the king quipped). In 1639, Louis XIII asked Poussin, who had settled in Rome, to join his court. Famous and well established in the Eternal City, Poussin played for time. The king sent emissaries, the Chantelou brothers, to persuade him. On the painter's advice, the brothers made casts of the most beautiful classic reliefs of Rome (Trajan's Column, the Arch of Constantine, the *Dancers*, and *Sacrificing Women* from the Borghese collection) in order to make copies for the Louvre. Finally, Poussin arrived in Paris in 1640. Housed in a pavilion in the Tuileries Garden, he was promoted to First Painter to the King. He set to work at the beginning of 1641, undertaking a cycle of the Labors of Hercules, while landscapist Fouquières had to create the views of ninety-six cities in France for the walls. However, Poussin soon grew weary and furious at having to work in an imposed framework, without an execution workshop, as well as having to deal with the schemes and jealousies of other painters. He left for Rome in November 1642, from where he simply sent drawings the following year.

But it was not only painters and sculptors who lived in the Louvre and Tuileries. At the end of the gallery, the tapestry weavers Maurice Dubout and Girard Laurent were set to work, installed by letters patent from 1617. They followed the patterns of the finest painters. As soon as Simon Vouet arrived in 1628, he was commissioned to produce full-sized tapestry sketches for the royal workshop. He provided six compositions from the Old Testament for a hanging for the Louvre. Of these, only two survive, including *Moses Saved from the Waters*, a high-warp wool-and-silk tapestry in the Department of Decorative Arts. The painter's palette was admirably transcribed by the weavers, who thus inaugurated the revival of this art, which would later flourish in the royal Gobelins Manufactory. Goldsmiths were also active in the gallery. The imaginative Pierre Delabarre, "the master of dragons," designed sumptuous settings for the royal gems, which the rulers loved; in particular, the sardonyx ewer decorated with a small head of a young Minerva and fantastical dragons.

The royal collection was not yet really on the agenda. Certainly, Louis XIII installed a *Saint Sebastian Tended by Saint Irene* by Georges de La Tour in his room, but this has disappeared. Many French painters with established reputations worked in Italy—such as Valentin, Poussin, and Claude Lorrain—or they found a private clientele. The Flemish painter Philippe de Champaigne, protected by Richelieu and the queen mother, belonged to the colony of northern artists who lived near Saint-Germain-des-Prés. He would become the king's official portrait painter, as well as that of Cardinal Richelieu. The so-called "painters from reality,"—Valentin, the Le Nain brothers, and Lubin Baugin, who legitimized the still-life genre—worked mainly for religious clients or individuals. The Louvre was not yet the great palace of the arts.

The Authority of a Queen Mother: Anne of Austria at the Louvre

Anne of Austria married Louis XIII when they were both just out of their teens. A Habsburg princess, but more Spanish than Austrian, she was a foreign queen. For a long time, she was a queen without an heir, married to a king who showed little enthusiasm for fulfilling his conjugal

Anne of Austria's summer apartment: the former second vestibule, or Peace Room
From behind: *Emperor Otto*, 69 A.D.
(former Braschi collection, Napoleonic confiscation, 1798)
Department of Greek, Etruscan, and Roman Antiquities

Opposite
Anne of Austria's summer apartment: the former second vestibule, or Peace Room, transformed into the Musée des Antiques in 1799, today the Roman Art room, Julio-Claudian period
Department of Greek, Etruscan, and Roman Antiquities

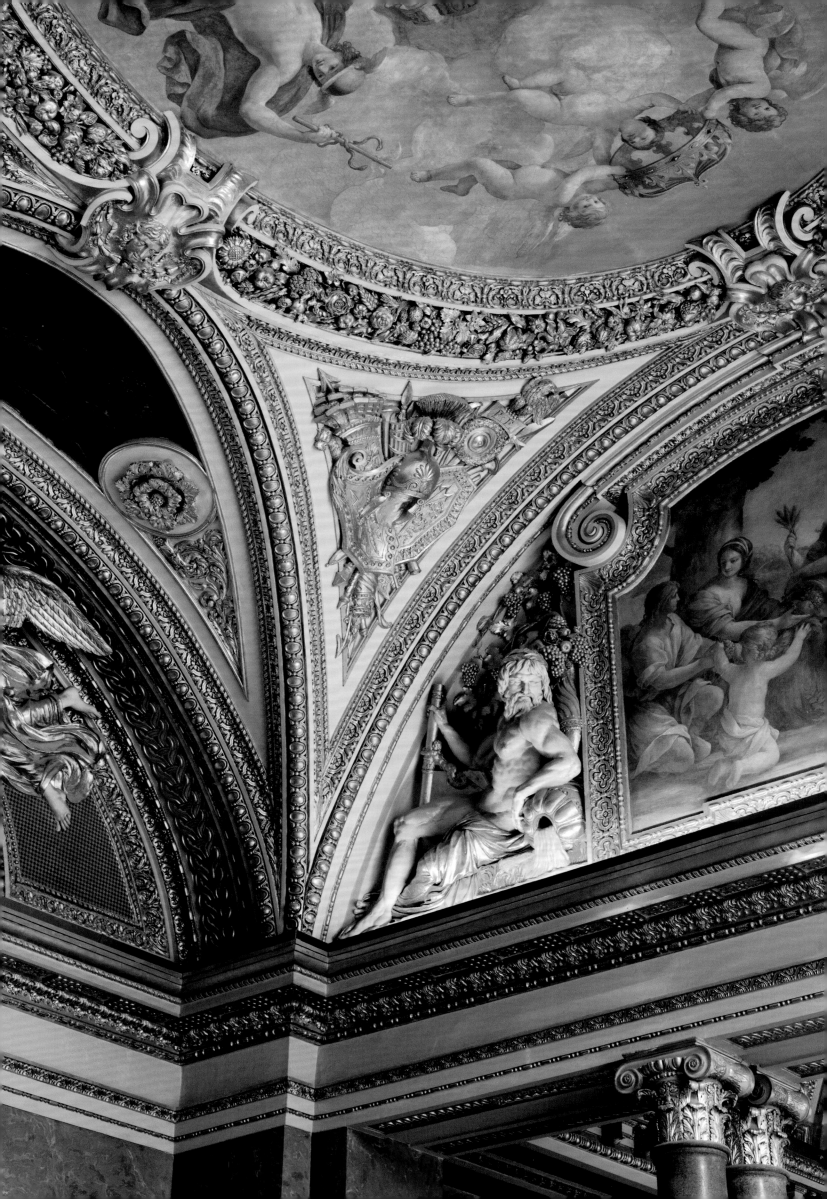

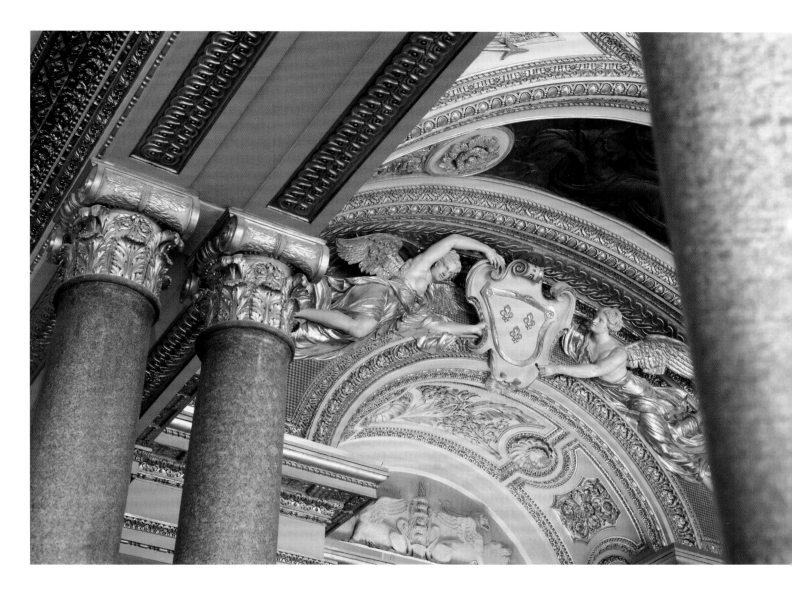

duties. Without giving too much credit to Alexandre Dumas's stories, the young queen's consideration for the handsome Duke of Buckingham, Richelieu's intrigues, and courtiers' gossip paint a very dark picture of poor Anne. But one stormy night, Louis XIII, who went to the Convent of the Visitation on rue Saint-Antoine to meet his former lover, Mademoiselle de La Fayette, could not return to the Château de Vincennes and came to share the queen's bed at the Louvre. Nine months later, in 1638, the dauphin Louis was born. Five years later, Louis XIII passed away, and, on 14 May 1643, the child began a seventy-three-year reign as Louis XIV.

The queen took over the regency. But the "princes" (les Grands) tried to take advantage of the situation. Richelieu, who died a few months after Louis XIII, bequeathed his Cardinal Palace, which became the Royal Palace, to the child-king. The queen settled there and thus moved closer to the palace of Cardinal Mazarin, the new strongman at the court who succeeded Richelieu. It was more than friendship that united the queen and her minister, while the civil wars of the Fronde of the Princes and the Parliamentary Fronde rose up against the state. In 1648, the Parisian revolt forced the king and his mother to flee the capital. However, in October 1652, the court returned to the Château du Louvre, which was safer than the Palais-Royal, since the medieval moats still provided protection.

The regent finally asserted herself, thanks to Mazarin's political intelligence. He stayed at the Louvre and settled his sister and his pretty nieces in the attic of the Lescot Wing. For the queen mother, all the stops were pulled to please her. As early as 1653–54, the architect Jacques Lemercier rebuilt the apartment on the ground floor of the south wing's Cour Carrée, nothing of which remains—neither the ceilings of Eustache Le Sueur nor the landscapes with episodes from the life of Moses by Pierre Patel and son. Only a few paintings have entered the museum's picture galleries: Charles Le Brun's *Crucifix with Angels*, a devotional painting from the oratory, and a portrait of the infanta Marie-Marguerite by Velázquez's workshop, sent by the Spanish court with other family portraits.

Anne of Austria's summer apartment:
the former second vestibule or Peace Room
Detail of the *Renommées* (figures of Fama)
in stucco by Pietro Sasso and Michel Anguier;
granite columns from the Carolingian church
of Aachen inserted in 1799

Opposite
Anne of Austria's summer apartment:
the former second vestibule, or Peace Room
On the ceiling: *Allegory of the Treaty of the
Pyrenees (Peace, the Fruit of War)*
Below: *The Goddess of Agriculture Encouraging
the Work of the Countryside*, mural paintings by
Giovanni Francesco Romanelli (1610–62);
The Garonne, 1660, stucco, by Michel Anguier
(1612–86)

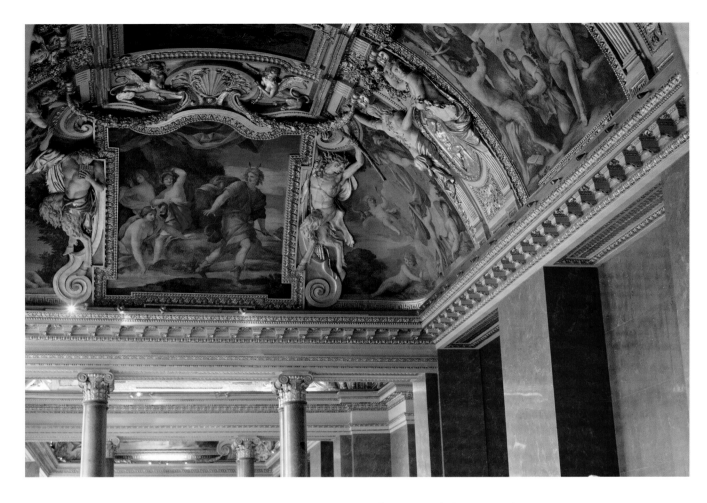

Anne of Austria's summer apartment: the former antechamber, or Seasons Room
From left to right: *Diana and Actaeon*, *Summer*, and *Apollo and Marsyas*, wall paintings by Giovanni Francesco Romanelli (1610–62); stuccoes, 1657, by Michel Anguier (1612–86)

Opposite
Anne of Austria's summer apartment: the former antechamber, or Seasons Room
Details of *Diana and Actaeon* and *Summer* (spandrel), wall paintings by Giovanni Francesco Romanelli (1610–62); *Leaping Satyr*, 1657, stucco, by Michel Anguier (1612–86)

Following spread
Anne of Austria's summer apartment: the former antechamber, or Seasons Room
Details of *Summer* and *Apollo and Marsyas*, wall paintings by Giovanni Francesco Romanelli (1610–62); center, caryatids and *Vulcan* or *Fire* (medallion), 1657, painted and gilded stucco, by Michel Anguier (1612–86)

The Queen's Summer Apartment

The apartment that Lemercier designed for Anne, called the Baths, and facing due south, would have been unbearable in the summer. She therefore had a summer apartment built on the ground floor of the Petite Galerie. It remains nearly intact, today housing the Roman sculpture rooms. On the ceiling, the colorful frescoes and large white figures with gold details conjure a magical world. They tell the story of a queen unlucky in love, then living through the tumults of a difficult regency; a woman who could finally enjoy the love of a brilliant son and assert her political and cultural ambitions before, while still at the Louvre, meeting a painful end.

Lemercier, and then his successor, Louis Le Vau, carved out six rooms for the queen mother, forming one large apartment: vestibule, antechamber (called the Seasons Room), second vestibule (called the Peace Room), large study, bedroom, and small study. A part of the former Salle des Antiques of Henri IV, reduced to create an oratory, was later added. It was here that the queen would come to relax and one day try to persuade Mazarin's niece, Marie Mancini—Louis XIV's first love—to give up her dream of marriage. The sermon in which Bossuet thundered against the royal lovers seems to still echo in the chapel on the first floor of the Pavillon de l'Horloge, as a reminder of the tears shed inside these walls.

The decoration is a kind of offshoot of the great Roman Baroque: Mazarin's taste is obvious, and the iconography is a coded salute to his glory. From 1655 to 1659, the ceilings were frescoed with a vibrant color palette and a light touch by the Roman Giovanni Francesco Romanelli, a student of Pietro da Cortona, who had already worked for Mazarin. The frescoes are surrounded by stuccoes, the work of the Italian artist Pietro Sasso and the French sculptor Michel Anguier, who trained in Rome under Algardi. We must imagine this Italian team handling the white stucco, a quickly hardening plastic material that has the luxurious appearance of marble. On a core with metal reinforcement, the thin, smooth, shiny surface is enhanced with gold detailing. Anguier retained the taste for ample and dynamic volumes acquired during his long stay in Rome, as evidenced by the interplay of sometimes surprising twists that contrast with less dynamic compositions. Sculptor of the queen mother, he would also decorate the church of Val-de-Grâce, raised in thanksgiving after the miraculous birth of the young Louis.

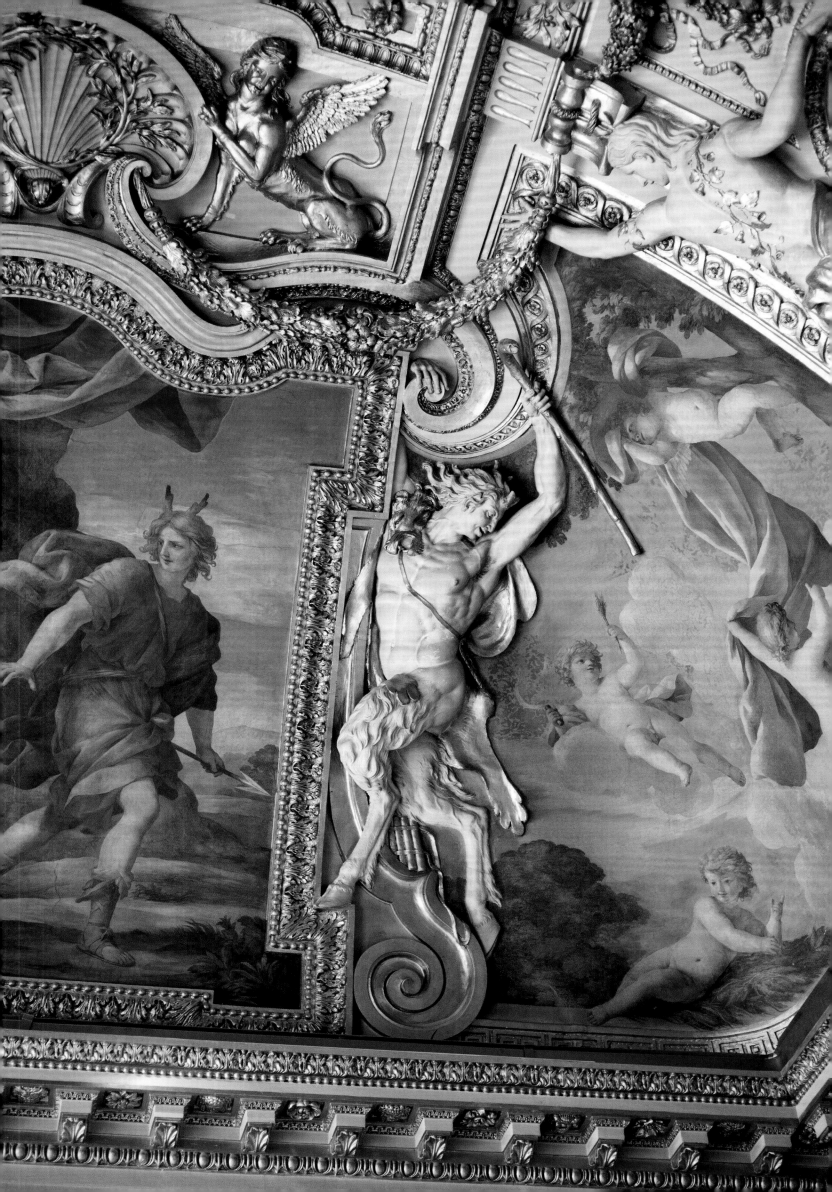

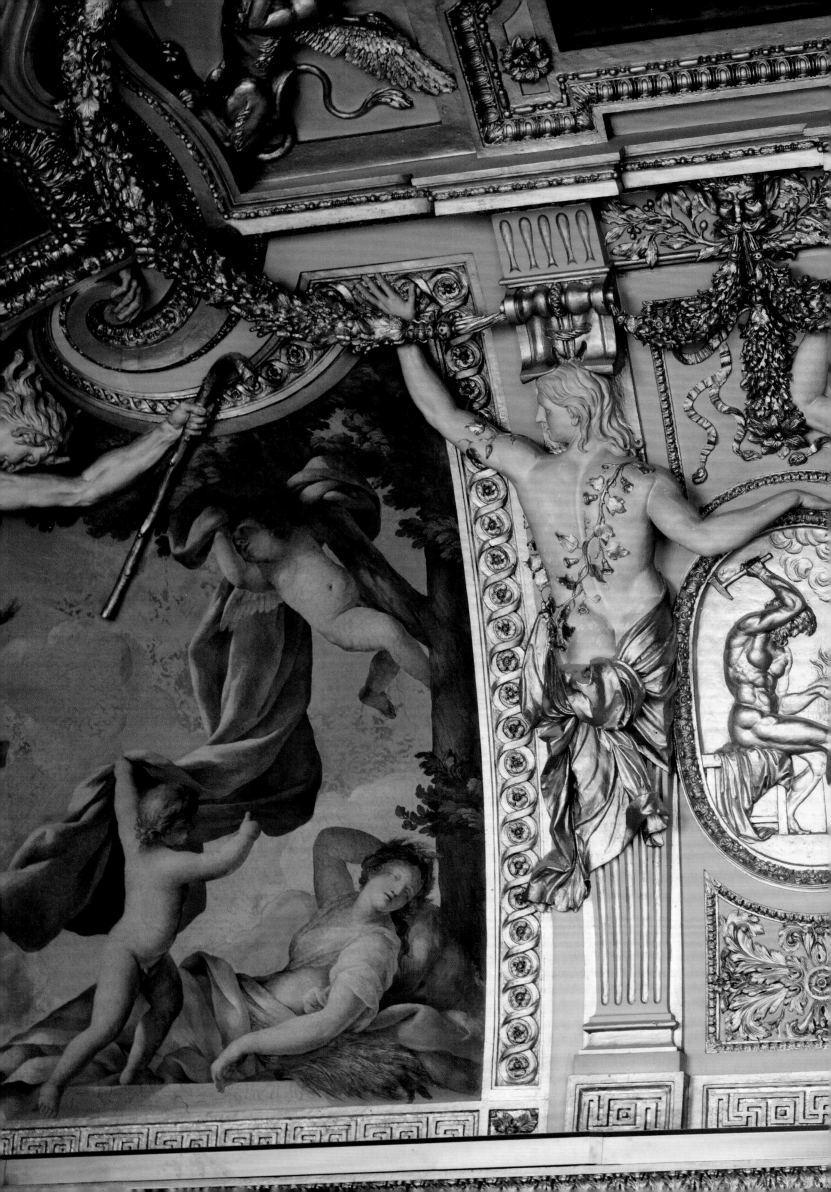

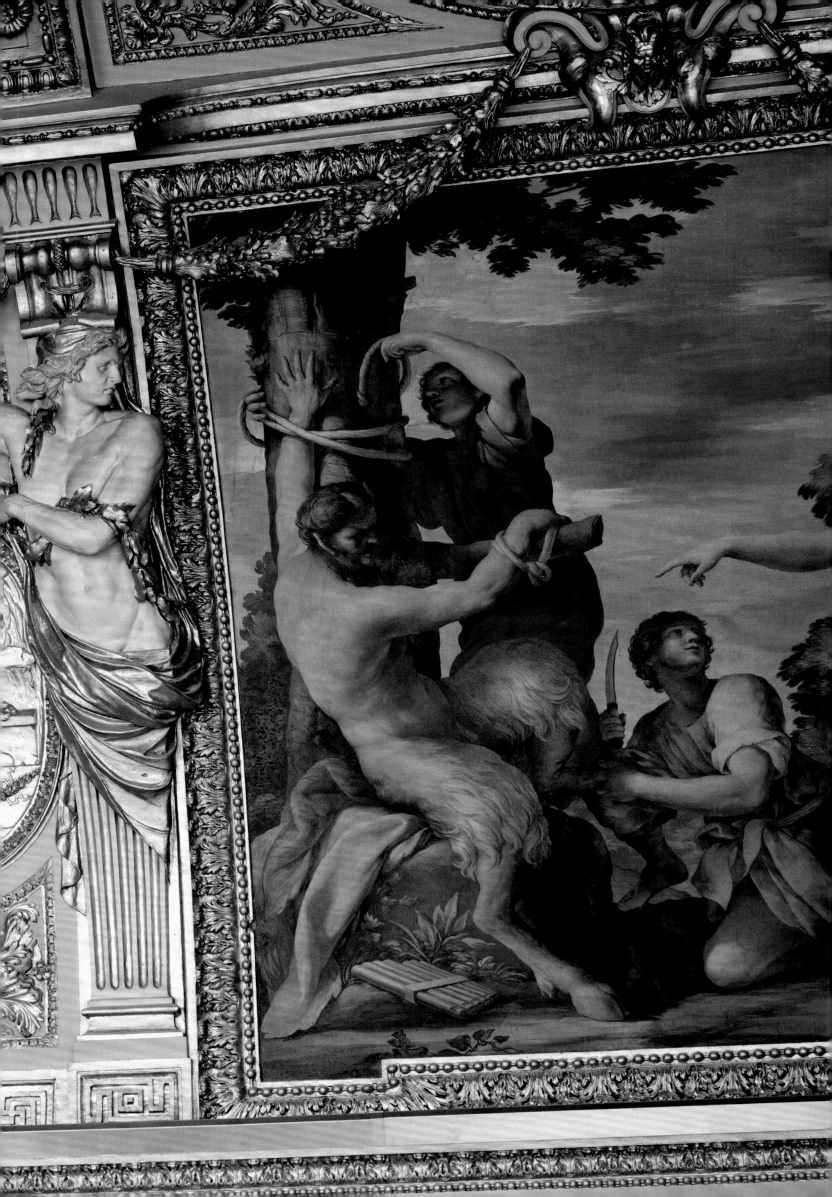

The *Time* cycle unfolds in the Salle des Saisons (Hall of the Seasons) (1657). The moon and the sun, day and night, are evoked by frescoes illustrating the myths of Apollo-Sun (*Apollo and Marsyas*, *Apollo Muscat*) and Diana-Moon (*Diana and Endymion*, *Diana and Actaeon*). The seasons are depicted at the corners, on two compartments of the vault; *Time* and its zodiac and *The Hour* and its water clock complete the thematic cycle. The elements also appear, represented by Olympian deities: *Vulcan* (Fire), *Juno* (Air), *Neptune* (Water), and *Cybele* (Earth).

One of the great political victories of Anne of Austria and Mazarin had been achieving peace with Spain by the signing of the Treaty of the Pyrenees in 1659; the queen had negotiated the marriage of her son to her young niece, Maria Theresa, the Spanish king's daughter. The vestibule, precisely placed under the sign of Peace, evokes the abundance of Nature. On the ceiling, Romanelli painted an allegory of the treaty in which Mars, Minerva, and Mercury meet, as well as two tympanums, *Peace* and *Agriculture*. Anguier modeled the supple female allegories *France* and *Navarre* in stucco, which figures contrast with the robust male figures of the rivers of France: the *Garonne* seated under vine branches, the *Rhône* supported by a lion (as Lyon was the main town on the river), the *Seine*, and the *Loire*.

Undoubtedly to please Mazarin, he is represented surreptitiously through the evocation of the heroic virtues of ancient Rome in the decoration of the large study (1655). Romanelli painted *The Rape of the Sabine Women*, *Mucius Scaevola before Porsenna*, *The Continence of Scipio*, and *Cincinnatus Chosen as Dictator*. Anguier modeled stucco medallions, painted in bronze: *Romulus and Remus*, *Marcus Curtius Throwing Himself into the Flames*, *The Innocence of the Vestal Virgin Tuccia*, and a *Sacrifice*. The portraits of the deceased king and the queen mother that preside over the overdoors, by Juste d'Egmontet Nocret, are now at Versailles.

The queen's chamber was the mecca for the affirmation of feminism. In the compartments above the doors, Romanelli painted the "strong women" of the Bible, *Judith and Holofernes*, and *Esther and Ahasuerus*, framed by Anguier's personifications of the queen's virtues: *Liberality*, *Majesty*, *Felicity*, and *Magnificence*. The room adjoined a small study that overlooked the Seine, whose Romanelli paintings, depicting the history of Moses, are now in the Louvre's history rooms, while the paneling has been remounted in the Livre d'Or Room at the Senate Palace.

Like the facades of the Grande Galerie and the wings of the Cour Carrée, the apartment is a palimpsest, like a parchment that still bears traces of earlier writings. The works of the past succeed one another in geological layers; the apartment of Anne of Austria has been

Anne of Austria's summer apartment: the former chamber of the queen *Judith and Holofernes*, mural painting by Giovanni Francesco Romanelli (1610–62), 310 × 208 cm (122 × 81 ⅞ in); *Magnificence*, holding the plan of the church of Val-de-Grâce, foundation of the queen mother, and *Liberality*, 1655, stucco, by Michel Anguier (1612–86)

Opposite
Anne of Austria's summer apartment: the former chamber of the queen *Sacred History*, *Secular History*, 1865, compartment of the octagonal ceiling, painted by Victor Biennoury (1823–93)

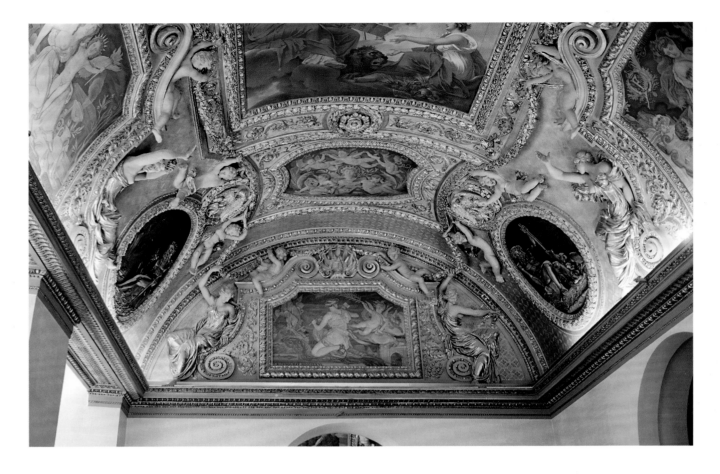

Anne of Austria's summer apartment: the
former first vestibule, or Salle des Empereurs
At the bottom: tympanum by Victor Biennoury
(1823–93).

Opposite
Anne of Austria's summer apartment: the
former first vestibule, or Salle des Empereurs
*Earth Receiving from the Emperors Adrian and
Justinian the Code of Roman Laws Dictated by
Nature, Justice, and Wisdom*, 1801, ceiling
by Charles Meynier (1763–1832)

buried under the museum's collections. Let's enter the Roman sculpture rooms, which contain large marbles and portraits. We are in the twenty-first century, in a museum room where the works are exhibited in a forest of light limestone sheaths and low pedestals. But we are also in the Musée des Antiques, inaugurated by Bonaparte on 9 November 1800, on the anniversary of the Coup of 18 Brumaire. Here, the Louvre of the Revolution wished to display one of the most beautiful collections of antique sculptures for the nation. It featured statues from the former royal collections, including those transferred from Versailles, confiscations made from emigrants, and, above all, masterpieces collected in Italy following the Revolutionary War, in accordance with the Treaties of Tolentino and Campo Formio (1798), which delivered to France an artistic booty from the Vatican, Rome, Venice, and Mantua. The archaeologists of the time protested in vain against the uprooting of these great ancient marbles that were integral elements of the grandeur of ancient and modern Rome. But the former curator of the pope's collections, Ennio Quirino Visconti, accompanied his former "residents" to France and organized them in their new home. And to display them to their fullest advantage, the Louvre administration chose to place them in the most exquisite rooms of the palace: Anne of Austria's former summer apartment.

This apartment was completely transformed to become the Musée des Antiques in 1799. Out of a succession of differently sized rooms, a long gallery was created. The architect Cheval de Saint-Hubert, Jacques-Louis David's brother-in-law, had initiated the project, which was taken over by a new architect, Raymond. Walls were replaced by a series of light partitions. Granite columns taken from Charlemagne's church in Aachen supported the old decorations, which seemed to float above. The queen's chamber and its small study were united into a single space, and new painted and sculpted decorations were commissioned from the artists.

Let's move on from the north toward the Seine. In the Rotonde de Mars (Rotunda of Mars), which served as an entrance hall, three successive states coexisted. For the King's Council, the decoration was entrusted in 1658 to the painter Charles Errard and the sculptor Thibaut Poissant, a student of Poussin in Rome. Only a few stucco figures remain. The rotunda, now the entrance hall of the Musée des Antiques, was decorated with stucco medallions thematically related to its new function. The *Genius of the Arts* and *The Union of the Three Arts* were modeled by Antoine-Denis Chaudet and, on the spandrels of the dome, Bernard Lange and Jean-François Lorta represented different art styles: Egyptian, Greek,

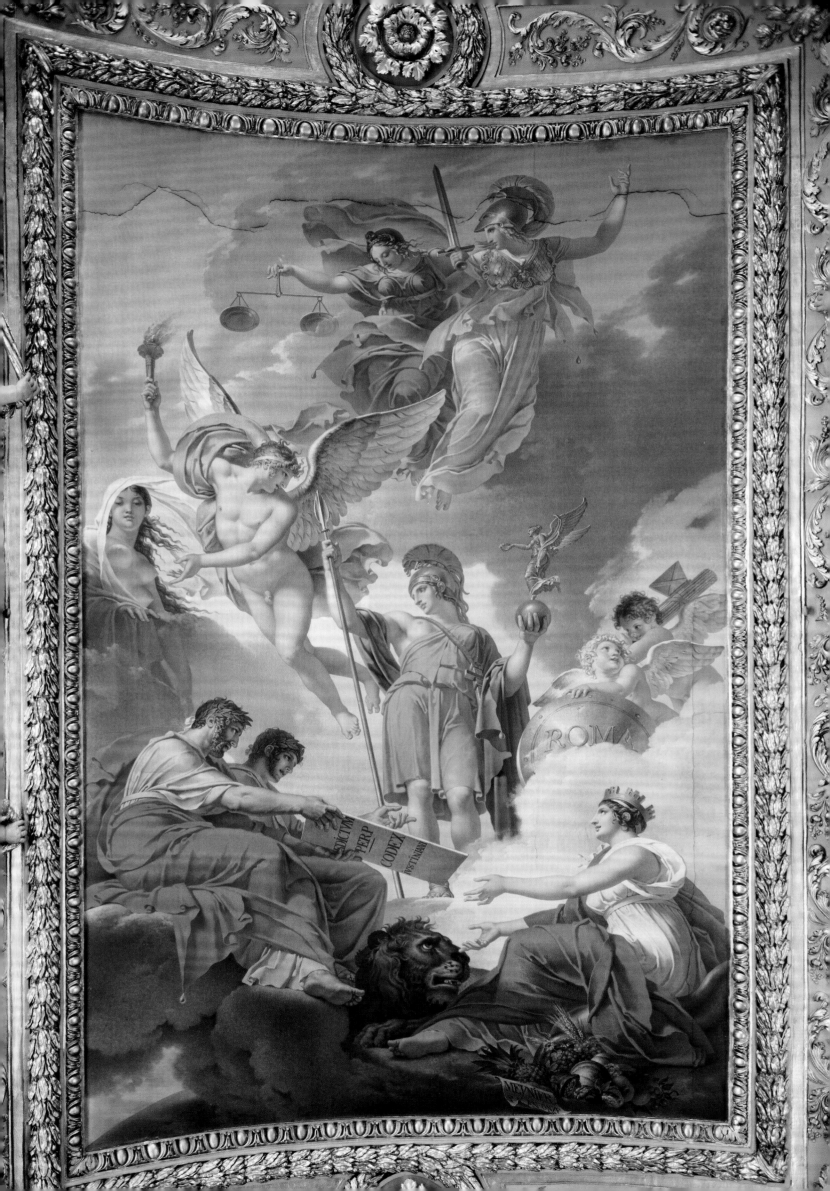

Rotonde de Mars
Geniuses and Fame, 1658, stucco, by Gaspard
(1625–81) and Balthazar (1628–74) Marsy,
after the drawings of Charles Errard; *Italian Art*
(medallion), 1801–3, stucco, by Jean-François
Lorta (1752–1837); *The Union of the Three Arts*
(medallion on the right), 1801–3, stucco, by
Antoine-Denis Chaudet (1763–1810)

Italian, and French. The last state dates back to 1826, with a ceiling, painted by Jean-Baptiste Mauzaisse, replacing that of Jean-Simon Berthélemy.

Then came the Salle des Empereurs, designed in 1800 to display statues of Roman rulers. Large bronze medallions depict rivers of the French Empire—*Nile, Tiber, Eridan*—plus a more political composition in these times of war in Europe: *The Germans Surrendering to Marcus Aurelius*. In 1801, Meynier painted two grisailles and an equally pacific ceiling, *Earth Receiving from the Emperors Adrian and Justinian the Code of Roman Laws Dictated by Nature, Justice, and Wisdom.*

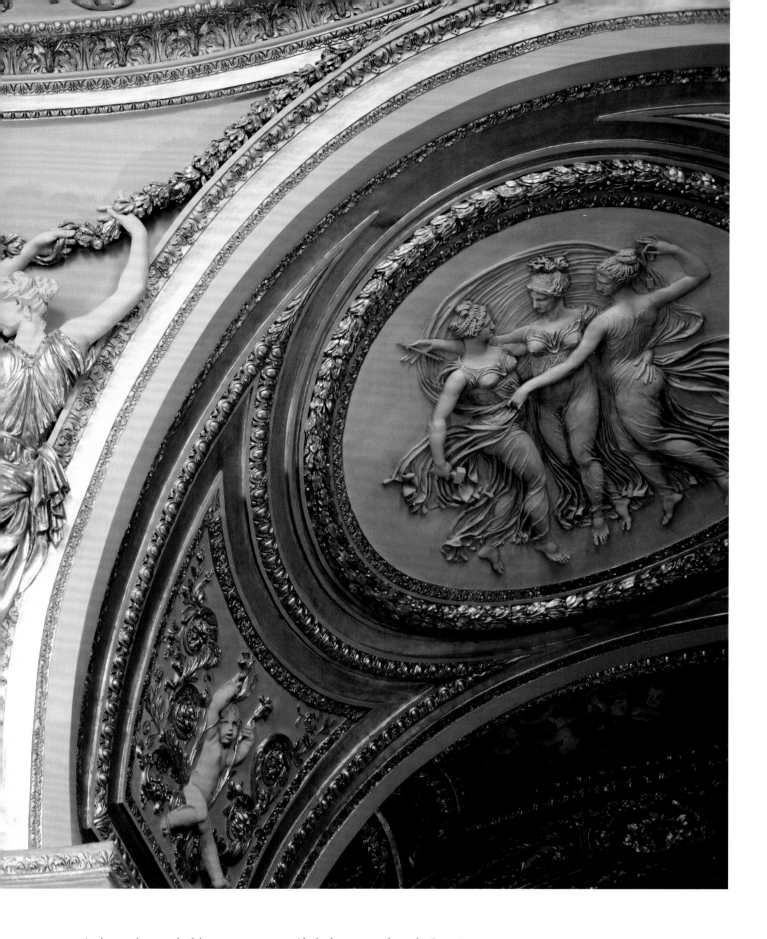

At the southern end of the apartment, to unify the last room where the *Laocoön* group from the Vatican was to be displayed, an astonishing operation took place: the southern tympanum was dismantled and reassembled at the end, including Romanelli's fresco and Anguier's stuccoes. In keeping with the decorative program of the Grand Siècle, the decoration of the vault and spandrels was completed in the center. Dejoux modeled the stuccoes, in the style of Anguier. Hennequin represented the *French Hercules*. The medallions and tympanums were completed by Guillon-Lethière, Peyron, Guérin, and Prud'hon. A composition by Victor Biennoury was added under Napoleon III.

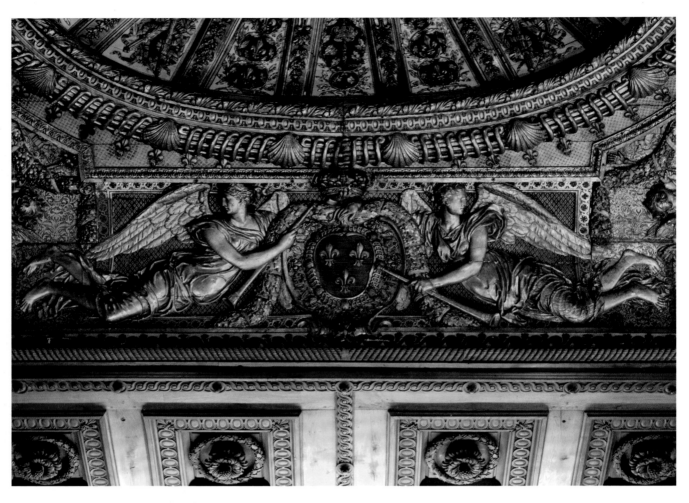
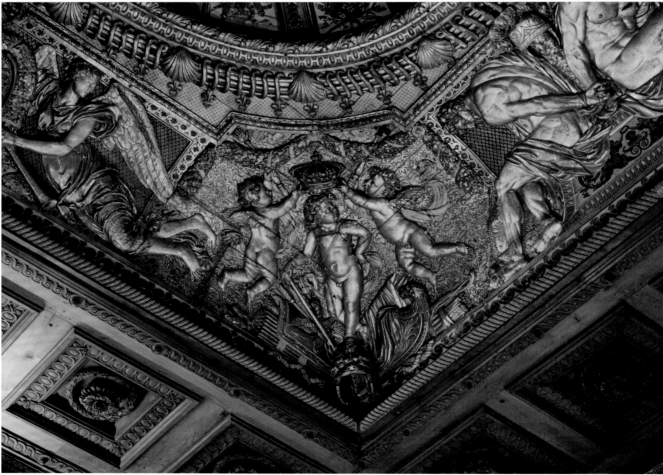

The King's Apartment

Our search for vestiges of the young Louis XIV's apartment takes us far from the Petite Galerie. Here again, successive reworkings have been carried out. There is nothing left of the original location of the king's chamber. However, between 1654 and 1656, there was a major decoration project in the king's apartment, in the heart of his former pavilion. All that remains is the ceiling of the room, which, like that of Henri II's chamber, was transferred in 1819 to a room in the Colonnade Wing. At that time, King Louis XVIII may have wanted to turn the latter into a reception hall. Under Napoleon III, it was an ephemeral museum —the Musée des Souverains. It later became the medieval rooms of the Department of Decorative Arts. Since the Grand Louvre, Egyptian sculptures took their place here under a vast oval of gilded wood, supported by chained captive figures, the work of sculptor Gilles Guérin, on which François Girardon, Laurent Magnier, Thomas Regnaudin, and Nicolas Legendre collaborated. The bedroom, where two children lift mock curtains, is now empty. Similarly, the fireplace of Pierre Bordoni and Gilles Guérin, where three children represented Authority, Fidelity, and Justice, have disappeared, as well as the paintings of Eustache Le Sueur, known only from drawings, including a great *Triumph of the French Monarchy* and *Justice and Value Giving Flight to France's Enemies*.

The Rotonde d'Apollon (Rotunda of Apollo) and the Salle des Bijoux (Jewelry Room) give a sense of the expansiveness of the king's apartment, which has since been transformed. The king ordered Louis Le Vau to widen the passage that led from his apartment to the Petite Galerie. The architect therefore created the Salon du Dôme (Dome Room), a rotunda comparable to the oval he designed for the Château de Fouquet in Vaux-le-Vicomte, and a new small wing, where a large study (Grand Cabinet) and a reception area were installed. The Salon du Dôme, decorated with stuccoes by Francesco Caccia, was meant to be used as a chapel, but in 1659, the first floor of the Pavillon de l'Horloge, dedicated to Our Lady of Peace and to Saint Louis, was assigned to this purpose—a new tribute to the greatly celebrated Peace of the Pyrenees.

In 1658, a painting by Nicolas Poussin, *Time Defending Truth Against the Attacks of Envy and Discord*, from the Palais-Royal (1641), was added to the ceiling of the Grand Cabinet

Ceiling and alcove of the king's chamber, 1654, wood, by Gilles Guérin (1606–1678) and his workshop, with François Girardon's participation; remounted in the Colonnade Wing in 1819

Opposite
Details of the ceiling of the king's chamber: *Renowned Figures Presenting The Royal Arms* (above) and *Chained Captives and Geniuses* by Gilles Guérin (1606–78)

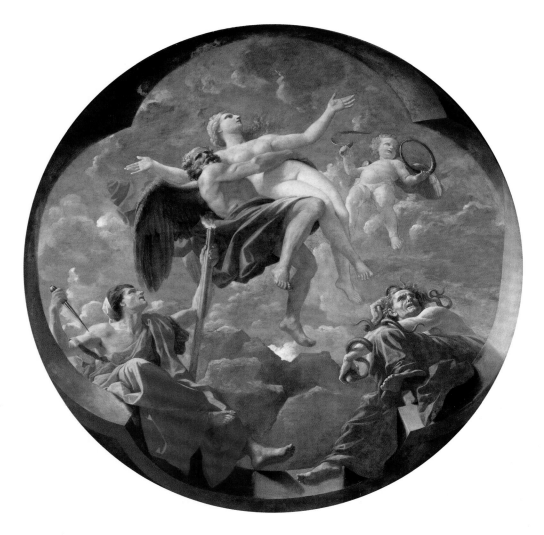

Nicolas Poussin (1594–1665)
Time Defending Truth Against the Attacks of Envy and Discord, 1641
Oil on canvas, D. 297 cm (117 in.)
Executed for the Palais-Royal, bequeathed by Richelieu to the king, remounted as the ceiling of the king's large study in 1658
Department of Paintings, Royal Collection

(was it done for reasons of economy or in homage to the great French painter from Italy?), which today is in the collection of the Department of Paintings. With the expansion of the museum in the nineteenth century, the precious decorative objects of the Middle Ages were brought together under the Restoration in this room, which took the name Salle des Bijoux. Jean-Baptiste Mauzaisse executed the ceiling paintings (1822) and the overdoors (1828): we see the Venus de Milo, newly installed in the museum, emerge from earth, dominated by the figure of Time, who points to her. Woodwork and large spandrels with sovereign monograms are made of gilded carton-pierre (a type of papier-mâché). Only the memory of Louis XIV's study and the high windows that look out onto the river remain.

The Glory of a Great King: Louis XIV

"L'État c'est moi" ("the State is me"), the young Louis XIV is said to have declared when he took power on 13 April 1655. A prosperous period of celebrations and building projects then opened for the Louvre and the Tuileries, which went dormant when the king found a larger residence: Versailles, with its larger garden, where he could ceaselessly play at building and rebuilding, so close to the hunting parks he loved and so far from Paris, which was in revolt. In 1666, Anne of Austria died in her bedchamber in the Louvre, watched over by this son who adored her. The king immediately relocated to Saint-Germain and then to the Château des Tuileries, which he ordered refurbished and embellished. He would never live in the Louvre again. In 1671, he spent his last night in Paris and thenceforth made the Château de Versailles his favorite residence and the object of his care.

But the memory of the brief royal residence remains engraved in the stone and, above all, in the names of certain places. The Carrousel keeps the name of the magnificent equestrian festival that the king held in 1662 to celebrate the birth of the dauphin, where all the nobility pranced about in Roman or other exotic costumes. At the western end of

the Grande Galerie, Henri IV's former "great pavilion over the river" became the Pavillon de Flore, since the king danced the sumptuous *Ballet de Flore* there in 1669.

Before leaving the Louvre, Louis XIV lived in the castle in a festive atmosphere. He enjoyed various entertainments there, for instance, Molière came to act in his *Love Doctor* in 1658 in the Salle des Caryatides, and later, performances of *The Blunderer*, *The Affected Young Ladies*, *The School for Wives*, and *The Forced Marriage*. The king laughed so much that he granted the playwright a handsome pension. In the Salle des Machines, the theater of the Tuileries built by the Modena specialist Gaspare Vigarani, major spectacles were held. Ballets were performed in the antechamber of the king's apartment. It was at the Louvre that he fell in love with Marie Mancini, Mazarin's niece; he renounced this love in the face of his mother's objections. Marie married Constable Colonna in 1661 at the Louvre, where Mazarin's other nieces had wed a few years earlier.

The Louvre was then considered a stitched-together assemblage of spaces with no overall unifying plan. In 1660, Claude Le Petit mocked of it in his *Paris ridicule* (*Ridiculous Paris*):

> This great new and old building
> They now call the Louvre!
> Do you see these walls unruly in every way?
> All gnawed away by time's decay?
> . . .
> Nothing's left but above every niche
> To engrave in stone
> "For rent today, a winter home."

It was therefore necessary to exalt the king, a decision that Mazarin and then his protégé, Jean-Baptiste Colbert, would put into action. From 1660 to 1678, the double palace of the Louvre and the Tuileries experienced an extraordinary fever of architectural campaigns under Louis XIV. Pushed by Mazarin, who was a mentor, Louis XIV took up his grandfather's Grand Design with a new ordinance dated 31 October 1660. The king was only twenty-two years old, charming, graceful, charismatic, fond of art and dance, and proud. He would transform the Louvre into a palace of festivity. A sovereign of divine right, the incarnation of the absolutist state, the insatiable instigator of monarchical power, he wished to affirm his "glory." After Mazarin's death, Colbert—a zealous minister, financial reformer, and superintendent of buildings from 1664 onward—set out to make the Louvre the premier statement of that glory.

In the Tuileries, Mazarin had been building the state-of-the-art Salle des Machines for Vigarani's shows. The architect Louis Le Vau, who worked on behalf of the cardinal, presented a new plan in 1660 to realize the Grand Design of the Louvre. Every resource was mobilized: prohibitions barring private individuals from employing construction workers that might cause slowdowns at the site; establishment of an expropriation plan; and bans on the building or renovation of houses within the precinct of the Grand Design.

Le Vau's Wall and the Cour Carrée

Le Vau was thus able to start shaping the palace's western facade, on the former Cour des Cuisines (Kitchen Courtyard), which had become the new Place du Louvre. Le Vau's Wall is still standing, a remnant of the moat that surrounded the Louvre and the base of the access bridge to the Pavillon de l'Horloge, discovered during the excavations of the Napoleon Courtyard in 1985. The carriages of the king, princes, and elected officials who had been granted such a privilege could enter here. This favor, called "the honors of the Louvre," was so closely linked to the history of the palace that in Versailles, the entrance to the château's courtyard took the same name, the marble courtyard being under the ancien régime like a courtyard of the Louvre.

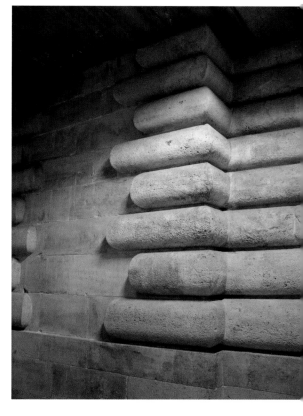

Decorative cladding of Le Vau's Wall, vestige of the access bridge to the Pavillon de l'Horloge, from the east side

Paving laid down in 1989 in the Cour Carrée,
leaving the well of the old keep visible

Opposite
Facade of the west wing, north part of the
Cour Carrée, built by Clément II Métezeau;
attic decoration executed under Napoleon I
in 1807

Following spread
Facade of the east wing of the Cour Carrée,
on the reverse side of the Colonnade, built
1667–78

Le Vau's main goal was to quadruple the Louvre courtyard. Everything that remained of
the medieval Louvre and its surrounding area was razed to the ground, with the exception
of a few houses in the center of the new courtyard that until the mid-eighteenth century
served as artists' workshops. In 1658, the wing of Lemercier and Métezeau was extended
by the elevation of the Pavillon de Beauvais, which formed the corner of what would ulti-
mately become the large Cour Carrée. Then Le Vau completed the north wing, starting from
the Pavillon de Beauvais in the northwest corner and attaching it to the south wing
between 1661 and 1663, decorating its center with a large pavilion similar to that of
Lemercier's, and another pavilion at its eastern end. In 1661, Le Vau laid the foundation for
an eastern facade that was to connect to the south wing. The project would be abandoned.
The foundation was only discovered in 1850, then excavated in 1964 during works carried
out on the orders of André Malraux, minister of culture, to dig out the dry moats; the
remains of the entrance culvert can be seen in the center of the current dry moats.

The elevation chosen by Le Vau for the Cour Carrée's facades matches that of Pierre
Lescot's. Here, a whole decorative vocabulary was borrowed from Lescot: oculi, columns,
a frieze decorated with playful cherubs. The sculpted decoration would not be finished,
however, even if the *putti* frieze, mixed with the initials of the royal couple, the "L" of Louis
and "MT" of Marie-Thérèse, was sculpted in 1661–62 by Antoine Guyot.

This Cour Carrée of Le Vau is not the one we see today. As elsewhere in the Louvre,
changes in taste and politics transformed the original project. The top floor is no longer as
Le Vau had designed it in accordance with Lescot's elevation. This change was the conse-
quence of the construction of the east wing, the fourth side of the courtyard, which was not
the work of Le Vau, but the result of a long series of trial and error, discussed in the next
section. This prestigious wing had to be wider and taller than the other buildings of the Cour
Carrée. It was therefore necessary to break with Lescot's order and replace the attic floor
with a third floor decorated with columns framing the upper part of the avant-corps, thereby
creating a discrepancy in the elevation with the other courtyard facades; especially since the
same order of the second floor with columns to the north began to be followed, but stopping
in the middle of the crossing point—in other words, after the central pavilion. Some projects
by Perrault or Charles Le Brun imagined a new order for this elevation—the French order
—with ornaments in the shape of lilies or roosters, but it was finally the Corinthian order that

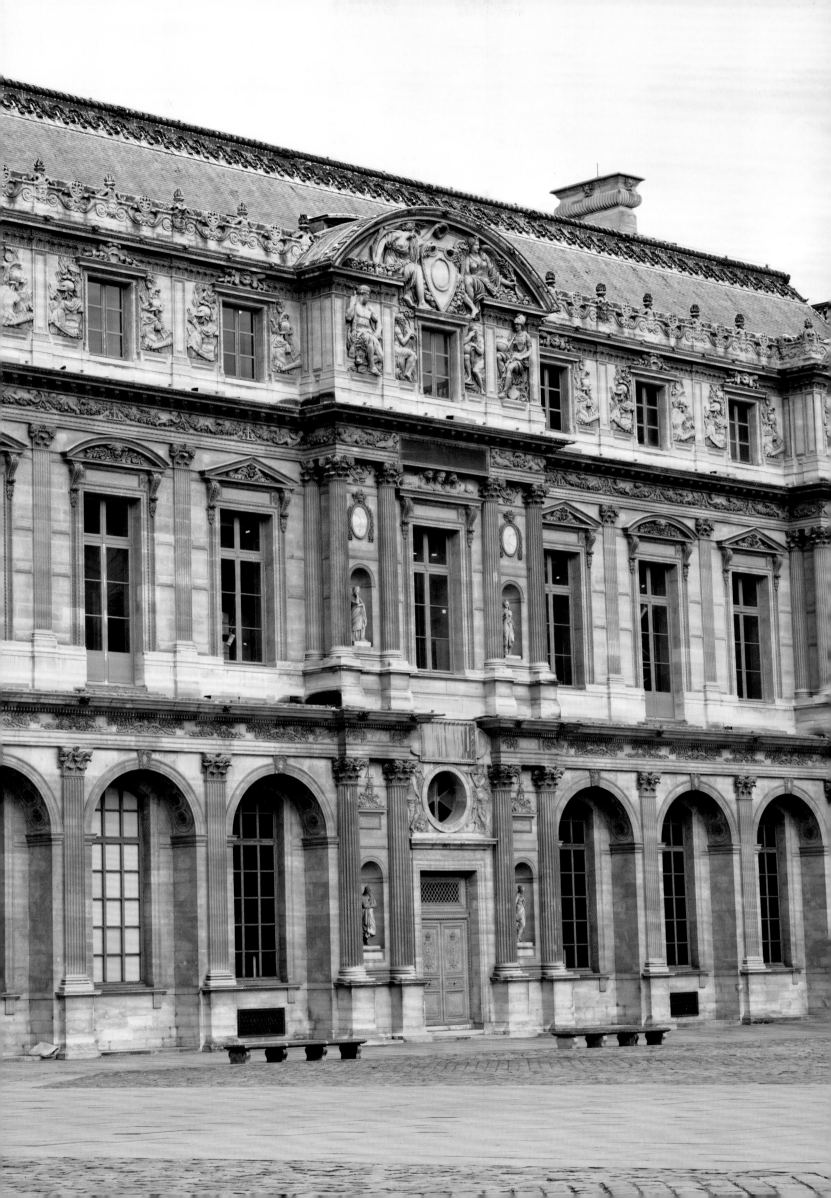

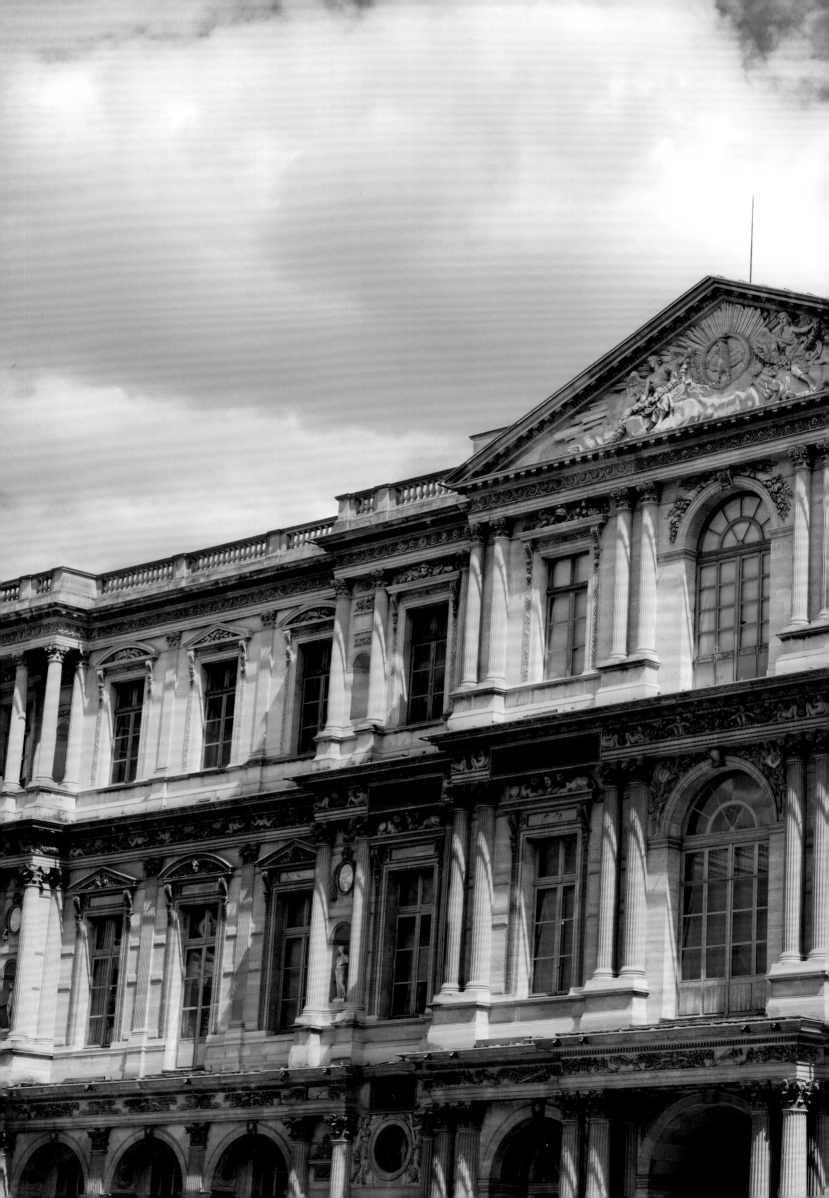

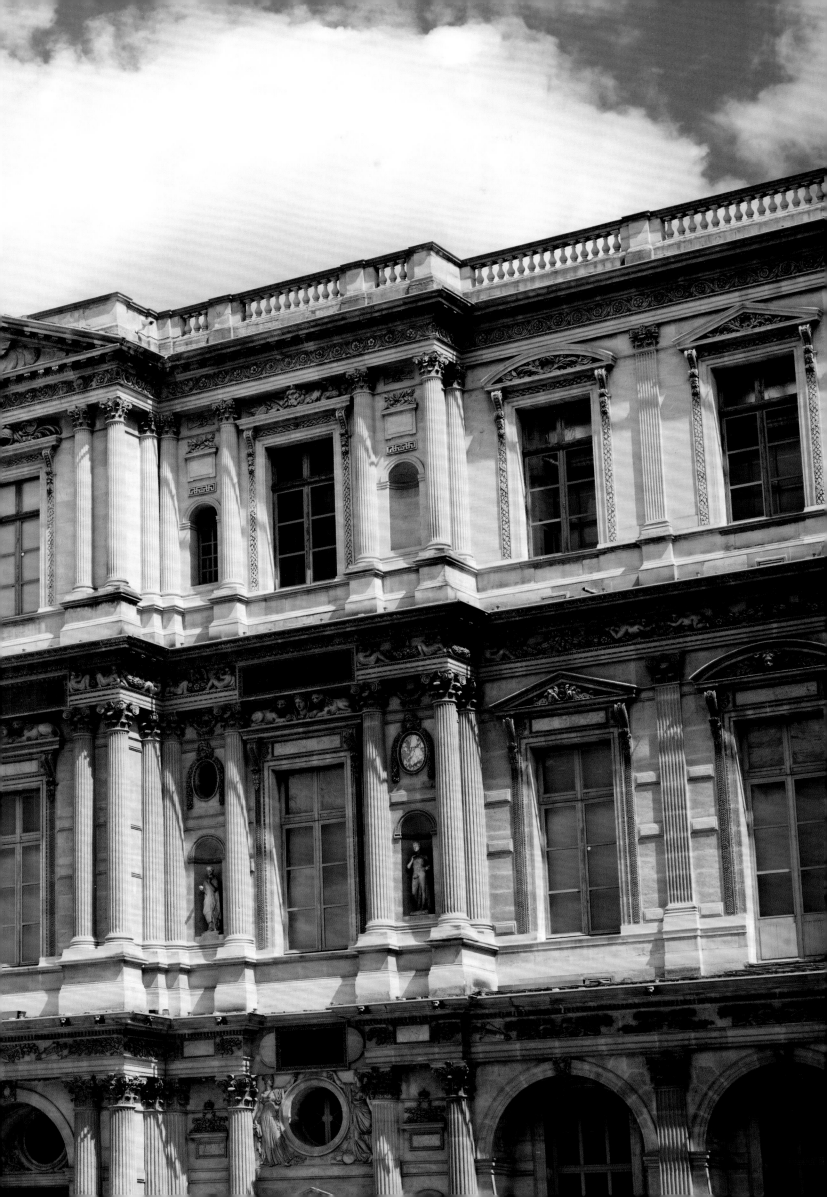

Passage des Arts (Passage of the Arts)
Colonnade under the Central Pavilion of the
south wing of the Cour Carrée, corresponding
to the vestibule of Louis Le Vau, redesigned and
opened by Germain Soufflot

was retained. The models were made in 1668 by the best team from the king's sculptors: Étienne Le Hongre, Jean-Baptiste Tuby, Nicolas Legendre, and Benoît Massou. They also executed the imposing grimacing masks of the arch keystones of the north facade (1669). But the oculi and pediments remained as projecting toothing-stones, and the wings of the Cour Carrée were left as large empty spaces, open to the sky.

Under Louis XV, a new architect, Ange-Jacques Gabriel, took over the site. He decided to unify the facades, but only carried out the restoration of the Colonnade Wing. Gabriel finally entrusted the sculptures of the eastern pavilion to Guillaume II Coustou: two angels framed the royal coat of arms; the angels were then replaced by a French rooster crowing in the center, symbolizing a Republic rebuilding itself, anxious to erase the emblems of the despised former regime. Jacques-Germain Soufflot, the architect of

the Panthéon, opened a passage between the courtyard and the outside, to the north. This "guichet du Coq" (Cock's Gate) faced the street of the same name, and was given a superb colonnade with fluted barrels that copied Lemercier's at the Pavillon de l'Horloge.

Under Napoleon I, Percier and Fontaine planned to completely unify the elevation of the courtyard by opting for a second floor with columns. But in 1806, a commission was agreed to transform all the attics in this way, except for the west wing. As we have seen, the architects dismantled the reliefs of the attic from the part of the south wing built under the Valois, in order to create a columnar order on three sides. The sculpted decoration of the three attics of the Lemercier Wing was completed by Roland, Moitte, and Chaudet (1807). As in Goujon's compositions, the main figure is accompanied by secondary characters who explain its meaning. In the center, Victory and Abundance—imperial virtues—and Hercules

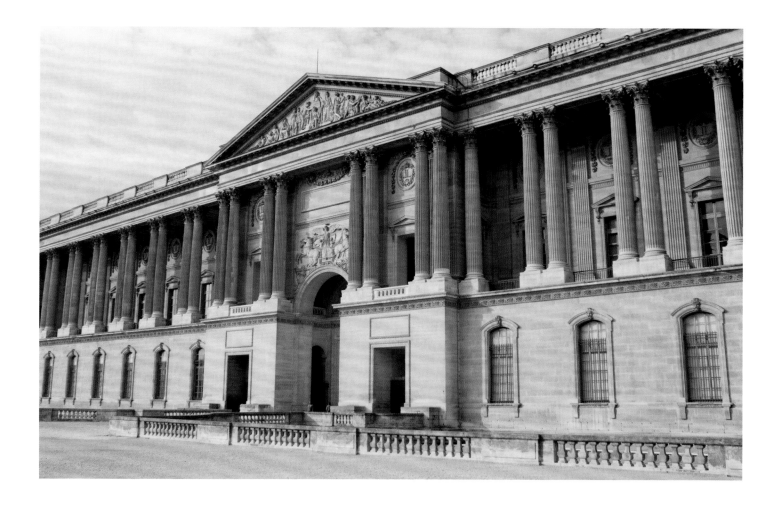

and Minerva—strength and intelligence, while the allegories of the Nile and the Danube express the geographic reach of Bonaparte's conquests. On the avant-corps to the left, Law is seated in a throne surrounded by two sphinxes, which is based on the tradition of Thucydides and Herodotus, and presents the great religious leaders and legislators (Numa, Isis, Moses, Manco Cápac) in an ecumenism with Masonic and syncretistic overtones.

The north and south pediments, by Claude Ramey (1811) and Jacques-Philippe Le Sueur (1814), are decorated with convoluted allegories, among the last to be carved to exalt the emperor: the *Genius of France* on one, and *Apollo Rewarding the Sciences and the Arts* on the other.

Power changed hands, but the architect Fontaine remained faithful to his imperial post in the Second Republic and continued his work. He removed the imperial figure from the pediments and chose themes praising the royal power for the new sculptures of the oculi: *France Receiving the Charter* and *Justice Protecting Innocence*. This last oculus is the most beautiful; the young David d'Angers drew a superb female nude as a model for Innocence. But elsewhere, the subjects are more typical, evoking figures of poetry, science, history, or theater. Everywhere in these allegorical personifications there are ancient female figures influenced by Jean Goujon's style—the "French Praxiteles," according to art historians of the time, who inspired the prevailing neoclassicism. In 1827, the Cour Carrée was finally completed.

The Colonnade

The king and Colbert wanted to concentrate all efforts on the east wing of the Louvre, where the new prestigious royal apartments were to be built. This fourth side of the Cour Carrée, which faces the city, had to be a theatrical facade, illustrating the "royal glory"—a symbol of the greatness that the sovereign wished to impart through the image.

The solutions proposed by the French architects (Louis Le Vau, François Mansart, Louis Marot) did not satisfy Colbert, so he turned to Italy; the most famous architects, such as Pietro da Cortona, Rainaldi, and Candiani, among others, submitted proposals. Also Gian Lorenzo Bernini, an architect as well as a painter and sculptor who dominated

Colonnade Wing, built by Claude Perrault, 1667–78; tympanum and pediment carved under Napoleon I by Lemot and Cartellier

Pierre-Antoine Demachy (1723–1807)
View of the Colonnade, 1772
Oil on canvas, 76 × 131 cm (29 ⅞ × 51 ⅝ in.)
Department of Paintings, inventoried in 1824

Opposite
Loggia on the first floor of the Colonnade (1667–78)

Following spread
Ceiling of the loggia of the Colonnade: symbol of the sun of Louis XIV, monogram "LL" executed during the Restoration

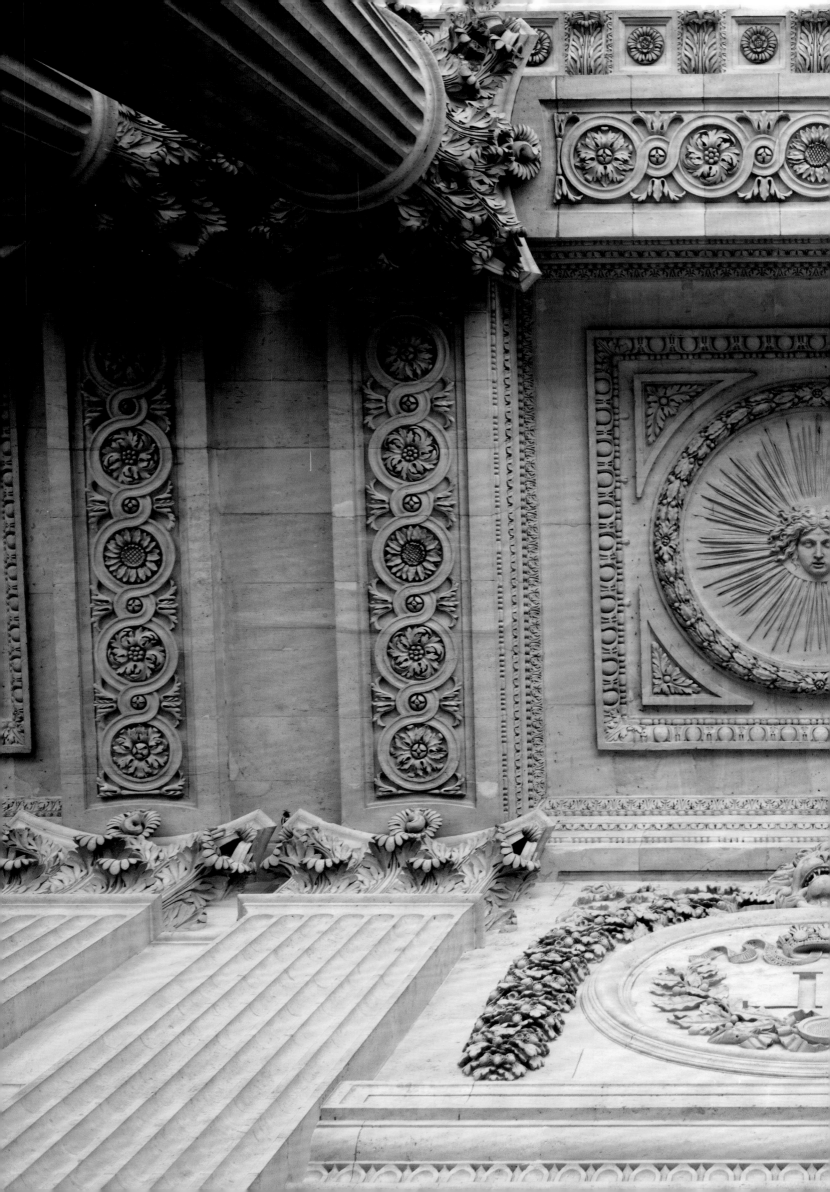

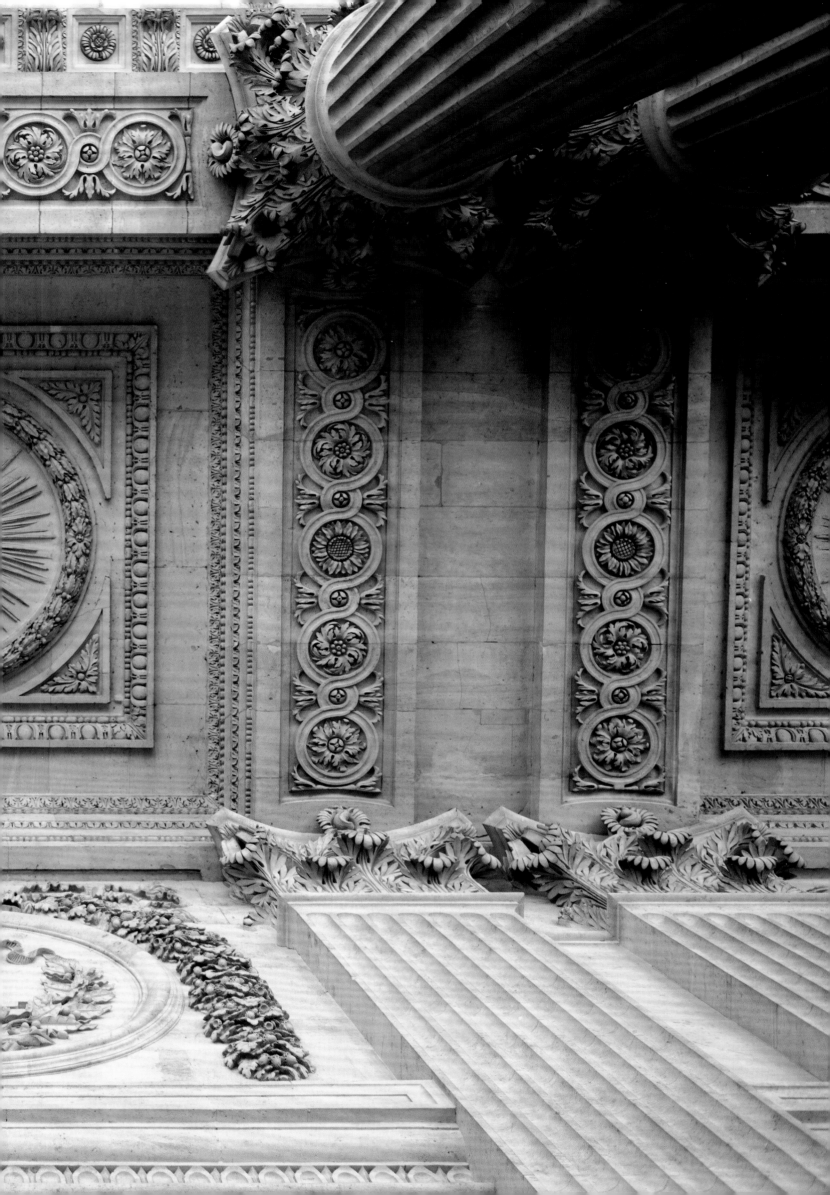

Roman art of the time. In June 1664, Bernini designed a grandiose palace that Colbert found poorly suited to the "mood of the times." Bernini submitted another, more sober design in January 1665. Its successive programs were not only a proposal for the east wing, but for the complete restructuring of the space of the double palaces of the Louvre and the Tuileries, brought together by courtyards.

In 1665, "il Cavaliere" Bernini was officially invited to Paris. He stayed there with his son, his collaborators, and his entourage; visited the monuments and attractions, analyzed them, and set to work, preparing the Louvre site and sculpting a marble bust of the king (today at the Château of Versailles). On 17 June 1665, the first stone of the future facade was laid in an elaborate ceremony attended by Louis XIV himself. Three days later, Bernini left, laden with honors, with a 12,000-pound pension certificate and a commission for a marble equestrian statue of the king. But his overall proposal was actually scrapped. Finally, in July 1667, Colbert broke his promises, claiming a lack of money.

But the real reason was that the French architects had taken a dim view of Bernini's intrusion. In addition, concerned about both convenience and magnificence, Colbert was set against the Italian by his clerk, Charles Perrault, the author of the tales and also brother of Claude Perrault, doctor, anatomist (he died after dissecting a camel), and architect. In 1667, Colbert gathered a small council (Petit Conseil) to discuss the project. It included the painter Charles Le Brun; Louis Le Vau, who would soon die; Le Vau's younger brother, François; and his son-in-law, François d'Orbay, as well as Claude Perrault. The latter was in particular credited as the creator of the observatory and, thanks to his brother's skill in magnifying his role, he was designated as the project manager. Nicolas Boileau, whom he had treated badly, considered him an "ignorant doctor, but a not unskilled architect." On the Louvre site, Perrault was interested in technical feats of force. This included the machines that would make it possible to raise the two gigantic Meudon stone blocks of the entablature (17 meters long by 2.50 meters wide/56 ft. x 8 ft.) in 1672. He also used sheathed iron to connect the stones of the superb stereotomy, a technique well known in medieval cathedrals, but which would cause problems here, when the iron rusted and shattered the stone.

Bernini's drawings of the facade consisting of a large central rotunda or monumental parallelepiped in the Roman style were successively rejected. In 1667, the council proposed to the king the monumental facade of the "Colonnade." The noble floor was enhanced by two peristyles of double columns framing a central pavilion with a pediment, while two large pavilions with high arched bays were to house the great staircases at the ends. The coupled columns had high pilasters at the bottom of the gallery, which originally surrounded niches. At 133 meters (436 ft.) long, perfectly rhythmic, with contrasts of light and shade, the Colonnade is considered the quintessence of classical architecture, the prototype of the great creations: from the pavilions of the Place de la Concorde, which were the work of Gabriel, to their neoclassical extensions throughout France and the United States, in cities such as Philadelphia.

The Colonnade rose fairly quickly, but work stopped in 1678. As in the Cour Carrée, the decoration was only sketched. Only the capitals and medallions had been carved; the rest was left as toothing-stones.

In front of the Colonnade, the old buildings were very close, making it impossible to stand back to properly view this gigantic frontispiece. The project for a royal square, designed by Le Brun, in the center of which would have been a monument to the glory of the king, nevertheless remained unrealized. It was not until Louis XV, pressured by the Parisian intellectual community, that work on the Colonnade resumed. Restored in 1756–57, following the trouble caused by iron, it would be lightened by removing the two domes of the side pavilions, which ensured the beautiful horizontality of the building. Gabriel and Soufflot oversaw this long construction project, which culminated in the installation of two small parterres that allowed for some open space and perspective.

But the decoration remained unfinished. Under the Empire, Fontaine reworked the facade. In 1807, he installed windows instead of niches and reduced the height of the gate of the central pavilion. Between 1807 and 1811, he commissioned Lemot to sculpt the

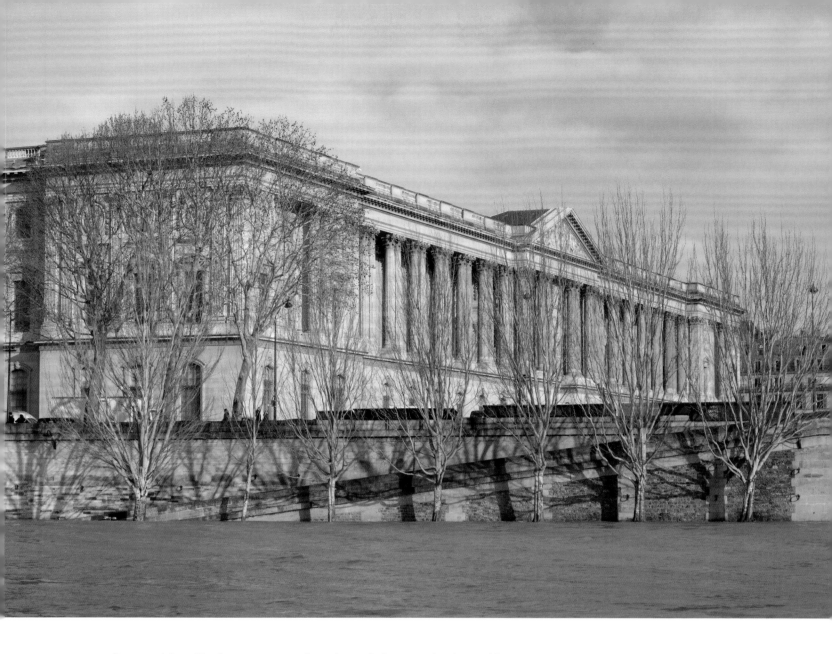

great pediment and Cartellier the tympanum, and to enhance the large wooden doors with bronzes. Added to the glory of the Sun King, Louis XIV, came that of the emperor. On the pediment, Minerva, the choir of the Muses, and Love crown the bust of Napoleon. On the tympanum, Victory, guiding her quadriga, bestows crowns, and the facade is stamped with "N"s (for Napoleon). Clio writes the emperor's name on the pedestal of the bust.

The facade had been designed with a high basement overlooking a moat that was to surround the castle, as in the west. The dry moat was restored on the rue de Rivoli side in 1903. Later, André Malraux, who had a particular interest in the Louvre, decided it should be dug on the Colonnade side, thus completing in 1964, a work begun three centuries earlier.

The Southern Facade of the Cour Carrée, on the Seine Side

The width of the Colonnade forced the architect to double the thickness of the south wing, which faces the Seine, and thus to raise a new facade a few meters in front of the one just erected. Matched to the same elevation as the Colonnade, the new facade did not have its sumptuous play of columns, but instead, a succession of pilasters that frame the windows of the second and third floors. On the first floor, the very high windows have triangular pediments, while the shorter second-floor windows have curvilinear ones.

This new wing remained unfinished under Louis XIV. Some spaces were not given any cover, thereby forming small and simple open-air courtyards. In the center, the pavilion, which had been crowned with a dome from the time of Le Vau, was made flush with this elevation in 1755 by Soufflot. In 1780, the quay and the Cour Carrée were connected. The pavilion thus became a "wicket gate" that allowed for a flow of traffic to a new urban space. Its pediment by Fortin (1808–9), and the decoration of the tympanum of the gate, were only completed during the Empire. The tympanum featured the geniuses of the Arts and

Colonnade Wing, view from the Seine

Detail of the facade: vermiculated decoration

Opposite
Facade of the queen's court, now known as
the Cour du Sphinx, built by Louis Le Vau;
Arts and Sciences, 1665, pediment with the head
of the Apollonian sun at the apex, sculpted by
Matthieu Lespagnandelle (1616–89)

War framing the imperial coat of arms, while on the spandrels, Renommées (Fama) sur-
rounded a bust of Napoleon, which, under the Restoration, was replaced by a helmet.

The Queen's Court

Beginning in the fall of 1660, Le Vau also doubled the Petite Galerie by attaching a parallel
wing to the west; its facade can still be seen in the queen's courtyard (now called the Cour du
Sphinx). The fire that destroyed the Petite Galerie in 1661 led him to rework the project that
he'd already begun. The new courtyard, named after the queen mother's summer apartment,
was closed on three sides, while the fourth side was occupied by rue Fromenteau, which
would remain in place until the major works undertaken by Napoleon III. On the
ground floor, Le Vau planned to expand this apartment to the south with an oratory and a
bathroom; to the east with a vestibule; and to the north with a theater, the "domestic theater
room." On the first floor, a large apartment was planned, dedicated to the royal collections
and to the arts, paintings, weapons, and medals; the king's paintings chamber (Cabinet des
Tableaux); and a library. To the south, from the Grande Galerie, the large rectangular recep-
tion room—called the Salon Carré—had to be raised to such a high elevation that the facade
facing the quay also had to be raised and modified.

In front of this new Petite Galerie, Le Vau designed a curious elevation—contrary to
the classical spirit—with two doors and two windows surmounted by a single triangular
pediment, sculpted by Lespagnandelle and illustrating the *Arts and Sciences* (1663).

The queen's court would quickly be abandoned by the sovereigns. The sculptor François
Girardon installed his luxurious collection of works there until his death (the same year as the
king, in 1715). The courtyard would then serve as a public access to the Salon of the Royal
Academy of Painting and Sculpture. When the Louvre became a museum, it was named the
Cour du Muséum until the immense Egyptian sphinx, from Tanis, was installed there, hence
its current name. When the Sphinx moved to the Department of Egyptian Antiquities, the
space remained the place where Greek and Roman antiquities were exhibited. The courtyard
was later completely redesigned under Napoleon III, with the construction of two new struc-
tures that formed the northwest corner: a large staircase in place of the remains of the old

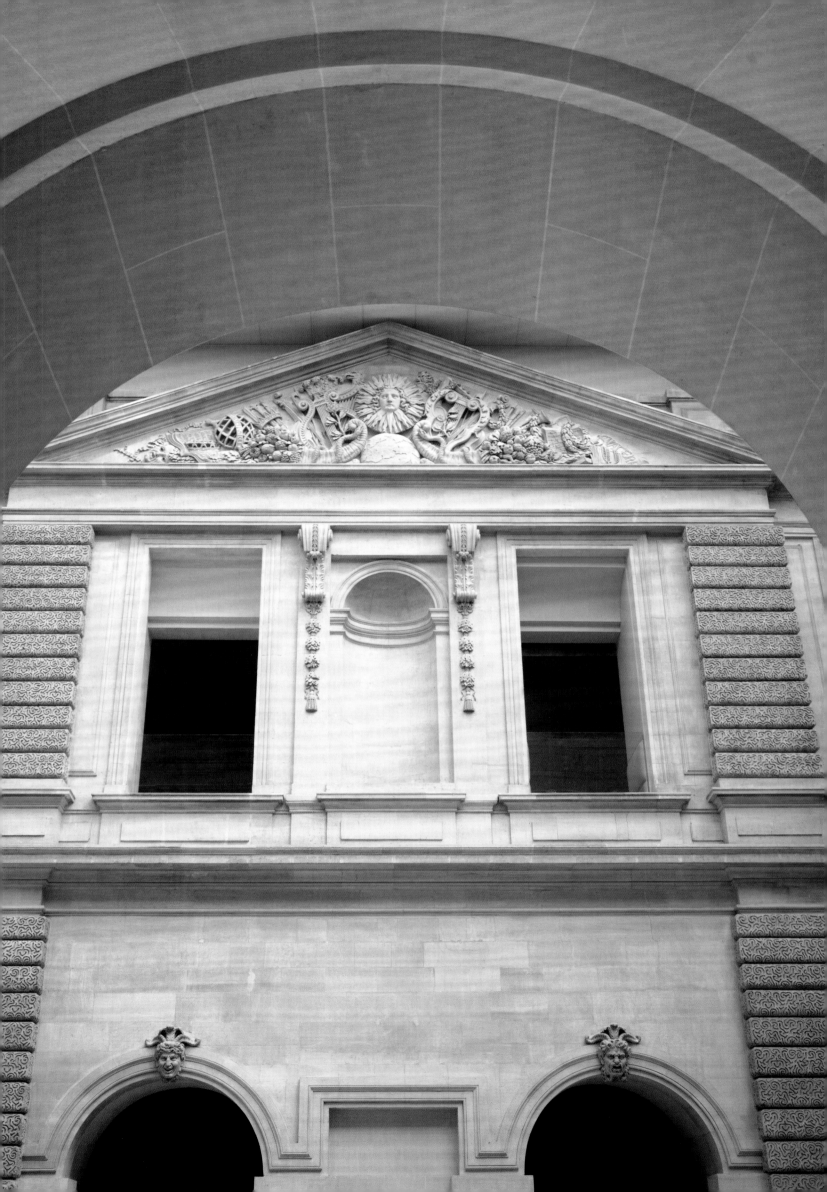

Galerie d'Apollon: door panel decorated with the emblem of the Muse Erato, 1850

Opposite
Galerie d'Apollon: woodwork on the west wall with *Portrait of Louis XIV*, 1863; panel of Gobelins tapestry by A. de Brancas, after Eugène Appert (1814–67)

Following spread
Galerie d'Apollon: detail of the grotesques painted on a window embrasure, view on the facade on the Seine, south wing of the Cour Carrée

theater, and a seven-meter-wide (23 ft.) building, hence the name: the Galerie des Sept-Mètres (Seven-Meter Gallery). The newly transformed courtyard was covered with a glass roof in 1929, with its doors and windows wide open, much like a loggia. Intended to present Greek reliefs, the frieze of the Magnesia on the Meander temple with its large antique marble and mosaics, the "Cour du Sphinx," now without Sphinx, is a distant reference to the former queen's court.

Galerie d'Apollon

In February 1661, a show was being prepared, *Ercole in Love* by Father Bitti, in which the king was to perform. The stage beams and fabrics made for a great source of combustible fuel if there should be a fire. And that's just what happened. Despite the human chain formed to bring water, an inferno reduced the floor of the Petite Galerie, and even the first bays of the Grande Galerie, to ashes. It was rebuilt by Le Vau, who modified its elevation to the east. He adopted an Ionic order for the floor, but reused some of the surviving elements. The higher section disappeared after Duban's works under the Second Republic, and what we see today is a layering of different styles: a base begun by Charles IX, completed by Henri IV, a floor remodeled by Le Vau, and upper sections reconstructed in 1848, inspired by the engravings from the earlier structure.

Le Vau also redesigned the side of the Petite Galerie facing the Seine. He commissioned a new pediment from Étienne Le Hongre, while the brothers Gaspard and Balthazar Marsy were busy sculpting the fourteen pediments of the Grande Galerie that had been left unfinished under Henri IV.

The interior decoration on the first floor of the Petite Galerie, known as the Galerie des Peintures and then the Galerie d'Apollon, is the great royal construction site of the years 1665–70. Although Le Vau was the architect of this space of more than sixty meters (196 ft.) long, it was the painter Charles Le Brun who played the premier role. Both collaborated on the Vaux-le-Vicomte castle for Fouquet before establishing themselves at Versailles. As early as 1664, Le Brun created a painted and sculpted decoration on the theme of Apollo, god of the arts, surrounded by the Muses. But Apollo was also god of the sun, traveling through the seasons, hours, signs of the zodiac, parts of the world in space and time; an iconography and an aesthetic of glory in which we recognize the figure of the Sun King, who had just adopted this emblem. The decorative system was complex, combining remounted canvases, plaster paintings, and gilded or natural stuccoes. In the center of the ceiling, Apollo (also a symbol of Noon and Sunday) dominates a vast canvas, while four other canvases, alternately oval and octagonal, symbolize the hours of day and night. In compartments, we see the planets corresponding to the days of the week. The arches are of extraordinary richness: at the ends, the parts of the world are represented by groups of captives modeled in stucco, attached to trophies of arms. Around the perimeter, reliefs of large figures and paintings on plaster illustrate the months of the year and the gods who preside over them. Between mock tapestries, two curved tympanums at the ends show the Elements: Water, Earth, Air, evoked by a few wind-heads on the vault, and Fire, probably represented by the central Apollo. In 1674, Le Brun proposed the same cosmogony (elements, parts of the world, months, hours) for the statues of the water parterre of Versailles, which was never completed.

Nor would Le Brun be able to complete his work at the Louvre. He painted *The Triumph of the Waters* in the half-dome on the south side, and three paintings on the ceiling: *Aurore* (Dawn), which has disappeared; *The Evening* or *Morpheus*, god of sleep, father of the monsters that surround him, reclining on the clouds with poppies in his hand; and *The Night*, in which Diana and her chariot are drawn by two deer, while Phoebe spreads the dark veil of night. Le Brun left designs for other compositions: *Apollo in His Chariot*, intended for the central compartment, and *The Triumph of Cybele*, an allegory of the Earth, for the tympanum at the northern end.

In 1666, the ornamentalist Léonard Gontier painted the six grotesque groups where the attributes of the planets of the week can be identified and which separate the vault's

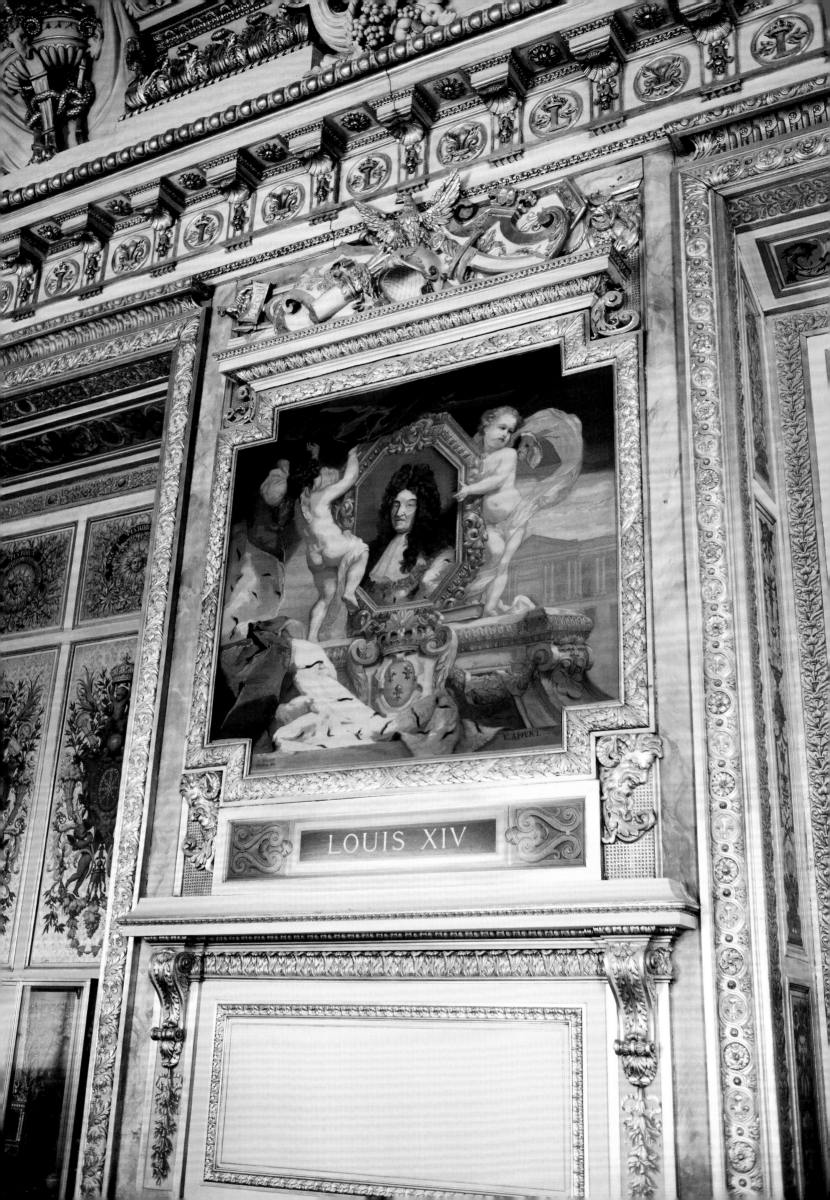

LOUIS XIV

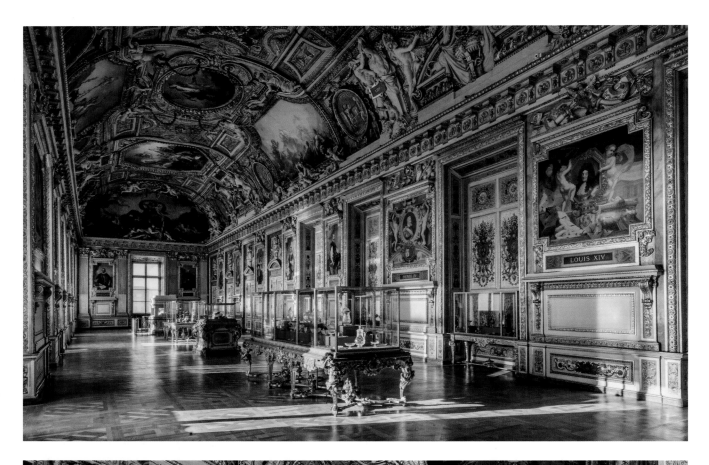

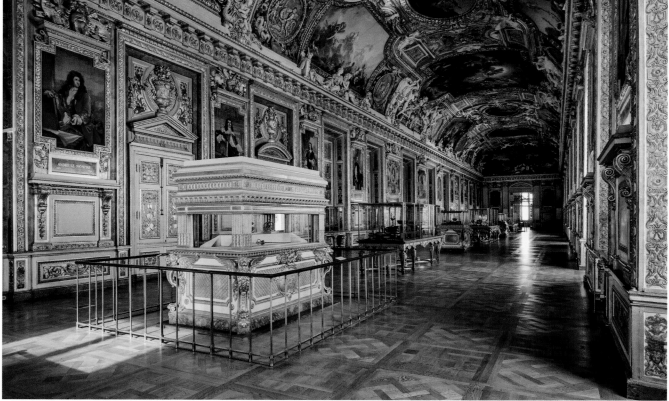

Galerie d'Apollon decorated by Louis Le Vau (architect) and Charles Le Brun (painter), beginning in 1663

Opposite
On the ceiling, center, from top to bottom:
Charles-Louis Muller, *Aurora* (1869);
Antoine Renou, *The Morning Star* (1781);
Eugène Delacroix, *Apollo Slays Python*, 1850–51 (see pp. 166–67)

large compartments. Between 1667 and 1670, Jacques Gervaise made nine medallions in monochrome gold for the work of the months, and pairs of animals symbolizing the gods of the months and the planets (Diana's does, Cybele's lions, Neptune's dolphins, etc.). This cycle of work of the months recalled the medieval tradition. The flower painter Jean-Baptiste Monnoyer framed each medallion with garlands, flowers, and fruits, also evoking each month.

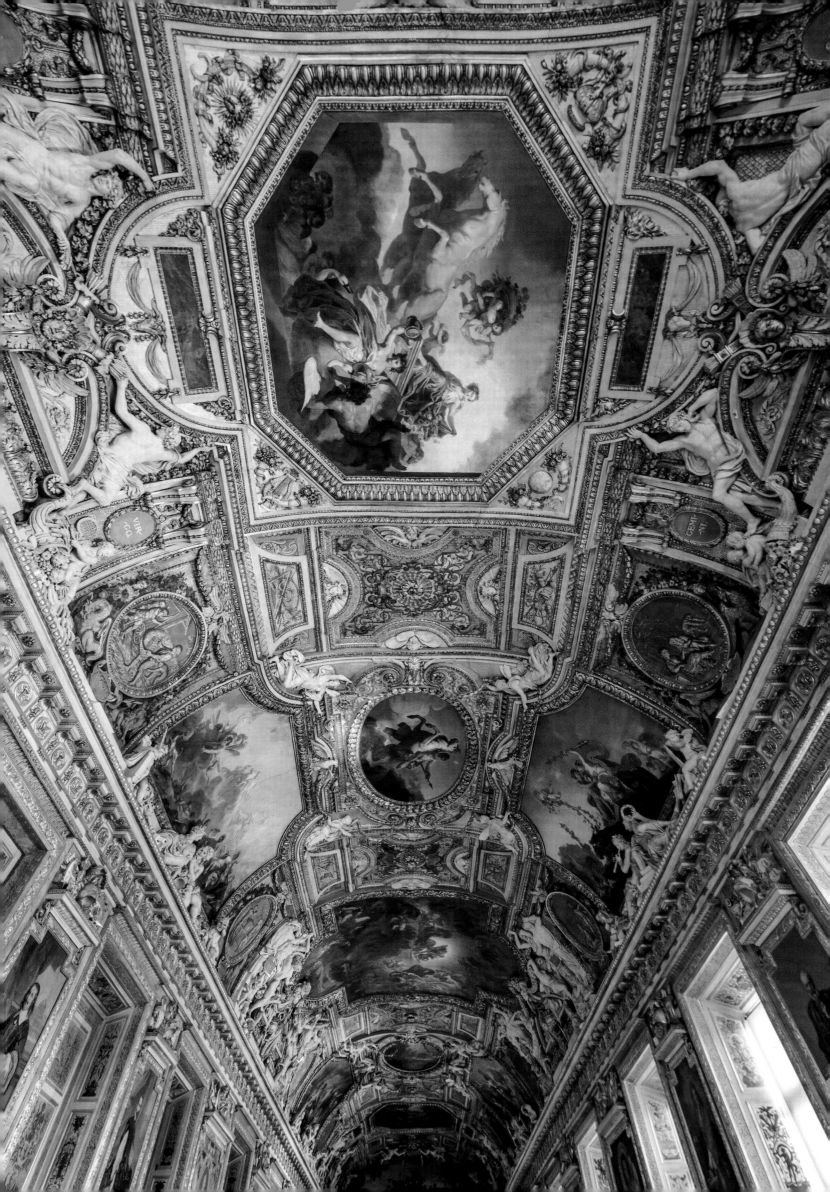

Galerie d'Apollon: south half-dome
The Triumph of the Waters, or *Neptune and
Amphitrite*, 1663, oil on plaster, 310 × 511 cm
(122 × 201 in.), by Charles Le Brun (1619–1690)
Center: a figure of *Neptune*, or a river, or
Hippocrene, River of Parnassus, 1665, stucco,
by François Girardon; on the sides, *Chained
Captives*, stuccoes depicting *Captives of Asia* by
François Girardon (left) and *Captives of Europe*
by Thomas Regnaudin (right)

The unfinished paintings in the gallery would be completed in due course. The Royal Academy of Painting and Sculpture, established in the Louvre and protected by the regime, occupied the gallery from 1763 until its abolition in 1793. It commissioned future academy artists with paintings intended for spaces left empty. Several reception pieces at the academy were then affixed to walls (utilizing the marouflage technique), always following the iconography provided by Le Brun. The *Seasons* were completed between 1764 and 1779: *Spring* or *The Triumph of Flora* by Antoine-François Callet; *Summer* or *Ceres Imploring the Sun* by Louis-Jacques Durameau; *Autumn* or *The Triumph of Bacchus* by Jean-Hugues Taraval; and *Winter* or *Aeolus Unleashing the Winds* by Jean-Jacques Lagrenée. *The Morning Star*, which was missing from the hours of the day, was created later (1781) by Antoine Renou, less a painter than the administrator of the academy.

The museum invested effort and resources into the gallery during the Revolution, but it was in such poor condition that nothing much could be done. In fact, the walls were concealed to present the first exhibition of drawings in Year V (1797) of the republican calendar. It was then turned into an exhibition space for drawings and miniatures. The vault fell into ruin, and the Bourbon Restoration simply decided to close the entrance off with a superb wrought-iron gate from the vestibule of the Château de Maisons in 1819, and to reinforce the gallery in 1826.

At a moment when better times were expected, a complete refurbishment of the gallery by Félix Duban followed in 1848–50. The National Assembly voted in favor of a huge budget for the restoration of the palace. Duban had the stucco altered by the molder Desachy and

Following spread
Eugène Delacroix (1798–1863)
Apollo Slays Python, 1850–51
Oil on canvas, 800 × 750 cm (315 × 295 ¼ in.)

The painter himself would detail the motifs of the immense central composition of the Galerie d'Apollon. The bloody monster struggles in the waters of the flood, attacked by the gods, and Apollo irradiated with light, but also Minerva and Mercury. Before him, Vulcan chases the night, and Boreas and the zephyrs dry up the waters with their breath.

Ceiling of the Galerie d'Apollon:
Spring, or *Zephyr and Flora Crowning Cybele
with Flowers*, 1780, oil on canvas, 270 × 360 cm
(106 ¼ × 141 ¾ in.), by Antoine François
Callet (1741–1823); *Terpsichore and Polyhymnia*,
1663–65, stucco, by Balthazar Marsy
(1628–74)

the paintings by Popleton, and he commissioned other paintings. Charles-Louis Muller's
Aurora on the ceiling (which was redone by the artist after an accident in 1869), or *Cybele*, an
allegory of the Earth by Joseph Guichard according to Le Brun's project, are overshadowed
by the piece of central bravura: the gigantic painting by Delacroix, *Apollo Slays Python*. Here,
Apollo shoots his arrows from the top of Olympus, where all the gods are gathered. He kills
the horrible, enormous, and powerful monster that struggles in the despair of defeat in the
raging waves. Take a moment to observe the strangely lascivious goddesses. Notice the jux-
tapositions of bright colors, where an iridescent turquoise dominates, while the sunny colors
of yellow and gold illuminate the feverish skies. When Delacroix received this major com-
mission, he was no longer the combative romantic of his early days; he was now a well-
established artist, almost an official one. He had to measure himself against Le Brun and
integrate his work into the Louis XIV setting, adopting its decorative and dynamic strengths,
while affirming the contemporary vocabulary. And so he did. Despite the enormity of the
canvas, the constraint of the support, and the evanescent light, he here provides a great les-
son in painting, where colors and shapes enact the struggle of the forces of nature.

However, the Galerie d'Apollon is not only the temple of painting, uniting three centuries
of artistic creation. It is also one of the most important places for great sculpture. Let your

eye follow the cornice edges of the stuccoes modeled in 1663–65 by François Girardon; the brothers Marsy, Gaspard, and Balthazar; and Thomas Regnaudin. Better than at Versailles—whose decoration would flow from it—the sculptors gave strength, gaiety, and suppleness to what might only have been a simple ornamentation and which instead became a series of stories. At the corners, the groups of chained captives (depicting the parts of the world) who express the pain of slavery are not unlike those on the ceiling of the royal chamber, which were created slightly earlier. For the zodiac groups, drawn by Le Brun, the sculptors rendered small, feisty spirits that embody Ares and Taurus, Leo and Sagittarius. Beautiful athletes show their muscles to smiling Muses who form Apollo's procession, while an old and paunchy Silenus lends a touch of the burlesque. At one end, a robust male figure—Neptune or the great river of Parnassus—reclining in the antique style, was sculpted by Girardon with a regal monumentality. At the other end, the Renommée (Fama)—the Muse Calliope—sounds the trumpet to announce the glory of the king. The pleasure of modeling is evident in these very large figures that were executed on the spot, probably on a shaky scaffold, in low light and with the need to work fast. Iron frameworks were first laid, then the sculptors gave an initial shape to a plaster core, protected by a red layer of clay and crushed brick, which ensured its impermeability during the execution of the surface layer: white to look like marble.

Ceiling of the Galerie d'Apollon: *Winter* or *Aeolus Unleashing the Winds Covering the Mountains with Snow*, 1775, oil on canvas, 320 × 320 cm (126 × 126 in.), by Jean-Jacques Lagrenée the Younger (1739–1821); *Erato and Urania*, 1663–65, stucco, by Gaspard Marsy (1625–81)

Following spread
Galerie d'Apollon seen through the entrance gate

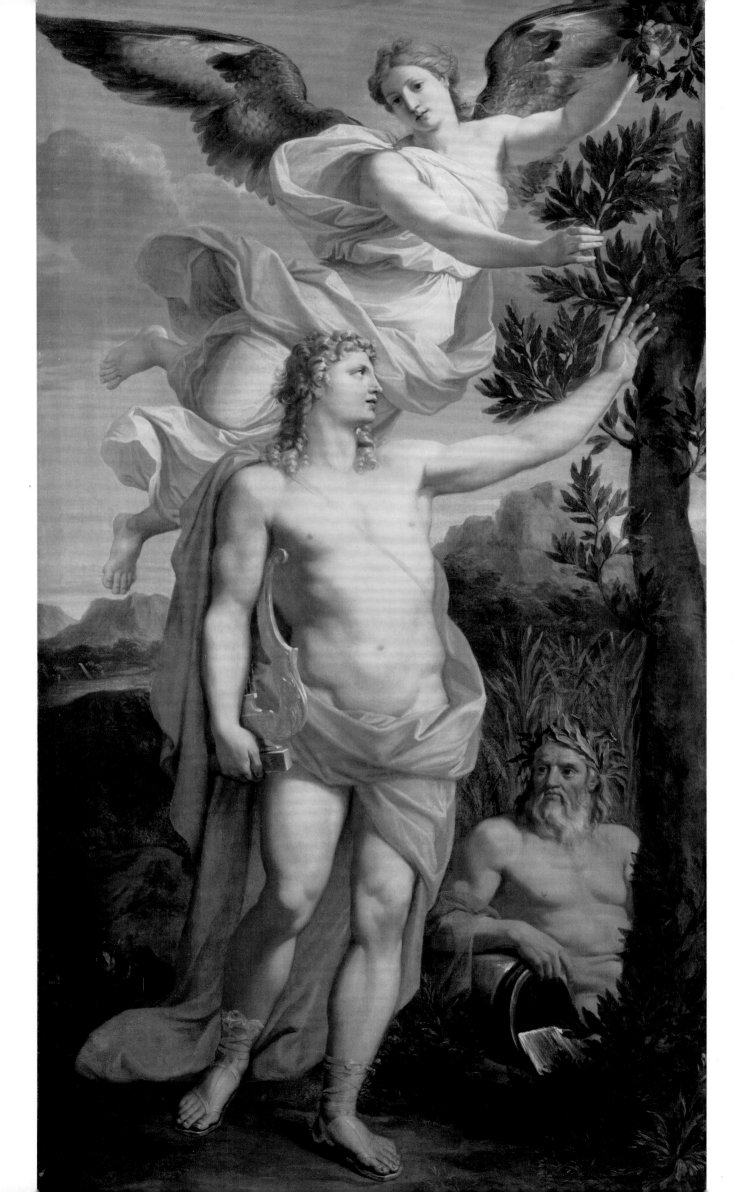

In the lower section, the walls were covered up to the cornice with paneling by Claude Buirette and Jacques Prou. On these joineries was placed a painted decoration with extremely delicate grotesques, probably made by the Lemoyne brothers.

For the furnishings, in 1664, the king commissioned thirteen carpets from Simon Lourdet's manufactory (at the Savonnerie), in the dimensions of the gallery, and four large cabinets designed by Domenico Cucci and Pierre Golle. The Louvre exhibits one of these carpets, a remnant of a set that is now dispersed.

The Tuileries Palace and Its Garden

For the western wing of the palace, the king also had his grandfather's Grand Design in mind. In 1662, he held a sumptuous equestrian display (Carrousel) in front of the Tuileries to celebrate the birth of the dauphin; he himself appeared at the head of the riders' quadrille. He would commission Le Vau and his assistant, François d'Orbay, to completely restructure the Château des Tuileries with large apartments and a new staircase and facade in keeping with the latest trends. Let us recall that Bernini, during his stay in Paris, strongly criticized this group of pavilions for their lack of homogeneity, which he compared to a group of little children. The central pavilion was redesigned, enlarged, and decorated with large stone figures, sculpted under the direction of Philippe de Buyster and Thibaut Poissant. The Château des Tuileries burned down at the end of the Paris Commune in May 1871, but when the ruins were demolished in 1883, some sculptures were saved. Can you tell which ones they are in the underground Carrousel Gallery? While they are very damaged today, we can still identify the royal virtues that supported the crown: Religion, Piety, Justice . . . and Sincerity.

A new structure to the north, the Pomona Pavilion (then called the Pavillon de Marsan), finally provided a little symmetry to a facade that was until then highly composite. The large apartments, where the king moved during work on the Louvre (between 1667 and 1674), were luxuriously decorated. The stuccoes were by Girardon, Tuby, Lerambert; the paintings by Noël Coypel, with several by Champaigne, Nicolas Loir, and Bertholet Flemalle, among others. Some elements of this decoration remain: Coypel's *Apollo*, and *Achilles' Education* painted on a gold background by Jean-Baptiste Champaigne.

In front of the windows, a new garden was being built to the west. Catherine de Médicis had one planted, but it was separated from the palace by a street; Henri IV had restored and completed it, importing mulberry trees to encourage the breeding of silkworms. But it was Louis XIV who shaped the space we still enjoy today. The new production was part of the king's Grand Design to unite the Louvre and the Tuileries, and was above all intended to lend a royal dimension to the Château des Tuileries. From the windows of the king's apartment, a long vista unfolded, leading the eye to the west of Paris. The future Champs-Élysées, originally a muddy marsh, where the Place de la Concorde would be located, provided a masterly axis, while the Cours la Reine turns off toward the Seine.

The king benefited from the inventiveness and experience of André Le Nôtre, his gardener and much more, because Le Nôtre could paint and handle the architecture of spaces, and he had knowledge of plant science. The son and grandson of the king's gardeners who had created the first garden, Le Nôtre was born in the Tuileries and lived there in a cottage all his life. After working in Vaux-le-Vicomte and Fontainebleau, but before the great achievements of the parks of Versailles, Chantilly, Saint-Cloud, Sceaux, and Meudon, he sculpted the new space of the Tuileries Garden in 1664. Le Nôtre skillfully took over the terraces bordering it. The north terrace existed before, while those to the west reused the old bastion of Charles IX's enclosure. As a result, one could stroll along the "terrace by the water" and enjoy the view of the Seine and the surrounding hills. When the king was in his château, he would have seen the large parterre with lush plantings colorfully framing a pond within the palace grounds and, in the distance, a more dense wood concealing the pleasure groves. The central aisle forms the axis, a long view that is magnified by a large horseshoe theater at the end of the park. The basins punctuate this progression.

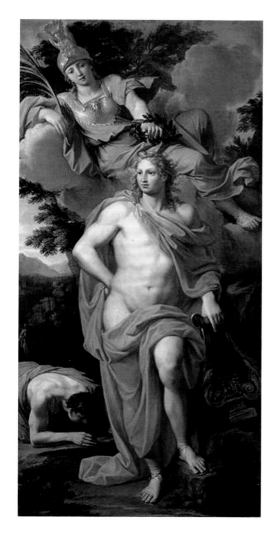

Noël Coypel (1628–1707)
Apollo Crowned by Minerva, 1667–68
Oil on canvas, 214 × 103 cm (84 ¼ × 40 ½ in.)
From the Château des Tuileries, study of the king's small apartment
Department of Paintings, collection of Louis XIV

Opposite
Noël Coypel (1628–1707)
Apollo Crowned by Victory, 1667–68
Oil on canvas, 214 × 115 cm (84 ¼ × 45 ¼ in.)
From the Château des Tuileries, study of the king's small apartment
Department of Paintings, collection of Louis XIV

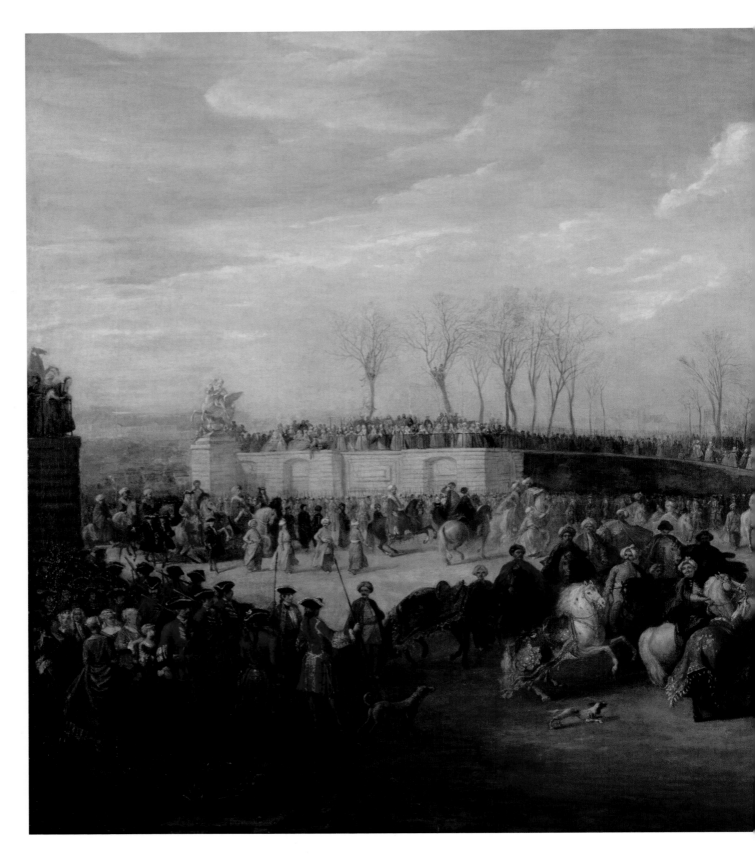

Charles Parrocel (1688–1752)
Arrival of the Turkish Embassy Led by Mehemet Effendi at the Tuileries Gardens, 21 March 1721,
Salon of 1727
Oil on canvas, 228 × 329 cm (89 ¾ × 129 ½ in.)
Versailles, Musée National des Châteaux de Versailles et de Trianon

Around the basin, we can distinguish the statues from Marly Park in 1716: *Mercury* by Antoine Coysevox, and *The Seine and the Marne* by Nicolas Coustou.

To organize the decoration of the large parterre, two small circular side pools dialogue with the large central one, while a large octagonal pool fixes the composition in the center of the horseshoe.

This garden was opened to the public thanks to Charles Perrault's persuasive appeal to Colbert. It was from then on the beloved promenade of Parisians. The beau monde, dressed as would have been proper under the ancien régime when stepping out to see and be seen, came to socialize. In the centuries that followed, parents brought their children, who played with small boats on the basin and enjoyed the attractions. It was the place for

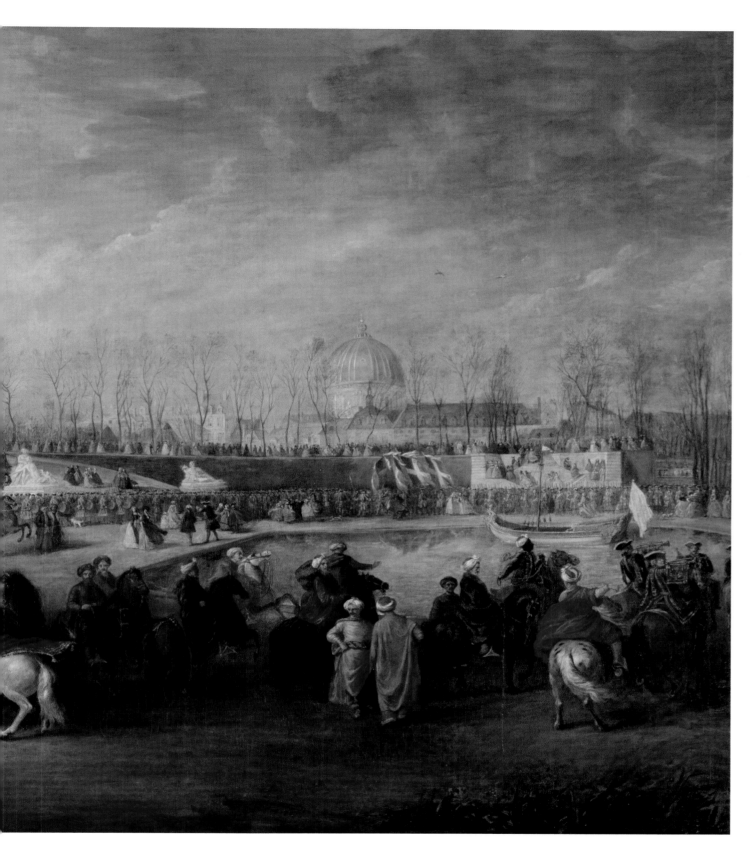

celebrations: the Feast of Saint-Louis under the monarchy; the feast of the Supreme Being during the Revolution, in 1794, and then under the Republics; charity celebrations; patriotic parades; banquets of the mayors of France, and of the automobile or painting salon, before the fairgrounds occupied it twice a year.

Here again, what we see has been transformed by time and people. The first major arrival of sculptures dates from the Regency, when the young Louis XV resided at the Château de Tuileries. Beautiful marbles were brought in from the parks of Marly and Versailles; others were commissioned or created specifically for the site. A conservation

Following spread
View of the Tuileries Garden from the Pavillon de Flore, the large parterre, and basins

Willem De Kooning (1904–97)
Standing Figure, 1969–84
Bronze, H. 375 cm (147 ½ in.), L. 640 cm
(252 in.)
Jardin des Tuileries, on loan from the
De Kooning Foundation, 2010

Opposite
Étienne-Martin (1913–85)
Characters III, 1967
Bronze, H. 250 cm (98 ³/₈ in.)
Jardin des Tuileries, on loan from the
Fonds National d'Art Contemporain, 1998

Giuseppe Penone (born 1947)
The Vowel Tree, 1999
Bronze, L. 20 m (65 ½ ft.)
Jardin des Tuileries, on loan from the
Fonds National d'Art Contemporain, 1999

policy gradually brought the originals together at the Louvre to decorate the Marly and Puget courtyards. But still remaining in the garden are some sculptures from the time of Louis XIV, copies of personifications of rivers, or of Roman figures made at the French Academy in Rome.

However, other sculptures have been added over time. A large campaign turned the garden into a sculpture museum under the Directory, 1798–99. Then, in 1858, Hector Lefuel, Napoleon III's architect, encircled the large round basin with statues and vases. Although many statues were added during the Third Republic, in the twentieth century, animosity toward "pompous" art resulted in the removal or destruction of a large number of works. But as testament to the "statuomania" of the Third Republic, two political monuments still remain: those of Jules Ferry and Waldeck-Rousseau, and another raised in honor of literature, that of Charles Perrault. André Malraux transformed the parterres of the Carrousel into the Musée Maillol, populating lawns and groves with Aristide Maillol's most famous figures (*Action in Chains*, for example). In 1998 and 2000, two campaigns to integrate modern and contemporary works were led by the sculptor Alain Kirili. From Rodin to Germaine Richier, from Étienne-Martin to Louise Bourgeois, from Dubuffet to Penone—sculptors now "live" in the groves and on the terraces of the Tuileries Garden.

The very structure of the garden has changed. The opening toward the Place de la Concorde dates back to Louis XV; the transformation of the terraces to the west—from diagonal to rectangular—was the work of Napoleon I at the time of the breakthrough of the rue de Rivoli, which now bordered the garden with bustling traffic. Louis-Philippe and Napoleon III shielded their privacy from the crowds by creating a reserved space, enlarged during the Second Empire. The château, destroyed in 1883, left the garden bereft of the place from which to enjoy the view. It was not until 1994 that it was given a new life. Landscape designers Pascal Cribier and Louis Benech eliminated the old reserved garden, redesigning the large parterre into a square, enlivened with flower beds, and dotted here and there with unusual trees, often from Napoleon III's garden.

Opposite
Artemis with a Doe
Antique-styled molding, plaster, H. 211 cm
(83 ⅛ in.)
Replaces the marble copy of the antique
original, executed by Guillaume I Coustou
for Marly Park, returned to the Louvre
Jardin des Tuileries

Laurent Honoré Marqueste (1848–1920)
The Centaur Nessus Abducting Deianira
Marble, H. 305 cm (120 in.), L. 250 cm
(98 ⅜ in.)
State commission, 1892
Jardin des Tuileries since 1894

Opposite
Louis Auguste Lévêque (1814–75)
Nymph
Carrara marble, H. 202 cm (79 ½ in.)
Commissioned by Napoleon III for
Fontainebleau in 1864, completed in 1866
and placed in the Tuileries Garden in 1872
Jardin des Tuileries

Jean-Baptiste Hugues (1849–1930)
Man and His Misery, or *La Misère,* 1907
Marble, H. 286 cm (112 ½ in.)
Acquired by the state in 1923 and placed
in the Tuileries Garden since 1923
Jardin des Tuileries

Henri Vidal (1864–1918)
Cain Having Just Killed His Brother Abel, 1896
Marble, H. 195 cm (76 ¾ in.)
Model exhibited at the Salon des Artistes
Français in 1894
Jardin des Tuileries, gift of Pierre Vidal,
son of the artist, 1980

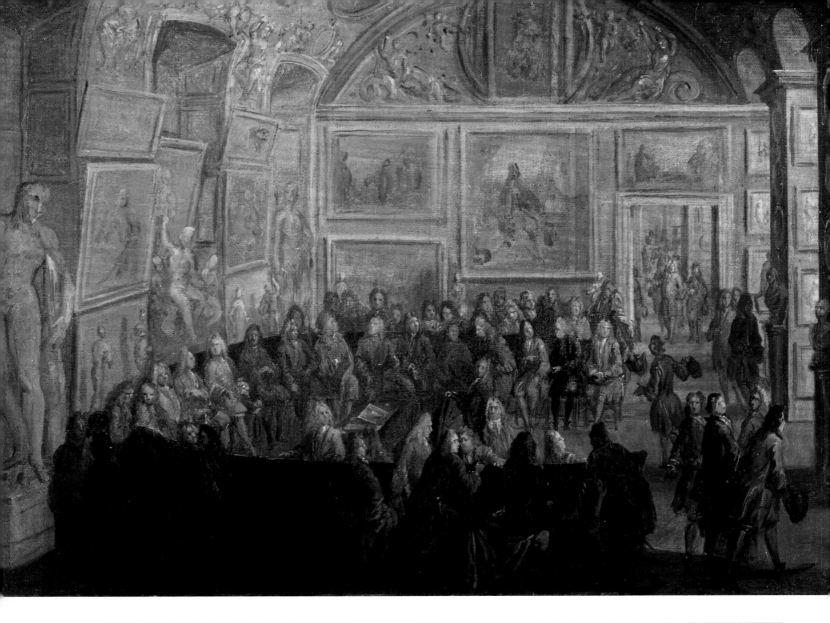

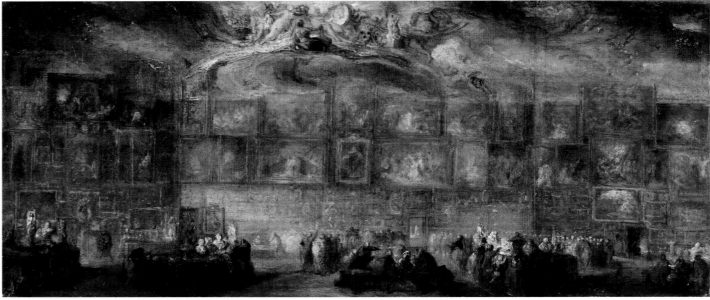

Jean-Baptiste Martin (1659–1735)
An Ordinary Meeting of the Royal Academy of Painting and Sculpture at the Louvre, 1712–21
Oil on canvas, 30 × 42 cm (11 ⅞ × 16 ½ in.)
Department of Paintings, acquired in 1998

The academy's collections can be seen in the room it occupied from 1712 to 1721 (Salle de Diane). These include the paintings on the walls and, on the perimeter, plaster copies of famous antiquities and reception pieces.

Gabriel de Saint-Aubin (1724–80)
The Salon of 1779, 1779
Oil on canvas, 19 × 44 cm (7 ½ × 17 ⅜ in.)
Department of Paintings, acquired in 1993

The paintings pack the walls up to the ceiling, while the public gathers between the tables where the sculptures are exhibited.

The Palais des Académies:
The Collection of Reception Pieces at the Royal Academy
of Painting and Sculpture

The king had abandoned Paris. The Grand Design was forgotten, and the new Louvre was left incomplete, like an empty shell. The roofs were unfinished. Every habitable place was used by royal administrators, courtiers, and especially court artists, who, not content to live under the Grande Galerie, were given accommodation and workshops in every available space.

The most beautiful royal apartments were devoted to the sessions of the Royal Academies, already ancient institutions, which gathered in the palace. The French Academy moved to the ground floor of the Cour Carrée in 1672, as did the academy of Inscriptions and Belles-Letters in 1685. The Academy of Sciences settled in the king's apartment in 1699. The Academy of Painting and Sculpture, which had been housed in the narrow premises of the Grande Galerie in its early days, left an outbuilding of the Palais-Royal in 1692 for the Salon Carré and the surrounding rooms, next to the king's paintings cabinet, located in the Galerie d'Apollon and the Rotunda. That same year, the king's antiques were exhibited in the Salle des Caryatides, now promoted to the new Salle des Antiques (Antiquities Hall) and the Academy of Architecture was established in the queen's apartment, on the first floor of the south wing of the Cour Carrée. Libraries and collections, jars and scaffolds piled up in the old rooms, while sessions were held in the antechamber and guardroom. There were still more: the Royal Printing House, the Chalcography, the Marine and Mechanics Cabinet, the Academy of Politics in the Pavillon de l'Horloge, the archives, and even the series of major relief maps of the fortresses of France, deployed in the Grande Galerie to serve as a teaching tool for military strategy.

The Academy of Painting and Sculpture was both a learned company of artists—meeting and sponsoring conferences that shaped aesthetic doctrine—and a teaching body,

Jean-Antoine Watteau (1684–1721)
Pilgrimage to the Isle of Cythera
Oil on canvas, 129 × 194 cm (50 3/4 × 76 3/8 in.)
Department of Paintings, seized during the
Revolution with the academy's collections

Watteau had been accredited at the Royal
Academy of Painting and Sculpture in 1712,
but was slow to submit his reception piece.
After being reprimanded for the delay, he
presented the painting on 27 August 1717.
This enormous landscape composition is a
masterpiece of the new genre of *fêtes galantes*.

Jean Siméon Chardin (1699–1779)
The Ray or *Kitchen Interior*
Oil on canvas, 114 × 146 cm (44 ⅞ × 57 ½ in.)
Department of Paintings, seized during the
Revolution with the Academy's collections

Chardin presented this painting and its
companion, *The Buffet* (opposite), as his approval
and reception pieces to the academy on the
same day, 25 September 1728.

Opposite
Jean Siméon Chardin (1699–1779)
The Buffet, 1728
Oil on canvas, 194 × 129 cm (76 ⅜ × 50 ¾ in.)
Department of Paintings, seized during the
Revolution with the academy's collections

Following spread
Jean-Honoré Fragonard (1732–1806)
*The High Priest Coresus Sacrificing Himself to Save
Callirhoé*, 1765
Oil on canvas, 309 × 400 cm (121 ½ × 157 ½ in.)
Department of Paintings, acquired by Louis XV

The approval piece that Fragonard presented to
the academy depicts a little-known episode from
Pausanias's *Description of Greece*: Coresus stabs
himself to save the young Callirhoé, whom he
loves and who is fated to be sacrificed to appease
the gods and save Athens from plague. The artist
then abandoned such theatrical subjects for
lighter, more carefree themes.

responsible for training future royal artists. Drawing was taught there using nude models or from casts of ancient statues belonging to the institution. The Louvre shared most of the academy's collections with the Musée de Versailles: portraits of academics, gifts and "reception pieces," i.e., the masterwork that every new applicant for admission had to present, after having obtained "approval" with a first work. During the Revolution, the Louvre collected reception pieces from academics of the past, while the most recent ones went to the Musée de l'École Française in Versailles.

Among the most outstanding works of the Department of Paintings, we find paintings submitted for admission that were divided into a hierarchy of genres that placed history painting at the highest level and still life at the lowest. But this selective compartmentalization was a purely administrative academic division, and time has since restored a hierarchy based on quality. When Watteau was admitted to the academy in 1712, he was given his choice of subject. He chose to show happy couples leaving or returning from the sanctuary of Venus, the *Pilgrimage to the Isle of Cythera*. Although the academicians refused him the title of history painter, he was the first recipient in the category of *fêtes galantes*, a telltale sign of an astonishing success to come. *The Ray* and *The Buffet* ensured Chardin's primacy in the still-life genre. His simple objects acquire a status of universal humanity through a rigorous composition and subtle use of light. In the case of Fragonard, he opted for an ambitious theme for his application to the academy in 1765, *The High Priest Coresus Sacrificing Himself to Save Callirhoé*, and an immense format in order to achieve the coveted status of history painter. He achieved success at the salon when the king bought the painting.

The Department of Sculptures reserved two spaces for reception pieces: the Galerie Girardon for the seventeenth century, and the small Salle de l'Académie for the eighteenth century. We can thus appreciate the evolution of an "official" art. All the techniques were

François Barois (1656–1726)
Cleopatra Dying
Reception piece at the Royal Academy
of Painting and Sculpture, 1700
Marble, L. 101 cm (39 ¾ in.)
Department of Sculptures, seized during
the Revolution with the academy's collections

Opposite
Jean-Baptiste Pigalle (1714–1785)
Mercury Tying His Winged Sandals
Marble, H. 58 cm (22 ⅞ in.)
Department of Sculptures, seized during the
Revolution with the academy's collections

Pigalle presented the model of this sculpture to
the academy as an approval piece in 1741, then
this marble statue as a reception piece in 1744.
"Pigalle, good old Pigalle, who in Rome was
called the mule of sculpture, by sheer force of
effort, was able to do nature, and make it true,
warm, and rigorous," wrote Diderot.

called upon, although terra-cotta and bronzes were rare, while marble reigned supreme. There are only a few busts, but by the most famous portrait artists, Coysevox and Lemoyne, and few religious works. At first, the academy asked for fairly simple reliefs: figures of the apostles, or Christ and the Virgin. Later, it asked for works illustrating the glory of the king and the academy, based on sketches by Le Brun given to the candidates. From the turn of the eighteenth century onward, most of the reception pieces were marble statuettes. The first, *Polyphemus* by Van Clève, was submitted in 1681; the academicians would commission another work as a companion piece, *Galatea*. Little by little, a new type emerged. There were a few erotic subjects, such as *Leda and the Swan*. Most sculptures depicted dramatic subjects: *The Death of Dido*, *Cleopatra Dying*, or *Meleager*. After the reign of Louis XIV, the themes were in the same vein: *Abel Dying*, *Milo of Croton* devoured by a lion, *Prometheus Chained*, etc. The best works, however, would circumvent the rules. Pigalle submitted *Mercury Tying His Winged Sandals* (1744), whose subject he himself had chosen and presented the model to obtain approval. Jean-Antoine Houdon would show *Morpheus*, sleeping peacefully.

The academy was also the laboratory of living art. It organized the periodic exhibition of its members' work. Initially held at the Palais-Royal, from 1699 onward the event took place in a portion of the Grande Galerie and then in the Salon Carré. Thus, in the eighteenth century, the academic exhibition held every two years for the Feast of Saint-Louis (August 25) became the highlight of Parisian artistic life. It was then called "the Salon," after the name of the place it occupied.

A Brief Look at Louis XIV's
Collections at the Louvre

Gallery of the Venus de Milo
Aphrodite (Venus Genetrix), 1st century A.D.,
based on a work created by Callimachus
around 420 B.C.
Italy, Paros marble, H. 194 cm (76 ⅜ in.)
Louis XIV collection, reproduced in engraving
by Étienne Baudet among the antiques of the
Palais des Tuileries in 1678, then placed near
the Basin of Apollo at Versailles
Department of Greek, Etruscan, and Roman
Antiquities, transferred during the Revolution,
1798

The Musée du Louvre is also largely the heir to the collections assembled by the king,
which populated his residences. Some we can still see: antiques, gems, bronzes, marbles,
and paintings, not to mention tapestries, drawings, coins and medals, books, weapons,
natural curiosities, and even the productions of royal manufactutories—Gobelins for
tapestries and furniture, and the Savonnerie carpets.

Apart from those inherited by the king, the most beautiful antiques were acquired upon
Mazarin's death in 1661. Many went to decorate the Tuileries apartments before leaving
for Versailles. Then attempts were made to bring in large statues from Rome, but the pope
was reluctant to part with heritage artifacts. It took a lot of diplomacy to obtain two beau-
tiful statues from the Montalto collection, the *Germanicus* and *Cincinnatus*, which are now
on display in the Salle des Caryatides. The consuls who worked under the authority of
Colbert and his son, secretaries of state for the Navy, sought other statues in Libya and on
the Anatolian coast in Smyrna. Neither were the cities of the kingdom ignored, which
provided the *Venus of Arles* and a *Senator* found in Langres.

The Louvre holds the nucleus of the royal collection of paintings, which increased nota-
bly during the reign of Louis XIV, through both commissions and the acquisition of early
works. The four monumental paintings in the Alexander cycle painted by Le Brun and his
assistants from 1661 onward—sometimes under the watchful eye of the king himself—
drew a parallel between the great deeds of the ancient conqueror and those of the young
sovereign, at the very beginning of his reign. Among the major acquisitions was the trea-
sure trove of works that the Cologne banker Everhard Jabach brought to the king: paint-
ings, more than 5,500 drawings, and small bronzes (acquired in two phases, in 1662
and 1671). Some works came from England, where the Stuart King Charles I had suc-
ceeded in obtaining the Mantuan collections. These collections were strong in Italian

and Northern European arts. Thus, masterpieces by Raphael, Leonardo da Vinci (*Saint John the Baptist*), Titian (*Pastoral Concert, The Burial of Christ, Man with a Glove*), Correggio (*Vices* and *Virtues*), Caravaggio (*Death of the Virgin*), Holbein (*Portrait of Erasmus*), Rubens, and Van Dyck, entered the Louvre.

The Crown Bronzes form another major collection in the Louvre. The king received it as an inheritance upon the death of his uncle Gaston d'Orléans in 1660. At the beginning of his reign, in 1662, he acquired beautiful copies from the well-known collections of Jabach and Hesselin. But he then seemed to lose interest in this type of work and was content to accept numerous donations, particularly from his painter Charles Errard and his gardener André Le Nôtre. He thus had a collection of ancient and modern bronzes, Roman statuettes, mirrors, Florentine Mannerist groups, works by Giambologna and Susini, sculptural reductions after Michelangelo or after antique originals, not to mention contemporary bronzes, such as equestrian statuettes of the king.

The sculpture collections were then divided according to their dimensions. Small formats went into the apartments of Versailles, where some rooms even formed a small gallery of antiques, medals, and bronzes, the nucleus of the future Cabinet of the Medals of the Royal Library under Louis XV. Busts, statues, and groups were lined up in large reception rooms and gardens. Of course, the Palace of Versailles still preserved the most beautiful sculptures. But chance and choice brought important pieces to the Louvre. Thus, the Romantic movement and the nineteenth-century taste for technical feats dovetailed to bring together in the Louvre the most extraordinary marbles by Pierre Puget, executed for Louis XIV. "The rage of a boxer, the impudence of a faun . . . Puget, emperor of the convicts," wrote Baudelaire. Far from Paris, in Toulon and Marseille, the Provençal Puget was inspired by Italian Baroque art. But Colbert authorized him to execute for the king a

Aphrodite, known as *Venus of Arles* (detail), late 1st century A.D., based on a work created by Callimachus around 370 B.C.
Italy, Paros marble, H. 194 cm (76 3/8 in.)
Discovered in 1651 in the ruins of the ancient theater of Arles and placed in the town hall of the city; offered in 1683 to Louis XIV, who had it restored by François Girardon and installed in the Hall of Mirrors in Versailles
Department of Greek, Etruscan, and Roman Antiquities, transferred during the Revolution, 1798

Above and opposite
Marcellus Divinized into Mercury Psychopomp,
also known as *Germanicus Savelli* (details),
ca. 20 B.C.
Marble, H. 180 cm (70 ⅞ in.)
Discovered on the Esquiline, reported in 1649

in the Villa Montalto; Louis XIV purchased
it in 1685 as an extra Germanicus; it is a funeral
portrait, inspired by a classical Hermes
Department of Greek, Etruscan, and Roman
Antiquities, Hall of Mirrors in Versailles,
transferred during the Revolution, 1798

group showing Milo of Croton devoured by a lion, a sign that official art was not only Parisian, and that what was called "classicism" was quite mixed with the Baroque. When the sculpture arrived at the Tapis Vert in Versailles, the praise was universal, and the queen exclaimed: "How he suffers!" Without the royal administration imposing the theme on him, Puget also sculpted the great relief of *Alexander and Diogenes*: the self-satisfied conqueror, surrounded by his soldiers with their sinister expressions, faces the impoverished philosopher who disdains honors and riches—a fine lesson in humility for the Sun King. It must be said, however, that the marble was never shown to the king but was prudently placed in storage at the Louvre. More typically, the high relief in which Perseus liberates an abandoned and grateful Andromeda from a rock was displayed in the place of honor at Versailles. Puget expressed movement and strength with consummate skill in the marble format, saying that "the marble shakes if the piece is huge."

Other testaments to the art of Versailles came to the Louvre, such as monumental allegories of the air and the earth, directed by Le Brun, or copies of antiques made by Antoine Coysevox, or vases with bodies animated by François Girardon's depictions of Amphitrite and Neptune cortege, with newts, nereids, and other water deities.

The gem collection is displayed in the Louvre in the Galerie d'Apollon. Gems were a real passion for Louis XIV, who ordered the most beautiful pieces available. He had inherited sumptuous works, trimmed with mounts from the time of the Valois or executed by artists like Pierre Delabarre in the Grand Galerie's goldsmith workshop.

Tiziano Vecellio, known as Titian (1488/90–1576)
The Pastoral Concert, ca. 1509
Oil on canvas, 105 × 137 cm (41 3/8 × 54 in.)
Department of Paintings, Louis XIV
collection, acquired from Jabach in 1671

This mysterious painting, formerly attributed to Giorgione but then given to Titian, is an allegory of poetry, signified by the flute and the pouring water, symbols shared between the two nude women of ideal beauty. These figures exist only in the imaginations of the two men they inspired.

Opposite
Tiziano Vecellio, known as Titian (1488/90–1576)
Portrait of a Man, known as *Man with a Glove*, ca. 1520
Oil on canvas, 100 × 89 cm (39 3/8 × 35 1/8 in.)
Department of Paintings, Louis XIV
collection, acquired from Jabach in 1671

This painting from Titian's youth heralded the coming of his great aristocratic portraits. The man with a glove emerges from shadow, his white shirt emphasizing his luminous complexion, giving the composition a vibrant dynamism.

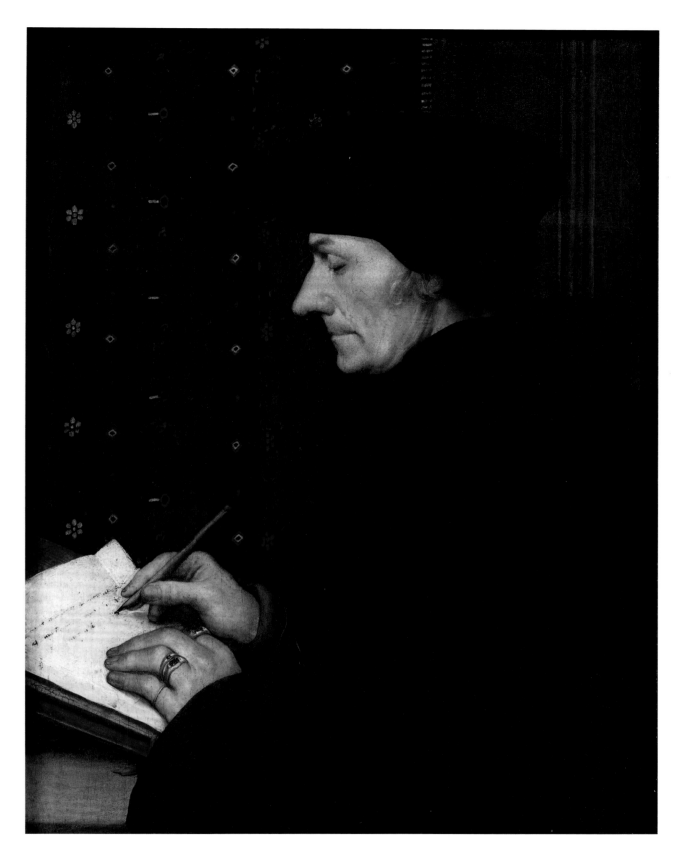

Opposite
Michelangelo Merisi, known as Caravaggio
(1571–1610)
The Death of the Virgin, 1601–6
Oil on canvas, 369 × 245 cm (145 ¼ × 96 ½ in.)
Department of Paintings, Louis XIV
collection, acquired from Jabach in 1671

Commissioned for Santa Maria della Scala in
Rome, the painting was refused by the monks,
probably because of the realistic depiction of
the apostles' poverty and of the Virgin herself.
Acquired by the duke of Mantua through
Rubens, it passed into the collection of Charles I
of England and then into that of Jabach.

Hans Holbein the Younger (1497–1543)
Erasmus Writing, Basel, 1523
Oil on wood, 43 × 33 cm (16 ⅞ × 13 in.)
Department of Paintings, Louis XIV collection,
acquired from Jabach in 1671

The humanist in profile, like in classical portraits on
medals, writes the beginning of a commentary on
the gospel of Saint Mark.

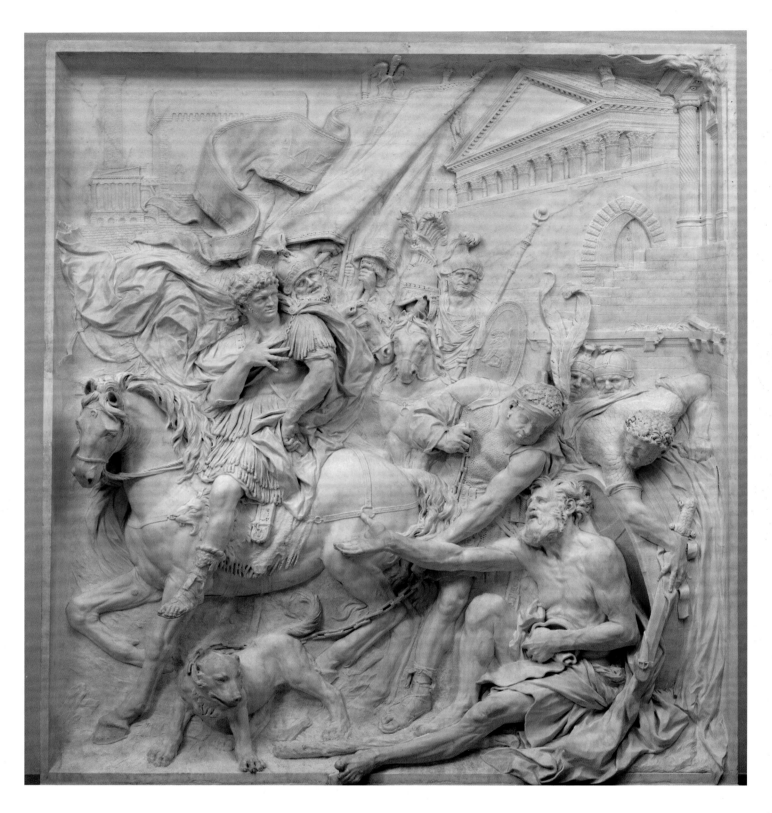

Pierre Puget (1620–94)
Alexander and Diogenes
Carrara marble, 332 × 296 cm (130 ¾ × 116 ½ in.)
Commissioned for the king by Colbert in 1671,
completed in 1679, transported to Paris in 1697
after the artist's death
Department of Sculptures, royal collection

The composition shows the philosopher
Diogenes, who renounced wealth and honor,
meeting Alexander the Great and his soldiers.
Puget references classical models and, in the
background, Roman monuments.

Opposite
Pierre Puget (1620–94)
Milo of Croton
Carrara marble, H. 270 cm (106 ¼ in.)
Department of Sculptures, transferred from
the Park of Versailles in 1819

Puget asked Colbert for permission to use
blocks of marble left in the port of Toulon
in 1670. Without an official commission, he
sculpted Milo, an aging athlete who tested his
strength by splitting a tree trunk but instead
trapped himself in the slit and was devoured by a
lion. The marble, left unfinished for a time, was
finally acquired by the king, finished in 1682,
and placed at the entrance to the Allée Royale at
Versailles in 1683.

Vitrine in the Adolphe de Rothschild room
(Richelieu, first floor, room 25): three busts
of the "Twelve Caesars," Italy, 17th century,
hard stone, partially gilded silver, H. 17 cm
Department of Decorative Arts, bequest
of Theodore Dablin, 1861

From the Regency to the Enlightenment

When Louis XIV died in 1715, King Louis XV was only five years old. Philippe of Orléans, the regent, moved him into the Château des Tuileries. The government also returned to Paris, and the duke of Orléans stayed at the neighboring Palais-Royal. During a brief interlude (1716–22), the little king resided in his capital, in this double palace of the Louvre and the Tuileries. In 1722, the very young infanta of Spain, Marie-Anne-Victoire, was engaged to the king at the age of four and moved into Anne of Austria's summer apartment. The architect Robert de Cotte redeveloped the adjoining garden and placed some statues of Diana's nymphs in it that had been planned for Marly Park. The marriage never took place, and the infanta was sent back, leaving her name to the Infanta's Garden.

At the time of the regency, there was a feeling of freedom in the air, breaking with the austere reign of Louis XIV, who had ruled until an advanced age. A light and festive style developed in the arts decorating the mansions of the noble suburbs of aristocratic society and of rich courtiers and bankers. A new way of life animated the Salons. At the same time, intellectuals, writers, philosophers, scientists, and antiquarians—lovers of ancient history and art—became central figures. In painting, at the end of the reign of Louis XIV, a dispute erupted between the partisans of color—the Rubenists—and champions of the primacy of drawing—the Poussinists. Under Louis XV, Paris's Encyclopédistes (1751–80), amateurs and philosophers alike, set the tone for the Europe of Enlightenment. While the French language conveyed a new intellectual model to the courts of Europe and learned societies, fashion, style, and the art of living spread widely, as did ideas, wherever reason prevailed.

The Louvre, the venue of the Salon, which housed the Royal Academy of Painting and Sculpture and the Royal Academy of Architecture, was at the time the center of discussions on art, and was also the venue for artistic creation, thanks to the many artists housed in

its galleries and courtyards, and in the buildings expropriated by the king to make way for the Grand Design but that had never been demolished.

The Cour Marly:
The Beautification of the Jardin des Tuileries

To lend more splendor to the palace of the little king, beginning in 1716, the Jardin des Tuileries was decorated with large marble statues from the parks of Versailles and Marly. The Revolution continued this policy of enriching the garden by transforming it into a kind of open-air museum, where sculptures gave the nation examples of artistic perfection and virtue. For reasons of conservation, this royal statuary was later sheltered from the elements at the Musée du Louvre, where they now reside in the Cour Marly and Cour Puget. Sculptures from Marly that had been scattered by revolutionary events were also brought together there.

Under Louis XIV, the Château de Marly had been the sovereign's place of pleasure. In a vast, landscaped park, animated by groves and waterfalls, the architect Jules Hardouin-Mansart had imagined a royal pavilion in the center of the prospect, surrounded by two rows of small pavilions. The steep slope of the land, dropping down toward the Seine, formed a verdant valley, where water from the basins and waterfalls shimmered. The sculpture underlined this verdant architecture. *Mercury* and *Fame*, each mounted on the horse Pegasus, formed the starting point of the great prospect, proclaiming the "king's fame" to the world. Antoine Coysevox proudly signed them, stating that he had sculpted the monolithic marbles in two years—a true feat. Groups of rivers, *The Seine* and *The Marne*, *Loire and Loiret*, showed the extent of the kingdom. Behind the château, the great waterfall cascaded over water deities, again by Coysevox; oceans and seas completed the geography lesson with *Neptune* and *Amphitrite*, and, again, *The Seine* and *The Marne*. But references to woods and hunting were also a constant in the iconography of the shady valley. Two robust groups

Vitrine in the Adolphe de Rothschild room (Richelieu, first floor, room 25)
Left: vase with intaglio decoration by Valerio Belli (1465–1546), Italy, mid–1600s, rock crystal, enameled gold, H. 15 cm (5 ⅞ in.), (gift of Baron Maurice de Rothschild, 1935)
Center: ewer in the shape of a dragon from the Sarachi workshop (?), Milan, last quarter of the 16th century, rock crystal, enameled gold frame, H. 26.5 cm (10 ⅜ in.), (former collection of Cardinal Mazarin and then of Louis XIV)
Right: ewer in the shape of a fish from the Sarachi workshop (?), Milan, last quarter of the 16th century, rock crystal, enameled gold frame, H. 15.5 cm (6 ⅛ in.), (former collection of Cardinal Mazarin and then of Louis XIV)
Department of Decorative Arts

Cour Marly, sculptures by Antoine Coysevox (1640–20) from Marly Park: *Fame Mounted on Pegasus* (1700–02), *The Marne* (1705), and *Amphitrite* (1705)

Opposite
Cour Puget, group by Thomas Regnaudin (1622–1706): *Saturn Abducting Cybele* or *Earth*, 1674, marble, H. 290 cm (114 in.), executed for Versailles, transferred to the Jardin des Tuileries in 1716, returned to the Louvre in 1972
Cour Marly, group intended for Marly Park: foreground and right, Anselme Flamen, *Diana* (1693–94) and *Companion of Diana* (1714); left, René Frémin, *Companion of Diana* (1717); in the background, Simon Mazière, *Companion of Diana* (1710–16)

Following spread
Cour Marly, marbles copied from antique originals, executed at the French Academy in Rome and placed in Marly Park: Pierre Lepautre, *Faun with Kid* (1685); behind, François Barois, *Venus Callipyge* (1683–86); right, Guillaume I Coustou (1677–1746), *Horse Restrained by a Groom*, known as *The Marly Horse* (see pp. 105–6)

of hunters killing a deer and a boar, by Nicolas Coustou, entered the Louvre in 2013. Four statues of nymphs, led by a flute satyr and a resting hunter, by the same Coustou and Coysevox, his uncle, formed two groups of pastoral divinities. In the groves, statues of Diana and her nymphs evoked hunting. Over the rustic waterfall reigned the Seasons and the Elements, including Flora, smiling and light, representing Spring. On the basins, the statues of "runners," poised on one leg, simulating running, showed an expressive dynamic that became the hallmark of a new generation of sculptors. Nicolas Coustou's younger brother, Guillaume, is one such example.

It is to him that Louis XV turned when he wanted to replace the groups of the *King's Fame* with new monolithic marbles. *The Marly Horses*, rearing and restrained by naked grooms, are the result of this search for movement in 1739–45. Universally admired, they would be transferred to the entrance of the Champs-Élysées at the initiative of the painter David, in 1794, then housed at the Louvre in the Cour Marly in 1993.

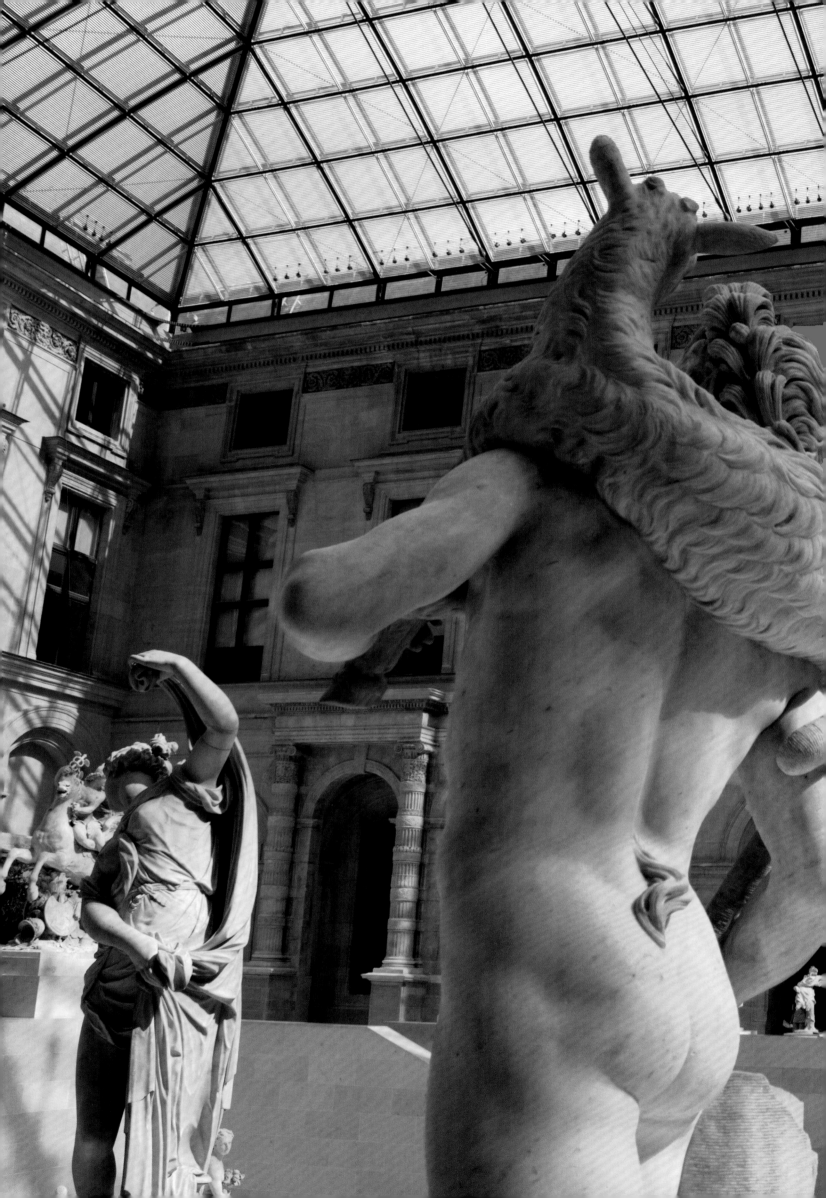

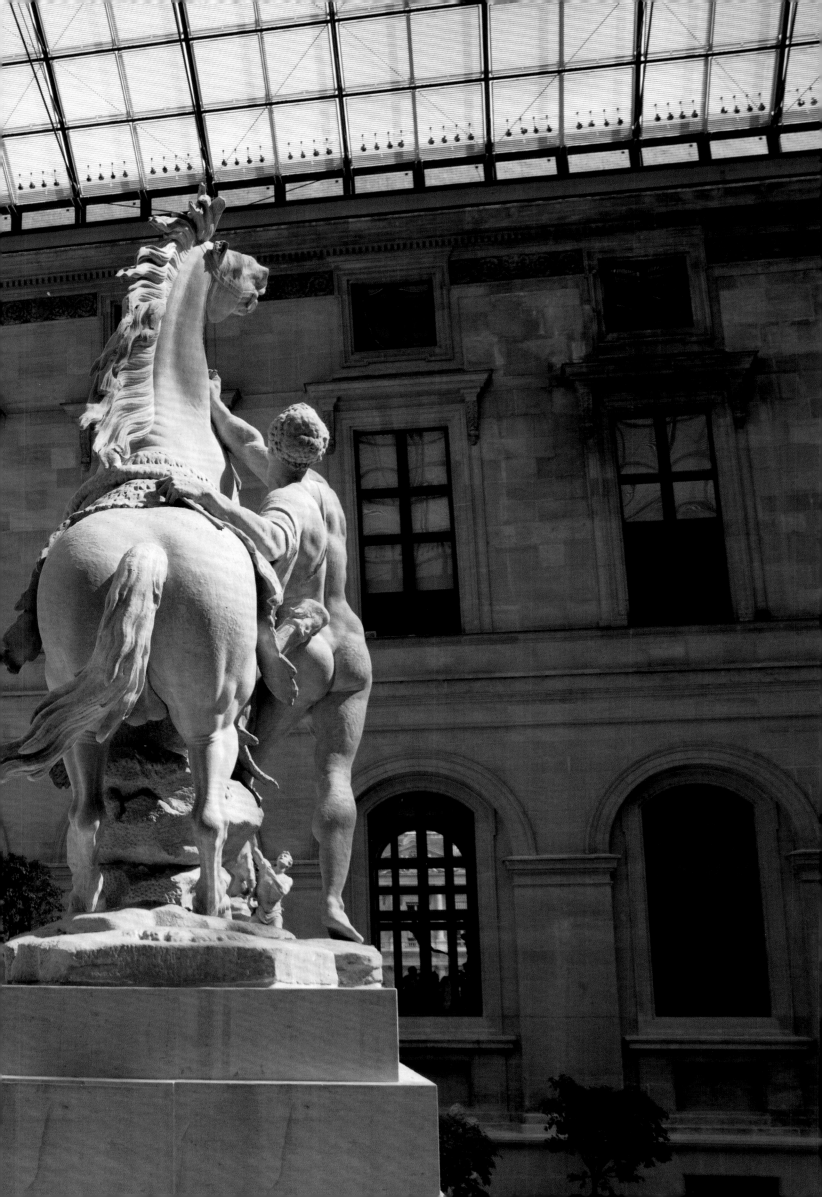

Anselme Flamen (1647–1717)
Diana, detail of the dog, 1693–94, marble,
H. 180 cm (70 ⅞ in.) (see p. 205)
Placed on Diana's fountain at Marly, seized in
the Revolution, sent to the Corps Législatifs,
Georges Hoentschel collection, then Jacques
Seligmann collection
Department of Sculptures, acquired in 1970

Opposite
Nicolas Coustou (1658–1733)
Hunter at Rest, detail of the dog, 1707–10,
marble, H. 177 cm (69 ⅝ in.)
Commissioned for Marly Park, transferred
to the terrace of the Tuileries in 1716–17
Department of Sculptures, entered the
Louvre in 1870

The "Grande Chaumière": Academy of the Louvre of Louis XV

Pierre-Antoine Demachy (1723–1807)
Stamp Shops in the Passage of the South Pavilion of the Cour Carrée, 1791
Oil on canvas, L. 104 cm (41 in.)
Department of Paintings, on loan from the Musée Carnavalet

Previous spread
Guillaume I Coustou (1677–1746)
Hippomene, 1712
Marble, H. 131 cm (51 ⅝ in.)
Foreground: detail of *Apollo Pursuing Daphne* by Nicolas Coustou (1713–14)
Executed for one of the carp basins at Marly Park, to match a copy of the classical *Atalanta* original by Pierre Lepautre (whose head can be seen), transferred in 1797 to the Jardin des Tuileries
Department of Sculptures, entered the Musée du Louvre in 1940

Abandoned by the king in 1722, the Louvre became, once again, only a home for the king's academies, institutions, protégés, retired artists, and courtiers. The cabinetmaker André-Charles Boulle set up his workshop in the remains of the Hôtel de Vendôme, which burned in 1720 with numerous drawings and sculptures, the debris of which was discovered in archaeological excavations prior to the construction of the pyramid.

The Louvre remained unfinished: the wings of the Cour Carrée were not covered, and a block of houses stood in its center; artists squatted in the available spaces. The Colonnade was invisible, hidden by the stables built in front of its facade. The men of the Enlightenment criticized the palace's state of neglect. In a pamphlet, a publicist, La Font de Saint-Yenne, imagined "the shade of the great Colbert" dissatisfied with the incompleteness of his work. And in 1739, Voltaire penned this macaronic verse:

Louvre, pompous palace of which France is honored,
Be worthy of Louis, your master and your support;
Come out of the shameful state where the universe abhors you
And in all your glory show yourself to be like him.

Fittingly, this was the time when the sovereign sought to appear as an enlightened monarch. The Louvre once again became a priority for the Bâtiments du Roi, especially since its works were to be directed by the brother of the king's mistress, Madame de Pompadour. Abel Poisson, Marquis de Marigny, embarked on a project to complete the Louvre, which was interrupted by the Seven Years' War in 1759 and then definitively at the end of the reign. The architect Ange-Jacques Gabriel, assisted by Jean-Germain Soufflot, began by restoring the Colonnade in 1753, whose iron frame designed by Perrault had rusted and caused the stones to burst. They cleared the Cour Carrée and the Colonnade (in 1756) of parasitic constructions and opened a passage between the courtyard and the north exterior, guarded by the "guichet du Coq" (Cock's Gate) facing the street of the same name, where the beautiful column order designed by Soufflot,

creator of the Panthéon, could be clearly seen. They worked to unify the second floor of the courtyard using Corinthian columns. Guillaume II Coustou was entrusted with the sculpture of the pediment on the reverse side of the Colonnade. Soufflot had a larger project: providing the complete remodeling of the spaces around the Cour Carrée. He proposed to redistribute the academies to the north and west wings, and to reserve the Colonnade Wing for the Royal Library. There would be insufficient funds to build a palace of learning in the Louvre.

The Academy of Painting and Sculpture participated in this great renewal. The teaching body was augmented in 1748 by the establishment of the École Royale d'Élèves Protégés, where selected artists received additional training. Located in the Galerie d'Apollon until 1766, the academy then moved to Versailles. This is how the paintings that this great palace lacked came to be executed. Supervised by Jean-Baptiste Pierre, director of the Academy from 1770 onward and renovator of the ceiling decoration, the future academicians produced compositions for their reception pieces devised by Le Brun in the previous century.

Toward the Muséum du Louvre

The other major project was to create a museum at the Louvre, a temple of the Muses, to present the royal collections, based on the model of the museum that the pope had opened in the Vatican. As early as 1750, a selection of 110 paintings belonging to the king was displayed in the Luxembourg Palace, which was open to the public.

In 1768, Marigny proposed transferring these collections of paintings, as well as medals and prints, to the Grande Galerie and the Salon Carré at the Louvre. It was not until the death of Louis XV in 1774 that his grandson, Louis XVI, placed his faith in Marigny's successor as director of the Bâtiments du Roi, the comte d'Angiviller. He would energetically resume the preparation of the future museum. In 1776, the plans in relief of the cities of France that were housed in the Grande Galerie were transferred to the Invalides, freeing up a vast space. After studying the best way to light the paintings, it was decided that it

Pierre-Antoine Demachy (1723–1807)
View of Paris from the Pont-Royal, 1778
Oil on canvas, 48 × 76 cm (18 ⅞ × 29 ⅞ in.)
Versailles, Musée National des Châteaux de Versailles et de Trianon

Following spread
Jean-Jacques Lagrenée the Younger (1739–1821)
Allegory on the Installation of the Museum in the Grande Galerie of the Louvre, 1783
Oil on canvas, 52 × 68 cm (20 ½ × 26 ¾ in.)
Department of Paintings, acquired in 1998

In front of a bust of Louis XVI, the allegories for Painting and Charity present a portrait of the comte d'Angiviller, director of the Bâtiments du Roi, to Immortality, seated on a throne. On the right, the genius of the arts, wings outstretched, points to the Luxembourg gallery, where little spirits carry a painting.

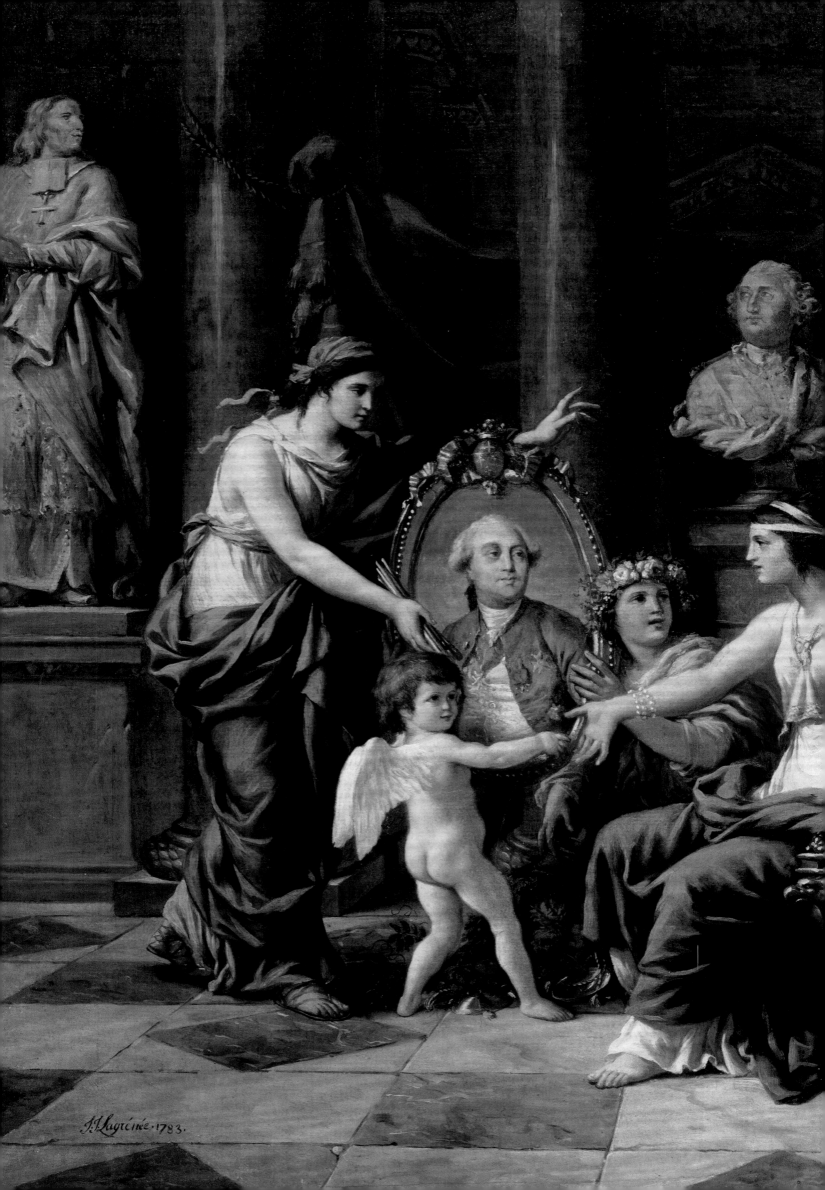
J.J. Lagrénée. 1783.

Bartolomé Esteban Murillo (1618–82)
The Young Beggar, ca. 1645–50
Oil on canvas, 134 × 110 cm (52 ¾ × 43 ¼ in.)
Certified in Parisian collections since 1742,
acquired in 1782 for the royal collections in
preparation for the opening of the museum
Department of Paintings, Louis XVI collection

would be done through the vault, that is, with zenith lighting. Soufflot proposed to raise the vault from an attic (1778) or to drill a hole through the dormers in the roof (1779). Hubert Robert, the Keeper of the King's Paintings, proposed to supplement the daylight provided by side windows with powerful zenith lighting obtained by skylights.

While the architects were discussing these issues, the comte d'Angiviller had the collection of the king's paintings restored and studied. At the same time, he pursued an acquisition policy in order to enhance the collection's quality and fill its gaps. He bought Spanish works, such as Murillo's *The Young Beggar*, and Dutch paintings. Each year, he commissioned four large marble statues of great French men—ministers, soldiers, artists, writers. They were to decorate the future gallery of the museum, whose presentation was being prepared by the architects. The greatest sculptors of the day—Pajou, Caffieri, Julien, Clodion—were put to work. The Louvre's sculpture rooms displayed a series of these eminent seated men, while others were kept at the Château de Versailles and the Institut de France.

Opposite
Hyacinthe Rigaud (1659–1743)
Louis XIV, 1701
Oil on canvas, 277 × 194 cm (109 × 76 3/8 in.)
Department of Paintings, Louis XIV collection

Rigaud, the preeminent portraitist of the court of Louis XIV, with Largillière, executed the official portrait of the sixty-three-year-old king at the height of his reign. Wearing the great coronation coat, he has with him the regalia, or insignia of power, the crown and scepter. The picture above shows the top of the frame.

A New Royal Art under Louis XV

A conservatory of the great monuments of the monarchy, the Louvre presented a panorama of royal art. The crown, which was executed for the coronation of Louis XV, was enriched with 282 diamonds—one is the famous Regent diamond, acquired in 1717—plus 64 precious stones and 230 pearls. It remains the only testimony to the coronation ceremonies that took place in Reims and conferred upon the king his divine power.

Under the reign of Louis XV, however, the conception of the royal portrait changed. In contrast to the majestic portrait of Louis XIV by Hyacinthe Rigaud (1701)—which included the regalia, or insignia of power, the crown and scepter—Louis XV would embody a more mythological image: he appeared as Jupiter with Queen Marie Leszczyńska/Juno in large marbles made by the Coustou brothers, who here took up a theme already used for Henri IV and Marie de Médicis. But Louis XV also presents himself as Vertumnus with his charming Pomona, in whom we recognize the features of the king's mistress, Madame de Pompadour. The latter—a spiritual patron, protector of the artists, and familiar with the intaglio engraving process herself—is also represented in her most beautiful attire by Boucher; with more simplicity by Maurice Quentin de La Tour; and in the allegorical marbles by Pigalle in *Friendship Receiving the King* and *Friendship Embracing Love*.

Under Louis XVI, the portraitist Élisabeth Vigée-Lebrun, already transposing Rousseau's lesson on education, gave Queen Marie-Antoinette and her children a warm and maternal image, reinforced by a colorful palette and the extreme elegance of the composition.

Although the great royal art still remained primarily at Versailles, such as Lemoyne's immense ceiling for the Salon d'Hercule, the Louvre presented cycles commissioned by the Bâtiments du Roi, such as the antiques described by Hubert Robert. In the Richelieu Wing, the Louvre also displays the most important sculptures commissioned for the director of the Bâtiments. We saw earlier Guillaume I Coustou's *Marly Horses*, an example of dynamism. More peaceful, Edme Bouchardon's *Cupid Cutting His Bow from the Club of Hercules* laughs at his own impertinence in a great spiraling movement. But both base their art on a meticulous observation of reality. Coustou was inspired by real horses, fiercely caught up in the action; Bouchardon, an excellent draftsman, had a young boy pose for a sculpture whose realism would cause a stir among the wicked Versailles courtiers—the "red heels," or *talons rouges*.

Opposite
Edme Bouchardon (1698–1762)
Cupid Cutting His Bow from the Club of Hercules,
1747–50
Marble, H. 173 cm (68 ⅛ in.)
Department of Sculptures, Salle des Antiques
since 1778

Bouchardon sculpted this marble for the Bâtiments
du Roi, after a model presented at the Salon of
1739. Originally placed in the Salon d'Hercule at
Versailles, it was banished to Choisy because of its
disturbingly realistic, unidealized appearance.

Christophe-Gabriel Allegrain (1710–95)
Diana (detail), 1778
Marble, H. 170 cm (66 ⅞ in.)
Commissioned by Madame du Barry for
Louveciennes, as a companion to a *Bather*
(1767), given to her by the king
Department of Sculptures, entered the Louvre
before 1824

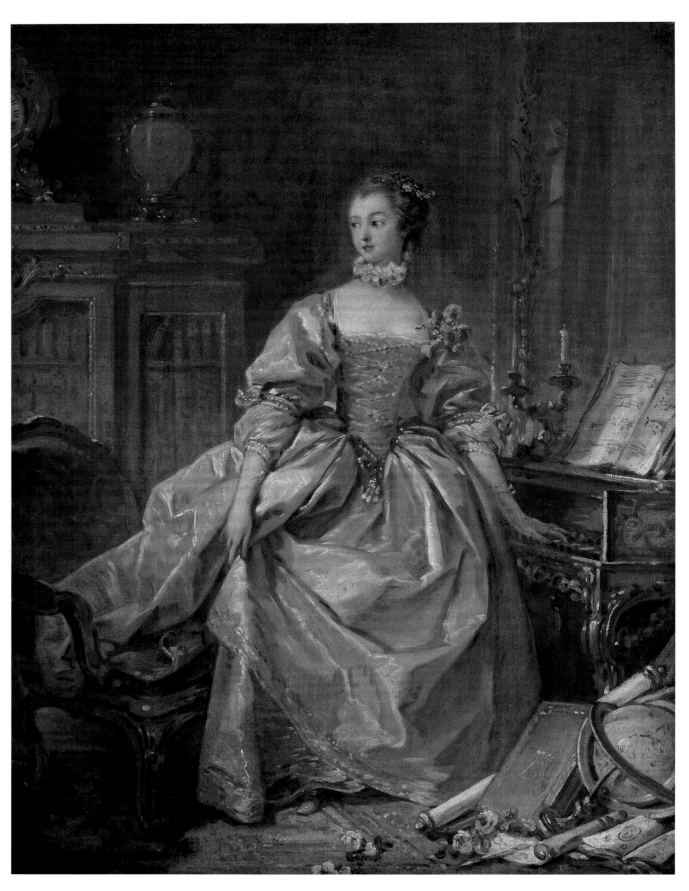

François Boucher (1703–70)
The Marquise de Pompadour, ca. 1750
Oil on canvas, 60 × 45.5 cm (23 ⅝ × 17 ⅞ in.)
Official portrait of Jeanne Poisson, the spiritual
mistress of Louis XV, protector of the arts
Department of Paintings, bequest of Baron Basile
de Schlichting, 1914

Opposite
Jean-Baptiste Lemoyne II (1704–78)
Vertumnus and Pomona, detail: head of Pomona
as Madame de Pompadour, 1760
Tonnerre stone, H. 163 cm (64 ⅛ in.)
Illustration of the story of Vertumnus, who dons
the mask of an old woman to approach Pomona,
and unmasks himself in front of the nymph
Department of Sculptures, bequest of
Mrs. Georges Hersent, 1952

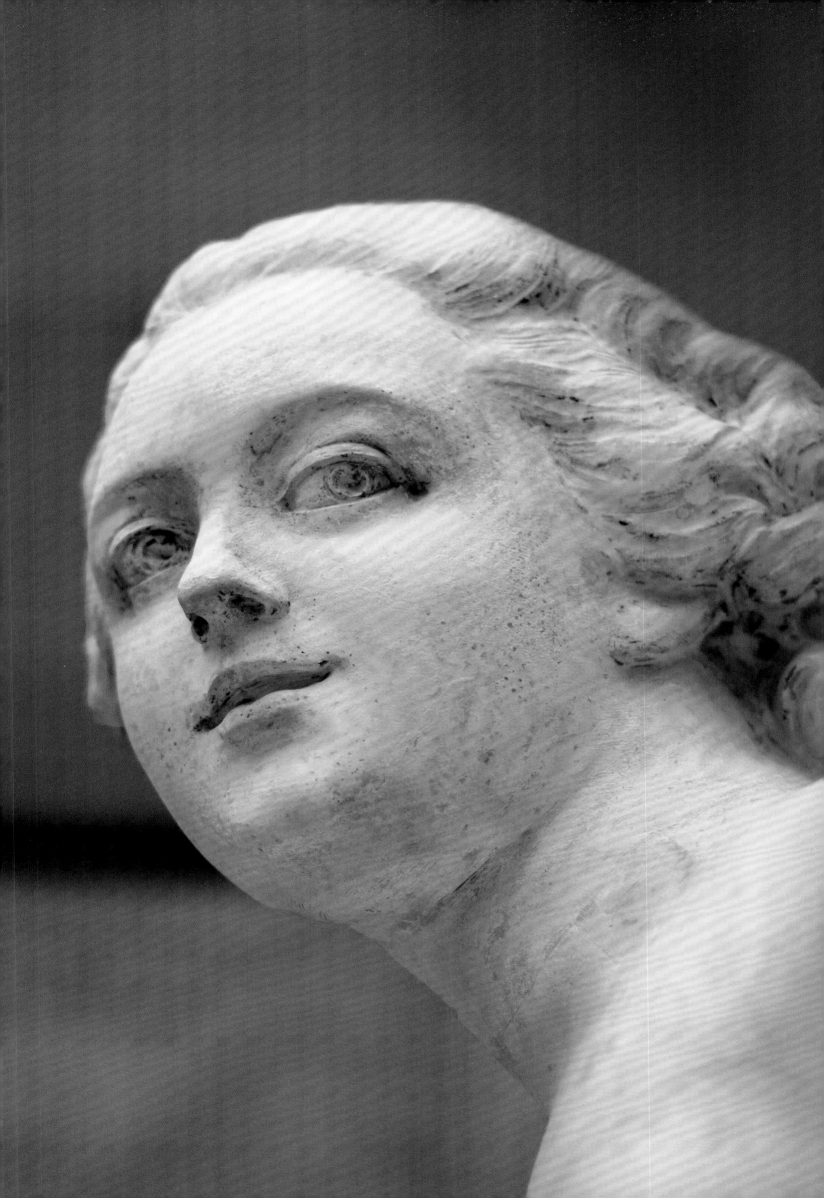

The Collection of Seventeenth- and Eighteenth-Century French Paintings

Charles Le Brun (1619–90)
The Battle of the Granicus River, 1665
Oil on canvas, 470 × 120 cm (185 × 47 ¼ in.)
Department of Paintings, Louis XIV collection

The First Painter to King Louis XIV had received the commission for four epic compositions that told the story of Alexander, the conqueror to whom the king would compare himself. The choice of battle scenes allowed the artist to indulge in grand decoration, competing with Raphael's frescoes for the Vatican *Stanzes*.

The layout of the French paintings circuit developed in several stages and experienced many changes over the centuries. It began in the Richelieu Wing with medieval and Renaissance works, then continued in the seventeenth century in a suite of rooms completely remodeled during the Grand Louvre building program in 1993. The flow was disrupted by the spaces built under Napoleon III and the rotunda that housed Nicolas Poussin's cycle of *Seasons* corresponding to the Colbert Pavilion. The circuit continued in the north and east wings of the Cour Carrée where, in 1992, the Italian architect Italo Rota built new rooms for seventeenth- and eighteenth-century paintings. A zenith lighting system of particularly elegant design allows for clear museography. The multiplicity of types of space—a large room for *The Battles* by Charles Le Brun, narrower corridors, and small cabinets that provide a view of the Cour Carrée—avoids monotony. These new rooms join those renovated in the 1960s in the south wing, where the display of nineteenth-century paintings begins, before tackling the other half of the west wing (also designed

in 1992) that completes the circuit with small- and medium-format paintings, from Corot to Romantic landscape artists. Thus, on the second floor of the Cour Carrée, a route of thirty-nine spaces unfolds, from the Richelieu Wing to the old Louvre with its newly mounted collections in 2018.

From now on, the most complete collection of French paintings in the world can be fully appreciated: from the portrait of John the Good to Fontainebleau's first workshops and its Second School. By making a tour of the second floor of the Cour Napoléon, after the Cour Carrée, you can follow the paintings produced during the time of the Bourbons, which in the Louvre is predominantly that of Paris, together with that of the leading French artists who settled in Rome for the greater part of their careers.

Valentin de Boulogne, known as Valentin
(1591–1632)
The Concert at the Bas-relief, ca. 1622–25
Oil on canvas, 173 × 214 cm (68 ⅛ × 84 ¼ in.)
Department of Paintings, Louis XVI
collection, acquired in 1742

Although born in Coulommiers, Valentin
spent his entire career in Rome, where he was
struck by the expressive strength, realism,
and palette of Caravaggio. He thus adopted
the Caravaggesque theme of tavern scenes,
here rendering a contemplative atmosphere
underscored by muted colors.

Opposite, top
Philippe de Champaigne (1602–74)
Portrait of a Man, formerly known as *Robert
Arnauld d'Andilly*, 1650
Oil on canvas, 91 × 72 cm (35 ⅞ × 28 ⅜ in.)
Department of Paintings, acquired in 1806

Antoine Le Nain (ca. 1600/1610–48) or
Louis Le Nain (ca. 1600/1610–48)
Peasant Family in an Interior, ca. 1643
Oil on canvas, 113 × 159 cm (44 ½ × 62 ⅝ in.)
Department of Paintings, acquired through
the bequest of Arthur Pernolet, 1915

Painters of the Seventeenth Century: From Vouet to Parisian Atticism, from Le Brun to the Colorists

The Parisian art of this time reflects the crosscurrents of the Italian Renaissance, international Mannerism, and Fontainebleau reminiscences, found in the works of French painters as well as their counterparts from the north, Ambroise Dubois or Frans II Pourbus.

The Roman influence arrived via the many artists who stayed in the papal capital and were confronted with the power of Caravaggio. The French "Caravaggesques," Valentin de Boulogne and Simon Vouet, as well as the Toulouse native Nicolas Tournier, fully absorbed the lessons of the master. In *The Concert at the Bas-relief*, which belonged to the collection of Louis XIV, Valentin depicted a tavern scene—a theme dear to Caravaggio—in a harmony of colors, where the red garment makes a low-key chromatic range vibrate, illuminating a dark and heavy atmosphere.

Flush with Roman inspiration, Vouet arrived in Paris in 1627 and revived the art of altarpieces, portraiture, and grand decoration through his refined colorist sensibility and the breadth of his compositions. The 1640s saw the birth of what has been described as Parisian Atticism, encompassing the art of Jacques Stella, Eustache Le Sueur, and Laurent de La Hyre. Architectural or idealized landscape backgrounds, antique figures, elegantly delineated lines, and balanced compositions produced a brilliant aesthetic vocabulary. The set of panels featuring nine Muses that Le Sueur painted for the Chambre des Muses at the Hôtel Lambert, on Île Saint-Louis, epitomizes this inspired classicism.

The style markedly contrasted with a parallel development favoring a kind of realism. The Brussels painter Philippe de Champaigne, close to the Jansenists, used subdued colors

Philippe de Champaigne (1602–74)
Mother Catherine-Agnès Arnauld (1593–1671)
and Sister Catherine de Sainte Suzanne Champaigne
(1636–1686), 1662
Oil on canvas, 165 × 229 cm (65 × 90 ⅛ in.)
Department of Paintings, seized during
the Revolution at the Port-Royal Abbey in
Paris, 1793

This canvas was painted by the artist between
22 January and 15 June 1662, in gratitude for
the healing of his daughter, a nun in Port-
Royal, paralyzed in both legs. The ex-voto
shows the moment of the miracle, when the
Mother Superior prays in front of the young
nun touched by grace.

Georges de La Tour (1593–1652)
The Cheat with the Ace of Diamonds, 1635
Oil on canvas, 106 × 146 cm (41 ¾ × 57 ½ in.)
Department of Paintings, acquired in 1972

Here, Lorraine painter adopted the
Caravaggesque theme of the card sharp in
the tavern, but he transcended the "low" subject
with the strict geometry of the composition
and the plastic density of the characters.

Nicolas Poussin (1594–1665)
The Rape of the Sabine Women, ca. 1637–38
Oil on canvas, 159 × 206 cm (62 ⅝ × 81 ⅛ in.)
Department of Paintings, Louis XIV
collection, acquired in 1685

Opposite
Charles Le Brun (1619–90)
The Sleep of the Infant Jesus, 1655
Oil on canvas, 87 × 118 cm (34 ¼ × 46 ½ in.)
Department of Paintings, Louis XIV collection

Pierre Mignard (1612–95)
The Deliverance of Andromeda, 1679
Oil on canvas, 188 × 247 cm (74 × 97 ¼ in.)
Department of Paintings, gift from the Société
des Amis du Louvre, 1989

and simple arrangements of elements, but imbued his paintings with power and audacity. It was in such an austere framework that he set his masterpiece, *Mother Catherine-Agnès Arnauld (1593–1671) and Sister Catherine de Sainte Suzanne Champaigne (1636–1686)*, in gratitude for the healing of his daughter Catherine, who was a nun in Port-Royal Abbey in Paris. This expressive force is found in the work of the Le Nain brothers as well, both in the peasant scenes that made their reputations when they were rediscovered by critics in the 1930s, and in classical allegories such as the pensive *Victory*, a flawless nude.

Many artists arrived by a more traditional route. Georges de La Tour and Claude Gellée were from Lorraine, which at the time was not part of French territory. Gellée, known as Claude Lorrain, would spend his entire career in Rome. De La Tour's *Cheat with the Ace of Diamonds* and *Saint Joseph the Carpenter* illustrate the two sides of his use of light, day or night, to model volumes. Lorrain, by contrast, illuminated his large landscapes with immense, modulated skies.

In a traditional sense, too, the French School includes those who stayed in Rome; first Valentin, then Nicolas Poussin. A "painter philosopher" and herald of the classical ideal, Poussin, born in the Andelys in Normandy and trained in Fontainebleau and Paris, lived in Rome from 1624—with the exception of the short interlude of 1640, when Louis XIII invited him to the Louvre. The museum's collection of Poussin's work is the most

comprehensive in the world, which makes it possible to follow his evolution. There we find large altar paintings (*The Apparition of the Virgin Mary to Santiago the Elder*, ca. 1629), small poetic paintings (*Echo and Narcissus*, ca. 1630), biblical or Roman subjects, even vehement ones (*The Plague of Ashdod, The Rape of the Sabine Women*, ca. 1637–38, *The Judgment of Solomon*, 1648), before the large animated landscapes of the *Four Seasons* (1660–64), where Nature is united with small characters who symbolize the episodes of the Bible (*The Flood, Ruth and Boaz, The Grapes from Canaan*). Here, the harmony of history, the ages of life, and the stages of the biblical unfolding are represented in a meditation on man's relationship with nature, both nourishing and destructive. *Et in Arcadia ego* (1637–38), a still-mysterious reflection on death and poetry, carries out this formal research where the expression of the characters, the drawing of the lines, and the rigor of the composition create a rhythmic language of profound nobility.

But Charles Le Brun's arrival at the forefront of the art of the court and the Academy would change everything. A powerful colorist and a hard worker, he took history by the horns and renewed pictorial language with his ardor and imagination. The First Painter to the King, he was at the center of Louis XIV's art, the great decorations of the Louvre and Versailles, provided models to the king's manufactories and sculptors, and directed the Academy of Painting and Sculpture. As with Poussin, the Louvre showed all his facets, from the early paintings of intimate piety (*The Sleep of the Infant Jesus*, 1655) to the great *Battles of Alexander* (1661–73), to the works of his old age (*The Adoration of the Shepherds*, 1685).

Opposed to him, Pierre Mignard "the Roman," was usually his rival, first unlucky, and later victorious when disgrace struck Le Brun at the court. The competition between the two painters is manifest in their renditions of the *Carrying of the Cross*, or in the portraits of Le Brun by Largillière and of Mignard, by the painter himself. Mignard had not been a second-tier artist prior to succeeding Le Brun as First Painter to the King—not even close. The creator of *The Deliverance of Andromeda*, made for the Grand Condé (1679), and a prolific decorator, he was also one of the great portraitists of his time.

This art of portraiture had reached the heights of a brilliant and eloquent vision, represented by Nicolas de Largillière and Hyacinthe Rigaud: monumentality, sumptuous colors, brilliant rendering of the play of draperies and complexion. Largillière's study of hands exemplifies this meticulous and fervid approach to nature.

The generation of painters who followed adopted color with even greater pleasure as the quarrel over this subject reached its peak. Largillière, Jean Jouvenet, Charles de La Fosse, and Antoine Coypel were deeply influenced by Rubens' art, and also by the Venetians, while extending Le Brun's line. But it was at this same time that Watteau abandoned the taste for the symphonic, preferring to translate his poetic reality in light, often melancholic, pictures, far removed from the kinds of themes and formats hailed by the academy and the Salon as markers of great art. And even when he did make a "grand" Pierrot, it was clear that the true subject of the painting was a reflection on appearance.

Eustache Le Sueur (1616–55)
The Muse Urania
Oil on wood panel, 116 × 74 cm (45 ⅝ × 29 ⅛ in.)
Department of Paintings, Louis XVI collection

In 1776, Louis XVI acquired part of the decoration of the Hôtel Lambert in Paris, built by Louis Le Vau: panels from the Cabinet de l'Amour and the Chambre des Muses, from which comes *The Muse Urania*. Le Sueur, the leader of "Parisian Atticism," here demonstrates his skill for harmonious design and color.

Opposite
Jean-Antoine Watteau (1684–1721)
Pierrot, formerly called *Gilles*, ca. 1718–19
Oil on canvas, 185 × 150 cm (72 ⅞ × 59 in.)
Department of Paintings, bequest of Dr. Louis La Caze, 1869

The large format of this unique image may be explained by the fact that it was intended for a café owned by a former actor, Belloni, a friend of the painter. In the background, the commedia dell'arte characters seem indifferent to the loneliness of Pierrot. The painting belonged to Dominique Vivant Denon, director of the Musée Napoléon.

·Leçs du Docteur MALECOT·

The Transformation of Painting during the Enlightenment

For a long time, too much emphasis had been placed on the existence of a "Louis XV style," a notion made fashionable by the Goncourt brothers. In fact, the period boasted a multiplicity of styles. Certainly, sensuality of subject and technique, celebration of color, and vibrant brushwork characterize a certain type of painting: that of Boucher, so beloved by Madame de Pompadour; but also that of Carle Van Loo, Jean-François de Troy, Jean Restout, and Charles Joseph Natoire. The code of gallantry thinly disguised the hedonistic celebrations of a society in love with life. Boucher and Jean-François de Troy did not disdain the genre scene, on the model of the Dutch masters so popular at the time, as long as it was elegant, like the protagonists of Boucher's *The Lunch* (1739).

At the same time Boucher was creating his idyllic pastorals, which Fragonard would also cultivate for a long time to come.

Chardin suffused his pictures of ordinary life with a quiet sentimentality. As in Dutch painting, his characters are simple people, without artifice (*The Provider*, *Child Spinning a Top*). But still life was the high point of his art (*The Ray*, *The Silver Cup*), and as Diderot so aptly put it: "Chardin, it is not only white, red, black that you grind on your palette; it is the very substance of objects; it is the air and light that you take at the tip of your brush and attach to the canvas."

Portraiture also showed a multiplicity of characters, in intimate or official settings, in action or in the truth of the simple face. After the great success at court of the mythological portrait that Jean-Marc Nattier brought up-to-date with a charming delicacy—and which would find adherents throughout the century—another, more sober clientele preferred contemporary, unidealized reality. Chardin, Jean-Baptiste Perronneau, and Maurice Quentin de La Tour advanced this more earthbound, modern model of portraiture, adding that extra spark born of familiarity or complicity.

To find sculptural equivalents of this type of painted portraiture—in clay, marble, and bronze—you have to descend two floors in the museum. Jean-Baptiste II Lemoyne provided continuity with the portrait art of Coysevox at the time of Louis XIV, while Pigalle confined himself to producing likenesses of close friends such as Diderot, rather in the style of Chardin. Like him, Pigalle would engage in self-portraiture. Both artists accomplished the ultimate goal of the genre through this uncompromising introspection.

François Boucher (1703–70)
Diana Leaving Her Bath, Salon of 1742
Oil on canvas, 57 × 73 cm (22 ½ × 28 ¾ in.)
Department of Paintings, acquired in 1852

The work sensually evokes the goddess Diana, accompanied by a nymph, whose subtly modulated flesh stands out against the blue of the drapery.

Opposite
François Boucher (1703–70)
The Lunch, 1739
Oil on canvas, 81 × 65 cm (31 ⅞ × 25 ⅝ in.)
Department of Paintings, bequest of
Dr. Achille Malécot, 1895

Under Louis XV, painters devoted themselves to contemporary genre scenes, while elsewhere they illustrated mythology or created large decorations. In this intimate family scene, Boucher uses the light streaming from the window at left, as seen in Dutch paintings of the time, to illuminate the interactions of the characters.

The Neoclassical Revolution

French painting underwent a radical change with the revival of interest in antiquity, fueled by recent archaeological finds in Italy and the writings of Johann Winckelmann, whose history of ancient art served as a model. Artists looked to Rome and Naples, where antiquity had been discovered in all its complexity. But what is called neoclassicism was not born in a day, nor is it limited to the "Louis XVI style" in the furniture arts. Early signs appeared in the 1730s and gradually became more pronounced during the reign of Louis XV. The taste for the antique, referring in a more archaeological way to the Roman past, developed as early as the 1750s. Marigny had already completed his tour of Italy with Soufflot, and the Louvre of Gabriel and Soufflot constituted an antiquarian manifesto. If the "Greek" taste spread more successfully under Louis XVI, when "antique-mania" was in fashion, it coexisted with an ever-present attachment to a belated Baroqueism, and to a search for truth without affectation.

During the years 1770 to 1780, a new appreciation for ordinary feelings emerged. People cried, laughed, felt sorry for themselves, and were moved. In art, this sentimentalism corresponded to the study of emotions by the philosopher Condillac. Greuze mined this vein in visual morality tales such as *The Marriage Contract* (1761). Diderot, standing before this painting in the Salon, "feels won over by a soft emotion when looking at it," especially the hen in the foreground with her chicks, a symbol of family joy, which the writer considered to be "a small but ingenious touch of poetry." Theatrical gestures and expressions abound in Greuze's two-act rustic drama *The Paternal Curse* (*The Ungrateful Son* and *The Punished Son*, 1777–78), which seems to offer lessons in good conduct, while elsewhere his ingénues (*The Broken Pitcher*, 1771) weep over a broken utensil, the implied subject being lost virginity.

Jean-Honoré Fragonard, on the other hand, did not bother himself with innuendo in his depictions of the joys of love, which exude a taste for the flesh that makes the light

Jean-Baptiste Greuze (1725–1805)
The Marriage Contract, 1761
Oil on canvas, 92 × 117 cm (36 ¼ × 46 in.)
Department of Paintings, acquired by
Louis XVI in 1782, seized during the
Revolution, entered the Louvre in 1807

Painted for the marquis de Marigny, brother of Madame de Pompadour and director of the Bâtiments du Roi, the painting opened the way to the genre of sentiment. The expression of passions, advocated by the academy, is illustrated here by the diversity of emotions that are painted on the faces of the rural family at the moment when the father grants his daughter's hand. "This is moral painting," wrote Diderot, the reviewer of the Salon.

Opposite
Jean Siméon Chardin (1699–1779)
The Provider, Salon of 1739
Oil on canvas, 47 × 38 cm (18 ½ × 15 in.)
Department of Paintings, acquired in 1867

In this ambitious composition with multiple spaces, Chardin demonstrates his facility as a genre painter, but the still life on the right is clearly one of his specialties along with the intimate portrait of the maid.

Jean-Honoré Fragonard (1732–1806)
The Bathers, 1763–64
Oil on canvas, 64 × 80 cm (25 ¼ × 31 ½ in.)
Department of Paintings, bequest of
Dr. Louis La Caze, 1869

Fragonard abandoned history painting to
devote himself to delicate compositions,
where his pleasure in the materials of his
medium is evident. The voluptuousness of the
flesh is achieved with the speed of a feverish
brushstroke.

vibrate with excitement. His sensual representation of the body and nature could enliven
an idyllic landscape (*The Bathers*) or describe the emotions of lovers (*The Bolt*). His trip to
Italy with the Abbé de Saint-Non awakened him not to archaeological antiquity, but to the
poetry of the light bathing the ruins. This *fa presto* painting—with its vivid, voluptuous,
and inspired touch—is the opposite of that of David, who brought back from Italy the
classical ideal. Was Fragonard sketching a real person or a fantasy figure? Just when you
think you recognize Diderot, the figure becomes someone else; so much does the whirl-
wind of his generous brush free itself from the rules of resemblance.

Hubert Robert, Fragonard's contemporary, not only traveled to Rome, he spent ten
years there. The poetry of the ruins fed his imagination. Although the four images of the
great French sites of antiquities—commissioned by the Bâtiments du Roi for the
Fontainebleau apartments in 1787 (*The Pont du Gard*, *The Antiques of Saint-Rémy*)—approach
an archaeological record, Robert was a specialist in quasi-romantic landscapes in which
small figures lend a picturesque aspect, introducing contemporary everyday life into the
memory of the grandiose past, dilapidated by time. Robert would become the Keeper of
the Musée du Louvre, where he would provide painted descriptions of the building's
spaces, real or fanciful, like his imaginary views of the Grande Galerie.

Jacques-Louis David's *Oath of the Horatii* (1784), painted in Rome and exhibited in the
Salon of 1785, is not part of the French painting circuit on the second floor of the Louvre,
but is housed instead in the large red rooms that open the route dedicated to neoclassicism.

Oath is considered the starting point, the manifesto of this movement of which David will be the undisputed leader until the fall of the Empire. Its subject, a tribute to virtue capturing the anguish of male sacrifice and female emotions, its friezelike composition, its dignified gathering and unfolding of energies, and its archaeological meticulousness constitute a summation of the new style's requirements. The ancient dramas (*Andromache Mourning over the Body of Hector*, 1783) and a skillful and intense portrait art are the glory of David. At the time, he dominated a school of attentive and respectful students in his workshops at the Louvre, where the public came to admire him.

Here again, we must take a detour to the sculpture rooms to understand that the art of this period was not limited to painting, but included the work of inspired sculptors whose aspirations coincided but who exhibited distinct personalities. Fragonard would correspond to Clodion, his terra-cottas as lightly spirited as the painter's rapid sketches. Facing David would be Augustin Pajou. In parallel to all the portraitists, the absolute masters would be Caffieri, with his robust and natural *Canon Pingré* (1788), and especially Jean-Antoine Houdon. Philosophers, heroes of the American Revolution, Houdon's daughters and relatives, as well as the royal family and the aristocracy sat for him. But was he only a portraitist? Neoclassicism was evident in his commissions for large statues and tombs, and in the graceful *Vestal*. It is therefore necessary to go down to the ground floor of the Richelieu Wing to complete our understanding of a century in which revolutions followed one after another, and styles intermingled and dialogued in an astonishing catalogue of nuances.

Jean-Honoré Fragonard (1732–1806)
The Bolt, ca. 1777
Oil on canvas, 74 × 94 cm (29 ⅛ × 37 in.)
Department of Paintings, acquired in 1974

Fragonard's misty and whipped-up style would soften as neoclassicism gained a foothold, but here, he retained a certain frenzied treatment of the contradictory emotions of the couple.

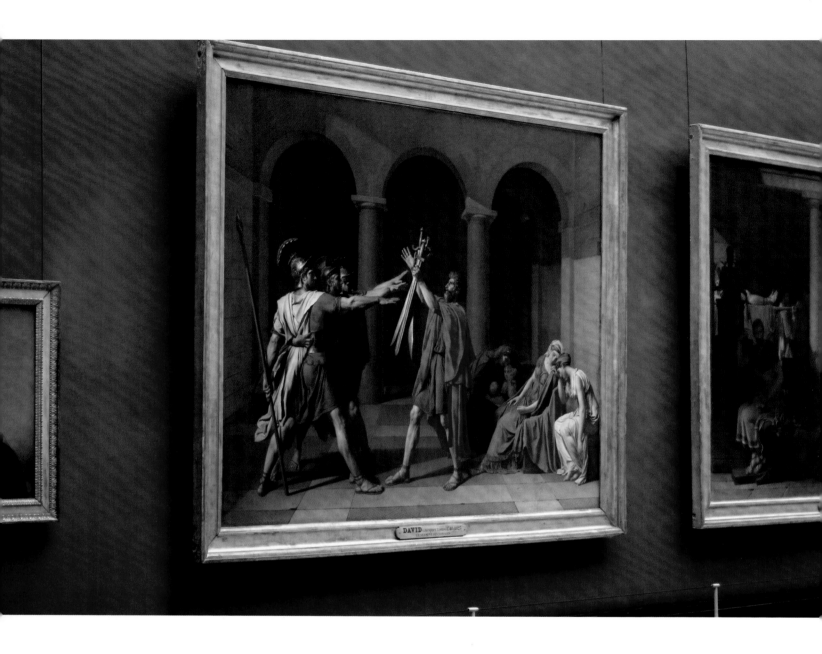

Salle Mollien
All the great masterpieces of Jacques-Louis
David (1748–1825) are gathered in this room;
in particular, the two paintings made for
Louis XVI, lessons in Roman morality but
also pure examples of the neoclassical style in
the strength of their composition, the rigor of
the drawing, and the clarity of the brushwork:
The Oath of the Horatii (1784, oil on canvas,
330 × 425 cm/130 × 167 ¼ in.), *The Lictors
Bringing Brutus the Bodies of His Sons* (1789,
oil on canvas, 323 × 422 cm/127 × 166 in.),
which can be seen on the right.
Department of Paintings

Opposite
Jacques-Louis David (1748–1825)
Andromache Mourning over the Body of Hector
(detail), 1783
Oil on canvas, 275 × 203 cm (108 ¼ × 79 ⅞ in.)
Department of Paintings, on loan from the
École Nationale Supérieure des Beaux-Arts,
Paris, 1969

In the end, we must agree with the Goncourt brothers. Under Louis XV and Louis XVI, art was also expressed in the marvelous delicacy seen in the decorative arts. The establishment of the royal porcelain manufactory at Vincennes, which would become that of Sèvres, ensured an unparalleled quality in this field. The great goldsmiths Thomas Germain and Roettiers and the bronzers, such as Jean-Jacques Caffieri, rivaled in inventiveness, while French furniture became the absolute standard. From Cressent to Gaudreaux, from Migeon to Riesener, from Risenburgh to Oeben, the art of desks, chests of drawers, chairs, pedestal clocks, hanging clocks, and small tables multiplied the refinement in the overall form of ornamental bronzes, veneers, and motifs, where the influence of exoticism and the memory of the antique are intertwined. The industriousness of the objets d'art merchants and the enthusiasm of cosmopolitan collectors combined to create a dynamic market. The maritime trade in precious woods and lacquers from China encouraged the use of new materials. But it is the extraordinary skill of an unparalleled craftsmanship that made for the indisputable success of eighteenth-century furniture. The Louvre's furniture rooms, which opened in 2014, offer a panorama of this art through collections on a scale of which the museum is especially proud. The woodwork from grand mansions has been reconstructed and reassembled to give a vision of the stylistic evolution of an art of living.

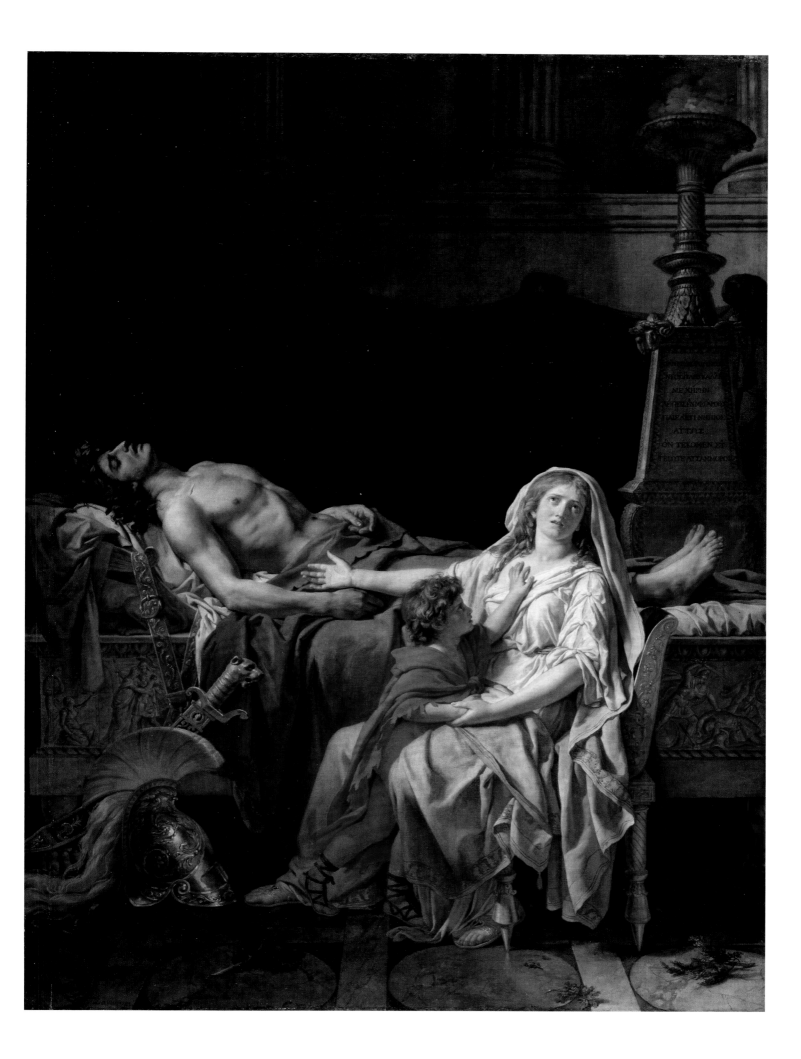

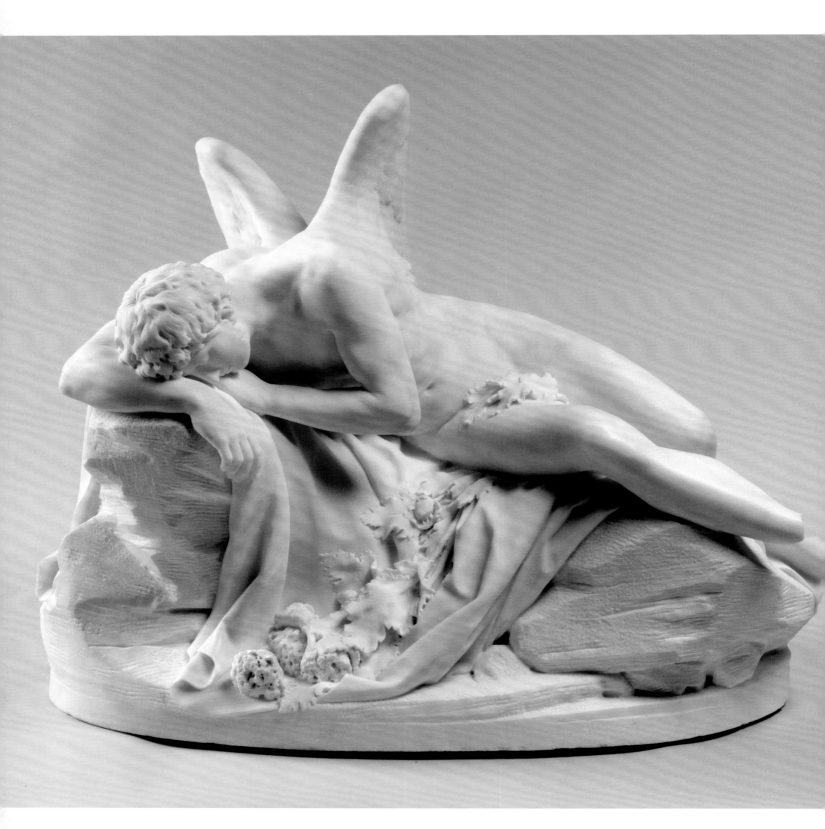

Jean-Antoine Houdon (1741–1828)
Morpheus, 1777 (plaster model presented
in 1770)
Marble, H. 36 cm (14 ⅛ in.)
Reception piece at the Royal Academy
of Painting and Sculpture
Department of Sculptures, seized during the
Revolution with the academy's collections

Opposite
Augustin Pajou (1730–1809)
Mercury, or *Commerce*, 1779 (unfinished)
Marble, H. 196 cm (77 ⅛ in.)
Commissioned by Abbé Terray, director of
the Bâtiments du Roi, for his mansion in Paris
Department of Sculptures, bequest of Baron
Basile de Schlichting, 1914

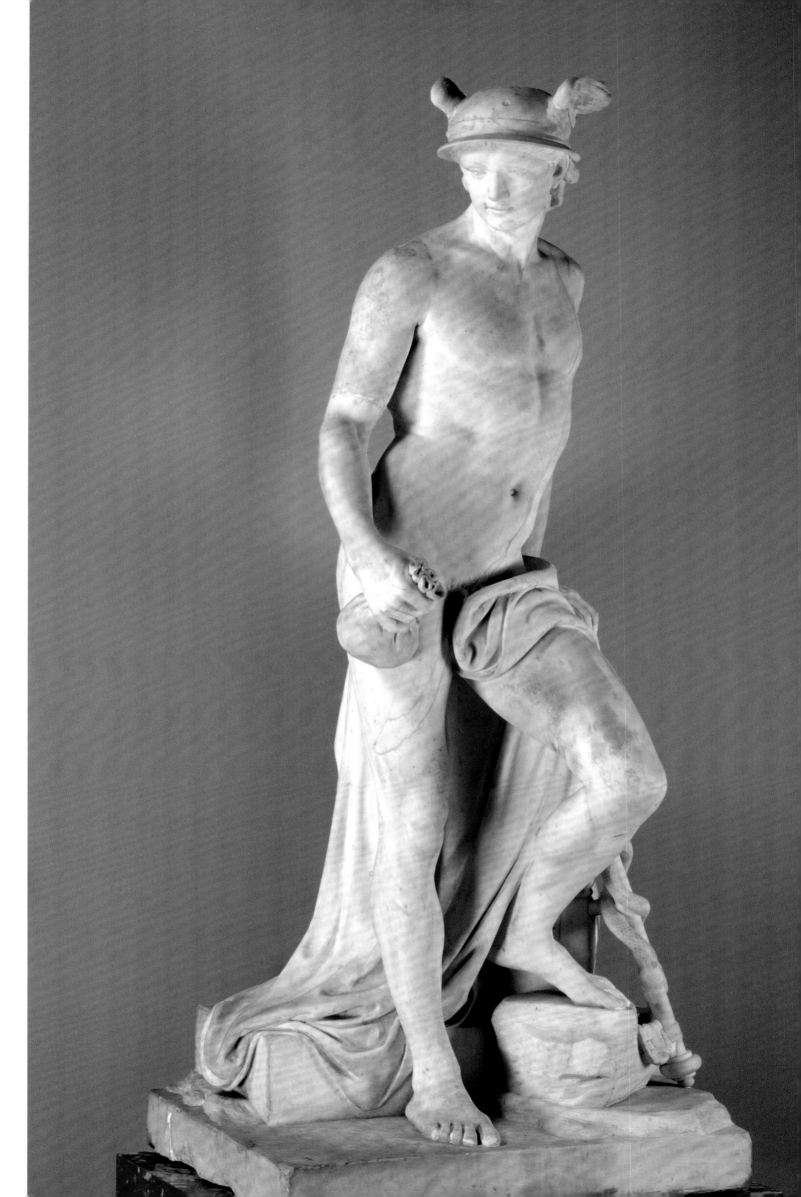

Opposite
Jean-Antoine Houdon (1741–1828)
Louise Brongniart, 1777
Terra-cotta, H. 34.5 cm (13 5/8 in.)
Department of Sculptures, acquired in 1898

Exhibited at the Salon, this bust of the daughter
of the architect Brongniart is one of the most
famous portraits of children, and a symbol
of innocence.

Jean-Jacques Caffieri (1725–92)
Canon Pingré, Alexandre-Gui Pingré (1711– 1796),
Librarian of Sainte-Geneviève Abbey, Astronomer
and Geographer to the King, 1788
Terra-cotta, H. 51.5 cm (20 ¼ in.)
Department of Sculptures, assigned to the
Louvre by the Sainte-Geneviève library in 1909

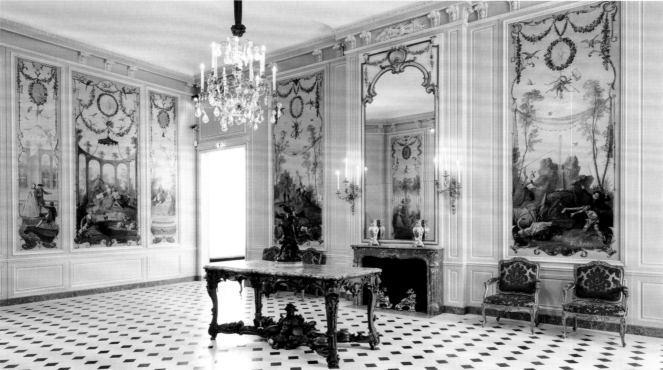

Paneling of the parade room of the Hôtel de Chevreuse, executed in 1766–68 under the direction of architect Pierre-Louis Moreau-Desproux (1727–94), by Jean-Simon Frégé and the sculptor Marchand
Department of Decorative Arts, room 622, bequest of Madame Lebaudy

Marie-Charles d'Albert, duke of Chevreuse and governor of Paris, had a great taste for the antique. His sumptuously decorated townhouse on rue Saint-Dominique was one of the first manifestations of neoclassicism.

Room of the Château de Bellevue, Meudon
Department of Decorative Arts, room 626, David, Pierre, and Michel David-Weill

The château was first the residence of Madame de Pompadour, favorite of Louis XV, then passed to his daughters. In 1785, one of them, Madame Victoire, ordered extraordinary lacquered furniture from Japan, including a writing table, a chest of drawers, and a corner table. Martin Carlin, a German cabinetmaker, decorated the Japanese cabinet panels with fine gilt-bronze foliage, a candelabra, and falling leaves.

Decoration of the Grand Salon of the Château de Voré, Perche
Department of Decorative Arts, room 607, Isaac de Camondo, acquired in 2002, as a gift of Mr. and Mrs. Guénant

For his Grand Salon, Louis Fagon, *intendant* of finances, hired Jean-Baptiste Oudry (1686–1755) to paint a cycle of nine canvases illustrating *Country Entertainments* ca. 1720–23, charming scenes with fanciful characters and ornamentation of delicate arabesques, medallions, and cascading flowers. From left to right: *The Promenade*, *Music*, *The Concert*, *Hunting*, and *Fishing*.

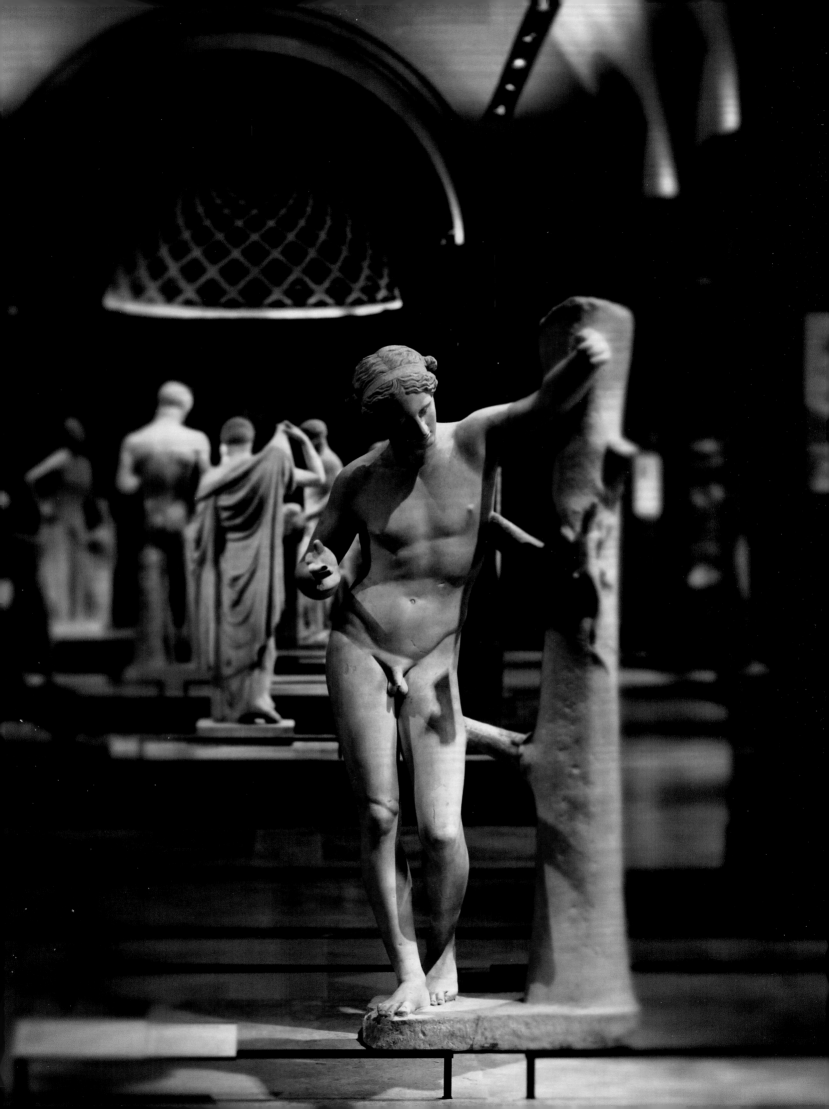

From the Muséum
National des Arts to
the Musée Napoléon

A Revolutionary Museum

T he Revolution would transform the ancient castles of the Louvre and the Tuileries. Places of power par excellence in the heart of Paris, they were the residences of the executive branch of the government until 1870, while the nation's cultural institution, the museum, developed within them. The king and his family were forced to leave Versailles on 6 October 1789. The court was housed at the Château des Tuileries, and the new assembly, the Constituante (National Constituent Assembly), was moved into the Salle du Manège (Riding Hall) in the Tuileries Garden. Despite these changes, the idea of the museum continued—even resuming the Grand Design. Once again, architects dreamed, imagining a vast square with an opera house in the center—a utopian city. Alas, it was in vain. However, the idea of creating a museum at the Louvre was not abandoned. Although the comte d'Angiviller, criticized and denigrated, was forced into exile, the National Assembly decreed in May 1791 that "the Louvre and the Tuileries together will be the National Palace, intended for the king's residence and for the reunion of all the monuments of science and art," and ordered the crown's collections to be housed there.

The Place of the Revolution

The king fled the Tuileries in disguise. His arrest in Varennes and pitiful return to Paris weakened monarchical power. The Revolution rumbled. On 10 August 1792, the people attacked the castle and massacred the Swiss Guards. Although the king would place himself under the protection of the assembly, he could not avoid the irreparable damage. The monarchy fell, and on 21 September, the Republic was proclaimed.

The new government occupied the Château des Tuileries, and was renamed the National Palace. The pavilions were now those of Equality (Pavillon de Flore), Liberty (Pavillon de Marsan), and Unity (Pavillon Central). The revolutionary committees settled into the apartments; the main one, the Committee of Public Safety, occupied the queen's apartment. For the assembly, which until then had convened in the Tuileries's Salle du Manège, the architects Vignon and Gisors renovated the Salle des Machines, the palace theater, to accommodate 780 representatives, as well as spaces for staff and the public. On 10 May 1793, the assembly, now the National Convention, sat in the new hall for the first time. The greatest moments of the Revolution would be played out there.

The Revolution made the Tuileries the center of power. Memories of the monarchy faded: the royal collections of art were dedicated to enriching the future museum; silverware and jewelry were promised to the Mint. A few days after the capture of the château, on 26 August 1792, a first celebration honoring the victims of the fighting was held, with a pyramid set up on the circular basin, surrounded by large torches. Other celebrations followed: in honor of the "Mânes de Marat" ("Marat's shade"), murdered in August 1793, and the young Bara, killed by the Vendeans (27 January 1794). The great civic pomp unfolded on 8 June 1794, under Robespierre's direction, when the Feast of the Supreme

*The Crossing of the Holy Family
from the Thuileries to Montmédy*, 1791
Etching in color,
31.5 × 47.4 cm (12 3/8 × 18 5/8 in.)
Satiric imagery referring
to the king's flight to Varennes
Department of Graphic Arts, Edmond
de Rothschild Collection, gift, 1935

Opposite
Jacques Bertaux (ca. 1745–1818)
*The Capture of the Tuileries Palace,
Carrousel Court, 10 August 1792* (detail), 1792
Oil on canvas, 124 × 192 cm (48 7/8 × 75 5/8 in.)
Versailles, Musée National des Châteaux
de Versailles et de Trianon

Previous spread
Left: *Apollo Sauroctonos* (see p. 332)
Right: *Nymph with Shell* (see p. 341)

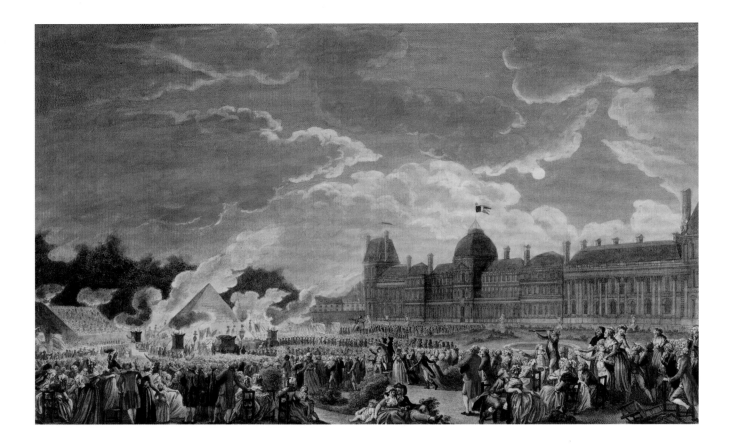

Isidore Stanislas Helman (1743–1809)
and Charles Monnet (1732–after 1808)
*Funerary Ceremony in Honor of the Martyrs
of the Day of the 10th, in the National Garden
(10 August 1792)*, 1794–95
Color burin, etching
Paris, Bibliothèque Nationale de France,
Département des Estampes et de la
Photographie, Vinck Collection

The pyramid is raised on the circular basin
in front of the Château des Tuileries.

Being opened with a ceremony in front of the palace. The effigy of Atheism, made of oakum, was set alight with the "torch of Truth," revealing a statue of Wisdom (a bit blackened), after which Robespierre led a long procession to Champ-de-Mars. He would not enjoy his power for long. Arrested at the Tuileries, he was guillotined on the following 28th of July during the Days of Thermidor.

The Reign of Terror ended with this Thermidorian Reaction. The Directory was established, and consisted of five members. The Constitution adopted in August 1795 entrusted legislative power to two assemblies: the Council of Elders, which settled in the Tuileries, and the Council of Five Hundred, which camped in the Salle de Manège while awaiting its permanent seat, the former Bourbon Palace. The national garden, or "new Eden" according to the bards of the time, resumed its role in the life of Parisian high society. And the garden's architect was ordered to embellish it with statues taken from Marly, Versailles, or Sceaux, in order to make it a kind of open-air museum.

The Opening of a Museum for the Nation

Very quickly, the triumphant Revolution fulfilled an old dream of the monarchy: to inaugurate the Louvre Museum. On 1 October 1792, the minister of the interior, Roland de la Platière, pressured by artists and the public, appointed a commission composed of six artists to prepare the event. This museum, he said, "must attract foreigners and capture their attention. It must nourish the taste for fine arts, inspire lovers of art, and serve as a school for artists. It must be open to everyone. This monument will be national."

The works of art kept in religious institutions or in the homes of fleeing aristocrats were seized for the benefit of the nation. They were grouped in repositories under the direction of a Keeper, in Paris at the convent of the Petits-Augustins (now École des Beaux-Arts) and at the Hôtel de Nesle, as well as in the royal châteaux. A first selection of works was transferred from Versailles and from these repositories to the Louvre.

In the assembly, supporters of federalism (Girondins) and of centralization (Jacobins) opposed each other with oratory. Jean-Marie Roland de la Platière was on the side of the former, and Jacques-Louis David on that of the latter. Placed in the minority, Roland resigned, and his successor ordered the opening of the Musée National des Arts on 10 August 1793, the anniversary of the fall of the monarchy. The opening featured both an exhibition of the nation's works of art in part of the Grande Galerie du Louvre and a Salon

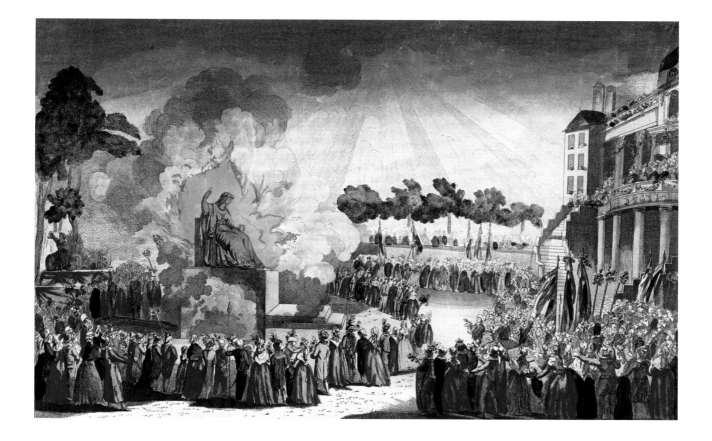

of living artists in the Salon Carré. After a period of closure and some work, the museum reopened permanently on 18 November 1793.

The organization of the conservation of works would change as the Revolution progressed and was subjected to a continuous barrage of criticism. A first commission of the museum with six members, including the painters Vincent and Regnault, was replaced by a conservatory of ten members (mostly artists, painters, architects, and sculptors), who were reduced to five after the Thermidorian Reaction from 1794 to 1797. The conservatory was then reconstituted as a council of five artists chaired by an administrator, the architect Léon Dufourny. The museum, named Musée National des Arts then Musée Central des Arts, was run in a collegial manner by artists with many ideas, including Hubert Robert and the architect Charles de Wailly. This collegial style of leadership ceased in November 1802 with the appointment of Dominique Vivant Denon, a man with a firm hand and a strong vision. He was not only the director of the Louvre, but also of the newly founded museums—those of the French school, created in Versailles in 1797, and of the Monuments Français, set up in the convent of the Petits-Augustins in 1795. Having control over government palaces, the collections of the Monnaies et Médailles (coins and medals) of Paris, and acquisitions of works of art and manufactures, he was in effect a minister of arts.

The museum building campaigns were entrusted to a series of architects. Jean-François Heurtier, who resigned in 1793, was briefly replaced by Pierre Alexandre Vignon; then in 1794, by David's brother-in-law, Auguste Cheval de Saint-Hubert (known as "Hubert" to erase any aristocratic overtones), who planned for the future Musée des Antiques. When he died suddenly in 1798, Jean-Arnaud Raymond took over the building sites, which he scrapped with the museum's commission. Étienne Chérubin Leconte was thanked in 1800 for installing the Convention in the Château des Tuileries. In 1805, two young architects with bright futures, Charles Percier and Pierre François Léonard Fontaine, succeeded Raymond on the Louvre site. The first, an excellent draftsman brimming with ideas, would remain in the shadow of the second, who supervised the work. Fontaine's long rule over the buildings continued until 1848, crossing all regimes successively.

The teams of architects would be faced with a multiplicity of projects in the museum: the Grande Galerie, of course, whose evolution we will follow; the Musée des Antiques and the Salle des Caryatides, where the National Institute was located (a resurgence of the former academies), all required space. Unified and organized into "classes"—Literature, Fine Arts, Sciences, etc.—the institute held its meetings there from 1795 to 1806. The

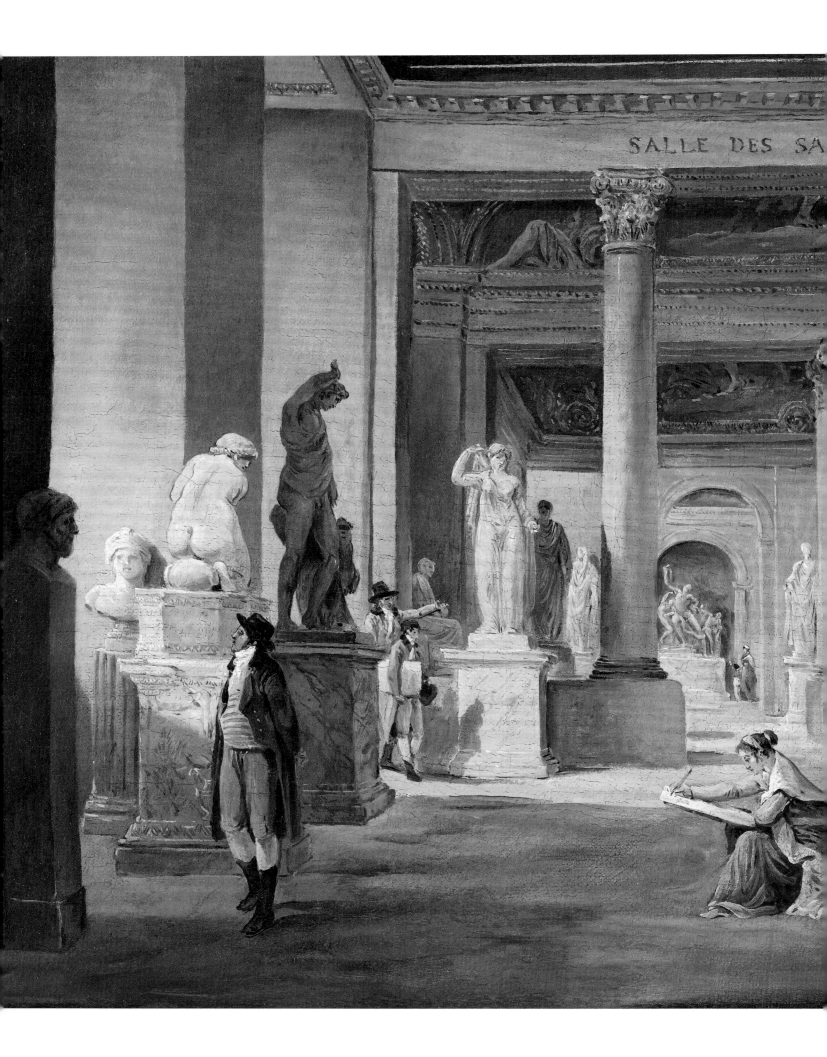

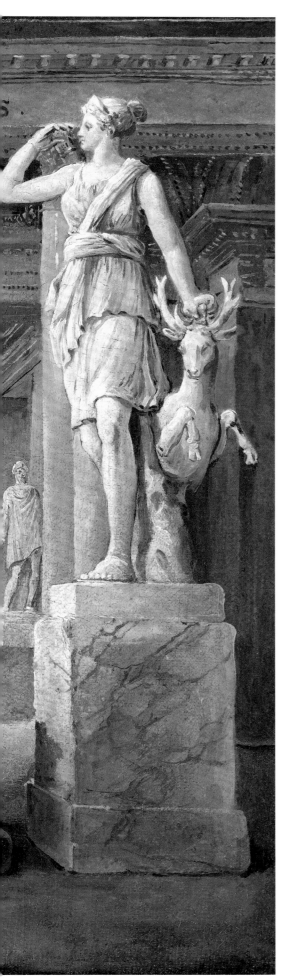

Galerie d'Apollon was established: the administrator, Léon Dufourny, exhibited the most beautiful drawings in Year V (August 1797). Part of the ground floor was devoted to a forerunner of the Musée des Antiques, where works from the royal collections were displayed. With the arrival of the sculptures collected in Rome, Anne of Austria's entire summer apartment was transformed into the Musée des Antiques in 1799. It was inaugurated by the new strongman, Napoleon Bonaparte, on 9 November 1800, the anniversary of the Coup of 18 Brumaire.

But the museum not only housed permanent collections. The Salon of Contemporary Artists continued to be held there during the Revolution. The influence of the academy declined, before it was finally suppressed (as were the corporations [guilds]) in 1792. In 1791, the Salon was open to all artists without a selection jury, which would be reestablished in 1798. The Salon was held in 1793, 1796, every year from 1798 to 1802, and every two years thereafter. From 1801 onward, the Louvre also became the place where "products of French industry" were periodically exhibited. It thus asserted itself simultaneously as the center of contemporary arts and the conservator of antique art. The public came to the museum in droves. Admittance followed the republican calendar, which divided months into three "decades" (ten-day periods): the first six days of the decade were reserved for artists and foreigners, the next three for the general public, and the last was dedicated to cleaning.

Hubert Robert (1733–1808)
La Salle des Saisons, ca. 1802–3
Oil on canvas, 37 × 46 cm (14 5/8 × 18 1/8 in.)
Suite of the Musée des Antiques with the
Versailles Diana on the right, the Vatican's
Laocoön at the back in the niche, and the
Venus Genetrix from the royal collections
to the left of the column, pointed out by
a visitor to the gallery
Department of Paintings, acquired in 1964

Florent Fidèle Constant Bourgeois (1767–1841)
Exhibition of the Drawings in the Galerie d'Apollon,
ca. 1802–before 1815
Black ink, brown wash, pen, 33.6 × 44 cm
(13 1/4 × 17 3/8 in.)
Department of Graphic Arts, gift of
Jean-Joseph Marquet de Vasselot, 1944

The walls of the gallery are lined with picture
rails to display the drawings.

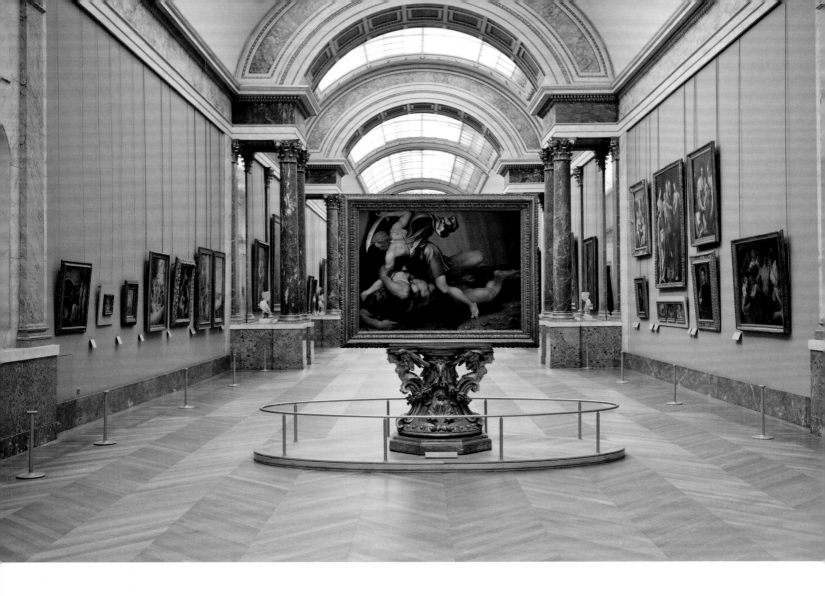

The Grande Galerie,
or Traces of the Museum of 1793

The Grande Galerie opened on 10 August 1793, and anyone who enters it today can imagine the atmosphere of this revolutionary museum, with its long picture rails covered with paintings, neoclassical architecture, and bays divided by columns. It's a mirage. The interior architecture was completely remodeled between 1938 and 1946, and the gallery's museography is only a few years old. Yet the memory of its long history is remarkably alive.

Built under Henri IV to connect the Louvre and the Tuileries, the Grand Galerie provided a convenient link between the king's châteaux, but also a place to stroll, contemplate the river, and hold large gatherings. Chances are that when the king first visited it in 1606, it was not completed. It was 460 meters (1,509 feet) long, a considerable length that would be shortened by a third under Napoleon III.

Henri IV made the very first decorating effort. He commissioned large triumphal arches with marble columns for both ends, and two large statues of Roman emperors were transferred there from the Salle des Antiques. Then the work stopped. This long, austere corridor, lit by high windows and paved with terra-cotta tiles, did not match the sumptuous royal galleries that graced the other courts of Europe. In 1641, Louis XIII tried to remedy this by entrusting the decoration to Nicolas Poussin, assisted by a team of stucco workers. Although well housed in a pavilion in the Tuileries Garden, Poussin did not like Paris, and he left for Rome in the summer of 1642, with no desire to return. He thus abandoned the ceiling where he had intended to illustrate the Labors of Hercules in large circular medallions, probably with compartments and stucco decorations. Only a few sketches remain of this draft project. They show architectural compositions where long frames, probably painted in shades of gray, alternate with tabernacles with cut pediments, surmounted by small fluttering cupids carrying torches, flanked by nude ephebes—*ignudi* in the pure Roman tradition. The administration of the Bâtiments du Roi also planned to insert a decoration of bronze bas-reliefs, copied after the most famous antiquities—cast on Poussin's instructions—in the great Roman collections: medallions of the Arch of Constantine, sarcophagi, reliefs of the

View of the Grande Galerie
Center: *The Battle of David and Goliath* by
Daniele Ricciarelli, known as Daniele da
Volterra (1509–66), double-sided painting on
slate, produced ca. 1550–55 for the Florentine
scholar Giovanni della Casa, with the same
composition on both sides; the artist had also
made a terra-cotta model (lost) in order to
compare the qualities of the painting and the
sculpture (the "*paragone*")
Department of Paintings, offered to Louis XIV
in 1715

Previous spread
Hubert Robert (1733–1808)
Imaginary View of The Grande Galerie, after 1801
Oil on canvas, 33 × 42 cm (13 × 16 ½ in.)
Department of Paintings, gift of Maurice
Fenaille, 1912

facades of the Medici and Borghese villas. A bronze bas-relief executed in 1643 by the foundryman Henri Perlan, after the *Sacrificing Women* in the Borghese collection, revised by François Anguier, is on display in the Department of Sculptures.

Work resumed under Louis XIV. The eastern part of the Grande Galerie was cut off to form the vast space of the Salon Carré. Once again, sculptors and painters were active, even between 1668 and 1673, when the decoration of the Galerie d'Apollon was in full swing. They repaired and completed the decoration of the east bays begun by Poussin. As for the Galerie d'Apollon, the Bâtiments du Roi commissioned large carpets from the Savonnerie royal carpet manufacturory. Then the decorating fever subsided as attention turned to Versailles.

In 1699 and 1704, the Salon Carré and the eastern part of the gallery were used for the first exhibitions of the work of academicians at the Louvre: paintings secured onto picture rails, and sculptures. These exhibitions were not yet called "Salons," a term that would be adopted later, when the academy took over the Salon Carré every two years. Between 1697 and 1777, most of the Grande Galerie was devoted to the collection of relief maps of the kingdom's fortified cities, presented on large tables in the center of the space. This meticulously surveyed set of maps was a tool for training in poliorcetics—tactics and defense maneuvers for future officers—as well as a precise documentation of Grand Siècle urban planning. The maps are now exhibited at the Musée des Invalides.

The relocation of the relief plans corresponded to the desire of Louis XV and his director of buildings, the comte d'Angiviller, to quickly begin work on the installation of the future Royal Museum in the gallery, which had already been in the making for twenty years. Architects proposed various projects from 1777 onward. It was then that the architect de Wailly and the painter Hubert Robert began to consider various solutions for the lighting and decoration of the museum. The work began with removing the vestiges of Poussin's decoration, while the architects dreamed of magnificent improvements. In the

View of the Grande Galerie with an antique bust of Emperor Trajan
Right: two compositions from the gallery of the Hôtel de La Vrillière: *Hersilia Separating Romulus and Tatius*, also known as *The Battle of the Romans and the Sabines* (ca. 1643) by Giovanni Francesco Barbieri, known as Guercino, and *Camille Delivers the Schoolmaster of Falerii to His Pupils* (1637) by Nicolas Poussin
Department of Paintings, seized during the Revolution, 1794

end, these would prove quite simple, designed by the architect Jean-François Heurtier. The gallery should be imagined as a very long corridor—much longer than today—with a simple barrel vault, lit by multiple windows opening onto the Seine to the south and onto the buildings in the Louvre district to the north, which did not favor lighting. The walls were painted green and the ceiling blue.

The eastern half of the museum's gallery opened on 10 August 1793. Hung on the picture rails were 538 paintings, side by side in several rows. The curators cared little about

chronology; they sought instead to arrange a colorful "flower bed" of art. Antique busts, two Egyptian statues from the convent of the Petits-Pères, hard stones, porcelains, and a few clocks were arranged on long tables in the center of the gallery. Eager to educate the public, the museum commission published a small descriptive booklet, the first in a long series of Louvre catalogues.

For political reasons, the opening to the public was rushed, even though the Grande Galerie was still in need of serious renovation. Hubert Robert once again proposed some ambitious

View of the Grande Galerie with paintings, at right, from the gallery of the Hôtel de La Vrillière
Department of Paintings

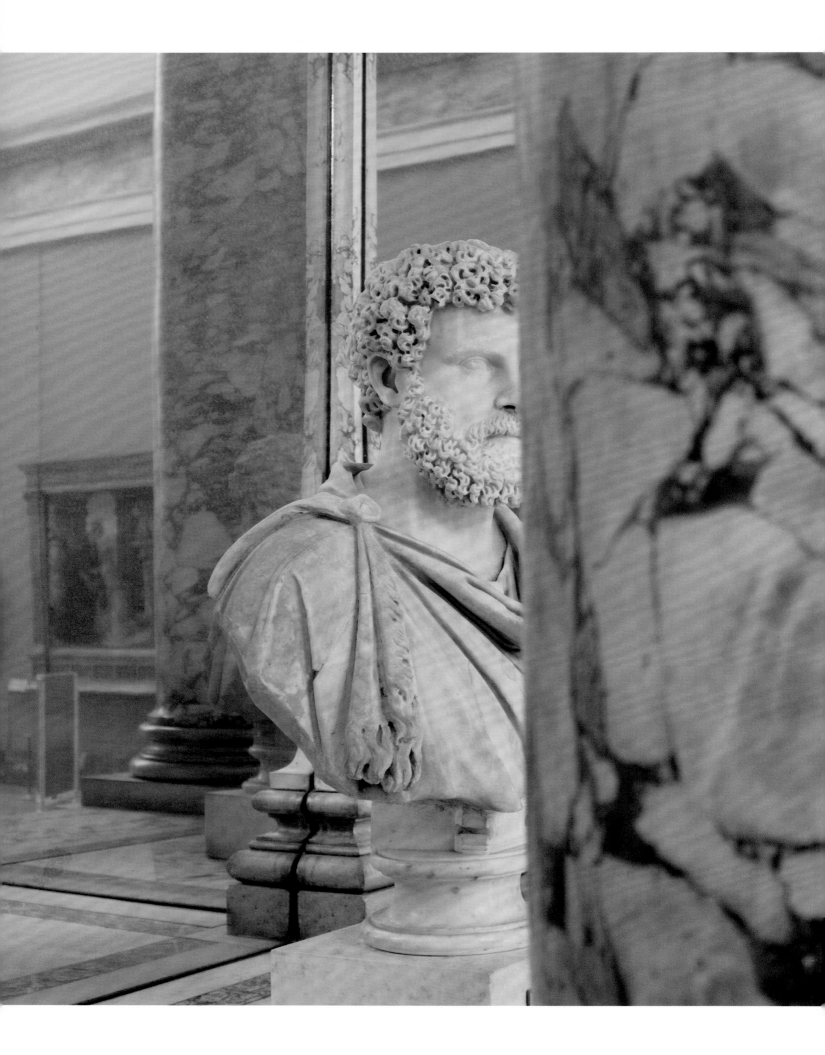

projects, largely inspired by Roman basilicas, such as coffered vaults pierced by zenith windows, with cornices and columns to punctuate the whole. The work would ultimately be limited to restoration, such as repairing the floor and creating a temporary storage area where artworks could be deposited before a selection was made for display. The gallery was therefore closed from 1796 to 1799. On 20 December 1797, however, a banquet of 700 place settings was held there in honor of the army, victorious in Italy, and its general, Napoleon Bonaparte.

The Grande Galerie reopened in April 1799 to present the first part of its collection, devoted to French and Flemish paintings, then in 1801 for the second part. It was necessary to sort and organize huge batches of paintings looted by the army all over Europe. However, the gallery's perpetual remodeling had not been finished. More or less open, but only partially, it was still undergoing work, stalled for various reasons—namely, to create depositories or the expansion of the Tuileries apartment assigned to the pope, who came to bless Napoleon's coronation in 1804.

Finally, in 1805–6, the architects Percier and Fontaine succeeded in imposing a design on this long space that broke the monotony of an endless row of paintings. They divided the gallery into six large bays and three smaller ones with groups of columns topped by highly ornate double arches, similar to a structure fashioned in the sixteenth century by Andrea Palladio and Sebastiano Serlio, hence its name "*serlienne*." Between the pilasters attached to the wall behind the columns, the architects placed large mirrors that reflected the light and expanded the space. For the decorations, from 1803 onward, the museum administration commissioned busts of the great painters of the past whose works were exhibited; this practice continued until the Second Empire. In each bay, the vault was equipped with zenith lighting from small windows pierced at its base, or simply decorated with antique coffers. On the north side, every other window was closed to form long picture

Colored marble flagging and base of the columns of the Grande Galerie

Opposite
View of the Grande Galerie with an antique bust: *Portrait of an Unknown Man*, formerly known as *Clodius Albinus*, early 2nd century A.D., marble, H. 60 cm (23 ⅝ in.) Department of Greek, Etruscan, and Roman Antiquities, former Albani collection, acquired in 1815

Following spread
View of the Grande Galerie with an antique bust: *Portrait of Antinous as Osiris*, ca. 130 A.D., marble, H. 76 cm (29 ⅞ in.) Department of Greek, Etruscan, and Roman Antiquities, former Albani collection, acquired in 1815

rails. The artworks, distributed according to the painting schools in each bay, were arranged in tight rows on several levels, the small formats at the bottom and larger ones above.

It is in this superb gallery that the wedding procession of Napoleon and Marie-Louise of Austria took place in April 1810. It began in the Tuileries and proceeded to the Salon Carré, where the religious ceremony was held. The train of plumed dignitaries filed past the paintings hung in the Musée Napoléon, most of which came from confiscations by the army. The museum was thus the setting for an imperial liturgy that mixed exaltation of military conquest with the idea of the benefits offered to the people by redistribution to the Nation, and even to humanity, of the wonders of art.

Five years later, the defeat of 1815 marked the end of this martial dream. After the emperor's first abdication in 1814 and the accession of Louis XVIII, the allies had left the museum intact. Not so after the Hundred Days, and Waterloo. Many of the paintings found their way back to their hometowns. The Grande Galerie's display was replenished with paintings from the Musée de Versailles. There, one saw great cycles such as the *Life of Saint Bruno* by Eustache Le Sueur or the *Ports of France* series commissioned from Joseph Vernet by the Bâtiments du Roi.

A new stage in the gallery's history coincided with the "new Louvre" that Napoleon III, like his uncle, protected and beautified. As a prelude to this stage, the Second Republic undertook major embellishments on the palace, and the director of the museum, the painter Philippe-Auguste Jeanron, imposed a new museography on the rooms, which required better lighting of the picture rails. The architect Félix Duban generalized the zenith lighting by piercing the vault along the entire length of the gallery in 1850. But his successor as the head of the Louvre's architectural operations, Hector Lefuel, was much more enterprising. After redesigning the decorations in 1856–57, he inflicted a radical amputation on the gallery, destroying more than a third of it in 1861. He did so as the emperor ordered him to rebuild part of the Tuileries Palace: its function as the residence of the head of state required more and more space. The western part of the gallery, connected to the imperial palace, became the Flora Wing.

This wing was rebuilt to house apartments for foreign rulers; a large staircase; a "gallery of splendor" (Galerie de Fastes) to connect the palaces; and a new, very large pavilion that would host parliamentary sessions. Between this new complex and the old gallery, which is still intact, the central part was also rebuilt to create the Grands Guichets on the ground

Benjamin Zix (1772–1811)
Wedding Procession of Napoleon I and Marie-Louise through the Grande Galerie of the Louvre, 1811
Graphite, pen and black ink, watercolor, 172 × 24 cm (67 ¾ × 9 ½ in.)
Drawing commissioned for the decoration of a large Sèvres vase to be produced as a souvenir of the emperor's wedding in 1810
Sèvres Manufactory, on loan to the Department of Graphic Arts

Above and opposite (details, top and bottom)
View of the Grande Galerie
Foreground: *Mars*, a copy of the *Ludovisi Ares*
by Luigi Valadier (1726–85), bronze,
H. 180 cm (70 ⅞ in.), executed in Rome
in 1780 for the count of Orsay
Department of Sculptures, seized during
the Revolution, 1794

Opposite (top)
Niche of the Grande Galerie with *Hygieia*,
2nd century A.D., marble, H. 141 cm (55 ½ in.)
Department of Greek, Etruscan, and Roman
Antiquities, former Campana collection,
acquired in 1861, entered the Louvre in 1863

floor, which allowed a north-south flow toward the Seine. In this section, the museum retains its Grande Galerie, but it is extended into the two pavilions of the Grands Guichets by wide rotundas. Their elliptical domes, clad in gold, are decorated with a vigorous Bacchanalian iconography, by Ernest Carrier-Belleuse, the master of Auguste Rodin. The Bacchic triumphal motifs, molded in stucco, are placed head to toe (alternately heads-up and upside down) to give the illusion of rows of different figures.

The history of the Grande Galerie doesn't end there. The purism of the 1930s will lighten the decorations of the nineteenth century. Then, red walls, black baseboards, and vaults with golden scrolls were dismissed with contempt. Between 1938 and 1946, the Louvre's architects, Albert Ferran and Jean-Jacques Haffner, tried to recapture the spirit of Hubert Robert's projects. Some windows offered views of the outside; others diffused the light. The glass roof was extended to provide more vertical light. Baseboards of pink Belgian marble, and walls repainted in a light gray-white softened the original colors. Niches framed by pilasters were set at intervals to house statues. Real colored marble, stucco imitating marble, and bases and capitals of golden pilasters lent discreet touches of richness.

Since this redevelopment, work in the gallery has largely been limited to technical or cosmetic modifications, such as ensuring climate control or changing the colors of the picture rails. A massive circular sofa was installed during renovations in the 1970s as part of a larger project to introduce contemporary furniture at both the Mobilier National and the Louvre, undertaken by designers Pierre Paulin and Joseph Motte. Marble and bronze sculptures—*Sitting Mars*, *Artemis with a Doe* (*Diana of Versailles*)—along with a large candelabra, antique busts between the columns, and porphyry columns at the ends have been arranged to animate this long suite.

The Grande Galerie is now entirely dedicated to Italian paintings from the Renaissance to the eighteenth century. The Italian tour begins with the fourteenth- and fifteenth-century "primitives" in the Salon Carré and in the small gallery known as the Sept-Mètres

Grande Galerie: left, *The Holy Family*
by Bartolomeo Schedoni (1678–15), from
the Farnese collection, acquired in 1891;
right, *Birth of the Virgin* by Annibale Carracci
(1560–1609), commissioned in 1605 by
the duke of Mantua, from the Basilica
of Loreto, seized in Italy in 1797
Department of Paintings

Opposite
Workshop of Raphael (1483–1520), attributed
to Giulio Romano (1499–1546)
*The Holy Family with Saint Elizabeth and the
Infant Saint John the Baptist*, called *The Small Holy
Family* (detail), ca. 1517–18
Oil on walnut panel, 38 × 30 cm (15 × 11 ⅞ in.)
Department of Paintings, collection of
Louis XIV, acquired from Loménie de Brienne
ca. 1663

Raphael, who worked on this small-format
painting during the last four years of his
life, is the author of the composition and
responsible for its quality, even if it is attributed
to his collaborator, Giulio Romano.

Workshop of Giulio Romano (1499–1546)
Venus and Vulcan (detail)
Oil on wood panel, 37 × 24 cm (14 ⅝ × 9 ½ in.)
Department of Paintings, collection of
Louis XIV, acquired from Jabach in 1671

(Seven Meters). The Renaissance flourished in the Grande Galerie, from Florence with
Ghirlandaio, from Mantua with Mantegna, or from Venice with Bellini. Perugino and
Raphael occupy a place of honor. While the *Mona Lisa* is displayed in a glass case in the
Salle des États overlooking the Grande Galerie, Leonardo da Vinci's other paintings are
hung here: *The Virgin of the Rocks*, *The Virgin and Child with Saint Anne*, and *Saint John
the Baptist*. The work of Venetians Titian, Tintoretto, and Veronese also reside in the Salle
des États, a necessary detour where the public flocks to the "star" of the Louvre. Then the
circuit resumes. In the center is a double-sided painting by Daniele da Volterra which is in
a surprising setting. The visitor trail continues with Guido Reni, Guercino, and Antonio
Carracci before moving on to the next room.

This abundance of masterpieces has made the Grande Galerie a legendary site in the
Louvre since the museum's inception. Copyists rushed there to study the paintings of
the masters of the past. Visitors from all over the world wrote down their impressions and
recorded their memories. The beating heart of the museum, often overflowing with
crowds, the Grande Galerie remains the very symbol of richness. Picasso made no mistake
about it when he hung eight paintings there on the occasion of his ninetieth birthday in
October 1971. The exhibition lasted only ten days, but the free admission offered to visitors
denoted the importance of this event.

Domenico Ghirlandaio (1449–94)
Portrait of an Old Man and a Young Boy, ca. 1490
Tempera on wood panel, 62 × 46 cm
(24 ³⁄₈ × 18 ¹⁄₈ in.)
Department of Paintings, acquired in 1880

This touching portrait of a Florentine patrician
with a face deformed by rosacea may have
been painted from memory, after the subject's
passing.

Opposite
Giovanni Bellini (active 1459–1516)
*Madonna and Child with Saint Peter
and Saint Sebastian* (detail), ca. 1487
Oil on wood panel, 82 × 58 cm (32 ¹⁄₄ × 22 ⁷⁄₈ in.)
Department of Paintings, acquired in 1859

Pietro di Cristoforo Vannucci, known
as Perugino (ca. 1450–1523)
The Battle between Love and Chastity, 1505
Oil on canvas, 160 × 191 cm (63 × 75 ¼ in.)
Painted for Isabelle d'Este's *studiolo* in Mantua's
Castle, Gonzaga collection, sold to Charles I
of England, sold to the Cardinal of Richelieu
and placed in his Château de Richelieu in
Poitou (see p. 321)
Department of Paintings, seized at the Château
de Richelieu in 1801

see p. 321

Opposite
Raphael (1483–1520)
*The Virgin and Child with the Young Saint John the
Baptist*, known as *La Belle Jardinière*, 1507–8
Oil on wood panel, 122 × 80 cm (48 × 31 ½ in.)
Department of Paintings, collection of
Francis I (?)

The painting was made in Florence before
Raphael left for Rome. The pyramid-shaped
arrangement of the figures stands out against
a green landscape.

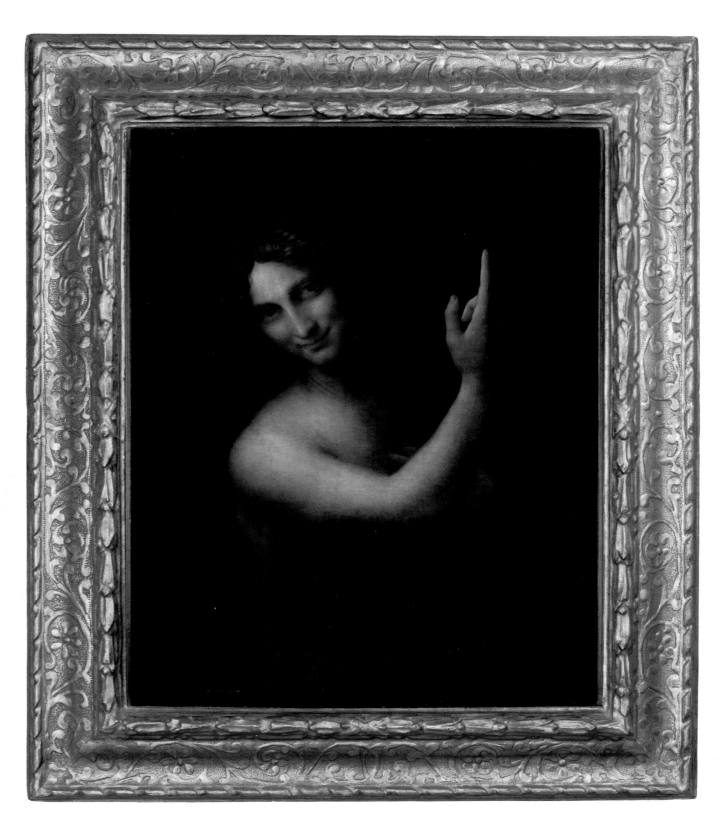

Leonardo da Vinci (1452–1519)
Saint John the Baptist, 1513–16
Oil on wood, 69 × 57 cm (27 ⅛ × 22 ½ in.)
Department of Paintings, collection of
Francis I, donated to king Charles of England,
collection of Mazarin, collection of Louis XIV,
acquired from Jabach in 1662

Holding the cross and preaching, the smiling
figure of the precursor was probably painted
at the end of Leonardo's life. In this almost
monochromatic composition, the luminous
saint seems to emerge from a dark void.

Opposite
Guido Reni (1575–1642)
David with the head of Goliath, ca. 1604–6
Oil on canvas, 237 × 137 cm (93 ¼ × 54 in.)
Property of the Marshal of Créqui in 1638
Department of Paintings, collection of
Louis XIV, passed to the king with the
Luxembourg Palace in 1696

Guido Reni (1575–1642)
The Abduction of Helen, ca. 1626–29
Oil on canvas, 253 × 265 cm (99 5/8 × 104 3/8 in.)
Commissioned by King Philip IV of Spain
ca. 1626, then owned by Queen Marie de
Médicis before 1631, the painting passed
into the gallery of the Hôtel de La Vrillière
(see p. 261)
Department of Paintings, seized during the
Revolution, 1794

Opposite
Giovanni Francesco Barbieri, known
as Guercino (1591–1666)
The Resurrection of Lazarus, ca. 1619
Oil on canvas, 201 × 233 cm (79 1/8 × 91 3/4 in.)
Painted for Cardinal Jacopo Serra, legate
of the pope in Ferrara
Department of Paintings, collection
of Louis XVI, acquired in 1785

Antonio Carracci (1583–1618)
The Flood, ca. 1616–18
Oil on canvas, 166 × 247 cm (65 3/8 × 97 1/4 in.)
Composition based on Guercino's fresco
painted at the Quirinale Palace in
May–October 1616
Department of Paintings, collection
of Louis XIV, gift of Cardinal Mazarin's
heirs in 1661

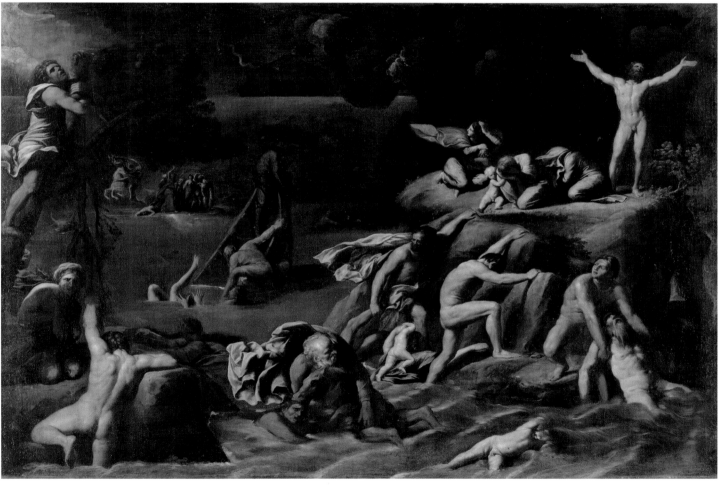

Hubert Robert (1733–1808)
Imaginary View of the Rotonde de Mars and the Musée des Antiques, ca. 1797–1800
Oil on canvas mounted on cardboard, 41 × 54 cm (16 ⅛ × 21 ¼ in.)
Department of Paintings, donation of Mr. and Mrs. David-Weill, 1948

Opposite
Étienne Bouhot (1780–1862)
View of the Salle de la Paix in the Musée des Antiques, ca. 1820
Oil on canvas, 65 × 54 cm (25 ⅝ × 21 ¼ in.)
Department of Paintings, acquired in 1977

The door, open to the former Infanta's Garden, was used as an exit through which the antique statues were carried from Italy.

At the Heart of the Musée des Antiques: The Salle de Diane

The Musée des Antiques, rich in particular with sculptures from the royal collections and the Vatican Museum, opened in 1800 in Anne of Austria's former apartment, the entry to which was first accessed through a side door. In 1803, the final circuit was organized along the north-south axis from another gate, overlooking the vast Rotonde de Mars. To the left, the administration planned to arrange the rest of the circuit starting with a small room. In 1801, they intended to install the antique *Diana* from the royal collections there, hence the traditional name given to this space—even though the *Diana* ended up elsewhere (it is now the central piece in the Salle des Caryatides).

The room was originally a passage built by Pierre Lescot, around 1566, to connect the Pavillon du Roi to what would become the Petite Galerie. Around 1655, Louis Le Vau expanded the passage to make it a small building that connected Anne of Austria's winter and summer apartments. The first seat of the Académie Française, it was then assigned to the assemblies of the Academy of Painting and Sculpture between 1712 and 1721, before being included in the apartments of the little Infanta of Spain, Louis XV's briefly betrothed.

In 1801, the architect Raymond destroyed all the ornaments on the walls, stuccoes and paintings, and undertook the work of the Salle de Diane, which would be completed by Percier and Fontaine. The decorations painted and sculpted between 1801 and 1803 was dedicated to the story of the goddess Diana. The central composition of the ceiling, *Diana Imploring Jupiter Not to Subject Her to the Laws of Marriage*, was commissioned from Prud'hon in 1801. The lunettes of the tympanums by Étienne-Barthélemy Garnier and Léonor Mérimée describe two episodes of the goddess's good deeds: *Diana Returning to Aricia Hippolytus Resurrected by Aesculapius* and *Hercules Obtaining from Diana the Doe with Golden Horns*. The bas-reliefs arranged along the walls, sculpted in 1808 by Jean-Joseph Foucou and Pierre Cartellier, evoke the cult of Diana, like: *Dance of Spartan Girls* and *Dance of the Amazons upon the Foundation of Diana's Temple*. Others illustrate mythical episodes such as: *Diana and Her Nymphs Asking Vulcan for Their Hunting Weapons* by Jean-Joseph Espercieux, *Orestes and Iphigenia Stealing the Statue of Tauric Diana* by Pierre Petitot.

The bare, sober walls are a product of the purism of the 1930s. They contrast with the rich frames and vault compartments dating from the era of triumphant neoclassicism.

Collections of antiquities have been exhibited there since the beginning. Nowadays, the room houses sculptures from the Parthenon.

The Imperial Château of the Tuileries and the Musée Napoléon

The Coup of 18 Brumaire (9 November 1799), led by the young conqueror of the Italian expedition, Napoleon Bonaparte, imposed a change of regime: the Consulate. First Consul Bonaparte officially settled at the Château des Tuileries in February 1800 with two other consuls, Cambacérès and Lebrun. The latter would soon give way to their ambitious colleague, promoted to consul for life in 1802 and then to emperor on 18 May 1804. From then on, state policy and the expansion of empire were commensurate. The emperor would pursue the Grand Design to astonish conquered Europe. Anxious to make people forget his origins and establish a dynastic power, he restored the liturgical rituals of the monarchy: etiquette, grandeur, and the ceremonial. Buildings and furniture were inscribed with an abundance of emblematic symbols: "N"s, eagles, and bees stamped the old palace that Napoleon had decorated. The Restoration erased most of these, but discreet bees can still be seen on the facade of the Colonnade. The First Consul also played at being the protector of the arts and enriched the museum, which in 1803 was named for him, Musée Napoléon, even before the official establishment of the Empire.

In 1806, the emperor expelled from the palace all its "undesirable" inhabitants—courtiers, artists, and even the very recent National Institute, which moved to the former Collège des Quatre-Nations (College of the Four Nations). "Let all these wretches go," he said, "they would eventually burn my conquests, my museum." And it was in this palace in full transformation, in this museum at the height of its glory, that Napoleon celebrated his marriage to Marie-Louise of Austria with great pomp and ceremony on 2 April 1810.

Gate of the Colonnade passage with the imperial emblems: winged lightning, "N" monogram of Napoleon I (probably redone under Napoleon III); wood and bronze

Opposite
Martin Guillaume Biennais (1764–1843)
Crown of Charlemagne (executed for the coronation of Napoleon I), 1804
Gilded copper, cameos and intaglios, velvet and embroidered braid, H. 25 cm (9 7/8 in.)

Cameos from Sainte-Chapelle at Bourges and the abbey of Saint-Denis, impounded during the Revolution and transferred to the museum Department of Decorative Arts, transferred by the Ministry of Finance for the Musée des Souverains in 1852

Martin Guillaume Biennais (1764–1843)
Hand of Justice (executed for the coronation of Napoleon I), 1804
Ivory, copper, gold, cameos, H. 132 cm (52 in.)
Knot enriched with the ring of Saint-Denis (13th century), seized in the treasury of the abbey in 1793 for the museum Department of Decorative Arts, transferred by the Ministry of Finance for the Musée des Souverains in 1852

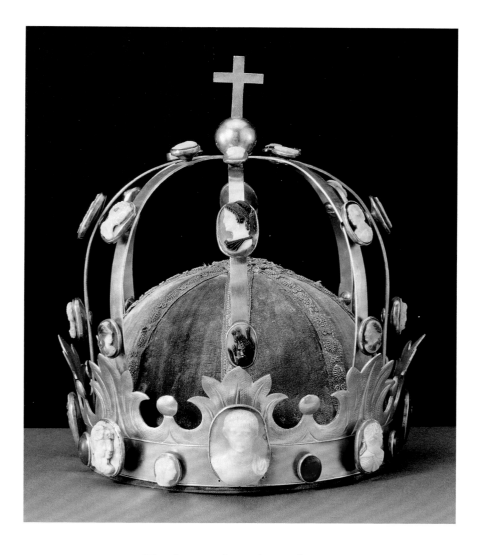

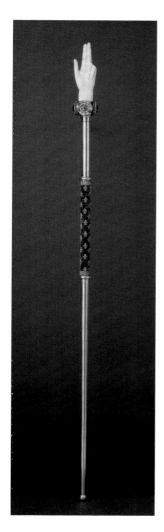

The Coronation of Napoleon I

Let's go back in time. Once proclaimed emperor, Napoleon sought the sacredness that was associated with the former dynasty. On 2 December 1804, in a grandiose ceremony at Notre-Dame de Paris, the new sovereign crowned himself, and his wife, the empress Josephine de Beauharnais. The Louvre preserves the memory of this extraordinary event: the immense painting of the *Coronation* by Jacques-Louis David, named the First Painter to the Emperor. After having been the leader of the neoclassical artists, organizer of the Republic's ceremonies, and even designer of the representatives' uniforms, in *Coronation* we see David exalting the greatness of an authoritarian monarch. It took him and his student Rouget three years to create the grandiose setting of Notre-Dame and the portraits of the fifty characters in the painting: Pope Pius VII, who had come from Rome to give his blessing, and the Bonaparte family in all their finery: Napoleon's mother (Madame Mère) in her loge, sisters (who, like his mother, do not appreciate their secondary roles behind Josephine), and brothers. The great officers stood in ceremonial dress, and the ladies in waiting crowded around the central stage.

The imperial regalia of the coronation were specially restored or rebuilt by the goldsmith Biennais. These "Honors of Charlemagne" were a testament to the new emperor's desire to reconnect with the Western Empire of the great Carolingian; all are now preserved in the Louvre. The so-called crown of Charlemagne had disappeared in the Revolution, and a "duplicate" was made after engravings from Bernard de Montfaucon's *Monuments of the French Monarchy* (*Monuments de la Monarchie française*). The crown, of great formal simplicity, was a closed, and therefore an imperial, crown. The director of the Musée Napoléon, Dominique Vivant Denon, provided cameos and intaglios impounded from the treasury of Sainte-Chapelle de Bourges and the abbey church of Saint-Denis in 1793. The Hand of Justice bears a knot decorated with the ring of Saint-Denis, dating from the thirteenth century, ornamented with a large sapphire, pearls, and precious stones. Charlemagne's legendary sword, the Joyeuse (The Joyful One), was also restored. The scepter was that of Charles V,

Following spread
Jacques-Louis David (1748–1825)
Coronation of Emperor Napoleon and Coronation of Empress Josephine in Notre-Dame de Paris, 2 December 1804 (detail), 1806–7
Oil on canvas, 621 × 979 cm (244 ½ × 385 ½ in.)
Department of Paintings

Commissioned by Napoleon I, the gigantic painting is an official reconstruction of the ceremony. David inserted the portrait of Madame Mère (who had not been present) in the loge and placed the crowd of dignitaries, courtiers, cardinals, and family around the main event: the emperor crowning the empress under the pontifical blessing.

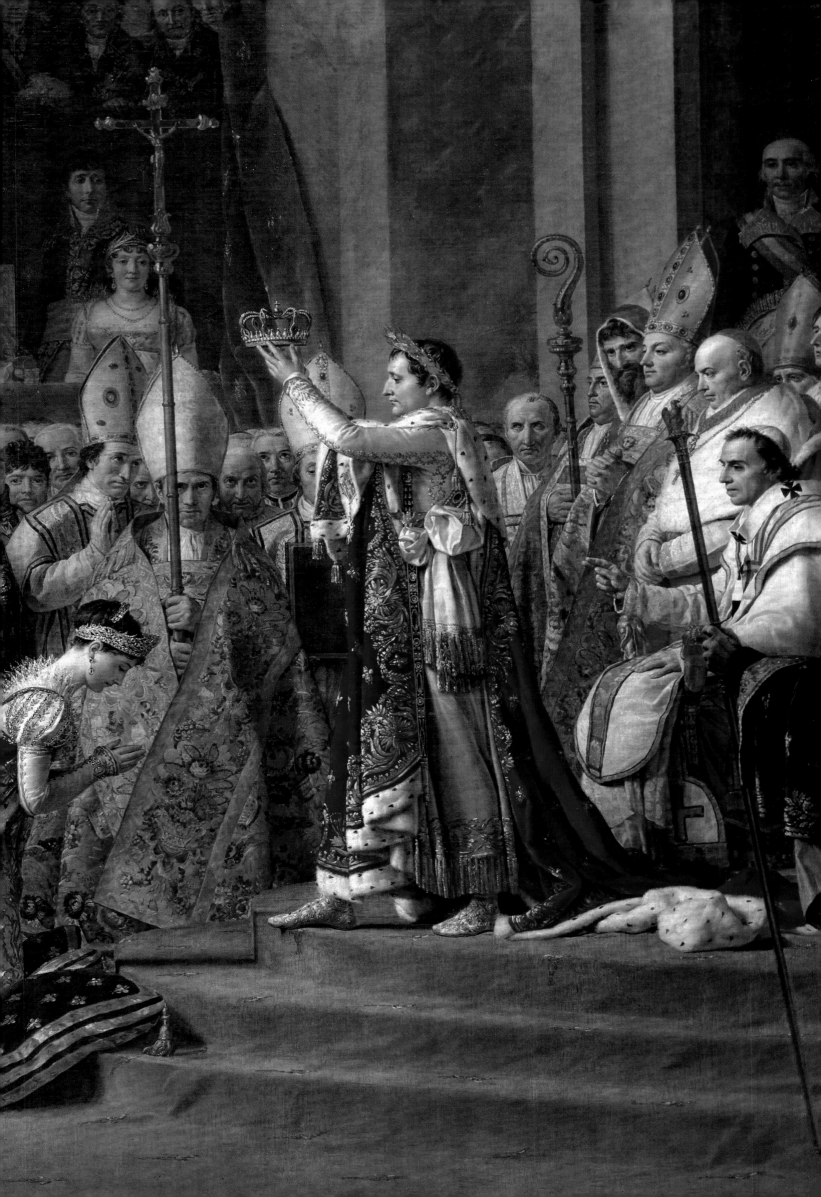

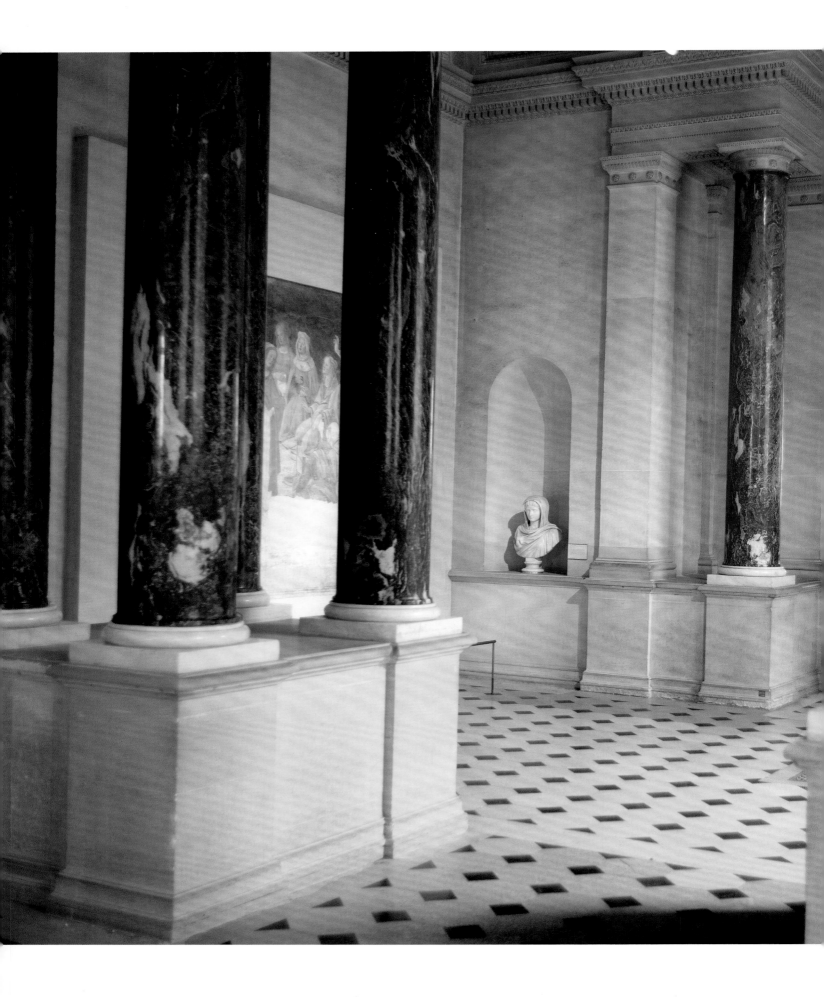

also called Charlemagne because it is topped by a statuette of the emperor enthroned. Biennais lengthened it by integrating part of the cantoral baton of Guillaume de Roquemont, choirmaster of Saint-Denis (end of the thirteenth century).

The Musée Napoléon: The Palace of the Empire

Napoleon Bonaparte made "his" museum a priority. The director of the Musée Napoléon, Dominique Vivant Denon, established as its emblem a colossal bronze bust of the emperor (1.90 m/6 ¼ ft.) crowned with antique laurels by the Florentine Lorenzo Bartolini. The bust was placed in the tympanum above the museum's entrance.

A Burgundian of minor nobility, a Freemason, a socialite, a smooth talker, a bawdy engraver, and a writer of light prose, Denon was skilled at ingratiating himself. He accompanied Bonaparte on his Egyptian expedition and brought back a host of engravings. A court favorite—at once dilettantish, hardworking, and adventurous—Denon was appointed by the First Consul to head the museum on 9 November 1802. He would become the instrument of Napoleon's goal to astonish Europe. At the same time, Denon waged a vicious battle against the other favorite, the architect Pierre François Léonard Fontaine, who, in his *Diary* in 1808, described him as "one of those unwelcome flies that you can't get rid of and against which you can only have patience." With Denon by their side, the curators did a remarkable job. Ennio Quirino Visconti, who curated the pontifical collections, had gone to Paris to watch over "his" antiques, which had been looted by the French Republic. He designed their layout and wrote the catalogues. Morel d'Arleux did the same for the vast collection of drawings.

The Percier and Fontaine Rooms in the Museum

Despite the strong influence of politics at the château, the museum benefited greatly from the work of the duo in charge of the buildings of the Louvre and Tuileries: Percier and Fontaine, the two masters of neoclassicism. Friends and collaborators, together they designed the many projects that Napoleon entrusted to them—even if Percier officially renounced his position in 1812. This would not happen without some conflict with the museum's ambitious director, Vivant Denon, whose rivalry with the architects was an open secret. Several rooms are indebted to them: the Grande Galerie, the upper landing of the staircase, the Salle des Caryatides, the antiquities rooms of the south wing.

The museum's staircase was rebuilt between 1807 and 1812 in the pavilion erected by Le Vau parallel with the Galerie d'Apollon. It still remains in the rooms rightfully called Percier and Fontaine, where elegant marble columns combine with opulent sculpted decoration. The staircase's original structure was complex: from the entrance of the ground floor to the Rotonde de Mars, it was necessary to connect the Grande Galerie to the south, and the Galerie d'Apollon to the north, with a slight difference in level. The architects arranged a set of columns and *serliennes* in a composition similar to the one they favored for the Grande Galerie.

While the decoration was completed under the Restoration, the new staircase would be mercilessly demolished in 1855 during Napoleon III's major refurbishments for the new Louvre. The architect Hector Lefuel designed an even more complex staircase, since it also had to connect the newly constructed buildings, the wing we now call the Denon

Percier and Fontaine Rooms,
landing of the old museum staircase, 1807–12
Left: *A Young Man Being Introduced to the Seven Liberal Arts*
by Sandro Botticelli (ca. 1445–1510), fresco discovered
in 1873 in the Villa Lemmi near Florence, former property
of the Tornabuoni family, acquired in 1882
Department of Paintings

Francesco Belloni (1772–1863)
The Emperor's Genius, Mastering Victory,
Brings Peace and Abundance
In the compartments: personifications of
four rivers (Nile, Po, Danube, Dnieper),
symbolizing the conquered countries
Mosaic of glass paste and hard stones,
295 × 338 cm (116 × 133 in.)
Commissioned for the flooring of the
Melpomene room and exhibited at the 1810
Salon; the figure of Napoleon replaced by
that of Minerva during the Restoration;
removed in the 1930s
Department of Sculptures since 1993

Opposite
Southeast view of the Napoleon Gallery (north
wing of the Tuileries connection to the Louvre),
built by Percier and Fontaine, 1806–14
Bottom: the gallery as rebuilt by Lefuel in 1875
Right: the gallery extension erected during
the Restoration and completed during the
Second Empire

Wing, with its large galleries on the ground floor and upstairs. He then changed the direction of the museum's staircase and destroyed the work of Percier and Fontaine, excluding the upper landing; the two bays comprising it now form the Percier and Fontaine Rooms. Their decoration was executed during the Restoration, but under the direction of the same architects. In the first room, the decoration was mineral, with a vault with embossed compartments. In the second, the ceiling was painted during the Restoration by Charles Meynier. As the staircase provided access to the museum, the iconography had to make a broad allusion to it. The painter thus represented *France in the Guise of Minerva Protecting the Arts*. In marble lunettes sculpted by Louis-Messidor Petitot, little cupids pay tribute to the busts of Minerva and Apollo. In the constant search for spaces where artworks could be exhibited, the Percier and Fontaine Rooms received frescoes that had been created by Botticelli for a Florentine villa. Although far removed from the master's other paintings, they appear here in an architectural environment that seems better suited to fresco than the picture rails of a gallery.

Percier and Fontaine also transformed the Salle des Caryatides, which, after having been home to the National Institute's sessions until 1806, was reserved for the museum. There, Denon presented the *Nile* and *Tiber* statues from the Vatican (the room was renamed Salle des Fleuves [Room of the Rivers]). The architects redeveloped the walls and vaults: fluted columns, marble fireplaces by Belloni that incorporated two statues by Jean Goujon, a musicians' gallery whose tympanum was decorated with the large bronze relief of *The Nymph of Fontainebleau*, created by Benvenuto Cellini for Francis I and impounded at Château d'Anet. The room opened in 1811.

The rooms on the ground floor of the south wing followed, decorated with columns, red marble tiling, and floor mosaics by Belloni. Belloni, who was of Italian origin, had opened a mosaic school in France and brought the art of marble marquetry with him, which during the Empire and then the Restoration, found a vast area of application in the Louvre.

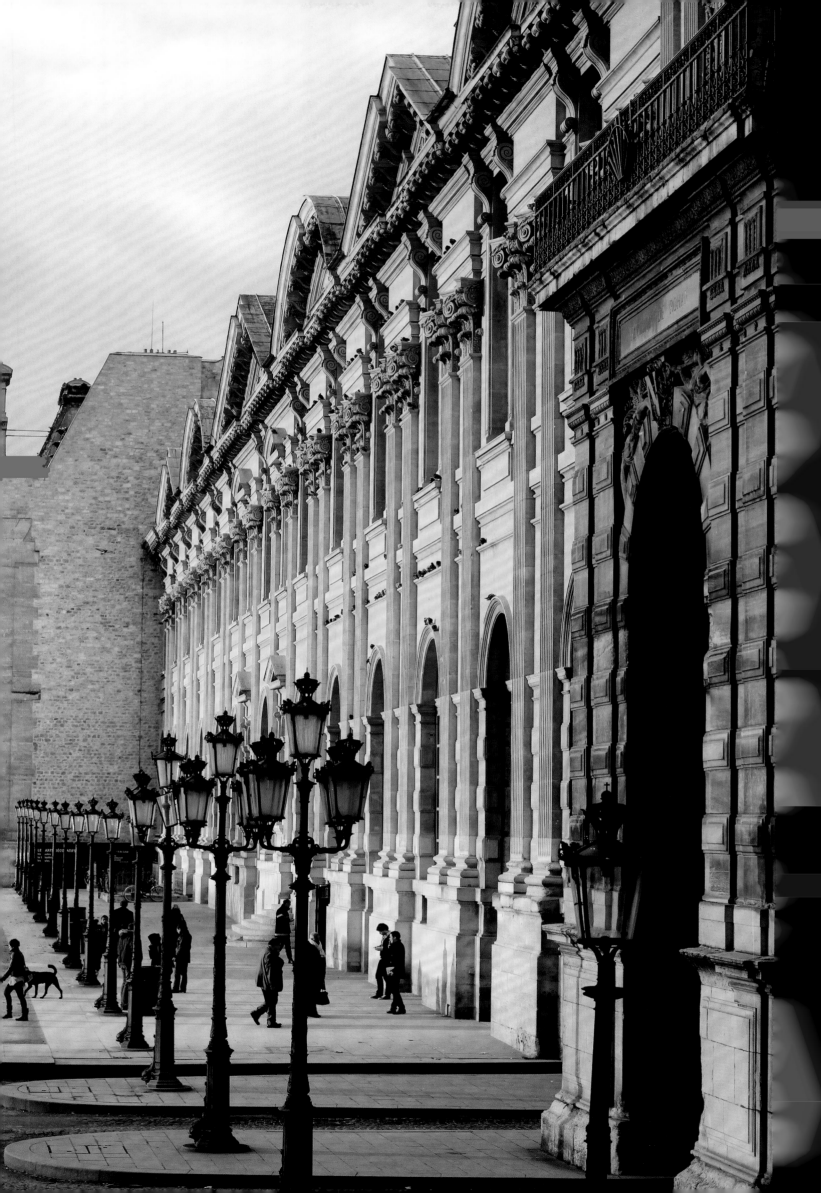

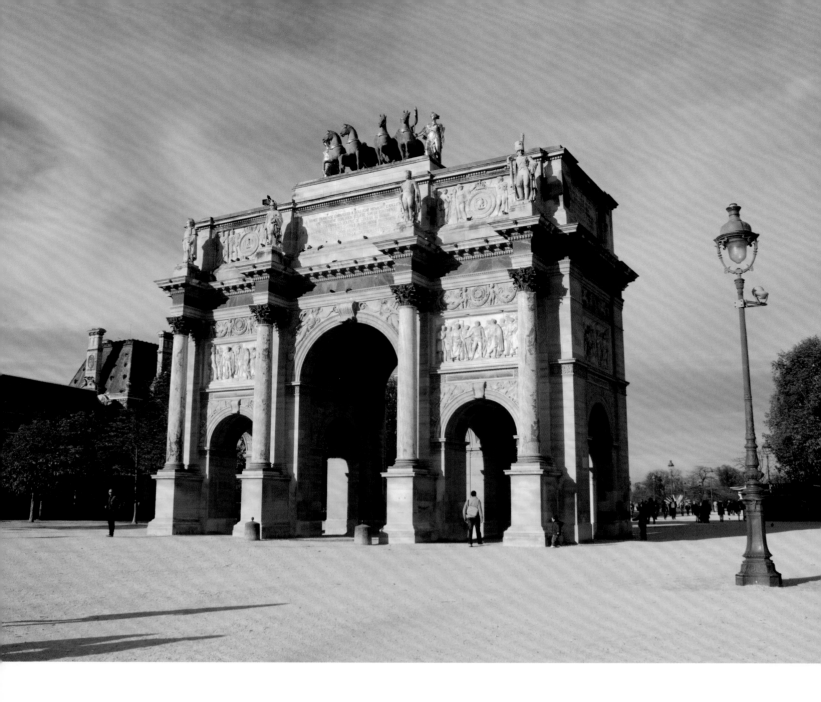

The Arc de Triomphe du Carrousel

The Arc de Triomphe du Carrousel (the entrance gate in the courtyard of the Château des Tuileries), built by Percier and Fontaine in honor of Napoleon's Grande Armée, 1806, stone, white marble reliefs, red marble columns with gilded bronze base and capitals
Top: *France*, or *The Restoration* or *Peace Driving Its Triumphal Chariot*, bronze by François-Joseph Bosio (1768–1845), cast by Crozatier, surrounded by *Victory* and *Peace*, 1808, gilded lead by François-Frédéric Lemot (1772–1827)

But the museum was only part of the imperial city of the Louvre and the Tuileries, the seat of power. Napoleon therefore revived the former royal project to bring the two châteaux together: "Everything big is beautiful," he asserted. First, he made a clean sweep. Started in 1801, a new street lined with arcades—named rue de Rivoli, in honor of a victory in the Italian campaign—ran along the north wing. It was intended to connect the two ends of the city. Another street pierced an area from the Pavillon de l'Horloge to the Carrousel to connect the Louvre and the Tuileries. It crossed a still dense and dangerous district, where the attack targeting Bonaparte took place in 1800 on rue Saint-Nicaise.

In 1808, several architects proposed a master plan. The emperor entrusted the realization of the new Grand Design to Fontaine, who was advised and assisted by his long-time friend Percier. The masons got to work. To the north, a wing was being built along the rue de Rivoli. Two sections, which had to meet, were engaged. To the west, there were still some bays on the south face whose elevation reproduced the one that Du Cerceau designed for Henri IV's Grande Galerie. To the east stood the circular chapel of Saint-Napoléon, built near the Beauvais Pavilion to match the rotunda of Le Vau's Salon du Dôme; it disappeared during the Second Empire. The most visible aspect of Napoleon's great works is the exterior decoration of the Cour Carrée and the Colonnade.

The emperor had decided to open a street between the two palaces. In the axis, in honor of the Grande Armée, the entrance gate to the courtyard of the Tuileries was built on the model of the arches of the Roman Forum, in particular that of Septimius Severus. Its cost was tremendous: one million francs, paid for by the Grande Armée. Percier and Fontaine

reduced its dimensions after having compared it to antique models (14.50 meters /47 ½ ft. high by 19.50 meters/64 ft. wide). Polychrome was used extensively: columns of red Languedoc marble, recovered from materials abandoned since Louis XIV, with bases and capitals of gilded bronze; white stone where reliefs of immaculate marble stood out. The decoration covered every surface: Renommées (Fama) and trophies of arms filled the spandrels of the arches. The four large marble reliefs evoking Napoleon's treaties and campaigns—the victory at Austerlitz and the entries into Munich and Vienna—were executed by the best sculptors of the time: Clodion, Cartellier, Deseine, and Le Sueur. Denon provided instructions; Charles Meynier, the preparatory drawings. In the upper frieze are the coats of arms of France and Italy and statues of soldiers from the various corps (dragoon, horse grenadier, sapper, cuirassier, chasseur, riflemen, etc.) paying tribute to

Detail of the Arc de Triomphe du Carrousel: *River*, 1807–9, stone relief by Guillaume Boichot (1735–1814), based on a drawing by Charles Percier

Following spread
Arc de Triomphe du Carrousel at dusk

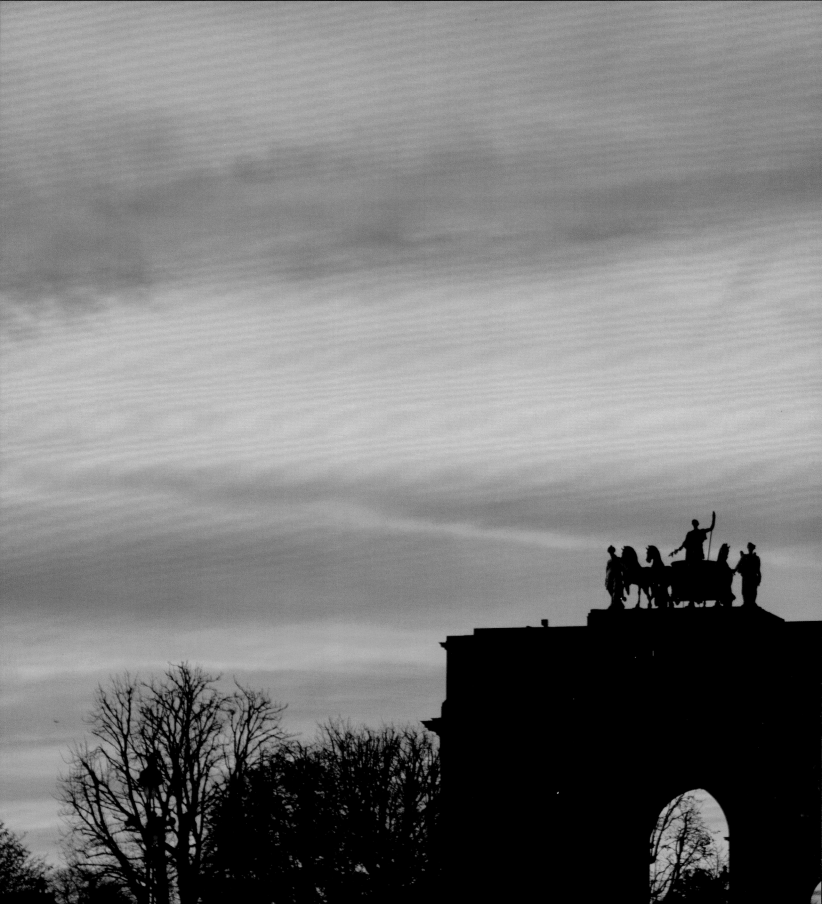

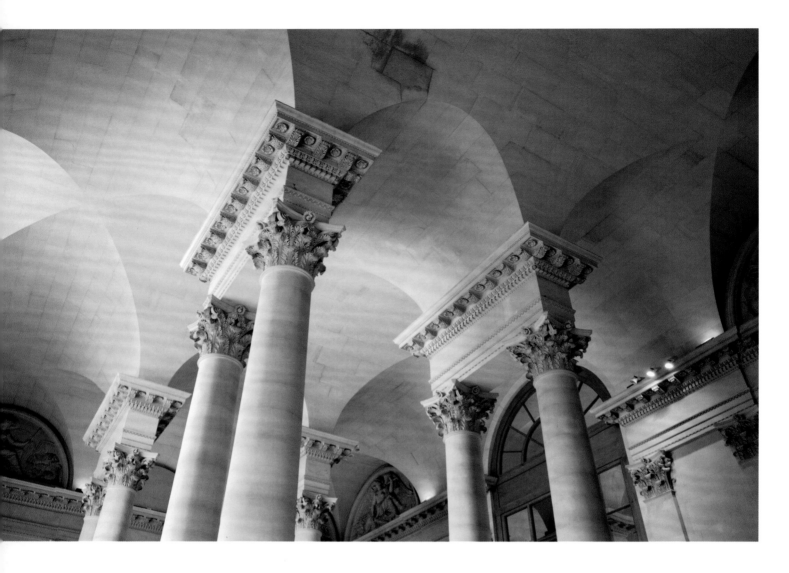

The vaults of the Midi staircase, built by Percier and Fontaine in 1807–11, in the south pavilion of the Colonnade Wing

Opposite
Upper landing of the Midi staircase

The Imperial Apartment Projects at the Louvre: The Colonnade Stairs, Henri IV Gallery, and Salle des Colonnes

Napoleon lived at the Château des Tuileries and ordered his architects to give it even more prestige. A chapel, rooms dedicated to the Conseil d'État, a theater, and the redevelopment of the throne room were by turns launched. From 1805, in the center of the large pavilion, a monumental room—called the Salle des Maréchaux, decorated with a caryatid platform inspired by that of Lescot—honors the marble busts of all the soldiers to whom the victories of the Republic and the Empire were due.

The insatiable emperor also wanted to invest more in the Louvre. In 1806, Percier and Fontaine were ordered to prepare large apartments on the piano nobile of the Colonnade. The facade of the Colonnade was then decorated and redesigned. Windows were opened on the first floor, the central door was adapted and decorated, the gateway under the central pavilion was provided with columns, and the tympanums of the side doors accommodated Renaissance reliefs from the south wing of the Cour Carrée.

At the same time, the architects were building two long, low galleries on the ground floor of the Colonnade to serve as a vestibule to the stairs placed in the pavilions. The southern gallery, dedicated to the "illustrious French," received statues of great men commissioned for the future museum under Louis XVI. Fontaine placed them in niches made for this purpose. He also had the ends of the gallery decorated with tympanums sculpted by Pierre Petitot. Official rhetoric is declaimed in the imposed theme: Naval Victory and Land Victory, "looking at the generals who so often made France victorious on land and at sea, seem proud of the favors they gave them." The gallery's name would change with the Restoration and the desire to erase the memory of the Empire. It is now called the Henri IV Gallery because, since 1818, it has housed a plaster statue of good King Henri

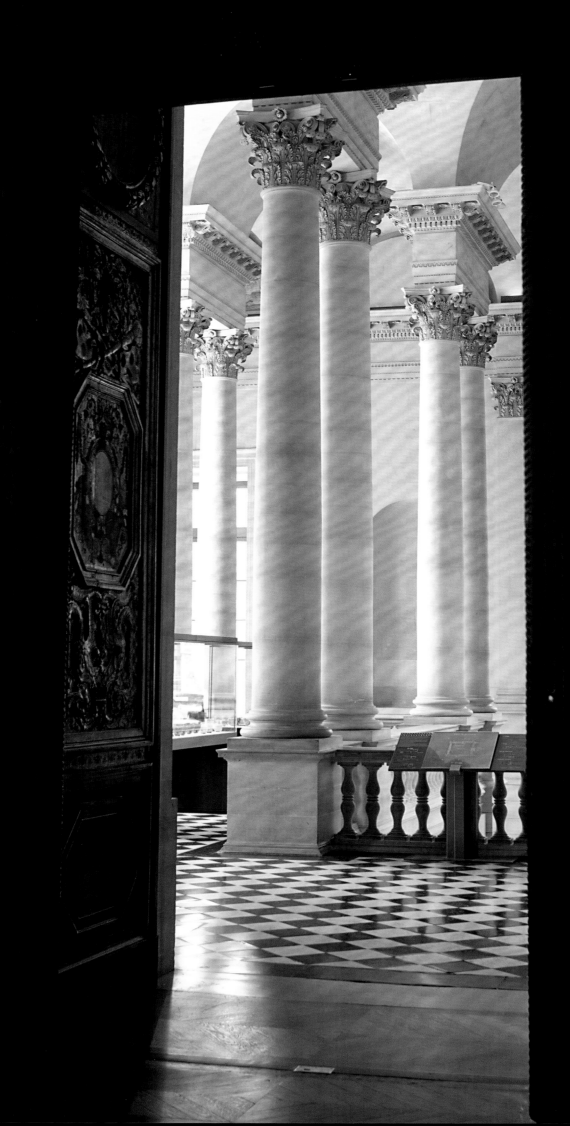

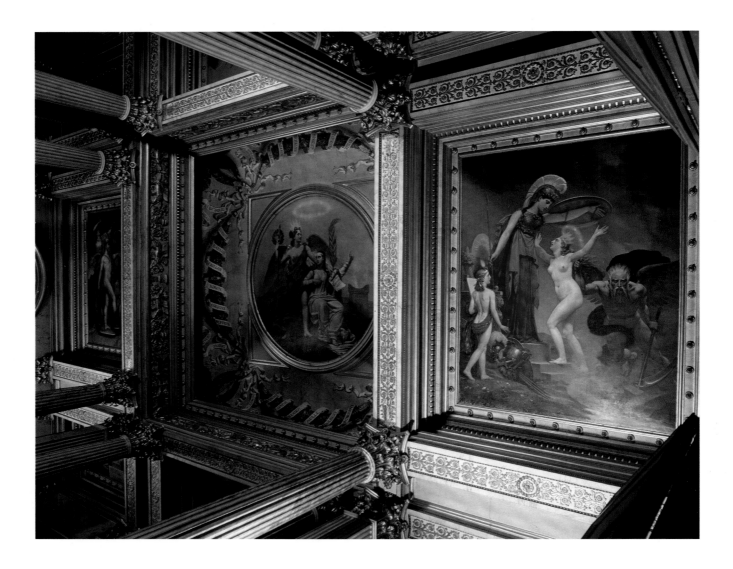

Ceiling of the Salle des Colonnes, architecture
by Percier and Fontaine; *Time Elevates Truth
to the Throne of Wisdom* and *True Glory Is Based
on Virtue*, paintings by Baron Antoine Jean
Gros (1771–1835)

Opposite
Alexandre-Louis Badenier
The Grand Staircase of the Musée de Peinture, 1835
Black ink and gouache highlights on paper,
85.1 × 60.1 cm (33 ½ × 23 ⅝ in.)
Department of Graphic Arts, purchase 1982

that the royal administration quickly commissioned from the sculptor Louis Roguet to
replace the equestrian statue of the Pont-Neuf, which was destroyed during the Revolution.
After having been used for exhibitions of industrial products, the gallery was assigned to
Egyptian antiquities in 1848. Its museography was completely redesigned in 1997 to pro-
vide the public a better understanding of the architecture of Egyptian temples.

In 1807, to serve the future large apartments, the architects erected large staircases at
the ends of the lower galleries in each of the pavilions, north and south. Work in the pavil-
ions had been abandoned in previous building campaigns, and, as in other areas of the
palace, artists and courtiers squatted in the defunct spaces. Jacques-Louis David even
established a second workshop in the south pavilion in 1796. But with the artists expelled
in 1806, the spaces were open for renovation. The architects concentrated their efforts on
the first-floor landing, where they especially liked a group of isolated Corinthian-order
columns. The vaults delimited tympanums at the top of the walls. Their designs for alle-
gorical figures—ancient gods and virtues—were assigned between 1811 and 1814 to the
most talented sculptors: Chardigny (who died from a fall off a scaffold), Gérard, Callamard,
Fortin, and others.

Fontaine would not have time to complete the structural link between the future Grands
Appartements and the former Louvre. However, he did succeed in freeing up a large
amount of space by removing the attic floor. In 1812, he was only able to build the south
pavilion's central hall. Its ambitious architecture featured a central box supported at
the four corners by groups of high columns (hence named the Salle des Colonnes—the
Column Room.) Each group consisted of a triangle formed by a central pillar and two
columns on a high marble base. Napoleon had also planned to set up a meeting room
to bring together the established bodies in the former Salle des Gardes; the project would
be executed under the Restoration.

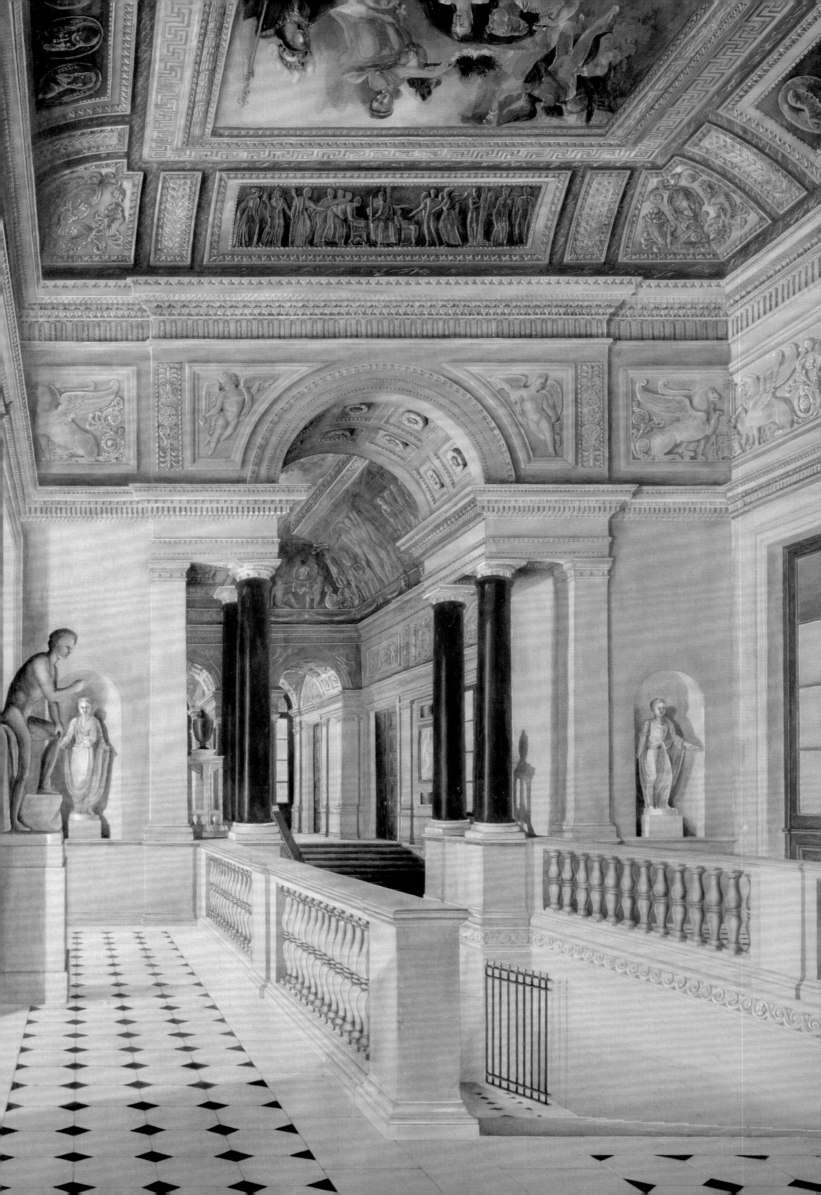

The large painting room of Salle Mollien
Department of Paintings

The "Large Red Room":
From the Glory of the Emperor to the Beginnings of Romanticism

Let's enter the large red room—Salle Mollien, Salon Denon, and Salle Daru—on the first floor of the Denon Wing. The construction dates back to Napoleon III, but the collections summarize the great paintings of the early nineteenth century. It seems that the former imperial glory is still alive and well here, given the way in which the works have been staged. In the center of Daru Gallery is David's *Coronation*. Enormous paintings show the sovereign both as a conqueror and as a man moved to pity for his victims. The most admired work of the 1804 Salon was the large canvas by Jean Antoine Gros, *Bonaparte Visiting the Victims of the Plague at Jaffa in March 1799*. The powerful color and the curiosity about an imaginary Orient already celebrated qualities that would be adopted by Romanticism. The political propaganda that marketed the general as a kind of miracle-working king is obvious, as is also the desire to treat a contemporary subject, which directs the taste for antiquity toward a traditional academicism. David had already practiced it, in both *The Oath of the Horatii* and the portrait of the murdered Marat. But then, contemporary war, in all its glory and devastation, formed the backdrop to art in the making. In 1807, a competition was opened to represent the Battle of Eylau. Gros won. Exhibited at the 1808 Salon opposite the *Coronation*, his painting shows a compassionate sovereign, simple and calm, forced to fight in spite of himself, while his medical officers treat soldiers on both sides equally. The emperor was so pleased that he gave the painter his own Legion of Honor medal.

But initially, the Louvre was not the recipient of such works. These paintings by living artists—purchased from the Salon or commissioned by the state—were to enrich a new museum, opened in 1818 at the Palais du Luxembourg, or to decorate imperial institutions and residences. After being in limbo under the Restoration, the historical paintings populated the rooms of the Musée de l'Histoire de France that Louis-Philippe established at the Château de Versailles. It was therefore only belatedly that the Louvre's collection of large history paintings was formed.

Taking official art as their model, painters depicted war with panache. Gros—at the height of his glory—painted Joachim Murat, king of Naples and brother-in-law of the emperor, on his horse, which is covered with a tiger skin and rearing on its hind legs. The painting appeared in

the 1812 Salon opposite *The Charging Chasseur*, or *An Officer of the Imperial Horse Guards Charging* by the then-unknown painter Théodore Géricault. The sumptuous royal cavalryman pales before the simple officer, who the painter invested all his energy in this unconventional composition. The young Géricault would make a double success with *The Wounded Cuirassier* at the 1814 Salon, which seemed to announce the drama of defeat at the same time as it exalted stoicism.

In addition, the large room shows that ancient history was not dead. David continued to cultivate it, despite the interlude of the commission for the *Coronation*. He painted *The Intervention of the Sabine Women* and presented it to his admirers, from 1799 to 1805, in his studio in the Louvre, before creating *Leonidas at Thermopylae* (1814). Others adopted this theme: Pierre Narcisse Guérin, whose *Phaedra and Hippolytus* was acquired at the 1802 Salon and the voluptuous *Aurora and Cephalus* was exhibited at the 1810 Salon. The beginnings of Jean Auguste Dominique Ingres's career also promised a rich future. Two singular painters, however, upset this classical order: Girodet and Prud'hon.

Girodet's *Scene of the Flood*, shown in the Salon of 1806, explored the sublime, the strange, the bizarre through heightened drama, while in his *Entombment of Atala* (1808), illustrating Chateaubriand's 1801 novel, Chactas's desperate farewell to his lost love is tinged with a gentle sweetness. Here, emotion is expressed in the virgin whiteness of the feminine body against the dark surroundings. As for Prud'hon, tasked with producing an allegory for the Palais de Justice, in *Justice and Divine Vengeance Pursuing Crime*, the inanimate body of a victim shimmers in dusky twilight, while the violent diagonal orientation of the hunt for the doomed criminal is illuminated by the gray light of the rising moon. At the same time, his *Psyche Carried Off by Zephyr* is a subtle and luminous female nude.

For a panoramic view of paintings under the Empire, you also need to visit the second floor of the Cour Carrée, which displays smaller paintings featuring genre scenes, landscapes, and portraits. However, the Red Room has the most significant examples of the art of portraiture: the languid Empress Josephine, painted by Prud'hon in the park of her Château de Malmaison; the enigmatic ingenuity of Mademoiselle Rivière captured by Ingres (Salon of 1806); the fixed gazes of beautiful ladies in white dresses affecting an attitude of simplicity, like Madame Récamier lying on a chaise longue or Madame de Verninac, who leans idly against the back of a chair.

The large painting room of the Salle Daru
Left to right: Baron Gros (1771–1835), *Christine Boyer*; Pierre-Paul Prud'hon (1748–1823), *Psyche Carried Off by Zephyr* and *The Empress Josephine*; François Édouard Picot (1786–1868), *Cupid and Psyche* (top); Jean Auguste Dominique Ingres (1780–1867), *Philibert Rivière*, *Mademoiselle Caroline Rivière*, and *Madame Rivière*; Jacques-Louis David (1748–1825), *Juliette de Villeneuve*; Ingres, *Count Mathieu-Louis Molé* and *The Apotheosis of Homer* (top)
Department of Paintings

Théodore Géricault (1791–1824)
The Wounded Cuirassier, Salon of 1814
Oil on canvas, 358 × 294 cm (141 × 115 ¾ in.)
Department of Paintings, acquired at the sale
of Louis-Philippe, 1851

Opposite
Jacques-Louis David (1748–1825)
The Intervention of the Sabine Women, 1799
Oil on canvas, 385 × 522 cm (151 ½ × 205 ½ in.)
Exhibited in David's studio at the Louvre from
1799 to 1805 and in the Salon of 1808
Department of Paintings, acquired in 1819

This large painting shows the Sabine women
standing between the Roman and Sabine men,
advocating national reconciliation after the
Revolution. It is the culmination of the purism
that the master taught his many students.

Jacques-Louis David (1748–1825)
Leonidas at Thermopylae, 1814
Oil on canvas, 395 × 531 cm (155 ½ × 209 in.)
Department of Paintings, acquired in 1819

David worked for ten years on this exaltation
of Spartan heroism, in which the nude becomes
the very symbol of this virtue.

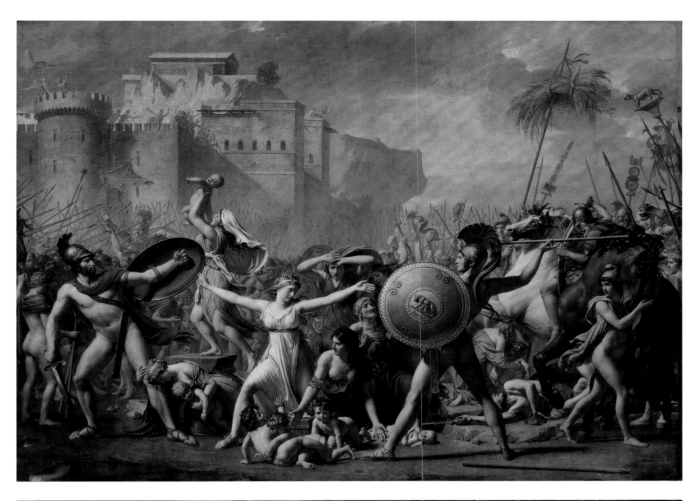

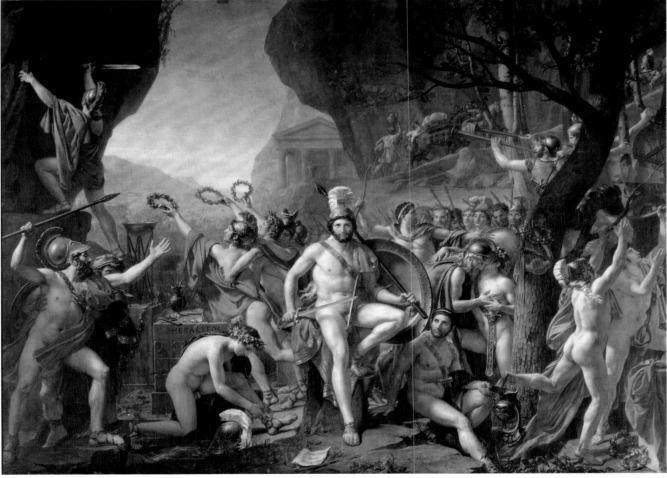

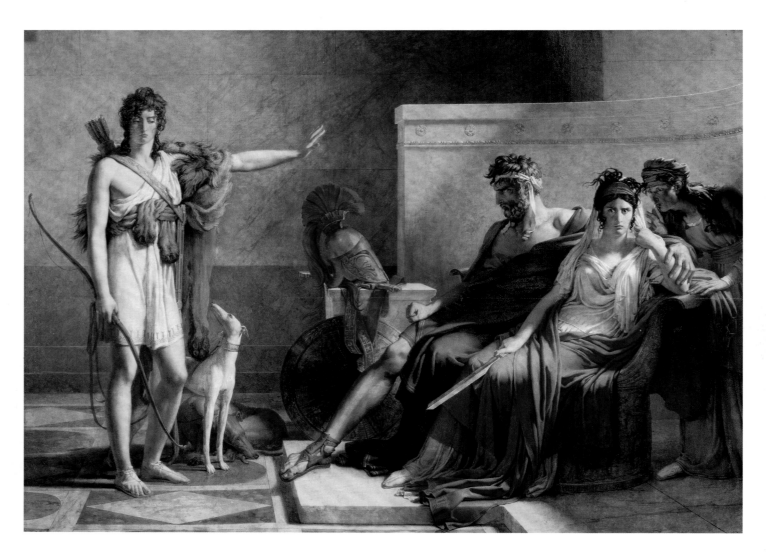

Baron Pierre Narcisse Guérin (1774–1833)
Phaedra and Hippolytus, Salon of 1802
Oil on canvas, 33 × 46 cm (13 × 18 ⅛ in.)
Department of Paintings, acquired in 1982

Opposite
Pierre Narcisse Guérin (1774–1833)
Aurora and Cephalus, Salon of 1810
Oil on canvas, 254 × 186 cm (100 × 73 ¼ in.)
Department of Paintings, bequest of Countess
Bernardin de Sommariva, born Catherine
Seillière, 1888

A student of Regnault and influenced by
David, Guérin emphasized dramatic effects,
reinforced by a powerful use of light. The
painting was commissioned by Sommariva,
patron of Canova and Prud'hon.

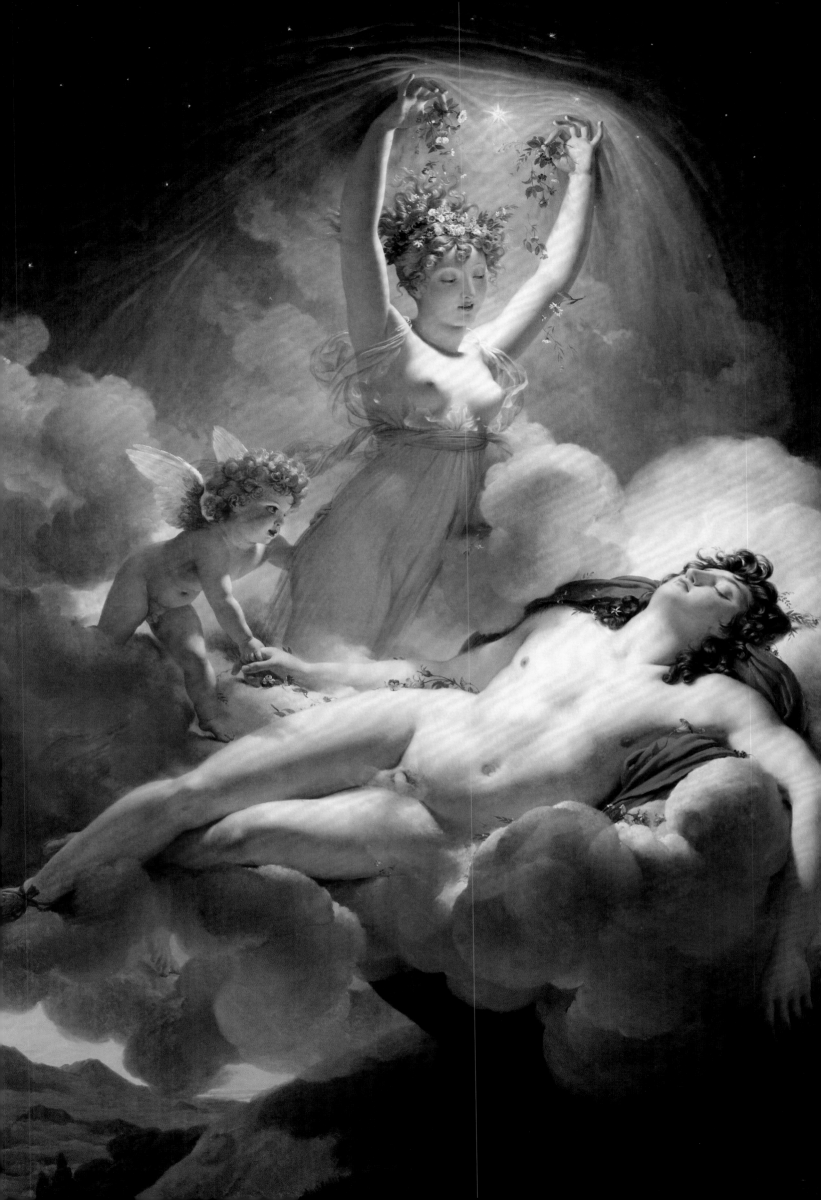

Opposite
Anne-Louis Girodet de Roucy, known as
Girodet-Trioson (1767–1824)
Scene of the Flood, 1806
Oil on canvas, 441 × 341 cm (173 ½ × 134 ¼ in.)
Department of Paintings, acquired in 1818

Here, Girodet tackles a "sublime" subject.
Despair and death are expressed with a rare
intensity in this monumental composition
in which bodies stand out against the terrible
darkness of nothingness. He was thus one of
the great proponents of Romanticism.

Pierre-Paul Prud'hon (1758–1823)
Justice and Divine Vengeance Pursuing Crime,
Salon of 1808
Oil on canvas, 244 × 294 cm (96 × 115 ¾ in.)
Department of Paintings, entered the Louvre in 1826

The allegory, with a highly appropriate theme for
its destination, was commissioned in 1804 for
the Palais de Justice in Paris. Prud'hon's powerful
figures meld with the gloom of twilight save for
the stark white pallor of the dead body in the
foreground.

Following spread
The large painting room of the Daru Gallery
Above: *Justice and Divine Vengeance Pursuing Crime*
by Pierre-Paul Prud'hon (detail; see p. 305)
Below: Jean Auguste Dominique Ingres (1780–1867),
Une Odalisque, also known as *La Grande Odalisque*,
1814, oil on canvas, 91 × 162 cm (35 ⅞ × 63 ¾ in.)
Department of Paintings, acquired in 1899

Ingres's large nude, painted for Caroline Bonaparte,
queen of Naples, favors a bodyline of impeccable
formal beauty at the expense of anatomical truth.
Here, Orientalism is a pretext for a refined harmony
of pearly flesh and intense blue.

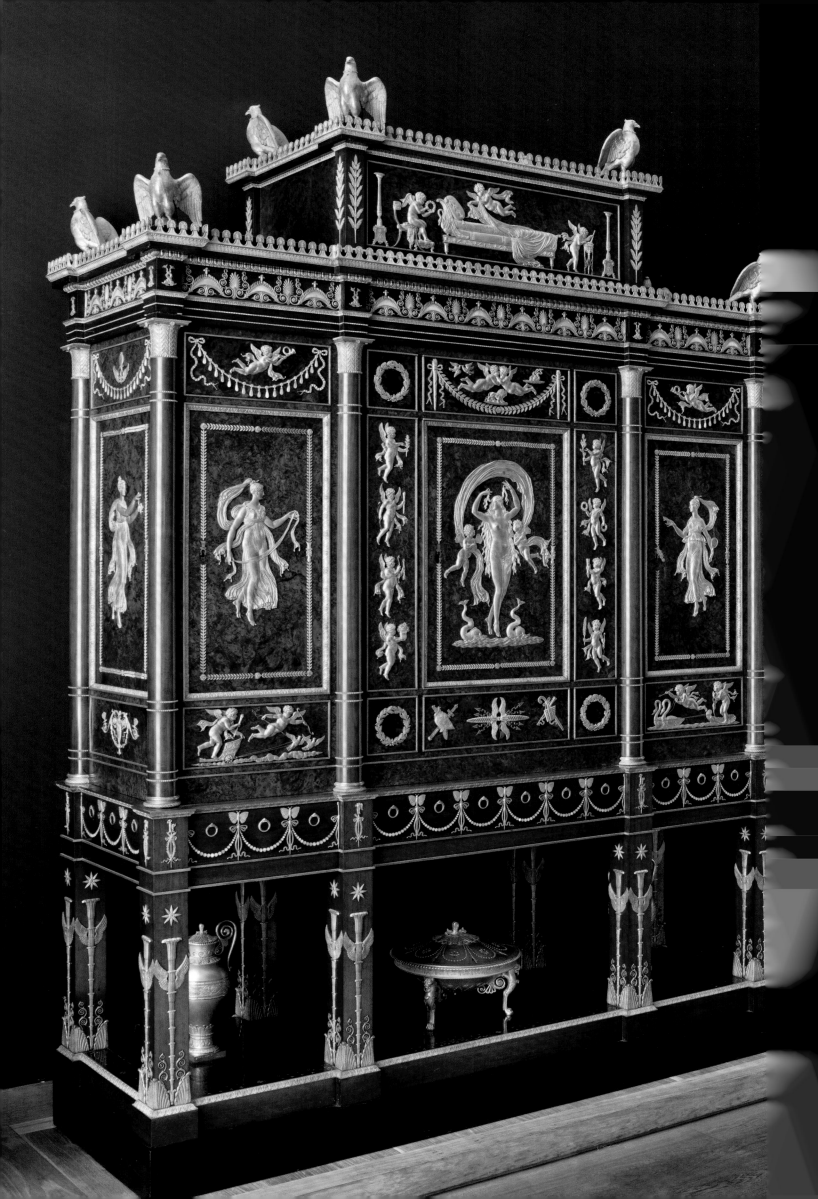

In the Department of Decorative Arts:
The Sophistication of the Imperial Manufactories

The art of the imperial manufactories is exhibited in the Department of Decorative Arts on the first floor of the Richelieu Wing, set up in 1993 in the former Ministry of Finance. The emperor in particular protected these institutions which dated from the Ancien Régime; they provided for the furnishing of his residences and demonstrated to Europe the expertise and ingenuity of French craftsmanship. The Savonnerie manufactory wove carpets such as the one intended for the Conseil d'État that, at the end of its long period of production (1806–9), was placed in the Tuileries throne room; only the central medallion, stamped with the crowned imperial eagle and surrounded by the necklace of the Legion of Honor, remains today.

The Sèvres Manufactory embarked on a series of brilliant technical innovations made possible by its director, Alexander Brongniart, and thanks to his training as a chemist. Under his authority, painters displayed their talent in charming and often intricate decorations of a stunning variety, executed with meticulous care. In the display cases, there are examples of pieces ornamented with large landscapes, portraits of illustrious men, and mythological scenes. Modelers produced complicated objects that have the qualities of fine sculpture and the most delicate relief. Elements of the imperial table's centerpieces, made of hard-paste porcelain (biscuit ware), reproduced the antiquities of the Musée Napoléon, an initiative that surely owed a great deal to Vivant Denon, director of both the museum and the manufactories. Some prestigious pieces were purely decorative. Napoleon celebrated the baptism of his son, the king of Rome, in 1811 with a series of gifts in Sèvres porcelain. Madame Mère, the child's godmother, received a spindle vase more than a meter long. The painter Georget depicted Napoleon on Mont Saint-Bernard on the vase's belly, after a painting by David.

The furniture rooms also feature a selection of the most emblematic imperial pieces. To store the jewelry-loving empress Josephine's extensive collection, an elaborate cabinet was delivered to the Tuileries Palace in 1809. Its author, cabinetmaker Jacob-Desmalter, working from Charles Percier's drawings, surpassed himself. The gilded bronze goddess at the center, modeled by the sculptor Chaudet, was cast and engraved by the bronze-maker Thomire, the most famous of his time. We have already seen the work of the goldsmith Biennais in his reconstruction of the coronation regalia. He, too, was an extraordinary professional of his trade.

Tripod of the personal centerpiece
of Napoleon I, 1810
Sèvres Manufactory, biscuit ware
H. 43.5 cm (17 ⅛ in.)
Department of Decorative Arts,
gift of Mr. Jacques Lejeune
The Louvre exhibits part of the centerpiece, which consisted of a quadriga, tripods, vases, and sixteen statues and famous objects inspired by antiques from the museum. The architect Alexandre-Theodore Brongniart provided the drawings, which Napoleon approved in 1808. The whole set was delivered to the Tuileries before the wedding of the emperor and Marie-Louise.

Pair of antique candelabras, part of the personal centerpiece of Napoleon I at the Tuileries, 1810
Sèvres Manufactory, biscuit ware of hard-paste porcelain, marble, H. 87 cm (34 ¼ in.)
Department of Decorative Arts,
gift of Mrs. Akram Ojjeh, 1997

Opposite
François-Honoré-Georges Jacob-Desmalter (1770–1841), based on Charles Percier's drawings; central motif by Pierre Philippe Thomire, based on a model by Antoine Denis Chaudet: *The Birth of the Queen of the Earth*
Jewelry cabinet of Empress Josephine, known as the "Grand Ecrin", 1809
Yew, amaranth, mahogany, ebony, mother-of-pearl, gilt bronze, H. 276 cm (108 ⅝ in.)

Produced for the large bed chamber in the Tuileries, where it was used successively by the empresses Josephine and Marie-Louise
Department of Decorative Arts, on loan from the Musée National du Château de Fontainebleau, 1964.

Collections from All over the World

A Universal Museum:
The Revolutionary Confiscations in France

The museum was getting richer. The revolutionary government had declared it a domain for the universal arts. The first confiscations were those of the royal collections. Even before the proclamation of the Republic, the Legislative Assembly decided to sort the statues and paintings from royal houses and monuments according to the criterion of "which deserve to be preserved for the instruction and glory of the arts." This was the work of the museum's commission, and then of the conservatory that succeeded it from 1794 to 1797. Of course, the paintings were the first to be selected, but drawings, enamels, and some sculptures would follow.

The confiscations of the Crown Collections brought a very important group of Italian and French works from Versailles, Fontainebleau, and Saint-Germain-en-Laye. At the end of 1792, 125 paintings were transferred from Versailles, including Leonardo's *La Belle Ferronnière*, Raphael's *The Virgin and Child the Young Saint John the Baptist* or *Belle Jardinière*, works by Poussin, etc. In 1798, the apartments and gardens of Versailles were emptied of their large ancient statues: *Diana with Stag*, *Bacchus*, the *Venus of Arles*, the supposed *Germanicus* and *Cincinnatus*, the *Triton*, the *Venus Genetrix*, *Jupiter* in term, and many busts.

The Crown Collections' furniture repository, open to the public in Ange-Jacques Gabriel's building on Place de la Concorde (formerly Louis XV), was inventoried. The bronzes were divided between those that the nation intended to keep and others that were given or sold for paying the suppliers of the Republic's armies. The Cabinet des Dessins, with its immense collection of drawings, was also impounded, as well as some sculptures by Sarazin and Van Opstal. The collections of the Academy of Sculpture and Painting were distributed based on periods and techniques. In painting, the oldest reception pieces remained in the Louvre, the most recent ones slated for the Musée Spécial de l'École Française, which was to be created at the Château de Versailles.

Confiscations in the Churches

After the decree of 2 November 1789, proclaiming that "all ecclesiastical goods are at the disposal of the Nation," the impounding of treasuries and works of art was foreseeable. In March 1791, Louis XVI gave the order to remove the most important pieces from Sainte-Chapelle: the cameos and manuscripts joined the king's library (the future Bibliothèque Nationale); the rest were taken to the abbey of Saint-Denis. In September 1791, inventories of church property were carried out, but the transfer of objects was delayed by the reluctance of the inhabitants, who were anxious to defend their heritage. Finally, on November 1793, when Saint-Denis was renamed Franciade, the treasuries of Saint-Denis and Sainte-Chapelle combined were delivered to the Convention as a "republican offering." Pieces were reserved for the museum and sent to the Louvre in December 1793. Thus, the most outstanding works of the Middle Ages were saved, despite the value of their gold and silver mounts and ornaments of precious stones. While major works ended up in the Mint's crucible, (such as Charles the Bald's gold altar), others, such as ivories, enjoyed a happier fate. Some elements were later transferred to the Bibliothèque Nationale's cabinet of antiquities, but at both the Louvre and the Bibliothèque, several robberies reduced these prestigious collections.

At the Louvre, however, the treasuries of Saint-Denis and Sainte-Chapelle still shine brightly in the vast Salle des Objets d'Art du Moyen Âge (Gallery of Decorative Arts of the Middle Ages), built in 1993. In addition to the regalia (scepter and sword)—symbols of the monarchical past that somehow escaped destruction—the Louvre exhibits sumptuous mounted hard stones: the serpentine paten inlaid with gold fish, set with a rich mount at the court of Charles the Bald, and the vases mounted for Abbot Suger. His term at Saint-Denis

Paten, 1st century B.C. or A.D. (paten),
and workshop of the court of Charles the Bald,
second half of the 9th century (frame)
Serpentine, gold, stones, glass,
D. 17 cm (6 ¾ in.)
From the Treasury of the abbey of Saint-Denis
Department of Decorative Arts, seized during
the Revolution, 1793

Opposite
Three precious vases from the treasury
of Saint-Denis, with goldsmith's mounts
commissioned by Abbot Suger
Left: Sardonyx ewer, Byzantium, 7th century (?),
mount before 1147 and 15th century, niello and
gilded silver, precious stones, pearls, H. 35.7
cm/14 in. (dedication inscription by Abbot
Suger: "Since we have to make sacrifices to God
with gold and precious stones, I, Suger, offer
this vase to the Lord")
Center: "Suger's Eagle" (vase), Egypt or
Imperial Rome, red porphyry, front mount
1147, niello and gilded silver, H. 43.1 cm (17 in.)
Right: "Vase of Eleanor," 6th–7th century (?),
rock crystal, mount before 1147, 13th and 14th
centuries, niello and gilded silver, precious
stones, pearls, champlevé enamels on silver,
H. 33.7 cm (13 ¼ in.)
Department of Decorative Arts

abbey (1122–51) represented a pinnacle in the arts. According to Suger, beauty, therefore precious stones or stained glass, offered a mystical pleasure close to divinity; he also recounted how he enriched the treasury with liturgical vases. Brightly shining in glass display cases include the Fatimid ewer of rock crystal, the "Vase of Eleanor," named after Queen Eleanor of Aquitaine; the Sardonyx ewer; and especially "Suger's Eagle"—a slender porphyry vase with two wing-shaped handles, surmounted by a long neck and a raptor's head, designed by the abbot himself. But Saint-Denis was also enriched during the Gothic period. In 1339, Queen Jeanne d'Évreux, wife of Charles IV the Fair, had offered one of the most precious statuettes of the Virgin in gilded silver, with a pedestal finely decorated with scenes from the life of Christ in opaque and translucent enamel. This royal gift is echoed by the ivory *Virgin* from the treasury of Sainte-Chapelle (ca. 1250–60), which is of exceptional size.

The large church paintings, deprived of their religious context and meaning, became museum works during the Revolution. After a stay in the Petits-Augustins repository, eighty-eight paintings reached the Louvre at the end of 1792, with a preference for very large formats. Simon Vouet's *Presentation in the Temple* (ca. 1640–41), which adorned the altarpiece of Saint-Louis, the church of the Jesuits in Paris (now Saint-Paul-Saint-Louis), can be found next to the

Following spread
Virgin and Child, 1324–39
Gilded silver, stones, and pearls, pedestal decorated with basse-taille enamel on gilded silver, h. 68 cm (26 ¾ in.)
Gift of Queen Jeanne d'Évreux to the abbey of Saint-Denis in 1339
Department of Decorative Arts, seized during the Revolution, 1793

The statuette rests on a pedestal decorated with scenes of the Passion in blue and red enamels on a silver ground. The Virgin holds a fleur-de-lis of gilded silver and crystal.

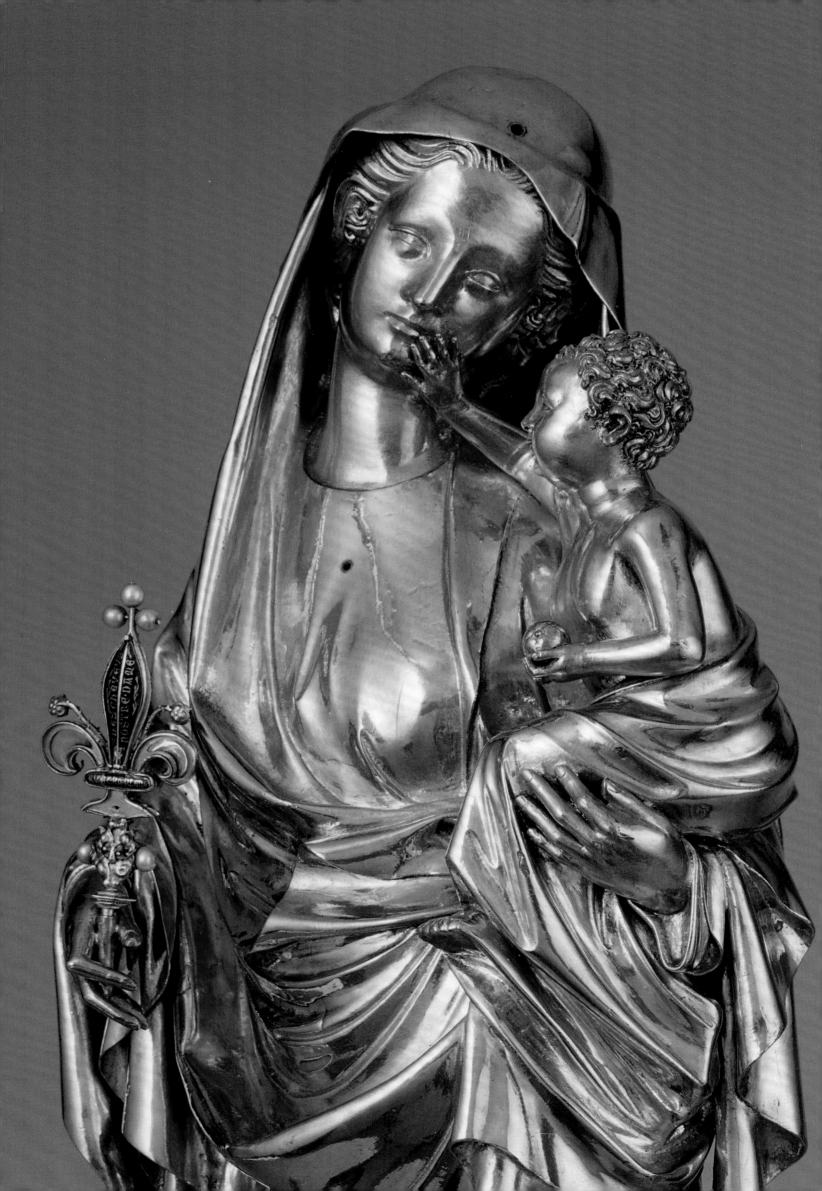

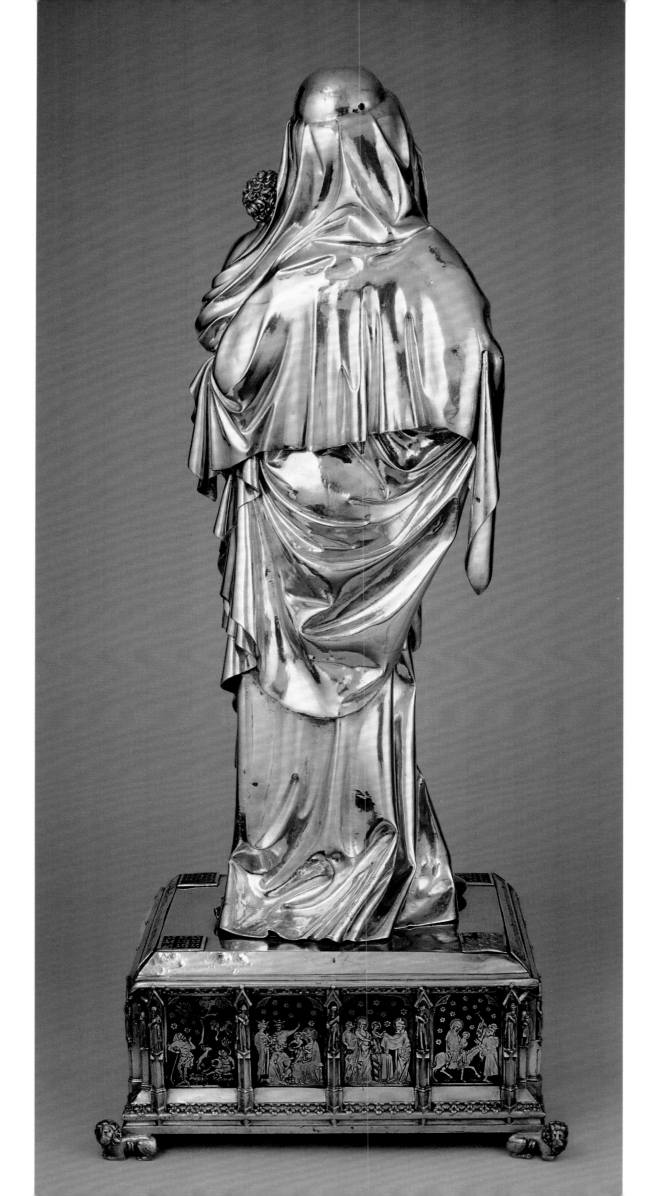

Jan Van Eyck (1390/95–1441)
Chancellor Rolin Praying Before the Virgin, also
known as *The Virgin and Child with Chancellor Rolin*
Oil on wood panel, 66 × 62 cm (26 × 24 ⅜ in.)
Commissioned ca. 1434–35 by Nicolas Rolin,
bishop of Autun and chancellor of the duke of
Burgundy Philippe le Hardi, for his oratory
at Notre-Dame-du-Châtel in Autun; left, the
terrestrial world; right, the celestial world;
bottom, a vast landscape that small characters
gaze upon from a balustrade
Department of Paintings, seized during the
Revolution, transferred to the Louvre in 1800

Opposite
Simon Vouet (1590–1649)
The Presentation in the Temple, ca. 1640–41
Oil on canvas, 393 × 250 cm (154 ¾ × 98 ⅜ in.)
Large painting on the altarpiece of the church
of Saint-Louis, Jesuit professed house in Paris,
now church of Saint-Paul-Saint-Louis
Department of Paintings, seized during
the Revolution

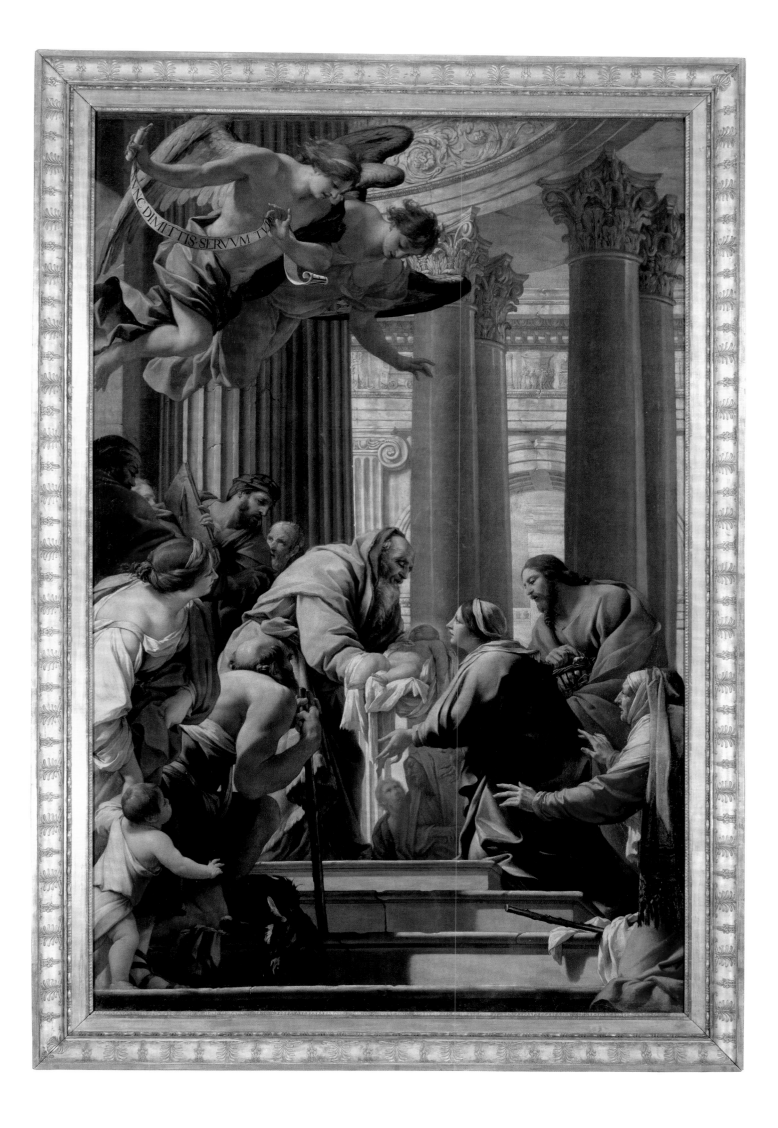

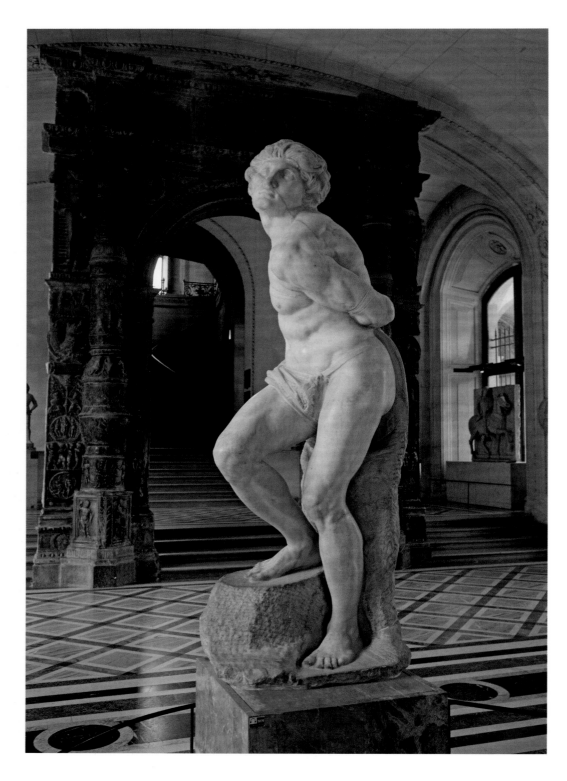

Above and opposite
Michelangelo Buonarroti, known
as Michelangelo (1475–1564)
Captive, known as *The Rebellious Slave*,
and *Captive*, known as *Dying Slave*, 1513–15
Marble, H. 209 and 228 cm (82 ¼ and 89 ¾ in.)
Executed for the tomb of Pope Julius II,
which remained unfinished; offered to
Francis I, who gave them to Constable Anne
de Montmorency, who placed them in a
niche in his Château d'Écouen; Henri de
Montmorency bequeathed them to Cardinal
Richelieu, who placed them on the facade of
his Château de Richelieu in Poitou
Department of Sculptures, seized during
the Revolution at the residence of the duke
of Richelieu in Paris, 1794

large painting by Le Sueur, *Martyrdom of Saint Gervais and Saint Protais* (1652), from the church of Saint-Gervais. However, it should not be assumed that the museum was only interested in classical art: for example, it chose *The Sacrifice of Christ* (1562) by Frans Floris, taken from Saint-Sulpice, and a *Descent from the Cross* from the early 16th century, seized at Val-de-Grâce. The museum also collected works of more private devotion, such as Jan van Eyck's *Chancellor Rolin Praying before the Virgin*, which came from the cathedral of Autun in 1800.

Confiscations of Émigré Property

Aristocrats, bankers, and parliamentarians who took the precaution of leaving the kingdom saw their property impounded by the nation. The most important collections found their way to the repository of the Hôtel de Nesle, rue de Beaune, where the museum would do its "shopping" among the 13,000 objects. Large collections of drawings became the nucleus of

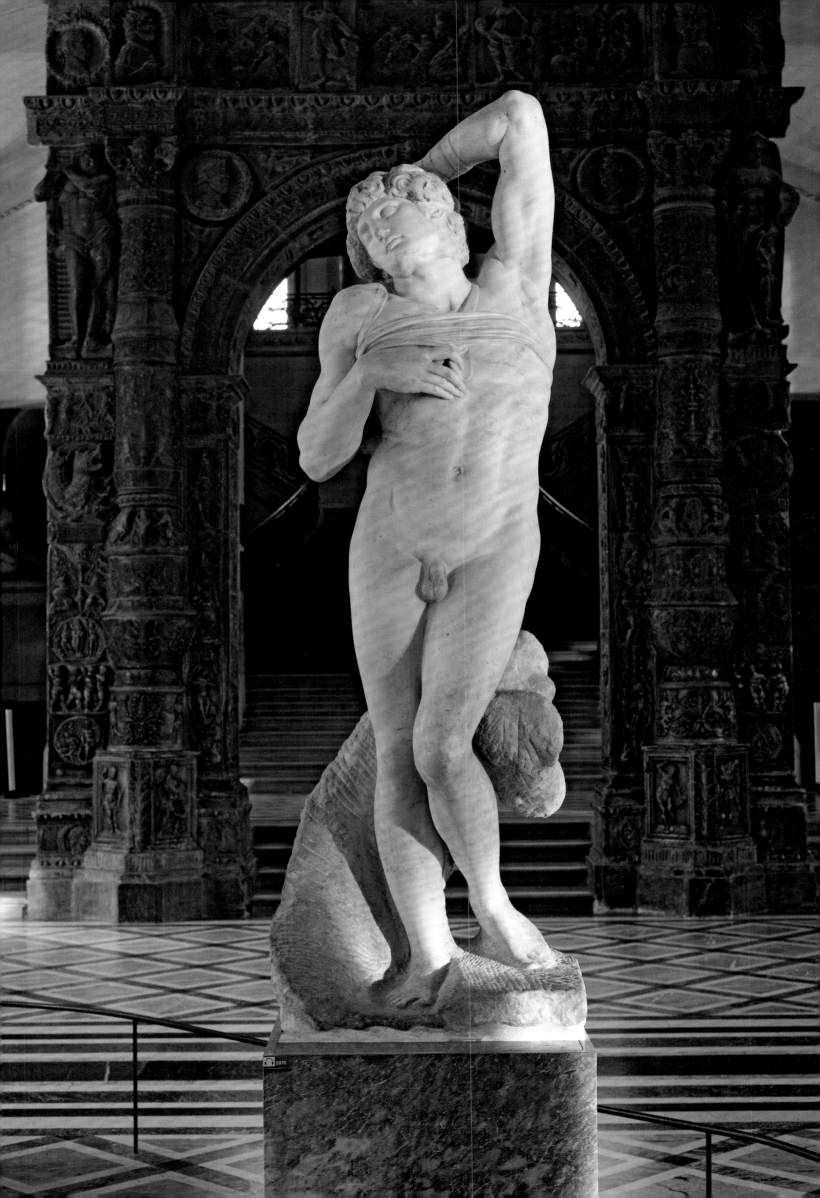

the Department of Graphic Arts—for instance those of the count of Orsay and Charles de Saint-Morys. From the residence of the duke of Richelieu in Paris, the museum would take the two figures of *Slaves* that Michelangelo carved in marble for the tomb of Pope Julius II. From the Condé family, the curators seized the relics of the Montmorency family: Léonard Limosin's enamel representing the Constable Anne de Montmorency (1556), which preserved in its frame two plaques inspired by the figures in the Francis I Gallery at Fontainebleau, and the *Pietà* from Château d'Écouen, painted by Rosso Fiorentino for the château's chapel.

Sometimes the curators collected their loot in faraway places. Thus, in 1800, Léon Dufourny and Ennio Quirino Visconti traveled to Richelieu, on the border of Poitou and Touraine, for the famous collection of antiques accumulated by Cardinal Richelieu, and a selection of paintings, including a set painted by Mantegna, Perugino, and Lorenzo Costa for Isabelle d'Este's *studiolo* in Mantua. At the Château d'Anet, the bas-relief of *The Nymph of Fontainebleau*, a masterpiece by Benvenuto Cellini, was removed. This exceptional tympanum, cast in Paris for Francis I and destined for the golden portal of his favorite château, was given by Henri II to his mistress, Diane de Poitiers, who installed it at the Château d'Anet. Fontaine decorated the Salle des Caryatides with it. The collection of ancient marbles of the count of Choiseul-Gouffier, former ambassador to Istanbul, was a prime target. It included the "Plaque of the Ergastines," the procession of young girls from the Parthenon frieze that he had exhumed in 1789. It was seized in Marseilles and transferred to the Louvre in 1798.

Revolutionary Confiscations in Europe

The revolutionary French armies that swept across Europe were to add an astonishing artistic booty to the museum collections. Under the Convention, during the invasion of Belgium in February 1794, a committee selected works of art and books. The victory of Fleurus, in June 1794, led to the conquest of the Netherlands and then of southern Germany. Rubens's large paintings from Antwerp's cathedral found their way to Parisian gallery walls. In army caravans, the quest continued in Holland, with the confiscation of Dutch statdholders' works in 1795, then in Germany. The elector of the Palatinate in Düsseldorf was forced to part with paintings from his collections, as was the king of Bavaria in Munich.

The booty was particularly fruitful in Italy under the Directory. However, at the initiative of Quatremère de Quincy, art historian and deputy, in 1796, a petition circulated by major figures demanded an end to the plundering in Italy, stating the principle that heritage was inseparable from the places where it was created, forming its spiritual and cultural soil. Nevertheless, confiscation by the French Republic continued unabated. The "Government Commission for the Search for Objects of Science and Art in the Countries Conquered by the Republic," chaired by the mathematician Gaspard Monge, helped itself to the masterpieces of Bologna, Modena, Parma, Milan, Ferrara, and Verona. The first convoy from Lombardy arrived in Paris at the end of 1796. After classification and study, 142 paintings taken in Lombardy were exhibited in the Salon Carré in 1798.

Through the Treaty of Tolentino, signed with the pope on 19 February 1797, the Louvre inherited the masterpieces of the Vatican: Raphael's paintings, including *Transfiguration*; Titian; Caravaggio; Veronese; as well as the most famous antiquities of the Belvedere and the Capitoline. The most prestigious artworks were appropriated on that trip: the *Apollo Belvedere*, the *Laocoön*, the *Nile*, and the *Tiber*. Through another treaty with the Austrian emperor, signed in Campo Formio (today Campoformido) on 18 October of the same year, the Republic conceded Venice to Austria against Milan. The commission took this as an opportunity to seize Venice's masterpieces. On 27 July 1798, the works from Rome and Venice thus arrived in procession and were paraded through Paris, from the Champ-de-Mars to the Louvre, before being placed in the museum. Mirliton's words accompanied them:

Greece gave them up: Rome lost them,
Their fate changed twice; it will never change again.

Giovanni Battista di Jacopo, known as Rosso Fiorentino (1494–1540)
Pietà
Oil on wood, transferred to canvas in 1802, 127 × 163 cm (50 × 64 ⅛ in.)
Executed for the chapel of Constable Anne de Montmorency
in Écouen castle; one of the figures inspired Jean Goujon's
Lamentation of Christ (see pp. 62–63)
Department of Paintings, seized during the Revolution, 1798

Andrea Mantegna (1431–1506)
*Minerva Expelling the Vices from
the Garden of Virtue*, 1500–02
Oil on canvas, 160 × 192 cm
(63 × 75 ⅝ in.)
Painted for Isabelle d'Este's
studiolo in Mantua castle,
Gonzaga collection, sold to
Charles I of England and then
to Cardinal Richelieu and
placed in his château in Poitou
(see another painting for
the *studiolo* on p. 274)
Department of Paintings,
seized by Léon Dufourny at the
Château de Richelieu in 1801

Cenni di Pepe, known as Cimabue
(active 1272–1302)
*The Virgin and Child in Majesty Surrounded
by Six Angels (Maestà)*, ca. 1280
Tempera on wood panel, 427 × 280 cm
(168 × 110 ¼ in.)
From the church of San Francesco in Pisa
Department of Paintings, seized
by Dominique Vivant Denon in the
repository of the Campo Santo in Pisa in 1813

Opposite
Giotto di Bondone (ca. 1267–1337)
Saint Francis of Assisi Receiving the Stigmata,
ca. 1298
Tempera on wood panel, 330 × 178.5 cm
(130 × 70 ¼ in.)
From the church of San Francesco in Pisa,
then from the church of San Nicola
Department of Paintings, seized by Dominique
Vivant Denon in the repository of the Campo
Santo in Pisa in 1813

The Horses of Saint Mark, ancient bronzes from Corinth, that were transferred to Byzantium and collected by the Venetians during the Fourth Crusade, arrived in Paris for a fairly short stay (1798–1815)—they would perch on the Tuileries entrance gate before decorating the imperial quadriga at the top of the Arct de Triomphe du Carrousel. While the paintings were quickly exhibited in the Salon Carré at the end of 1798, installing the collection of sculptures would have to wait for the refurbishment of new rooms.

The pope wasn't the only supplier in Rome. Prince Albani's collection was also confiscated, as well as Prince Braschi's, whose colored marble centerpiece—with antique marble, bronze gems, statuettes, and busts—exhibited in the Department of Decorative Arts. A third exhibition, with works from Turin and Florence, took place. Even the *Venus de' Medici*, which had been placed in storage and joined the Musée des Antiques in 1803, was displayed.

The Republic's campaigns were followed by those of the emperor, in which an avid Denon, nicknamed the "vulture," participated. To conquer Germany, Napoleon allied himself with the Russian czar and led a victorious campaign all the way to Berlin. The exhibition of artworks taken in Brunswick, Cassel, Danzig, and Berlin was held in October 1807 in the Rotonde de Mars and the Salle de Diane. Antiquities, paintings, enamels, and drawings were swept up in huge quantities by Denon, who carefully followed the progress of the conquests and deployed army convoys to collect the works.

Denon hadn't had his last word with the conquests in Germany. In 1809, he was at the Vienna Belvedere, hunting new prey in the capital of the defeated Habsburg Empire. In 1811, he left for Italy, where the artworks of the suppressed convents were collected into repositories, in imitation of the impounded works in France. He negotiated the transfer

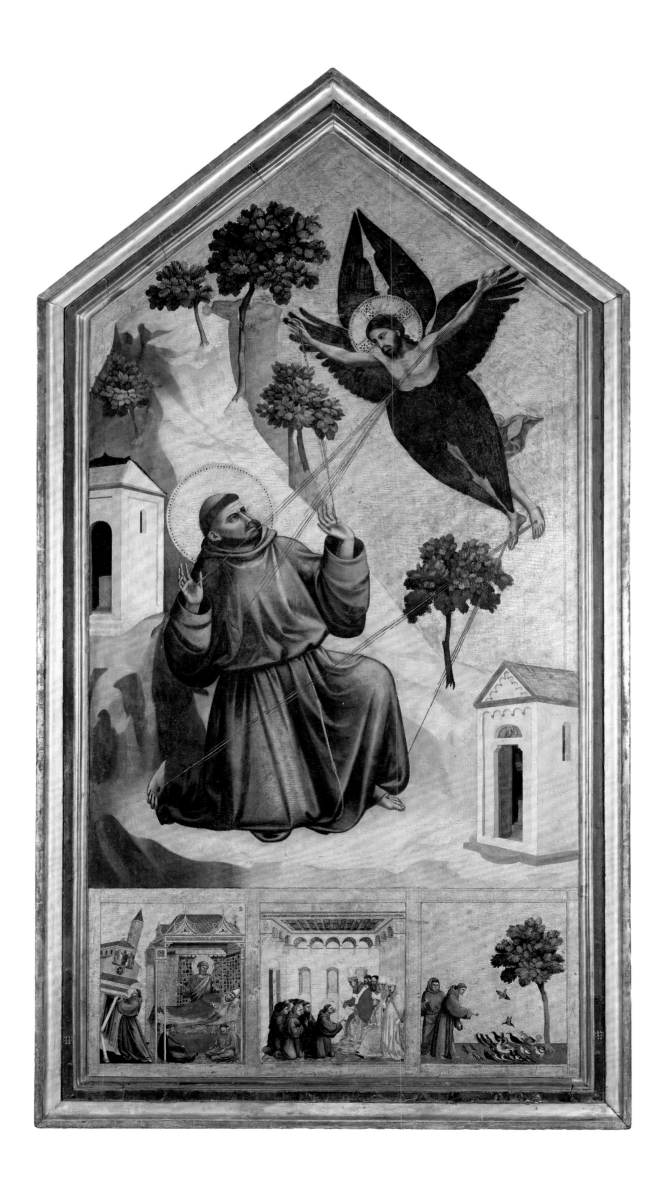

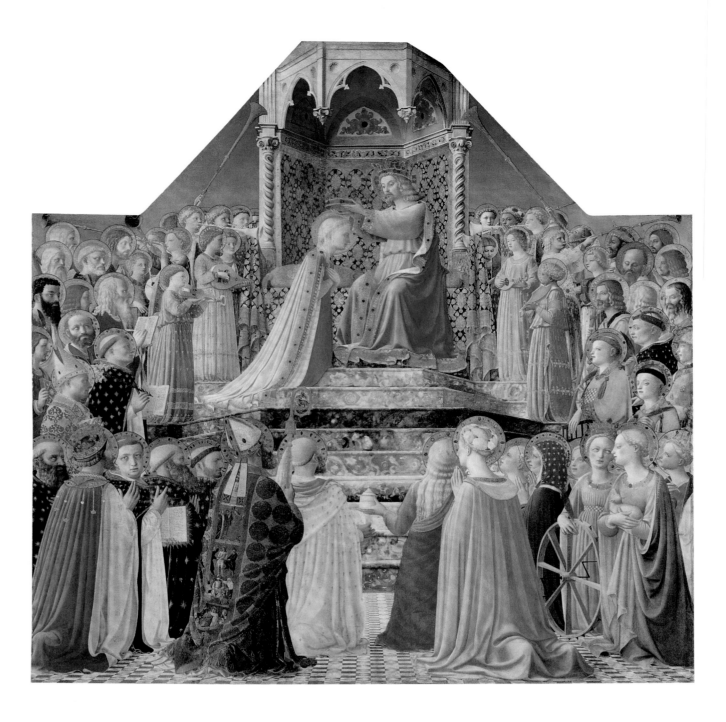

Guido di Pietro, known as Fra Angelico
(active 1417–55)
The Coronation of the Virgin, ca. 1430–32
On the predella: scenes from the life
of Saint Dominic
Tempera on wood panel, 209 × 206 cm
(82 ¼ × 81 ⅛ in.)
Altarpiece painted for the Dominican
convent of Fiesole, of which Fra Angelico
was to become prior
Department of Paintings, seized
by Dominique Vivant Denon in 1812

of what he considered essential to the museum. Ahead of his time, he favored the oldest painters, to whom the term "primitive" was applied from that time on. In 1813, the two large altarpieces *(pala)* from the Franciscan convent of Pisa, *The Virgin and Child in Majesty Surrounded by Six Angels* by Cimabue and *Saint Francis of Assisi Receiving the Stigmata* by Giotto, entered the Louvre. At the very end of the conquests, the war in Spain provided a final batch of paintings. But this haul was less than expected and disappointing, such that two other predators, King Joseph Bonaparte, the emperor's brother, and Marshal Soult took the lion's share of the pillaged works for themselves.

When the Empire fell in 1815, curators from Berlin, Madrid, and Rome—supported by the British—came to reclaim their property. Denon, however much he may have wanted to resist, threw in the towel, resigned, and withdrew into his apartment on Quai Voltaire, opposite the Louvre he loved so much and which was being dismantled. Antonio Canova intervened for the pope, even though the artist had sculpted so many works for the imperial family and had even just finished a heroic nude statue of Napoleon, which he managed to sell in England; yet, he was certainly less motivated than the German curators. Few works escaped these restitutions. Among the antiquities, the Louvre preserved the great *Tiber* from the Vatican, probably because it was too large and its base was in poor condition. It also kept a sarcophagus of San Francesco a Ripa with a beautiful marine thiasos, and several marbles from the Albani collection, including the Sarcophagus of the Muses. The prince, however, recovered most of his possessions and sold them in Bavaria.

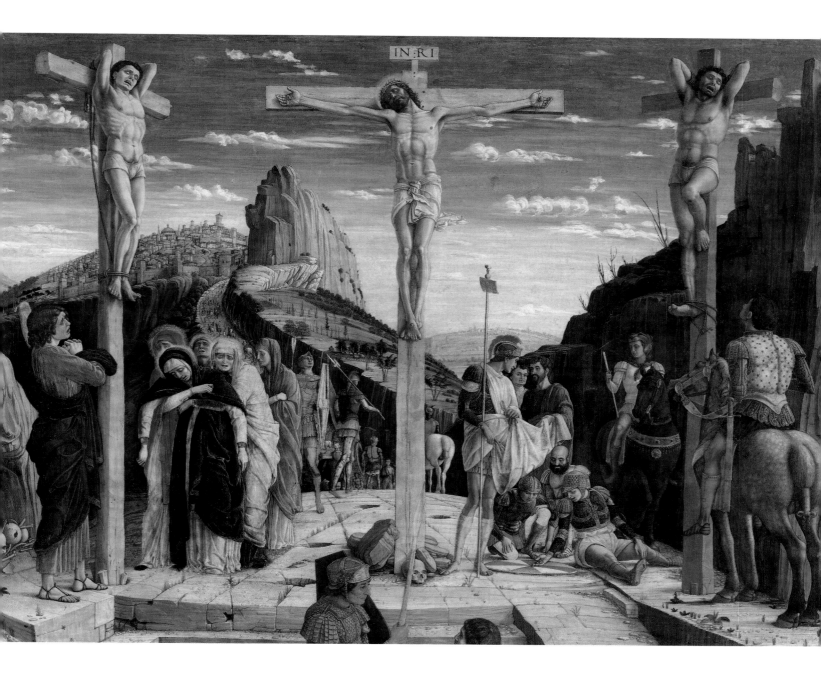

A rather exceptional group of paintings remain in the Louvre, some because their style had not yet been fully appreciated: the two paintings from Pisa by Cimabue and Giotto, *The Coronation of the Virgin*, painted by Fra Angelico for the Dominican church at Fiesole, and the *Calvary*, the central part of the predella of the altarpiece from San Zeno of Verona by Mantegna—the other two fragments of which have been deposited in the Musée de Tours. By the same artist, the great *Virgin of Victory*—an ex-voto of Francesco II Gonzaga for the Santa Maria della Vittoria chapel in Mantua—remained in the Louvre. It was more difficult to retain the masterpieces of the Renaissance at its height. However, Louis XVIII succeeded in preserving Veronese's gigantic canvas, *The Wedding Feast at Cana* (1562–63), which adorned the refectory of San Giorgio Maggiore in Venice, in exchange for a *The Meal at the House of Simon* by Charles Le Brun and a sum of money. Also from Venice, the Louvre retained the sketch of the *Paradise* by Tintoretto from the Grand Council Chamber of the Doge's Palace—the preparatory studies were not as appreciated as the finished paintings. Germany also left some major works, many drawings and enamels, as well as Cranach's little *Venus*.

Other works were probably too large to survive the journey, such as Annibale Carracci's altarpiece, painted for the cathedral of Reggio Emilia, *The Apparition of the Virgin to Saint Luke and Saint Catherine*, which remains to testify to the colorful eloquence of Bolognese art. Some works had been inserted into the architecture and could not be removed. The bronze reliefs from the tomb of Marcantonio della Torre, masterpieces by Riccio, did not return to Verona

Andrea Mantegna (1431–1506)
The Crucifixion, known as *Calvary*, 1456–59
Tempera on wood panel, 76 × 96 cm
(29 7/8 × 37 3/4 in.)
Central part of the predella of a polyptych
from the church of San Zeno in Verona
commissioned by the protonotary
Gregorio Correr
Department of Paintings, seized in Italy in 1798

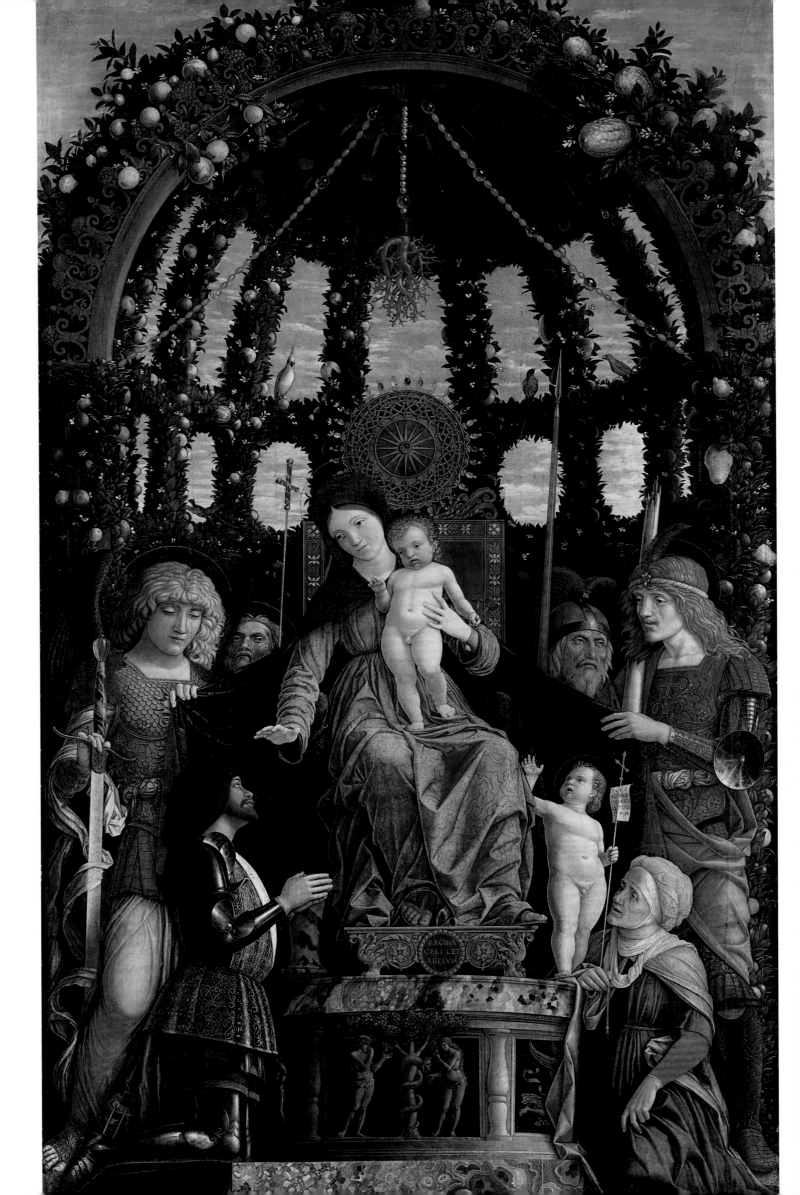

Opposite
Andrea Mantegna (1431–1506)
The Virgin of Victory
Oil on canvas, 285 × 168 cm (112 ¼ × 66 ⅛ in.)
Ex-voto commissioned by Francesco II
Gonzaga for Santa Maria della Vittoria in
Mantua after the victory of Fornovo against
the French Army (1496)
Department of Paintings, seized in Italy in 1798

Domenico Ghirlandaio (1449–1494)
The Visitation, 1491
Tempera on wood panel, 172 × 167 cm
(67 ¾ × 65 ¾ in.)
Commissioned by Lorenzo Tornabuoni
for his chapel in the church of Cestello,
today Santa Maria dei Pazzi, in Florence
Department of Paintings, seized
by Dominique Vivant Denon in 1812

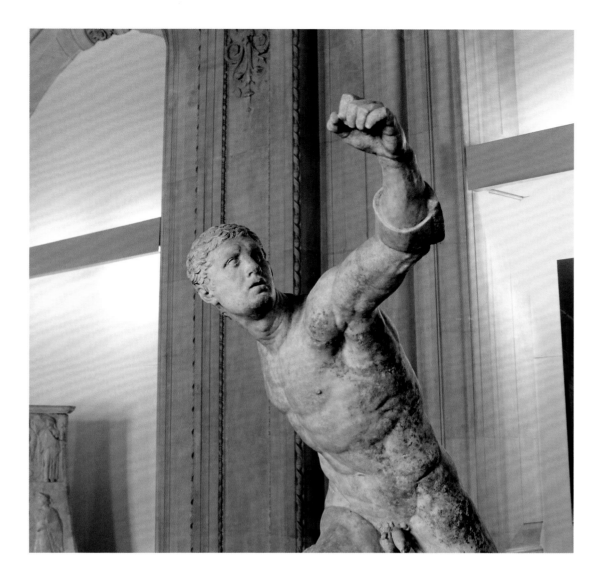

because Denon had them mounted as panels for the doors of the Salle des Caryatides; as well as the granite columns of Charlemagne's rotunda in Aachen, which remained to support the walls of the gallery of antiquities. Curiously, the Department of Decorative Arts kept the silver reliquary of Charlemagne's arm, also from the Imperial Chapel.

This vast confiscation enterprise should not be considered in a totally negative light. It provided an opportunity to create museums in the major cities of the Empire, like those that the Revolution had set up on French territory by the decree of 1801 at the initiative of minister of the interior Jean-Antoine Chaptal. This decree marked the birth of a network of great museums, to which many paintings were sent on loan: fifteen museums, including those in Brussels, Geneva, and Mainz—regions that were then integrated into French territory. The Brussels Museum of Fine Arts thus brought together masterpieces, some of which were shipped from Paris, such as *The Martyrdom of Saint Livinus* by Rubens, which had been acquired on behalf of the museum by Louis XVI. In the Kingdom of Italy, the transformations of the former academies into art galleries would come a little later. The Brera Pinacotheca of Milan became the central museum of Lombardy, inaugurated by Eugene de Beauharnais, king of Italy, in 1810. It received Flemish paintings, including Rubens's *Last Supper*, which ensured the cosmopolitanism of the collection. Based on this model, Bologna's Pinacotheca was established, in 1802. The gathering, and therefore, the preservation of church paintings in these Italian museums were the result of imperial policy.

The Borghese Collection

Prince Camillo Borghese had married the beautiful and frivolous Pauline, the emperor's sister. As early as 1806, he asked Denon and Visconti to study the acquisition of the fabulous collection accumulated by the Borghese family since the time of the extravagant

Agasias of Ephesus, son of Dositheos
Fighting Warrior, known as *Borghese Gladiator* (detail), ca. 100 B.C.
Marble, H. 199 cm (78 3/8 in.)
Discovered in Anzio in excavations financed by Cardinal Scipio Borghese, who included it in his collection before 1611; arm restored by Nicolas Cordier (1565–1612) or Guillaume Berthelot (1583–1648)
Department of Greek, Etruscan, and Roman Antiquities, Borghese collection, acquired in 1807

Opposite
Artemis (Diana) (detail)
Roman copy, 1st century A.D., of a Hellenistic original, the type of which is named after a statue from the Rospigliosi collection
Marble, H. 163 cm (64 1/8 in.)
Department of Greek, Etruscan, and Roman Antiquities, Borghese collection, acquired in 1807

Previous spread
Paolo Caliari, known as Veronese (1528–1588)
The Wedding Feast at Cana, 1562–63
Oil on canvas, 677 × 994 cm (266 1/2 × 391 1/4 in.)
Executed for the refectory of the Benedictine abbey of San Giorgio Maggiore in Venice
Department of Paintings, seized in 1798 and exchanged in 1815 for *The Meal at the House of Simon* by Charles Le Brun

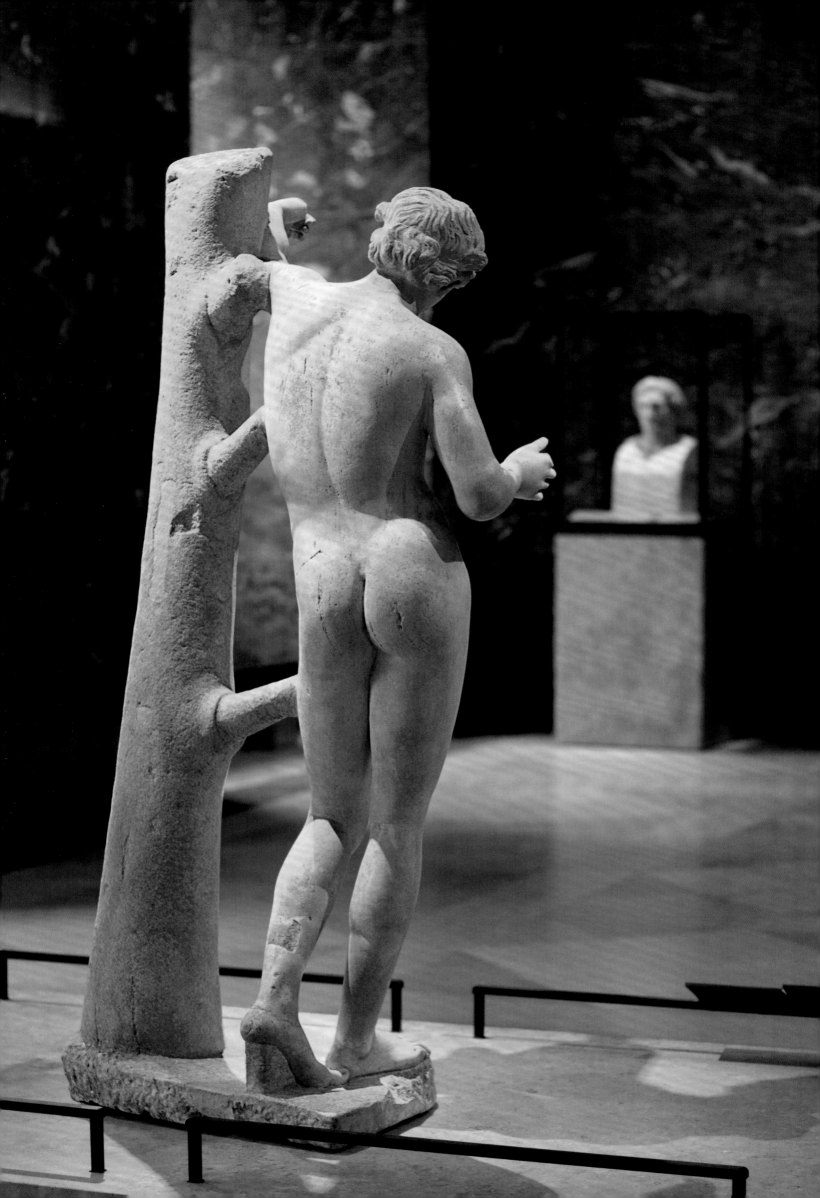

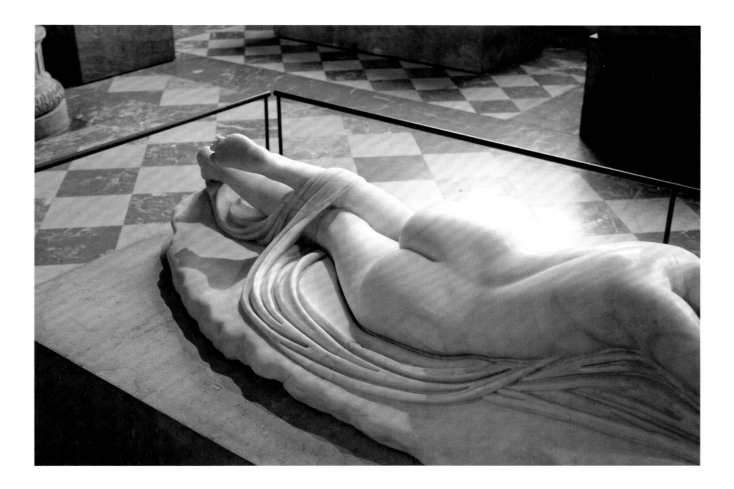

Cardinal Scipio Borghese at the beginning of the seventeenth century. The following year, its sale at the phenomenal price of thirteen million francs raised the coffers of the impecunious brother-in-law, and the superb Villa Borghese on Pincio Hill was relieved of 695 marbles that had been selected with great pleasure. Most of them figured among the most famous antiquities. A room in the villa was dedicated to the famous *Gladiator*, signed by Agasias of Ephesus; in Paris, it now introduces visitors to the Galerie Daru, across from the great *Borghese Vase*. An important part of the collection populates the Salle des Caryatides: *Sleeping Hermaphrodite* reclining on a marble mattress sculpted by Bernini; the *Faun with Child*; the *Nymph with Shell*; *The Three Graces*, restored by the Lorraine sculptor Nicolas Cordier, who worked for Cardinal Borghese at the beginning of the seventeenth century; and the *Centaur*, tortured by Love, who plays on his back. You have to go to the Salle du Manège (Riding Hall) and its vestibule to find the sculptures where white and colored marbles mingle. The antique *Old Fisherman*, in mixed marble, was placed in a basin whose surface was lined with red marble to transform it into an evocation of Seneca's suicide, bathed in his own blood. *Il Moro* (Moor), featuring its antique bust, was completed by Nicolas Cordier with a head of black paragon marble to give him the appearance of a rich Oriental king. The *Zingara*, which was considered Bohemian, combines these colors and this decorative overabundance. Visconti had chosen copies of antiques in the Egyptian style, sculpted a short time earlier by a Frenchman, Antoine-Guillaume Grandjacquet. He also collected a number of reliefs, busts, and sarcophagi. The collection included sculptures found in Gabii excavations by Gavin Hamilton in 1792–95, including the *Diana Pinning Her Cloak*, known as the *Diana of Gabii*.

More difficult to find in the Louvre's rooms, the modern works of the Villa Borghese are exhibited in the Department of Sculptures, in the Italian sculpture rooms, on the ground floor of the Denon Wing. They come from the former vestibule of St. Peter's in Rome, destroyed for the expansion of the facade. Cardinal Scipione Borghese took the opportunity to obtain the funeral relief of the *condottiere* Roberto Malatesta which belonged to the pope, and two reliefs of the tomb of Paul II by Mino da Fiesole and Giovanni Dalmata.

Sleeping Hermaphrodite (detail)
Roman copy, ca. 130–150 A.D., of a Greek original
Marble, L. 149 cm (58 5/8 in.)
Found in Velletri, collection of Pope Pius VI
(1775–78), Palazzo Braschi in Rome
Department of Greek, Etruscan,
and Roman Antiquities

Opposite
Apollo Sauroctonos (see p. 248)
Roman copy, 1st century A.D., of a Greek
original by Praxiteles, ca. 350–340 B.C.
Marble, H. 167 cm (65 3/4 in.)
Found in Rome in the 17th century and restored
Department of Greek, Etruscan,
and Roman Antiquities, Borghese collection,
acquired in 1807

Following spread
Sleeping Hermaphrodite
Roman copy, 2nd century A.D., of a Greek
original Marble, L. 169 cm (66 1/2 in.)
Discovered in the gardens of Santa Maria della
Vittoria (former thermal baths of Diocletian)
in 1617–18, acquired in 1619 by Cardinal
Borghese, who had the marble mattress
executed by Gian Lorenzo Bernini (1598–1680)
Department of Greek, Etruscan, and Roman
Antiquities, Borghese collection, acquired
in 1807

Pages 336–37
The Three Graces, 2nd century A.D. (?)
Marble, H. 119 cm (46 7/8 in.)
Fragments found near the Caelian Hill in Rome
and acquired in 1608 by Cardinal Borghese,
who had the group restored by Nicolas Cordier
(1565–1612), who created the three heads
Department of Greek, Etruscan, and Roman
Antiquities, Borghese collection, acquired
in 1807

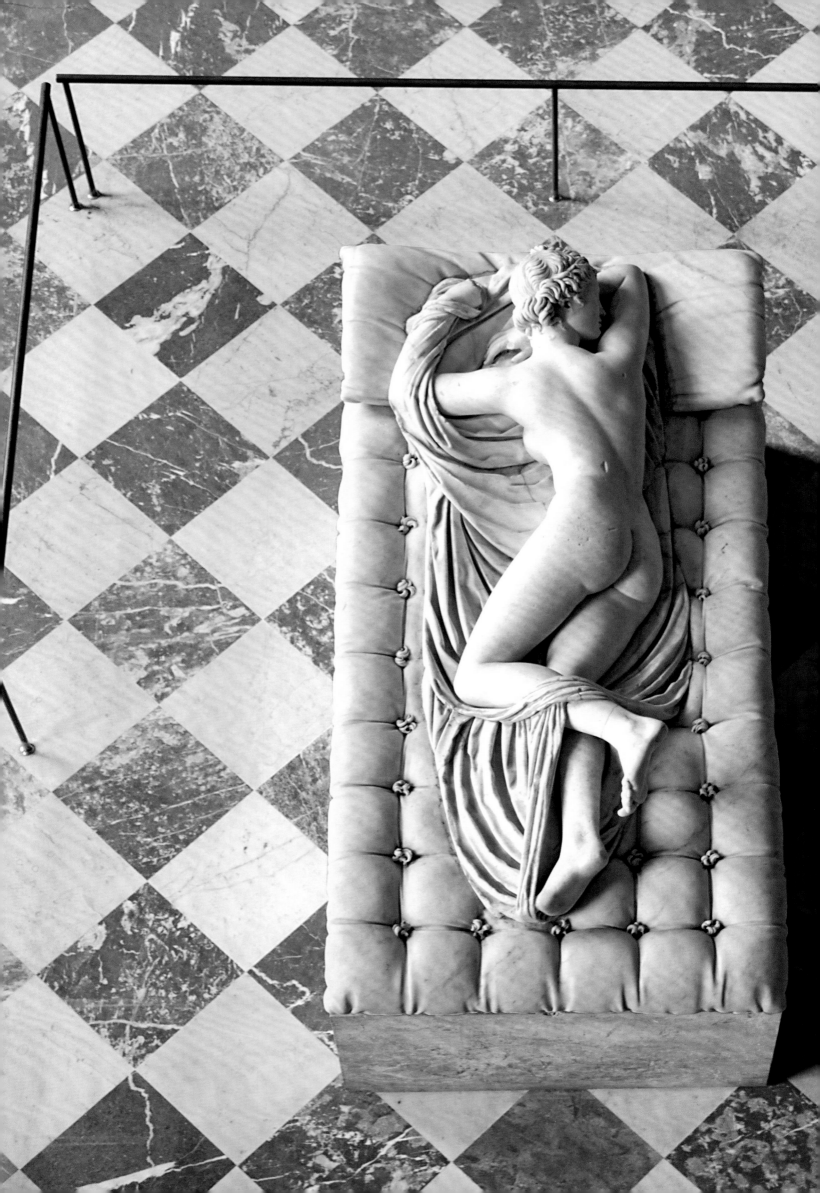

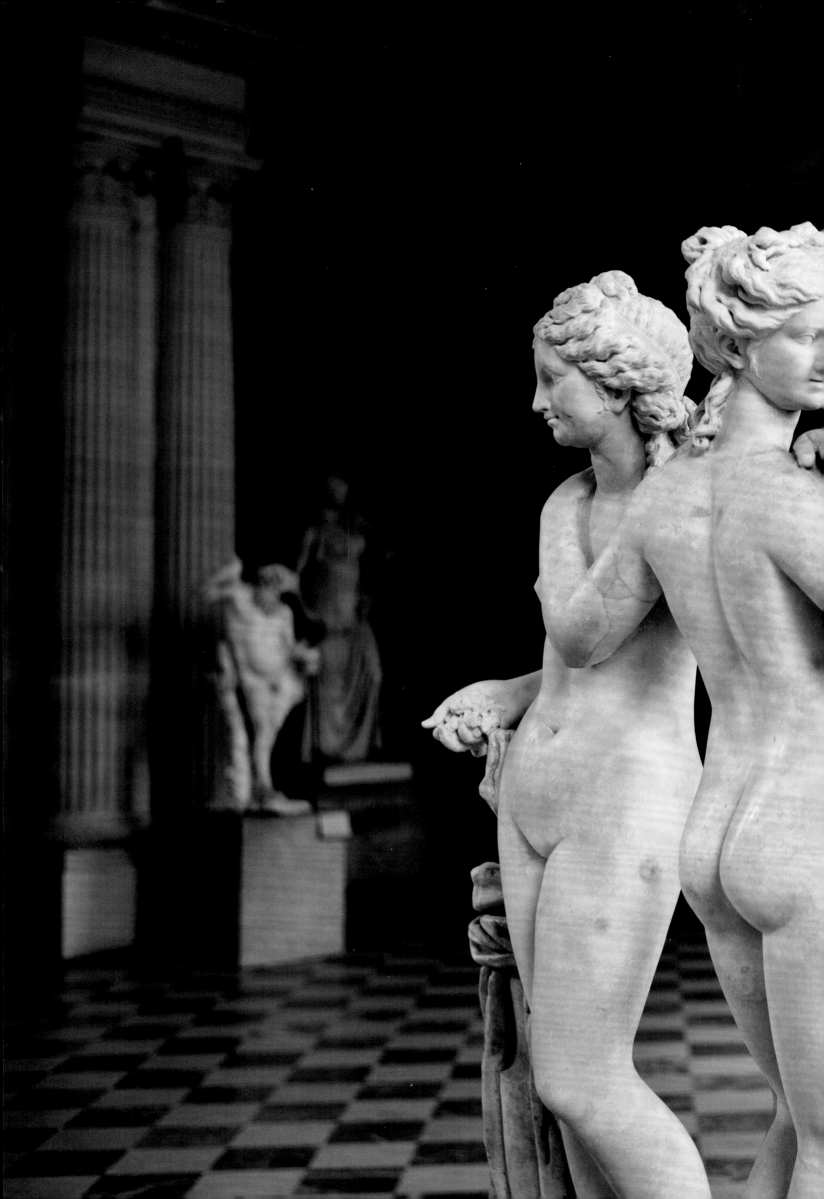

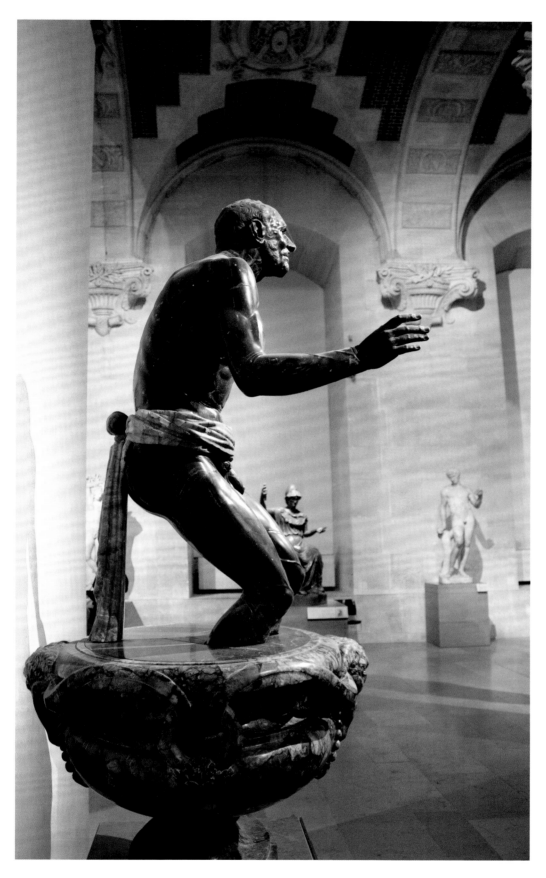

Opposite
Young Moor, known as *Il Moro*
Roman period, restored and completed by
Nicolas Cordier (1565–1612) in 1607–12
Black paragon marble, floral alabaster,
lapis lazuli, colored marbles, H. 163 cm (64 ⅛ in.)
Recorded in Cardinal Borghese's collection in 1613
Department of Greek, Etruscan, and Roman
Antiquities, Borghese collection, acquired in 1807

Old Fisherman, known as *Dying Seneca*,
2nd century A.D.
Black and alabaster marble, purple basin,
H. 183 cm (72 in.)
Mentioned in the collection of Duke Altemps,
the statue was acquired by Cardinal Borghese,
who had it altered
Department of Greek, Etruscan, and Roman
Antiquities, Borghese collection, acquired in 1807

The Centaur Ridden by Eros (detail),
1st–2nd century A.D.
Marble, H. 147 cm (57 7/8 in.)
Discovered on the Caelian Hill in Rome
before 1608, acquired by Cardinal Borghese
and restored by Nicolas Cordier and then by
Alessandro Algardi
Department of Greek, Etruscan, and Roman
Antiquities, Borghese collection, acquired in 1807

Nymph with Shell (detail; see p. 249),
mid-2nd century A.D. (?)
Marble, H. 60 cm (23 ⅝ in.)
Attested at the Villa Borghese in 1638
Department of Greek, Etruscan,
and Roman Antiquities, Borghese collection,
acquired in 1807

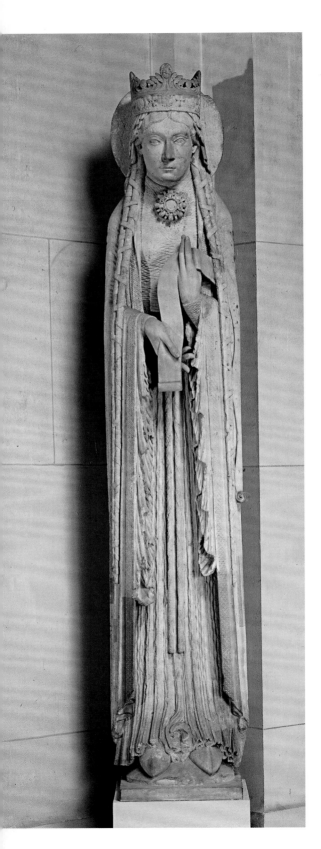

Another Revolutionary and Imperial Museum:
The Musée des Monuments Français and Its Heritage in the Louvre

Let's go to the Department of Sculptures on the ground floor of the Richelieu Wing. The large number of monumental tombs from the Middle Ages, the Renaissance, and the seventeenth century is striking, while for later centuries, busts, reliefs, and statuettes dominate. This is because the museum is the heir to an institution founded in 1795 that became the laboratory for the discovery of the Middle Ages and the repertoire of the great aristocratic and royal monuments: the Musée des Monuments Français (Museum of French Monuments). Its creator, Alexandre Lenoir, painter and student of Jacques-Louis David, was appointed keeper of one of the impounded art repositories. In the disused convent of the Petits-Augustins, he received cartloads of architectural fragments, statues, stained-glass windows, paintings, and other works of art, and while he was forced to turn the paintings over to the Louvre, he aspired to create a real museum, organized in chronological order. Using the premises of the former convent, he first installed the vestiges of the most important tombs and reliefs in the chapel, then created a circuit where each room was dedicated to a century, beginning with the thirteenth. Although the dates were random, the identifications of the characters often fallacious, and the monuments recreated fake, he nonetheless produced a global historical panorama. This spectacular presentation and its small garden populated by funerary monuments exuded a Romantic atmosphere. Here, the French historian Jules Michelet would have a vision of the history of France. A Freemason, Lenoir wished to show the progressive affirmation of light, from the sepulchral rooms of the Middle Ages to the room of the eighteenth century, the Enlightenment, but the museum did not survive the end of the Empire. It was ruthlessly closed by the monarchy in 1816.

The collections were then redistributed. Some families or churches recovered their past properties. Lenoir, appointed administrator of the Basilica of Saint-Denis, transferred a large part there. Three museums became heirs: the Louvre, where a sculpture gallery opened in 1824; the future Musée de Cluny; and the Musée d'Histoire de France, founded in Versailles by Louis-Philippe.

In the Louvre, there were therefore many leftovers from the former Musée des Monuments, such as two large column statues, the "Kings of Corbeil," traditionally considered to be figures of Solomon and the Queen of Sheba, which Lenoir had interpreted as those of King Clovis and Queen Clotilde. The tombs from Parisian churches were exceptional: the medieval recumbent effigies; the great tombs of Germain Pilon, in honor of Valentine Balbiani and Cardinal Birague; the monument to the heart of Henri II by Pilon, that of Anne de Montmorency by Barthélemy Prieur, and the dukes of Longueville by Anguier. Lenoir had also acquired the vestiges of the dismantled Château de Gaillon; he brought back sculpted marbles for Cardinal Georges d'Amboise, minister of Louis XII, including the altarpiece of the chapel by Michel Colombe. Coming from Château d'Anet, the great fountain of Diana, leaning on her deer and surrounded by dogs—which was admired in Lenoir's Élysée Garden—now overlooks the collection of Renaissance sculptures in the Louvre.

A Queen, known as *The Queen of Sheba*,
last quarter of the 12th century
Stone, H. 244 cm (96 in.)
Statue-column traditionally considered
as the Queen of Sheba (her counterpart would
be King Solomon), from the west portal of the
collegiate church of Notre-Dame de Corbeil,
sold by the municipality during the destruction
of the church, acquired by Alexandre Lenoir
for the former Musée des Monuments Français
(as Queen Clotilde)
Department of Sculptures, transferred from
Saint-Denis, 1916

Opposite
Fountain of Diana, known as *Diana d'Anet*,
mid-16th century
Marble, H. 211 cm (83 ⅛ in.)
From the park of Château d'Anet
Department of Sculptures, seized during the
Revolution, former Musée des Monuments
Français, exchanged with the dowager duchess
of Orléans for a modern statue, 1823

Museum and
Monarchical Power:
A New Royal Palace

When Napoleon abdicated in 1814, the count of Provence returned from Brussels, went to the Louvre, and settled into the Château des Tuileries to sleep in the emperor's bed, literally and figuratively, assuming the name Louis XVIII. He arrived with the coalition army; everyone proceeded cautiously, not wishing to shock either the elites or the people. The victorious armies occupied Paris, and the rulers followed: Czar Alexander I went rowing on Lake Malmaison with the former empress Josephine, who was always pretty and lightly dressed (she would then catch cold and die). In the company of the king of Prussia, the czar visited the Louvre Museum with great pleasure, guided by the architect Fontaine, without raising any protest as he stood before the masterpieces that the armies of the Revolution and the Empire had brought back as booty from Europe. The king of Prussia, despite having lost the most exquisite pieces from his Berlin collections in 1806, even claimed that he didn't want to "take anything from the beautiful collection of the Paris Museum" and that he "didn't [view] the beautiful paintings, statues, and all the works of genius as objects of conquest." At hearing this, Louis XVIII was overjoyed: "The monuments of the glory of the French armies remain, and the masterpieces of the arts now belong to us by rights more secure than those of victory."

But this euphoria was brief. Napoleon returned from the island of Elba in 1815. The "flight of the eagle" plunged into Paris, and war resumed. This interlude, which lasted a hundred days and ended with his defeat at Waterloo, decided the fate of the collections. This time, the allies demanded the return of the masterpieces to their countries of origin. Louis XVIII procrastinated, and Fontaine and Denon grumbled. "As ever, to the winners go the spoils. We must give in; we are defeated," Fontaine wrote. And the foreign curators arrived in Paris to pack and transport the works to be sent back home. Coming from Prussia, Commissioner Henri, a descendant of Protestants, who were exiled under Louis XIV, was a lover of France, but also resolute in his mission. Sent by the pope, the sculptor Canova was a skilled equivocator, while at the same time imposing his views. The museum was emptied out. "The trophies of our conquests, the paintings, the statues of the Museum of Arts are being removed with great force, without formalities, without precautions, and in haste," Fontaine complained.

Construction work was halted, and the Louvre seemed to have been largely depopulated, with a few major exceptions. Artists and poets mourned its death, but the government decided to hold its head high again. Denon was replaced as director of the museum

Previous spread (left)
Aphrodite, known as the Venus de Milo
Marble, H. 202 cm (79 ½ in.)
Department of Greek, Etruscan, and Roman
Antiquities, gift of Louis XVIII, 1821

A masterpiece of the late Hellenistic period
identifiable by the slight twirling movement that
makes the drape slide over the hips, the statue is
composed of two marble blocks joined together
with vertical pegs, following a technique used in
the Cyclades and Rhodes.

Opposite
Patrick Allan Fraser (d. 1890)
View of the Grande Galerie of the Louvre, 1841
Oil on canvas, 110 × 93 cm (43 ¼ × 36 ⅝ in.)
Department of Paintings, gift of Galerie Didier
Aaron, 1989

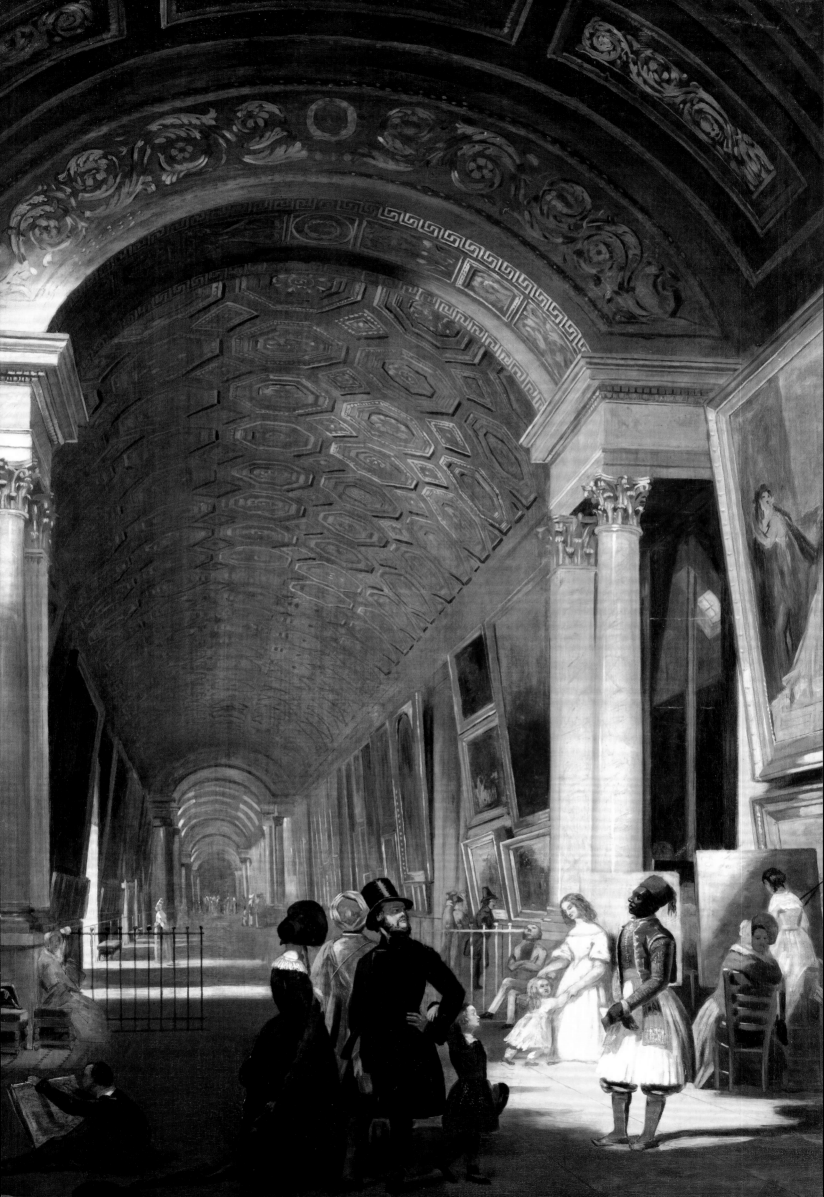

in June 1816 by a Provençal nobleman, the count of Forbin, who was widely traveled and a skilled draftsman. The museum now depended on the king's civil list. Under his authority, the collections decimated by the repatriations had to be reorganized. First, gaps were filled by bringing in works from other residences or the Musée du Luxembourg. Then the museum set to redeveloping itself. It bought works; commissioned painted and sculpted decorations; opened new sections, such as those of Greek Vases, Modern Sculpture, and Ancient Egypt. Among the major acquisitions was the Venus de Milo, exhumed on an island in the Cyclades and offered to Louis XVIII in 1821. The king could admire it in the Rotonde d'Apollon when he went from the Tuileries Palace to the Royal Sessions Room (Salle des Séances) at the Louvre.

Royal patronage turned to the exaltation of national creations. Painters would henceforth have to express through their canvases the quality of French art in its continuity and the benefits of a monarchy that had revived the ancien régime.

The First Restoration: The Renewal of the Musée du Louvre

While the return of the Bourbons marked a near-complete break with the revolutionary and imperial era on a political level, it did not manifest itself in the Louvre in a brutal way —quite the contrary. This was a question of reaffirming power, of laying the foundations for a new monarchy that sought to renew the ancien régime without, however, totally denying the achievements of the recent past, as abhorred as that was. Two large government complexes were created in the Old Louvre: a Royal Sessions Room for the meeting of the chambers, which included a Napoleonic project, and a large apartment for the Conseil d'État (Council of State), which was to relocate from the Tuileries. In this undertaking, Napoleon's architect, Fontaine—accompanied by his unobtrusive acolyte Percier—stayed true to the job and continued to organize for the monarchs all the details of their residence at the Louvre and the Tuileries.

The kings were anxious to pursue the Grand Design of the Louvre and Tuileries, especially since this would allow the expansion of the Tuileries. Under Louis XIV, barely a bay had been added to the Pavillon de Marsan. Percier and Fontaine dove into the project by moving forward on the alignment of the rue de Rivoli. As of 8 November 1814, a law provided for the resumption of work, but it remained limited. An additional bay extended the wing built under the Empire to the rue de Rohan, and was then covered. Fontaine was mainly responsible for continuing the major works at the Louvre and therefore intervened relatively little on the exterior. He had Montpellier carve the pediment on the north side of the Cour Carrée, toward the rue de Rivoli (1815), and continued the sculpting of the oculi of the Cour Carrée between 1820 and 1824. Reluctantly, he assisted in the dismantling of the Arc de Triomphe du Carrousel, which was his pride and joy.

Traces of the Tuileries: The Chamber of Louis XVIII

In the Department of Decorative Arts, the rooms in the Rohan Wing, which display the furniture and decoration of the Restoration and the July Monarchy, open with an evocation of the king's chamber in the Tuileries, as it was under Charles X. The gilded wood balustrade was taken from Napoleon I's throne room, and the bed was provided by Pierre Gaston Brion in 1824. The armchairs and folding chairs reveal the purely ceremonial purpose of this chamber. Louis XVIII, who had commissioned the room, never occupied it, because he died a few weeks before work was completed.

Indeed, Louis XVIII and his government moved into the Tuileries. Afflicted by gout, the king was confined to the ground level and would need to be transported to the Louvre

Reconstruction of the king's chamber
at the Château des Tuileries
Double bed by Pierre Gaston Brion (1824,
golden walnut, H. 220 cm/86 ⅝ in.,
L. 240 cm/94 ½ in.); bed trim by the Maison
Grand, Lyon (1817–19, silk velvet, embroidered
and brocaded with gold); balustrade of
Napoleon I's throne room, later of the chamber
of Louis XVIII, by François Honoré Georges
Jacob-Desmalter, after Percier and Fontaine
(1804); three bestowals from the Mobilier
National in 1965
Completed by a sofa, armchairs, and six
Jacob-Desmalter chairs from Napoleon I's
room (1808), bestowed by the Mobilier
National in 2007
Department of Decorative Arts

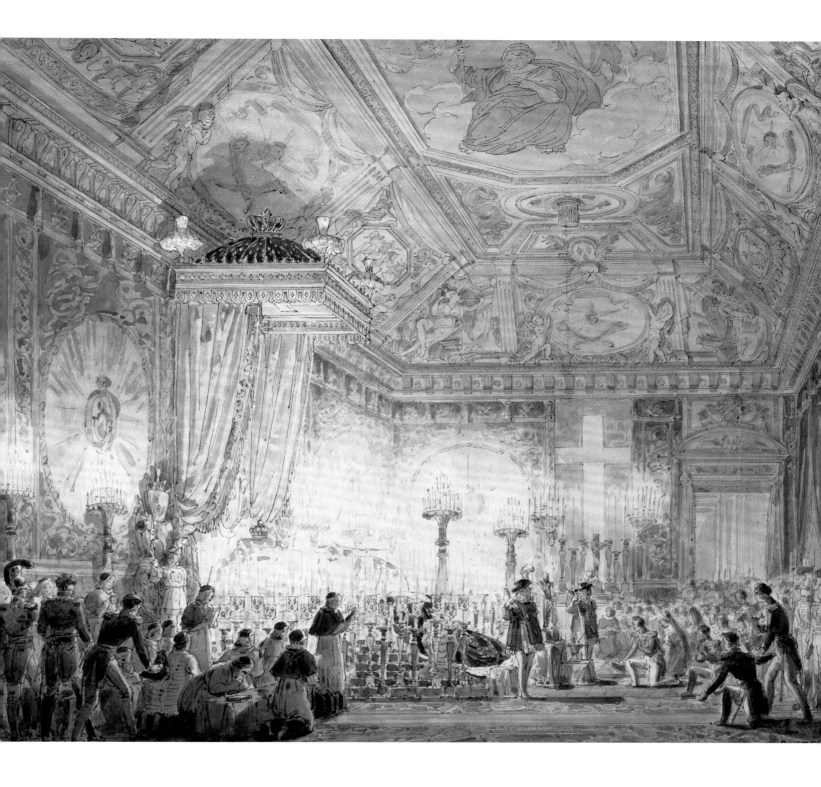

in a small carriage to preside over the royal sessions. He was the only ruler to die in the Tuileries, in September 1824, at the age of sixty-nine. His remains were honored for five days by the crowds in what was still called a "castle" and not a "palace." His successor, the count of Artois—who became Charles X—also resided there, as did his court. His son, the duke of Angoulême, who then became a dauphin, married his cousin, Madame Royale, daughter of Louis XVI, whose imprisonment and family misfortune had made her particularly melancholy. Life in the Tuileries was dull, suffocating, and cut off from the world, even if the romantic Marie-Caroline of Bourbon-Sicily, duchess of Berry, moved there in 1820, after the murder of her husband, the second son of the count of Artois. She gave birth to her husband's posthumous son: "the child of the miracle," the duke of Bordeaux and last heir to the crown. Her apartment in the Pavillon de Marsan—furnished in a contemporary, troubadour style—hosted pleasant social activities, balls, concerts, and vaudevilles, which brought a little gaiety to the otherwise dour life of the palace.

Jean-Baptiste Isabey (1767–1855)
*Louis XVIII's Mortuary Chapel at
the Château des Tuileries*, 1824
Watercolor
Musée Carnavalet, Paris

Pierre François Léonard Fontaine (1762–1853)
Opening of the Session of Parliament by Louis XVIII at the Louvre, 1820
Watercolor, brown ink, black chalk, pen,
28.3 × 28.5 cm (11 ⅛ × 11 ¼ in.)
Department of Graphic Arts,
gift of Henri Baderou, 1967

Previous spread
Upper terrace of the Arc de Triomphe du
Carrousel: *Victory* by François-Frédéric Lemot
(1808, gilded lead, H. 260 cm/102 ⅜ in.);
France; or *The Restoration*; or *Peace Riding in a
Triumphal Chariot*, modeled by François-Joseph
Bosio, cast by Charles Crozatier (1828, bronze,
H. 320 cm/126 in.)

At the Carrousel: The Erasure of the Empire, and the Affirmation of the Monarchy

In the darkness of the Carrousel galleries, under the arch built by Napoleon, large marble bas-reliefs bear witness to the desire of one regime to replace another. The king first ordered all the emblems of the Napoleonic era to be erased. The bust of Louis XVIII replaced that of the emperor above the entrance to the museum. The "N"s and the eagles were mercilessly hacked away; all that would remain would be a few small bees, well hidden on the facade of the Colonnade, where, on the pediment, Napoleon's bust was retouched and transformed into Louis XIV. On the southern facade, a helmet of Minerva replaced the imperial figure, which was also removed from the pediments of the Cour Carrée. Everywhere, Louis's lilies and "L"s would reappear.

Louis XVIII refused to pass under the arch of the Carrousel, symbol of the victory of the Grande Armée, and ordered its destruction. In the end, it was simply dismantled. The *Horses of Saint Mark* were sent back to Venice, the statues at the summit were taken down, and the marble bas-reliefs were pulled off. Charles X, however, was concerned with making the entrance arch to his palace more presentable. In 1824, he commissioned a new decoration. Marble bas-reliefs were sculpted to celebrate the victorious campaigns of the duke of Angoulême in Spain. Pradier, one of the finest sculptors of the time—who shared with Victor Hugo the love of the beautiful Juliette Drouet—represented the duke of Angoulême dismissing the envoys from Cádiz. Louis Petitot illustrated the surrender of General Ballesteros to Campillo, and Raggi, the surrender of Pamplona. The plaster casts were presented at the Salon, but it took time to acquire the marbles and cut them. The Revolution of 1830 erupted before the work was completed. The marbles, which remained unfinished, are now on display in the space of the Carrousel. There, you can see the stages of the work. The large reliefs are made up of several blocks, whose vertical sides are contoured to the shape of the figures, thus reducing the gap between them. Some parts are only sketched and reveal a surface created with a point or a serrated chisel.

On the upper terrace of the arch, a new chariot was installed, pulled by four horses freshly cast by Crozatier after Baron Bosio's models. A female figure, sometimes identified as a personification of France and sometimes as that of the Restoration, guides the chariot, thus taking over the reins of government. At its side, it was resolved to replace the gilded lead *Victories* of the imperial era. Later, the Republic would again make a discreet pruning by removing the scepter of France, which was crowned by a tiny figure of Louis XVIII, enthroned as Charlemagne on the scepter of the regalia.

The Royal Sessions Room
Department of Greek, Etruscan,
and Roman Antiquities

Cy Twombly's ceiling, inaugurated in 2010, features large circles containing the names of the great artists of antiquity: Phidias, Euphronios, Skopas, and Praxiteles.

Power in the Old Louvre: The Royal Sessions Room

Entering the vast space, it's hard to imagine today that this was an official room in which royal pomp and affirmations of power unfolded before the constituted bodies. In essence, the king wished to be at the heart of the museum. Certainly, he renounced the king's apartment, abandoned by Louis XIV, but he needed to ensure monarchical continuity in a symbolic place. The former guardroom of the Renaissance building was thus transformed into the Royal Sessions Room. In the eighteenth century, the space was divided up in order to delimit the courtroom of the Royal Hunting Court, where Beaumarchais had been judge, based to the south, and a room to the north, where a collection of ship models assembled by Duhamel du Monceau (now at the Musée de la Marine) could be presented. After the Revolution, the room regained its original dimensions.

The Sessions Room was designed by Fontaine at the end of the Empire. He destroyed the floor of the upper story in order to clear all the space on the first and second floors, thus forming an enormous room. But the space we now see was reduced in height before World War II to ensure the continuity of the circuit of French paintings on the second floor.

To economize, and because the king was in a hurry, the decoration, was rather sober: everything needed to be done in time for the solemn session of December 1820. At both

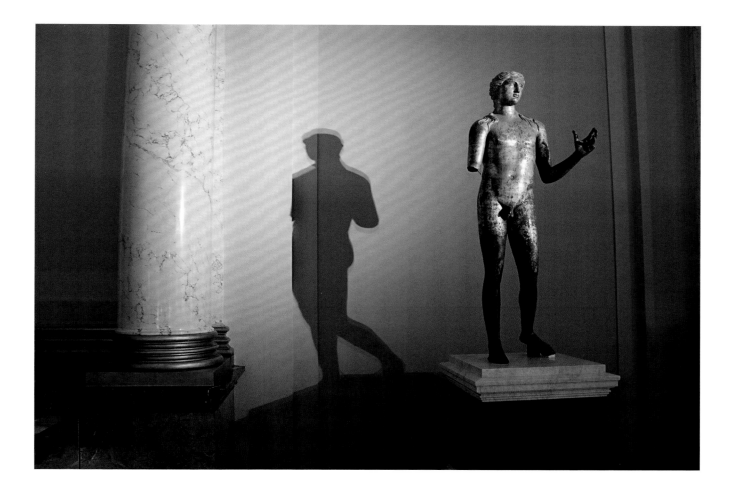

ends, a portico creates a strong monumentality; the northern gable framed the royal throne. The original ceiling was a simple stretched canvas, imitating a gilded coffered ceiling. But in the upper section, a gallery serving as a tribune for the public ran along the walls, surmounted by a luxurious balustrade with gilded bronze ornaments on which spectators could rest their elbows. Today, we see only the line of corbels that seems to support the ceiling.

As is customary in the Louvre, the room was later extensively altered. In 1862–63, Lefuel provided it with zenith lighting. It then became the heart of the Musée Napoléon III, where the fruits of the archaeological campaigns financed by the emperor in northern Greece, and the beautiful antique pieces from the Campana collection—acquired by the state in 1863— were displayed. This arrangement did not last long. In 1869, the gift of Louis La Caze's collection of paintings, rich in masterpieces (*Pierrot* by Watteau, *The Gypsy Girl* by Frans Hals, etc.), made it necessary to turn it into a large painting salon. Later, the room became the destination for ancient bronzes. From 1935 to 1938, the architect Albert Ferran further transformed the space, lowering the ceiling, reopening the windows, using the niches, and remounting the balustrade in the reading room of the library of the Musées Nationaux. The room was inaugurated after the war. Some of the vitrines with their rich marble bases were designed in 1905 for another location: the Salle des Colonnes. They have been religiously preserved and are complemented by other display cases of the same style.

In 1995, the presentation of the bronzes was completely redesigned, keeping the vitrines, now lit by an optical fiber system, for the exhibition of the entire bronze collection of the Department of Greek and Roman Antiquities. In 2020, the Etruscan antiquities will be newly displayed.

In 2010, the American painter Cy Twombly was entrusted with the large ceiling, which until then had remained blank. Against an azure sky, he designed large circles inscribed with the names of Greek artists, ensuring coherence between the contemporary intervention and the ancient works.

As a preamble to the Sessions Room, the former antechamber of Henri II was also rebuilt. In 1822, large canvases by Merry-Joseph Blondel were inserted into the woodwork by Scibecq de Carpi (*The Dispute between Minerva and Neptune*, *Peace*, and *War*), which would give way to *The Birds*, the large compositions by Georges Braque in 1953.

Above and opposite
Apollo, 2nd century A.D.
Gilt bronze, H. 194 cm (76 3/8 in.)
Department of Greek, Etruscan,
and Roman Antiquities, acquired in 1853

Found in Lillebonne (Seine-Maritime) on 24 July 1823, near an ancient theater, this *Apollo* is the largest gilded bronze statue discovered in Roman Gaul. He originally held a lyre in his left hand. The proportions and attitude show the influence of Greek statuary.

For the sake of continuity, Charles X planned to transform the large space known as the Seven Chimneys Room into the Coronation Room (or "Gérard Room"), created by unifying the entire former Pavillon du Roi; on the order of Louis XVIII, Fontaine had already removed the Renaissance woodwork in the two royal rooms in 1817. Charles X did not have time to complete the project or to see the transformation of the Colonnade rooms into a prestigious historical apartment.

The Rotonde d'Apollon

The Rotonde d'Apollon (Rotunda of Apollo), which precedes the gallery of the same name, also belonged more to the palace than to the museum. This spectacular space was built under Louis XIV by Louis Le Vau. Known as the Dome Salon, the rotunda (actually an oval), which had been considered for a new chapel, served as the vestibule of the Galerie d'Apollon. The painter Charles Errard directed the decoration work, whose only stuccoes on the ceiling were executed by the Italian Francesco Caccia, before the work was abandoned. After having been part of the king's paintings chamber (*cabinet des tableaux*), the rotunda became the main salon of the Royal Academy of Painting and Sculpture from 1722 until its abolition in 1792. Decorated with paintings and sculptures that constituted the most beautiful part of the collection of the academicians' reception pieces, the Salon received the annual exhibition, on 25 August, of the works of the students who competed for the Grand Prix. During the Empire, it was an annex to the museum that housed exhibitions of works seized by the army, including the one that displayed the loot taken in Germany in 1807.

During the Restoration, Louis XVIII had the rotunda redesigned and the sculpted decorations completed. He entrusted Merry-Joseph Blondel with the painting of a ceiling to be inaugurated for the Salon of 1819. The general theme was adapted to harmonize with that of the neighboring gallery. The central composition thus evoked the myth of Apollo through *The Fall of Icarus*, which occupied the large oval. Icarus, who aspired to fly, came too close to the sun's rays, which melted the wax holding his wings together. Apollo passes over on his chariot drawn by white horses, while Icarus—upside down, encircled by the draperies of his great wings—falls from a sky flooded with warm light to the darkness of the abyss. Blondel sought to reconnect with Le Brun's spirit in this vast ceiling composition. In the four main compartments of the cupola, Charles-Auguste Couder and Blondel inserted symbols of the four elements, represented by mythological scenes in pure continuity with the iconology dear to Le Brun: *The Fight between Hercules and Antaeus*, son of the Earth, who was invigorated when he touched it; *Achilles Almost Swallowed Up by the Xanthe River* (symbolizing Water); *Aeolus Unleashing Boreas and Aquilon against the Fleet of Aeneas* (Air). Finally, V*enus Receiving from Vulcan the Weapons He Forged for Aeneas* appears in the glow of Fire. Among these grand scenes, Jean-Baptiste Mauzaisse painted *ignudi* in grisaille around medallions in faux bronze monochrome.

The decorations were completed by the beautiful latticework grate from the Château de Maisons, which had, till that time, closed the Galerie d'Apollon since 1819; Fontaine placed another gate, of the same origin, at the door of the chapel.

The Rooms of the Conseil d'État

To ensure the presence of royal authority at the heart of the museum, the Conseil d'État, located at the Château des Tuileries under Napoleon, moved to the piano nobile of the Louvre, between the Pavillon de l'Horloge and the Pavillon de Beauvais. Leaving one royal castle for the other, the king manifested the notion of the uniqueness of the palatial complex by firmly anchoring himself in it. Under the ancien régime, the floors of the Louis XIII Wing of the Cour Carrée had been divided into courtiers' apartments for no specific reason. In 1819 and 1823, they hosted exhibitions of industrial products, showcasing French know-how. From 1825 to 1828, Fontaine set up four rooms there for the sessions and other

Merry-Joseph Blondel (1781–1853)
Central composition of the ceiling
of the Rotonde d'Apollon: *The Fall of Icarus*
271 × 210 cm (106 5/8 × 82 5/8 in.)
Commissioned in 1818, unveiled at
the Salon of 1819
Department of Paintings

Merry-Joseph Blondel (1781–1853)
Ceiling of the first room of the Conseil d'État:
France Victorious at Bouvines (1214) (detail)
Commissioned in 1828
Department of Decorative Arts

meetings of the Conseil d'État. They were decorated with superbly painted ceilings, inaugurated during the Salons of 1827 and 1828. This was a disproportionate effort for a short stay, since the Conseil d'État moved in 1832. It was replaced by the Cabinet des Dessins (Department of Drawings), which then had permanent exhibition rooms where the drawings were presented on a rotating basis, and the bulk of the collection remaining carefully packed away, hence the name "*salle des boîtes*" ("boxes room") sometimes given to these spaces. The Department of Decorative Arts would take over after World War II.

Everywhere the iconography of the works commissioned by the Maison du Roi (King's Residence) is animated by references to contemporary concerns. In 1826, the person in charge of Fine Arts, Viscount Sosthène de La Rochefoucauld, chose historical or legal themes. The titles are evocative. In the first room, the antechamber, *France Victorious at Bouvines*, by Blondel, recalls that the communal militias supported King Philip Augustus in 1214 to save the kingdom from coalition enemies. The evocation of this first manifestation of national sentiment was particularly well adapted to what the monarchy wished to inspire in its subjects. The choice of an ancient episode also reflected recent interest in national history from its earliest days. However, the treatment by Blondel was far from medieval. The flying figure of Fame, with wings spread, guides a France lifted aloft, accompanied by standard-bearing cherubs. Jean Bruno Gassies's trompe l'oeil voussoirs completes the disquisition: *Peace*, *Justice*, *Strength*, and *Law*.

The second room is the largest, as it was intended for government meetings under the king's reign. This is where contemporary politics presented itself as drama: *France, in the Midst of French Legislators and Jurisconsults, Receives the Constitutional Charter from Louis XVIII*. Blondel, champion of the decorations painted in the monarchical Louvre, conceived the gathering of the most popular rulers and those most closely linked to the history of the Conseil d'État as a kind of Olympus. Louis VI, Saint Louis, Henri IV, and Louis XIV can be seen seated on clouds around the throne of Louis XVIII. Significant allegories accompany them: Justice and her scales, Law holding the tablets of Moses. Behind the rulers, the figures of their advisers, including Maximilien de Béthune, Duke de Sully for Henri IV,

appear in the background. Faux bas-relief scenes in the voussoirs, executed in mono-chrome gold, explain the general meaning: Louis VI gave charters to the communes and freed the serfs; Saint Louis installed parliaments and promulgated the Pragmatic Sanction; Philippe le Bel created the Court of Accounts; Louis XIV established the Conseil d'État; and finally, Louis XVIII maintained freedom of worship and convened the chambers. In each instance, the king, well identified by his crown, is the hero of this amplification of freedom and law. In the corner voussoirs, large figures of gods and seated heroes, with very heroic nudity, recall Carracci's *ignudi* in the Farnese Gallery in Rome. The couplings are highly original: *Apollo and Mucius Scaevola, Hercules and Vulcan, Mercury and Silence, Mars and Neptune.* These male characters with powerful anatomy respond to female groups escorted by children, occupying the side voussoirs. The female figures symbolize virtues, obviously associated with the happiness that the sovereign offers through his charter: *Piety and Fidelity, Charity, Abundance, The Spirit of the Law Showing the Charter to Hope and Faith.*

The third room of the Conseil d'État, the Salle du Contentieux (Litigation Room), focuses on the law. The painter Michel-Martin Drölling was inspired by Guido Reni's famous *Aurora* in Rome. In a frieze composition—*The Law Descends to Earth, Establishes Her Domain, and Distributes Her Benefits*—imperturbable Law, dressed in bright red and looking straight ahead, sits rigidly in her chariot driven by Minerva, the personification of wisdom. Behind her is the procession of the good fairies: Abundance spilling her cornucopia; Mercury walking with a martial air, holding his caduceus; Ceres crowned with ears of corn, raising her sickle. Faced with such a procession, the frightened monster of igno-rance, driven out by a flying figure, falls into the clouds under the hoofs of the divine horses. The voussoirs are more architectural, with successions of trompe l'oeil faux bas-reliefs and medallions held by small winged terminal figures. The novelty here is in the painted panels, plated to the walls. All the great legislators of history are present: *Moses, Justinian, Charlemagne,* and *Numa,* each handing down his own law: the Tablets of the Old Testament, the Pandects, the Capitularies, and the Roman laws. *Justinian* was the work of Eugène Delacroix, then a newcomer. Unfortunately, this was his only commission, and

Merry-Joseph Blondel (1781–1853)
Ceiling of the second room of the Conseil d'État: *France, in the Midst of French Legislators and Jurisconsults, Receives the Constitutional Charter from Louis XVIII*
Commissioned in 1826, unveiled at the Salon of 1827
Department of Decorative Arts

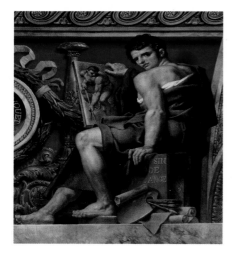

Charles Meynier (1763–1832)
Ceiling of the Salle Duchâtel: *The Triumph of French Painting: The Apotheosis of Poussin, Le Sueur, and Le Brun*
Oil on canvas, 814 × 352 cm (320 × 138 ½ in.)
Commissioned in 1820, unveiled at the Salon of 1822

Salle Duchâtel: detail of the landing ceiling
Department of Paintings

Opposite
Guido di Pietro, known as Fra Angelico
(active 1417–55)
The Calvary, ca. 1440–45
Fresco, 435 × 260 cm (171 ¼ × 102 ⅜ in.)
Painted for the convent refectory
of San Domenico of Fiesole
Department of Paintings, acquired in 1880
Salle Duchâtel

the painting was destroyed in the 1871 fire at the Cour des Comptes, which was built on the site where the Musée d'Orsay now stands. Like the other three, it had been quickly removed from its original location.

The last room was intended for conferences. The large painting on the ceiling, by Jean-Baptiste Mauzaisse, repeats the illustrated rhetoric of the law: *Divine Wisdom Giving Laws to Kings and Legislators, Surrounded by Equity and Prudence*. The legislators from the previous room are in the foreground: Moses kneeling and receiving the Tablets of the Law; Numa; and Charlemagne, dressed in red and wearing the regalia, are clearly recognizable. Others join the procession: Lycurgus; Solon; Romulus; Alfred the Great; Semiramis (at last a woman!), demurely lifting her veil; Confucius; and Muhammad in a green turban. We can see the mustache of Czar Peter the Great, the feathers of a Native American chief, the neatly rolled wig of a Quaker Penn, and the admiring gaze of George Washington. In heaven, the kings of France form a line contemplating the event. Among them, Joan of Arc prays piously. The dynastic line culminates with panache with Henri IV as a warrior, a majestic Louis XIV, and an obviously potted Louis XVIII. Unlike Law seen on the other ceiling, Wisdom is surprisingly naked, like Innocence, with a lamb by her side. Here, too, the walls were covered with paintings recalling the benefits of Justice. There was an allegory of War as a counterpart to that of Peace, bringing justice and abundance to the Earth, but both have since been lost. On the other hand, kept in the Musée des Beaux-Arts at Quimper, are Wisdom, in the figure of Minerva approving the code of laws, and Innocence taking refuge in the arms of Justice (which echoes an oculus in the Cour Carrée, sculpted by David d'Angers). Four overdoors reinforced the theme: allegories of Arts and Laws, one bearing the arms of Hercules, and an allegory of Strength.

The Salle Duchâtel and the Glory of French Paintings

In the museum's rooms, the architect Fontaine completed the work he had undertaken during the Empire. In 1818, the ceilings above the recently completed staircase in the king's residence were finally executed. The original design, which referred to artistic conquests, was no longer relevant. The ceiling of the staircase itself, commissioned from Prud'hon, was finally painted by Abel de Pujol (*The Renaissance of the Arts*). It was destroyed during the Second Empire, but

the four marble reliefs depicting the arts—commissioned in 1825 and which, after a long exile from the Louvre, came to decorate the hall of the Porte des Lions (Lions' Gate) in the year 2000—were preserved. The Porte des Lions entrance gave access to the Pavillon des Sessions, where the collections of African, Asia, Oceania, and the Americas were located.

The ceiling of the first landing of the stairs, *France in the Guise of Minerva Protecting the Arts*, painted by Charles Meynier, was inaugurated at the Salon of 1819, like the Rotonde d'Apollon (see p. 288 in the Percier and Fontaine Rooms section for the discussion on this painting).

The next room, now called the Salle Duchâtel, served as a vestibule for the Salon Carré and the Grande Galerie, and thus as an introduction to the large painting rooms. Meynier was given the task of exalting the nation's art in *The Triumph of French Painting: The Apotheosis of Poussin, Le Sueur, and Le Brun* (1822). Constrained by the room's elongated rectangular shape, the painter organized a vertical composition. At the bottom of the painting, a winged figure pushes back against the scythe of Time. In the center, the three seated painters look up as they ascend to the firmament, where the masters of the Italian Renaissance—Leonardo da Vinci, Raphael, and Michelangelo—await them.

It would take ten years to complete the decorations. The iconography of the voussoirs, also painted by Meynier, explains the meaning of the central composition. Occupying the north and south ends, France Protectrice and Royal Munificence preside over a succession of trompe l'oeil medallions in which the ancestors of French painting—Vouet, Le Sueur, Le Brun, Lorrain, Poussin—are joined by the great lights of a more recent vintage: Joseph Vernet, Jacques-Louis David, and Anne-Louis Girodet de Roussy-Trioson. The red background is decorated with large golden branches, ribbons, and crowns. The voussoirs on the long sides are airier. Faux arcades are treated à la Veronese, like loggias opening on to a cloudy azure sky, from which nude figures emerge bearing crowns and books. Here again, tribute was paid to the modern painters of the French school: Drouais, Vincent, David, Girodet, Vernet, Prud'hon, and Regnault.

The room has served several purposes: it was once devoted to the most precious goldsmiths' work, but the Department of Paintings remained its primary overseer, since it was the main entrance to the collection's south circuit.

Galerie d'Angoulême: *Baal Brandishing a Thunderbolt*, 14th–13th century B.C. Bronze and gold, H. 19.9 cm (7 7/8 in.) Department of Oriental Antiquities, excavations of Claude Schaeffer and Georges Chenet, 1929

Opposite
Galerie d'Angoulême, architecture by Pierre François Léonard Fontaine: details of the colored marble floors Department of Oriental Antiquities

Antonio Canova (1755–1822)
Cupid and Psyche (detail)
Carrara marble, H. 145 cm (57 ⅛ in.)
Commissioned by Colonel John Campbell
in 1797, kept in the workshop, acquired in 1801
by Joachim Murat, who sold it to Napoleon I
Department of Sculptures, entered in 1822

Opposite
Antonio Canova (1755–1822)
Psyche Revived by Cupid's Kiss
Carrara marble, H. 155 (61 in.),
L. 168 cm (66 ⅛ in.)
Commissioned by Colonel John Campbell
in 1797, acquired by Hope and kept in the
workshop, acquired in 1801 by Joachim Murat,
who sold it to Napoleon I
Department of Sculptures, entered in 1822

The Galerie d'Angoulême

While Louis XVIII had commissioned the decorations, his successor gave a new impetus to architecture and painting, as well as to the expansion of the departments. New sections were added to extend the museum's areas, mainly under Charles X's reign: "modern" sculptures, Egyptian antiquities, Greek vases, and the Musée de la Marine (Navy Museum). The Galerie d'Angoulême (Angoulême Gallery), named in honor of the crown prince, was installed in five rooms on the ground floor of the Cour Carrée. Inaugurated on 8 July 1824, it housed Renaissance and modern sculptures in a beautiful staging by Fontaine. The architect varied the decoration: colored marble floors, walls with columns, and alternating large and small rooms. The collection—ninety-four marbles and bronzes—was partly made up of sculptures from the former revolutionary Musée des Monuments Français (abolished in 1816), including the *Diane d'Anet*. Some masterpieces from Versailles were added to it, notably Pierre Puget's *Milo of Croton* and Bouchardon's *Cupid Cutting His Bow from the Club of Hercules* from Saint-Cloud. A deceased sculptor was honored:

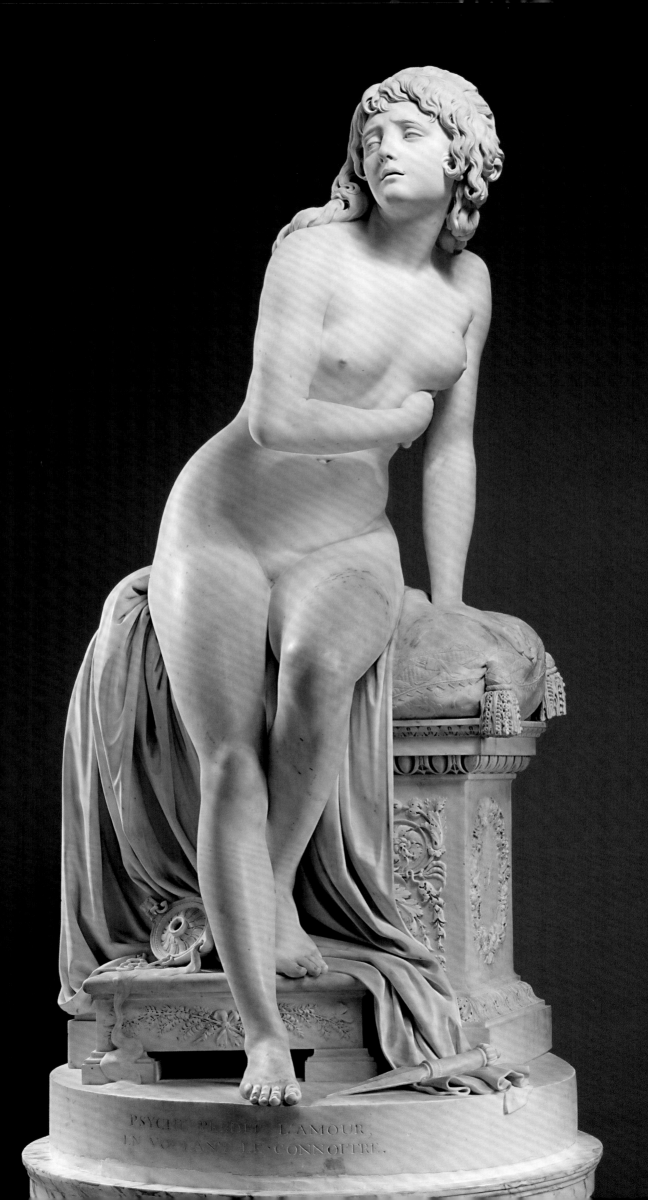

PSYCHE PERDIT L'AMOUR,
EN VOULANT LE CONNOITRE.

Antonio Canova (died 1822), who had served the emperor before repatriating the looted Roman works on behalf of the pope. His *Cupid and Psyche* and *Psyche Revived by Cupid's Kiss*, offered by Murat to Napoleon and which had adorned the Château de Compiègne, were transferred to the Louvre. They give a feeling of erotic, carnal grace, qualities also found in two female nudes acquired by Charles X for the gallery: the *Diana* by Houdon—and the *Psyche Abandoned* by Pajou, whose nudity had caused a scandal at the dawn of the Revolution. The Galerie d'Angoulême now serves as a setting for oriental antiquities.

The objets d'art of the Middle Ages are brought together in the Salle des Bijoux (Jewelry Room), Louis XIV's former great chamber, which joins the Salle des Sept-Cheminées (Seven Chimneys Room) and the Rotonde d'Apollon. This was where, in 1822, Jean-Baptiste Mauzaisse painted *Time, Showing the Ruins That He Causes and the Masterpieces He Brings to Light*,

Jules-Robert Auguste (1789–1850)
La Salle des Bijoux, second quarter
of the 19th century
Oil on canvas, 100 × 81 cm (39 ⅜ × 31 ⅞ in.)
Department of Paintings, acquired in 1931

Opposite
Augustin Pajou (1730–1809)
Psyche Abandoned, Salon of 1790
Marble, H. 177 cm (69 ⅝ in.)
Department of Sculptures, entered in 1829

Hippolyte Lecomte (1781–1857)
Mortuary Chapel of the Duke of Berry at the Louvre in February 1820, 1822
Watercolor, 34 × 47 cm (13 3/8 × 18 1/2 in.)
Versailles, Musée National des Châteaux de Versailles et de Trianon

which includes a depiction of the Venus de Milo. Then the painter tackled the overdoors (1828) and figures in the voussoirs that represented the four seasons, the four elements, the arts, the sciences, commerce, and war.

The Musée Charles X

Let's go to the first floor of the south wing of the Cour Carrée. The rooms are still called the Musée Charles X, since the Louvre is faithful to traditional, historical names. The emperor had his Musée Napoléon, so Charles X had to leave his mark on the Louvre (as Napoleon III would do in turn). It was important to establish his popularity and perpetuate his memory.

The rooms constituted the former apartment of the queens of France, donated to the Academy of Architecture in 1692. After the Revolution, artists appropriated these spaces for workshops. As early as the Empire, Fontaine proposed alterations, but he could only undertake the central pavilion room (Salle des Colonnes). The remodeling was not completed until 1819. Henceforth, periodic exhibitions of the products of industry were held in this series of nine rooms with the Salle des Colonnes at the center, forming a monumental lounge in the Pavillon des Arts. The Salle des Colonnes also served as a mortuary chapel for the duke of Berry, heir to the throne but who was assassinated in February 1820.

Faced with an influx of collections, however, Charles X decided to assign this suite of rooms to the museum. He thus consecrated "his" museum, which he financed, on 15 December 1827. Originally, the gallery was intended for three distinct collections —Egyptian antiquities; paintings, ceramics, and small antique bronzes from the Tochon and Durand collections; and objets d'art—but the use of the spaces has varied over time. Since 1997, the Musée Charles X has had a new look, housing the Egyptian collections of the New Kingdom (eastern part) and Greek and Hellenistic terra-cottas (western part).

Musée Charles X, first room
Detail of the ceiling: *The Genius of France Animates the Arts and Protects Humanity*, 1833, by Baron Antoine Jean Gros (1771–1835)
Department of Egyptian Antiquities

Percier and Fontaine imagined a long string of rooms, all of which would be connected by a large semicircular arch, with gold archivolts and gilded boxed decoration on the underside. The Salle des Colonnes would be closed by narrower doors and topped with tympanums, formerly sculpted. Under large ceilings painted by the finest artists of the time, a rich stucco decoration imitating precious marbles punctuates the architecture: a cornice with gilded friezes and double Ionic pilasters to frame the arcades. In this palatial context, the objects are encased all around the walls in tall mahogany vitrines, designed by the cabinet-maker Jacob-Desmalter. The paintings are consonant with the collections displayed. The details were carefully studied, from gilded bronze espagnolettes to colored marble fireplaces, decorated with bronzes and mosaics and topped by large window-facing mirrors that intensify the light. The mosaic artist Francesco Belloni, who opened a mosaic school during the Empire, did a wonderful job of varying the fireplaces designed by Charles Percier. Huge paintings on stretched canvas were produced in record time in 1826–27 for the ceilings in all nine rooms. Most are encircled by voussoirs with historical scenes, and below them, scenes often painted in grisaille. The artists provided complete sketches for these ceilings.

Coming from the Midi staircase, the first room of the Musée Charles X was the favored entrance. The task was to magnify the sovereign, and no one could do that better than Baron Gros, a major painter and practically the head of a school. The theme of his commission was simply stated: *The King Giving the Musée Charles X to the Arts*. When the 1830 Revolution ended his reign, the July Monarchy could not stomach this kind of toadyism. So when Baron Gros resumed his composition in 1833, he offered instead a nationalist and universalizing lesson: *The Genius of France Animates the Arts and Protects Humanity*. But Alexandre-Évariste Fragonard's first grisaille decoration, *The Geniuses Paying Tribute to the Sovereign*, remained at the tops of the walls.

The themes illustrated in each of the following rooms were related to the objects on display, except in the Salle des Colonnes, where Baron Gros still officiated. Look carefully

at the voussoirs and you're likely to spot in them—more than in the ceiling paintings—lovely hidden treasures such as impish geniuses and other amazing details. Above the display cases, grisaille paintings complete the iconographic programs.

The second room was dedicated to the Renaissance. Horace Vernet created a historical composition that departed from the tradition of trompe l'oeil ceiling painting. In a complex arrangement of columns, we see *Julius II Ordering the Work of the Vatican and Saint Peter's from Bramante, Michelangelo, and Raphael*; the two elders present the plan for Saint Peter's and the young Raphael, posed with his back to the viewer, holds the design for a *Stanze* tympanum. Four faux bas-reliefs show Raphael, Bramante, and their birth cities, Urbino and Rome. Abel de Pujol painted fourteen portraits of Renaissance artists at the top of the walls.

The themes of the next two rooms, three and four, evoked Egypt: Alexandre-Denis Abel de Pujol's *Egypt Saved by Joseph*, then *Study and Genius Unveiling Ancient Egypt to Greece* by François-Édouard Picot, which again were atypical of ceiling decoration. In the latter, two cherubs unveil Egypt, represented Cleopatra, before a sage Greece, who is guided by a nude Genius and a laurel-crowned Study. Thus, Egyptian art was recognized as an important precedent and source of classicism. The voussoirs in both rooms were also dedicated to Egypt. Of these, Abel de Pujol's are the most imaginative: Joseph's life was depicted in four trompe l'oeil paintings imitating bronze, separated by sixteen cherubs representing the cubits of the annual Nile flood. The grisaille paintings at the top of the walls illustrated daily life in ancient Egypt.

Above and opposite
Musée Charles X, second room
Detail of the ceiling: *Julius II Ordering the Work of the Vatican and Saint Peter's from Bramante, Michelangelo, and Raphael* by Horace Vernet (1789–1863); opposite: voussoirs by Alexandre-Denis Abel de Pujol (1785–1861)
Department of Egyptian Antiquities

Following spreads
Musée Charles X, succession of rooms
Department of Egyptian Antiquities

Musée Charles X, third room
Detail of the decoration: voussoirs and scenes of daily life in ancient Egypt by Alexandre-Denis Abel de Pujol (1785–1861)
Department of Egyptian Antiquities

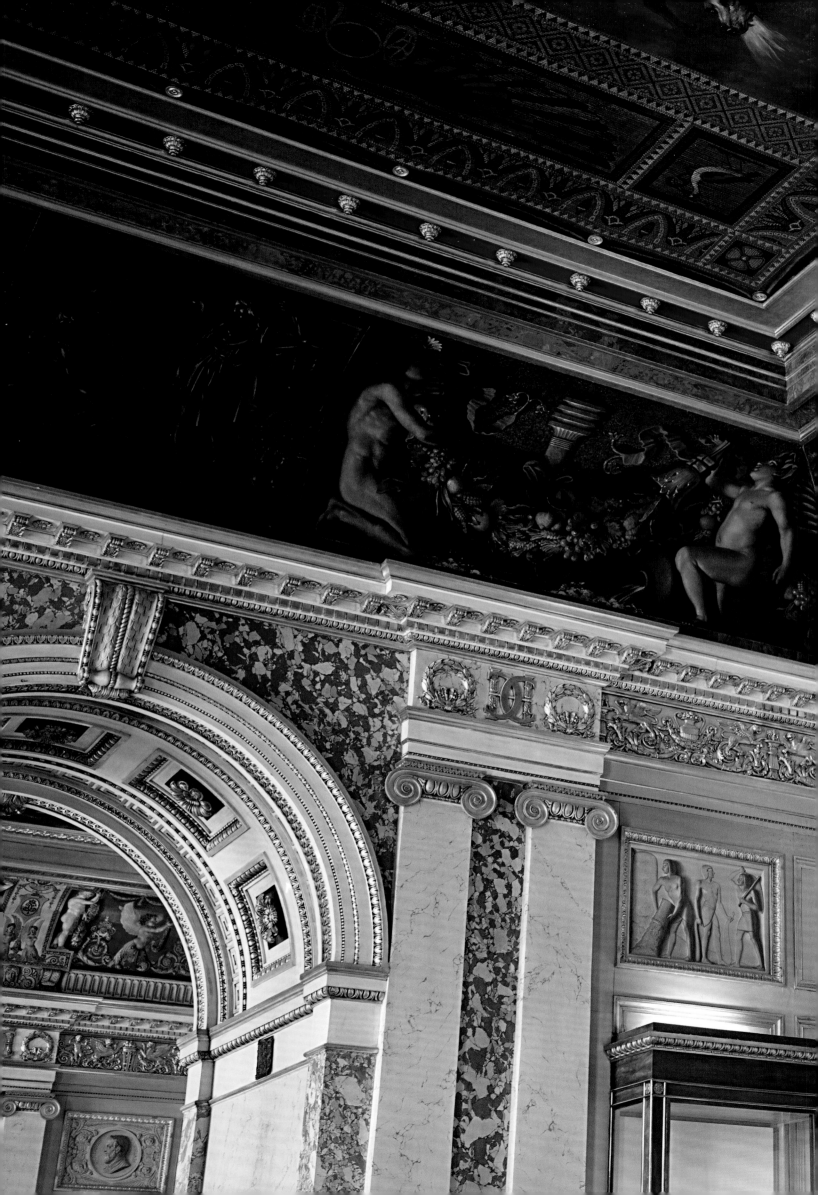

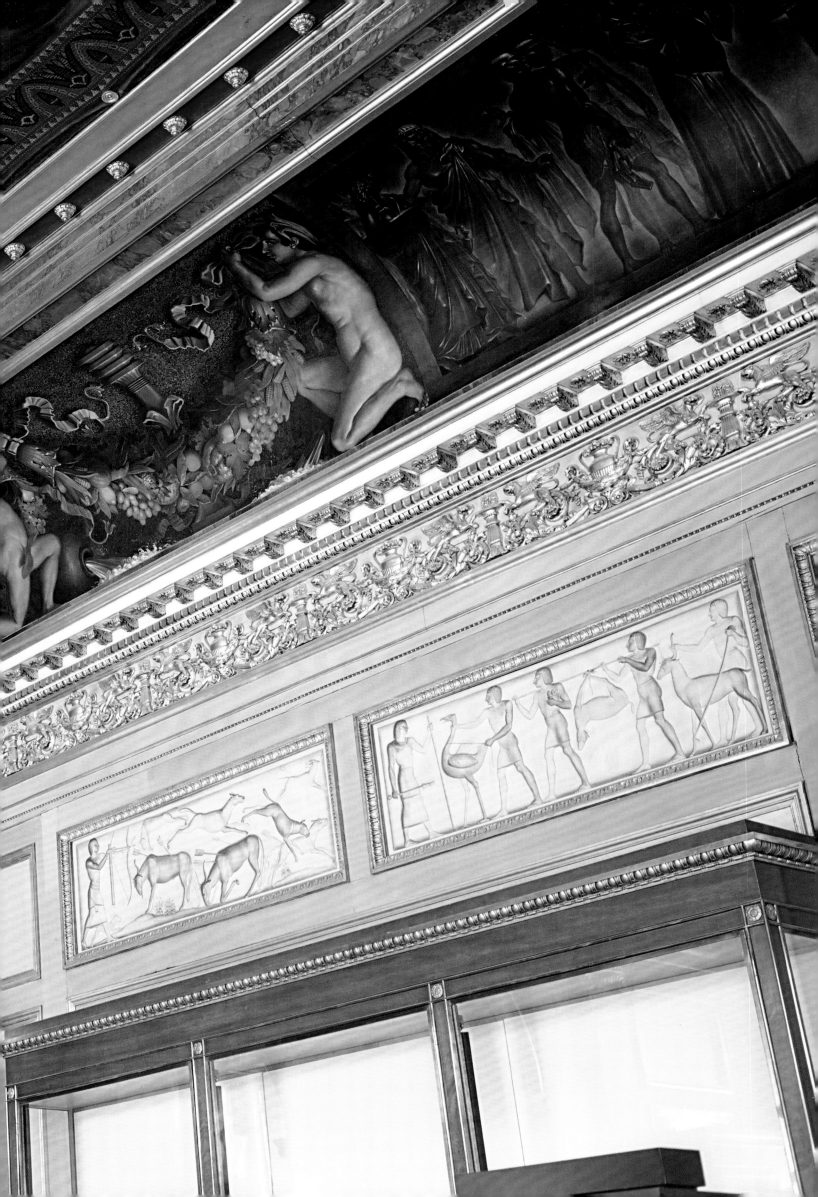

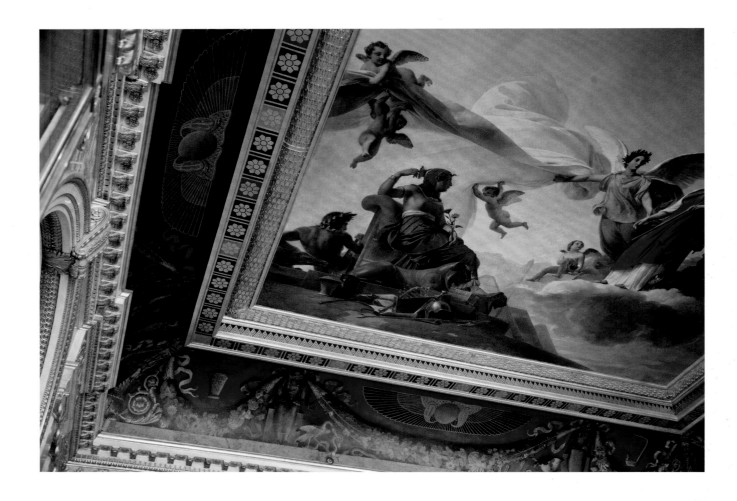

Musée Charles X, fourth room
Detail of the ceiling: *Study and Genius Unveiling Ancient Egypt to Greece* by François-Édouard Picot (1786–1868)
Department of Egyptian Antiquities

Opposite
Musée Charles X
Vitrine designed by François Honoré Georges Jacob-Desmalter (1770–1841)
Department of Egyptian Antiquities

Following spread
Ceiling of the Salle des Colonnes: architecture by Pierre François Léonard Fontaine and Charles Percier; *True Glory Is Supported by Virtue*, painted by Baron Antoine Jean Gros (1771–1835); voussoirs decorated with phylacteries bearing the names of great servants of the state

Then came the Salle des Colonnes, which formed a hiatus in the pavilion. An antique mosaic, installed by Belloni, graced the center of Percier and Fontaine's elegant architecture; Belloni also created the mosaic pavement in the room. The room was designed to praise the master of the place: the king's bust by Pradier that presided over the room. (It was the only work broken when the museum was seized by rioters in July 1830.) Baron Gros, in charge of the compositions of the three main compartments, offered political content cloaked in morality tales favoring Virtue and Wisdom over Strength and Power, heroic allegories illustrating themes intended to unite the populace around the person of the king: in the center, *True Glory Is Supported by Virtue*; on the left, *Mars Listening to Moderation*; on the right, *Time Elevates Truth to the Throne of Wisdom*. The king appeared again as one of a series of painted busts in trompe-l'oeil windows nestled in the side compartments representing great patrons of the arts: Pericles, Augustus, Leo X, Francis I, and Louis XIV. Thus, Charles X was inscribed as the culmination of an illustrious lineage.

In the next three rooms, the paintings clearly alluded to the archaeological finds from Herculaneum and Pompeii. The museum had, in fact, taken possession of works from the former Portici Museum; in particular, the wall paintings offered by the king of Naples to Josephine de Beauharnais and sold to Edme Durand after her death. In the first room, the original ceiling by Alexandre-Évariste Fragonard, son of the famous Jean-Honoré Fragonard, represented Francis I, a theme that was not related to the antique collection exhibited there and probably corresponded to a redesign of the museum program. The painting was therefore transferred to a parallel gallery and replaced with François-Édouard Picot's *Cybele Protecting the Cities of Stabies, Herculaneum, and Pompeii from Vesuvius* (1828–32). The voussoirs are consistent with the current ceiling: views of the cities destroyed by the eruption of Mount Vesuvius, rendered in the ancient style, stand out against a dark blue background. Fragonard's grisailles, on the other hand, refer to the old ceiling; they show figures bearing arms and attributes of science, art, industry, and history.

Following the circuit, we see successively *Vesuvius Receiving from Jupiter the Fire That Will Consume Herculaneum, Pompeii, and Stabies Despite Minerva Interceding for the Grieving Cities*, by François-Joseph Heim, and *The Nymphs of Parthenope Carrying Figures of Their Household Gods to the Banks of the Seine*, by Charles Meynier. The beautiful Neapolitan nymphs, their

Floor of the Salle des Colonnes: Roman
mosaic decorated with butterflies, mounted by
Francesco Belloni (1772–1863); right, *Taurus
and Griffin*, marble mosaic by Francesco Belloni

Following spread
Musée Charles X, sixth room
Detail of the decoration of the upper sections
Department of Greek, Etruscan, and Roman
Antiquities

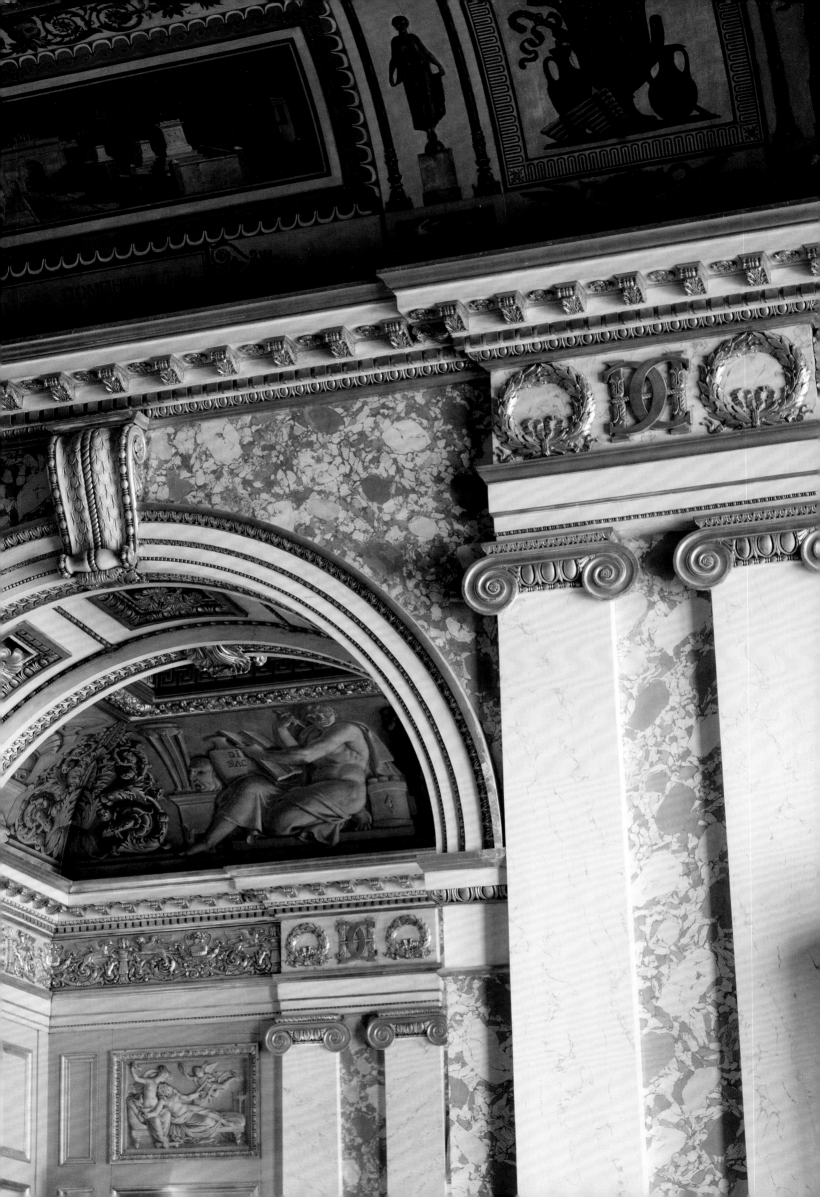

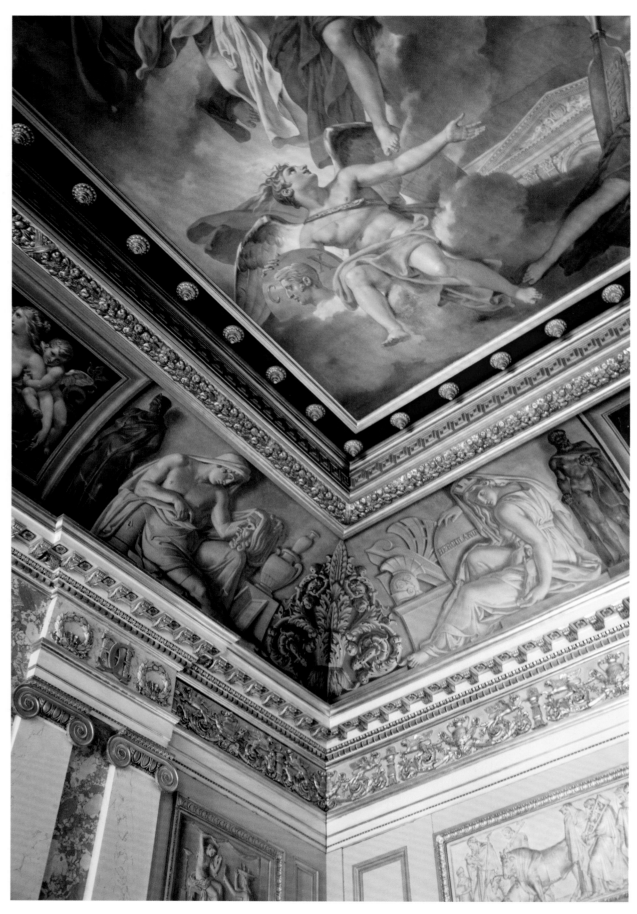

Musée Charles X, seventh room
Detail of the ceiling: *The Nymphs of Parthenope
(Naples) Carrying Figures of Their Household Gods
to the Banks of the Seine* by Charles Meynier
(1763–1832); top of the wall, *Sacrifice of a Bull*,
composition in grisaille by Gosse and Vinchon
Department of Greek, Etruscan, and Roman
Antiquities

Opposite
Musée Charles X, eighth room
Detail of the ceiling by François-Joseph Heim
(1787–1865) on the theme of Vesuvius; in the
voussoirs, a scene of desolation and a cherub
carrying objets d'art
Department of Greek, Etruscan, and Roman
Antiquities

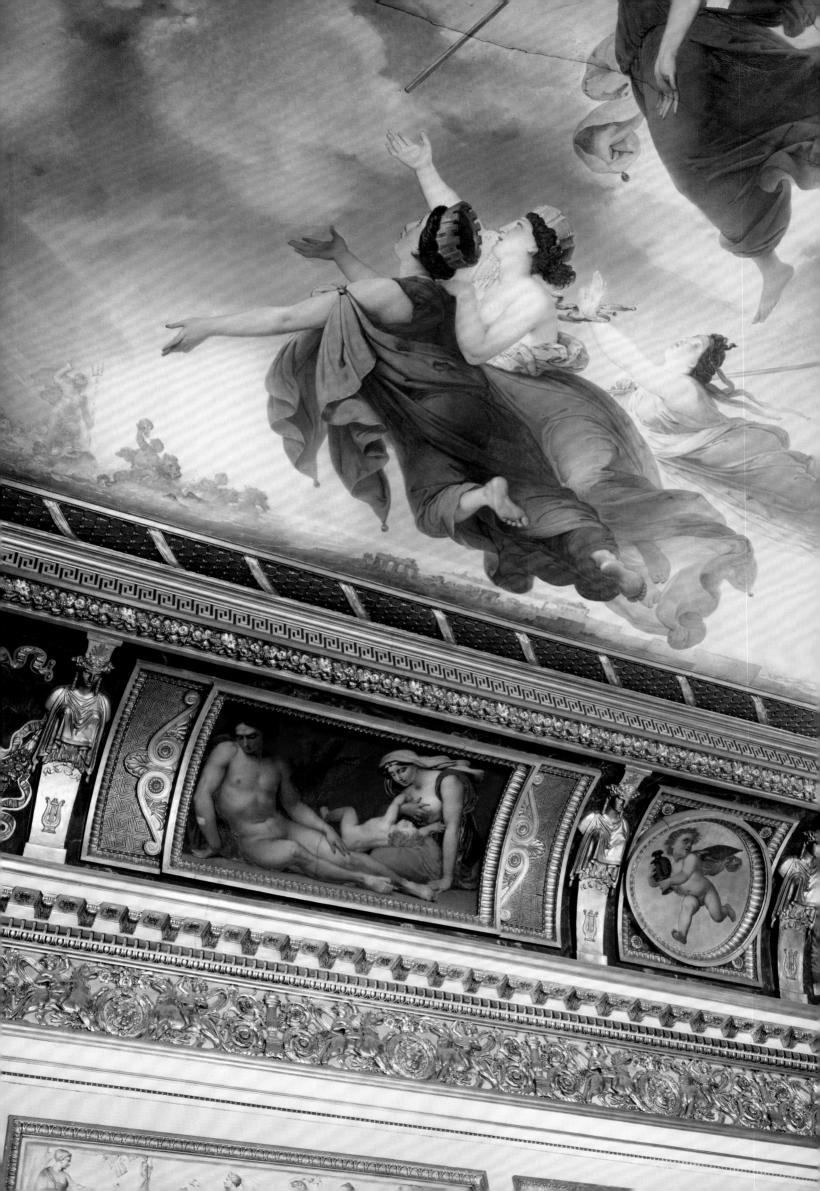

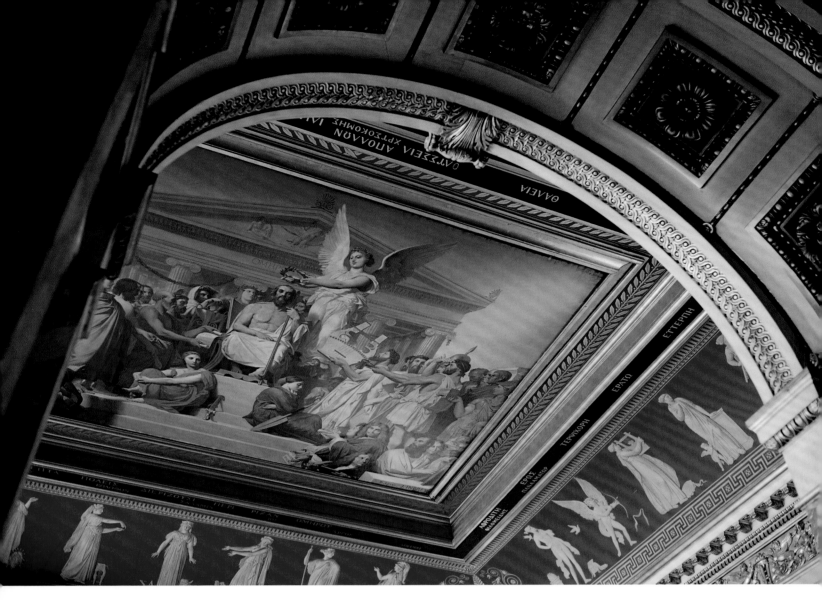

Musée Charles X, ninth room
Ceiling: *Homer Deified*, also called
The Apotheosis of Homer, by Paul and Raymond
Balze (1815–84; 1818–1909), after an original
by Ingres; in the voussoirs, *The Muses* by
the Moench brothers
Department of Greek, Etruscan, and Roman
Antiquities

nakedness softly highlighted by colored drapes, flew into the sky above the Louvre's pediment, guarded by the nymph of the Seine and the Genius of France with a medallion bearing the effigy of Charles X. In the voussoirs, François-Joseph Heim painted the eruption of the volcano, scenes of desolation, the death of Pliny the Elder, his nephew Pliny the Younger writing his account of the catastrophe, and cherubs bearing objets d'art. Meynier chose to execute his voussoirs in a Pompeian style.

In the last room (to the west), intended for Greek antiquities, Ingres painted *The Apotheosis of Homer*. As if in a new Raphaelesque *School of Athens*, we see Homer crowned, the personifications of the *Iliad* and the *Odyssey* at his feet. The transmission of knowledge, poetry, and the arts was expressed through the presence of other great men: Alexander carrying the gold box in which Homer's manuscripts were kept; Virgil with his arm draped around Dante; and Apelle grasping Raphael's hand. On either side, a gallery of portraits paid tribute to Poussin, Corneille, Racine, Molière, and La Fontaine, not to mention great foreign authors such as Tasso, Camões, and Shakespeare. The original, replaced in 1855 with a copy made by the Balze brothers, was exhibited in the painting rooms. In the voussoirs, following Ingres's models, the Moench brothers represented the seven cities that claim Homer's birth, as well as Apollo accepting the *Iliad* and the *Odyssey* on behalf of the Muses. In addition, grisailles by Nicolas Gosse and Auguste Vinchon illustrated eight scenes from the Homeric epic (the departure of Ulysses, Ulysses with Circe, Ulysses recognized by Penelope, Diomedes, etc.). All of Ingres's artistry unfolded here, in the beautiful definition of the figures on the red voussoirs and in the suppleness of the grisailles. The relationship between the works that made up the painter's imaginary museum and his creation provided a valuable lesson in decoration.

Today, the room is named after Clarac, in homage to the curator of antiquities under the Restoration. The wood, ceramic, and stucco objects found in Kerch, in the kingdom of Pontus (Crimea), a large part of the Messaksoudy collection acquired in 1918, are on display here.

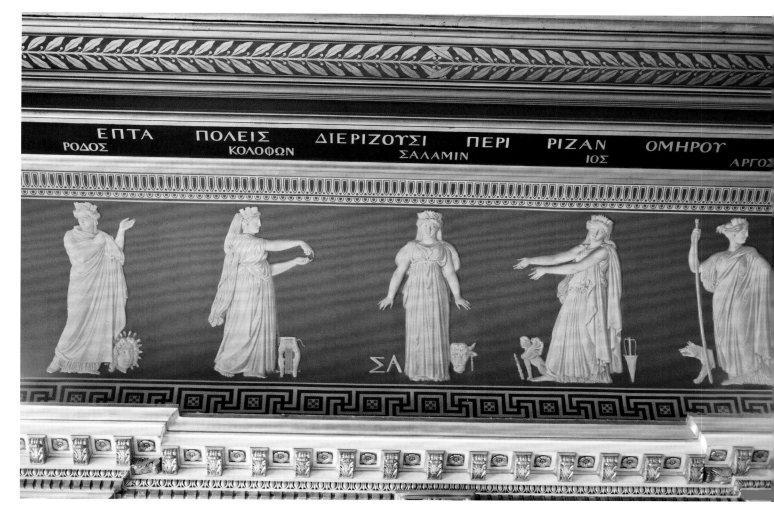

The Nine Rooms on the River Side
(Galerie Campana)

Parallel to the opening of the Musée Charles X, a second series of rooms was being prepared in a section that doubled the original building toward the Seine in 1668. Under the ancien régime, this addition remained unfinished, without a roof, and was squatted by various occupants of the palace. The shell, already undertaken by Fontaine during the Empire, was therefore of importance. As in the Musée Charles X, rooms were created running parallel to the river: four on each side, with the largest one located in the central Pavillon des Arts. Between 1819 and 1827, the Exhibition of Industrial Products and the Salon des Artistes Vivants (Salon of Living Artists) took place there. In 1828, they were devoted to the collections of objets d'art (in particular those acquired from the Lyon painter Pierre Révoil) and to early French painting.

Here, Percier and Fontaine conceived a minimalist architecture that undoubtedly stemmed as much from a concern for economy as from a desire for sobriety: bare walls, painted in forest green, and a few display cases. The decorations were once again focused on the ceilings, and illustrated the benefits of the kings of France—and even of Napoleon—in historical compositions that no longer owed anything to allegory. The first painted canvases were inserted into the ceilings in 1828, framed with voussoirs, as in the Musée Charles X. The whole was unveiled at the Salon of 1833. The iconography highlighted the patronage of the kings of France, from Charlemagne to Louis XIV; Francis I was shown twice, first being knighted by Pierre Terrail, seigneur de Bayard, then receiving masterpieces from his artists. But there was also a very political emphasis on consensual and generous sovereigns who knew how to ensure the confidence of the people through their prodigality.

The first room leading off the Midi staircase showed a painting that Léon Cogniet began in 1828: *The Egyptian Expedition under Bonaparte's Orders*. The monarchy then appropriated the Napoleonic past, as evidenced by the monochrome faux relief voussoirs where *The Battle of Abukir*, *The Cairo Revolt*, *The Pardon Granted to the Rebels in Cairo*, and *The Plague in Jaffa* were illustrated.

Musée Charles X, ninth room
Detail of the voussoirs painted by
the Moench brothers: five of the *Seven Cities That Claim Homer's Birth*
Left to right: Rhodes, Colophon, Salamine, Chio, Argos
Department of Greek, Etruscan, and Roman Antiquities

The second room underlined the desire to practice a certain form of democracy, with the representation of *Louis XII Proclaimed "Father of the People" at the Estates General Held in Tours in 1506*. Michel-Martin Drölling painted this scene along with the voussoirs containing the coats of arms of the cities that sent delegates to the assembly.

In the third room, Charlemagne's guardian figure, already so present in the rooms of the Conseil d'État, appears again here, this time as a protector of culture. Jean-Victor Schnetz painted Charlemagne receiving the scholar Alcuin, who presents him with manuscripts written by the monks of Tours. On his throne, the emperor, near whom we recognize his nephew Roland—who died in Roncesvalles in 778—reaches out to Alcuin, bishop of York, then abbot of Saint-Martin de Tours, and a major player in the Carolingian renaissance. The allegories in the corners align with the general picture of a cultivated and powerful court: *Science*, *Music*, *War*, and *Civil and Religious Legislation*.

The chronology of the kings of France then resumed with *Francis I Knighted by Bayard* on the evening of the victory at Marignano (1515). Alexandre-Évariste Fragonard had already exhibited his composition at the 1819 Salon; it was to serve as a model for a tapestry by the royal Gobelins Manufactory. The painter completed the decoration with a frieze of medallions in which geniuses symbolized the military arts cultivated by the knight-king in parallel with his passion for the visual and decorative arts.

The theme was taken up in *The Renaissance of the Arts in France*, painted by Heim in the large central hall; the space allowed him to add two small compartments to the composition in which the genius of Music and the genius of the Arts were inserted. In the voussoirs, octagonal tableaux illustrated royal patronage: Perugino painting the portrait of Charles VIII; the entry of Charles VIII into Naples; Leonardo da Vinci receiving Francis I on his deathbed at the Manor House of Cloux near Amboise; Francis I visiting Benvenuto Cellini's workshop and meeting the king of England, Henry VIII, at the Field of the Gold Cloth.

We find Francis I again in the neighboring room, the sixth, where he appears with his sister, Margaret of Navarre, receiving the paintings and statues brought from Italy by Primaticcio. This work by the son of Jean-Honoré Fragonard adorned the ceiling of the Musée Charles X in 1827 before being placed here. The voussoirs, where geniuses preside over the arts, highlight the general theme.

Galerie Campana, second room
Ceiling: *Louis XII Proclaimed "Father of the People" at the Estates General Held in Tours in 1506* by Michel-Martin Drölling (1786–1851); in the voussoirs, coats of arms of the cities of France Commissioned in 1828, unveiled at the Salon of 1833
Department of Greek, Etruscan, and Roman Antiquities

Opposite
Galerie Campana, first room
Detail of the ceiling: *The Egyptian Expedition under Bonaparte's Orders* by Léon Cogniet (1794–1880)
Commissioned in 1828, presented unfinished at the Salon of 1833, signed and dated 1835
Department of Greek, Etruscan, and Roman Antiquities

Galerie Campana, third room
Detail of the ceiling: *Charlemagne,
Surrounded by His Main Officers, Receives
Alcuin, Who Presents Him with Manuscripts
Made by His Monks* by Victor Schnetz
(1787–1870)
Commissioned in 1830, installed in 1833
Department of Greek, Etruscan, and
Roman Antiquities

Galerie Campana, fourth room
Detail of the ceiling: *Francis I Knighted
by Bayard* by Alexandre-Évariste Fragonard
(1780–1850)
Exhibited at the Salon of 1819,
installed in 1833
Department of Greek, Etruscan,
and Roman Antiquities

Galerie Campana, fifth room
Detail of the ceiling: *The Renaissance of the
Arts in France* by François-Joseph Heim
(1787–1865)
Unveiled at the Salon of 1833
Department of Greek, Etruscan,
and Roman Antiquities

Opposite
View of the Galerie Campana, fifth room
Greek vase collection
Department of Greek, Etruscan,
and Roman Antiquities

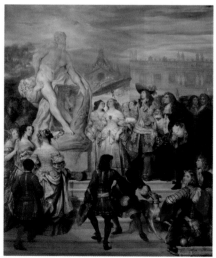

For the seventh room, Eugene Devéria painted a rather unexpected and historically false episode: *Puget Presenting His Statue of Milo of Croton to Louis XIV*. In reality, the sculptor did not leave his native Provence in 1683 to attend the event, but *Milo of Croton*'s dramatic group was relocated from the Versailles park to the Louvre's new modern sculpture rooms. The sculptor was given the place of honor in the main painting, while other great personnages of the century of Louis XIV occupied the voussoirs: *Le Brun Presenting Paintings to the King*, *Laying of the First Stone of Les Invalides* (1671), which paid tribute to Hardouin-Mansart; *The First Meeting of the Academy of Sciences* (1666); and, another surprise, the German scientist *Leibnitz Submits to the King His Project for a Crusade on Egypt* (1699). Eight medallions in the voussoirs showed the main foundations of the monarch.

In the eighth room, the theme of patronage was abandoned in favor of stressing the popular consensus around the figure of good King Henri, leader of the Bourbon and Orléans dynasties, and ancestor of the present rulers. *The Clemency of Henri IV after the Battle of Ivry* by Charles de Steuben (a battle in which the king defeated the Catholic League and their leader, the duke of Mayenne) contrasted with a small relief by Matthieu Jacquet, after

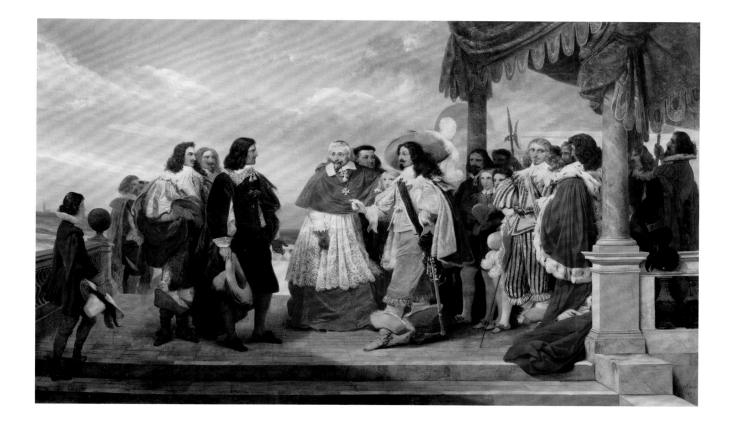

Antoine Caron, from the Belle Cheminée de Fontainebleau, which was displayed in the Galerie d'Angoulême. In the painting, it was not the conquering and fighting king, but the generous monarch who was highlighted, and prefigured the national reconciliation promoted by the regime (in words and images). The voussoir medallions, alternating between coats of arms and portraits of the great characters of Henri IV's reign (Mornay, Sully, Lesdiguières, Crillon, etc.), underlined the brilliant reconstruction of the kingdom after the conquest.

In the last room, Jean Alaux illustrated an episode directly related to the history of the Louvre: *Poussin, Arriving from Rome, Is Presented to Louis XIII by Cardinal de Richelieu*. Thus, Poussin's stay in 1640 to decorate the Grande Galerie—a project that, in fact, was something of a failure—was curiously magnified. On either side of the main canvas, personifications of Truth and Philosophy paid tribute to the talent of Poussin, the most intellectual of French painters, who in the same period, we should remember, figured in Ingres's *Apotheosis of Homer* and in *The Triumph of French Painting* in the Salle Duchâtel. For the voussoirs, specialists in stone-cardboard, a technique also used in the Salle des Bijoux, reproduced the Labors of Hercules, which Poussin had designed for the grisaille decoration of the Grande Galerie and for which drawings survive, in gilded medallions.

These spaces now housed one of the most beautiful collections of antique ceramics. France was a little behind in acquisitions for these collections, when compared to England, but quickly caught up. Under the ancien régime, Vivant Denon bought pieces during his stay in Naples to use at the Sèvres porcelain manufactory as technical models and formal repertoire. At the Musée Napoléon, antique vases were still rare. It was not until 1817 that 574 vases from Joseph-François Tochon's collection were brought in, which were first exhibited in the former Grand Cabinet du Roi. This acquisition paved the way for many others. In 1824, Charles X bought Egyptian and Pompeian works from the merchant Edme Durand, as well as a large number of vases, particularly from Magna Graecia (Greater Greece.) The ceramics of the two Tochon and Durand collections were therefore the first to be displayed in the vitrines of the Musée Charles X. Under Louis-Philippe, a second Durand collection was purchased in 1836 and then, from 1837 to 1845, the Greek vases from the necropolis of Vulci—which had been assembled by Napoleon's brother, Lucien Bonaparte, prince of Canino (among which is the Attic plate signed by Epiktetos)— were acquired.

The department truly expanded with Napoleon III's purchase of Marquis Campana's collection in 1862–63. It was then that ancient ceramics were redeployed to the gallery that

Galerie Campana, ninth room
Ceiling: *Poussin, Arriving from Rome, Is Presented to Louis XIII by Cardinal de Richelieu* (1640) by Jean Alaux (1786–1864)
Oil on canvas, 407 × 1140 cm (160 ¼ × 448 ¾ in.)
Commissioned in 1828, signed and dated 1832
Department of Greek, Etruscan, and Roman Antiquities

Opposite
Galerie Campana, sixth room
Ceiling: *Francis I, Accompanied by the Queen of Navarre, His Sister, and Surrounded by Her Court, Receives the Paintings and Statues Brought Back from Italy by Primaticcio* by Alexandre-Évariste Fragonard (1780–1850)
Oil on canvas, 69 × 286 cm (27 ⅛ × 112 ½ in.)
Commissioned in 1826 for the Musée Charles X, unveiled at the Salon of 1827, moved and assigned to the Galerie Campana in 1828
Department of Greek, Etruscan, and Roman Antiquities

Galerie Campana, seventh room
Ceiling: *Puget Presenting His Statue of Milo of Croton to Louis XIV in the Gardens of Versailles* by Eugène Devéria (1805–65)
Oil on canvas
Commissioned in 1828, signed and dated 1832, on display on the ceiling at the Salon of 1833
Department of Greek, Etruscan, and Roman Antiquities

Berlin Painter or Andokides Painter
Krater with red-figure decoration
Athens, ca. 500–490 B.C.
Terra-cotta, H. 33 cm (13 in.)
Department of Greek, Etruscan, and Roman
Antiquities, Campana collection, 1861

Opposite
Circular pyxis
Athens, ca. 740 B.C.
Terra-cotta, D. 34 cm (13 ⅜ in.)
Department of Greek, Etruscan, and Roman
Antiquities, acquired in 1887

Phiale
Eretria, ca. 510–500 B.C.
Terra-cotta, D. 20.8 cm (8 ¼ in.)
Department of Greek, Etruscan, and Roman
Antiquities, Rayet acquisition, 1874

Following spread
Galerie Campana, room 44
Vitrines by Hector Lefuel displaying early
red-figure pottery from southern Italy
(Lucania, Apulia, and Campania)
Department of Greek, Etruscan, and Roman
Antiquities

then bore his name. The Galerie Campana was inaugurated on 15 August 1863 for the Emperor's Day; the architect Hector Lefuel had designed huge oak vitrines along the walls. The objects accumulated by the marquis came from the rich Etruscan tombs of the Cerveteri region—namely Greek ceramics and especially imported Attic ceramics, which were thus classified as "Etruscan" in the eighteenth century. Numerically, the Campana collection formed the most important grouping of ancient vases. Of varying quality, it possessed masterpieces such as the "Krater of Anteus" signed by Euphronios.

The collection was further enriched by numerous donations and acquisitions thereafter. This was a phenomenon to which Edmond Pottier, ceramologist and initiator of the separation of oriental antiquities and antique ceramics, contributed. In 1881, he launched the *Corpus vasorum antiquorum* (Corpus of ancient vases), ensuring that French archaeology had a prominent place in ceramology.

The Galerie Campana therefore offered a panorama of the ceramic output of the Greek world as a whole, organized by region and chronologically, from Geometric styles to the late productions of Greater Greece, as well as orientalizing works. The Attic styles, with black or red figures, constitute the heart of the collection. Their scenes were painted by artists who were often assigned names that related to the place of conservation of a reference piece, sometimes linked to that of the potter who signed the work, such as the "Swing Painter," whose name derived from a black-figure vase in the Louvre; the "Amasis Painter," also a creator of black figures; the "Andokides Painter"; and the "Berlin Painter," author of a krater decorated with a delicate Ganymede in red-figure. Other masterpieces bore the artists' signatures, such as Euphronios or Douris, who painted a cup that showed Eos supporting the body of her son Memnon, who had been killed by Achilles. The Galerie Campana was restored and refurbished in 1997; while Lefuel's large display cases have been preserved, some groupings of objects have been inserted into a contemporary museography.

During the Revolution of 1830—the "Three Glorious Days" of July—the Louvre was attacked through the facade of the Colonnade. The painters, led by Ingres and Delacroix, came to protect the artworks. During the invasion of the palace, the rioters destroyed the bust of the ousted king in the Musée Charles X. Some were killed in the battle and hastily buried on the spot, in front of the Colonnade—allegedly, with some Egyptian mummies that had rotted in the Parisian climate. The victims of 1830 would be the object of a certain veneration, relayed by the story of "Médor, the dog of the Louvre," who had faithfully cried for his master in this improvised cemetery. The remains of the victims —apparently including the mummies— would later be transferred to the memorial erected at Place de la Bastille, the July Column.

Louis-Philippe, king of the French but not of France—the "bourgeois king" as he was often called—then settled into power. He owed his throne to a complex political balance, and he feared the capital. It was with resignation that he abandoned the Palais-Royal for the Château des Tuileries. Fontaine dug for him a solid ditch delimiting a "reserved garden," a haven of tranquility and possible defense. Leading a relatively simple family life, the king had most of the architectural work done on his residence. His children lived in contemporary-style apartments, especially Princess Marie d'Orléans, a gifted sculptor who was fond of the troubadour genre.

The project of bringing the two palaces together, always planned but never accomplished, was still ongoing. And Fontaine remained in charge of the embellishments of the Tuileries. He undermined Le Vau's work with a beautiful insouciance. Destroying the staircase and replacing it with a new one, that had been decorated with a gilded bronze banister by De la Fontaine, he organized a superb reception hall for the court's entertainments (1833) and that reconnected with the former Salle des Machines theater and obliterated the memory of the Revolutionary Assembly Hall. These alterations led to the disappearance of one of the terraces on the west facade of the palace in 1836.

Within the museum itself, due to a lack of resources and commitment, the king took an offhanded approach to the work of his predecessors. As we have seen, he finished the row of rooms parallel to the Musée Charles X and commissioned a series of paintings for the Galerie d'Apollon that evoked the history of the Louvre. But the last of the French kings had little interest in the Musée du Louvre. He clearly preferred "his" museum of French history at the Château de Versailles. Yet it was in the Louvre, on the first floor of the Aile de la Colonnade, that he set up two institutions of his own: the library left to him by Lord Standish, and a museum for Spanish painting with 450 paintings. After his abdication in 1848, the sovereign obtained the return of the Spanish collection, arguing that it was his personal property and not that of the crown (inalienable once deposited in a museum). However, this ephemeral Spanish gallery had a profound impact on contemporary artists, who thereby discovered the tenebrism and realism of the Spanish Golden Age.

Under Louis-Philippe's reign, the bulls of Sargon II's palace in Khorsabad entered the Louvre, becoming the nucleus of an immense collection of oriental antiquities. An Assyrian museum thus opened in the Cour Carrée, next to a museum of primitive Greek art. At the same time, an "Algiers gallery," located in the basement of the Colonnade, presented the fruits of Commander Delamarre's first archaeological campaigns in Algeria, featuring mosaics and Roman sculptures, as well as some evidence of Islamic art.

In 1848, the Louvre was still a major unfinished project. The Chamber of Deputies refused to vote the necessary appropriations to pursue the Grand Design, although it was supported by Adolphe Thiers in 1833, and in 1840 by his successor. In *Cousin Bette* (1846), Honoré de Balzac described the dilapidated state of the environs: "houses are permanently in the shadow of the high galleries of the Louvre, which on that side are blackened by the north wind. The darkness, the silence, the icy chill, and the low-lying cavelike site, all combine to make these houses a kind of crypt, tombs of the living."

Winged Human-headed Bull
Khorsabad (ancient Dur-Sharrukin, Assyria), Iraq, neo-Assyrian period, reign of Sargon II (721–705 B.C.)
Gypsum alabaster, H. 420 cm (165 ¼ in.)
Discovered in 1843 and placed on 1 May 1847 in the new Assyrian museum, with its counterpart, both guardians of the entrance to Sargon II's palace
Department of Oriental Antiquities, excavations of Paul-Émile Botta, 1843–44

New Areas of the Museum

The Restoration and the July Monarchy greatly expanded the museum's horizons. The traditional approach of the Revolution and the Empire—when classical painting and sculpture dominated—gave way to a more universal curiosity. Three men fueled this development: the count of Forbin, who brought back Egyptian and Greek works from his long sojourn in the Levant; his curator of antiquities, the count of Clarac, a prolific author of catalogues; and the young Champollion, curator of the Division of Egyptian Antiquities. Thanks to them, new collections established permanent residence in the Louvre: objects from ancient Egypt and the Orient, Greek sculpture, modern sculpture, ancient ceramics, and medieval and Renaissance decorative arts. Others have since emigrated to other museums, such as collections of artifacts from the Pacific or Mexico.

The Egyptian Museum

The most important creation was that of an Egyptian museum, under the direction of Jean-François Champollion, the philologist who had deciphered hieroglyphic writing in 1822. Of course, there had been some seizures of Egyptian works during the Revolution in Paris, and then of Roman collections, including the Albani collection, under the Directory. Denon had planned a room dedicated to the Egyptian goddess Isis on the ground floor of the south wing in the Cour Carrée, which was finally opened in 1817. But the harvest of worthy artworks was paltry, and in general had passed first through the filter of Roman antiquity. Meanwhile, travelers and consuls were gathering an extraordinary yield of objects in Egypt that came from thousands of more or less authorized excavations. The count of Forbin himself, then the director of the museum, brought back a monumental statue of the goddess Sekhmet. However, Louis XVIII's only purchase was the relief from a ceiling in the temple of Dendera, decorated with a zodiac, which went to the Royal Library in the Cabinet of Antiquities, which was headed by Edme-François Jomard, editor of the *Description de l'Égypte*.

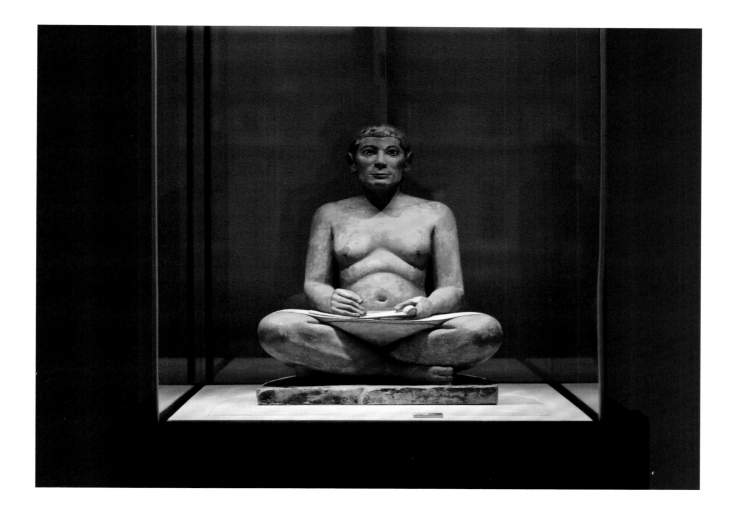

In this respect, the pioneering museum was the one in Turin, which the king of Piedmont and Sardinia built up by acquiring the first collection by Bernardino Drovetti, the French consul in Egypt, in 1824. Propelled by Champollion's curiosity, competitiveness, and initiative, Charles X acquired a group of objects and sculptures from Edme-Antoine Durand in 1824 and, in May 1826, appointed Champollion curator of the Egyptian division of the Musée des Antiques. A year later, the king authorized the purchase of some four thousand items assembled by the English consul Henry Salt in Alexandria. This is when the pink granite *Great Sphinx of Tanis* arrived and was installed in the courtyard of the museum, which henceforth took the name Cour du Sphinx. Champollion managed to buy Consul Drovetti's second collection before placing his objects in the Egyptian rooms of the Musée Charles X in 1827. An ardent proponent of thematic presentations, he distributed them in the vitrines of four rooms: the room of the gods, two funerary rooms, and the historical room.

Champollion, who had not yet traveled to Egypt, embarked on a mission in 1828, and two years later brought back important acquisitions, including the statuette of Karomama, the "divine adoratrice of Amun," inlaid with gold and electrum. His early death in 1832 deprived the museum of a forceful champion.

In 1850, Auguste Mariette came to the Louvre to write the museum labels. Sent to Egypt to collect Coptic manuscripts, he settled in Saqqara and began excavating the Memphis Serapeum, the sanctuary of sacred bulls, from which the great statue of the Apis bull originated. When the temple's discovery was announced in 1851, it was a stunning success. Officially authorized to export his finds, Mariette sent forty-four cases containing six thousand objects to the Louvre in 1852–53. Among them were the famous *The Seated Scribe* from fourth of fifth dynasty, and five statues from the same mastaba. He sent another 200 cases in 1854, while the Louvre also acquired 2,500 pieces from the collection of Clot-Bey, physician to Muhammad Ali of Egypt. The rooms were becoming cramped, despite an expansion under the Second Republic. Fortunately, Empress Eugénie went to Egypt to inaugurate Ferdinand de Lesseps's Suez Canal, and Mariette showed her the Serapeum. Dazzled, she returned to France and demanded the dedication of a room to this temple. This is how the Egyptian department expanded, particularly on the ground floor of the Colonnade.

The Seated Scribe
Saqqara, 4th or 5th dynasty (2600–2350 B.C.)
Painted limestone, eyes inlaid with rock crystal in copper, H. 53.7 cm (21 1/8 in.)
Department of Egyptian Antiquities, sharing from the Mariette excavations in 1854

Opposite
One of the six sphinxes that lined the path leading to the Serapeum of Saqqara (detail)
Saqqara, early Ptolemaic period (4th or 3rd century B.C.)
Limestone, H. of sphinxes 66.5–74 cm (26 1/8–29 1/8 in.)
Department of Egyptian Antiquities, gift after the Mariette excavations, 1852

Lion that guarded the entrance to a chapel of the Serapeum of Saqqara (detail)
Saqqara, 3rd dynasty, reign of Nectanebo I (378–361 B.C.)
Limestone, H. 56 cm (22 in.)
Department of Egyptian Antiquities, gift after the Mariette excavations, 1852

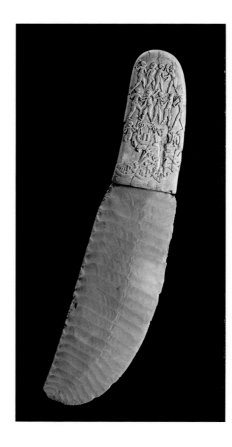

Dagger from Gebel el-Arak
Gebel el-Arak (?), ca. 3300–3200 B.C.
Flint blade, ivory handle (hippopotamus
tooth), H. 25.5 cm (10 in.)
Department of Egyptian Antiquities,
acquired in 1914

Opposite
Sepa and *Nesa*
Unknown provenance, 3th dynasty
(2700–2620 B.C.)
Painted limestone, H. 165 and 154 cm
(65 and 60 5/8 in.)
Department of Egyptian Antiquities,
Minaut collection, acquired in 1837

Following spread
Princess Nefertiabet and Her Food
Giza, 4th dynasty, reign of Khufu
(2590–65 B.C.)
Painted limestone, 37.7 × 52.5 cm
(14 7/8 × 20 5/8 in.)
Department of Egyptian Antiquities,
gift from the Curtis family, 1938

While Mariette left the Louvre shortly afterward—in 1858, he became the first director of the Department of Egyptian Antiquities, where he remained until his death in 1881—he could still be proud of his role in introducing the science of Egyptology during the Second Empire. Following him, the Department of Egyptian Antiquities would continue to be run by Frenchmen, including Gaston Maspero. The Institut Français d'Archéologie Orientale (French Institute of Oriental Archeology, or IFAO), founded in 1880, organized brilliant excavation campaigns using scientific methods. The enrichment of the collections would now mainly involve sharing the yields of excavations. The number of sites grew, and included Abu Rawash, burial place of Pharaoh Djedefre, whose moving pink sandstone portrait that had been kept in the Louvre had been broken off a sphinx's body; and Deir el-Medina (1909), a workers' village from which the coffin of Lady Madja, the elements of the tomb of the artisan Sennefer, and many figured or inscribed ostraca were obtained. As of 1925, Medamud—sanctuary of the god Montu—near Luxor, yielded the statue and mask of Sesostris III, the great conqueror. Then followed Edfu, Tanis, and the site of El-Tod, where a treasure trove of silver was discovered in 1936. In the delta, the Antinoë site was excavated in 1898 for the Musée Guimet. In 1945, the Louvre's Asian collections were transferred to the Musée Guimet in exchange for the latter's Egyptian collection, which contained many examples of Roman Egyptian objects and Coptic textiles. The Coptic domain was further enhanced a little later thanks to Jean Clédat's excavations in the churches of Bawit, in Middle Egypt, which revealed the richness of this art.

After World War II, the sharing of excavation finds became rare and then stopped altogether. However, Egypt offered the large bust of Amenhotep IV-Akhenaten, from an Asiatic pillar of a temple in Karnak, in gratitude for France's help during the campaign to save the temples of Nubia, which had been threatened by dam construction on the Nile. Excavation campaigns are still being carried out by Louvre staff to this day, in both Egypt and Sudan (since 2007).

The museum's Department of Egyptian Antiquities has gradually acquired more space. Originally, it occupied only part of the Musée Charles X, but then gained the Galerie Henri IV on the ground floor of the Colonnade. In the 1930s, when the director of the Musées Nationaux was formulating a more coherent organization for the Louvre's collections, the Egyptian department occupied the former rooms of the sculptures department, in half of the ground floor of the south wing in the Cour Carrée, and the other half of the Musée Charles X. It also benefited from crypts, dug out under passages, which not only allowed a continuous circuit of rooms, but also the installation of spectacular pieces such as the Great Sphinx of Tanis, sarcophagi, and a statue of Osiris. The project of the Grand Louvre ushered in a complete redevelopment. Thus, although it had lost half of the Musée Charles X, the department moved to the first floor of the Colonnade Wing, inhabiting the space formerly occupied by the Department of Decorative Arts, which had been then transferred to the Richelieu Wing.

Since 1997, the Louvre's Egyptian collection, one of the richest in the world—after the Cairo Museum, of course—has developed in two sequences. On the first floor, the masterpieces are presented in chronological order. The circuit opens on the votive stone palettes from the Naqada period, including the Four Dogs Palette, and on the extraordinary dagger from Gebel el-Arak (ca. 3300–3200 B.C.) with its hippopotamus-ivory handle decorated with a fine relief of human combats. The time of the pharaohs began with writing and the unification of the Nile Valley. The sculptures of Sepa and Nesa, the first examples of life-sized statues in Egyptian art, and the stela of the serpent king, from Abydos, already show the refinement of the art of the Old Kingdom. Of course, *The Seated Scribe* is the centerpiece of that period. Sculpted in fine limestone, it is still covered with lively polychrome. The insistent eyes were meticulously made—a copper piece enclosing a white stone sclera, encrusted with a pointed, hollow rock crystal cone—reinforced the lifelike impression. The volumes of the body, both real and stylized, were modeled with a sobriety that eschews superfluous detail in favor of the essential. It is difficult to imagine that such a realistic portrait was created between 2600 and 2350 B.C.

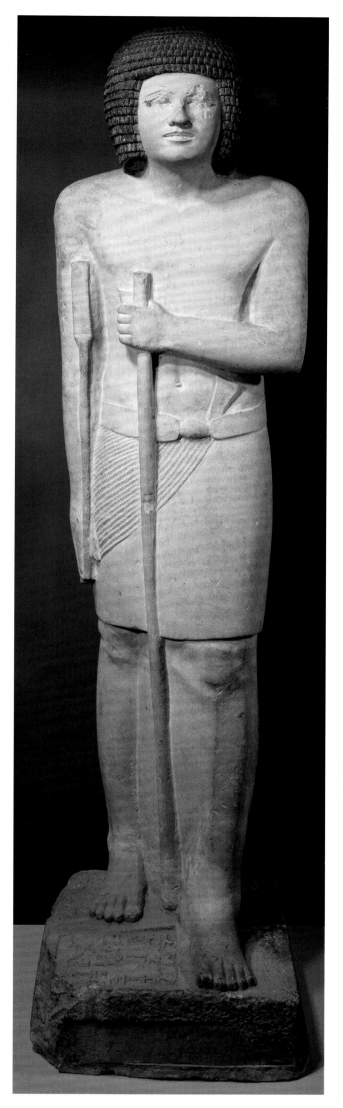
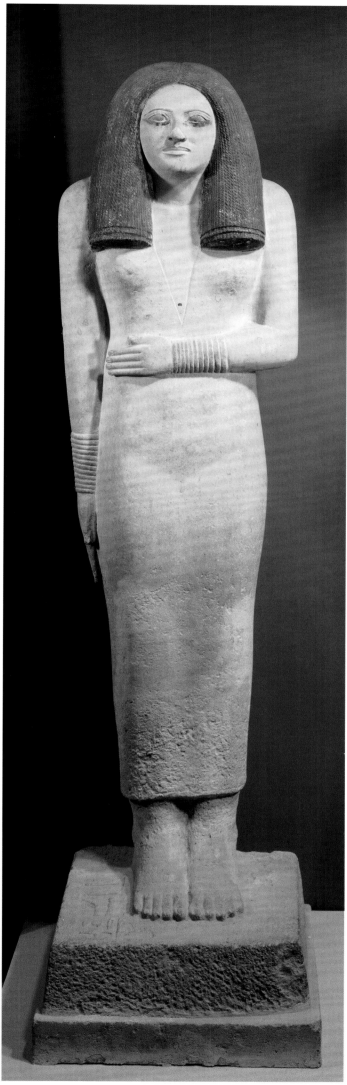

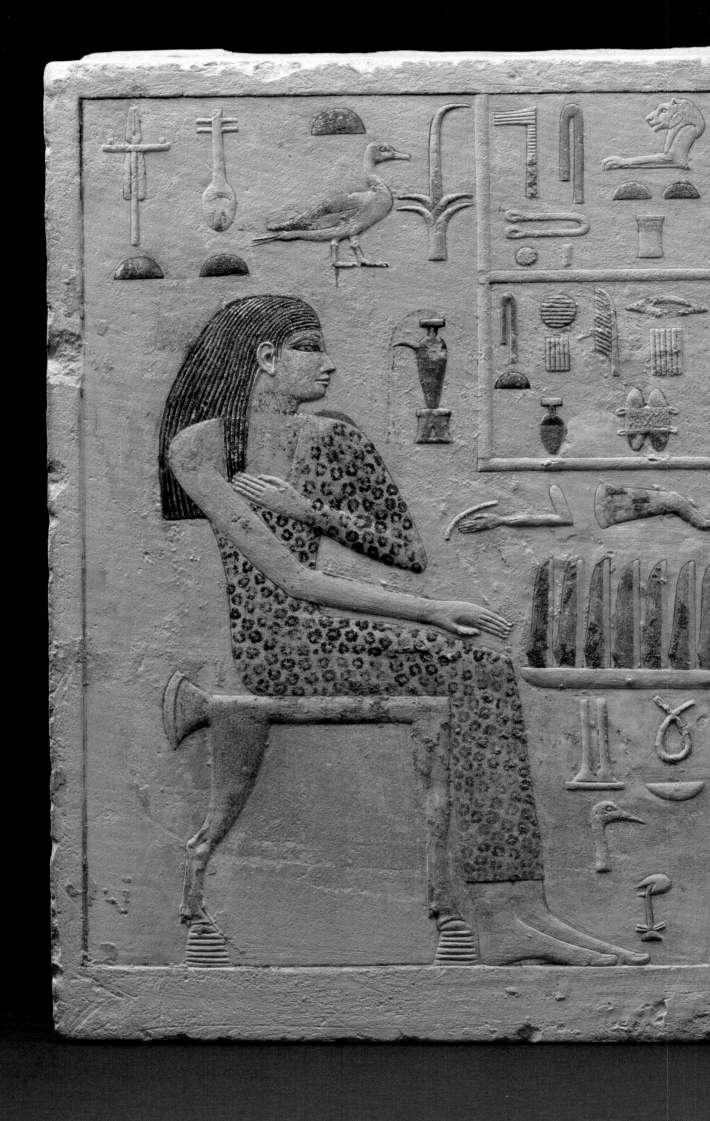

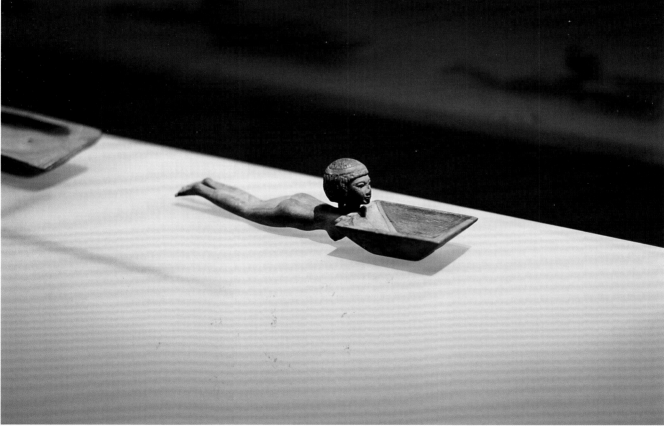

Opposite
King Amenhotep IV-Akhenaten
Karnak, ca. 1350 B.C.
Fragment of a pillar of a building, sandstone,
formerly painted, H. 137 cm (54 in.)
Department of Egyptian Antiquities, gift from
the Egyptian government to France, 1972

Pendant with the name of King Osorkon II,
known as the *Osorkon II Triad*
Unknown provenance, 22nd dynasty
(874–850 B.C.)
Gold, lapis lazuli, and red glass, H. 9 cm (3 ½ in.)
Department of Egyptian Antiquities, acquired
in 1872

Spoon in the shape of a swimmer
Gurob (after the seller), 25th dynasty
(715–656 B.C.)
Carob wood, L. 20 cm (7 ⅞ in.)
Department of Egyptian Antiquities,
acquired in 1907

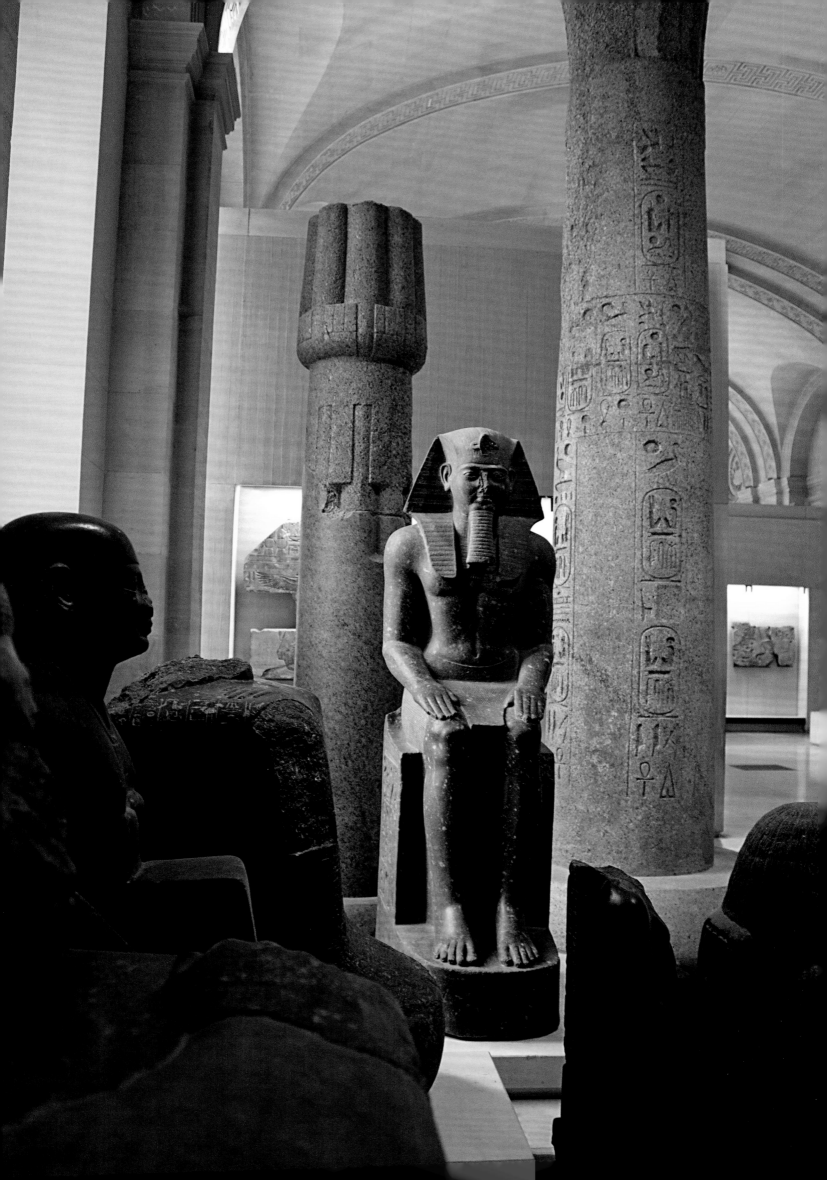

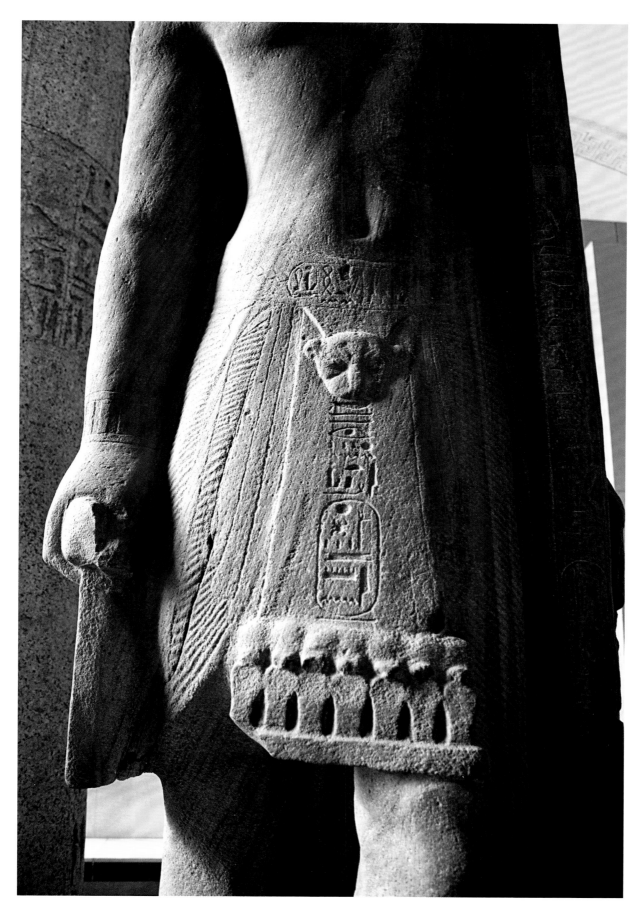

Opposite
View of the Galerie Henri IV (Temple Room)
Colossal statue of Ramesses II found in Tanis
(1279–13 B.C.); left, Bubastis column
(ca. 1400 B.C.); right, column with the name
of Ramesses II reused in the East Temple of Tanis
Department of Egyptian Antiquities

King Seti II (detail)
19th dynasty (1200–1194 B.C.)
Sandstone, H. 389 cm (153 in.)
Framed the entrance to a barque chamber
in the temple of Amun, Karnak, with another
statue (kept in Turin)
Department of Egyptian Antiquities,
acquired in 1827

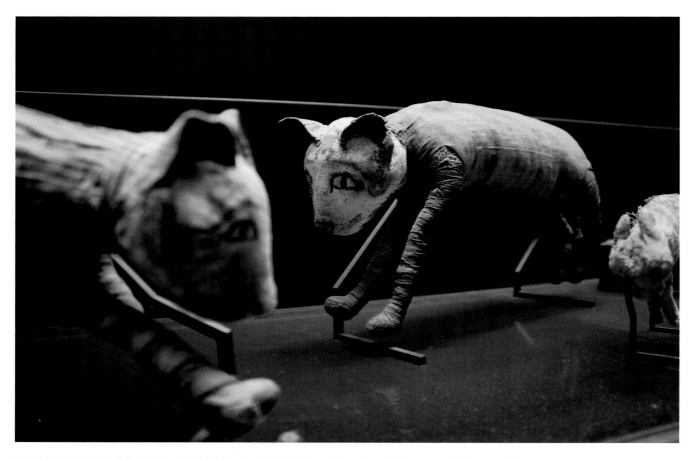

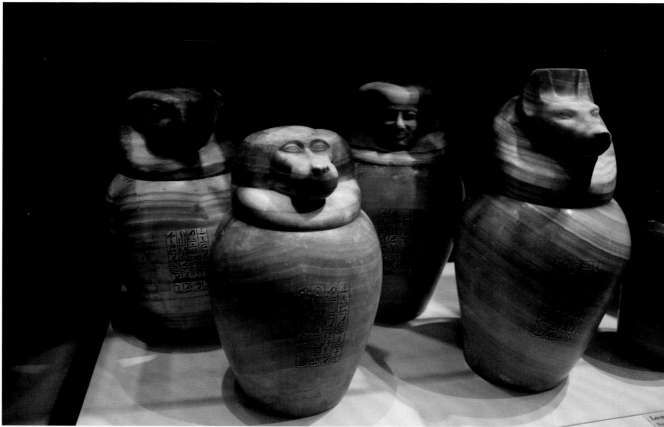

Cat mummies
Unknown provenance, late period
(664–332 B.C.)
L. 17–30 cm (6 ¾–11 ⅞ in.)
Department of Egyptian Antiquities,
Clot-Bey collection, acquired in 1852

Vases of the head of the Horiraa court
Saqqara, late 26th dynasty (ca. 525 B.C.)
Alabaster, H. 40–49 cm (15 ¾–19 ¼ in.)
Department of Egyptian Antiquities,
Brindeau collection, acquired in 1827

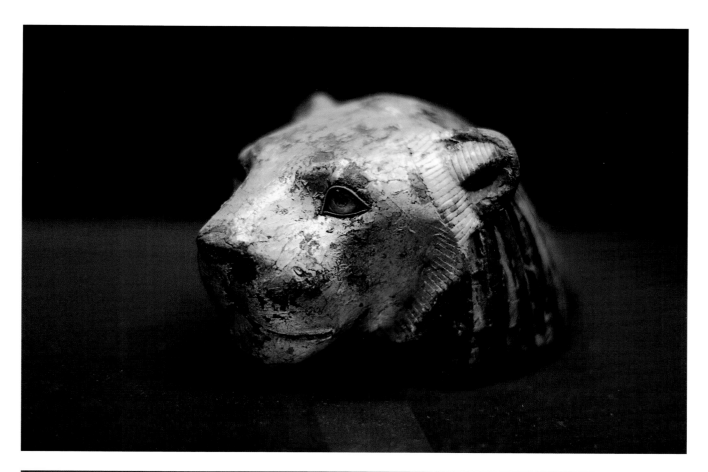

Lion's head (furniture element)
Unknown provenance, late period
(664–332 B.C.)
Tamarisk wood, coated and gilded with gold,
H. 8.3 cm (3 ¼ in.)
Department of Egyptian Antiquities,
Clot-Bey collection, acquired in 1852

Statue of the god Horus (detail)
Memphis (?), 1069–664 B.C.
Bronze formerly covered with precious
materials (gold plating, metal sheets),
H. 95.5 cm (37 ⅝ in.)
Department of Egyptian Antiquities,
Posno collection, acquired in 1883

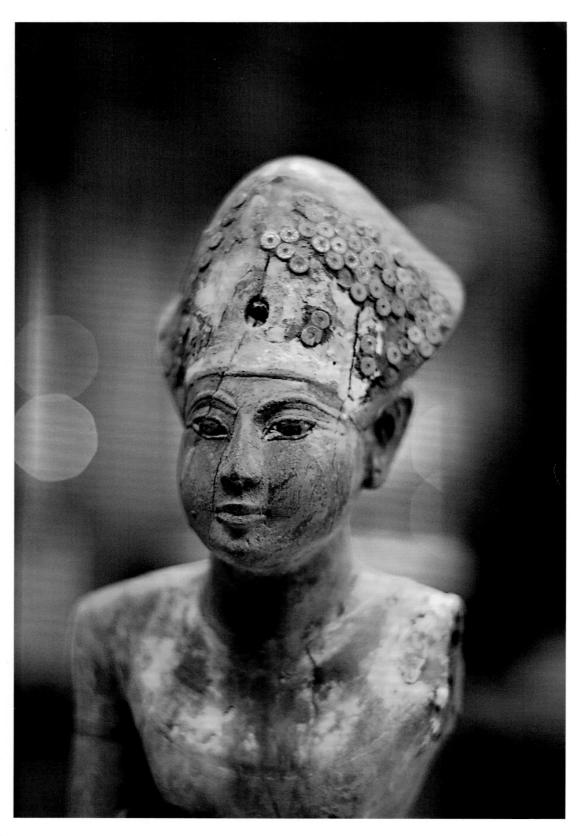

A King (Ramesses II or the former divinized
king Amenhotep I) (detail)
Deir el-Medina, probably 1279–13 B.C.
Shea wood, coated and painted, siliceous
earthenware bead headdress, H. 69 cm (27 ⅛ in.)
Department of Egyptian Antiquities, gift after
excavations, 1939

Opposite
The Goddess Isis (detail)
Unknown provenance, 332–30 B.C.
Wood, coated and painted, H. 60.5 cm (23 ⅞ in.)
Department of Egyptian Antiquities,
Salt collection, acquired in 1826

Following spread
Sarcophagus of Udjahor (detail)
Unknown provenance, 664–332 B.C.
Limestone, H. 195 cm (76 ¾ in.)
Department of Egyptian Antiquities,
Clot-Bey collection, acquired in 1827

Inner coffin lid and Tanethereret mummy cover
Western Thebes, 1069–945 B.C.
Wood, coated and painted, H. 189 and 173 cm
(74 ³/₈ and 68 ¹/₈ in.)
Department of Egyptian Antiquities,
transmitted in 1907 by the Bibliothèque
Nationale de France

Mummy of a man (detail)
Unknown provenance, 332–30 B.C.
Human mummy, linen strips, cardboard,
L. 166 cm (65 ³/₈ in.)
Department of Egyptian Antiquities,
Salt collection, acquired in 1826

Opposite
Mummy mask of a man with backrest
Western Hermopolis (Tuna el-Gebel) (?),
2nd century A.D.
Wood, stuccoed and painted, H. 27 cm (10 ⁵/₈ in.)
Department of Egyptian Antiquities, acquired
in 1905 (IFAO mission)

For the Middle Kingdom, the strongest figure is the life-sized Chancellor Nakhti, found in his tomb in the necropolis of Asyut, which had remained untouched until the excavations of 1903. Executed in acacia wood, the statue has an astonishing presence, thanks to its volumes and his gaze, created by carefully inlaid eyes. There are many New Kingdom masterpieces, and images of kings multiplied: Amun protecting Tutankhamen, where the god reflects the features of the young pharaoh's face; the statuette of a king making an offering to the goddess Ma'at, in gold-plated silver, which was an element of a processional boat. The most subtle works are perhaps fragments of Amarna art, when a breath of naturalness passed through the relative rigidity of Egyptian art: a princess's head, a female torso in red sandstone, whose full shapes round out under a clinging pleat. The New Kingdom display ends with a masterpiece of silversmithing: the *Osorkon II Triad*, in which Osiris crouches between Isis and Horus (ca. 874–850 B.C.).

On the ground floor, the presentation is thematic (as Champollion had designed it). Here, we discover daily life and religious and funerary rites. The evocation of the Nile opens the circuit, followed by labor, domestic dwellings and furniture, writing and scribes, trades, techniques, agriculture, and fishing. Transferred to the Louvre in 1903, the Akhethotep mastaba, from Saqqara (ca. 2400 B.C.), allows one to enter the heart of the chapel of a tomb where the family of the deceased could communicate with the afterworld. Its walls are covered with fine reliefs depicting human activities: farming, fishing, hunting,

and boat transport. In the former Galerie Henri IV, dedicated to the theme of the temple, the large columns; the monolithic colossi (or their gigantic feet); the animals, depicted in granite, diorite, or sandstone, reconstruct the world of religion. The aligned sarcophagi; the *Book of the Dead*, in a nearby gallery; and the crypt of Osiris illustrate funerary rites.

We can learn the rest of the story in the basement of the Denon Pavilion. Since 2012, Roman Egypt has been presented in large display cases, following a scheme similar to the thematic gallery, where the funerary art predominates: mummy masks made of plaster, modeled or painted on thin wooden panels. This is especially striking in the series of realistic portraits using the Greco-Roman technique of painting with wax. Also since 2012, a suite of rooms has been dedicated to the Mediterranean East in Roman times. Here, small bronzes, ivories, and terra-cotta from the Alexandrian and Roman periods interact with all the productions of the Roman world.

Coptic art has been exhibited since 1997 (as was Roman Egypt) in the basement of the Denon Wing, but the insertion of the Islamic art galleries has necessitated a complete overhaul. Various elements of a Coptic church—facade, reliefs, columns—have been reconstructed in the Bawit room, once the amphitheater of the Louvre School. One can also see the extremely rare painted panel, *Christ and Abbot Mena*, portraying the superior of Bawit Monastery. The adjacent gallery presents some textiles, Coptic embroideries, and small liturgical objects from burial sites.

Funerary portrait of a young woman
Antinoë (Antinopolis), 1st century A.D.
Cedar wood painted in encaustic and gilded,
42 × 24 cm (16 ½ × 9 ½ in.)
Department of Egyptian Antiquities,
acquired in 1951

Opposite
Christ and Abbot Mena
Bawit Monastery, 8th century A.D.
Wax and tempera painting on fig tree wood,
57 × 57 cm (22 ½ × 22 ½ in.)
Department of Egyptian Antiquities,
excavations of Émile Chassinat and
Jean Clédat, 1901–2

The Cour Khorsabad:
The Discovery of the Ancient East

A few oriental objects had been in the royal collections for a long time. Curiously, André Le Nôtre owned two Phoenician sarcophagi, which passed into the collections of Louis XIV. The first two copies of Palmyra funerary busts arrived at the Louvre in 1846. But the curtain-raiser really came in 1847, with the Assyrian antiquities discovered in Khorsabad by Paul-Émile Botta, French consular agent in Mosul. Since 1842, Botta had been searching for the remains of ancient Nineveh. Yet it was not Nineveh that he uncovered, but the palace of Sargon II of Assyria, founded in 717 B.C. in Khorsabad (now Dur-Sharrukin). In March 1843, he pulled colossal reliefs of winged bulls from the sand. A selection of the finds was almost immediately sent to France, and the first two winged bulls from the Khorsabad palace were placed in the rooms of a small Assyrian museum opened on 1 May 1847 in the north wing of the Cour Carrée. Linked to the Department of Antiquities, it belonged to the series of Egyptian, Judaic, Algerian, Mexican, etc. "museums" that were all subdivisions, then attached to classical art.

Victor Place, who succeeded Botta at the Mosul consulate, continued the excavations at Khorsabad in 1852–54, when an official mission was established. He shipped cylinders and statuettes, as well as a new winged bull from the palace of Sargon. It was a difficult expedition: another bull and a cargo of finds sank in the Tigris in 1855. At the same time, English archaeologists were kind enough to offer large reliefs of Nineveh and Nimrud. Ten years later, in 1865, large Assyrian reliefs were sent from Nineveh by the consul Pacifique-Henri Delaporte.

Other areas of the Eastern world were opening up to research, often in relation to Bible studies. The pioneers Félix de Saulcy; Honoré d'Albert, duke of Luynes; Charles Clermont-Ganneau; and Melchior de Vogüé traveled throughout the Levant, Palestine, and Jerusalem. In 1855, the duke of Luynes donated the great sarcophagus of Eshmunazar II, king of Sidon. In 1860, the philosopher and orientalist Ernest Renan went on a mission to Phoenicia; he brought back the first nucleus of antiquities from the Levant, namely from Byblos, Tyre, and Sidon.

In 1862, Melchior de Vogüé led the Cyprus mission, accompanied by William Henry Waddington and the architect Edmond Duthoit. They would return with a first harvest of

The Cour Khorsabad with the *Winged Human-headed Bulls*
(see p. 398)

King Sargon II and a High Dignitary
Khorsabad (ancient Dur-Sharrukin, Assyria), Iraq, neo-Assyrian period, reign of Sargon II (721–705 B.C.)
Gypsum alabaster
Department of Oriental Antiquities, excavations of Paul-Émile Botta (1802–70), 1843–44

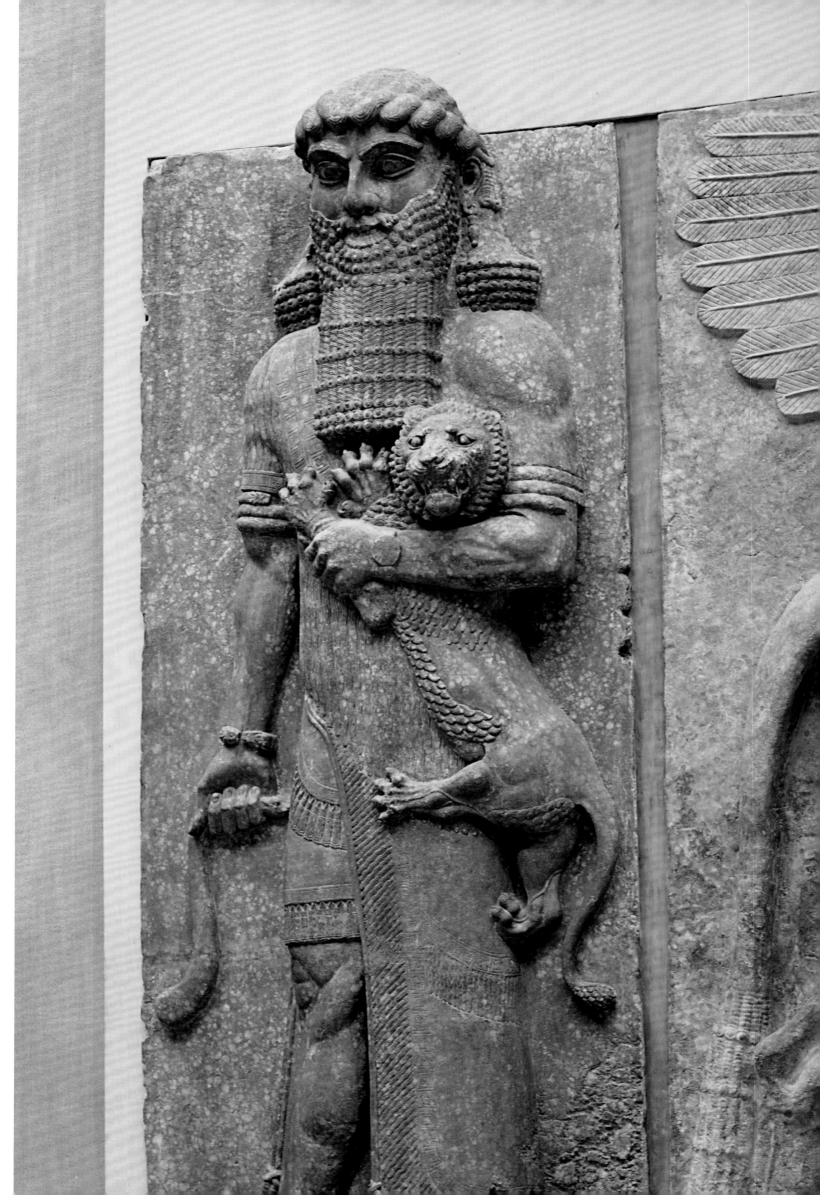

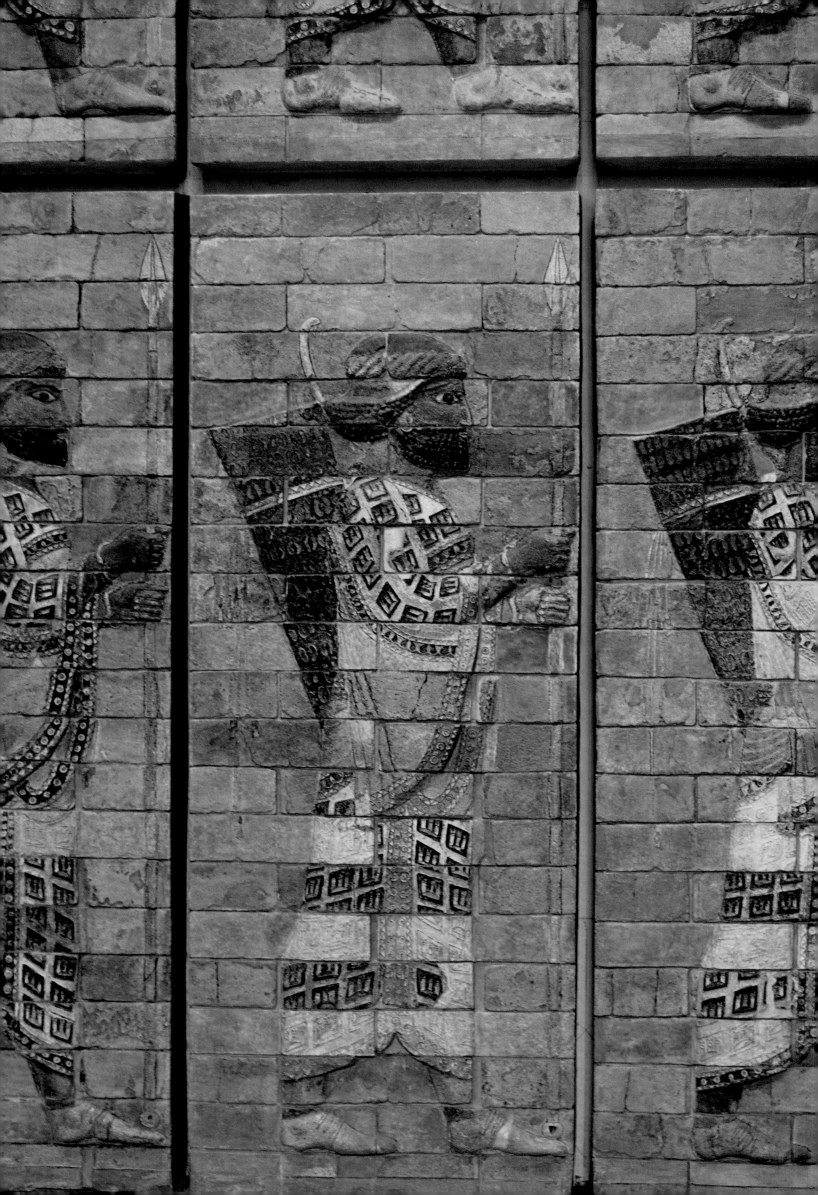

objects. Duthoit left again in 1865 for a new mission in Cyprus, which produced votive sculptures from the Golgoi sanctuary; Frankish epitaphs; and, above all, the giant monolithic Amathus vase, which was unloaded in Le Havre and placed in the museum with great difficulty in 1866. Finally, the Cernola collection was acquired in 1870. The collection of Cypriot antiquities expanded after the island came under British rule. In 1924, Claude Schaeffer excavated the Enkomi site, destroyed around 1150 B.C., then discovered a 2300 B.C. necropolis in Vounous that provided a beautiful piece of ceramic tableware.

Research was directed toward the west of Iran, where an English mission discovered vestiges of Susa, the capital of Elam, before it became the capital of the Persian kingdom. From 1884, Marcel Dieulafoy, an engineer in France's bureau of roads and bridges, began excavations of Darius's palace there. Then Jacques de Morgan, also an engineer, carried out a general reconnaissance of the site between 1896 and 1912 that proved to be extraordinarily fruitful. It contained the enameled brick walls of the palace, with its famous *Frieze of Archers* and fabulous animals, the monumental capital from the Apadana audience hall, and the Elamite war booty of the twelfth century B.C. It also held the most famous antiquities of the Babylonian cities, including the *Code of Hammurabi* and the victory stela of Naram-Sin, ruler of Akkad. The excavations of Susa resumed in 1921, yielding rare Elamite funerary portraits, glazed brick decorations, griffins, confronted sphinxes, and ceramics.

The diplomat Ernest de Sarzec, stationed in Basra in southern Iraq, focused on the site of Tello (ancient Girsu) capital of the Neo-Sumerian prince Gudea, whose black diorite statuettes were discovered from 1877 onward. Excavations resumed in the interwar period, thanks to abbot and Assyriologist Henri de Genouillac, relayed by André Parrot, who then devoted himself to the Tell es-Senkereh site of ancient Larsa, from which the Ishtar vase, in particular, came. Several objects from these sites were acquired at that time. In 1930, David-Weill bought nearly seven hundred objects, tablets, and cylinders from Tello from the collection of Allotte de La Fuÿe before it was put up for sale. The exceptional *Worshipper of Larsa*, dedicated to Hammurabi, king of Babylon, entered the museum in 1932.

After World War I and the dismantling of the Ottoman Empire, France exercised a League of Nations mandate over Syria and Lebanon, while England did the same in Iraq and Palestine. In Syria, French archaeologists organized the antiquities service, carrying out research whose results were shared between the Louvre and Syrian museums. The two main sites were excavated by Schaeffer and Parrot, the latter of who would be the first director of the Musée du Louvre. In 1929, Schaeffer discovered the famous *Baal with Thunderbolt* (fourteenth to thirteenth century B.C.), with the Hunt Patera, a testimony to royal goldsmithing, ivories (including the *Mistress of the Animals*), ceramics, and Phoenician tablets in Ras Shamra (ancient Ugarit) near Latakia.

From 1933 onward, Parrot excavated Tell Hariri (ancient Mari) destroyed by the Babylonians in 1760 B.C. His contributions were crucial: the statuette of Intendant Ebih-Il (alabaster and lapis lazuli); the "standard" animated with shell figurines (2400 B.C.); and the *Investiture of Zimri-Lim*, a wall fresco found in the Mari ruler's palace, from the first half of the eighteenth century B.C., as well as the *Lion of Mari* from the temple of Dagon. In 1936, nearly twelve thousand tablets were sent to the Louvre for study.

But by then, many sites were under excavation: Kadesh, Qatna, Dura-Europos from which the *Hunting Fresco* comes, Til Barsip (Tell Ahmar), Arslan Tash (ancient Hadatu), where the mission exhumed a remarkable series of ivories from luxury furniture in Assyrian palaces (eighth century B.C.). Also, the votive statuettes from the Temple of the Obelisks in Byblos, Lebanon, which brought Phoenician art to the Louvre (nineteenth to eighteenth century B.C.).

In the interwar period, research in Iran was extended to sites other than Susa: Tepe Giyan, Nahavand, Tepe Sialk, and Bishapur. It may be added that, although the collection of Luristan antiquities gathered by André Godard was not, strictly speaking, obtained from excavations, its acquisition process was similar to a sharing of finds in excavations, given that he was in charge of the Persian antiquities department.

Capital of a column from the audience hall (Apadana)
Susa, palace of Darius I, ca. 510 B.C.
Limestone
Department of Oriental Antiquities,
Marcel Dieulafoy mission, 1885–86

Opposite
Frieze of Archers (detail)
Susa, palace of Darius I, ca. 510 B.C.
Glazed siliceous bricks, H. of an archer 196 cm (77 ⅛ in.)
Department of Oriental Antiquities, Marcel Dieulafoy mission, 1885–86

Previous spread (right)
Hero Overpowering a Lion
Front of the entrance courtyard of the palace at Khorsabad
Gypsum alabaster, H. 450 cm (177 in.)
Department of Oriental Antiquities,
excavations by Paul-Émile Botta (1802–70),
1844

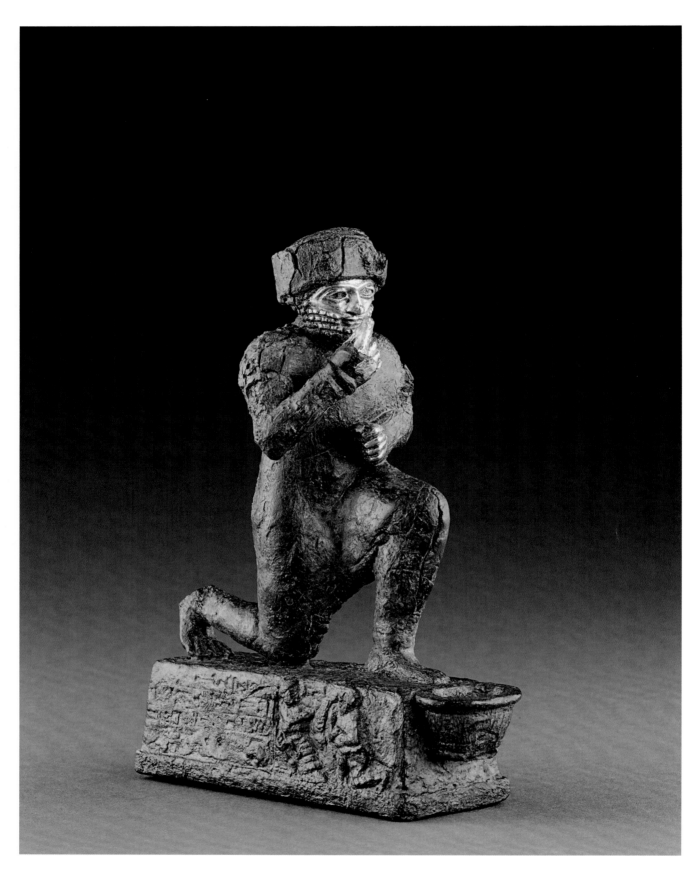

Statuette of a kneeling man,
known as the *Worshipper of Larsa*
Bronze, gold, 19 cm (7 ½ in.)
Statue dedicated to the god of Amorite
nomads, Amurru or Martu, by a man from
Larsa, Awil-Nanna, to preserve the life
of Hammurabi, king of Babylon
Department of Oriental Antiquities,
acquired in 1932

Opposite
Code of Hammurabi, King of Babylon
Susa, 1792–50 B.C.
Basalt, H. 225 cm (88 ⅝ in.)
Department of Oriental Antiquities,
excavations of Jacques de Morgan, 1901–2

The *Code of Hammurabi* is the compendium
of laws that governed the kingdom of Babylon.
At the top of the stela is the king before the sun
god Shamash.

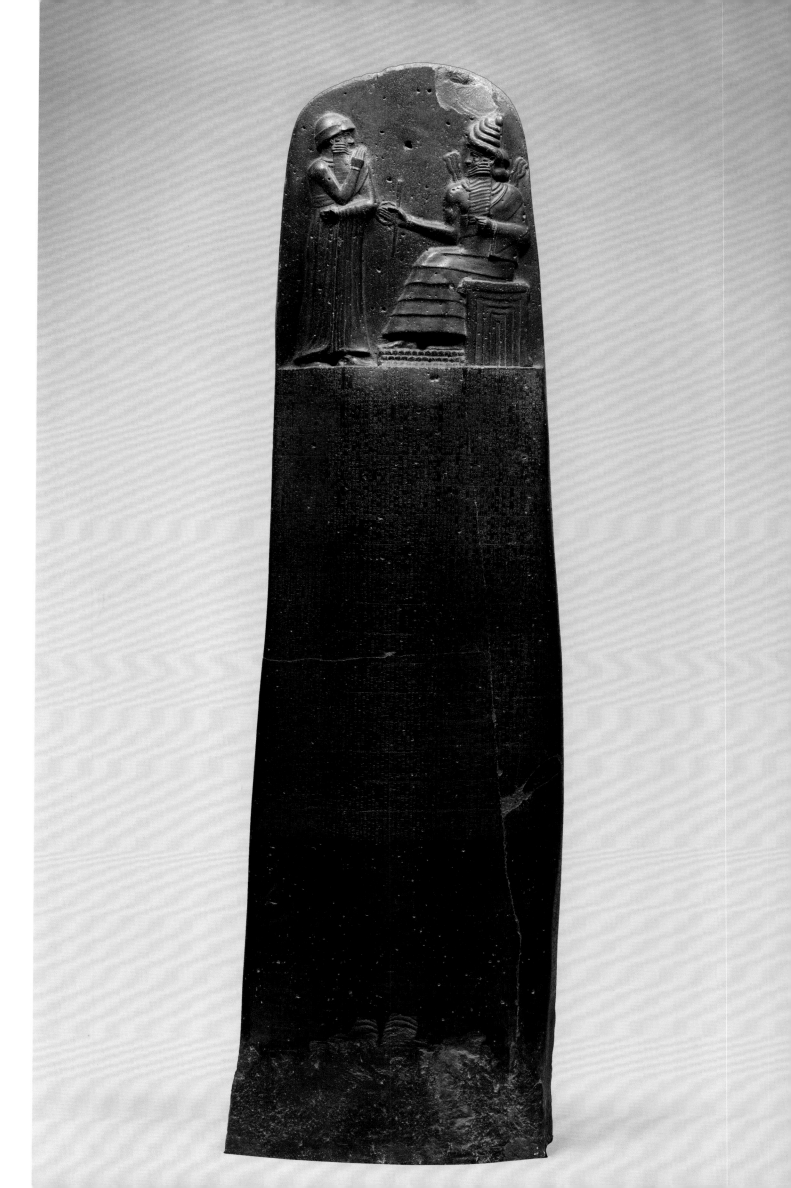

Opposite

Statuette of a woman (detail)
Umma (?), Akkad period
Limestone, H. 22 cm (8 ⅝ in.)
Department of Oriental Antiquities,
acquired in 1911

Statue of a human form (detail)
Ain Ghazal (Jordan), pre-ceramic Neolithic
period (7th millennium B.C.)
Hand-modeled in gypsum plaster on a rope
frame, eyelids and pupils in bitumen,
H. 105 cm (41 ⅜ in.)
Department of Oriental Antiquities,
excavations led by Gary Rollefson and Zeidan
Kafafi, 1985, loan from the Jordan Antiquities
Directorate, 1997

Opposite

Ebih-Il, nu-banda (detail)
Mari (Tell Hariri), temple of Ishtar,
time of the archaic dynasties (ca. 2400 B.C.)
Alabaster, lapis lazuli, shale, shell,
H. 52.5 cm (20 ⅝ in.)
Department of Oriental Antiquities,
excavations by André Parrot, 1934–35

A masterpiece of Mari statuary, the figure
wears the *kaunakes*, a skirt made of fur,
rendered here with great realism.

Statuette of a standing naked woman, possibly
representing a great Babylonian goddess (detail)
Babylon, 3rd century B.C.–3rd century A.D.
Alabaster, gold, ruby, terra-cotta, H. 24.8 cm
(9 ¾ in.)
Department of Oriental Antiquities,
gift of Pacifique-Henri Delaporte, 1866

The Department of Oriental Antiquities became autonomous in 1881, thanks to Edmond Pottier. Also, Pottier separated the field of Greek pottery, in which he was a specialist, from Greek and Roman antiquities and added it to the Department of Oriental Antiquities. The space gradually grew; however, the successive arrival of objects of all kinds quickly filled the barely opened rooms. Until 1947, the department had rooms distributed in no particular order throughout the museum. Napoleon III had ordered his architect Lefuel to arrange a remarkable staging of the three winged bulls of Khorsabad and the reliefs in the large room on the ground floor of the Colonnade. A copy of another bull was cast so that two pairs could be placed at either end of the room in a symmetrical layout that did not reflect their placement in situ. Under the Second Empire, antiquities from the Levant, Cyprus, and Phoenicia occupied the eastern half of the north wing in relative continuity. With the harvest from Iran, rooms were opened on the Colonnade floor, then in the Pavillon de Sessions. Fortunately, the decision by Henri Verne (director of the Musées Nationaux) to join the departments under a coherent plan accommodated a grouping and redistribution of oriental antiquities into major geographical and cultural areas. After the work carried out between 1936 and 1945—in particular, the clearing of crypts under the passages of the Cour Carrée, which allowed a continuous route—the department reopened in 1947. It had gained access to the modern sculptures space, the former Galerie d'Angoulême, and the vast crypt under the Marengo passage. This provision was considerably increased by the Grand Louvre project, with the allocation of the north wing, previously occupied by the Ministry of Finance. The Mesopotamia rooms that begin the circuit—those of Lagash and the vast courtyard in which the Khorsabad palace has been reconstructed—were opened in 1993. Now, two bulls flank the entrance corridor as guardian figures. The third bull is placed flat against the wall inside the courtyard. A fourth, cast from an original in Chicago, also parallels the courtyard wall, but in this case, the head is turned toward the viewer.

Subsequent patronage made it possible to redevelop the north wing. In 2012, the latest collections were added to those of the Egyptian department and Greek and Roman antiquities, to form the new rooms of the eastern Mediterranean during the Roman period.

Since 1947, the department has favored the presentation of objects by geographical region. The three major areas are Mesopotamia, Iran, and the Levant. Chronologically,

Gudea, Prince of Lagash (detail)
Colossal statue dedicated to the god Ningirsu
Tello (former Girsu), ca. 2120 B.C.
Diorite, H. 158 cm (62 ¼ in.)
Department of Oriental Antiquities,
excavations of Ernest de Sarzec (1832–1901),
1881

Opposite
Gudea with Overflowing Water Jar (detail)
Tello (former Girsu), ca. 2120 B.C.
Dolerite, H. 62 cm (24 ⅜ in.)
Department of Oriental Antiquities,
acquired in 1967

the collection spans several thousand years, from the seventh millennium B.C. to the appearance of Islam. The Jordanian government's loan of the strange stucco statue from Ain Ghazal is today the oldest work on display in the Louvre, dating back to the seventh millennium.

The Gallery of Greek Art:
The Discovery of the Venus de Milo

Until the early nineteenth century, Greek works were known through the prism of their Roman copies, many of which resided in the royal collections, were seized during the Revolution, or had been acquired by Napoleon. Only the relief of the Panathenaic Games, from the Choiseul-Gouffier collection, and a metope of the Parthenon from the same collection that entered a little later (1818), testify to the great classical art of Athens. In 1820, a statue of Aphrodite, larger than natural size, was discovered on the island of Melos, in the Cyclades archipelago, which became famous under the name of Venus de Milo. The marquis de Rivière, ambassador to "the Sublime Porte," the Ottoman government, bought the work and offered it to Louis XVIII, who gave it to the Louvre, where it caused a sensation when it arrived in 1821. The beauty of the female body emerging from the folds of drapery—a Hellenistic work at a time when the return to classicism was taking hold—made it a success.

Nine years later, the Greek senate decided to offer France—in gratitude for its support of Greek independence—metopes from the Temple of Zeus in Olympia. The Ottoman Empire must not have been offended because, in 1838, the sultan gave the Louvre the elements of the archaic Greek temple of Assos, and the vase from Pergamon. Meanwhile, Charles Texier led a mission in Asia Minor from which he brought back the frieze of the Artemis Temple of Magnesia on the Meander. In northern Greece, which was still under Turkish rule, experts collected reliefs and stelae. Thus was established a primitive Greek museum in the north wing of the Cour Carrée, not far from the Assyrian museum.

During the Second Empire, the emperor's interest in antiquity prompted a mission in northern Greece. Léon Heuzey, the epigrapher Léon Renier, and Henri Daumet left for Macedonia, in the footsteps of Caesar; they took the opportunity to excavate the first tombs of the Macedonian dynasty in Pydna, as well as the Palatitza palace. Then they moved on to Thessaly, the islands, and Asia Minor. The famous *Exaltation of the Flower* from Pharsalus thus entered the Louvre in 1863. In 1865, Miller studied Thessaly and the island of Thasos, and brought back the relief of Apollo Nymphagètes and the Nymphs, from the Passage of the Theoroi.

The collection of masterpieces was completed by the arrival of the colossal *Winged Victory of Samothrace*, sent by Charles Champoiseau, consul of France in Adrianople, in 1864. After having appeared in the rooms with other statuary, *Winged Victory* was placed at the top of the Daru staircase, on the great ship's prow of the sanctuary from which it comes. The presentation was incorrectly redesigned in the 1930s, so a new restoration carried out in 2013–15 restored the ensemble to its full archaeological integrity, while retaining the demonstrative power of its staging.

The Greek art tour begins with the preclassical Greek gallery, near the Denon entrance. It is dedicated to pre-Hellenic civilizations and to Cycladic art, famous for its marble "idols" of great formal simplicity. The chronological thread continues with some objects from Minoan Crete, and then with the evocation of Mycenaean art through pieces of goldwork, ceramics, and terra-cotta.

The archaic period is represented in the Louvre by kouroi (male statues) and korai (female statues) with stylized shapes, the most beautiful of which came from the sanctuary of Hera on the island of Samos. The *Rampin Horseman* is one of the great masterpieces of the mid-sixth century B.C. (only the smiling head, which retains traces of polychrome, is in the Louvre; the fragments of his horse are in Athens).

Female figurine
Early Cycladic II (2700–2300 B.C.)
Marble, H. 14 cm (5 ½ in.)
Department of Greek, Etruscan, and Roman Antiquities, Codess gift, 1997

Spedos-type figures with crossed arms mark the apogee of Cycladic creative output in the second millennium B.C. The stylized simplification of the volumes augments their expressive power.

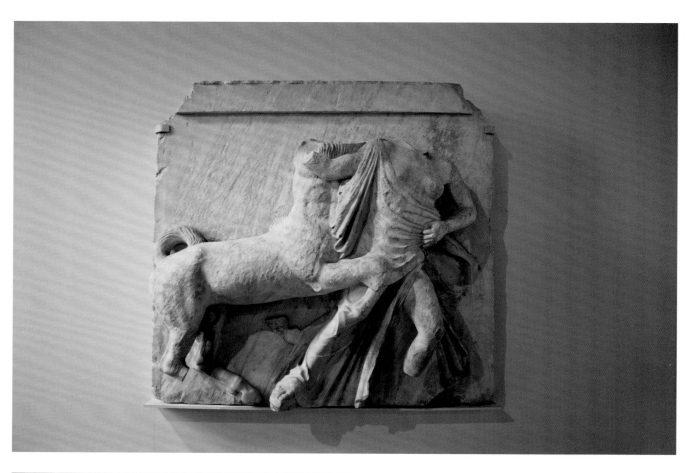

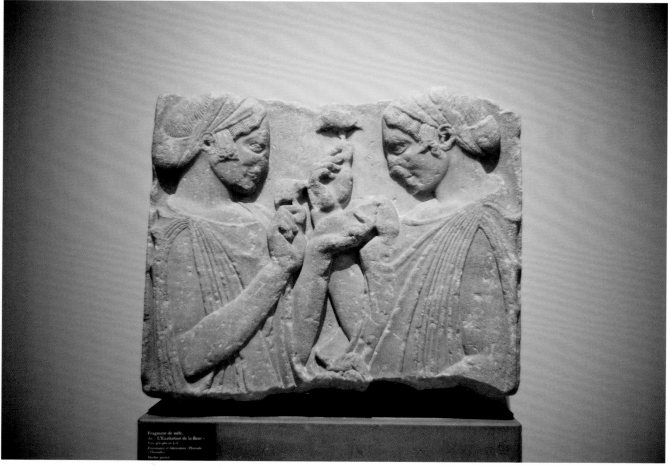

The severely styled room, dominated by Miletus's torso, gives access to two mono-graphic spaces dedicated to two major temples. The Salle d'Olympie, located under the Daru staircase, displays one of the western metopes from Zeus's temple at Olympia, where Heracles tamed the Cretan bull. It is accompanied by other fragments and didactic mate-rial. Then comes the Salle de Diane, now housing the Parthenon Marbles, with a plaque of the Panathenaic procession, a metope, and a head from the collection of Léon de Laborde, curator of antiquities at the end of Louis-Philippe's reign.

We approach the two parallel galleries on the ground floor of the south wing in the Cour Carrée—built by Raymond, architect under the Directory—in Anne of Austria's former winter apartment (of which nothing remains). Raymond had completely reshaped the space, giving it the impression of galleries, while enlargements and contractions created by arcades organized the partitions. At the bottom of the south gallery, he even planned the monumental niche that was intended to showcase the *Medici Venus*. Fontaine, whose neoclassical style is instantly recognizable, designed the decoration on Raymond's struc-ture. The walls were covered with red marble slabs, where reliefs were originally inserted. An elegant marble frieze runs along the base of the vault. The bottom of the niche was most certainly enriched with ornaments. During the Empire, the great statue of *Melpomene* was displayed there, in front of which was placed a large mosaic of Francesco Belloni extolling the glory of the emperor. The *Melpomene* was replaced by the *Pallas of Velletri*, and the mosaic, which the purist alterations of the 1930s had exiled to a cellar of the Château de Compiègne, is today exhibited in the Department of Sculptures.

Since the 2010 redevelopment, the galleries are no longer populated only by large mar-bles, as was the case at the beginning of the nineteenth century. In order to exhibit all the arts in a more pedagogical way, marbles are now mixed with small bronzes, ceramics, and jewelry; even coins are placed in display cases. The circuit is organized around two themes, which begin in the north gallery, then circle back to the south gallery and end with the Venus de Milo, which has returned to exactly the same position it occupied upon its arrival

Horse's head (detail)
Attic, late 6th century B.C.
Marble, traces of polychrome (black, blue, and red), H. 52.5 cm (20 ⅝ in.)
Department of Greek, Etruscan, and Roman Antiquities, former Feuardent collection, acquired in 2004 with the participation of the Société des Amis du Louvre

Opposite
Centaur Abducting a Lapith Woman
Athens, 447–440 B.C.
Pentelic marble, H. 135 cm (53 ⅛ in.)
Department of Greek, Etruscan, and Roman Antiquities, former Albani collection, acquired in 1818

This is the tenth metope from the south face of the Parthenon, which featured a centauromachy. Here, a man-horse attacks a woman in a subtle interplay of lines and volumes.

Fragment of a funerary stela known as *The Exaltation of the Flower*
Pharsalus (modern Farsala), ca. 470–460 B.C.
Paros marble, 56.5 × 67 cm (22 ¼ × 26 ⅜ in.)
Department of Greek, Etruscan, and Roman Antiquities, mission of Léon Heuzey and Henri Daumet, 1863

This funerary stela shows two women who seem to be exchanging flowers. The perfect serenity of the faces is highlighted by the sophistication of the hair.

Vase from Pergamon (detail), 2nd century B.C.
Marble, H. 97.4 cm (38 3/8 in.)
Large *dinos* decorated with a race of
fifteen riders
Department of Greek, Etruscan, and Roman
Antiquities, gift of the Ottoman Empire, 1838

Opposite
Winged Victory of Samothrace
Island of Samothrace, ca. 190 B.C.
Gray Lartos marble for the ship's prow,
Paros marble for the statue, H. 328 cm (129 in.)
Department of Greek, Etruscan, and
Roman Antiquities, missions of Charles
Champoiseau, 1863

in 1821. The beautiful southern light streaming through the large windows ensures a natural and lateral lighting that is perfectly suited to the artworks.

In the north, the smaller rooms are each dedicated to a region where Greek art flourished: Southern Italy, Macedonia, Northern Greece, Asia Minor, the Near East, Egypt, and Libya. To the south, the vast space bathed in light opens onto more thematic pieces dedicated to the main gods. Here, the practice of creating replicas is illustrated by the juxtaposition of two identical compositions, such as in the case of the *Aphrodite Leaning against a Pillar*: one copy comes from the royal collections, the other from the Borghese collection. The cult of Athena, the male nude, and the draped female form are all iconographic pieces that also evoke the art of the two great sculptors Praxiteles and Lysippos.

Armed with new knowledge, visitors can approach the Venus de Milo in its artistic context. They then move on to the Salle des Caryatides, where the Roman replicas of Hellenistic Greek sculpture, marked by the legacy of Praxiteles and Lysippos, are displayed. Their memory is recalled by the symmetrically arranged marbles to the north and south. On one side, female grace; on the other, a powerful male nude. In the center, the *Diana*, known as the *Louvre Diana* or *Versailles Diana*, presides over this final room on the antiquities trail.

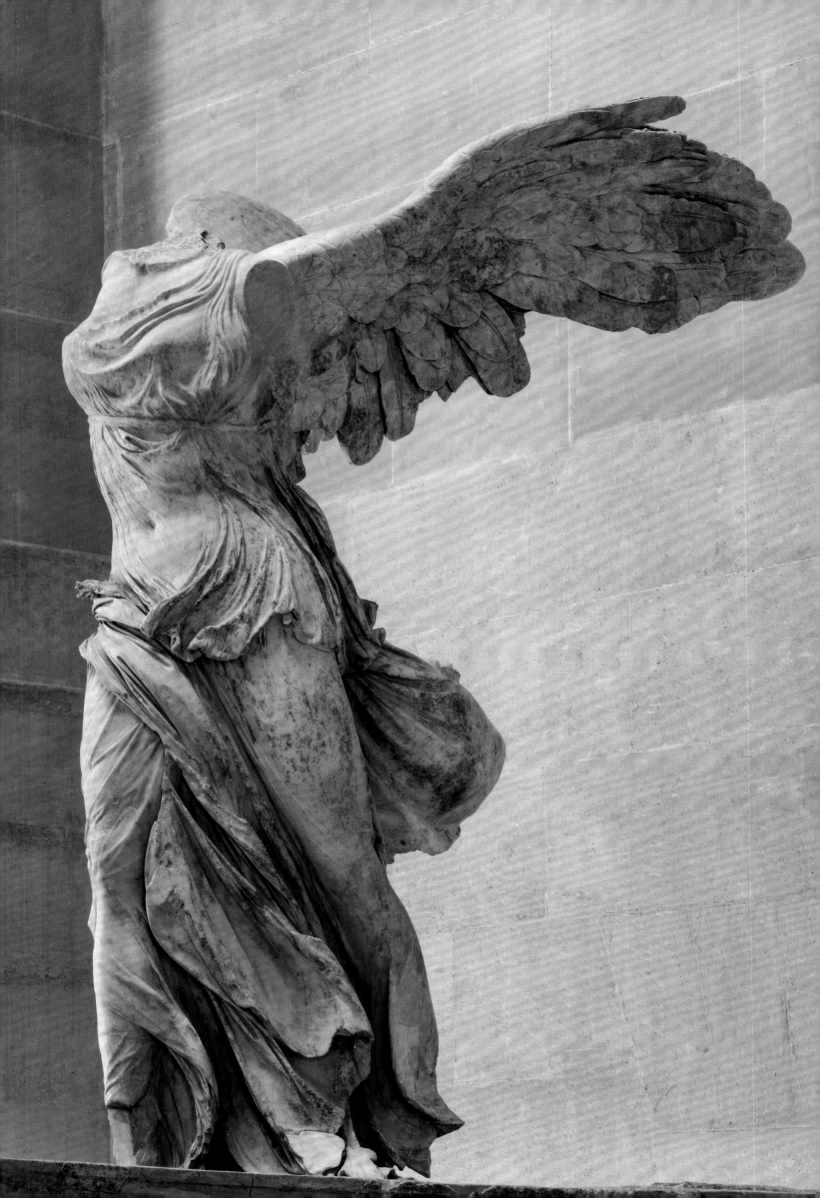

Head of a Horseman, called the *Rampin Horseman*
Athens, ca. 550 B.C.
Island marble, traces of polychrome, remains of a metal point at the top of the skull,
H. 27 cm (10 ⅝ in.)
Department of Greek, Etruscan, and Roman Antiquities, bequest of Georges Rampin, 1896

Kore head
Miletus, ca. 520–510 B.C.
Marble, traces of red paint on the veil,
H. 14.8 cm (5 ⅞ in.)
Department of Greek, Etruscan, and Roman Antiquities, acquired in 1982

Opposite
Female statuette, known as the *Lady of Auxerre*
Crete (?), ca. 640–630 B.C.
Limestone, incised decoration originally painted, H. 75 cm (29 ½ in.)
Department of Greek, Etruscan, and Roman Antiquities, exchange with the municipal museum of Auxerre, 1909

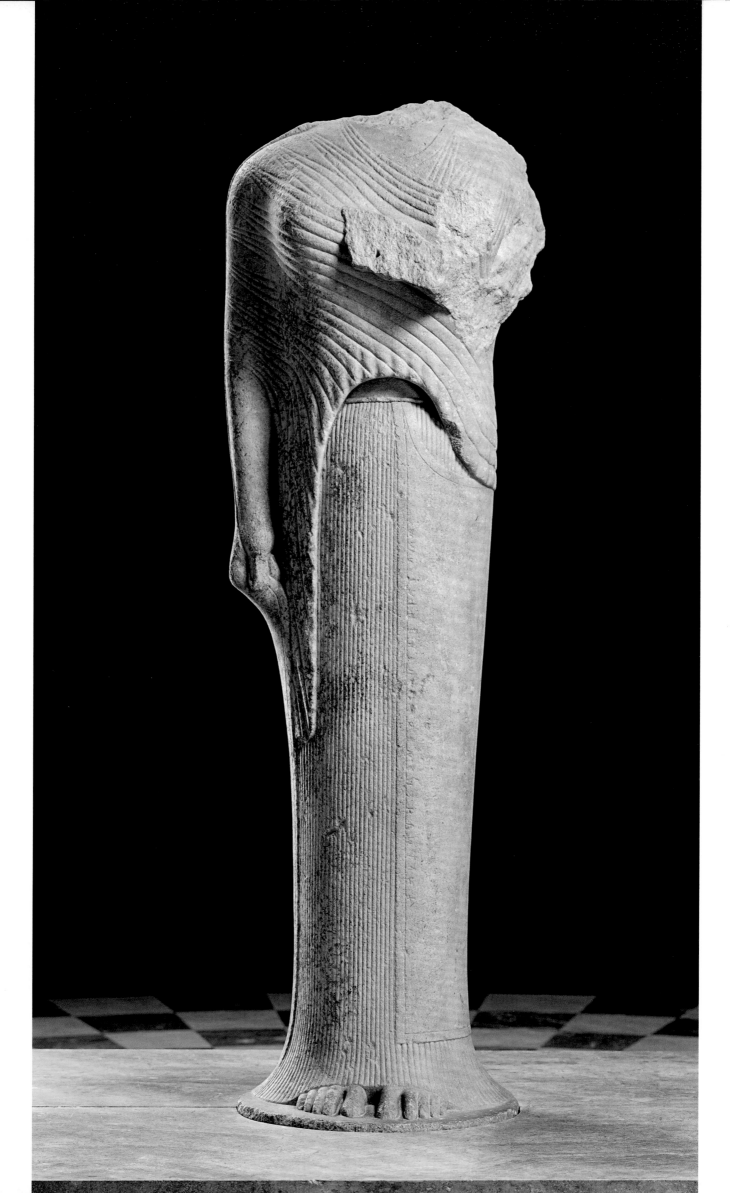

Previous spread (left)
Kore, known as *Hera of Samos*, ca. 570–560 B.C.
Marble, H. 192 cm (75 ⅝ in.)
Department of Greek, Etruscan, and Roman
Antiquities, excavations of Paul Girard in 1879,
acquired in 1881

This statue was found in the sanctuary of Hera
(Heraion), mythical place of the goddess's
birth on the island of Samos. A similar statue
(Berlin Museum) and a group of the same style,
which adorned the processional way (Samos
Museum), were later discovered.

Previous spread (right)
Male torso
Miletus, ca. 480–470 B.C.
Island marble (from Paros?), H. 132 cm (52 in.)
Department of Greek, Etruscan, and Roman
Antiquities, excavations of Olivier Rayet and
Albert Thomas at the Hellenistic Theater
of Miletus, gift of Edmond and Gustave de
Rothschild, 1873

Of imposing size, this torso of a man with its
powerful muscles shows the transition from
archaism to a more assertive anatomy that
heralds Classicism.

Gallery of the Venus de Milo:
Athena Mattei (detail)
Department of Greek, Etruscan,
and Roman Antiquities

Opposite
View of the Gallery of the Venus de Milo
Immense *Athena* (3.05 m/10 ft.), known as
the *Pallas of Velletri*, purchased in 1802 from the
restorer Vincenzo Pacetti, and (left) statue
of an ephebe, known *Narcissus*
Department of Greek, Etruscan, and Roman
Antiquities

Following spread
Seated woman known as the *Barberini Suppliant*
(detail), 1st century B.C. (?)
Marble from Mount Pentelic, H. 90, L. 104 cm
(35 ½, 41 in.)
Copy of a Greek figure from the late 5th
century, possibly depicting one of Zeus's lovers,
framing the altar of Zeus Polieus to the east
of the Parthenon
Department of Greek, Etruscan, and Roman
Antiquities, former Barberini collection,
acquired in 1935

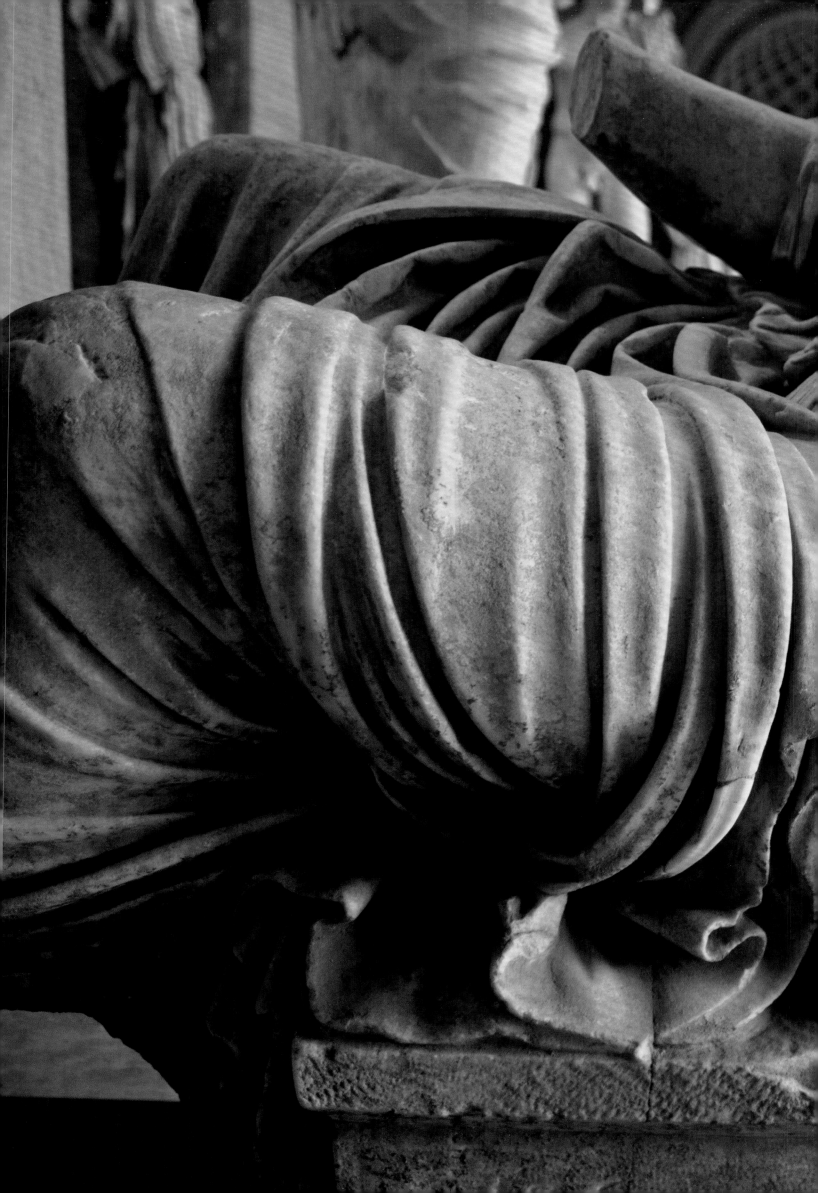

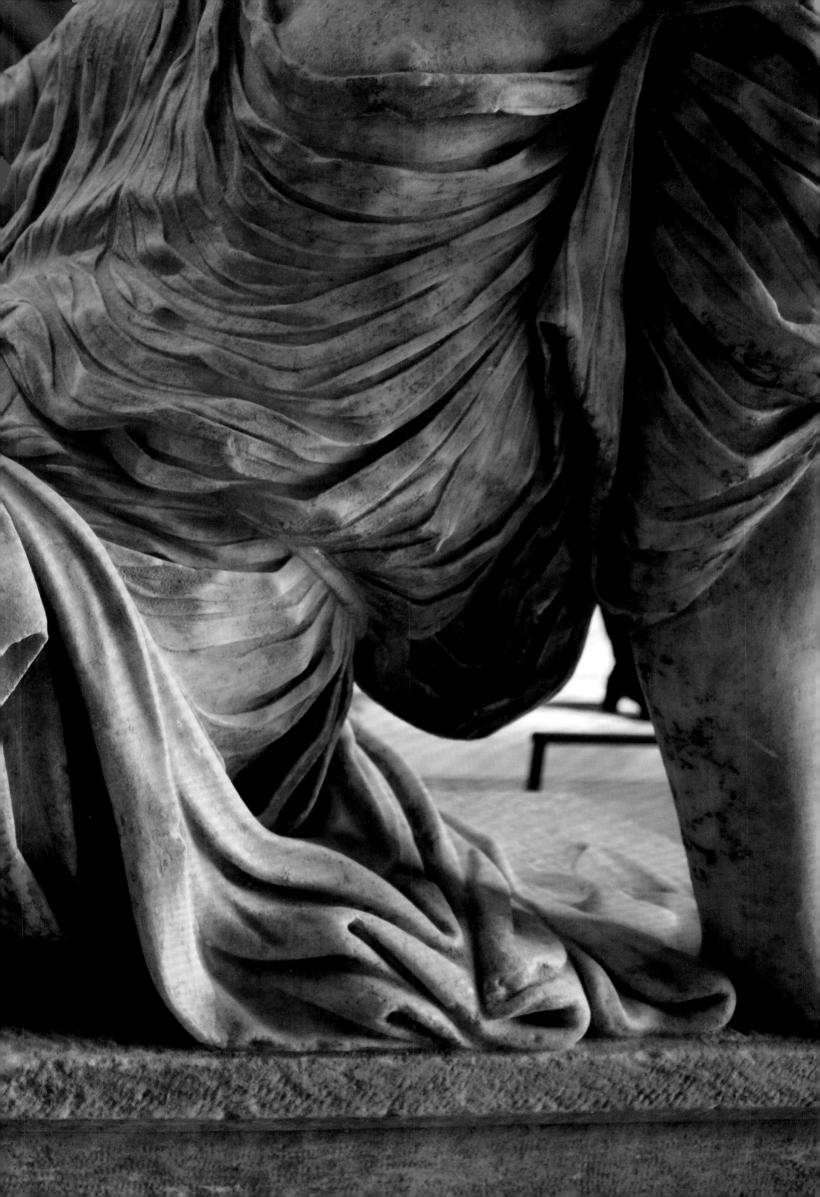

Art under the Restoration
and the Emergence of Romanticism

Théodore Géricault (1791–1824)
The Raft of the Medusa (detail), Salon of 1819
Oil on canvas, 491 × 716 cm (193 × 281 ⅞ in.)
Department of Paintings, acquired
from the posthumous sale of Géricault
through the intermediary of his friend
Pierre Joseph Dedreux-Dorcy, 1824

This large composition treated a modern
subject (the 1816 shipwreck) as a tragedy,
mixing hope, horror, and death.

Opposite
Eugène Delacroix (1798–1863)
Dante and Virgil in Hell, or *The Barque of Dante*,
Salon of 1822
Oil on canvas, 189 × 241 cm (74 ½ × 94 ⅞ in.)
Department of Paintings, acquired at the Salon
of 1822

Delacroix's first important painting was
immediately admired by the Romantics for its
ardor and evocative power.

The arts and products of industry, which were exhibited periodically at the Louvre, were of such variety and elegance at the beginning of the nineteenth century that it was described as "the golden age of the decorative arts." The relics of the royal family are still present in the Louvre's decorative arts rooms. Among the jewels are a stand-out pair of bracelets belonging to the duchess of Angoulême; their light and graceful design incorporates stones that had been reset by Pierre-Nicolas Menière from an ornament of the empress Marie-Louise. The memory of Louis XVIII survives with his snuffbox holder, made at Sèvres and exhibited in 1820. The manufactory, managed by Alexandre Brongniart, then employed the best painters, who varied their style and themes by imitating ancient works, from landscape to exoticism, as evidenced by the Chinese coffee and tea service of Queen Marie-Amélie, wife of Louis-Philippe. This eclecticism demanded knowledge of ancient classicism, the Renaissance, and the Middle Ages, as evidenced by the furniture of Princess Marie d'Orléans, in the troubadour style.

Neoclassicism and Romanticism: In Conflict?

The Restoration saw the opposing—and often complementary; mixed, even—currents of neoclassicism and Romanticism in confrontation at the Salon du Louvre. The latter also asserted itself in literature—with the battle over Victor Hugo's *Hernani* (1830), and when Théophile Gautier wore a provocative "red doublet." To get a good sense of this, you need to walk quite a bit through the vast painting rooms of the Louvre. The large canvases hang from the walls of the Denon Wing; the smallest are in the French painting circuit on the second floor of the Cour Carrée, where—to complicate the conscientious visitor's treasure hunt—you also need to search out its gems in the rooms of collections bequeathed to the Louvre, which their donors insisted should be kept unbroken.

The works of Jacques-Louis David—who was a revolutionary regicide, official painter of the Empire, and in exile in Brussels—are still sought out for the lessons they offer. In 1818, the count of Forbin acquired *The Intervention of the Sabine Women* and *Leonidas at Thermopylae*. The master would not receive the Louvre's honors until after his death (1825), as the works of living artists were exhibited at the Musée du Luxembourg. At David's posthumous sale, Forbin bought the portrait of Madame Récamier.

Following spread
Eugène Delacroix (1798–1863)
The Death of Sardanapalus, Salon of 1828
Oil on canvas, 392 × 496 cm (154 ¼ × 195 ¼ in.)
Department of Paintings, acquired on the arrears of Maurice Audéoud's bequest, 1921

Inspired by a poem by Byron, the monstrous suicide of the king of Babylon, besieged in his city, taking his worldly possessions —including people—with him to his death, became for Delacroix a manifesto of feverish Romanticism. The calm of the horses and the ruler, who had his favorites killed, dominates a scene of desolation in which the color red sets the tone for a violent and sensual drama.

Neoclassicism and Romanticism are represented in the Louvre through the iconic works of their exponents. Géricault's *Raft of the Medusa* became a cause célèbre at the 1819 Salon. Forbin wanted to acquire it then, but the painter preferred to assign it elsewhere. After the artist's premature death in 1824, Forbin bought it for the Louvre. Here, Géricault transformed a real event into a macabre narrative. The painting is an impassioned denunciation of a French naval frigate's negligence in ignoring the desperate plea of the shipwrecked crew set adrift on a raft. It also exemplifies the Romantic penchant for dramatic extremes of emotion and behavior. A tormented dandy himself, Géricault expressed his dual personalities in his depictions of horse races and in frighteningly modern portraits of the mentally deranged.

The herald of Romanticism in painting was, of course, Delacroix. As early as the Salon of 1822, the king's civil list purchased *The Barque of Dante* (or *Dante and Virgil in Hell*), which caused a sensation. Two years later, he returned with a true manifesto of Romantic aesthetics: *The Massacre at Chios*, in which oriental exoticism and political lessons are channeled through violent color and free-form. Most of Delacroix's large pictures exhibited at the Salon were afterward displayed in the large Louvre red rooms: the fiercely sensual *Death of Sardanapalus*, from the Salon of 1828, based on a poem by Byron, and *Liberty Leading the People*, from the Salon of 1831, an allegory of the July Revolution. The latter, acquired by Louis-Philippe, was removed from public view so as not to fan the flames of revolt. The famous *Women of Algiers in Their Apartment*, painted after a trip to Morocco and Algeria, paved the way for all Western orientalism, such as Delacroix's own *Jewish Wedding in Morocco*. The mythical Orient depicted in *Entry of the Crusaders in Constantinople*, commissioned by Louis-Philippe for the Crusades rooms at Versailles Palace (1838), is shot through with vibrant colors, magnified by a visible brushstroke. But Delacroix should not be forgotten as a portraitist, as both his self-portrait and his likeness of Chopin (1838) make clear.

At the same time, Ingres was well into a long career, and we have already seen *The Apotheosis of Homer*. Beyond his roles as academician, professor at the École des Beaux-Arts, and director of the Académie de France in Rome, he was a perpetual innovator, and fostered a smoother and softer brand of neoclassicism. The Louvre exhibits his most beautiful portraits: those of the duke of Orléans, acquired by the museum, and of Monsieur Bertin, a figure of the triumphant bourgeoisie. There is also the *Grande Odalisque*, the monumental yet discreet nude made at the apex of his artistic development, while his first *The Valpinçon Bather*, sent from Rome in 1808, and his last statement, *The Turkish Bath* (1863), demonstrate his unceasing work on the line and shape of the female body in its fullness.

Ingres cultivated the historical genre, like in his *Don Pedro of Toledo Kissing Henri IV's Sword*, which paralleled the historicist movement's taste for the Middle Ages and the Renaissance, which Gros had been promoting since the Empire. At the same Salon in 1827, Eugène Devéria and Paul Delaroche presented two great historical evocations: *The Birth of Henri IV* and *The Death of Elizabeth, Queen of England*.

Eugène Delacroix (1798–1863)
Liberty Leading the People (28 July 1830),
Salon of 1831
Oil on canvas, 260 × 325 cm (102 3/8 × 128 in.)
Department of Paintings, acquired at the
Salon of 1831

Delacroix executed his most famous painting, his first political composition, shortly after the July Revolution of 1830. While the allegorical aspect still dominates through the figure of Liberty, the barricade shows the reality of the people in revolt.

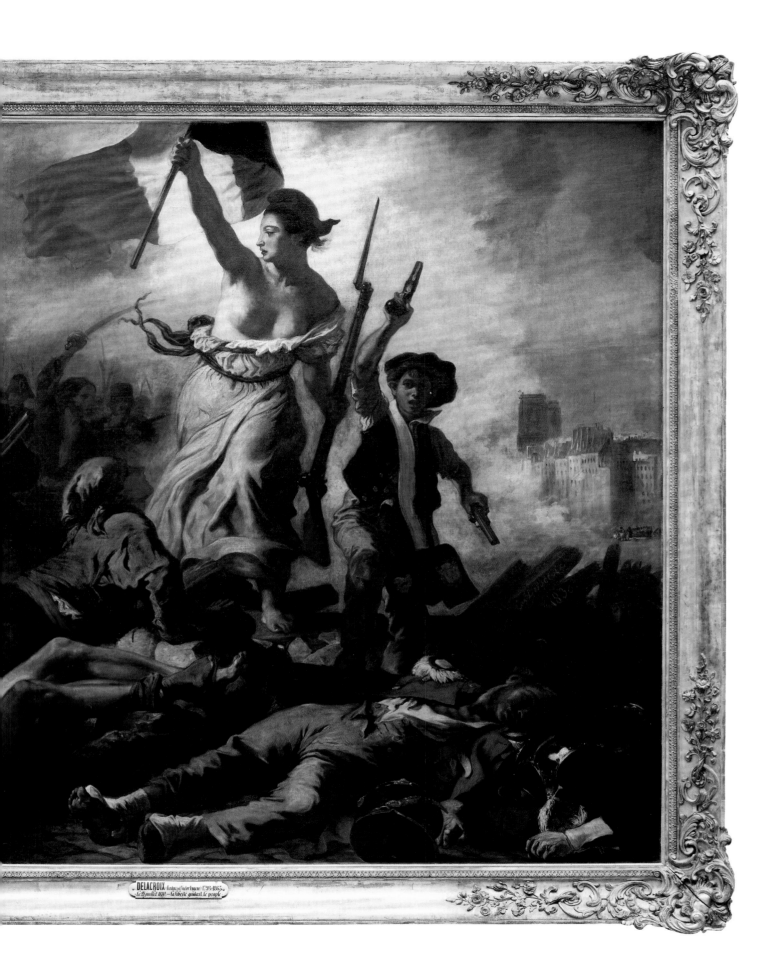

DELACROIX Ferdinand Victor Eugène 1798-1863
Le 28 juillet 1830 – La liberté guidant le peuple

Jean-Auguste-Dominique Ingres (1780–1867)
Bather, known as *The Valpinçon Bather*, 1808
Oil on canvas, 146 × 97 cm (57 ½ × 38 ¼ in.)
Department of Paintings, acquired in 1879

This bather viewed from behind anticipates
the *Grande Odalisque* and *The Turkish Bath*
of the painter's last years.

Théodore Chassériau (1819–56)
Esther Preparing Herself to Meet King Ahasuerus,
or *The Toilette of Esther*, 1841
Oil on canvas, 45 × 35 cm (17 ¾ × 13 ¾ in.)
Department of Paintings, bequest of Baron
Arthur Chassériau, 1934

This canvas illustrates the dual influences inspiring
the painter: the nude evokes the sensuality of
Ingres; the characters' pronounced orientalism,
the universe of Delacroix.

Jean-Baptiste-Camille Corot (1796–1875)
Recollection of Mortefontaine, 1864
Oil on canvas, 65 × 89 cm (25 5/8 × 35 1/8 in.)
Department of Paintings, acquired on
Napoleon III's civil list at the Salon of 1864,
attributed to the national museums by court
decision in 1879, entered the Louvre in 1889

Ary Scheffer and Théodore Chassériau also pursued historical painting and portraiture. A student of Ingres, Chassériau succeeded in fusing the sensuality of his master and the free touch of Delacroix—the color of the one, and the drawing of the other—in *The Toilette of Esther* or *Andromeda Chained to the Rock by the Nereids* (1840). Thanks to the bequest of his descendant, Baron Chassériau, the Louvre has a complete panorama of the work of this imaginative and tortured artist.

Landscape paintings occupy the second-floor walls, in rooms dedicated to the painters or in those of the great collectors who have bequeathed their masterpieces with the proviso that they be displayed together. Jean-Baptiste-Camille Corot was the first to assert himself in the genre. The group of Barbizon painters around Théodore Rousseau and Narcisse Diaz de la Peña, and later Jean-François Millet, surveyed the Fontainebleau Forest and captured the dappled light through the leaves. The Louvre owns abundant and diverse works by Rousseau and Corot. From his trip to Rome in 1825, to the great poetic compositions produced during the Second Empire and the portraits of his family members, Corot's entire oeuvre is represented, thanks in particular to Étienne Moreau-Nélaton, who donated his massive collection.

It should be noted in this regard that while the Louvre's program theoretically ended in 1848, when the Musée d'Orsay's picks up, the Louvre exhibits the entire career of artists born before 1820. This means that, in practice, the early nineteenth-century galleries extend well past this chronological terminus. The life of forms and those of artists cannot be constrained by arbitrary borders.

Romanticism was a European movement, and thus not confined to the French artists who dominate the Louvre's collection. The English selection is limited: the only Turner landscape preserved in France, *Landscape with a River and a Bay in the Background*, and some of John Constable's work, including *Weymouth Bay with Approaching Storm*, both of which

demonstrate the poetic vigor of the British approach to the genre. The museum has sought to diversify its collection by acquiring German and Scandinavian examples, such as Caspar David Friedrich's wild and dreamlike rendering of nature, *The Tree of Crows*. The gallery dedicated to the northern schools is on the second floor of the Richelieu Wing.

But art alone is not the prerogative of painting. The same opposition between neoclassicists and romantics is seen in the sculpture rooms, as it was at the Salon. The finest artists combined the qualities of both currents. On the upper terrace of the Cour Puget, we discover the series of great men commissioned by Louis-Philippe for the Tuileries Garden: David d'Angers's stoic *Philopoemen*, removing a javelin from his thigh; Denis Foyatier's *Spartacus*, ruminating on his revolt; Jean-Baptiste Roman's *Cato of Utica*, preparing to die. All the great figures of Romanticism are in the rooms: Augustin Dumont's *Spirit of Freedom*, a replica of the statue on top of the July column in the Place de la Bastille; the satyr toppling a bacchante, where James Pradier stages his tumultuous relationship with Juliette Drouet; and the Neapolitan dancers of Duret. The two great geniuses of Romanticism in sculpture face each other in the last room: François Rude, who infused his forms with an unequaled dynamism, such as in his sketches for the *Marseillaise* on the Arc de Triomphe; and Antoine-Louis Barye, who created feminine allegories in the purest classical style, but also mastered the realistic depiction of wild animals in action. Barye's bronzes and plaster models, commissioned for a table centerpiece in 1835 by the duke of Orléans—a sophisticated patron—are composed of groups of wild animals, and included *Indian Mounted on an Elephant*, *The Bull Hunt*, and *The Lion Hunt*, all expressing the spirit of Romanticism in animal art and supported by the anatomical studies that the sculptor carried out with Delacroix in a zoological garden.

Denis Foyatier (1793–1863)
Spartacus
Carrara marble, H. 225 cm (88 ⅝ in.)
Model executed at the Académie de France in Rome and exhibited at the Salon of 1827, commissioned by the civil list in 1828 and dated 1830, precisely during the days of the Revolution; exhibited at the Salon of 1831 and placed in the Tuileries Garden Department of Sculptures, returned to the Louvre in 1877

John Constable (1776–1837)
Weymouth Bay with Approaching Storm,
ca. 1818–19
Oil on canvas, 88 × 112 cm (34 5/8 × 44 1/8 in.)
Department of Paintings, gift of John
W. Wilson, 1873

Joseph Mallord William Turner (1775–1851)
*Landscape with a River and a Bay in the
Background*, 1835–45
Oil on canvas, 94 × 124 cm (37 × 48 7/8 in.)
Department of Paintings, purchased in 1967

Never exhibited during the artist's lifetime,
this work shows the result of his research
on light.

Opposite
Caspar David Friedrich (1774–1840)
The Tree of Crows, ca. 1822
Oil on canvas, 59 × 73 cm (23 1/4 × 28 3/4 in.)
Department of Paintings, acquired in 1975

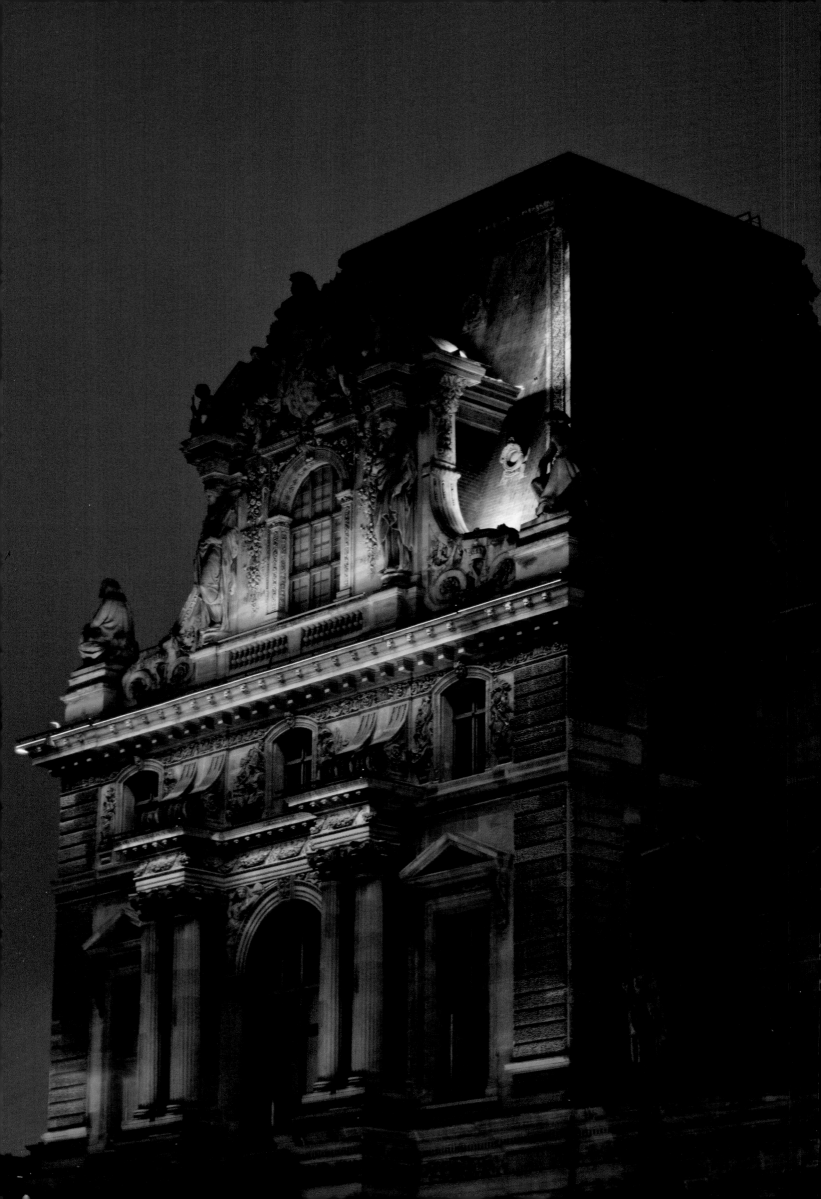

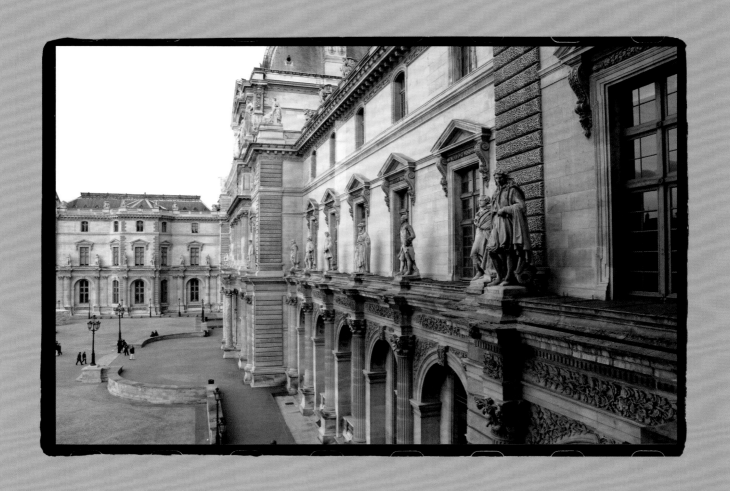

The New Louvre:
A Dream Come True

The Louvre of the Second Republic:
A "Mecca of Intelligence"

The February Revolution of 1848 swept through Europe as a great social and utopian movement that roused elites, students, and workers alike. On 24 February 1848, Louis-Philippe abdicated in favor of his grandson, the count of Paris. And yet the Republic was proclaimed. The troops returned to their barracks, leaving the multitudes free to throng the royal residences, out of curiosity at first, but then with a thirst for revenge and plunder. Much of the anger took aim mainly at the Orléans residences; the Palais-Royal; and the Tuileries Palace, which the king had abandoned upon abdication. The ransacking was, nevertheless, relatively restrained. The throne from the Tuileries was brought to the July Column at the Bastille and set ablaze, in an act that symbolized the annihilation of the monarchy. It was not too long before the governor of the palace and an officer of the national guard—whom Lamartine is said to have begged to go "save the Tuileries"—were able to bring the damage under control. Volunteers—including Prosper Mérimée and Léon de Laborde, curator of antiquities and sculpture—removed the most precious works of art to safety, but were unable to prevent a band of recalcitrants from camping in the palace. In order to get them out and supply the royal residence with a new purpose, the Republic installed a hospice for civil invalids on its grounds.

Effigies of the royal family took a beating. In the Cour Carrée of the Louvre, the equestrian statue of Louis-Philippe's son, the duke of Orléans, sculpted by Baron Marochetti in 1845, was hastily removed and taken to Versailles. This work has been at the Château d'Eu in Normandy since 1971, while another version of the statue was returned from Algeria in 1962 and placed at Neuilly.

The Revolution spared the Louvre, protected by a committee of artists that had taken shape around the former director of museums, Alphonse de Cailleux: forty-four artists and students from the Beaux-Arts came together on 25 February 1848, with forty-eight more joining them between 25 and 27 February, including Célestin Nanteuil, Auguste Préault, Paul Huet, Johan Barthold Jongkind, Tony Johannot, and even the German scholar Otto Mündler. They set up guard around the collections. As early as 25 February, the provisional government appointed as their leader a man "charged with the conservation of the paintings at the Louvre and all of the art objects found there." This man was the republican Philippe-Auguste Jeanron, a landscape and genre painter who fluctuated between Romanticism and Realism, but who was also passionate and efficient. When the insurgents demanded entry into the museum, Jeanron delivered such a tirade that they were the ones who ended up assuring him of "the respect of the people for the riches of the nation." Harriet Beecher Stowe's retelling of this episode is notably more dramatic (she is best known as the author of *Uncle Tom's Cabin*).

Echoing the position taken in 1793, the palace and collections of the Louvre were again seen as goods of the nation. Still, Jeanron would be forced to protect the museum several times more. Standing at the head of the guardians of the museum, he preserved the peace on the days of 17 April, 15 May, and more particularly during the workers' uprising of 24–26 June 1848, when events jeopardized the nascent Republic. An ambulance was then installed in the Galerie Henri IV, on the ground floor of the Colonnade, where a regiment destroyed three Egyptian wood sarcophagi and a hieroglyphic inscription.

The new Republic, connecting back to the First Republic, made the Louvre one of the jewels of its cultural policies. Whereas the direction of the Beaux-Arts and museums had been attached to the king's civil list, Ledru-Rollin, minister of the interior, placed it under the authority of his ministry, which made it possible for Jeanron to carry out a complete overhaul of the institution in accordance to a set of principles that was greatly admired by his contemporaries and is still a model in use today in the museums of France. His reforms were intended "to serve as the foundation for a new, more liberal, more knowledgeable and more worthy institution, to: 1. Inventory. 2. Conserve. 3. Describe. 4. Classify. 5. Communicate. 6. Exhibit." Over a period of three years, Jeanron introduced new areas

Preceding spread
Facade of the Cour Napoléon at night (left)
and east facade of the Cour Napoléon (right)
(see p. 487)

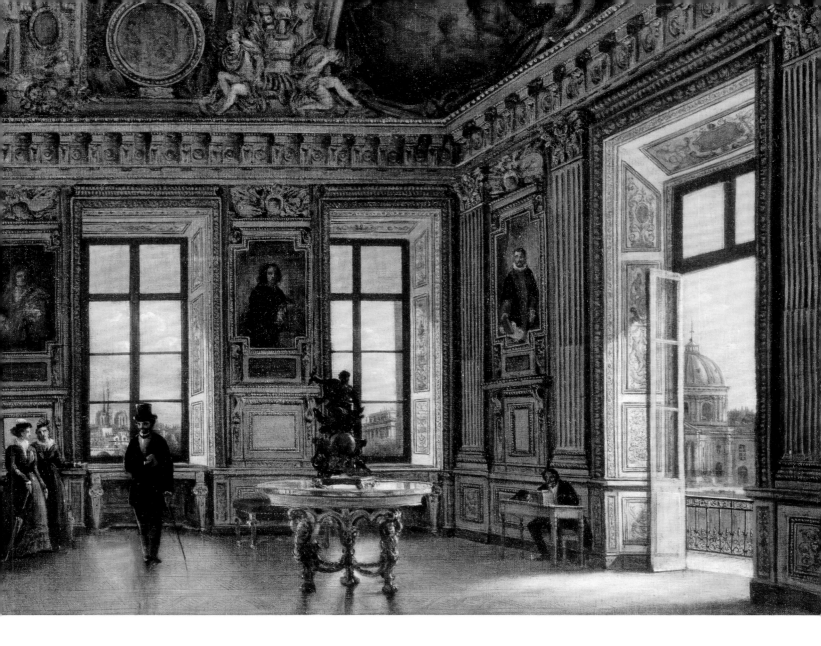

Attributed to Victor Duval (1795–1889)
*View of the Galerie d'Apollon at the Louvre,
Seine Side*, after 1871
Oil on canvas, 44.8 × 60 cm (17 5/8 × 23 5/8 in.)
Department of Paintings, acquired in 2003

into the Louvre: Archaic Greek art, Paleo-Christian art, medieval art, ethnography, Chinese art. With the help of Frédéric Villot, the curator of paintings, and a painter as well, Jeanron reorganized the collections of paintings and placed them in the new large spaces of the Salon Carré and Salon des Sept-Cheminées. It was around this time that Villot wrote the first catalogue raisonné of paintings, an impressive work of research and erudition, following the path forged by the count of Clarac for antique and modern sculpture.

The Project to Finish the Grand Design

Financial motives led the minister of the interior to join forces with the minister of public works, Ulysse Trélat, in order to promote a policy of large public works, which resulted in the creation of the Ateliers Nationaux (National Workshops). Guided by the view that it was "important to concentrate all of the fruits of thought, which are like the splendors of a great people, within a single large palace," on 24 March 1848 the provisional government decreed that "the Louvre Palace shall be finished, and given the name of palace of the people. This palace shall be designated for the exhibition of paintings, the exhibitions of the products of industry, and the National Library." This noble ambition was supported by Victor Hugo, then a *député* in the National Assembly, where he declared that the Louvre must become a "Mecca of intelligence." Construction on the Louvre would, in a Keynesian approach, create employment and jump start the economy. On 19 May, the minister of public works requested architect Louis Tullius Joachim Visconti to draw up a plan to link the palaces of the Louvre and the Tuileries. Visconti was the son of Ennio Quirino Visconti, the former curator of antiquities, who had arrived in France in 1798 to look after the ancient statuary that had been seized in Rome by the by the Armée d'Italie, the French Army stationed in Italy. Classical in spirit and in training, the younger Visconti had designed some of the most beautiful fountains in Paris (notably, the Saint-Sulpice and Molière fountains) and combined a deep respect for the

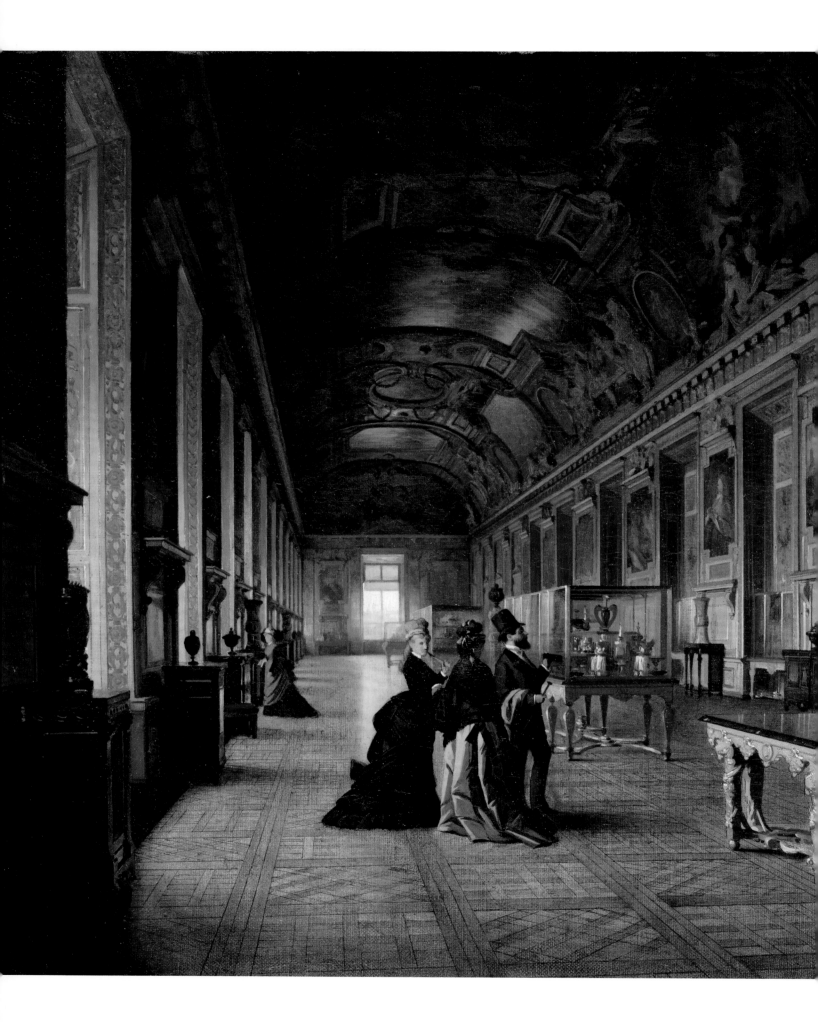

architecture of the past with a new functionality. He was chosen to integrate the National Library, short on space, into the Louvre. Émile Trélat, the son of the minister of public works, worked as his collaborator. Betrayed by lack of political will, the project they presented two months later was never carried out. The only works that did receive approval, in October 1849, were the clearing of the Place du Carrousel and the extension toward East of the rue de Rivoli to the Hôtel de Ville.

The Restoration of the Old Louvre

The other phase of the government's project—to restore the Louvre and the Galerie d'Apollon and furnish two much-needed large galleries for paintings—was also begun. On 12 December 1848, the National Assembly approved a massive credit of two million francs. Work began the following year. The eighty-four-year-old architect of the Louvre and Tuileries, Pierre François Léonard Fontaine, who had remained in his post against all odds since 1800, resigned in October 1848. He was replaced by Félix Duban, who was already famous for his restoration of the Sainte-Chapelle and Château de Blois. An eclectic architect, Duban had notably designed the Palais des Études, or the large central building of the École des Beaux-Arts, and the Château de Dampierre for the duke of Luynes. A Legitimist, he seemed to have adapted to the social upheavals of the Revolution, in particular following the political reversal that rid the new power of its left wing. Toward Louis-Napoléon Bonaparte, however, he remained more circumspect. The clashing personalities of the architect-restorer and the prince-president, who enjoyed giving lessons in good taste, led to a fallout in 1851. Duban nevertheless retained his position as architect of the older parts of the Louvre, while Visconti was placed in charge of the project to unite the Louvre and Tuileries. Duban's task was rapidly accomplished: he restored the facades, the Galerie d'Apollon, the Salon Carré, and the Salon des Sept-Cheminées in a record time of two years. Louis-Napoléon inaugurated the restored complex on 5 June 1851, and Duban was thanked for his service in 1853.

In 1849, work focused on the pressing restoration of the Grande Galerie and Petite Galerie, which were falling into ruin. Between 1850 and 1852, Duban set about cleaning the facades, replacing worn stones, and sculpting the unfinished pediments. Within the framework of the Republic's social policies, sixteen sculpture workshops functioning as one large national atelier (to alleviate unemployment) executed the decoration of the Grande Galerie overlooking the Seine, which was partially restored and partially completed, and specifically, the frieze and pediment.

Duban remade the facade of the Petite Galerie by eliminating Le Vau's additions and recuperating its appearance from the period of Henri IV. In 1850, he had Pierre-Jules Cavelier carve an allegorical figure on the pediment facing the Infanta's Garden. The ornamental sculptors Pyanet and Duvieux redecorated the facade toward the Seine, the pediment, and the legendary "Charles IX balcony," which was transformed into a gilded tribunal. The Infanta's Garden in front of the Petite Galerie was also reworked. There, Duban placed a marble exedra with a colored pavement.

Duban mainly set his sights on the Cour Carrée, wishing to transform this empty square into an architectonic space. The carved decoration of the *Fountain of the Innocents* by Jean Goujon would have nicely echoed Pierre Lescot's facade, but after failing to have it moved there, Duban drew up a number of alternative plans. He wanted a fountain at the center of the square, marble exedras at its corners, screen gates, vases, candelabra, and most of all, grass lawns, in the fashion of the Parisian squares then being created. But in this enterprise, the architect ran up against the entrenched tastes of Louis-Napoléon.

The Galerie d'Apollon, ca. 1880
Oil on canvas, 46 × 55 cm (18 1/8 × 21 5/8 in.)
Department of Paintings, acquired in 1938

The gallery had twenty-eight pieces of Boulle marquetry furniture, brought from the Château de Saint-Cloud in 1871, on which porcelain and porphyry vases were placed.

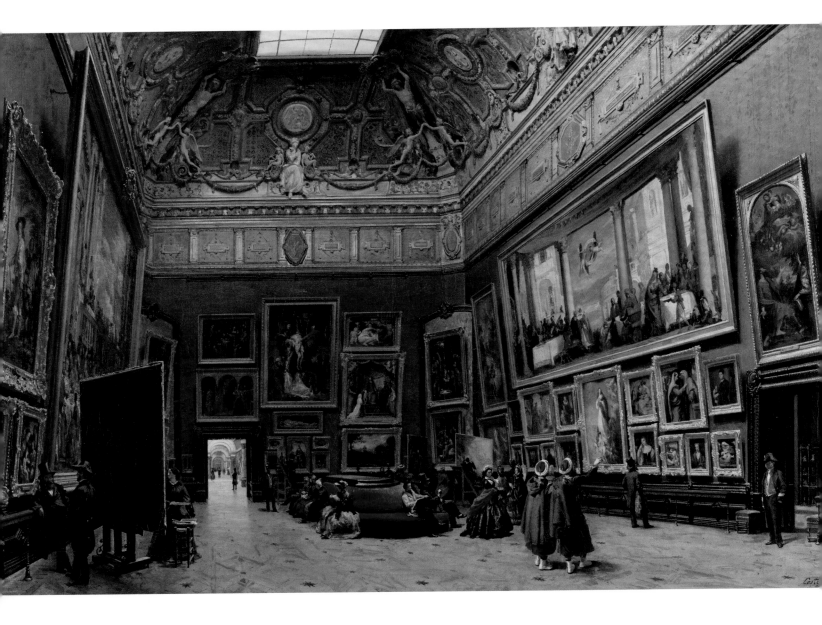

Giuseppe Castiglione (1829–1906)
View of the Large Salon Carré, at the Louvre Museum, 1861
Oil on canvas, 69 × 103 cm (27 ⅛ × 40 ½ in.)
Department of Paintings, transfer from the Ministry of Finance in 1933

The paintings are hung in three rows. At right is Veronese's large canvas, *The Feast in the House of Simon*, which has since returned to its place at the Château de Versailles.

Opposite
Ceiling of the Salon Carré: architecture by Félix Duban, stucco sculpture by Pierre-Charles Simart (1806–57), 1851
Department of Paintings

After numerous discussions and proposals, a rather simple decoration consisting of exedras and candelabras was installed. It remained there until it was destroyed in 1984.

Work continued inside the museum as well. The Galerie d'Apollon was completely renovated. Duban reinforced the structure of the barrel vault, placing iron rods to ensure the stability of the construction, and shored up the crumbling southwest corner. In 1850, he turned to the decoration of the gallery. The modeler Desachy restored and whitened the stuccoes, while the painter Popleton restored Le Brun's compositions. Duban put the painters Muller and Guichard to work on completing the unfinished decorations. The ceiling's central compartment was given over to Delacroix's stunning painting of *Apollo Victorious Over Python*. With the gallery's paneling in a bad state of repair, Duban decided to return this aspect of the room to its seventeenth-century decoration. He planned for portraits of illustrious men to alternate in the lateral panels, as a way to express the room's historical continuity. His successor, Hector Lefuel, had tapestries made by the Gobelins Manufactory to complete the gallery's program. Lastly, portraits of the artists, architects, painters, and sculptors who made the Louvre were placed on the trumeaux, along with large compositions that evoked the building's sovereign patrons.

The Salon Carré: A Gallery for Art from All Times and All Countries

If today the Salon Carré is just one among many rooms of a museum, for centuries it was *the* Salon—a term derived from the Italian "*salone*", meaning "big room"—of the Louvre. It was initially a vast rectangular space (at the time, the word "*carré*"—"square" in

French—did not indicate a specific geometric form) that had been broken off from the Grande Galerie during the works led by Le Vau in the 1660s, and also given height. The space was lent to the Academy of Painting and Sculpture, whose members exhibited there every other year from 1725 to 1793. The Salon exhibition was thus named after the room, and the term was subsequently extended to all major painting exhibitions, and even to some seasonal events (such as the *Salon de l'automobile*, or "exhibition of automobiles"). Following the suspension of the academies, the *Salon des artistes vivants* ("exhibition of living artists") was still held at the Louvre until 1848. The critics, known as *salonniers*, who customarily praised or disparaged these exhibitions, owe their name to this room as well.

As early as 1789, the Salon Carré boasted natural top lighting, thanks to a system of glass windows supported by metal beams. It was the result of architects Axel Guillaumot and Augustin Renard's experiments with a novel technique for building large metallic

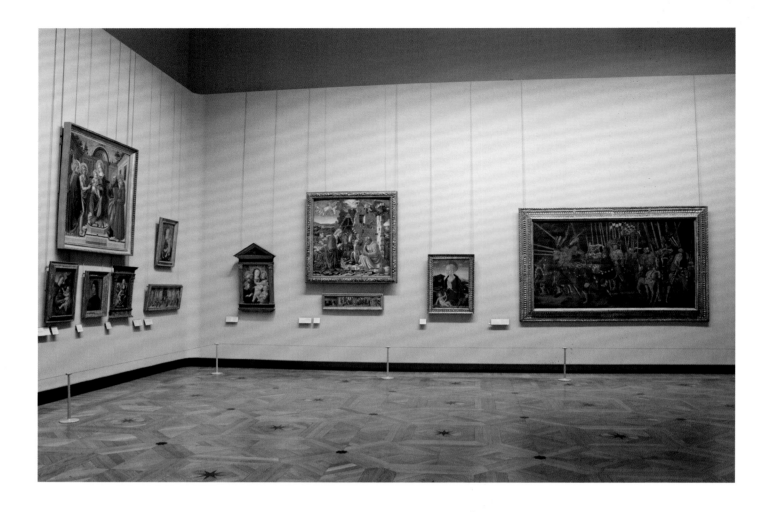

The Salon Carré
The three largest paintings are: on the left
wall, the *Madonna and Child with Saints
Zenobius (?), John the Baptist, Anthony the Abbot,
and Francis of Assisi* by Francesco di Stefano,
known as Pesellino; at center, the *Nativity* by
Fra Diamante; at right, *The Battle of San Romano*
by Paolo di Dono, known as Uccello (see p. 522)
Department of Paintings

structures, and has survived through all the modifications instigated by Duban and his
successors. It is one of the oldest, if not *the* oldest, of its kind to be preserved in situ.

At the Salon exhibition, which was greatly beloved by the public, each artist wanted to
see his works displayed better than anyone else's; but the room's tapissier, who at one time
was the painter Chardin, instead sought to emphasize the overall richness of artistic pro-
duction in the arrangement of the works. During the Revolution, the museum continued
to use the Grande Galerie for its permanent collection and the Salon Carré for temporary
exhibitions of works by living artists. Between Salon exhibitions, however, the Salon Carré
was hung with works from the permanent collection. For the wedding of Napoleon I and
Marie Louise of Austria, on 2 April 1810, the walls were masked and the room was trans-
formed into a chapel.

For every Salon exhibition, part of the permanent collection therefore had to go into
storage, which resulted in the improper handling of some of the works. The 1848 Salon
was even more invasive than the earlier ones because the artists insisted on a "democratic"
presentation, without any prior selection being made, which caused an astonishing pileup
of canvases. In 1849, Jeanron removed the Salon exhibition to the Tuileries Palace. This
departure became permanent, and the Salon Carré could finally have its own perennial
installation of works from the collection. Jeanron was then able to have Duban furnish
two large spaces for paintings: on the one hand, the Salon Carré, a sanctum for master-
pieces of art, like the Tribuna of the Uffizi in Florence, and on the other, the Salon des
Sept-Cheminées, for modern French painters.

To enhance the value of these two palatial spaces, Duban devised a decoration using
only sculptures, and therefore without the colors of a painted ceiling to compete with the
works exhibited there. From 1849 to 1851, Duban focused on the architecture of the Salon
Carré and entrusted Pierre-Charles Simart, who came from Troyes, with the sculptures.
At the center of each side of the ceiling are classical pensive female figures wrapped in the
antique folds of their white tunics. Our attention is drawn to the corners of the ceiling,
where supple figures hold up the RF emblem of the French Republic. The main arts (sculp-
ture, architecture, painting, and engraving) appear in four medallions and are also present

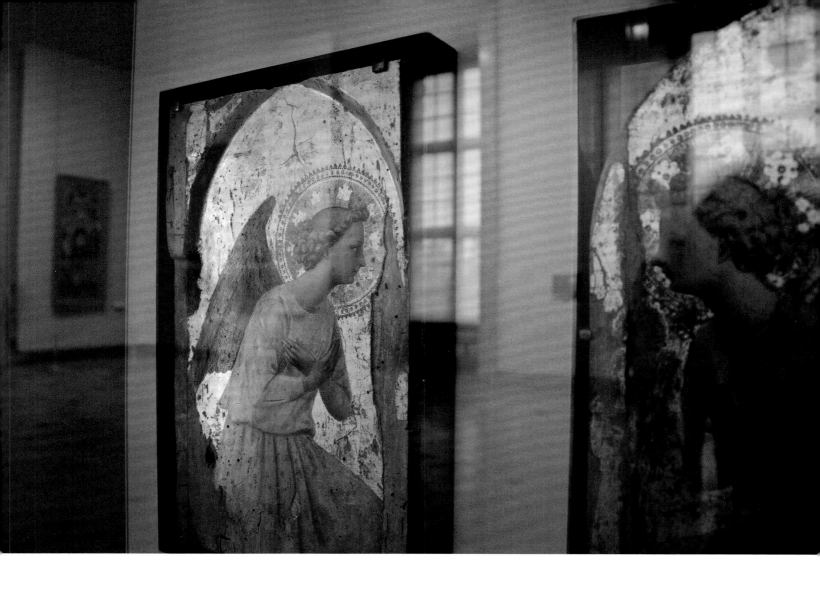

in the Mars Rotunda and the museum's staircase. Yet in these medallions, the four arts (sculpture, architecture, painting, and engraving) are represented by French artists instead of allegories: Jean Goujon, Philibert Delorme, Nicolas Poussin, and Jean Pesne, witnesses to the nationalism of their day. A series of cartouches line the top of the walls and are inscribed with the names of the authors of the main paintings in the room.

During this period, the windows were blocked to make room for long, tall picture rails. The corners of the walls were chamfered so paintings could be hung there as well. Somber black-molded plinths and a large central canapé, which one critic compared to a cata-falque, created an impression of austere majesty, of a temple-museum, which was only intensified by the gilt ceiling.

This arrangement was completely turned around in 1945. The room was squared, the windows opened, and the walls painted in a light tone. The ornate ceiling, however, was preserved. A last transformation occurred in 1972, under the direction of Michel Laclotte, then curator of paintings, by installing a flexible display system; a "skin," around the room with a central vitrine placed at a right angle. This delicate intervention, along with the room's new surround lighting, was conceived by the Mobilier National research lab, under the direction of designers Pierre Paulin, Joseph-André Motte, and André Monpoix. The Salon Carré is now the starting point for the rooms of Italian paintings at the Louvre, beginning with works by Cimabue, Giotto, and Fra Angelico.

The Salle des Sept-Cheminées:
From Salon to French Modern Art

The history of the Salon or Salle des Sept-Cheminées is less grand, and the use of this room has been more varied, as if it never succeeded in establishing its place within the great spaces of the museum. Its origins date back to the king's pavilion. The space contained the king's privy and outer chambers and formed the seat of power. Under Louis XIV, a new facade was raised in front of the pavilion, facing the Seine, but construction was never completed and a roof was never built. During the First Empire, the decision was made to unite the pavilion

Guido di Pietro, known as Fra Angelico
(1417–55)
Two Angels in Adoration (detail), ca. 1430–40 (?)
Tempera and gold leaf on wood panel,
37 × 23 cm (14 5/8 × 9 in.)
Department of Paintings, gift from a group of
Friends of the Louvre in 1909 and the Société
des Amis du Louvre in 2002

The two panels were part of a ciborium in the
church of the convent of Saint Dominic
in Fiesole. They are seen here through the
reflections in the windows of the Salon Carré.

François Gérard (1770–1837)
Gallic Courage, 1830
Oil on canvas, 41 × 24 cm (16 ⅛ × 9 ½ in.)
Sketch for an overdoor of the Salon Gérard,
the name that was given under Charles X
to the Salon des Sept-Cheminées, after
Baron Gérard, who was commissioned to
execute the decoration
Department of Paintings, acquired in 1992

and adjoining spaces. The old rooms were finally joined in 1817, and their wood paneling was taken up to the Colonnade apartments. This created a gigantic room, the so-called Salon Gérard, after Baron Gérard, the official painter who was commissioned to design enormous canvases to decorate the walls: the *Coronation of Charles X* and *Entry of Henri IV into Paris*, both exhibited at the 1827 Salon (the same year that the Musée Charles X was inaugurated). Then the Revolution of 1830 happened. Louis-Philippe confirmed to the artist that he wanted the *Entry of Henri IV into Paris* to remain there, but as a pendant chose *The Battle of Austerlitz* (painted in 1810). The reminder of the imperial victory completely overshadowed the tribute to Charles X. The two canvases were subsequently deposited in the Musée de Versailles. Smaller paintings that Charles X had commissioned in 1829 for the overdoors—*Gallic Courage*, *Clemency Leaning on Fortitude*, *Genius Rising Despite Envy*, and *Constancy*—were never installed, and the room served mainly to exhibit the products of industry.

In 1849, Jeanron decided to use the space to highlight works of the modern French school, no doubt in a surge of nationalism, but also out of a desire to exalt modernity. Duban brought

in zenith lighting (as Fontaine had originally planned), and Francisque Duret executed the decoration, under his guidance, including the large winged figures of Victory with extended arms, linked by palm leaves and crowns. The medallion portraits in profile and set in hexagons represent the main artists exhibited in the room: Guérin, Gérard, Gros, David, Girodet, Chaudet, Prud'hon, Percier, Géricault, and Granet. There is also one sculptor (Chaudet) and the architect Percier; a nice homage to Fontaine's alter ego. Excessive decorations by Pyanet draw the viewer's eye to the corners of the ceiling, where attributes and allegorical animals celebrate the arts, peace and agriculture, commerce, the navy and war.

Just as in the Salon Carré, the windows were blocked and the mood was somber. The high, wood-carved plinths; the walls covered in muted shades of violet and chocolate brown; the molded railings and painted doors—they created a quasi-religious atmosphere that was silent and heavy, dark and rich. Unfortunately, this room was not always very well maintained. A recent study has shown that the colors of the walls, even high up, were reworked many times. The museum has been at pains to give this room a precise function, and it is often used for

The Salon des Sept-Cheminées: architecture by Félix Duban, stucco sculpture by Francisque Duret (1804–65), 1851

Two medieval Virgins dating to the first third
of the 14th century
Foreground: *Virgin and Child* (H. 175 cm/
68 7/8 in.) from the Abbey of Blanchelande
in Varenguebec (Manche), formerly in the
collection of Carlo Micheli, acquired in 1850
Background: *Virgin and Child Trampling the
Serpent* (H. 190 cm/74 3/4 in.) from the region
of Sens, acquired in 1905
Department of Sculptures

Opposite
Christ Detached from the Cross
Burgundy, second quarter of the 12th century
Wood (maple) and polychrome,
H. 155 cm (61 in.)
Part of a group sculpture of the Descent
from the Cross
Department of Sculptures, donated by
Louis Courajod, curator of the Department
of Sculptures, 1895

temporary installations. When a department is closed for renovation, when a new collection has been acquired, when a show doesn't quite find a place within the museum, the Salle des Sept-Cheminées provides a space. From 1958 to 1969, it exhibited early Christian art, a part of the collection that was still in development. The Department of Egyptian Antiquities placed its masterpieces there during the early phase of work on its permanent installation in 1997. The room has also been used for temporary exhibitions, for example on Enki Bilal, or Michelangelo Pistoletto in 2012. The Etruscan Antiquities exhibited there in 2020, as well as in the antechamber and the Royal Sessions room nearby.

New Museums

Thanks to Jeanron's efforts and the assistance of capable curators, the museum's collections were completely reshuffled in a matter of years. Frédéric Villot reorganized the paintings, and other areas were diversified. Adrien de Longpérier, who is still considered one of the great early specialists in the art of the Americas and Asian antiquities, organized the collection of pre-Columbian art. On 26 May 1850, the Louvre inaugurated its "Mexican museum" in a small room on the ground floor of the Cour Carrée's north wing. More than a thousand works were jammed into the space.

After presenting the collections of Assyrian art, Longpérier created a museum of Archaic Greek art, transferred the *Sphinx* and other weighty Egyptian objects to the Galerie Henri IV in the Colonnade, and even opened some rooms devoted to sculptures. From then on, the museum occupied the whole perimeter of the Cour Carrée; or one should say, museums, since each section was its own entity, under the direction of the curator of antiquities. The four passageways under the central pavilions prevented a continuous flow from one to the other, and each museum had its own entrance. An ethnographic museum and a Chinese museum were opened next to the Marine museum. Jeanron would have liked the sculptor Barye to create a museum of casts, to be used for teaching, but this project was never realized.

The First Room of Medieval Sculpture

Longpérier divided the sculpture collection from the Galerie d'Angoulême into two parts, which he presented in chronological fashion. Works from the seventeenth through the nineteenth centuries were placed in the rooms of the old gallery, while sculptures from the Middle Ages and the Renaissance were installed on the ground floor of the south wing of the Cour Carrée. The museum acquired its first medieval sculpture, the *Virgin and Child* from the Abbey of Blanchelande (Normandy), in 1850. This acquisition led to the installation of a small room of medieval art with the *Childebert* that had come from the École des Beaux-Arts, where a collection of sculptures from the former Musée des Monuments Français had been preserved. We can trace the development of this collection through the centuries, and it is now so large that it takes up thirteen rooms of the Richelieu Wing. The collection grew thanks to the concerted efforts of its nineteenth-century curators, Léon de Laborde and then Louis Courajod from 1880 to 1896. Passionate and fascinating, admired and controversial, Courajod imprinted the Middle Ages on the Louvre and donated among other works the superb *Christ* from a Burgundian group of the Descent from the Cross, which the museum's petty despots (and purists) did not want. The curators, without spending a dime, ferreted out works at both the École des Beaux-Arts and the depository of the Abbey of Saint-Denis, rich in vestiges from the Musée des Monuments Français. Courajod, however, broadened his search to the large repositories of French cathedrals and churches in order to construct a panorama of medieval art. The art market would supply the rest, feeding on the remains of monuments destroyed under the Revolution and the Empire. This method of collecting explains the wealth of architectural fragments in the collection: Romanesque capitals primarily from Burgundy (Flavigny, Moutiers-Saint-Jean), Île-de-France, and Languedoc; and early Gothic art mainly from the Champagne and Île-de-France regions, which provided the ensemble from the restorations of the portals of Saint-Denis and the fragments from

Capital sculpted on three sides (here two
quadrupeds devouring each other's tails)
from the Benedictine abbey of Saint-Pierre
de Flavigny (Côte-d'Or), 11th century, stone,
H. 40 cm (15 ¾ in.)
Department of Sculptures, acquired in 1890

Opposite
Funerary marker with a prince of
the Lusignan (?) dynasty in prayer
Cyprus, second half of the 14th century
Marble, H. 56 cm (22 in.)
Department of Sculptures, found at the Cyprus
bazaar by Camille Enlart, who donated it to
the Louvre in 1899

Notre-Dame-en-Vaux in Châlons-en-Champagne. The crop from Notre-Dame de Paris was
largely transferred to the Musée de Cluny, where the collection had come largely from the
administration of Historical Monuments (Monuments Historiques), to which it was
attached. Still, the Louvre preserves some beautiful pieces from Notre-Dame de Paris, such
as a fragment from the rood screen where a frightening head burning in the flames appears
behind the nude figures of Adam and Eve in hell. At the beginning of the twentieth century,
Courajod's successor, André Michel, pursued an acquisitions policy focused on master-
pieces. He assembled a collection of fourteenth- and fifteenth-century statues of the Virgin;
obtained a large set of fourteenth-century marble pieces from Maubuisson through the
Friends of the Louvre, which included the tomb of Charles IV and Jeanne d'Évreux; and
introduced sculptures from the Val de Loire region. The Louvre thus became a museum of
note for French medieval sculpture, along with the Musée de Cluny.

At first, only French art was really of interest. There were, of course, the Renaissance mar-
bles from the Borghese collection and a few medieval fragments that had slipped into the
troves sent from the Holy Land or Cyprus. But then the museum began cultivating two main
areas of European art, to varying degrees: Italian Renaissance and Northern European late

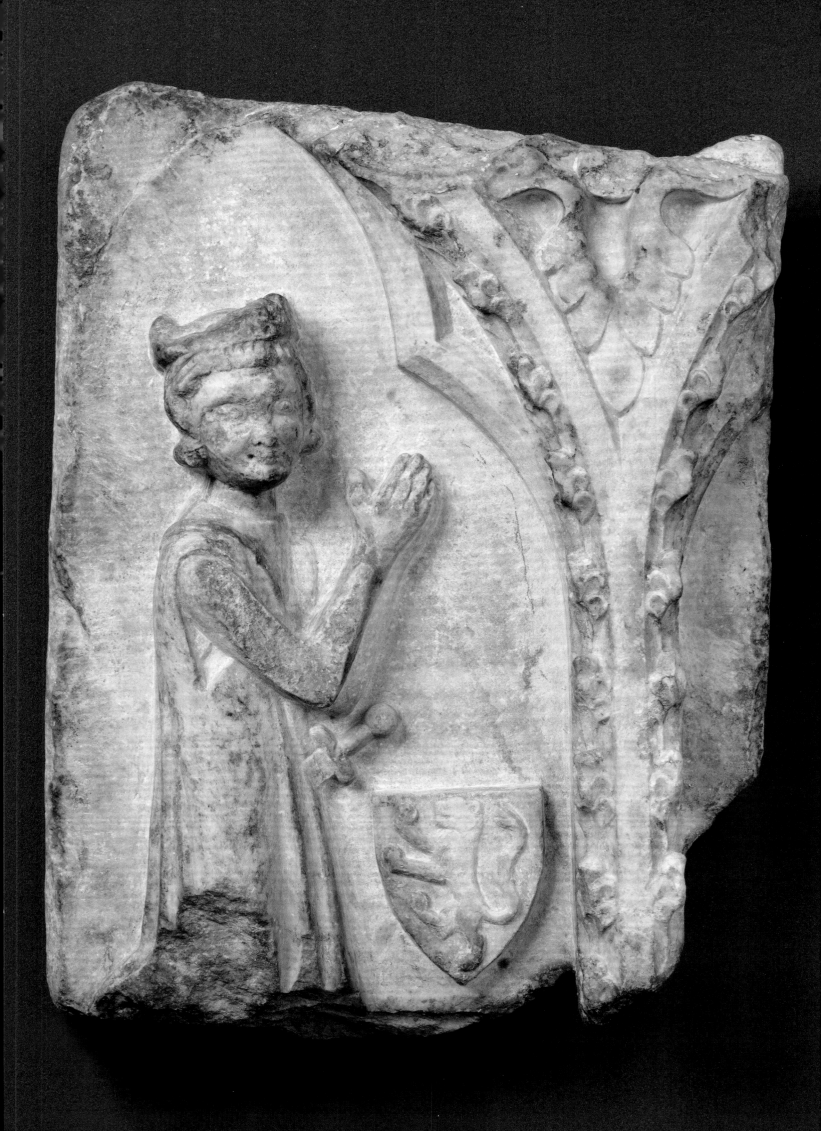

Gothic. Courajod, who has been wrongly accused of nationalism, went on a mission to Italy and built up the core of the Louvre's collection of Italian Renaissance sculptures, mainly from Florence and to a lesser extent Lombardy. André Michel, in turn, introduced German sculpture with some important masterpieces: Gregor Erhart's *Mary Magdalene* and Tilman Riemenschneider's *Virgin of the Annunciation.* The acquisitions policy then shifted largely to Italy, Germany, and the Low Countries.

As a result, other geographic areas are regrettably not well represented. From his mission to Cyprus, Camille Enlart brought back a relief sculpture with the figure of a prince of Lusignan. Some fifteenth-century English alabaster reliefs, on deposit from the Musée Carnavalet, were installed with similar pieces that had been gathered by Vivant Denon. A few Virgins from Spanish territories indicate there was a faint interest in that area.

The End of the Republic

Jeanron's position weakened quickly. When Napoleon I's nephew, the prince Louis-Napoléon Bonaparte, was elected president of the Republic on 10 December 1848, he took up residence at the Élysée Palace. As early as December 1848, he appointed by decree a new director of museums, Count Émilien de Nieuwerkerke, who was a close friend of Princess Mathilde, the prince's cousin. This sculptor, a handsome, elegant socialite, will create the Louvre of Napoleon III. For a while, however, the ministers scoffed at this imposed nomination, and Jeanron was able to keep his position until the end of December 1849.

But the winds had shifted. In an industrious France, where the bourgeoisie had thrown itself into economic gain, dreaming of progress, mechanization, and wealth, the Revolution

Harvesting Scene (detail), ca. 1125
Stone, H. 63 cm (24 ¾ in.)
Capital from the church of the Benedictine abbey of Moutiers-Saint-Jean (Côte-d'Or)
Department of Sculptures, acquired in 1929

Opposite
The Cauldron of Hell (detail), from *The Descent into Hell,* mid–13th century
Limestone, H. 82 cm (32 ¼ in.)
Relief from the rood screen of the Cathedral of Notre-Dame de Paris (dedicated to the Passion), destroyed ca. 1700
Department of Sculptures, assigned in 1894

was seen as a sign of disorder. The uprisings of June 1849 turned into a veritable insurrection before General Cavaignac suppressed the workers' movement. Jeanron remained steadfast in his opinions and loyal to his friends, providing a safe haven to Ledru-Rollin at the Louvre when he was forced to flee due to his opposition to the regime. The galleries under the terrace of the Bord-de-l'Eau in the Tuileries Garden were made into dungeons for insurgents, where they were held in inhumane conditions described by Gustave Flaubert in his novel, *Sentimental Education*. Many died while attempting to escape.

A rift quickly opened between Louis-Napoléon and the National Assembly. On 2 December 1851, he dissolved the assembly, in a coup d'état reminiscent of his uncle's, on the anniversary of the victory at Austerlitz and Napoleon's coronation. He held a referendum to consult voters on extending the presidential term to ten years, and on 1 January took up residence in the Tuileries Palace, as a means to reconnect with the monarchy and the Empire. Another referendum was called in November 1852 to "reestablish the imperial dignity in the person of Louis-Napoléon Bonaparte."

Napoleon III's "New Louvre," State Palace

On 2 December 1852, one year after the coup d'état, the Empire was restored. The imperial regime had arrived, to reassure and protect. Napoleon III fully assumed the heritage of his uncle and reverted to imperial grandeur at the Tuileries Palace, now his official residence. He organized impressive soirées and surrounded himself with a brilliant court. It might appear as though Louis-Napoléon, a man of advanced ideas and formerly linked to the Carbonari, was taking up the projects of the Republic on his own terms. In reality, he was the head of an authoritarian power.

The project to connect the Louvre and the Tuileries was back on the table, and the major undertaking of the Second Empire was the Grand Design. But the days of the "Mecca of intelligence" were over; in fact, the Imperial Library no longer had a place in the plan and was moved to the new buildings designed by Henri Labrouste. Napoleon III remade the double Louvre and Tuileries Palaces into an imperial city. This complex would include the Palais de l'État, where the constitutional bodies met and the administrations carried out their duties. It also housed the imperial stables, horses, carriages, and barracks.

Just prior to his confirmation in March 1852 as the architect in charge of connecting the two palaces, Louis Visconti presented his plan to the Civil Buildings Council in February, where it was approved, and Visconti was given five years to complete it. Delays did occur, but these happened under his successor.

Work commenced with the demolition of a neighborhood between the two palaces, and this site was quickly put under the command of Baron Haussmann, prefect of the Seine, who openly relished such vast Parisian "renovations." A whole town vanished, with its old *hôtels* and partially medieval houses. The expropriations were well under way by March 1852. In "The Swan" (1859), dedicated to Victor Hugo, Charles Baudelaire lamented the loss of Old Paris in the most famous verse ever written on the ravages of urban development:

> Old Paris is no more (the shape of a town
> Changes faster, alas, than man's heart). . . .
> Paris is changing! Yet in my melancholy nothing
> Has moved! New palaces, scaffoldings, blocks,
> Old *faubourgs*, are all symbolic to me
> And my dear memories are heavier than stone.

The first stone of what at the time was called the "New Louvre" was placed with great pomp and circumstance in front of the Palais-Royal on 25 July 1852 by the minister of state, the

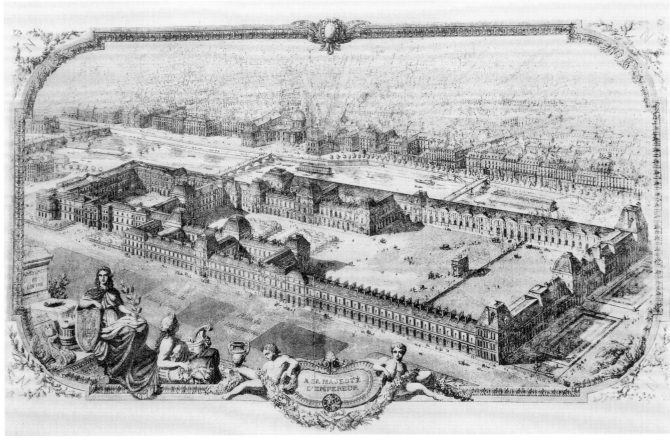

count of Casablanca, accompanied by the clergy from the two parishes of the Louvre and the Tuileries, Saint-Roch and Saint-Germain-l'Auxerrois.

Visconti envisioned a series of courtyards and wings around a main central space, the Cour Louis-Napoléon, soon to be known simply as the Cour Napoléon. His design for the north side included an almost completely new wing running along the rue de Rivoli, adjoining the one Fontaine had built onto the Pavillon de Marsan and doubling its length, with sections that enclose three courtyards. On the south side, where the Grande Galerie and the wings built by Le Vau were, the situation was more complex. The new buildings on this side had to harmonize symmetrically with their counterparts on the north, including courtyards, and be reconciled with existing large structures.

Sitting perpendicular to a bend in the Seine, the Louvre and Tuileries were not exactly parallel to each other. To disguise this flaw, adjustments were made to the interior design of the new buildings, specifically by making the courtyards trapezoidal in shape. Visconti's solution was classical, intended to merge into the aesthetic of his predecessors, Lescot and Le Vau: "The general features have been faithfully borrowed from the old Louvre," he wrote.

Visconti died abruptly on the job in December 1853. Hector Lefuel, his successor, took over the site and modified his plans. He added an attic floor to the buildings that overlooked the Cour Napoléon and, after reviewing the interiors, decided to transform the facade of the part of the Old Louvre facing the square with a new decoration. Sculptures sprouted on the rooftops, and the pavilions started to expand.

Lefuel and American architect Richard Morris Hunt orchestrated an enormous construction site. They opened an architecture firm that included draftsmen, accountants, and inspectors, and directed an army of three thousand workers. The emperor himself followed the work, visited the site, distributed gratuities, and, with accidents—a regular occurrence on the unsteady scaffoldings—arranged for the care of five hundred wounded or their widows.

Between 1852 and 1857, the long-awaited junction of the Louvre and Tuileries was finally accomplished in the gigantic works along the rue de Rivoli. The first phase was inaugurated on 14 August 1857, in time for the feast day of Saint Napoleon. In his inaugural speech, the emperor declared: "The completion of the Louvre has not been a whim of the moment, but rather the realization of a great design supported by the instinct of the country for over 300 years." The site was now finished. Théodore de Banville showered the project with rave descriptions in rambling verse:

> With its vastly unfolding expanses,
> With its rooftops lost in the heavens above,
> With its bright pediments, its crowd of figures,
> Its black peaks, its hardy pinnacles;
> With its intrepid-faced generals,
> Giants of stone, the pride of living squadrons,
> With its nude groups and caryatids,
> Its victories smacking the lips of clarions . . .
> Finished, and shining with youth and glory,
> Looking on both the universe and the city,
> Our Louvre is standing, as tall as our history,
> Harmonious colossus in its immensity!

Nicolas Gosse (1787–1878)
Napoléon III Visiting the Construction Site of the North Wing of the Louvre, 1854
Oil on canvas, 34 × 23 cm (13 3/8 × 9 in.)
Sketch of a composition intended for the Senate throne room; the Tuileries Palace and the Arc de Triomphe du Carrousel are visible in the background
Department of Paintings, acquired in 1995

Most of the new buildings were assigned to government services. There was some confusion at first, until the organization was settled. The north side was occupied by the Ministry of State, which, in fact, oversaw the works on the palace. Minister Achille Fould furnished himself with superb offices of course, but also with reception rooms and private apartments. These are now known as the "Napoleon III apartments." This side also retained a division of the Beaux-Arts, a library, and barracks. The south side was prepared for the stables and a state room, to replace the old one.

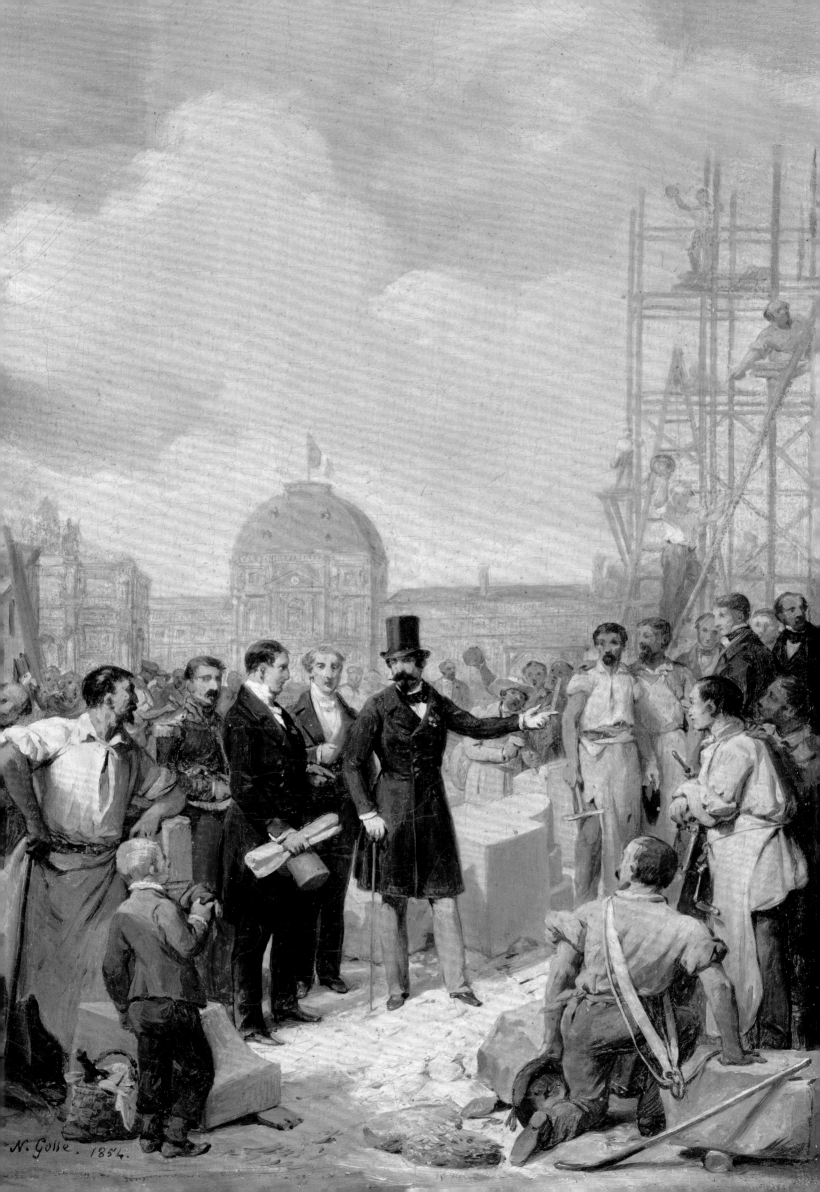

N. Gosse. 1854.

The Daru staircase
Vaults and openings conceived by Hector
Lefuel for the museum's new staircase,
transformed by Albert Ferran in 1934

Opposite
The library staircase, known now as the Lefuel
staircase, designed by Hector Lefuel between
1855 and 1859 as the access to the Louvre's
Imperial Library in the Richelieu Wing

The Library Pavilion and the Rivoli Wing

From the Place du Palais-Royal, there was now a clear view onto the north facade of the
New Louvre, where the first stone was laid. The north wing, along the rue de Rivoli, with
the so-called Pavillon de la Bibliothèque (Library Pavilion) which overlooked this square,
and the Rohan Pavilion all retain Visconti's identity. On the rue de Rivoli side are arch key-
stones that imitate ones that were sculpted during the reign of Henri IV for the north facade
of the Grande Galerie, as well as high, ornate dormers. But the truly dazzling element is on
the Library Pavilion, which was inspired by Philibert Delorme's facades for the Château des
Tuileries, with its annulated columns and classical succession of Doric, Ionic, and Corinthian
orders. The relatively simple pediment was commissioned from Pierre-Édouard Charrier
in January 1855 and finished by May: a genuine tour de force of iconography depicting
the arts and sciences. This theme appears again in the two large groups placed above, by the
important Romantic sculptor Auguste Préault. The iconography was therefore consistent
with the Imperial Library, for an institution that was not formally attached to the Louvre
Museum or to the library, but one that boasted an important collection donated by the
scholar and collector Charles Motteley. The magnificently decorated library was installed in
the large building that linked the Library and Richelieu Pavilions, facing the Cour Napoléon.
Sadly, its books and decorations disappeared in the fires of the Commune in 1871.

To give access to the Imperial Library, Lefuel designed his most beautiful staircase,
currently named after him. Its cleverly orchestrated double flight of stairs, landings embel-
lished with low-relief carvings—and overhead natural lighting and candelabra—enhance
the elegant force of the architecture. The sculptures of children's games on the ground
floor oculi, ramping vaults, and upper archivolts represent the arts and sciences, the main
intellectual objectives of a library. They are the work of Lefuel's mistress, Noémi Constant,
known as Claude Vignon, a sculptor and woman of letters. She later married Eugène

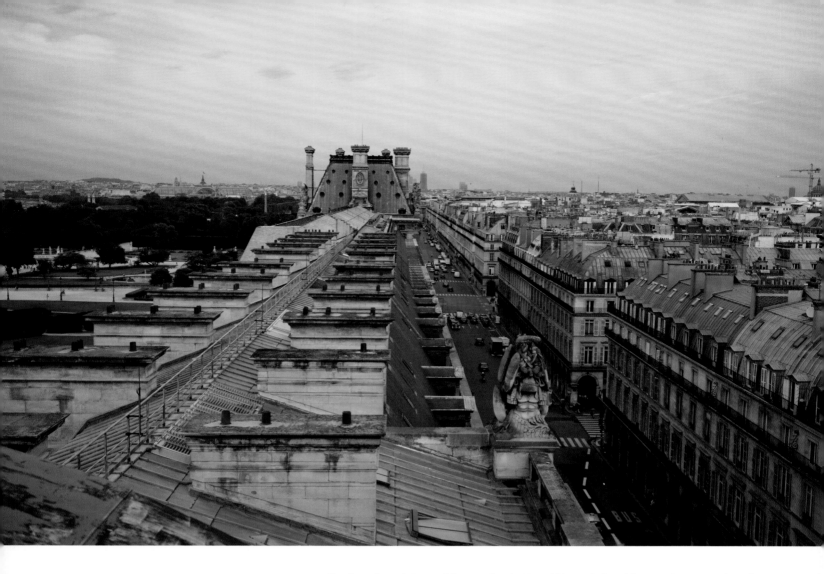

The roofs of the north wing as seen from
the Rohan Pavilion
Right: rue de Rivoli; left: Tuileries Garden

Opposite
Detail of a balustrade on the Rohan Pavilion,
with the "N" monogram of Napoleon III,
surmounted by the imperial crown

Rouher, the minister of finance for the Republic, and played hostess in a space that she
had helped decorate, and was then attached to that ministry.

Another staircase led to the barracks. Less ornate, it is set in the Colbert Pavilion, and
its decorative motif of helmets is a reminder of the purpose of the space. An elegant portico
with double columns that allow circulation to the upper floor was inspired by the staircases
designed by Percier and Fontaine.

The Rohan Wing and Pavilion

Visconti had also planned the decoration of the Rohan Wing, which runs between the
Tuileries Palace and the pavilion that owes its name to the street facing it, dedicated to
Cardinal Rohan. Four large archways, or guichets, allow traffic to pass. The north facade,
on the rue de Rivoli, is solemn and military: eight soldiers from the armies of the First
Empire tower in their niches, accompanied by armorial trophies.

On the south side, the pediments of the wing are carved with trophies and symbols of the
arts. The pinnacle of the Rohan Pavilion is more ornate. It still carries the "LN" monogram for
Louis-Napoléon, later replaced by the Napoleonic "N" that flourished everywhere. Théophile
Gautier admired the superimposed orders, a key motif of French classicism. On the ground
level are Tuscan pilasters with diamond-shaped bosses, and on the second level, fluted
Corinthian pilasters, with composite columns above. At the apex, on a majestic frontispiece,
is the figure of *France Artiste* by Diebolt (1854), reminiscent of the composition on the Molière
fountain by Visconti. All the way at the top, a slender turret forms a small lookout.

The Cour Napoléon

Now forever graced by I. M. Pei's famous Pyramid, the Cour Napoléon is surrounded by
high pavilions named for great French statesmen (Turgot, Richelieu, Colbert, Sully, Daru,
Denon, Mollien). These are connected by wings—some of which stretch toward the
Carrousel—and together comprise a long loggia promenade, with terraces above. Statues
of important French figures loom over the columns of the gallery. Visconti thought they
should be in arcades, but Lefuel placed them on the terraces. Marble was preferred, but after

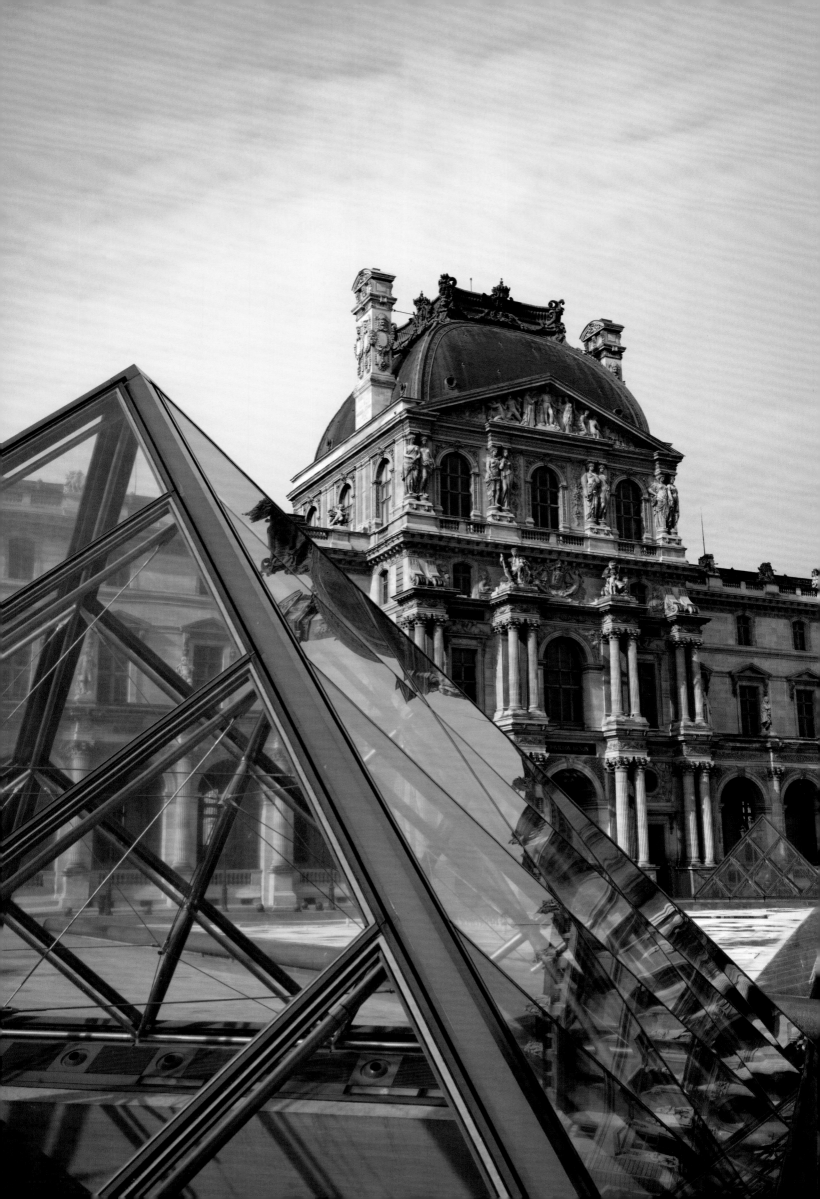

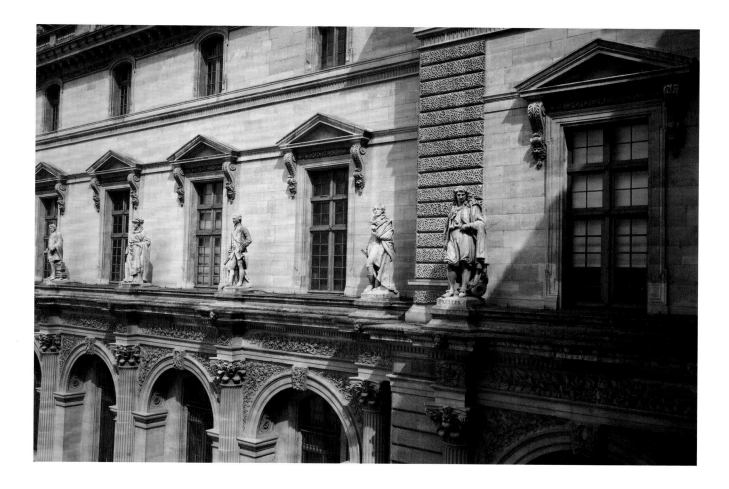

the first statue was made, the ministry deemed the cost of the enterprise to be too high, and was satisfied with sourcing blocks of stone from the two quarries of Saint-Leu-d'Esserent and Savonnières. Eighty-three gigantic statues (3.15 meters/10 ¼ ft. in height) of great men represent the arts (Poussin, Houdon, Hardouin-Mansart), literature (Racine, Corneille, Voltaire), history (de Thou, Mézeray), the Church (Saint Bernard), and the state (Mazarin, Colbert). They do not include military figures (their place faces the rue de Rivoli) or women.

The decorative motifs of the Old Louvre (allegorical carvings around oculi, caryatids, trophies on attics, female heads on lintels) were adapted but not forgotten in Lefuel's architecture. Out of personal taste, or perhaps to accommodate the demands of the imperial court, he exaggerated decorative effects and draped the facades with luxuriant sculptures. Beginning in 1854, he hired the greatest sculptors. The animalier Antoine-Louis Barye, by then quite old, made the large groups for the Richelieu and Denon Pavilions. The last representatives of the Romantic generation, Rude and Préault, classicizing artists such as Cavelier, Jouffroy, Duret, and Simart, and up-and-coming artists such as Carpeaux and Guillaume were joined by more than three hundred sculptors. The pediments of the facing Denon and Richelieu Pavilions exalt the figure of the emperor much like the pediments of the Cour Carrée: on one side, Napoleon III appears in coronation dress, and on the other, the personification of France greets the allegories of the Arts and Commerce.

The statues crowning the building are also a new concept: large seated figures rise above the quoins of the pavilions, and groups of allegorical figures ("children" measuring 1.80 meters/5.9 ft. in height) conceal the base of the roof. Official art strived to conjure a variety of subjects—seasons, continents, arts (sculpture, painting, theater), activities (hunting, fishing, industry, commerce), sciences (astronomy, anatomy, mechanics)—depicted by immense putti and attributes.

Equally impressive are the galleries and the magnificent Richelieu Passage, which links the Place du Palais-Royal and the Cour Napoléon. With its pairs of fluted columns, the Richelieu Passage was directly inspired by those designed by Lemercier and Soufflot in the Cour Carrée. It also serves as a majestic entrance to the central space of the Louvre. The vaults have symmetrical, carved decorations of armorials, scrolls, and fanciful allegorical figures.

The passage leads to the courtyard, where Napoleon III had wanted to place equestrian portraits of Napoleon I and Charlemagne, his great symbolic predecessors. This plan was

The Cour Napoléon, east facade
Above the cornice, statues of great men commissioned in 1856 (stone, H. 315 cm/124 in.), left to right: Regnard, Jacques Coeur, the marquis de Marigny, André Chénier (by Auguste Préault), Keller

Opposite
The Cour Napoléon, with the Richelieu Pavilion: architecture by Hector Lefuel, pediment by Francisque Duret, commissioned in May 1854, finished in late 1856

Following spread
The Cour Napoléon, between the Turgot and Richelieu Pavilions: the terrace on the north wing with the statues of great men commissioned in 1854 (stone, H. 315 cm), front to back: Rabelais, Malherbe, Abélard, Colbert, Mazarin

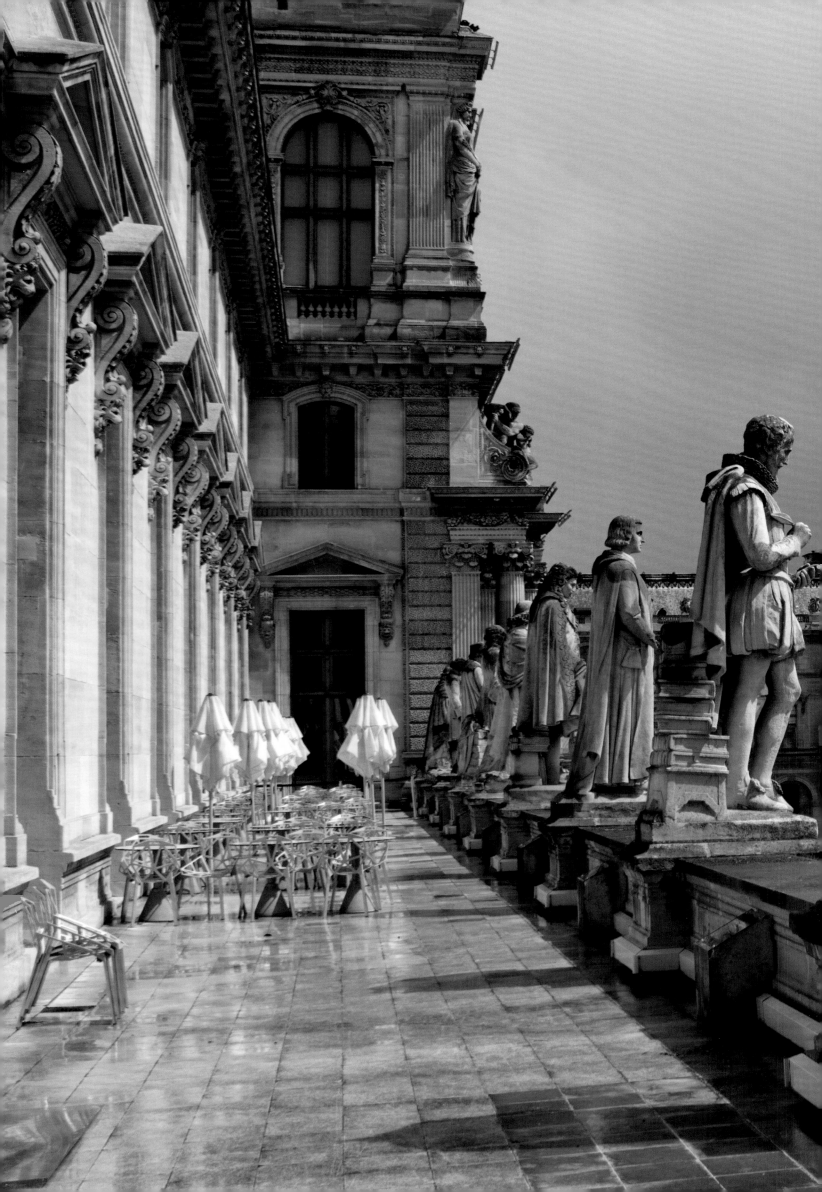

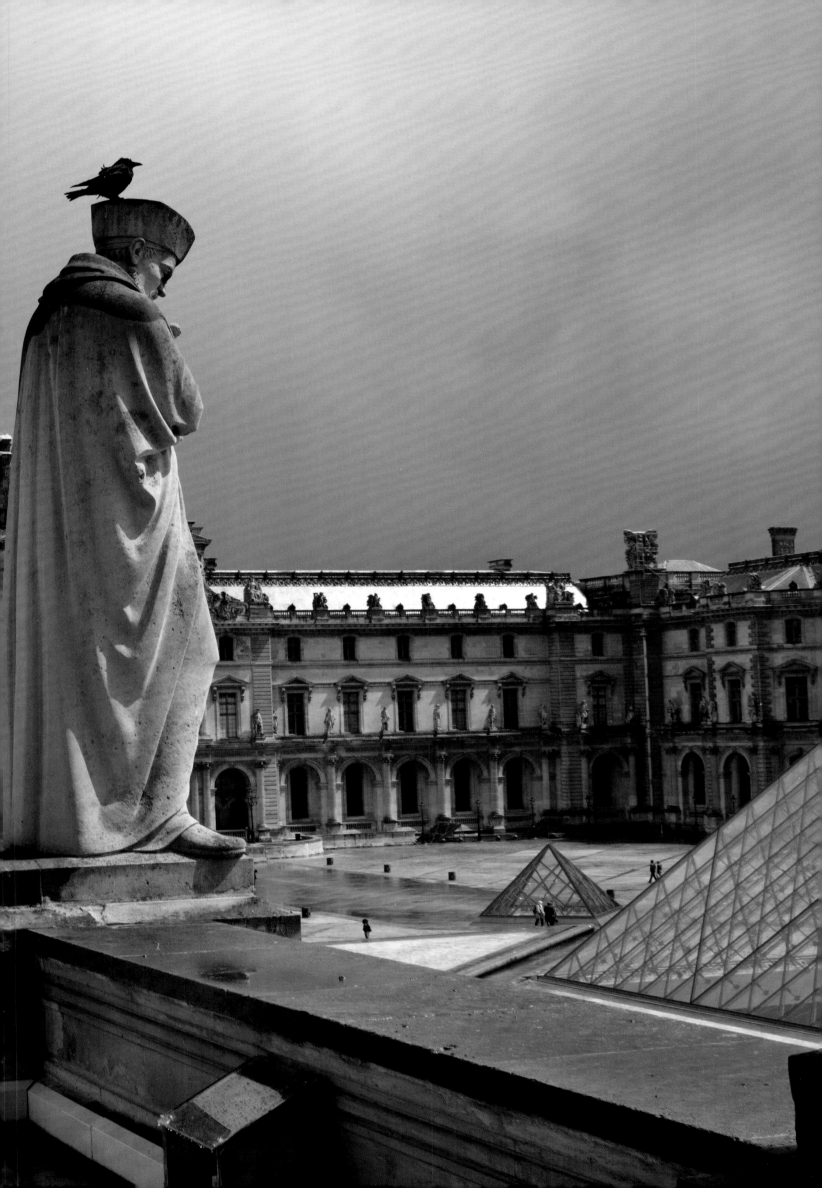

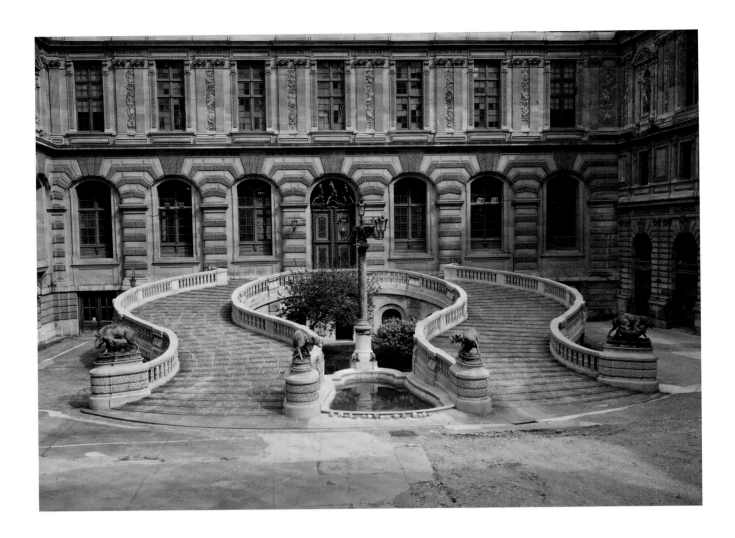

never executed, and instead the two squares were planted with trees. From 1906 to 1911, at the initiative of Étienne Dujardin-Beaumetz, secretary of state for fine arts, one of these squares became a kind of campo santo, with large statues that paid tribute to the arts (painting, sculpture, poetry, etc.) and artists (Corot, Houdon, Watteau, Puget) around a large group representing the *Genius of the Arts*. The other became an American enclave, with an equestrian monument to Lafayette by Paul Wayland Bartlett, erected thanks to a subscription to raise funds in 1898 from American schoolchildren, who were eager to celebrate the friendship between the two nations. The first square was cleared of its sculptures in the 1930s, when grandiose sculptures were no longer in fashion; and both squares disappeared when Pei's Pyramid was built. The statue of Lafayette is now part of a suite of bronze sculptures on the Cours-la-Reine, and the only piece that remains from the campo santo, Paul Landowski's *Sons of Cain*, was moved to the terrace of the Bord-de-l'Eau in the Tuileries Garden. This sculpture is a personification of the first artists and a philosophical reflection on Man.

The Facade of the Old Louvre on the Cour Napoléon

Works were well under way in early 1856 when the decision was taken to modify the wing of the Old Louvre that is now situated at the end of the Cour Napoléon. It conflicted with the rest. At the time, of course, from north to south, there were the rotunda of the chapel of Saint-Napoléon (early nineteenth century), the wing designed by Louis Metézeau and the pavilion by Lemercier (ca. 1640), the Henri II Wing (mid-sixteenth century), and the rotunda by Le Vau (ca. 1660). Lefuel leapted into action: Lemercier's pavilion was broadened and capped with a high dome to harmonize with the central pavilion of the Tuileries across the way. The decoration of the lower story was revamped with false arcades, ornate tympana, and red marble columns. A clever use of cladding hid the absence of a circulation gallery and terrace, disguised any disparities, and blocked windows. The suite of statues of great men on the upper story, the groups of allegorical figures on the attic level, and fluted columns and oculi preserved a degree of consistency with the rest of the Cour Napoléon. Two young

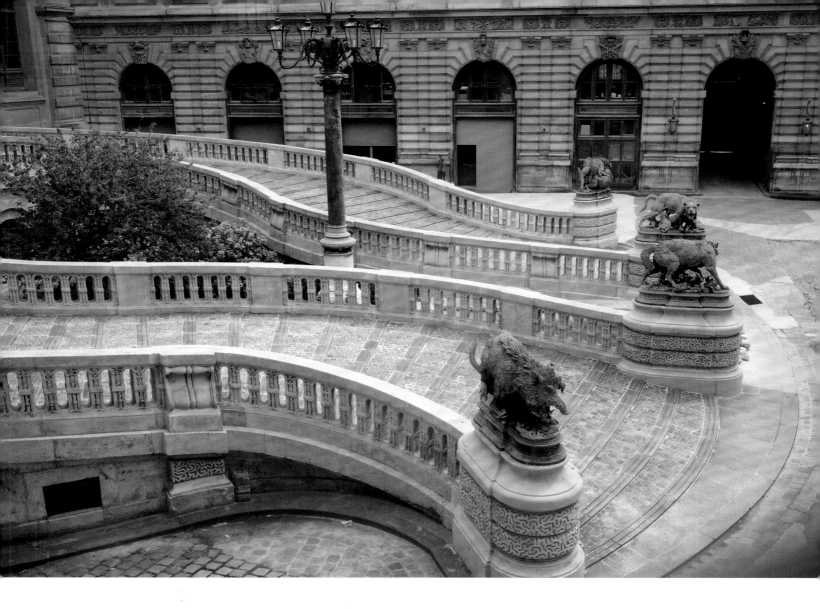

female figures in the style of Jean Goujon, representing art and beauty, were sculpted on either side of an oculus by Lefuel's son-in-law, the sculptor Eugène Guillaume, and we can see on the relief the figure of the Diane d'Anet fountain (symbol of Beauty); and Antoine-Louis Barye created a bust of Napoleon I flanked by History and the Fine Arts for the pediment of the central pavilion, in keeping with the iconography of the courtyard. Two enormous groups of *War* and *Peace* by the Romantic sculptor Préault were added to the summits of the square's corners.

The Cour Lefuel and the Cour Visconti

From the windows of the Michel-Ange and Daru Galleries, one has a pleasant view onto the south face of the courtyards, which contrasts with the north face, where Visconti's austere sense of classicism prevails. Looking south, one can see the elevation of the Grande Galerie, largely redesigned by Duban between 1850 and 1851. Lefuel reproduced and enriched this design on the adjacent sides, with carved pediments, statues in niches, and trophies in pendentives. There is again a plethora of allegorical motifs, in particular on equestrian themes (the birth of the horse, equestrianism) that correspond to the uses given to the surrounding buildings: imperial stables, a carriage house, a saddlery, housing for groomsmen, and the apartment of the grand squire. These service buildings have since been converted into museum rooms (for Coptic art and Mediterranean art of the Roman era, archaic Greek art, the Donatello gallery, and Northern European sculptures). The former courtyard of the grand squire that had opened onto the Salle du Manège (Imperial Riding Hall) is now known as the Cour Lefuel, named in honor of its architect. Its gently sloping horseshoe ramp frames a basin that may have served as a drinking trough for the horses, whose stables were underneath the new building. The door to the Manège was given a lively bronze tympanum of four galloping horses by the animalier Pierre-Louis Rouillard, who three years earlier had executed the four groups of animals in combat for the base of the railing (1857–58). The art of Versailles seems to have served as a model: similar horses, sculpted by Louis Leconte, surge from the pediment on the Great

The Cour Lefuel with its horseshoe staircase leading up to the Imperial Riding School: architecture by Hector Lefuel, sculptures by Pierre-Louis Rouillard (1820–81)

The base of the railing and four groups of animals in combat by Rouillard, 1857–58, bronze

Following spread
Niche in the Cour Lefuel: *Peace*, 1860–62, by Bernard Prouha (1822–88), stone

Niche on the ground floor of the Cour Carrée:
Phryne, commissioned in 1857, finished in
1860, by Élias Robert (1821–74), marble

Opposite
Niche on the ground floor of the Cour Carrée:
Pensierosa, commissioned in 1857, finished
in 1858 by Giovanni Antonio Lanzirotti
(1836–after 1881), marble

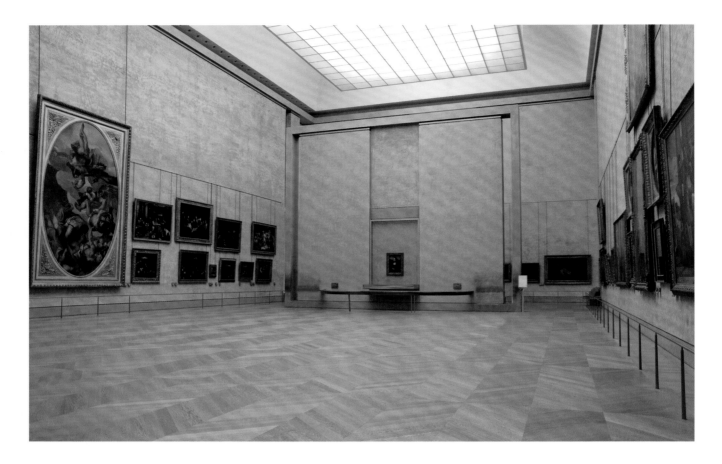

The Salle des États, built by Hector Lefuel, new architecture and museographical design by Lorenzo Piqueras in 2005
Left: *Jupiter Hurling Thunderbolts at the Vices* by Paolo Caliari, known as Veronese, from the Doge's Palace in Venice; background: Leonardo da Vinci's *La Gioconda* in its glass case, awaiting the throng of visitors to the museum

Stables of Versailles, and bronze groups of animals in combat had been cast for the park's *Cabinet des Animaux*.

The Cour Visconti is more sober. The building on the east side is lower than the rest. Known as the Galerie des Sept-Mètres, its name refers to its seven-meter width, and it occupies the last side of the Cour du Sphinx, the old courtyard of the museum. It is now the Department of Islamic Art, opened in 2012.

The Theater of Niches

Lefuel also took care to fill the niches that had been left empty on the facades. In the Cour Carrée, some of the niches contained copies of ancient statuary that had been brought from the French Academy in Rome. Duban's plan for a suite of twelve statues was only partially realized by his successor, who in 1859–60 placed voluptuous marble female figures from classical myth and the Bible (Circe, Phryne, Omphale, Venus, Bathsheba) in the niches on the ground floor. These were later joined by personifications of art techniques (goldsmithing, ceramics).

The sculptures placed in the niches on the other facade obeyed no specific program and randomly include gods, nymphs, and heroes, as well as simple fishermen and huntresses. And whereas marble was the material of choice for the Cour Carrée, elsewhere stone provided a more affordable alternative. These sculptures were, in fact, quite numerous and placed throughout the Visconti and Lefuel courtyards, the Grande Galerie where Duban was unable to finish his plan, and the Flora Wing.

The Salle des États

Once the buildings were up, Lefuel focused his energies on the rooms of the palace, setting the stage for imperial pomp and circumstance: stairways, ministries, and reception rooms. On the upper floor of a new building on the south wing that connects the Grande Galerie to the Denon Pavilion (and thus, right at the heart of the museum), he created a new state room, the Salle des États. Beginning in February 1859, this room is where the emperor presided over special meetings of the Chambers. Of the room's original decorations of marouflaged wall paintings

by Charles-Louis Müller, only the *Triumph of Charlemagne* survives. This work was originally a counterpart to an image of Napoleon I. Thankfully, a number of preparatory drawings for the ceiling canvas survive as proof of the quality of the allegorical decoration. The fabric and cardboard decoration were quickly removed after the fall of the Empire, and the room was transformed to display paintings, with natural overhead lighting—the third of this kind in the museum. New picture rails were placed on the walls, leaving only traces of the cheap, flashy imperial decoration of faux colored marble. The architect Edmond Guillaume designed a sculpted decoration modeled on the Salon Carré and the Salle des Sept-Cheminées.

All those large stucco figures, allegories, and emblems—executed in gold and opulent colors—were derided in the decades from the 1930s through the 1950s, when purism ruled the day. We may study and protect this "fluff" now, but it was despised back then. The stuccowork was mercilessly destroyed and replaced by substandard picture rails, made on what could be afforded after World War I, to display Veronese's *The Wedding Feast at Cana*. The room received a new museographic design in 2005, to exhibit the *Mona Lisa* to a large public. *The Wedding Feast at Cana* was shifted to the other side of the room, and *La Gioconda* was protected behind bulletproof glass and a railing to keep visitors at bay. She is now far removed from the other works by Leonardo in the Grande Galerie, and in the company of Venetian paintings by Titian and Tintoretto. In 2019, the room was redesigned for the Leonardo exhibition with midnight blue walls that better showcase the works.

The Salon Denon

As a prelude to the Salle des États, the vestibule known as the Salon Denon was a huge space, like the Salon Carré and the Salon des Sept-Cheminées. Its high vaulted ceiling soars above large painted draperies in the central pavilion of the Cour Napoléon's south wing. Between 1864 and 1866, the painter Charles-Louis Müller painted scenes of patronage of the French sovereigns Saint Louis, Francis I, Louis XIV, and Napoleon I, in reference to the joint artistic and political functions of the room. Each ruler presides over an assembly of artists and writers, placed before works that were executed under his reign: the Sainte-Chapelle for Saint Louis, the palace of Fontainebleau for Francis I, and the Arc de Triomphe du Carrousel for Napoleon. Large female figures theatrically pull back curtains to reveal the scenes. In the

Ceiling of the Salon Denon:
architecture by Hector Lefuel
In the tympana, at left, *Louis XIV*, and at right, *Napoleon I*, paintings by Charles-Louis Müller; in the central vault compartment, *France Presenting the Medallion of Napoleon III* by Duchoiselle (1864–66), gilt stucco; in the corners, eagles, wings spread, and the crowned imperial "N"
Department of Paintings

Salle du Manège: architecture by Hector Lefuel
Antique sculptures, left: *Adonis*; rear: *Antinoüs
as Aristaeus*; center, *Atalanta* (all three from
the Mazarin collection); right: *Praxiteles Venus*
(from the Richelieu collection), four *Satyr
in Atlantis* (from the Albani collection)
Department of Sculptures and Department
of Greek, Etruscan, and Roman Antiquities

Opposite
Salle du Manège: architecture by Hector
Lefuel, carvings on capitals by Pierre-Louis
Rouillard, Germain Demay, Emmanuel
Frémiet, and Alfred Jacquemart (1855–60),
modeled on designs by Rouillard
Center: *Worshipper* between two Ionic
columns and porphyry "bathtub"; right to
left: Egyptian-style statues by Grandjacquet,
La Zingarella, the *Borghese Eros*, statues from the
Borghese collection, acquired in 1807
Department of Sculptures and Department
of Greek, Etruscan, and Roman Antiquities

trompe-l'oeil niches, allegorical figures personify the style of each reign (*Naiveté, Taste, Invention, Thought, Fantasy, Inspiration*, and so on). In the center of the vault, a stuccowork by Duchoiselle shows a personification of France who appears to be engraving a medallion portrait of the emperor onto a marble slab. In the lower corners, we again encounter the four arts that also appear in the Mars Rotunda and the Salon Carré. In this case, however, they are represented by the busts of great artists: Poussin, Goujon, Delorme, and Gérard Audran.

The Salle du Manège

Beneath the Salle des États lies the large Salle du Manège, where equestrian demonstrations were staged under Napoleon III. Twelve huge columns support a Henri IV-style vaulted brick-and-stone ceiling. The keystones and transverse arches are still decorated with the pervasive imperial "N," while large eagles with spread wings fill the corners of the ceiling. The heads of horses, fox, herons, donkeys, bears, and eagles on the column capitals by Pierre-Louis Rouillard, Emmanuel Frémiet, Alfred Jacquemart, Germain Demay, and Houguenade (1861) evoke riding and hunting themes. Empress Eugénie would watch her son riding from a superb wood-carved tribune by Houguenade, which is now in Compiègne. At the time, this space was not connected to the museum or to the Barbet-de-Jouy door located directly south, which would have been used as needed to discreetly escort the emperor and his entourage up to the floor of the Grande Galerie and to the Salle des États. The Salle du Manège was primarily accessed from the ramp staircase designed for horses in the Cour Lefuel.

In 1879, the museum took over this space, at first to install the plaster cast museum, and from 1929, as an atrium for visitors, until the inauguration of the Pyramid in 1989. The space is now devoted to the history of the antiquities collections, including the royal, Richelieu, Mazarin, Borghese, and Albani collections.

Detail of the staircase for the former Ministry of State, known as the "Escalier du Ministre"

Opposite
Reception rooms of the Ministry of State (Napoleon III apartments): the large drawing room, architecture by Hector Lefuel, painting by Charles Raphaël Maréchal, sculpture by Louis Alphonse Tranchant, furniture by Alexandre Georges Fourdinois (1859–60)
Department of Decorative Arts

The Napoleon III Apartments

Inside the Louvre Palace, a number of prestige apartments were created for various important individuals. The director of the museum, Count Emilien de Nieuwerkerke, often organized exclusive soirées in the Marengo Pavilion, where he had a beautiful apartment built by Lefuel at the center of the north wing of the Cour Carrée, after the architect had chased him out of his initial lodgings there in order to build the Louvre's new staircase. The painter Eugène Giraud made a number of droll sketches of the guests who attended these receptions. The space now displays eighteenth-century furniture and decorative arts.

General Fleury, the grand squire, had two apartments built one after the other in the Mollien Wing. The decoration has been preserved, and these apartments now house the executive offices of the museum, with the meeting rooms installed in what were the dining room and antechamber.

The most prestigious of all of these apartments belonged to the minister of state. A powerful figure at court, this minister acted as the nexus between the emperor and the Chambers, and also oversaw all the major construction sites of the reign. Achille Fould, the first man to hold that office, wanted his residence to reflect his power. His successor, Alexandre Walewski, inaugurated the apartment with a fancy masked ball on 11 February 1861. Between 1859 and 1861, a number of painters (Appert, Gendron, Maréchal, and even the landscapist Daubigny) and sculptors (Tranchant, Knecht) rushed to create a decoration reminiscent of Versailles and worthy of the era of Louis XIV.

On the ground floor, the service areas, including the kitchens, are now medieval sculpture rooms. From the minister's courtyard (now the Cour Marly) and up the likewise-named Escalier du Ministre (Minister Staircase; the endurance of such toponyms is truly a tradition at the Louvre!), one reached the state apartments. The Christofle workshops produced the grand railing on a model by Jean-Pierre Hurpin and Marie Etienne Cousseau, and the ornaments that, together with the columns and sconces, make the staircase shine. In the two landscapes painted for its walls by Daubigny, one can spot the Flora Pavilion and the Tuileries Garden.

The succession of state rooms, built by Lefuel between 1856 and 1861, gleam with gold: the antechamber, entrance hall, salon-théâtre, large drawing room, small dining room, large dining room . . . and lest we forget, the small "family" apartment. The reception rooms look just as they did under the Second Empire, furnishings and all, marble statues and drapes and rugs, upholstery in royal red. These rooms constitute one of the most important examples of the decorative opulence of the Second Empire.

The ceiling painting in the antechamber by Victor Biennoury is devoted to the arts. Daubigny painted landscapes for the hall leading to the large drawing room. For the ceiling of the salon-théâtre, where performances could be staged, Auguste Gendron painted a lyrical Seasons of Flowers. The large drawing room, taking up the entire corner space, is dominated by a lavish red canapé in the middle of the room, the fireplace with gilt bronze mounts; and an enormous crystal chandelier; whose machinery is concealed in a room above, from where it could be lowered to be lit. Musicians performed on a raised tribune, hidden by a movable painted curtain, which delighted the guests watching the spectacle in the adjoining salon-théâtre. In a manner similar to what Muller had done in the Salon Denon, Maréchal used a light brush to paint the lunettes with images of different rulers —Francis I, Catherine de Médicis, Henri IV, and Louis XIV—surrounded by their architects and artists, busily preparing the decorations of the Louvre and the Tuileries Palaces. In the central cupola, Maréchal illustrated the Grand Design, now finally completed, in a composition with the adulatory title Wisdom and Strength Show the Imperial Couple the Grand Designs That Bring Glory to Napoleon III.

From the reception rooms, one can reach the small dining room, followed by the large dining room, which could be joined for larger gatherings. The large dining room is crowned by a light blue sky filled with exotic birds, painted by Eugène Appert. All of the sculpted decorations—including the chubby papier-mâché cherubs at play in the corners of the

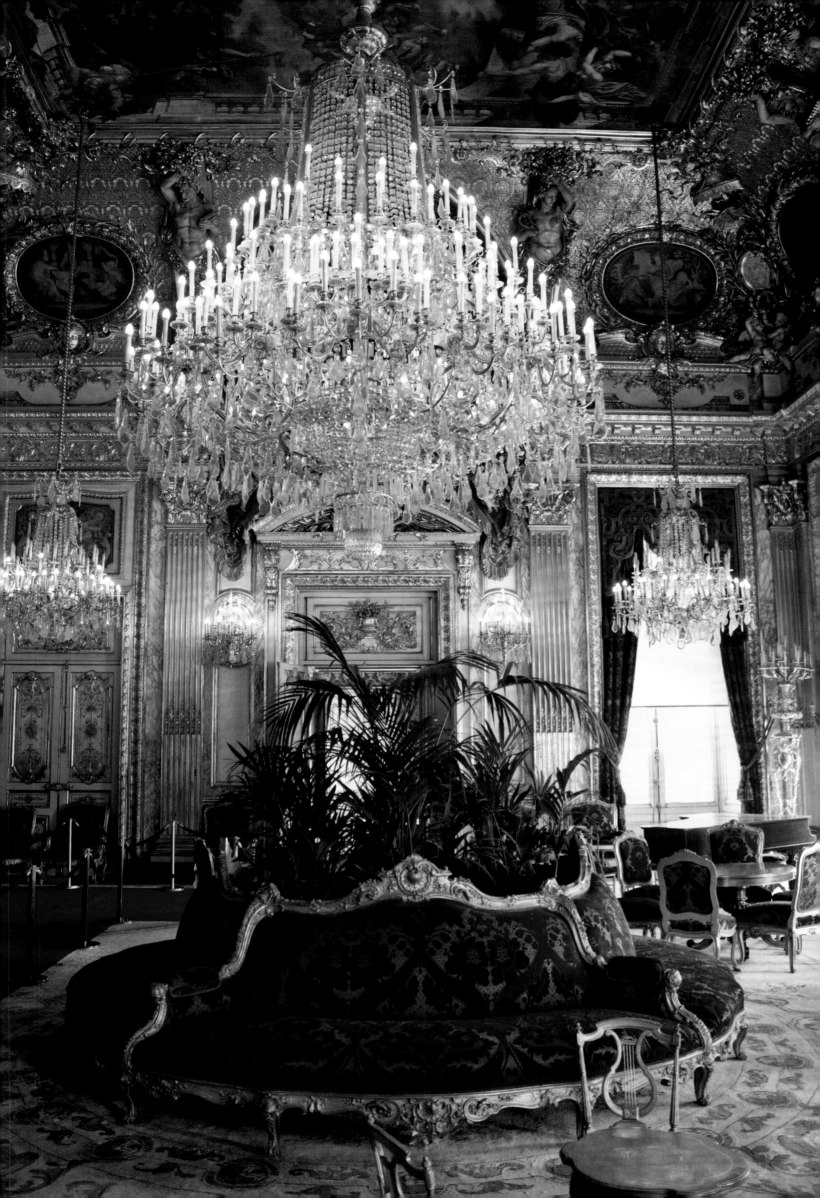

ceiling, the winged caryatids, and festoons of flowers and fruit—was designed by Émile Knecht. Numerous details evoke life at court. Behind the large dining room is a pantry, and a service hall running parallel to the dining room has a spiral staircase that led to the silverware cabinet.

The museum has revived the spirit of this unique ensemble, setting the long dining-room table with fancy silverware to capture the splendor of the receptions once held there and garnishing the center of the canapé in the large drawing room with green plants. On the other side are the adjoining rooms of the private apartments, which include the "family drawing room" with its blue cameo ceiling painted by Émile Lévy, and papier-mâché decoration by Simouillard and Bernard, based on Knecht's designs.

After the fall of the Empire and the Commune, the whole north wing was used as offices of the Ministry of Finance, whose premises had burnt down in 1871. The courtyards were transformed; one got a glazed roof and was used for various accounting services open to the public. The ministry took over the space of the Imperial Library, which had gone up in flames in 1871, and of the barracks, which no longer had a purpose. The minister installed his office in the central pavilion and kept the reception rooms. Between 1929 and 1936, a request to transfer the ministry was made and almost approved, with a new building put up on the nearby rue Saint-Honoré. And yet this project was never completed. It was not until 1981, with the prospect of the Grand Louvre and how it would affect the whole palace, that the move was truly contemplated. The Ministry of Finance finally left the Louvre for Bercy once the Pyramid was inaugurated in 1989.

View of the reception rooms of the Ministry of State (Napoleon III apartments): the *salon-théâtre*, architecture by Hector Lefuel, painting by Auguste Gendron, sculpture by François Théophile Murgey, 1859–60
Department of Decorative Arts

Opposite
The violet breche marble fireplace in the large drawing room (1861), framed by gilt bronze sconces made by Christofle, based on designs by Tranchant; the clock, a copy of the one in Louis XVI's bedroom at Compiègne, was delivered by Crozatier in 1852 for the throne room in the Tuileries

Following spread
The large dining room, trumeau paintings by Louis Godefroy Jadin, ceiling painting by Eugène Appert, sculpture by Frédéric Émile Knecht, 1859–60; on the table: silver-plated table setting by Christofle, 1853

The Pavilion de Flore and western tip of the
Grande Galerie, toward the Seine: architecture
by Hector Lefuel; above, the south gate
of the Tuileries, known as the Porte des Lions

Opposite
Jean-Baptiste Carpeaux (1827–75)
Triumph of Flora (detail), 1863–65
Terra-cotta, H. 137 cm (54 in.)
Department of Sculptures, gift of Adrien,
Lilla, and Laure Dollfus, 1912

A New Pavillon de Flore

In 1861, Lefuel embarked on a new building campaign that would involve destroying part of
the Old Louvre and replacing it with profusely decorated new construction. The Pavillon de
Flore (Flora Pavilion), which had fallen into ruins, was torn down, along with a good third
of the Grande Galerie. In its stead, a new Pavillon de Flore and adjacent wing were built,
adding more space to the Tuileries apartments; an amplified building to house the assembly
sessions; and the Grands Guichets, or passageways, opening onto the quays of the Seine.

Two great masters of sculpture competed on the exterior of the Pavillon de Flore. On
the south side, facing the Seine, Jean-Baptiste Carpeaux created the gigantic group of
Imperial France Lighting the World, flanked on the slopes of the pediment by two reclining
Michelangelesque male personifications of science and agriculture. His lively, smil-
ing *Triumph of Flora* sits below, a large relief sculpture that Carpeaux had to convince Lefuel
to allow him to place there. For the west side pediment, in 1863, Cavelier created a colossal
group of three figures, with two carved sentinels below, inspired by Donatello's *Saint
George*, and friezes in which children play a major role.

The Flora Wing

The north and south facades of the Grande Galerie were rebuilt with different elevations
that bore no resemblance to the ones that existed from the period of Henri IV. On the
Seine side, sculptors were directed to fill the alternating triangular and curved pediments,
with the pediment over the emperor's guichet receiving a more elaborate decoration.
Languid goddesses inhabit the curved pediments, including the *Venus at Her Bath* and
Triumph of Amphitrite by Cabet (1868), while lively, small allegorical figures fill the triangu-
lar pediments. By contrast, the elevation facing the Tuileries Garden reinterpreted the
design of the Lescot Wing, with a succession of reliefs roughly inspired by Jean Goujon's
work on the attic story, and a series of statues in niches.

The Flora Wing was intended for the apartments of visiting sovereigns, and a reception
hall connecting the Grande Galerie to the Château des Tuileries. The staircase leading up
to the apartments was begun, but only the upper landing was completed, between 1869
and 1871. The decoration is even more exuberant than that of the first phase of work.

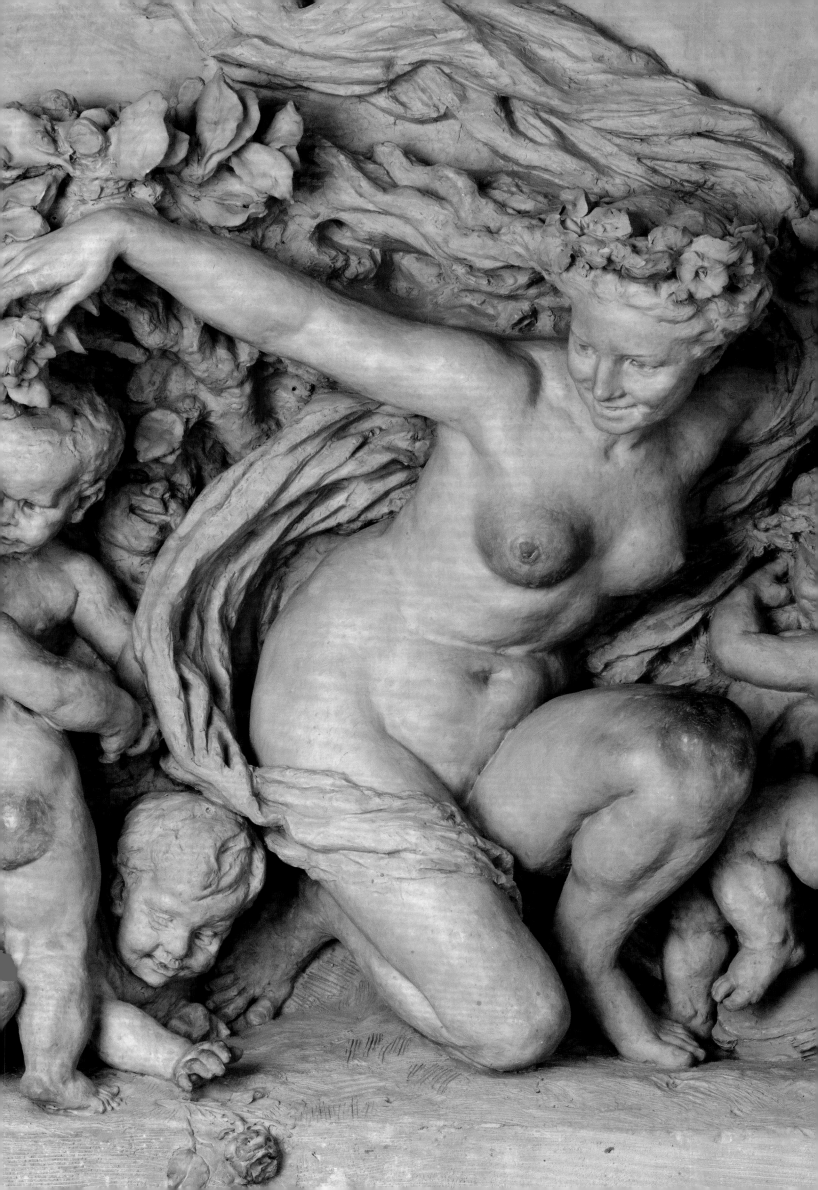

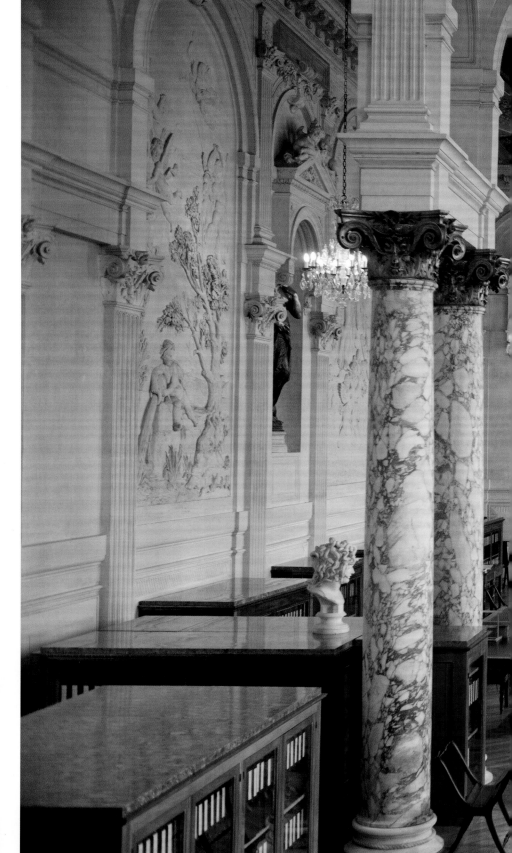

After Gian Lorenzo Bernini (1598–1680)
Head of Medusa, a copy of the head in the
Capitoline Museums, Rome
Marble, H. 51 cm (20 ⅛ in.)
From the collection of the count of Artois
at the Château de Maisons
Department of Sculptures, seized during the
Revolution, on deposit in the study room of
the Department of Graphic Arts

In honor of the goddess for whom the building is named, Eugène Guillaume carved four large reliefs of the myth of Flora. Alexandre Cabanel prepared the *Triumph of Flora* for the ceiling. He was working on this canvas in the north wing of the Cour Napoléon, close to the library, when it was damaged by fire in 1871. Cabanel managed to complete and install the painting. Left unfinished during the Second Empire, this wing would successively house the Préfecture of the Seine, the Ministry of the Colonies, an exhibition that foreshadowed the Musée des Arts Décoratifs, and finally, offices of the Ministry of Finance. In 1961, the keys to the Pavillon de Flore and Wing were given to André Malraux, then minister of cultural affairs. After important renovations, the Department of Paintings

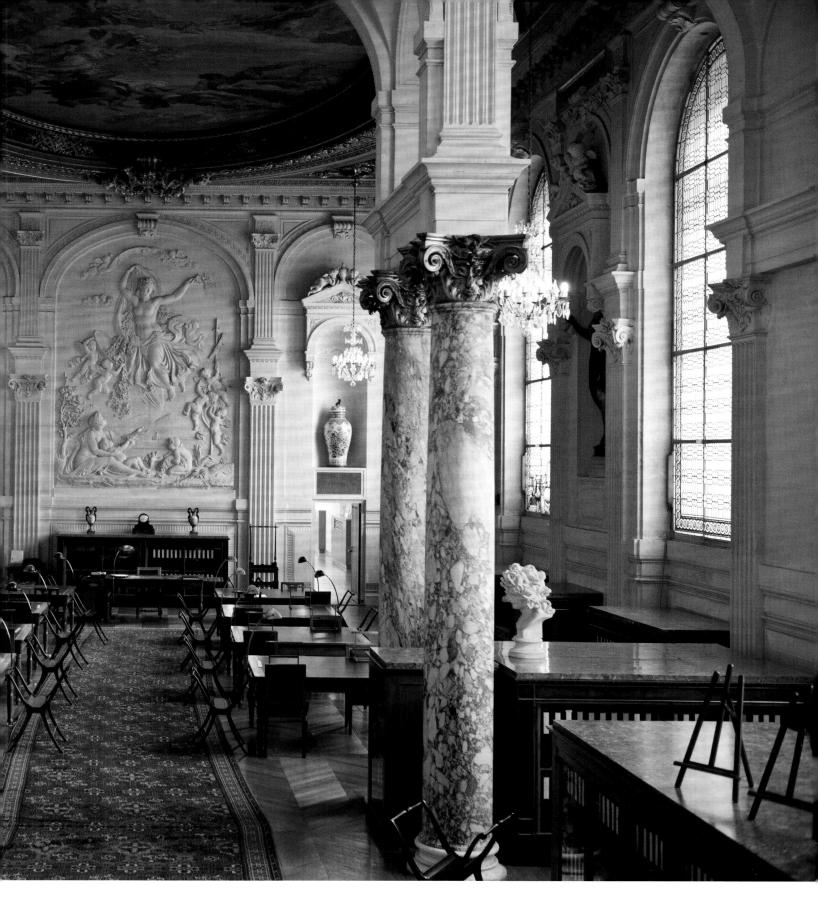

came to occupy the upper floor, with the Department of Sculptures on the ground floor. In 1970, the Department of Graphic Arts was set up within the sumptuous décor of the landing of the Escalier des Souverains (King's Staircase), where the staircase itself was never actually built.

In the Grand Louvre project, the École du Louvre took over the ground-floor space from the Department of Sculptures, while the Department of Paintings made way for the restoration services of the Musées de France. The Department of Graphic Arts, however, with its collection of forty thousand engravings and drawings bequeathed by the generous patron Baron Edmond de Rothschild, continues to receive visitors in the same, enlarged space.

Formerly the upper level of the King's Staircase in the Pavillon de Flore (currently the study room of the Department of Graphic Arts): architecture by Hector Lefuel, ceiling by Alexandre Cabanel (1823–89), sculpture by Eugène Guillaume (1822–1905), 1869–72 Department of Graphic Arts

The Pavillon des Sessions and Grands Guichets

Top of the Grands Guichets, Seine side:
architecture by Hector Lefuel
Center: *The Genius of The Arts*, 1877, by Antonin
Mercié (1845–1916), bronze, replacing the
equestrian figure of Napoleon III; left and
right: river gods by Antoine-Louis Barye
(1795–1875), stone; on the crown of the
pediment: *The Throne of the State* by Théodore
Charles Gruyère (1814–85), surmounted by
an eagle and flanked by two reclining allegorical
figures, 1868

The pavilion designed for parliamentary sessions was intended to replace the newly built state rooms. Plans called for a large room on the upper floor, reached by a grand circular staircase, with stables (again) and lodgings for the grooms around the Cour de l'En-Cas, a large space where one could climb into a carriage and make a swift exit. But the spaces ended up never being used for these purposes. The large room once hosted a conference on geography, as well as the sale of the Crown jewels in 1900, and later it was used to exhibit Rubens's *Marie de Médicis* cycle. In 2000, a new museum installation was designed there to exhibit Spanish paintings.

The exterior decoration of the Pavillon des Sessions is relatively restrained, with a suite of ten marble female allegories configured like the "great men" in the Cour Napoléon, except that instead of on a terrace, they are placed within simple arches. And following the binary principle developed by Antoine-Augustin Préault for the Cour Napoléon, one again finds *Peace* and *War* represented above, this time by Jean-Marie Bonnassieux.

The sculptural apotheosis of the Grands Guichets facing the Seine (1868–69) is much more rich and complex. Lefuel intended the guichets to be part of a new axis through Paris, which would run from the Opéra to the southern part of the city, crossing the river over the wide Pont du Carrousel. On the left bank, the inroad was never completed, though a triple triumphal arch in honor of the emperor was raised as a passageway between the Place du Carrousel and the quay. Between the piers of the guichets, François Jouffroy sculpted two monumental female personifications of the merchant marine and the navy. On the pediment, a carving of the state throne holds the imperial coat of arms, surmounted by a gigantic eagle. Antoine-Louis Barye contributed the more classical, elegant, and reclining youths as two river gods, both wearing crowns of reed. Barye's sculptural style became an issue within official discourse. He also executed a bronze equestrian high relief of Napoleon III (1867), but it did not please, and a replacement was commissioned from Jacquemart, who had time to make only a sketch and the model. In 1870, immediately after the fall of the Empire, Barye's high relief was torn down; the surviving fragments are exhibited at the Château de Compiègne. Under the Third Republic, it was replaced by Antonin Mercié's dynamic *The Genius of The Arts*.

On the north side, the decoration is more reserved, as Lefuel had to adapt it to the elevation of the square. He had already lifted the height of a portion of the Grande Galerie, in order to match the roofline and create a pendant to the high pavilion of the Salon Carré built by Le Vau. To the east, the Lesdiguières Pavilion was redone. Augustin Dumont, who had been responsible for an earlier decoration that had then been removed, sculpted the two strangely masculine figures of *Architecture* and *Sculpture*. The Trémoille Pavilion to the west was given two Michelangelesque Roman warriors. High turrets with a shiny gilt imperial "N" on their balustrades echo the turret on the Rohan Pavilion.

The south Flora Wing was just one stage of an enormous project. Lefuel expected to continue his renovations into the Tuileries and toward the Rivoli Wing. He had already redone a wing of the Château des Tuileries and made the designs for a new wing on the north side of the Louvre, which would include a theater. The war interrupted his plans.

The Napoleon III Museums

Engrossed as he was by the state rooms, the emperor nevertheless did not completely forget about the museum, though he did see it primarily as an instrument of prestige. Inside the new imperial city, the museum was allotted some additional space. It began to occupy a larger part of the Old Louvre around the Cour Carrée, and part of the buildings to the south of the Cour Napoléon, with the Denon vestibule as its new entrance. But it also lost a good third of the Grande Galerie to new palace rooms. Most importantly, however, it acquired important new collections, which were managed by excellent curators.

Count Emilien de Nieuwerkerke, the museum's director, was a decent sculptor and a kind of potentate, less of a connoisseur and more of a man about town. He did away with the collegial curators' meetings. With the support of the court and of his beloved princess Mathilde, Nieuwerkerke was appointed superintendent of fine arts. Unable to maintain a clear distinction between what constituted installations for the imperial residences and those of the museum, Nieuwerkerke failed to properly defend the interests of the Louvre. Forced into exile after the fall of the Empire, he retired to Italy, where part of his voluminous collection was acquired by Sir Richard Wallace, the founder of the Wallace Collection in London.

Meanwhile, the curators remained efficient. Frédéric Villot, the curator of paintings who had drawn up an excellent inventory and written very knowledgeable catalogues, was forced to relinquish his post in 1860 following certain controversies surrounding the restoration of paintings. Yet it was not as though his successor deviated much from Villot's policies (which may be why critics nicknamed him "Villot-alkali"). Appointed curator of drawings by Nieuwerkerke in 1850, Frédéric Reiset happened to be an important collector (he sold his collection to the duke of Aumale, who wanted it for the Château de Chantilly) and a talented author of catalogues. He continued Villot's legacy and brought the two collections under his informed leadership. Other curators—Henri Barbet de Jouy and Clément de Ris for decorative arts, Léon de Laborde for sculpture, Adrien de Longpérier for antiquities—were all remarkable. Laborde researched Renaissance arts and enamels in France, but he locked horns with the director and withdrew to his ivory tower, before leaving to direct the Archives de l'Empire, which he did brilliantly. In 1869, Nieuwerkerke also pushed Longpérier to resign, despite the fact that he had completely revitalized the collections of antiquities and oriental art.

Detail of the mosaic decoration in a rotunda of the Grande Galerie: architecture by Hector Lefuel, 1869–70

The Musée des Souverains

The first sign of Napoleon III's interest (and therefore of Nieuwerkerke's interest) in the museum was the creation of a Musée des Souverains, an institution with a clear-cut royal and imperial ideology. Decreed as early as 15 February 1852, the project was entrusted to Duban. On the piano nobile of the Colonnade, room after room each exalted a dynasty that

had governed France, including, of course, the Bonapartes. These large rooms were covered in wood paneling from the royal rooms that had been remounted in 1819 and from the apartments of Anne of Austria at Vincennes. Tall vitrines displayed relics and symbolic objects from deceased rulers: bees from the tomb of Chilperic to Napoleon I's hat, and along the way, souvenirs from Louis XVI and Marie-Antoinette, as well as 141 objects that had belonged to Napoleon's son. It was an opportunity to assemble prestigious objects that had remained scattered among various state warehouses. It was the minister of finance who therefore handed over these regalia to the museum. Other masterpieces were borrowed from the Cabinet des Médailles, the Bibliothèque Nationale, the Garde-Meuble, and the Musée de l'Armée.

These relics, brought together to appease political passions, were organized in chronological order and according to dynasty. Naturally, the large room of the central pavilion was devoted to Napoleon I, with a high dome decorated by Alexandre-Dominique Denuelle, similar to the paintings galleries. In 1872, as soon as the Republic was declared, the Musée des Souverains was closed and its objects returned to the various institutions from whence they came. The wood paneling has survived and can be seen in the rooms for Egyptian antiquities. But the central room was made into a mezzanine in the 1920s and is barely recognizable today.

The Rooms of the New Louvre

In Lefuel's New Louvre, one entered the museum from the Denon vestibule on the ground floor of the central pavilion of the south wing, from where two long Denon and Daru galleries flowed, both in theory devoted to sculptures. Under Napoleon III, electrotype reproductions of the Roman column of Trajan lined the galleries in sections placed on a multicolored marble flooring.

On the upper floor, the Department of Paintings had lost a third of the Grande Galerie, where the western portion had been destroyed in order to enlarge the Palais des Tuileries,

for the future Salle des Sessions and the south wing of the Tuileries, to be used by the regime for ceremonial purposes. However, a section was rebuilt above the new Grands Guichets. To compensate for the loss of space, the Department of Paintings was assigned a major part of the floor of the new buildings on the Cour Napoléon, where long picture rails could be accommodated. To either side of the Salon Denon, two large galleries with red walls and armorial decoration by the painter Denuelle could be hung with the large canvases of the French School. They are connected to the Grande Galerie by two transversal galleries. One of these is the Galerie des Sept-Mètres; it starts at the Daru staircase and exhibits early Italian paintings. The other is known as the Mollien Wing, as it begins at the Mollien staircase and is divided into four rooms devoted to the "little masters."

Most of the new museums were set up quickly but not without a degree of opulence, which often did not survive the purist purges of the 1930s–50s. The picture rails of the paintings rooms were given gilt friezes, mainly by Denuelle. Two rotundas were placed in the reconstructed portion of the Grande Galerie, with stuccowork on the ceilings by Rodin's master Carrier-Belleuse, depicting lively, voluptuous bacchanals. The walls, covered in mosaic in 1869, shimmered with gold. Painted ceilings, on the other hand, were rare and generally reserved for the state rooms, the Salon Denon, and the large room of the Musée des Souverains, where the now-lost ceiling injected politics into the museum.

The lavish Salles des Empereurs does survive, in the former location of the Salle des Antiques, and still displays antique sculptures. The decorations of this room were clearly political, with references to the modern, victorious emperors Napoleon III and his uncle Napoleon I, following on from the emperors of antiquity and the Middle Ages, with antique sculptures of emperors placed in the room on plinths. In 1865, Louis Matout painted the gigantic, 52-meter-long (170 ft.) *Assembly of the Gods*, a composition that is largely styled after Ingres. It is surrounded by medallions with historical subjects by Duchoiselle, following the pattern of stucco medallions Michel Anguier had made for the Grand Cabinet de la Reine. They illustrate the great deeds of emperors, from Constantine to Charlemagne to Napoleon. Two portrait medallions also pay tribute to the imperial couple.

View into the former Musée des Souverains in the Colonnade Wing: room with wood paneling from the Council Chamber in the queen's pavilion at the Château de Vincennes, remounted in 1832 by Fontaine, architecture by Le Vau, paintings by Dorigny
Department of Egyptian Antiquities

Following spread
Galerie Michel-Ange: architecture by Hector Lefuel, 1856–57
Left to right: *Flying Mercury*, bronze, by Giambologna; *Friendship* (seen from the back), marble, by Cristoforo Stati; *Bacchus and a Young Satyr*, marble, by Giovanni Francesco Susini after Michelangelo; *Slaves*, marble, by Michelangelo; portal from a palazzo in Cremona, marble, attributed to Pietro da Rho; *Young River God*, marble, by Pierino da Vinci; *Mercury Abducting Psyche*, bronze, by Adriaen de Vries
Department of Sculptures

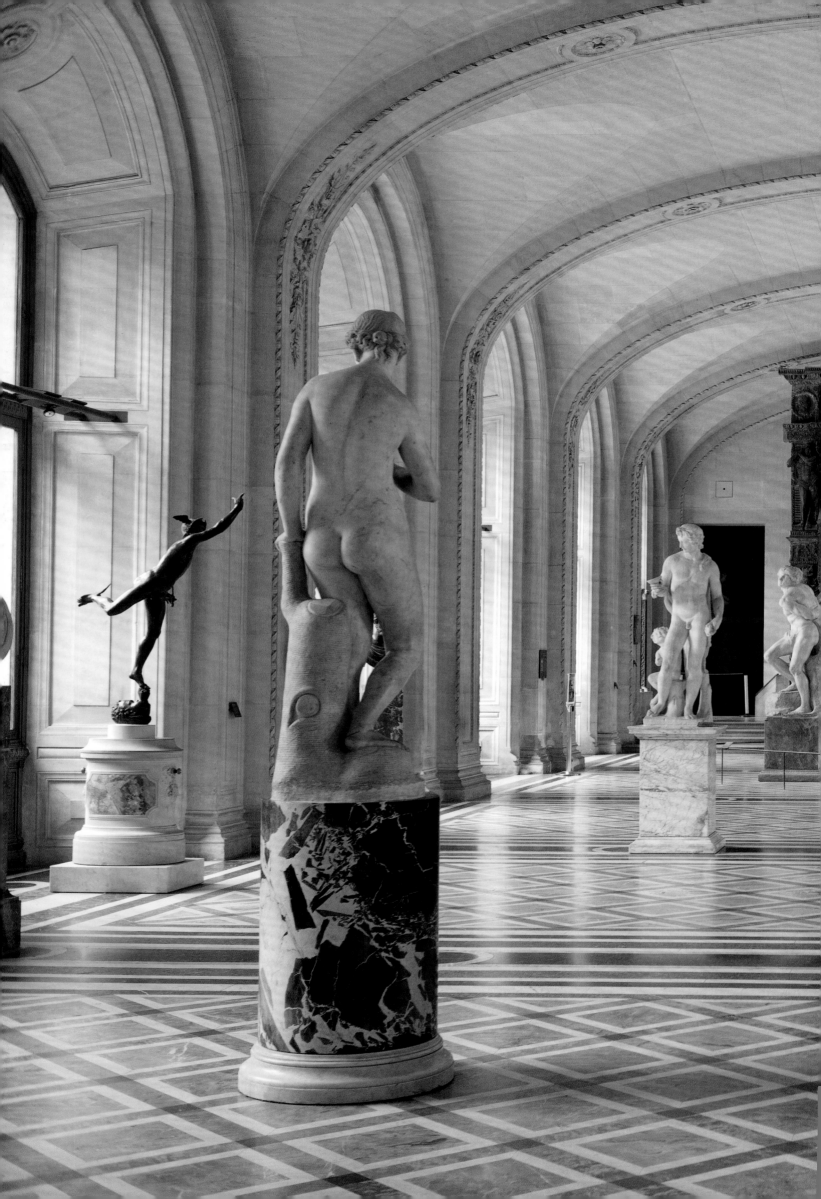

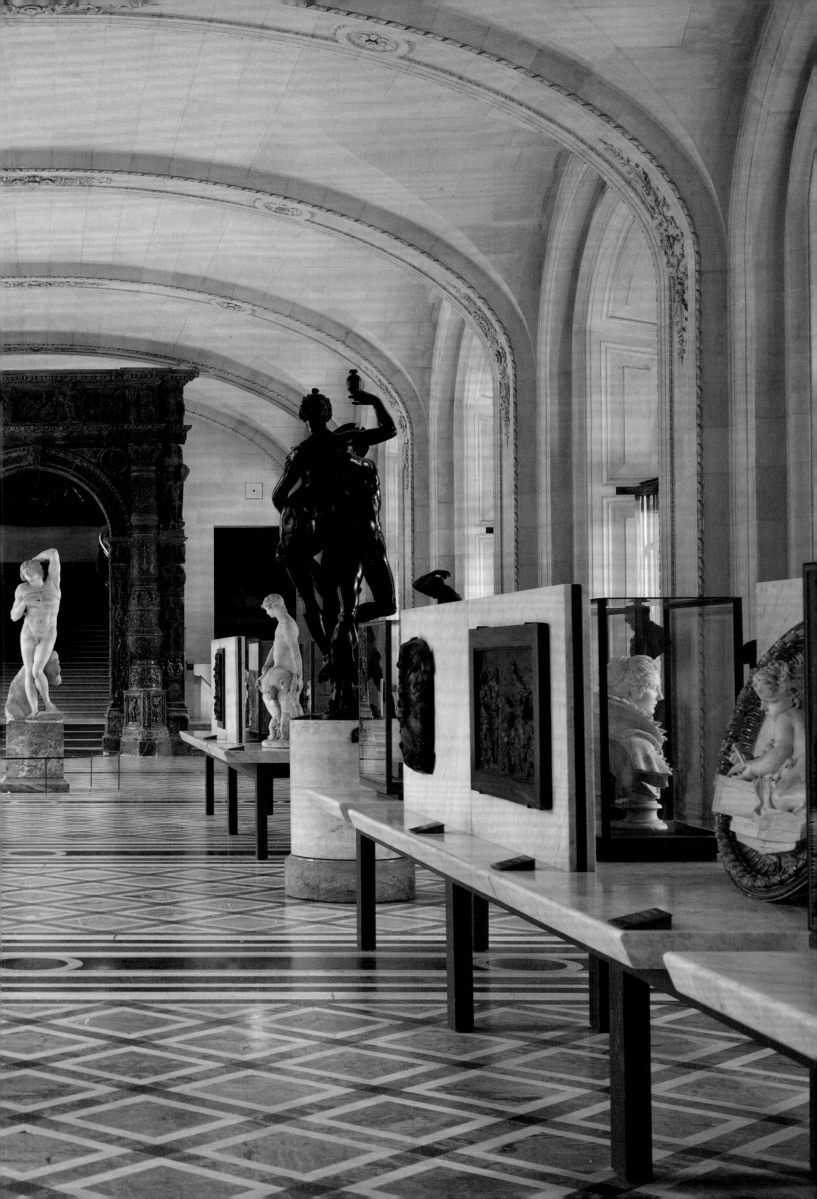

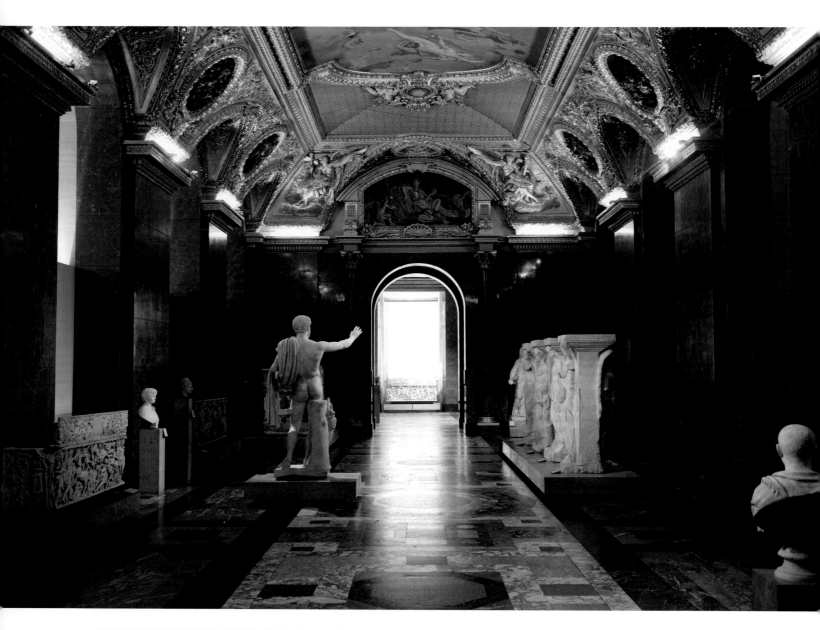

Salle des Empereurs (Roman Sculpture Room): architecture and decoration by Hector Lefuel, 1865–68, painting by Louis Matout, sculptures by Duchoiselle; right: *Incantadas* pillars from Thessaloniki (Emmanuel Miller mission, 1865)

Under Henri IV, this was the Salle des Antiques, transformed by Anne of Austria, and then again at the creation of the Musée des Antiques (1800) for the installation of the *Apollo Belvedere*.

Detail of the decoration: *Empress Eugénie in Profile*, 1865–68, by Victor Biennoury (1823–93)

Opposite
Ceiling detail: *The Assembly of the Gods*, 1865–68, by Louis Matout (1811–88)
Department of Greek, Etruscan, and Roman Antiquities

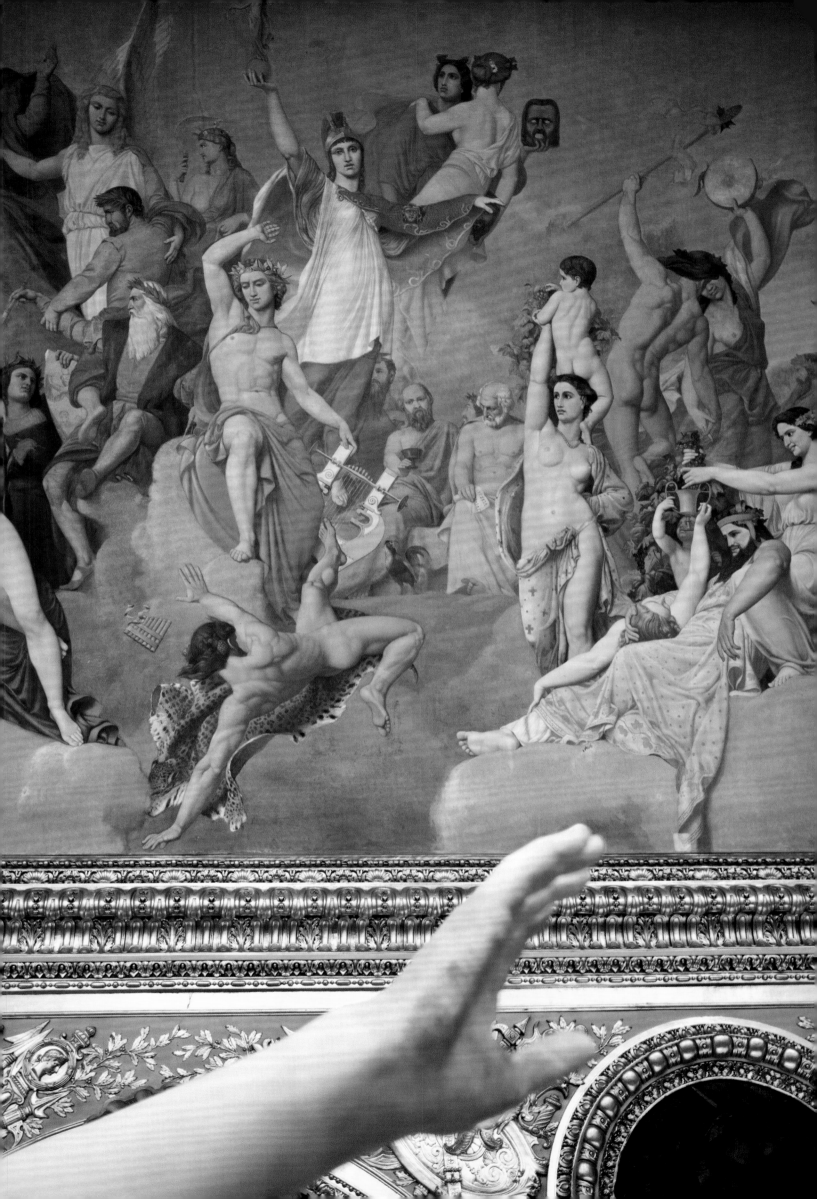

Charles Giraud (1819–92)
*Musée Napoléon III. The Terra-cotta Room
at the Louvre*, Salon of 1866
Oil on canvas, 97 × 130 cm (38 ⅛ × 51 ⅛ in.)
Department of Paintings, acquired in 1930

Preceding spread
The Mollien staircase, 1905–14

The Louvre Museum in the Napoleon III reign was also a palace of many staircases. At each end of the new wing, two large staircases lead to the various rooms. Of course, the museum's great staircase, where the *Winged Victory of Samothrace* now stands, owes its solid, ambitious structure to Lefuel but was not completed during the emperor's reign. The Mollien staircase to the east, leading to the paintings galleries, was largely decorated during that period. Built mainly between 1854 and 1857, the decoration of the staircase was initially entrusted to the sculptor Jules Klagmann, but was suspended due to lack of funds. When the project was resumed by François-Théophile Murgey, very accomplished sculptors were chosen to execute the final stuccowork based on his designs. Cavalier and Duchoiselle modeled robust atlantids; Sanson, Duchoiselle, Hiolle, and Janson made the tympana reliefs of the four arts, following an iconography that is found repeatedly on the ceilings throughout the Museum. The central medallion of the vault was reserved for a painting by the always energetic painter Charles-Louis Müller, whom Lefuel so greatly appreciated for his ingenious, accommodating work. Müller marouflaged his canvas, *Glory Distributing Crowns to the Arts*, to the ceiling on 17–19 January 1870, a year that proved fateful for the regime.

Etruscan and Primitive, the New Collections

The Musée Napoleon III and the Campana Collection

Napoleon III was passionate about archaeology. A great admirer of Julius Caesar, he ordered the excavation of Alesia and established the Musée des Antiquités Nationales in Saint-Germain-en-Laye. He sponsored a number of archaeological missions that brought back a host of objects from Macedonia, the Greek islands, northern Greece, Asia Minor,

ARISTOTELI STAGIRITAE

PLATONI ATHENIEN

the Near East, and Cyrenaica, and personally oversaw the acquisition of the vast Campana collection. It was all exhibited at the Louvre in the so-called Musée Napoleon III. The former Salle des Séances was incorporated into the museum in 1862. This made it possible to display the fruits of the excavations ordered by the emperor on a long central platform and in tall vitrines, along with a portion of Campana's archaeological collection, including numerous Greek vases and objects he had acquired in Etruria. The emperor inaugurated this room on the feast day of Saint Napoleon, 15 August 1863, as well as twelve other rooms, including the Galerie Campana and the Musée de la Renaissance.

In 1861, the French Senate approved exceptional funds (4.8 million francs) to purchase the collection that had been assembled by Giampietro Campana, director of the Monte di Pietá in Rome, who was in financial ruin. A year earlier, Russian and British collectors had purchased several sculptures, ancient ceramics, jewels, and majolica from his collection, but the paintings, primarily by pre-Raphael Italian masters, remained largely untouched, as were the antique vases and bronzes, and Florentine sculptures and majolica—in all a total of 11,835 objects. This ensemble was exhibited in 1862 at the Palais de l'Industrie on the Champs-Élysées to wide acclaim. A lively debate ensued, on the question of the appropriate home for these works: the Louvre or a separate museum. Nieuwerkerke argued vigorously and effectively in favor of the Louvre, against the Cornu clan, led by the emperor's foster sister, Hortense, and her husband, Sébastien Cornu, a painter and member of the Institut de France (along with Ingres and Delacroix). This group wanted to establish a museum of industrial art named in honor of the emperor, with Cornu as its administrator. His aim was to provide artisans and manual workers with models of antique and medieval art on which to develop their own creative taste. The idea was abandoned as early as June 1862, only to be reborn later as the Union Centrale des Arts Décoratifs, but without the Campana Collection.

Justus of Ghent (active 1460–75) and Pedro Berruguete (ca. 1450–before 1540)
Aristotle and *Plato*
Oil on poplar wood panel, 104 × 68 cm (41 × 26 ¾ in.) and 101 × 69 cm (39 ¾ × 27 ⅛ in.)
Two of twenty-eight portraits of illustrious men commissioned by Federico da Montefeltro, duke of Urbino, for the upper walls of his *studiolo* in the ducal palace, decorated in 1476 (fourteen portraits are at the Louvre, the rest are still in situ)
Department of Paintings, formerly in the Campana collection, acquired in 1861, entered the Louvre in 1863

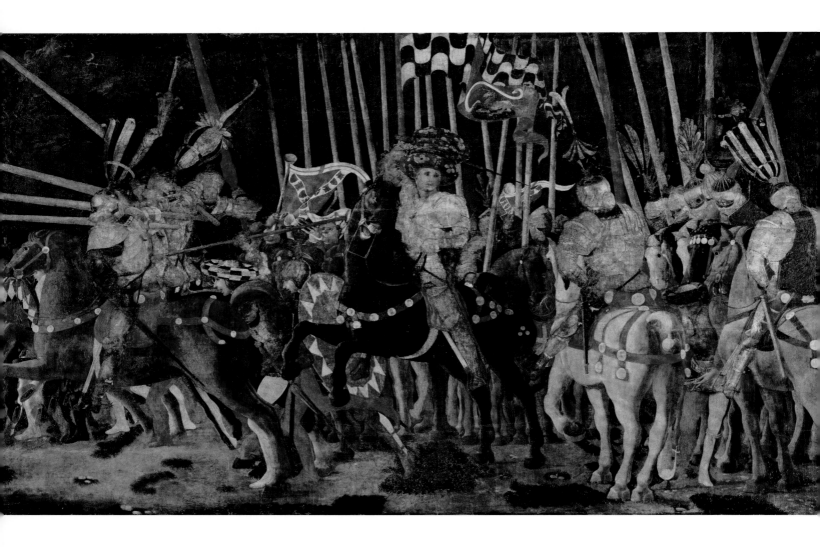

Paolo di Dono, known as Paolo Uccello
(1397–1475)
The Battle of San Romano, ca. 1435(?)
Oil on wood, 182 × 317 cm (71 5/8 × 124 3/4 in.)
Department of Paintings, formerly in the
Campana collection, acquired in 1861, entered
the Louvre in 1863

The Florentine victory over Sienna in 1432 was
illustrated by Paolo Uccello in three panels
for Cosimo de' Medici's palace in Florence
(now dispersed between Paris, London, and
Florence). The painter's investigation of
geometry, perspective, and foreshortening,
in particular, do not overshadow his taste for
color and precious detail.

In July 1862, the Vichy decree established the Musée Napoléon III at the Louvre and made provisions for the dispersal of duplicates. A new controversy erupted, this time pitting the academy (led by Ingres) against Nieuwerkerke, over the opportunity to exhibit art at the Louvre that did not yet quite fit into the accepted canons. Ingres and the academy prevailed, standing up courageously to the supposed "connoisseurs, dismayed and upset" by all things not classical. A commission was then formed to make a selection of works and objects. After cherry-picking the collection, this commission doled out works to the Cluny, Sèvres, and provincial museums—including numerous duplicates (or supposed duplicates), but mainly antiques, majolica, and paintings. The fact that the Campana collection was intended to be used primarily as a study resource for the *métiers d'art* explains how it came to be dismantled. In order to fulfill this purpose, it had to be dispersed throughout the country and into institutions in the provinces. At first, 206 paintings were reserved for the Louvre, while 322 were distributed among 67 museums. In 1870, the Louvre curators were requested to make yet another selection to be sent to the provinces, leading to the dispersal of another 141 paintings in 1872, and 38 in 1876. Batches of antiques were sent out in 1875, 1893, and 1895.

In 1863, the Musée Napoléon III thus acquired the most prestigious paintings: Uccello's *Battle of San Romano*, the series of illustrious men from the Urbino *studiolo*, works by Cosimo Tura, Bernardo Daddi, Filippino Lippi, Giotto, Paolo Veneziano, and Bernardo Parentino, all now masterpieces of the museum's collection. And there was also an abundant selection of Renaissance art objects, sculptures, and above all, antiquities.

Etruscan Art

The Campana collection was indeed rich in antique art, especially from Latium and Tuscany: jewelry; bronzes; vases; paintings; marbles (including a relief from the Augustan *Ara Pacis*); ivories; lamps; statuettes and figurines; a thousand inscriptions; 5,791 pieces of pottery; and 1,146 jewels and gems, from a mix of periods, including Corinthian, classical Greek, Etruscan, and Roman.

A large number of objects had been found during the gleeful and often casual excavations of the Etruscan tombs at Cerveteri. This is the path that brought the famous *Sarcophagus of the Spouses* to the Louvre, known at the time as the "Lydian sarcophagus" because some of its features were thought to be Asian. A suite of small urns featuring sculpted vessels topped by the figures of a recumbent couple, resting on their forearms as if they were attending a funeral banquet, repeated this composition in miniature. The relief terra-cotta coverings known as the "Campana slabs" came from these excavations as well. There was also a particularly rich array of funerary objects: bronze mirrors, jewels, Etruscan blackware known as bucchero, and high-end Greek ceramics. Two exceptional sculptures came out of this lot: the terra-cotta female bust (*Ariadne*) from Falerii Novi and the bronze head of a young man from Fiesole, both acquired in 1863.

Since the 1980s, the Etruscan collection has occupied rooms along the Cour du Sphinx, though the bronzes and jewelry are in rooms on the first floor devoted to these arts in antiquity. These works are expected to get a space of an appropriate scale in the near future, the first Salle des Séances and the Salle des Sept-Cheminées in the Henri II Wing of the Old Louvre. In the meantime, the collection has been enriched with the addition of a large-scale anatomical ex-voto, acquired in 2012.

Female bust: *Ariadne*, 3rd century B.C.
Terra-cotta, H. 61 cm (24 in.)
Discovered in 1829 during the excavations of land owned by Count Lozano at Falerii Novi, near Civita Castellana
Department of Greek, Etruscan, and Roman Antiquities, formerly in the Campana collection, acquired in 1861, entered the Louvre in 1863

Sarcophagus of the Spouses
Cerveteri (Banditaccia Necropolis), ca. 520–510 B.C.
Terra-cotta and polychrome, H. 114 cm, L. 194 cm (44 ⅞, 76 ⅜ in.)
Department of Greek, Etruscan, and Roman Antiquities, formerly
in the Campana collection, acquired in 1861, entered the Louvre in 1863

Influenced by Ionic Greek art, this large sarcophagus shows an Etruscan
couple in a banquet pose.

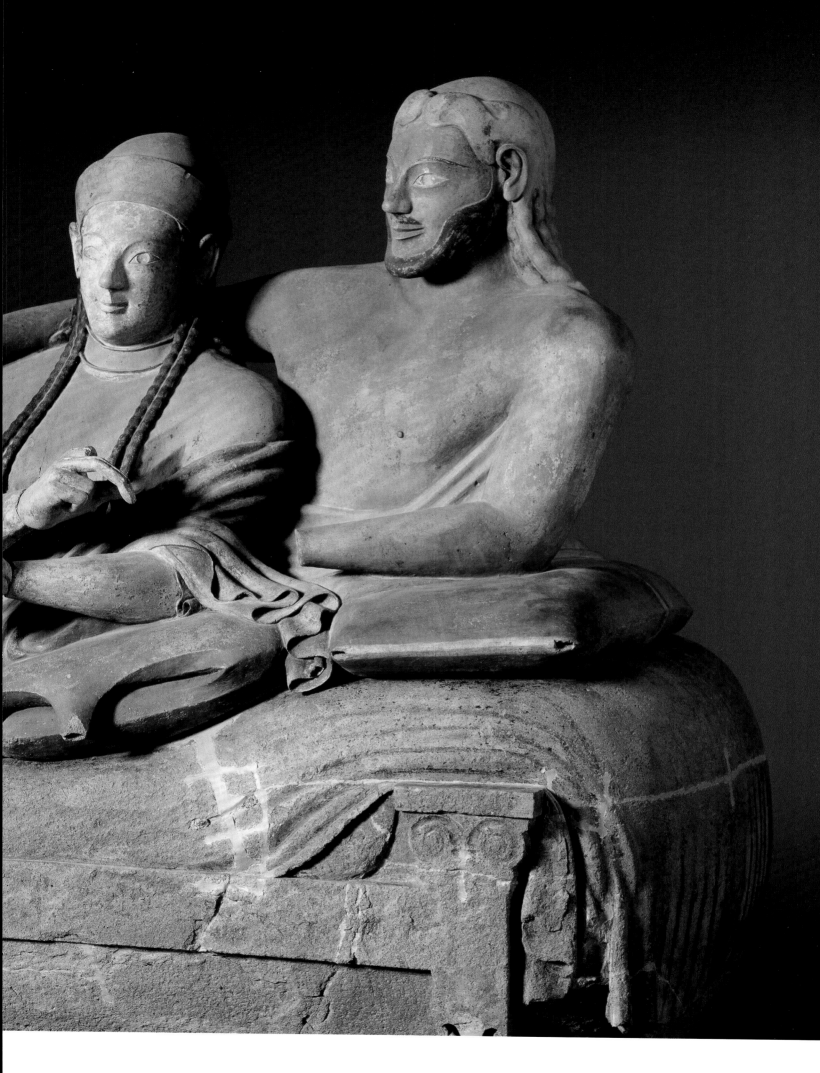

Attributed to Giovanni della Robbia
(1469–1529/30)
Two candelabra-bearing angels, late 15th
century
Terra-cotta, partially enameled, H. 50 cm
(19 5/8 in.)
Department of Sculptures, formerly in the
Campana collection, acquired in 1861, entered
the Louvre in 1863

From the Musée de la Renaissance to the La Caze Collection:
The Expansion of the Collections

On the same day the Musée Napoléon III opened, so too did the seven rooms of the Musée de la Renaissance, on the first floor of the Cour Carrée's north wing. The display of 2,250 pieces was particularly dense. One part already belonged to the museum; another part came from the collection of Alexandre-Charles Sauvageot, a violinist at the Opéra who was the inspiration for the hero of Balzac's novel *Cousin Pons*; and yet another part came from the Campana collection. And while this museum did include modern pieces, its emphasis was on the great Renaissance period that dominated artistic taste. Medallions, reliefs, and glazed terra-cottas from the Della Robbia workshops of Florence plastered the walls. The first room was devoted to ivories; the second paid tribute to Sauvageot with a string of Renaissance furniture stacked with objects and statuettes, and horizontal vitrines displaying small decorative objects, colored waxes, miniatures, combs, boxes, and utensils. This was followed by a room devoted to Venetian glass and iron, bronze, and metal works, a room for French ceramics, and two rooms for Italian majolica, to which was added the Luca Della Robbia vestibule, with enameled sculpture by Della Robbia and Santi Buglioni.

Since then, the collections of decorative art and of sculptures have been separated. The Della Robbia terra-cottas were moved to a bay in the Donatello gallery, dominated by a large altar-piece from Città di Castello that was acquired in 1893 and reassembled. One can catch a glimpse of this lost world in the Department of Decorative Arts on the second floor of the Richelieu Wing. The Campana majolica and the objects from the Sauvageot collection constituted the early core of its Renaissance collection. This department has grown substantially thanks to certain large donations, such as Baroness Salomon de Rothschild's gift in 1922, which included a wealth of Venetian glass, majolica, Bernard Palissy platters, and painted enamels.

The Second Empire was indeed a high point of prosperity for the Louvre. Beyond the new rooms of the new "museums," a host of smaller reshufflings kept the Louvre in flux. Here is a recap of the most important ones: the repurposing of the Conseil d'État rooms, the Cabinet of Drawings, and part of the north wing, in 1852, where Frédéric Reiset devoted each of the fourteen spaces to a different "school," while the thirty-six thousand drawings he had so patiently inventoried were organized into boxes (hence the name "Salle des Boîtes"); the installation of large vitrines in the Galerie d'Apollon in 1861 to exhibit the Crown jewels; and the staging of the large gallery of Assyrian art on the ground floor of the Colonnade in 1862, when the Khorsabad bulls were removed from their small room.

Just prior to the fall of the Empire, the museum received the important donation from the *bon docteur* La Caze, a learned philanthropist and collector. This was, in fact, the largest and most beautiful donation ever made to the Louvre! Two hundred seventy-five paintings were reserved for the museum, while 307 were dispersed among a hundred or so regional institutions. Marie Frédéric Eugène de Reiset drove out the Musée Napoleón III in order to create the Salle La Caze in the former Salle des Séances, but not without the imperial couple in attendance to inaugurate the new room, and the Henri II antechamber, on 14 March 1870. The selection departed from the classicism that had ruled over the Louvre collections: instead of Italian Renaissance or seventeenth-century French paintings, the works were primarily eighteenth-century French, more than two hundred in all, including *Pierrot* and *The Indifferent Man* by Jean-Antoine Watteau, still lifes by Jean-Siméon Chardin and his *Prayer Before a Meal*, and Jean-Honoré Fragonard's *Bathers* as well as some of his fantasy figures. Dutch painting also figured prominently, with

Attributed to Francesco Durantino
(active 1537–83)
The Feast of Romulus in Honor of Neptune,
ca. 1535–40
Faience, D. 29 cm (11 ³/₈ in.)
Bowl bearing the Sforza-Farnese arms
(Alessandro or Paolo?)
Department of Decorative Arts, formerly
in the Campana collection, acquired in 1861,
entered the Louvre in 1863

Frans Hals (ca. 1581/85–1666)
The Gypsy Girl, ca. 1626
Oil on canvas, 58 × 52 cm (22 ⅞ × 20 ½ in.)
Department of Paintings, Louis La Caze
donation, 1869

Opposite
José de Ribera (1591–1652)
The Young Beggar, known as *The Clubfoot*, 1642
Oil on canvas, 164 × 94 cm (64 ½ × 37 in.)
Department of Paintings, formerly in the
Stigliano collection in Naples, Louis La Caze
donation, 1869

The sheet he holds reads "da mihi elemosinam
propter amorem dei" ("Give me alms, for the
love of God"). The Neapolitan beggar belongs
to a popular type adopted by the Caravaggisti.
Ribera frequently employed this type in Naples,
where he spent most of his career.

Frans Hals's *Gypsy Girl* and Rembrandt's *Bathsheba at her Bath*. And lastly, a series of seventeenth- and eighteenth-century Italian paintings, with a few Spanish works, such as Ribera's masterful *The Clubfoot*. It was like a Salon Carré for another style of painting, and an assertion of the taste for sketchiness and rapid brushstroke. Manet and Degas, who found inspiration in these works, may well have seen them when they were still in the possession of Louis La Caze.

In 1870, it would seem that the museum was at its height. The public was eager for new discoveries, numerous collections were acquired, and construction on the Louvre flourished. The only cloud over this idyll was that the Louvre remained subject to the good will of the prince, so long as it remained on the civil list. The paintings could just as easily be requisitioned for one of the royal palaces as placed on view for the public to see. The unpredictability and informality of this arrangement was bitterly criticized by opponents of the regime. The fall of Napoleon III was abrupt. The Republic brought a degree of calm to the museum, donations and archaeological missions continued to enrich its collections, but the imperial bonanza and major construction works ceased.

Toward the
Grand Louvre
and After

The Museum's Victory

The Marsan Wing: Traces of the Tuileries Palace

September 1870: France is in the midst of defeat. The emperor is imprisoned at Sedan, and the empress has fled the Louvre, abandoning the seat of power for England. The Republic is proclaimed, but the situation is somber. By mid-September, Prussian forces encircle Paris and begin the tragic siege that will last until February 1871. At the Château des Tuileries, ambulances care for the injured. In March, the Paris Commune is proclaimed and stages a few large concerts in the imperial apartments to signify the people's seizure of the spoils of empire. The museum later retrieves some of the paintings and art objects from these apartments.

A new catastrophe erupts in May 1871. Civil war rages between the Commune and the Versailles government. Summary executions on both sides increase during the "bloody week." Bit by bit, the Versailles forces regain control over the neighborhoods of Paris. On 23 May, a few communards—led by Bergeret, Bénot, and Boudin—systematically set fire to the centers of power: the Court of Accounts, the Ministry of Finance, the Hôtel de Ville, and the Hôtel de Salm, headquarters of the Legion of Honor. The Tuileries Palace also goes up in flames: the main wing, the Pavillon de Marsan, the north wing on the rue de Rivoli, and the Imperial Library of the Louvre. At the museum, Henri Barbet de Jouy, curator of sculptures, leads the guards to keep the fire from spreading to the Grande Galerie. Army reinforcements arrive, led by Bernardy de Sigoyer, who dies a few hours later at the Bastille. The museum is saved thanks to the courage of those guards, but the Tuileries is in ruins, and the fire continues to smolder for several days.

The blackened ruins of the Tuileries could be rebuilt, even though the interiors and timber framing had been completely decimated by fire, along with the Louis XIV painting and stuccowork, Empire furnishings, and décor of the Bourbon Restoration. There was less destruction to the Flora Pavilion and Wing, thanks to the fire-resistant metal framing Lefuel had built there. This empty carcass, open to the skies, made an impression on artists and on personnel in charge of protecting patrimony. The building remained in its ruined state through ten years of debate between the various parties in favor of restoration, reconstruction, or demolition. It is important to remember just how tenuous the Republic was at that moment, as monarchists led by the count of Chambord dithered about the form of government to adopt. Those who most fiercely opposed reconstruction of the damaged buildings clustered around Jules Ferry, in a desire to eradicate the remains of the royal power they detested. They were challenged by the defenders of conservation, who articulated one of the earliest statements on the need to safeguard patrimony. Eugène Viollet-le-Duc's opinion made a strong impact in a report he coauthored in 1876 that recommended keeping the Delorme and Bullant parts of the château des Tuileries, even if they had to be altered. But sadly, he died in 1879.

In the midst of all this political infighting, Lefuel began to restore the Pavillon de Flore in 1873, giving it a new facade on the north side, where it connected to the Château des Tuileries. It is a copy of the south facade, except for the initials "RF," which replaced the Napoleonic "N."

Lefuel also rebuilt the Pavillon de Marsan, modeling it on the new Pavillon de Flore, as well as a large portion of the connecting wing. This was a project he had been mulling over for some time, and now seized the moment as the Court of Accounts needed new premises. His design called for a tall, large nave with overhead lighting for the public lobby, surrounded by office spaces. The pavilion would also have a large staircase, modeled on the ones in the Louvre. But the Court of Accounts never fully set up there again. This did not deter Lefuel from proposing, in the year of his death in 1880, a project to install the

Previous spread (left)
The Louvre Pyramid and one of the smaller pyramids by I. M. Pei

Previous spread (right)
Under the Pyramid: the spiral staircase

Opposite
Ernest Meissonier (1815–91)
The Ruins of the Tuileries, ca. 1871
Oil on canvas, 132 × 98 cm
(52 × 38 5/8 in.)

Compiègne, Musée National du Château, on deposit at the Musée d'Orsay

The view is from the ground-floor central vestibule, opening onto the Arc de Triomphe du Carrousel and, on the first floor, the Salle des Maréchaux.

GLORIA MAIORVM PER FLAMMAS VSQVE SVPERSTES
MAIVS MDCCCLXXI

Niche on the Marsan Wing, south facade,
ground floor, sixth bay: *Young Harvester*,
ca. 1878–79, stone

Opposite
The Pavillon de Marsan, rebuilt by Hector
Lefuel in 1875–78

legislative chambers in the Tuileries, with the Senate in the Pavillon de Flore and the Chamber of Deputies in the Pavillon de Marsan. This project was never carried out.

Faithful to his eclectic style, Lefuel designed these buildings to mirror the south wing. The decorative programs of the Pavillon de Marsan and Pavillon de Flore match. The large sculptural groups form pendants but have different iconographies. The groups on the Pavillon de Marsan refer to the Court of Accounts, which was supposed to occupy the space; for instance, on the south side, the pediment figures and two reliefs represent *Accounting*. In his usual fashion, however, Lefuel randomly added other subjects, such as *Architecture*, a languid allegorical figure by Louis-Ernest Barrias.

In 1905, the Union Centrale des Arts Décoratifs settled into the Marsan Wing and Pavilion. Established in 1877 and modeled on London's South Kensington Museum (now the Victoria and Albert Museum), this Society of Decorative Arts had already installed some collections in the Pavillon de Flore. Beginning in 1898, the Louvre architect Gaston Redon oversaw major construction to transform the lobby into a vast central hall, allowing this space to become a museum.

The Remains of the Tuileries

After numerous proposals for the reconstruction of the royal palace, the National Assembly passed two resolutions, on 29 July 1879 and 21 March 1882, to demolish this ostentatious symbol of monarchy. From then on, the Louvre became the focal point of the long axis through Paris: a tilted axis, because the Louvre was built at a right angle to the Seine and not perfectly parallel to the Tuileries. What remained of the Tuileries was partially integrated into the Louvre in the south wing, and a few important fragments of its architecture are preserved in the museum's collections. In reality, the state did not sit idly by while the Tuileries continued to crumble. Based on a report issued by Paul Boeswillwald on 24 October 1882, the subcommittee on historical monuments counseled in favor of preserving vestiges of the building. Charles Garnier, the architect of the Paris Opéra who succeeded Lefuel as the Louvre architect in 1880, drew up a list of pieces to retain. The list was long and included columns, capitals, corbels, and attic statues among many other items—a total of 788 square meters (8,481 sq ft.) of architecture. Fragments from the Delorme and Bullant structures were reserved for the nation as valuable historical specimens for future generations of artists and architects, and for the public at large.

The museum received two statues from the central pavilion, now exhibited in the Carrousel complex with figures from the pediment that were acquired at a later date. Two archways, one from the Delorme Pavilion and the other from the Bullant Wing, were plucked by the architect of the Louvre for the Tuileries Garden. Some elements were assigned to public institutions, such as the École des Beaux-Arts, the École des Ponts et Chaussées (the school for bridge and road engineering), and the École Spéciale d'Architecture. The city of Paris received a large window, which was placed in the Trocadéro Gardens; and the pediment from the central pavilion, which it gave to the Musée Carnavalet and which is now installed along with other stone fragments from the Louvre in the Square Georges-Cain, on the rue Payenne.

The remainder was auctioned off on 4 December 1882 and purchased whole for 33,500 francs by Achille Picart, the entrepreneur who was hired to demolish the palace. In less than a year, there was nothing left of it. By 30 September 1883, it had been completely dismantled, but only after Picart had sold parts of the ruins to dozens of private buyers. The Château de la Punta, near Ajaccio, was, in fact, built with some of the ruins from the Tuileries that had been acquired by Jérôme Pozzo di Borgo, a descendent of one of Napoleon's notorious opponents. However, most of the ruins were acquired for their sentimental value, by individuals who had been attached to the imperial power, and placed in their private gardens: the clothes designer Charles Frederick Worth at his home in Suresnes; the marble dealer Stéphane Dervillé at his estate in Domont; the stage director

Léon Carvalho at his villa in Saint-Raphaël; the emperor's chamberlain Charles Toinnet at the Château de La Turmelière, near Mans; the architect Gustave Clausse at his home on the rue Murillo in Paris; the playwright Victorien Sardou at his property in Marly-le-Roi; and even Charles Garnier, at his villa in Bordighera (Italy), and so many others, including an industrialist from Berlin.

Since 2010, the Louvre has exhibited, on the upper terrace of the Cour Marly, the arch from the Tuileries, which was formerly in the courtyard of the École des Ponts et Chaussées and is also the best-preserved of these arches, having been well-protected from the weather. It stands not far from the funerary sculpture of Catherine de Médicis, as a tribute to the queen who had commissioned Philibert Delorme to build the palace. The widowed queen's emblems are still perfectly visible on the drums of the Ionic columns: shattered mirrors, broken chains, airborne feathers, along with symbols of power, such as Hercules's clubs as Fortitude and the plumb line for Equity. Floral motifs elegantly run through the flutes of the shafts.

With the reinstallation in 2011 of another archway in the Tuileries Garden that had been taken down in 1989, the Louvre has memorialized this prestigious monument, a landmark of architectural history and a witness to the history of France.

The Sad Fate of the Decorations of the Third Republic

During the war of 1870, the paintings of the Louvre were evacuated to Brest. Once they were returned to the museum, life resumed as well, and the "savior" of the Louvre, Barbet de Jouy, assisted by Villot, became its administrator. Some reconstruction was needed, and would be done quickly. In theory, the museum had control over the whole space of the Louvre, but in reality, certain public administrations were set up there and limited the museum's expansion. The Rivoli Wing was assigned to the Ministry of Finance in 1872. And the Pavillon de Flore, after housing the Prefecture of the Seine while Eugene Poubelle was prefect (his last name became the word for "waste bin" in French), was also assigned to the Ministry of Finance.

Echoing the Second Republic, the Third Republic made the Louvre into a national symbol. Not only did it restore the Louvre to its glory before the fire, it also commissioned the architect Edmond Guillaume to create lavish decorations modeled on the Salon Carré and Salon des Sept-Cheminées. A professor of architecture at the École des Beaux-Arts and trained in archaeology, Guillaume's intention was to transform the museum into a palace in the tradition of his predecessors. In 1886, he completely remodeled the Salle des États to outfit the space as a museum. Between 1889 and 1891, he redesigned the large room in the Beauvais Pavilion for Flemish and Dutch drawings. And he did this on a shoestring budget: as a tribute to Rubens's paintings, he recouped a canvas by Carolus-Duran in 1878 for the Palais du Luxembourg that depicts *The Triumph of Marie de Médicis*. Guillaume inserted it into a lavish cardboard ceiling, in the style of the wood paneling of the Chambre du Roi. In the small adjacent room, devoted to pastels, he installed painted ceilings by Hector Leroux. Disdained by the purist tastes of the mid-twentieth century, these paintings were concealed in 1962. Only the Carolus-Duran ceiling has been uncovered, in 1993. These rooms are now part of the Department of Decorative Arts, which was relocated in 2014. The Salon de Beauvais is now devoted to the great cabinetmaker André-Charles Boulle.

In the Cour Carrée, Guillaume lavishly decorated three rooms on the upper floor, which were inaugurated by President Carnot in 1888. These rooms exhibited the discoveries made by Ernest de Sarzec at Tello and Marcel Dieulafoy at Susa. A pedagogical impulse and concern for context led Guillaume to conceive of large decorative pictorial compositions. Charles Lameire painted several figures of the god Ashur on the ceiling of the Salle Sarzec, and a frieze decoration on the walls where lions, fig trees, and royal figures recall the palace at Khorsabad. The Salle de Suze had enamel friezes from the palace of Darius

Opposite
Charles Durant, known as Carolus-Duran (1837–1917)
The Triumph of Marie de Médicis, 1878
Oil on canvas, 730 × 630 cm (287 3/8 × 248 in.)
Commissioned in 1875 for one of the rooms of the Palais du Luxembourg and installed in the Louvre in 1890 in the large corner room of the Beauvais Pavilion
Department of Decorative Arts

Louis Béroud (1852–1930)
The Salle Rubens at the Musée du Louvre, 1904
Oil on canvas, 200 × 300 cm (78 ¾ × 118 in.)
Department of Paintings, on unlimited loan
from the San Francisco Museums, 1978

In 1899–1900, architect Gaston Redon
installed the large paintings of the *Marie de
Médicis* cycle by Rubens in strong gilt frames,
with large cartouches surrounded by garlands.
The faux-marble colonnaded portico and walls
painted to imitate embossed and gilt leather
bolstered the feeling of palatial opulence.

on the upper walls and an analogous ceiling painted by Chauvin. In the third room, land-scapes of Susa by Chaperon and Jambon unfurled on the walls. The bright colors of these paintings, their clear and simple drawings, and their repertoire of forms influenced art of the period, as did the enameled brickwork that was also exhibited in the room. These three rooms were destroyed in 1937.

The Galerie d'Afrique, another of Guillaume's projects, met the same fate. It occupied the mezzanine of the Galeries des Sept-Mètres, where the stables had been lodged, and contained North African antiquities and Roman mosaics. The Pompeian-red color of the walls was removed in 1934. The only trace of that time is the black-and-white mosaic floor.

The Last Decorations of the Louvre:
The Salle Rubens

Edmond Guillaume also wanted to transform the former and unfinished Salle des Sessions, but that plan was never executed. The room had been used for meetings of the Paris city council while the Hôtel de Ville was under reconstruction, and in 1887, for the sale of the Crown jewels that had been seized during the Revolution. The profits from that sale went to the fund for museum acquisitions, which later became the Réunion des Musées Nationaux (RMN); thus, the RMN was built on the loss of priceless patrimony. The room also hosted the centenary exhibition of the French Revolution in 1889.

The architect Gaston Redon, whose brother was the painter Odilon Redon, redesigned the space between 1897 and 1900 for Dutch and Flemish paintings, dividing it into the small Van Dyck room and the large room for the *Life of Marie de Médicis* cycle by Rubens. The Salle Rubens was the last great eclectic architectural decoration for a room in this palace-museum. Inaugurated by President Loubet at the turn of the century, on 21 May 1900, the room and its portico were destroyed in 1998. In the Grand Louvre transformations, the Salle Rubens became a room for Spanish paintings, installed by the architect Yves Lion in 1999.

The Mollien staircase, completed in 1910–14, was the final expression of a palatial aes-thetic. From then on, the decorations no longer focused on the most important rooms of the palace, but on those that housed the collections and abandoned classical references, paint, and stucco in search of an extreme purity of architectural lines.

The Louvre,
a Museum of Great Collections

Under the Third Republic, the Louvre experienced a growth in the number of rooms, or more precisely, the number of subsidiary "museums" for the display of important donors' collections. These donors were interested in perpetuating their names through the presentation of their gifts in dedicated rooms. The Musée Sauvageot (1856) and the Salle La Caze (1869) had already appeared in the days of the Second Empire. The Horace His de La Salle rooms exhibited drawings that belonged to this connoisseur at a time when the Cabinet des Dessins still displayed its treasures in the former rooms of the Conseil d'État. At the death of Madame Thiers in 1881, the collection of art objects she and her husband, Adolphe Thiers, former president of the Third Republic, had assembled was placed in the large room of the Marengo Pavilion; it is now exhibited in the Napoleon III apartments. Then came famous banker Adolphe de Rothschild's collection of art objects in 1900; the bronzes by Barye and paintings of the Barbizon School bequeathed by Thomy-Thiéry in 1902; and in 1910 the collection of Alfred Chauchard, owner of the Grands Magasins du Louvre. Each collection was assigned its own room. A room in the Flora Wing was dedicated to Baron Basile Schlichting, who in 1914 donated the *Odalisque* by Boucher and Veronese's *Bella Nani*. The marquise Arconati-Visconti, a universal philanthropist, and benefactress of the Université de Paris and the Belgian state, also made a donation to the Louvre, in a gesture motivated by the fire at Reims Cathedral at the beginning of World War I. A room in the north wing of the Cour Carrée was remodeled for the 124 sculptures and art objects she offered the Louvre in 1916. Since then, these works have been redistributed among the various museum departments. They include the very beautiful *Arconati-Visconti Tondo*, a delicate Florentine relief sculpture by Desiderio da Settignano, and an ensemble of German and Flemish sculptures. The collection belonging to Isaac de Camondo, offered to the Louvre in 1911, was placed in a sumptuous apartment on the second floor of the Mollien Wing in 1914, with eighteenth-century paneling from the Hôtel de Villemaré, now reinstalled in the new eighteenth-century furniture rooms. Masterpieces of Impressionism (Cézanne, Monet) were exhibited there, notably Manet's *Fifer*, and *The Dance Class* by Degas, but also the marble head of a Byzantine empress. There was the huge donation from Étienne Moreau-Nélaton, who had lost his family in the tragic fire of the Bazar de la Charité (1897). He offered his remarkable

Antoine-Louis Barye (1795–1875)
Theseus Fighting the Centaur Bienor
Bronze, H. 34 cm (13 ³⁄₈ in.)
Department of Sculptures, Georges
Thomy-Thiéry bequest, 1902.

The donor bequeathed more than 140 sculptures by Barye to the Louvre.

François Boucher (1703–70)
Odalisque, ca. 1745 (?)
Oil on canvas, 53 × 64 cm
(20 ⅞ × 25 ¼ in.)
Department of Paintings,
Baron Basile de Schlichting
bequest, 1914

A Russian who settled in Paris at
the start of the twentieth century,
Baron Basile de Schlichting
bequeathed the museum more
than sixty paintings, statues
(including the *Young River God*
by Pierino da Vinci), 114 tobacco
boxes, and superb eighteenth-
century furniture such as the
"monkey" commode by Cressent.

collection of nineteenth-century paintings to the Louvre in 1906. In the absence of a suitable space, it was initially exhibited in the Musée des Arts Décoratifs.

And the list goes on throughout the twentieth century. On the second floor of the Cour Carrée, the Department of Paintings presented several donations: the collection of Princess Louise de Croÿ (with a rich array of Dutch paintings that had been acquired by her father and grandfather), which came to the Louvre in 1930; the collection of Carlos de Beistegui, who loved portraits (ranging from the *Dauphin Charles-Orland* by the Master of Moulins to the *Marquise of La Solana* by Goya) in 1942; and the collection of Hélène and Victor Lyon, in 1963. Likewise, the Department of Decorative Arts acknowledged a gift from Mr. and Mrs. Grog-Carven in 1973 with a room devoted to fine eighteenth-century furniture.

Some collections focused on a specific medium. In 1894, Ernest Grandidier gave the Louvre thousands of oriental ceramics, and upon his death in 1912, left the institution eight thousand pieces. The Grandidier collection made the Louvre into a great repository of oriental art, despite its poor installation on the mezzanine of the Grande Galerie. This collection was the core of the Department of Asian Art, which was created in 1935 and transferred to the Musée Guimet in 1945.

The Department of Decorative Arts acquired a number of pieces—primarily of Islamic, Chinese, and Japanese origin—under the leadership of curator Gaston Migeon, an early specialist in these areas. The 1912 gift of the collections of the baroness Delort de Gléon, whose husband lived for many years in Cairo, allowed the museum to open up a large multilevel room in the upper stories of the Pavillon de l'Horloge, decorated with Islamic-style latticework reminiscent of the exterior of Arabian palaces, ten years later.

Paolo Caliari, known as Veronese (1528–88)
Portrait of a Venetian Woman, known as *La Bella Nani*, ca. 1560
Oil on canvas, 119 × 103 cm (46 ⅞ × 40 ½ in.)
Department of Paintings, Baron Basile de Schlichting bequest, 1914

Opposite
Francisco de Goya y Lucientes (1746–1828)
The Countess del Carpio, Marquise of La Solana, ca. 1793–95
Oil on canvas, 181 × 122 cm (71 ¼ × 48 in.)
Department of Paintings, gift of Carlos de Beistegui with usufruct reserved, 1942, entered the Louvre in 1953

An amateur painter, Carlos de Beistegui put together a rigorously high-quality collection, sometimes making purchases, at the request of Louvre curators, of pieces the museum could not acquire on its own.

Desiderio da Settignano (1430–64)
Jesus and Saint John the Baptist as Children,
ca. 1455–57
Marble, D. 50 cm (19 ¾ in.)
Department of Sculptures, from the wardrobe
of the Grand Duke Cosimo I de' Medici,
gift of the marquise Arconati-Visconti, 1914

Ceremonial ax decorated with the head
of a camel
Arsenical copper
Department of Oriental Antiquities,
gift of Pierre David-Weill, 1972

Opposite
Empress Ariana (?)
Constantinople or Rome, early 6th century
Marble, H. 25 cm (9 ⅞ in.)
Department of Sculptures, bequest of the count
Isaac de Camondo, 1911

In addition to his rare Impressionist collection, the
count of Camondo also possessed objects from
the Middle Ages and Renaissance, the Far East,
and eighteenth-century furniture from Paris.

Some donors were less concerned with exhibiting their collections at the Louvre than
helping to enrich the institution. Baron Edmond de Rothschild largely financed a number
of excavations in the Near East, and in 1895 acquired the Boscoreale Treasure of Roman
silver and gold objects, found near Pompeii, which he gave to the museum before also
bequeathing his enormous prints and drawings collection (the "Cabinet Rothschild"). The
great philanthropist David David-Weill was just as inclined to finance public housing,
sanatoriums, and universities as the world of culture, and for his efforts, was elected to the
Académie des Beaux-Arts in 1934. He was a member and then president of the Conseil
des Musées, and was also president of the Amis du Louvre. Prior to donating his excep-
tional collection of eighteenth-century objects of precious metal, he purchased seven
hundred objects originating in Tello, from the Allotte de la Fuÿe collection (in 1930), and
various Luristan bronzes for the Louvre.

These patron-collectors sometimes joined forces. A group of friends, for example,
might have pooled funds for an acquisition of sculptures for the Louvre. This is how the
Société des Amis du Louvre was born. Since 1897, it has brought together "thousands of
patrons," to quote the title of a 1997 exhibition in their honor. The society remains an
unflagging champion of the museum, attracting many enthusiastic members.

The Verne Plan
and the Purism of the 1930s

With this subdivision into "museums," the Louvre was unable to display its collections in
a coherent fashion. Sometimes items that belonged to a specific department were spread
all over the palace. It was time to redesign the layout. The project to reorganize the collec-
tions, which would allow the public to better understand and appreciate this wealth of
national patrimony, was drawn up by the director of the Musées Nationaux, Henri Verne.
The so-called Verne Plan was outlined in a 1926 report and proposed to the government
in 1929. At a time of impending financial crisis all over the world, the plan closely aligned
with the need to initiate large public works as way to prop up the economy. With the
rise of the Popular Front, this campaign was supported by the national plan to fight

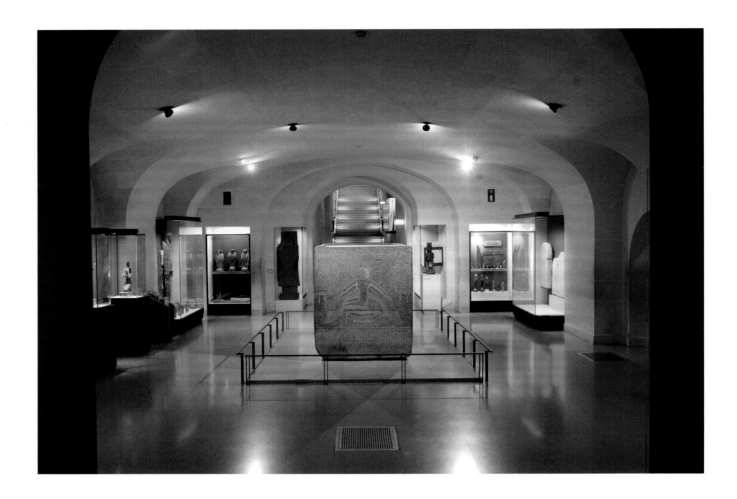

The Osiris Crypt (Cour Carrée, east wing, ground floor)
Department of Egyptian Antiquities

At center is the sarcophagus of King Ramesses II. Also visible are the vaults adopted by the architects Albert Ferran and then Jean-Jacques Haffner in the 1930s to give these new rooms a monumental character.

unemployment and received funding. The Verne Plan was interrupted by the war, but later continued into the 1970s and even the 1980s. One could say that the Grand Louvre, by completing the reorganization of the Department of Paintings in the Cour Carrée, was, in fact, a direct heir to this plan, though with a different emphasis and at a different scale.

Verne came up with two solutions for the reorganization. The first was to redistribute the collections in the areas of the palace that were already assigned to the museum. His second idea was revolutionary, as it called for annexing the Pavillon de Flore and the Rivoli Wing, then still in the hands of the Ministry of Finance. Even though public opinion was largely in favor, and despite continuous planning and detailed programming, this solution was not carried out until 1961 for the Pavillon de Flore, and 1989 for the Rivoli Wing, which was then rebaptized as the Richelieu Wing. The plan also called for moving the Musée de la Marine, which was still on the second floor of the Cour Carrée, to the Palais de Chaillot.

Between 1927 and 1929, the various departments of the Louvre were shifted around the museum. The Salle du Manège became the main lobby. The Department of Sculptures was exiled to the Pavillon de Sessions and the Flora Wing, a move that allowed Oriental and Egyptian Antiquities to extend chronologically on the ground floor of the Cour Carrée, where the Department of Decorative Arts occupied the first floor, from the Colonnade to the Sully Pavilion. The Department of Antiquities lost half of the Musée Charles X to Egyptian art, but acquired the nearby Salle des Bronzes in the first Royal Sessions Room. Paintings were to take over the second floor, all the way around the Cour Carrée, and of course remained in the Salon Carré and the Grande Galerie and extended to the Pavillon de Flore.

The two successive architects of the Verne Plan were Camille Lefèvre, and then Albert Ferran, who trained at MIT. Both were practitioners of a strong, sober, monumental style. Their imprint is recognizable in the plain, imitation stone vaults in the crypts, the ground-floor rooms on the Cour Carrée, and the Daru staircase, then known as the staircase of the *Winged Victory of Samothrace*. In 1938, Jean-Jacques Haffner revived a more decorative style, which he applied to the Grande Galerie and Salle des États.

A good deal of the nineteenth-century ornamentation was eliminated to make way for light, austere stone walls. The Pompeian red color of the upper walls and the black wooden plinths disappeared. Purism prevailed in the architecture: functionality, simplicity, and

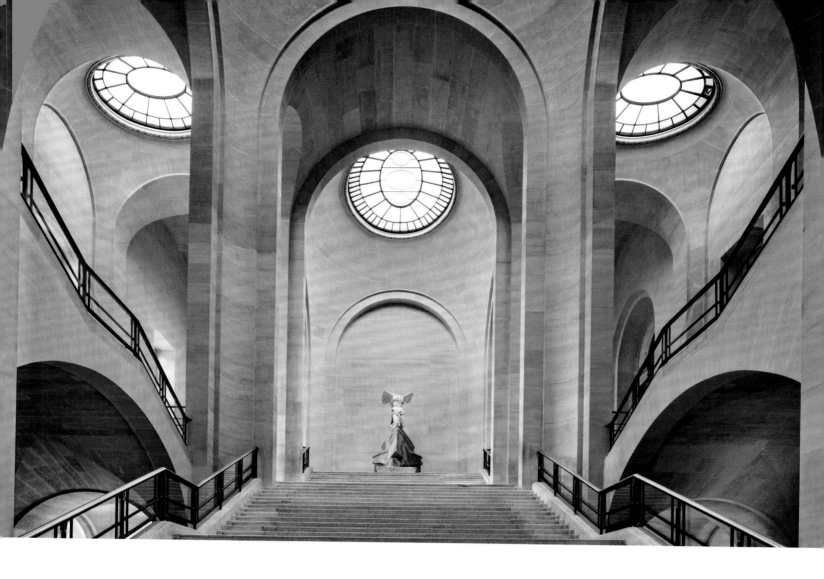

grandeur—to the detriment of earlier decorations—were the watchwords for barrel vaults, strong transverse arches, monumental volumes, rounded forms, and oftentimes elliptical forms for staircases. The windows opened onto light and landscape. Ferran's style accorded with the nascent science of museography, which called for a smaller number of works to be presented in airy, light-filled spaces, and for the museum's principal itineraries to be separate from the "study rooms."

A number of technical innovations were included in the modernization of the nineteenth-century palace. A new glass roof covered the Cour du Sphinx and made possible the installation of Greek and Roman sculptures there, as well as a mosaic from Antioch. The introduction of electricity opened the way for evening visits, continuous lighting in the underground passages that connect the four wings of the Cour Carrée, and lighting for the display cases.

The Daru Staircase: A Palimpsest-cum-Icon of the Louvre's Architecture

Even though the Daru staircase was designed by Hector Lefuel, due to its forceful structure it is regularly associated with the purist authority of Albert Ferran, the Louvre architect in the 1930s. A large flight of stairs leads to the central landing, with the Galerie d'Apollon and Cour Carrée to the left, and the Percier and Fontaine Rooms to the right, with access to the Salon Carré. Two smaller flights of stairs connect to the new buildings, the large paintings rooms, and the Galerie des Sept-Mètres. The need to create an access to both the Old and New Louvre left Lefuel no option but to destroy the old staircase by Percier and Fontaine and install this monumental piece of architecture where the Louis XIV Salle des Comédies had once stood. Built within a rectangle, the staircase is lit from above by two oval-shaped cupolas in the center and four smaller ones in the compartments. Lefuel also intended to decorate his staircase with two large atlases, in the manner of Puget, on the four corners of the massive piers, but he ran out of time.

The architect Edmond Guillaume turned to the decoration of the staircase once the *Winged Victory of Samothrace* was installed on the landing. His idea was to cover the walls

The Daru staircase and the *Winged Victory of Samothrace*
Department of Greek, Etruscan, and Roman Antiquities

The structure of the staircase built by Hector Lefuel was transformed into a less ornate style by Albert Ferran in 1934.

with mosaics produced by the new national ceramics workshop. Guillaume was encouraged in this idea by Édouard Gerspach, the director of the Gobelins Manufactory. In 1883, the commission for public works proposed an ambitious program for models to be executed by the painter Jules-Eugène Lenepveu. The long preparation phase was fraught with tragicomic episodes: individual quarrels (Guillaume versus Gerspach), political criticism (was there not to be a figure of Germany carrying the model of a medieval church at the heart of the land of cathedrals?), and aesthetic disagreements. The strongest dispute arose between the architect, who had visions of "grand genre" history painting, and Félix Ravaisson-Mollien, the curator of antiquities who had orchestrated the placement of the *Winged Victory of Samothrace* on the landing and who disliked the incongruity of a shiny, colorful, overworked decoration for the staircase and the time-battered and proud Greek marble statue.

At first, the architect and the commission for public works won that debate. The program, as developed, summarized the history of art, placing the three great periods of Western art in the central spans: antiquity, the Renaissance, and modern times. The four smaller cupolas contained depictions of countries and artists. The allegories were based on popular clichés: a "svelte, very elegant" figure of France holding up a Limousin enamel and Giambologna's *Mercury*, a Rubenesque "rosy-fleshed" figure of Flanders, a blond Germany, and a "beautifully tan" figure of Italy. Elsewhere, medallions depicted patrons and artists, from Gudea to Phidias through to Poussin. For ten years, the mosaicists slowly laid their enamels and gold squares. The work then petered out, and the decoration remained unfinished by Guillaume's death in 1894.

In 1934, Albert Ferran picked things up again. He masked the mosaics under a thin coat of stucco made to look like stone, lengthened the steps, finished the pillars, and installed a large metal railing by Gilbert Poillerat. The staircase recovered its monumentality. All eyes then focused on the *Winged Victory of Samothrace*. To increase its visibility, the ship's prow that support the figure was lengthened and the statue was raised on a cement block. In 2013, a new restoration removed these additions, lowered the figure to its original surface, and reintegrated fragments, thus recovering the archaeological authenticity of the masterpiece.

The End of the Universal Museum

The Verne Plan covered the total reorganization of the museum and its collections. Yet the Musée de la Marine did not relocate to the Palais de Chaillot until World War II, and in 1945, Asian art was moved to the Musée Guimet. Beginning in 1878, the museum was forced to part with its pre-Columbian objects, which had been assigned to the Department of Antiquities and to the "ethnographic museum," and the latter was part of the Musée de la Marine. Consequently, non-European art was transferred to the Musée du Trocadéro and to the area of comparative archaeology at the Musée de Saint-Germain-en-Laye.

In 1947, the decision was made to take Impressionist art to the Jeu de Paume in the Tuileries Garden. Born as an extension of the Louvre's Department of Paintings, the Jeu de Paume was closed in 1986 and its collections were brought to the new museum opening in the restored Orsay train station, devoted to art between 1848 and 1914. The Musée d'Orsay also received some nineteenth-century art from the Louvre, notably the Courbet paintings and Carpeaux sculptures. On the other hand, in the year 2000, African, Asian, and Oceanic art, and the Art of the Americas were moved from the future Musée du Quai Branly, opening a branch in the Louvre's Pavillon des Sessions.

Little by little, the Louvre was becoming less of a universal museum. At first it had seven "departments": three for antiquities (Egyptian; Oriental; and Greek, Etruscan, and Roman) and four "modern," meaning Middle Ages through 1848: (Paintings; Sculptures; and Decorative and Graphic Arts, the latter becoming its own department in 1987). An eighth department was created for Islamic art in 2004, the same year that the Musée Delacroix was attached to the Louvre.

Peter Paul Rubens (1577–1640)
Hélène Fourment with a Carriage, ca. 1639
Oil on canvas, 195 × 132 cm (76 3/4 × 52 in.)
Department of Paintings, gift (?) of the city of Brussels to J. Churchill (1650–1722), first duke of Marlborough, Blenheim Castle, 1706; Alphonse de Rothschild collection, Paris, after 1884; acquired by dation in lieu of transfer tax, 1977

The new dation law, established at the initiative of André Malraux in 1968, allowed many masterpieces to be added to the national patrimony.

The Waning of the Louvre's Programs
of the Glorious Thirty Years

The Grand Louvre program, begun in 1981, cast aside all of the new and sometimes innovative and ambitious developments of the previous decades. In order to justify such a project, a darkened image had to be painted of the museum as old and dusty, which it wasn't, but it did need more space for the collections, for its behind-the-scenes activities, and for public entrance and reception areas.

Between 1945 and 1981, the Louvre was under constant reorganization. The Verne Plan was loyally pursued, first by Georges Salles, director of the Musées Nationaux. The years when André Malraux was minister of cultural affairs were a boon for the museum. The facades on the Cour Carrée were cleaned, ditches were dug in front of the Colonnade, and more significantly, Malraux focused all his attention on the Louvre. In 1961, he received

Johannes Vermeer (1632–75)
The Astronomer, or *The Astrologist*, 1668
Oil on canvas, 51 × 45 cm (20 ⅛ × 17 ¾ in.)
Department of Paintings, acquired by dation
in lieu of payment of tax on inheritance, 1983

Aristide Maillol (1861–1944)
River, 1943
Lead
Tuileries Garden, on deposit from the Musée
National d'Art Moderne (at the initiative of
André Malraux and Dina Vierny) in 1964

Opposite
Aristide Maillol (1861–1944)
The Three Graces, or *Nymphs of the Meadows*
(detail), ca. 1938
Lead
Found on the grounds of the Third Reich by
the Commission de Récupération Artistique
and entrusted to the Musée National d'Art
Moderne
Tuileries Garden, on deposit since 1964

the keys to the Pavillon de Flore, which the Ministry of Finance had finally vacated. In the Department of Paintings, the Daru and Denon galleries, the Salle Rubens, and its small surrounding cabinets were given new installments, and the south end of the second floor of the Cour Carrée was rearranged as well. The substantial remodeling in the Flora Pavilion and Wing lasted from 1964 to 1972. The Cabinet des Dessins took over the former large staircase (Escalier des Souverains) and was transformed into a study room. The Musées de France research laboratory occupied the upper floors. The Department of Sculptures finally had beautiful rooms to exhibit works from the seventeenth to the nineteenth centuries that had not been on view since the 1930s, and Spanish paintings were hung in the Pavillon de Flore at the end of the Galerie de Flore, where Italian seventeenth- and eighteenth-century art was displayed. In the 1960s, the Department of Decorative Arts took over the first floor of the north and east wings in the Cour Carrée.

One novelty was the appointment of interior architects, who were put in charge of the interior renovations and installations, alongside the chief architect. In the 1950s, these were Charles Moreux and then Emilio Terry, who worked together with Germain Bazin, the curator of paintings; and then Pierre Paulin, Joseph Motte, and André Monpoix, who were appointed by Michel Laclotte beginning in 1966. The earlier interior architects worked in a more "evocative," decorative style, while the later ones were decidedly more modern and introduced a design style that quickly rendered earlier styles passé.

The Louvre received a new impetus in 1978, when the Barre government adopted a program law for museum construction and renovation projects. The goal was still to complete the Verne Plan, or at least its most recent incarnations. The main beneficiary this time was the Department of Greek, Etruscan, and Roman Antiquities, with the modernization of its display rooms. The Musée d'Orsay was also created under this program law, and in 1986 received the Louvre's collections of post–1848 paintings and sculptures.

In addition, the tax scheme known as dation, which allows for the donation of works of art as an option to settle inheritance or wealth tax, dates to this period and has constituted an unprecedented source of enrichment for the museum. A number of major works were added to the national patrimony and became part of the national collections, such as Rubens's *Hélène Fourment with a Carriage*, Vermeer's *Astronomer*, and the delicate stone reliefs by Clodion for the bathroom of the Hôtel de Besenval.

Of course, none of these interventions at the Louvre lasted very long, with the exception of a few installations by designers from the 1970s. Changes in taste, the demands of museography, and the need to adapt to new technologies and audiences reduced fifty years of museum design to a few pouffes, picture railings, and yellowed photographs.

Contemporary Art in the Carrousel Garden

In the nineteenth century, the Tuileries Garden was a kind of extension of the museum. Modern sculptures were installed there or in the Carrousel upon their makers' deaths. A certain disenchantment with this type of monumental art, later viewed as official and traditional, led to the removal—or destruction—of these pieces in various phases, beginning in the 1930s, then in the 1960s, when André Malraux was minister, and again more recently. Some have managed to survive, such as the two monuments in honor of ministers Jules Ferry and René Waldeck-Rousseau, in contrast to the monument to Léon Gambetta, which was almost completely destroyed.

In 1964, Malraux wanted to turn the Carrousel Garden into a "Maillol garden." He obtained authorization from the sculptor's beneficiaries, Lucien Maillol and Dina Vierny, to make new casts of each of Aristide Maillol's most beautiful sculptures, and added works from French museums. Installed on the lawns, on mounds, or on the terrace, *Action in Chains*, *Île-de-France*, *The Three Graces*, *Flora*, *The Mountain*, *The Mediterranean*, and others provide a full overview of Maillol's oeuvre. The original placement of the sculptures was later changed by Vierny, who rearranged them among the topiaries of the new garden designed by Jacques Wirtz (1994).

The Grand Louvre

The Louvre was sorely lacking a proper public entrance and reception area that could accommodate the growing number of visitors and include ticket booths, restaurants, an auditorium, a cloakroom, restrooms, and a bookstore. The Salle du Manège had served this purpose since 1926, but it was no longer large enough, even with the addition of the Mollien Gallery. The public had to be at the heart of this new project, consonant with changes at other museums across the globe. Museum services—including workshops, storage, and offices—were also becoming cramped as new functions—outreach, documentation, and security—grew in importance.

When François Mitterrand announced on 26 September 1981 that the Richelieu Wing of the Louvre, still occupied by the Ministry of Finance, must be given over to the museum, a radical transformation began, thanks to an unprecedented level of government funding. The ministry's 125-year tenure had ended; the museum received what it had been promised before the war, and it could finally redeploy its collections. The Grand Louvre was born, and just as new rooms were being created, a proper space for receiving visitors sprang from the ground.

The Grand Louvre project was programmed in great detail, and the task of creating the new spaces was awarded by competition to Jérôme Dourdin, with construction to be carried out by the Établissement Public du Grand Louvre (EPGL). The EPGL was created on 2 November 1983, with Émile Biasini as chairman. Biasini had been director of theater, music, and cultural affairs under Minister Malraux. The EPGL had numerous teams of architects, programmers, and specialists at its disposal. Meanwhile, the curatorial departments got to work programming the selection, restoration, and exhibition of artworks. In January 1984, at a retreat in Arcachon, Biasini, Michel Laclotte (the director of the Louvre), and the heads of the seven curatorial departments defined the spaces for each and set the foundations for a complete restructuring of the collections. This did not include a reexamination of the administrative structure of the museum and its constituent departments. All of the collections were allocated additional rooms, to enhance the installations and exhibit more works, including some that had been in storage for many years. New visitor itineraries were designed, with the public's well-being and the coherence of the museum program in mind.

Step by step, the offices of the Musées de France and the Réunion des Musées Nationaux were removed from the Louvre, the École du Louvre was placed in the Flora Wing, the restoration services of the Musées de France were installed in the Pavillon de Flore, and the research laboratory was set up in the basement of the Carrousel Garden. The layout of the museum changed radically, from an L-shaped plan to a "U," with two long wings apart, and the Pyramid—that is, the new visitor reception area—at its center. Giving up the faraway west wing of the "U," where complementary functions were allocated, the museum gained compactness.

While the curatorial departments went about fine-tuning their museological programs, the EPGL set up a gigantic construction site. In July 1983, the Chinese American architect I. M. Pei was chosen to direct the project. Born in 1917 near Canton, he had already made his mark with his design for new wings of the National Gallery of Art in Washington, D.C., (1978) and the Boston Museum of Fine Arts (1981). Pei was selected for the aesthetic he had developed in those two buildings and because they fulfilled similar functions to the ones the Louvre wanted for its new visitor reception area. Pei went on to design other beautiful museums, such as Deutsches Historisches Museum in Berlin and the Museum of Islamic Art in Qatar.

Discovery and Restoration of Historic Patrimony

An investment in patrimony was made alongside the modernization of the museum. The facades were all restored, one by one, beginning with those facing the Cour Carrée (1986), then the Cour Napoléon (1993), and the rest of the palace in more recent years. Underground

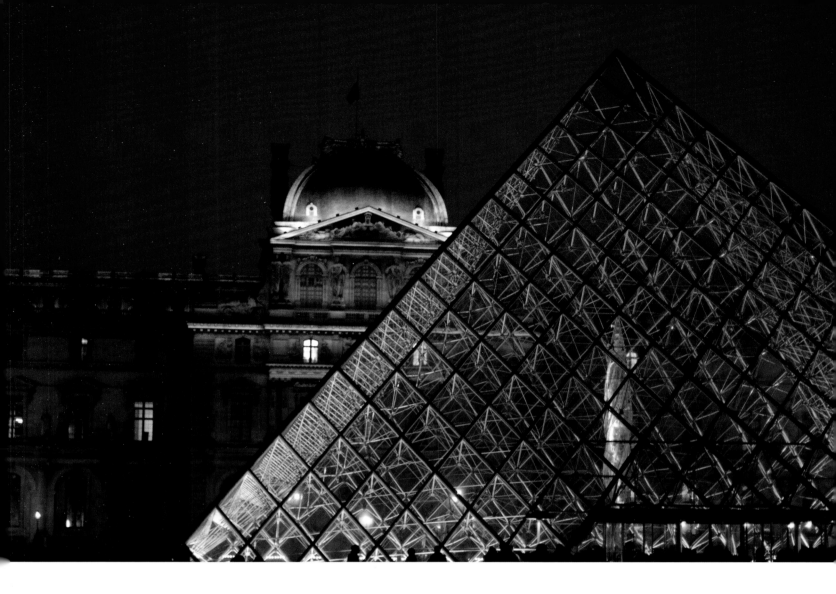

digging led to full-scale archaeological excavations. In 1984 and 1985, the Commission du Vieux Paris, its president Michel Fleury, and archaeologist Venceslas Kruta unearthed stunning architectural remains of the medieval Louvre and royal objects dating to the reign of Charles VI. Preserved and showcased, these remains steer visitors toward the crypt of the Great Sphinx of Tanis and the start of the Egyptian antiquities itinerary.

In the Cour Napoléon—entirely excavated during the Pyramid and annexes works—and in the Carrousel Garden, where the laboratory will later be located, two archaeological campaigns led by Yves de Kisch and Pierre-Jean Trombetta yielded information about the Louvre neighborhood from Gallo-Roman times to its destruction, and on the tile factories that loaned their name to the palace built by Catherine de Médicis. Only the wall of the ditch in front of the Sully Pavilion and the tile kiln that Bernard Palissy used have been preserved, in addition to numerous objects, some of which are on display in the Salle Saint-Louis.

Next, Paul Van Ossel's research in 1989–90 in the Carrousel Garden led to the discovery of Neolithic, Gallo-Roman, and medieval settlements, and more impressively, to the astonishing wall of Paris with masonry dating to the sixteenth century that towers over the trench dug by Charles V to defend the city to the west. These remains can now be viewed in the Carrousel complex.

The Napoleon Hall and the Pyramid

The Pyramid, framed by the facades looking onto the Cour Napoléon, has become the symbol of the Louvre, and something of a logo. Interestingly, the key point of the Grand Louvre project originally was the creation of a large underground visitor reception area, which would finally give the Louvre a heart and lungs, hidden from view. This space would work as a new, central reception area for the public, a nucleus connecting to all technical areas, and a proper logistical solution. The solution had been contemplated by various architects since the 1960s, but had been constantly tabled for lack of funds.

Pei conceived his famous Pyramid as a weblike structure of steel and glass over a light-filled hall, thus integrating a strong symbol of modernity into the patrimony. The Pyramid

The Pyramid and the Pavillon de l'Horloge, also known as the Pavillon Sully, at night

Following spread
The Pavillon de l'Horloge, seen through the Pyramid

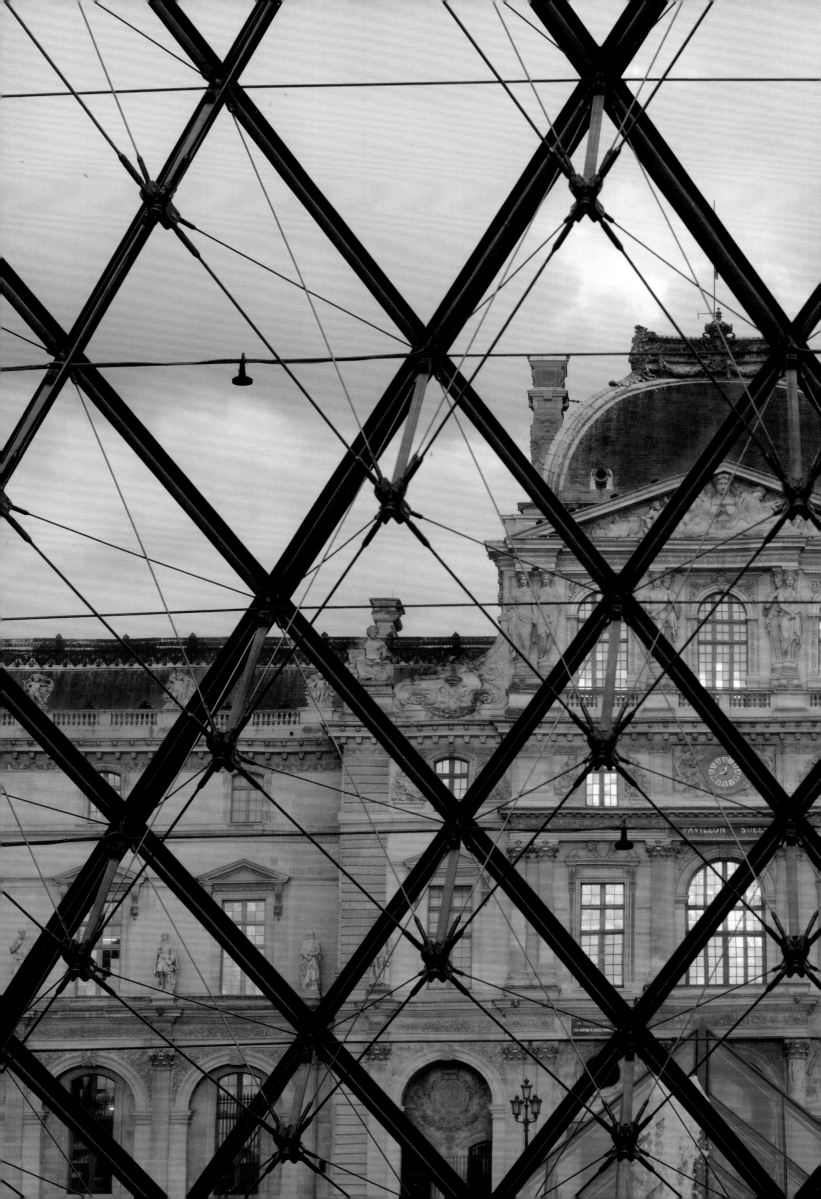

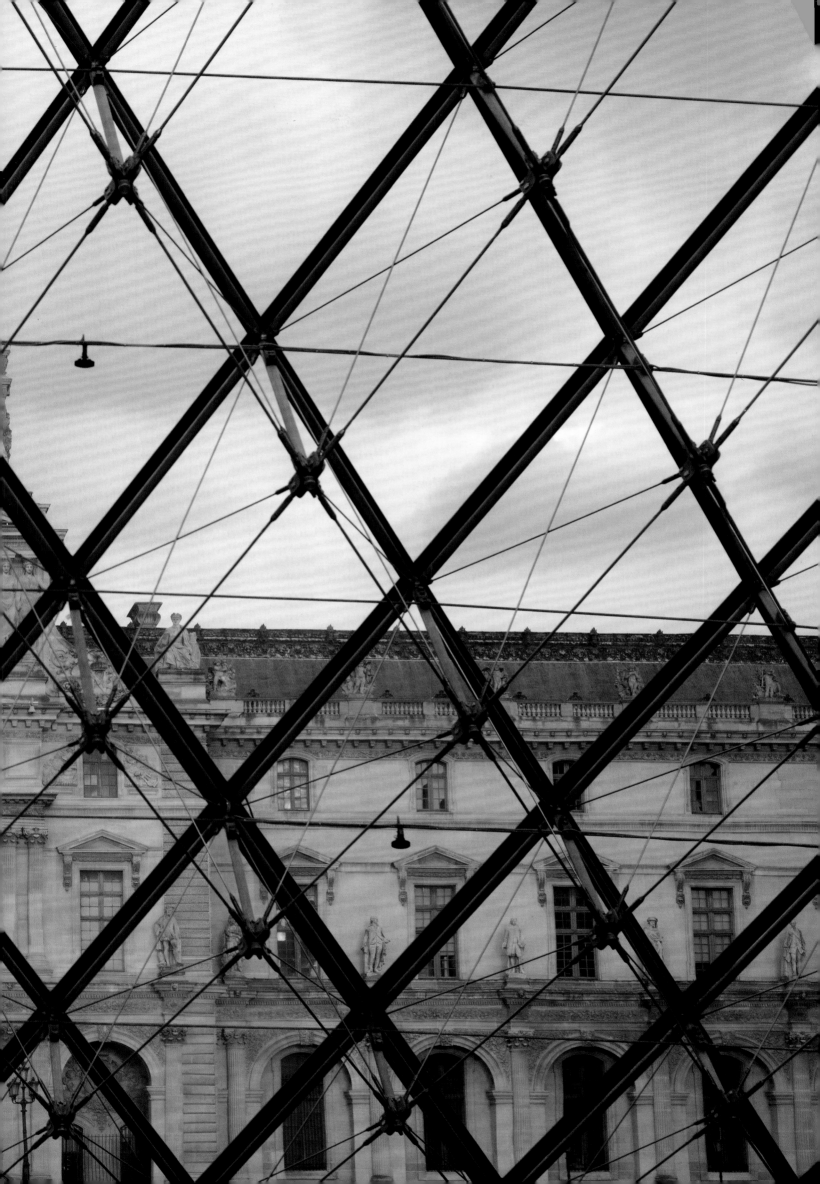

Under the Pyramid: the spiral staircase leading to the entrance

was nevertheless a source of controversy, and the press had a field day with it. The geometric volume unleashed passions both aesthetic (old versus new) and technical (about programming). Political issues found their way into the debate, with questions raised about why Pei was selected without competition or consultation and was criticized over the pyramidal shape, seen by some as a pharaonic symbol with authoritarian overtones, or even Masonic connotations. Responding to critics, the EPGL had a model made of cables set up in the center of the courtyard. The dimensions, while imposing, did not interfere with the facades on the Cour Napoléon. President Mitterrand and Jacques Chirac, then the mayor of Paris, agreed on the beauty of the project, which remained on course.

Working with Michel Macary, Pei's primary objective was to design a concourse to receive museum visitors. The central hall had to provide essential services (ticket booths and visitor information) and ancillary services (cloakrooms, group entrance, workshops, bookstore, café, and restaurant). Temporary exhibition rooms also had to be accessible from the central hall. An auditorium managed by a special service—with a strong program of lectures, conferences, concerts, films, and more—was added to the entrance structure.

Pei's style is characterized by perfect geometry: the proportions of his glass pyramid—21.65 meters (71 ft.) in height over a base width of 35.40 meters (116 ft.) and sides set at a 52–degree angle—are similar to the Great Pyramid of Giza. Engineer Peter Rice erected the large grid that supports the glass rhombs using a system akin to ship rigging, with cables and tie rods linked by four thousand nodes. The strikingly white and transparent glass, which was custom-made by Saint-Gobain, covers 2,000 square meters (21,527 sq ft.). At ground level, three small pyramids—surrounded by basins with water jets—animate the stony texture of the Cour Napoléon. The pyramids pour natural light into the three main arteries leading to the collections—Sully, Richelieu, and Denon—corresponding to the pavilions created under Napoleon III.

Bathed in natural overhead light, the hall forms a square within the square of the pyramid. The entrance is oriented on a central pillar. Escalators and a spiral staircase surrounding a round telescopic elevator lead visitors down to the lower level. The walls and floor are covered in blond Burgundy stone. The atmosphere is luminous and calm, in harmony with the geometric purity of the space, and echoed in the other construction materials, namely pale concrete and glass. The cruciform plan of the central pillars, the open corridors at half level, and the coffered ceilings indicate a concern for perfect proportions and grand modern classicism. The details were painstakingly studied, including the joints where the walls meet the floor, the texture of the dense Oregon pine formwork in the cement ceiling coffers, and transparent glass railings. Inaugurated on 30 March 1989, this perfectly proportioned glass pyramid and the Napoleon Hall are a testament to the creative continuity of a place where classical, neoclassical, and eclectic styles were developed.

Other spaces opened on the same day: the historic areas of the medieval château; the dungeon and square fortress dating back to Philip Augustus that had been cleared in recent excavations; and the Salle Saint-Louis, discovered by chance in 1889, had until then remained hidden from view. A well-lit medieval itinerary led the public through this ensemble. A small room exhibited findings unearthed in the Cour Carrée; other rooms were devoted to the history of the Louvre, while a rotunda covered in reliefs by Goujon from the Cour Carrée provided a glimpse into the underground access to the spaces for temporary exhibitions.

Many people contributed to the concept during this first phase. The architect Richard Pedruzzi designed picture rails in Oregon pine and a gray *pietra serena* floor for the Louvre history rooms and the Salle Saint-Louis. As a specialist in theater-set-and-exhibition design, he was particularly attentive to lighting. Architect Georges Duval focused on the medieval remains. Jean-Michel Wilmotte designed the furnishings for the temporary exhibition spaces, the library, and the restaurants.

The project was also a reflection on urban space. On the ground level, the museum opens up to the city by playing on transparency; a transparency that magnifies the Passage

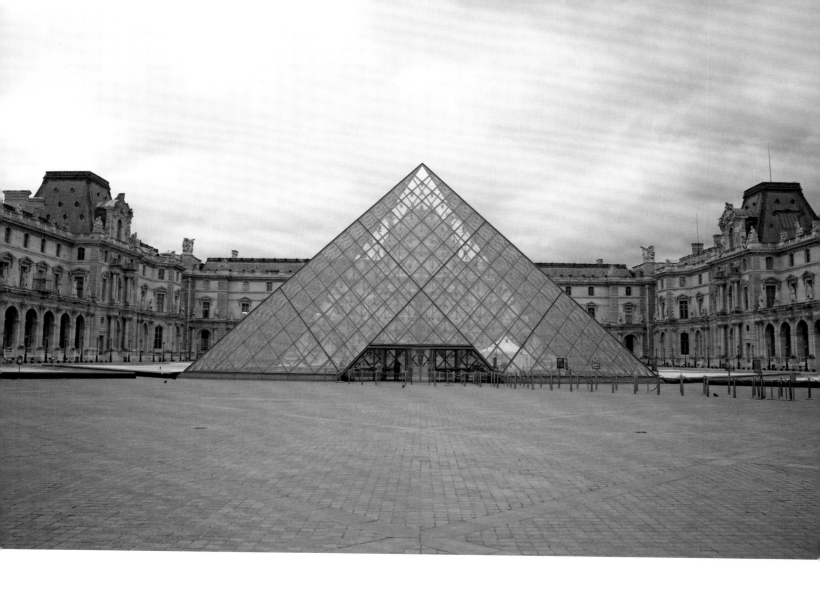

Richelieu and allows a view onto the rooms from the rue de Rivoli or the Cour Napoléon. And yet the Pyramid is the tip of the iceberg. A whole world stretches out underneath, pumping life through the Louvre. An annex city extends underground—thanks to the tunneling of the street that separates the Carrousel from the Tuileries garden—as well as connecting parking lots, notably for a large number of buses, and a delivery bay to receive works that will be displayed in exhibitions and for the general operations of this new "Louvre-city." An underground service passage, four meters (13 ft.) high and four in width, also starts from the tunnel and is connected by service elevators and stairs to the old and new art storage areas, technical areas, and museum rooms for logistical purposes.

The Pyramid is a place of social interaction and a nod to urban life. The Louvre now interacts with the city, and the large Tuileries garden designed by André Le Nôtre (a point of reference for Pei) communicates with the Seine, its bridges, and the flow of pedestrians. The Pyramid's deliberate classicism, in the French tradition, its pursuit of monumentality and rigorous geometry also inflect a modern accent.

The Pyramid by I. M. Pei, and the Cour Napoléon

The Richelieu Wing:
The Redesign of Its Prestigious Spaces

A few months after the inauguration of the Pyramid, in July 1989, the Ministry of Finance handed over the keys to the north wing, known as the Richelieu Wing, leaving this legendary space for a much larger and more functional building in Bercy, on the bank of the Seine in east Paris. The move had actually begun under Minister Pierre Bérégovoy, but his successor, Édouard Balladur, preferred to remain in the Richelieu Wing, halting the operation until a new political majority took over the government. In 1988, the museum began work on the building's interior, still encased in Lefuel's original shell. The space—21,500 square meters (231,424 sq ft.) in all—was gutted and remodeled, except for the historical parts —the private apartments, ministerial reception rooms, and annex (where the Café Marly would be go)—and three staircases: the Minister, the Library (also known as the Lefuel staircase), and the Barracks (also known as the Colbert staircase). The only addition was

Richelieu Wing: detail of the escalators
by I. M. Pei, 1993

to the section that separates the Puget and Khorsabad courtyards, which was raised, in the old style, to improve museum flow.

The Passage Richelieu was opened in late 1988 and allows direct access to the Cour Napoléon from the Place du Palais-Royal, thus recuperating the original function it had been assigned by Lefuel. However, works continued up to the museum's bicentenary celebration on 18 November 1993. Just a few months earlier, the Louvre had become a public establishment, and with this new status came more financial and administrative independence.

Pei also directed the most significant modernizations on this part of the museum, which included covering the roof of the three courtyards with glass and building two large escalators to serve all three floors, piercing the wall with giant oculi to allow a view onto the Cour Napoléon and the interior courtyard with the works exhibited there. Peter Rice's innovative technique for the Pyramid was again used to cover the courtyards: a network of cables and steel connected rods, creating an unusually light glass grid. As a result, the sculptures in the courtyards receive natural light, diffused by aluminum screens, and depending on the weather and the season, the changing colors of the sky animate the space. According to Michel Macary, the roofs, which are not visible from the rue de Rivoli, must be "a volume that breathes and softly extends the verticality of the facades." And there *is* a soft elegance to the four rounded sides of the roofs.

Pei worked in conjunction with other architects on the new museographic spaces: Macary for the Department of Sculptures, Jean-Michel Wilmotte for the Department of Decorative Arts, and Stephen Rustow for the Department of Oriental Antiquities. Two restaurants were built: the Café Marly, which can be accessed from the exterior of the building, and the Café Richelieu, which was placed in the spaces formerly occupied by the offices of the Ministry of Finance, and was decorated by contemporary artists, including Daniel Buren and Jean-Pierre Raynaud.

The Carrousel Complex

At the same time the Richelieu Wing was inaugurated, a new, privately financed 65,000-square-meter (699,654 sq ft.) complex under the Carrousel Garden, which connected to the Napoleon Hall, opened. This complex offered visitors a new means of access to the museum, as it is also linked to the Métro, the rue de Rivoli, the Carrousel Garden, and the parking lots. The vast Charles V Hall is delimited by the fortress walls of the old city. A gallery was created to house different visitor services, such as a post office and museum shops. The rest of the complex is filled mainly with restaurants and other shops. Large conference rooms, which originally were intended for fashion displays but have since been used for other large gatherings and fairs, were designed by Gérard Granval. The complex also houses some spaces related to museum research, such as the École du Louvre's new amphitheater and the research laboratory of the Musées de France, designed respectively by Guy Nicot, and by Jérôme Brunet and Éric Saunier.

The design and materials used in the commercial spaces were selected by a team of architects under Michel Macary and match the geometric aesthetic and materials used for the Pyramid. The same goes for the hallway that links the two areas, with its lively diagonal pillars. The crossing is lit by a second pyramid designed by Pei and Rice that echoes the large one but is inverted, with the tip pointing down and suspended 1.40 meters (4 ½ ft.) above the ground.

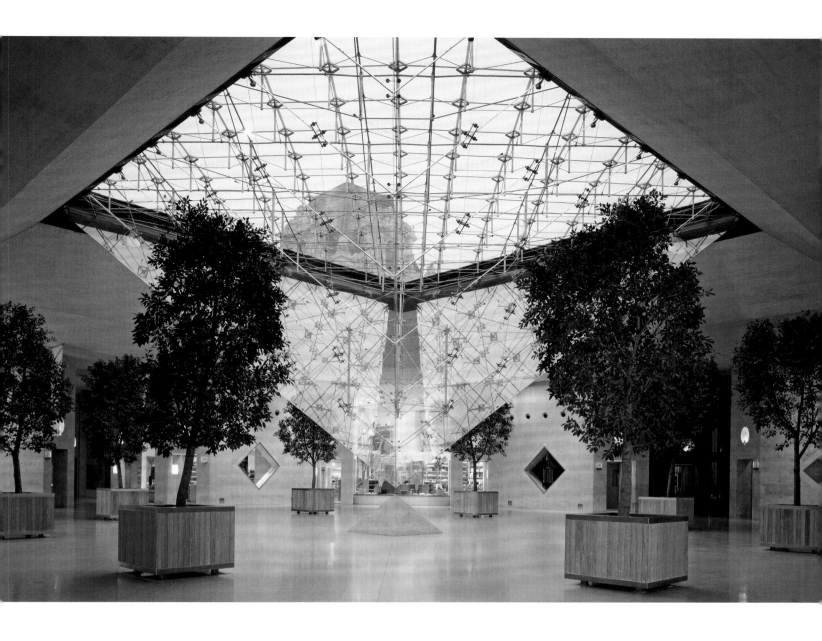

The New Itineraries
of the Archaeological Collections

The renovations on the Richelieu Wing were the starting point for a vast redeployment, in stages, of the Louvre's collections. This went on until 1998, when the EPGL was replaced by the Établissement Public de Maîtrise d'Ouvrage des Travaux Culturels (EPMOTC). From that moment on, the Louvre began to manage its own redesigns and renovation projects, through patron financing, relying only occasionally on the EPMOTC until 2004, when it created its own department of construction management.

As early as 1993, the Department of Oriental Antiquities began working on its layout, starting at the Richelieu access of the new museum design created by Pei and Stephen Rustow. Mesopotamian antiquities were placed around the open courtyard, where remains from the Assyrian palace of Sargon II at Khorsabad are displayed. Near Eastern antiquities were installed in the beautiful neoclassical rooms of the old Angoulême Gallery. Here, the display cases present the fruits of important French excavations in Syria, at Ras Shamra, the site of the ancient town of Ugarit, where the stela depicting Baal with a thunderbolt and the *Hunt Patera* were found.

In 1997, the Louvre was able to create a new presentation for its antiquities from the Near East, Iran, Cyprus, and the pre-Islamic Arabian Peninsula, in the north wing of the Cour Carrée. The collections itinerary follows a chronological and geographical order. Geneviève Renisio and Jean-Paul Boulanger from the agency Pylône designed the new display of the two thousand objects selected by the curators, and also new staircases. In the basement, visitors move along a stone walkway between spectacular Phoenician

View of the inverted pyramid in the underground Carrousel complex

Following spread
View of the rooftops of the Louvre, with the skylight by Peter Rice

Vitrine in the Salle du Levant
(formerly the Galerie d'Angoulême)
Foreground: goblet with a female face from
Minet el-Beida (the port of Ugarit), tomb 6,
6th century B.C., polychrome-glazed
earthenware, H. 16.2 cm (6 ⅜ in.)
Department of Oriental Antiquities,
excavations by C. Schaeffer and
G. Chenet, 1932

sarcophagi. The palace of Darius I at Susa is evoked in a large room dominated by a gigantic column capital from the Apadana (audience room), with friezes of Persian archers on the walls. Instead of the Burgundy limestone Pei favored, the lava floor in this room is another reference to the Persian palace. And some years later, in 2003, the *Code of Hammurabi* room was redesigned by Jean-Michel Wilmotte.

In December 1997, a major redesign shook up the old Louvre. The Department of Egyptian Antiquities was completely reinstalled in the Colonnade Wing and the east side of the south wing. This department gained 60 percent more space, up to 5,000 square meters (53,819 sq ft.), justified by the size of its collection and its popularity with visitors. The ground floor has a dense thematic presentation, with masterpieces displayed in clear chronological evolution on the upper floor. Dominique Brard and the team of Atelier de l'Île respected the historical environment (the Musée Charles X, the Galerie Henri IV, the wood-paneled rooms of the sixteenth and seventeenth centuries) in their design by playing on strict geometry for the new plinths and display cases. The whole layout is oriented on a very strong axis, echoing the axes of Egyptian temples: north-south like the Nile, east-west like the sun. The clear display cases give priority to the works, while the subtle colors relate to each subject and define the room-to-room sequence: blue-green to suggest the Nile, night blue for the world of the dead, gray-blue for the Old Kingdom, yellow ochre for the Middle Kingdom, and brick red for the New Kingdom.

The Department of Greek, Etruscan, and Roman Antiquities had already begun renovations under the 1978 law, specifically in the display devoted to Etruscan and Roman art in the ground-floor rooms. So this department came to life in stages. The rooms on the ground floor essentially follow geographical and chronological lines, with sculptures often

dominating, whereas the rooms on the first floor are devoted to artistic techniques. The former Salle des Séances (Royal Sessions Room), for example, was remodeled in 1995 and in 1997 to exhibit ancient bronzes. The west part of the Musée Charles X was turned over to Greek terra-cottas, figurines, and objects; vases went into the Galerie Campana; and precious metalwork and cameos were placed in the king's antechamber, and glass in the king's large cabinet. Color was brought into the large vitrines designed by Fontaine and Lefuel: alternating yellow ochre and brown to bring out the clay of the statuettes, and pine green, the original color, for the ceramics. Large display cases were designed by Atelier de l'Île (Dominique Brard, Olivier Le Bras, Marc Quelen) to highlight the transparency of the glass objects. Pierre-François Codou and Franck Hindley, of the firm Architecture et Associés, were more intrusive, with their design of Burgundy limestone central islands on the floors of the Musée Charles X, with low walls in that same stone to support the vitrines. On the other hand, in the Galerie Campana, they retained the axial perspective, aligning the vitrines with the thick, slanted uprights on a high mahogany plinth.

The chronological itinerary took much longer to complete, despite the first renovation of the Salle des Caryatides. Beginning in 1994, the former stables of the Cour Visconti were restored and devoted to Archaic Greece, plus a narrow epigraphy room. The brick-and-stone vaults and etched stone floors, a sign of Lefuel's admiration of the Henri IV style, were accentuated. The architects François Pin and Catherine Bizouard added tall, sparse display cases. They also rethought the Daru Gallery, where the restored *Borghese Gladiator* on a red marble base, and other antiquities from the Borghese collection preside.

It was only much more recently that this department saw another spate of renovations, to address recent installations that were already outdated. For instance, the Salle du Manège, which had been allocated to the department in 1994, was devoted in 2004 to marble sculptures from important historical collections, with a museum itinerary determined by the Louvre's office of architecture and museography. The room was outfitted with new staircases. The full itinerary of the Classical Greek art rooms was finished in 2010, from the Olympus and Parthenon rooms, to the rooms on the Cour Carrée and the Salle des Caryatides. Following that, the Cour du Sphinx and the Roman art rooms in the former apartments of Anne of Austria and the Salle des Empereurs were also renovated.

Spiral staircase for the Galerie Thorvaldsen and Northern European Sculpture in the Mollien Wing, architecture by François Pin, 1994 Department of Sculptures

Sculpture and Decorative Arts: New Spaces

The entire Department of Sculptures was moved shortly after the junction between the prewar and 1970s rooms had been completed in 1977. The collection was split, with French sculptures going to the Richelieu Wing (1993) and non-French sculptures to the ground floor of the Denon Wing (1994). To the north, Pei and Macary had lowered the floors of the two large courtyards, formerly belonging to the Ministry of Finance, and had covered them with glass roofs. In the Cour Puget and the Cour Marly, it was now possible to exhibit some of the Louvre's great French sculptures in natural light, with the rest of the collection in adjacent rooms. The wall treatments mark the chronological sequence: stucco imitating stone for the Middle Ages, red ochre for the Renaissance and seventeenth century, and gray-green for the eighteenth and nineteenth centuries. To the south, non-French sculptures were distributed on two floors in rooms designed by the architects François Pin and Catherine Bizouard, who had also worked on the Archaic Greek Gallery. The Donatello Gallery now occupies the former stables of the Cour Lefuel, where Quattrocento sculptures line the walls on long gray stone tables or against light green backgrounds. The floor alternates large areas of Saint-Maximin limestone with smaller areas of bluestone. Visitors can then proceed up a new stairway that had been subtly inserted under the Mollien staircase, to the upper floor where the rich colored-marble floor and white stone vaults of the former Galerie Mollien have been preserved. Magnificent Italian sculptures, from Michelangelo's *Slaves* to Canova's *Cupid and Psyche*, are placed on stands, with vitrines and smaller sculptures on white marble tables.

Northern European Sculpture Room,
architecture by François Pin and Catherine
Bizouard, 1994

Opposite
Gregor Erhart (1470–1540)
Saint Mary Magdalene, ca. 1515–20
Lindenwood and original polychrome,
H. 177 cm (69 5/8 in.)
Department of Sculptures, probably from
the church of Saint Mary Magdalene of the
Augustinian convent of Augsburg; acquired
with the interests from the bequest of
Mme Émile Louis Sévène, née Laure Eugénie
Declerck, 1902

This sinner of the Gospels, once converted,
adopted an ascetic life. In a grand mystical
gesture, the saint, wrapped in her long hair,
ravishing in the splendor of her carnal body.

Northern European sculpture has its own itinerary on two floors. On the ground floor, large glass cases meet the conservation needs of Gothic polychrome wood sculptures (primarily Flemish and German), and a study room has been recently refurbished. A new concrete spiral staircase designed by François Pin leads up to the seventeenth- and eighteenth-century rooms displaying Baroque and neoclassical sculptures. The selection has been broadened since the 1990s to include Flemish artists such as Bergé, Quellien, and Duquesnoy, a few Scandinavian artists (Sergel and Thorvaldsen, for example), one Austrian, and a few Irish and English sculptors, as the Louvre has recently acquired a bust of Robert Walpole by John-Michael Rysbrack and a "character head" by Franz-Xaver Messerschmidt.

With the move to the Richelieu Wing in 1993 of the decorative arts from the Middle Ages, Renaissance, and early nineteenth century, the transformation of the Department of Decorative Arts was nearly complete. The chronological thread unravels in one gallery, beginning with the late antique *Barberini Ivory*, followed by the equestrian statuette of Charlemagne from the Carolingian Renaissance, fourteenth-century royal regalia and Parisian ivories, and finishing with the very large Poissy altarpiece. The end of the Gothic era is rich in tapestries, and fine metalwork is represented primarily through the reliquary angels belonging to Anne of Brittany. The rooms devoted to Renaissance art follow, with *The Hunts of Maximilian* tapestry suite, woven on designs by Bernard van Orley, and the *History of Scipio* tapestry, produced by the Gobelins Manufactory in the seventeenth century. In the center of the large rooms, display cases set on long Burgundy limestone bases hold the collection of Italian majolica, Venetian glass, Saint-Porchaire ceramics, and Limoges painted enamel. Different paths can be followed through the collection, either through the small rooms on the rue de Rivoli or the rooms on the Cour Khorsabad, one of which displays the mantles and treasure of the Order of the Holy Spirit behind glass. And in the rotunda of the Colbert pavilion, the bronze groups from the collection of Louis XIV by Giambologna and Ferdinando Tacca are caressed directly by the light, unfettered by glass cases.

Wilmotte's agency was meticulous in dealing with the sequence of the rooms, with porticoes and different types of large vitrines to set the rhythm and wonderful fiber-optic lighting to illuminate the objects. Persuaded to work with color, Wilmotte highlighted the diversity of the collection through the use of strong tones: Chinese red, blue, and even

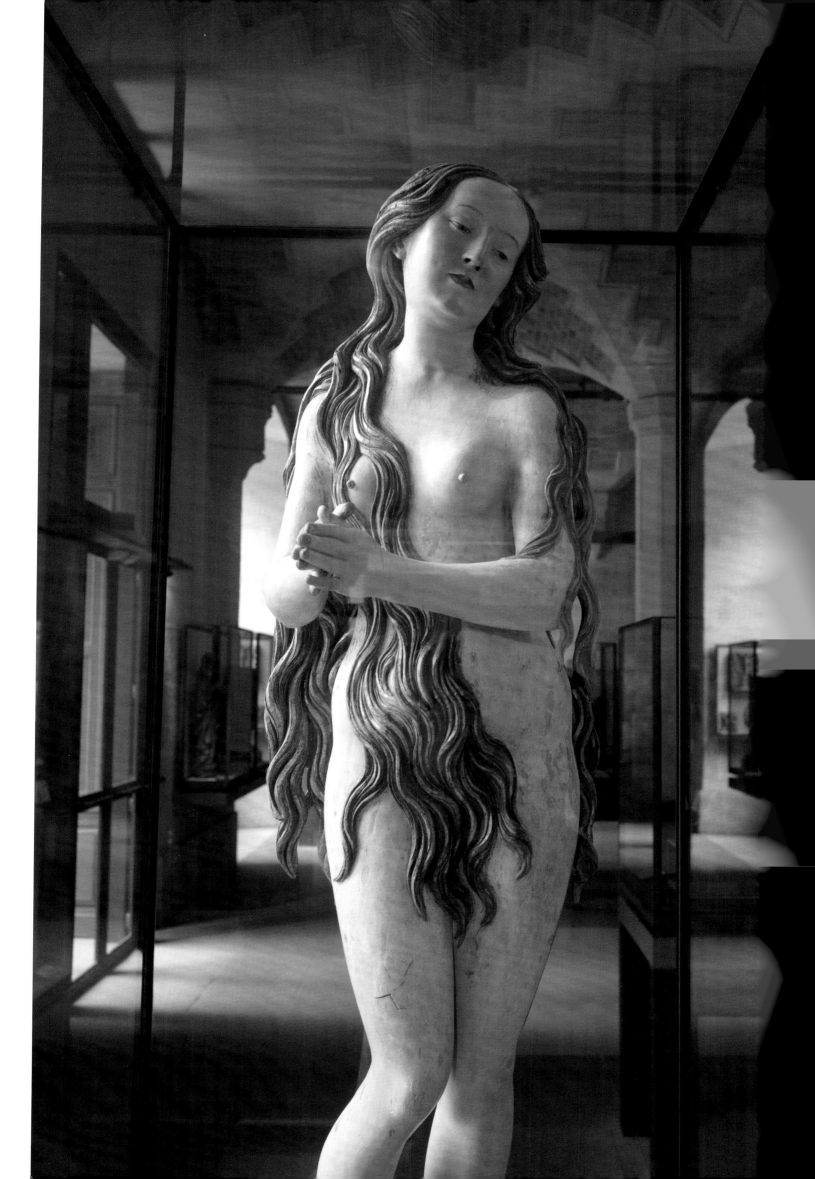

Embriachi workshops
Scenes from the Life of Christ between Scenes from the Lives of the Two Saint Johns
Northern Italy, ca. 1400
Bone, traces of polychrome and gilt, *alla certosina* marquetry, 267.5 × 236 cm (105 ¼ × 92 ⅞ in.)

Retable from the abbey of Poissy, as a gift from Jean, Duke of Berry, probably in 1397
Department of Decorative Arts

Opposite
Equestrian statuette of Charlemagne or Charles the Bald
Horse: Late Empire or 9th century, restored in the 18th century
Rider: 9th century
Bronze, previously gilt, H. 25 cm (9 ⅞ in.)
From the treasury of Metz Cathedral
Department of Decorative Arts, formerly in the Alexandre Lenoir collection and in the Evans Lombe collection, on exchange from the Musée Carnavalet

Following spread
Vitrine with 17th-century ivories
Tankard with a depiction of the Triumph of Silenus (Southern Germany or Flanders, 1635); large drinking vessel with a scene of the combat of centaurs and Lapiths (Germany, 17th century); tankard with a depiction of the Triumph of the Child Bacchus by Johann Jakob Betzoldt (1621–1707)
Department of Decorative Arts

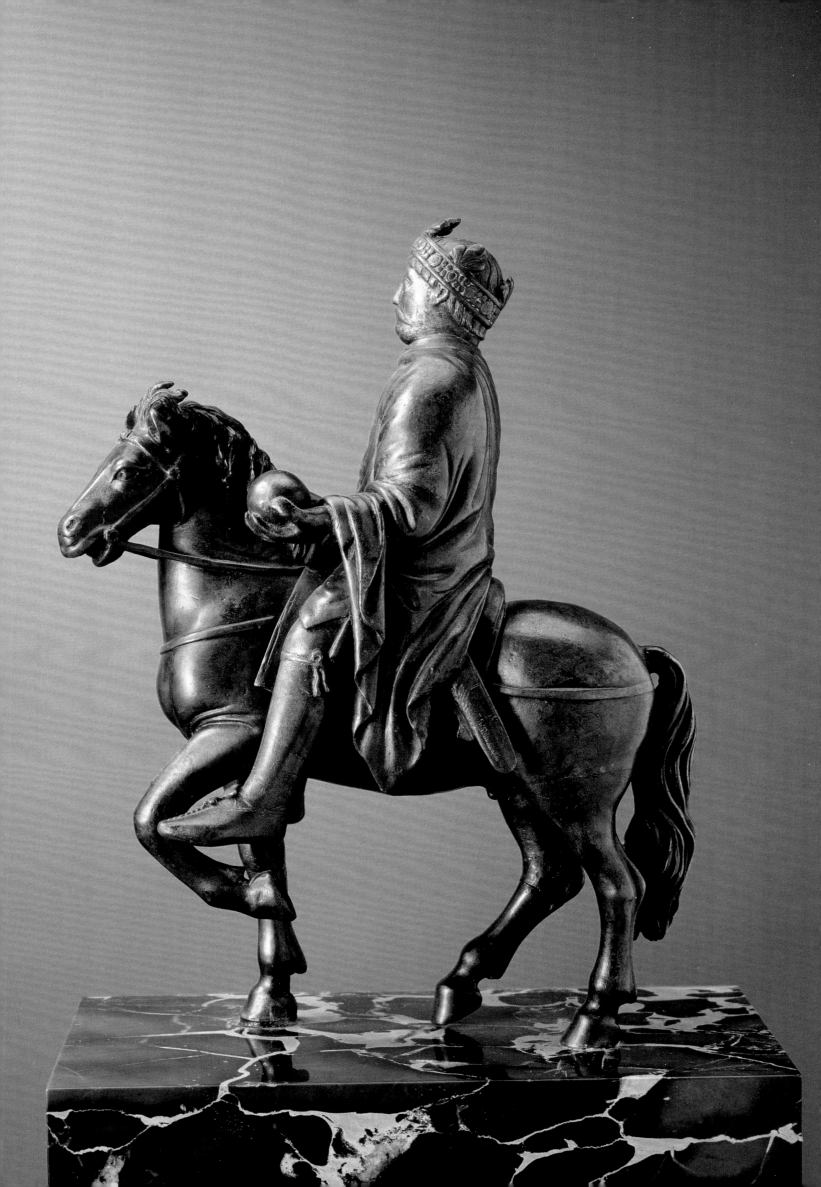

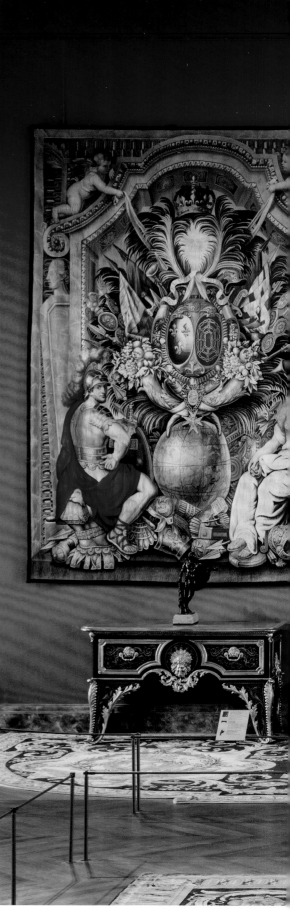

lime green for *The Hunts of Maximilian* tapestries. The chronological itinerary was extended in 1997 to include the Grog-Carven collection in the Beauvais Pavilion, and the seventeenth- and eighteenth-century furniture rooms in the north wing of the Cour Carrée, were completely transformed in 2014 with recreations of elegant period rooms featuring elegant woodwork from Parisian castles and hotels, along with porcelain and goldsmithery.

The conservation of the Napoleon III apartments (the former ministerial reception rooms) was also entrusted to the Department of Decorative Arts, which has chosen to present nineteenth-century objects there, with Empire objects in the Richelieu Wing, and pieces from the Restoration and July Monarchy periods in the Rohan Wing. In this latter wing, in 2001, Pei and Dominique Brard created a series of rooms—some with quite low ceilings—to present neoclassicism and Eclecticism from Charles X to Louis-Philippe. Whimsically decorated objects by the goldsmith Froment-Meurice, Romantic bronzes, crystal lighting fixtures, the neo-Gothic temptations of Marie d'Orléans, have all found a place here, one that had long been denied to such underappreciated, profusely decorated objects. A few recently acquired Austrian Biedermeier chairs indicate a desire to open up the collection to creations from other parts of Europe. The Department of Decorative Arts is also in charge of the Galerie d'Apollon, which was restored in 2004 and exhibits the collection of Crown gems in large vitrines.

Gallery with *The Hunts of Maximilian*,
museography by Jean-Michel Wilmotte, 1993

Opposite
Louis XIV Room
Department of Decorative Arts, room 602

The installation around Hyacinthe Rigaud's spectacular
full-length portrait of Louis XIV wearing the regalia,
loaned to the monarch by the monks of Saint-Denis for
this painting, evokes courtly decorum. To either side,
two commodes decorated with masks (ca. 1690–1710)
exemplify the originality of the great cabinetmaker
André Charles Boulle, whose creations combine
the magnificence of gilt bronze with the ornamental
refinement of marquetry.

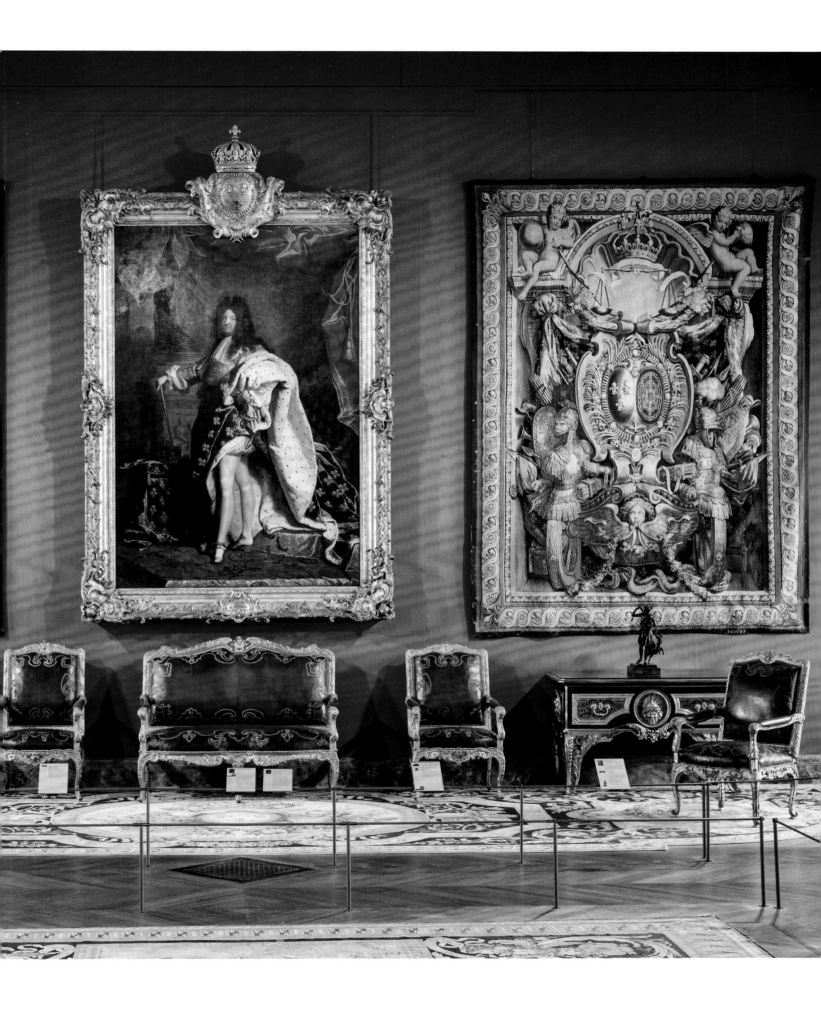

The Great Rearrangement of Paintings

Rogier van der Weyden (1399/1400–1464)
Triptych of the Braque Family, ca. 1450–52
Oil on wood panel, 41 × 136 cm
(16 ⅛ × 53 ½ in.)
Department of Paintings, acquired in 1913
from the Galerie Kleinberger

This portable altarpiece, made for Jean de
Braque and his wife, Catherine of Brabant,
who lived in Tournai, has eucharistic meaning:
Christ the Redeemer is seen between the
Virgin and Saint John the Evangelist, with
Saint John the Baptist and Mary Magdalene
on the wing panels. The large landscape and
rigorous symmetry may have been inspired
by the painter's trip to Italy.

The paintings collections at the Louvre have been constantly reorganized since the 1930s.
One such rearrangement was ongoing when the Grand Louvre project was announced.
Michel Laclotte, who had been curator of paintings prior to becoming director of the Louvre,
and Pierre Rosenberg, Laclotte's successor in both of those roles, had laid out the collection
into four large sections: French paintings and the Northern European Schools in the
Richelieu Wing, Italian art in the Denon Wing, and Spanish art in the former Salle Rubens
in the Pavillon des Sessions. The exceptions confirming the rule were the red rooms (the wall
color choosen by painter Pierre Soulages), the Salon Denon with its large canvases from
David to Géricault, and the rooms allocated to the donations of specific collectors.

The appropriation of the Richelieu Wing made it possible to hang paintings through the
entire second floor. Under the watchful eye of King John the Good, an itinerary linked French
and Northern European paintings (since French medieval art was influenced by Northern
European painters) and then had them go their separate ways. The itinerary of French paint-
ings, which may be considered the best overview from the fifteenth century onward, begins in
the rooms designed by Pei and continues toward the Cour Carrée in new rooms that were
remodeled by the Italian architect Italo Rota in 1992, to then rejoin the rooms that had been
renovated earlier by Joseph Motte. The second floor, therefore, is a unified itinerary from the
Richelieu Wing, all the way to the "Vieux Louvre." The list of masterpieces is long, from
the French Primitives, which notably include Malouel's *Pietà* (acquired in 2013), exhibited
in the Richelieu Wing, to numerous landscapes by Corot, in the west wing of the Cour Carrée.
The layout is varied, with alternating small and large rooms, such as the large room devoted
to *The Battles of Alexander* by Le Brun, where the display can be changed, as it was in 2017.

Rota and Pei both considered that overhead lighting has the advantage of unifying nat-
ural light and introducing artificial light when needed; for example, in the evening hours
and in winter. Pei designed an elegant and perfectly geometrical architecture that varies
according to the shape of the room, with cross-shaped ceilings that are a departure from
the traditional and sometimes tedious rectangular glass ceilings. The forty paintings by
Poussin, for example, including *The Four Seasons*, are exhibited under this lighting in the
rotunda of the Colbert Pavilion. Rota thought more of shifting light—where transparency
plays a key role—just as he sought to vary the floors and picture railings, which are some-
times light in weight, sometimes like walls, and often with contrasting and lively bright
colors to suit the paintings.

Flemish and Dutch paintings are displayed together in spaces around the large room
with Rubens's cycle for the Luxembourg, to reflect their shared spirit and history up till
the seventeenth century. These works go all the way around the Richelieu Wing, on the
second floor, in a museography designed by Pei. The system of ceiling lighting installed
for French paintings is repeated here, but with deeper tones of green and blue, and the
paintings are hung more closely together because of their numbers, which is nevertheless
smaller than the Louvre's collection of French paintings but larger than its Italian

collection. This abundance stems from the beautiful acquisitions made by Louis XIV and Louis XVI (whose project it was to open the museum), and from the La Caze donation in 1869. The small core of fifteenth-century Flemish Primitives—around *The Virgin of the Chancellor Rolin*—by Van Eyck reflects the art of great painters, with the *Braque Triptych* by Rogier van der Weyden, and works by Bosch, Memling, and Bouts. The sixteenth century is represented by painters such as Quentin Metsys' (*The Moneylender and His Wife*, *Mary Magdalene*), Van Cleve, and Bruegel (with his *Beggars*); and an interest in Mannerism has added works by Wtewael and Spranger. Seventeenth-century paintings constitute the bulk of the collection, since this period was most appreciated by past collectors. The most famous Flemish masterpieces, including more than fifty paintings by Rubens, great Van Dycks, and Jordaens, are largely on view, along with forty works by Teniers and other genre painters. Still lifes by Snyders, animal paintings by Boel, and landscapes by Bril and Momper line the upper walls.

Dutch Golden Age painting at the Louvre is no less impressive. The collection contains works by the Utrecht Caravaggisti such as Hendrick ter Brugghen, hung together with great works by Frans Hals (*The Gypsy Girl*, *Buffoon with a Lute*) and a group of twelve Rembrandts, including *The Philosopher in Meditation*, *Bathsheba at Her Bath*, and *The Supper at Emmaus*. Two paintings by Vermeer, *The Lacemaker* and *The Astronomer*, are mesmerizing in their powerful evocations of suspended time and their spaces carved from light. The serenity of these works is also felt in Saenredam's *Church Interior* and Van Hoogstraten's *Slippers*. All of the pictorial genres are present, from the landscape and marine painting of Van Goyen and Van Ruisdael to still life and portraiture.

Jan Gossaert, known as Mabuse (1478–1532)
Diptych of Jean Carondelet (detail), 1517
Oil on wood panel, 42 × 27 cm
(16 ½ × 10 ⅝ in.), on each panel
Department of Paintings, acquired from the
architect Bernard, Valenciennes, 1847

Jean Carondelet, dean of the church at
Besançon who accompanied the future
Charles V to Spain in 1517, is seen here in prayer
before the Virgin. On the reverse, a skull and
a verse from Saint Jerome serve as reminders
of mortality.

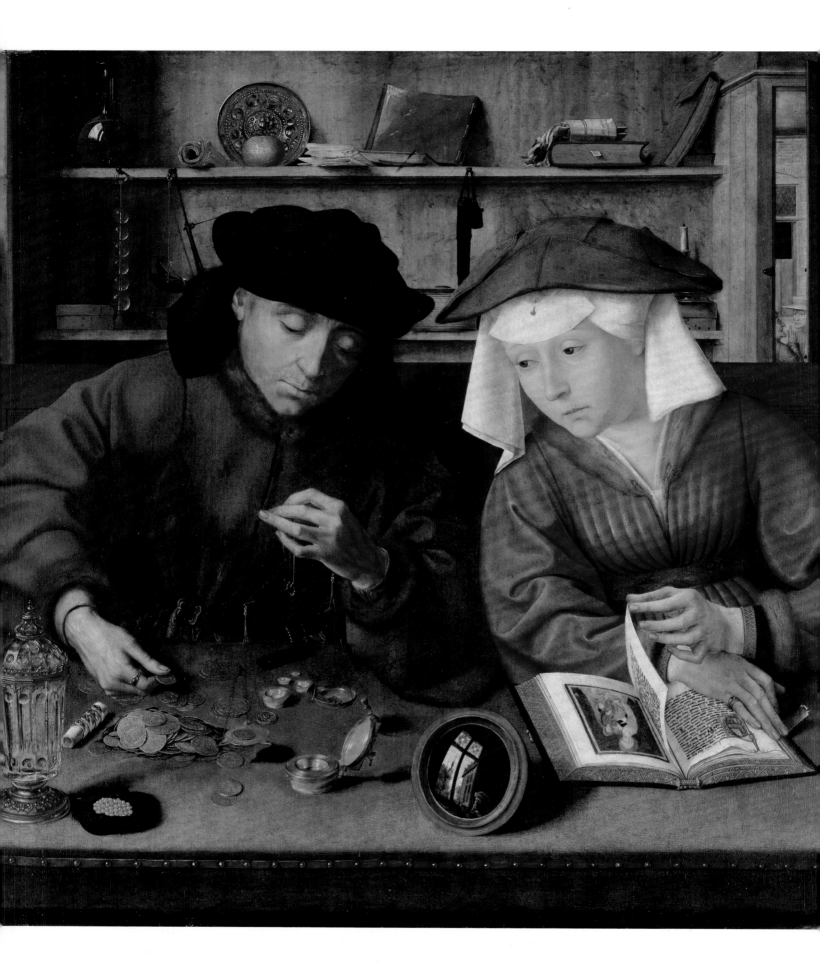

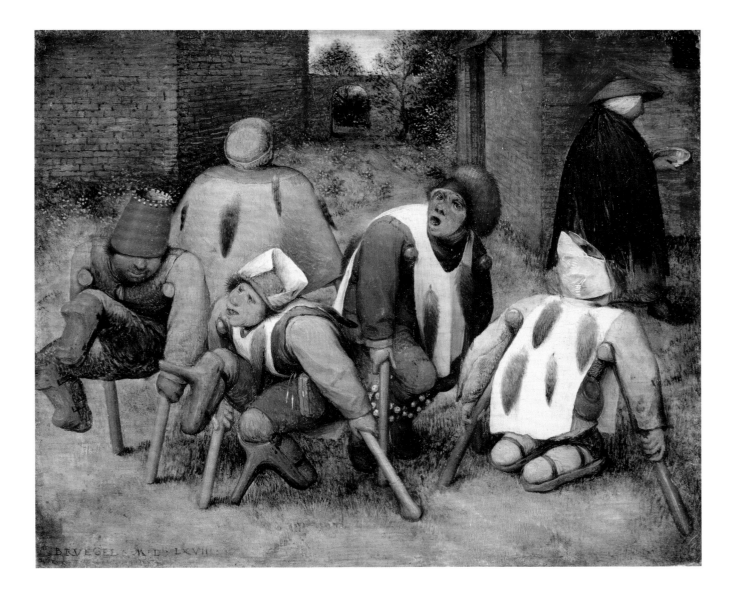

The Louvre's collection of German paintings is exceptional, albeit somewhat smaller than the other schools. The itinerary begins with fifteenth-century painting from Cologne, followed by German Renaissance masterpieces such as Albrecht Dürer's *Self-Portrait* and works by Lucas Cranach, including *The Three Graces*, which was acquired by the Louvre, thanks to a successful appeal for donations in 2011. The Holbein portraits, acquired by Louis XIV as part of the Jabach collection, are astonishingly powerful. A rich variety of movements and subject matter then follows, with Mannerist paintings; seventeenth-century still lifes; eighteenth-century mythological paintings; and Romanticism, including Caspar David Friedrich's *The Tree of Crows*. The latter, acquired in 1975, was crucial in shifting the Louvre's acquisitions policy toward nineteenth-century art from countries that until then were poorly represented in the museum: Scandinavia, Russia, Switzerland, and the United States. Shortly after the inauguration of the Richelieu Wing in 2001, a few rooms in the Rohan Wing were opened to display those northern schools that the Louvre was endeavoring to develop. It has recently acquired an important painting by Benjamin West.

Italian paintings have also been entirely rearranged on the first floor of the Denon Wing, where French paintings once hung. While the Salle Duchâtel hasn't changed much, except for the addition of a fresco, and the Salon Carré still shows signs of the remodeling from the 1970s that was meant to enhance the collection of Italian Primitive art, the Galerie des Sept-Mètres was completely transformed by Lorenzo Piqueras in 1997. By placing partitions at right angles to the walls in this narrow gallery, he created nooks that are suitable to small-format Italian paintings of the thirteenth and fourteenth centuries: Lorenzo Monaco, Sassetta, Piero della Francesca, Antonello da Messina, and others. At the end of the room, the half-domed fresco from the School of Raphael seems to float below the frame of the old door.

Pieter Bruegel the Elder (ca. 1525–69)
The Beggars, 1568
Oil on wood panel, 18.5 × 21.5 cm
(7 1/4 × 8 1/2 in.)
Department of Paintings, gift of Paul Mantz, 1892

The meaning of the only painting by Bruegel the Elder at the Louvre has not been entirely deciphered. Is it an evocation of human suffering or an ironic description of society? The curious foxtails pinned to the back of one of the beggars have prompted multiple interpretations.

Opposite
Quentin Metsys (1465/66–1530)
The Moneylender and His Wife, 1514
Oil on wood panel, 70 × 67 cm
(27 1/2 × 26 3/8 in.)
Department of Paintings, acquired at a public sale in Paris, 1806

A biblical inscription in Latin on the reverse ("Let the balance be just and the weights be equal") provides the moralizing lesson of this sternly quiet painting. In the foreground, a mirror reflects the image of a man reading, modeled on Jan van Eyck.

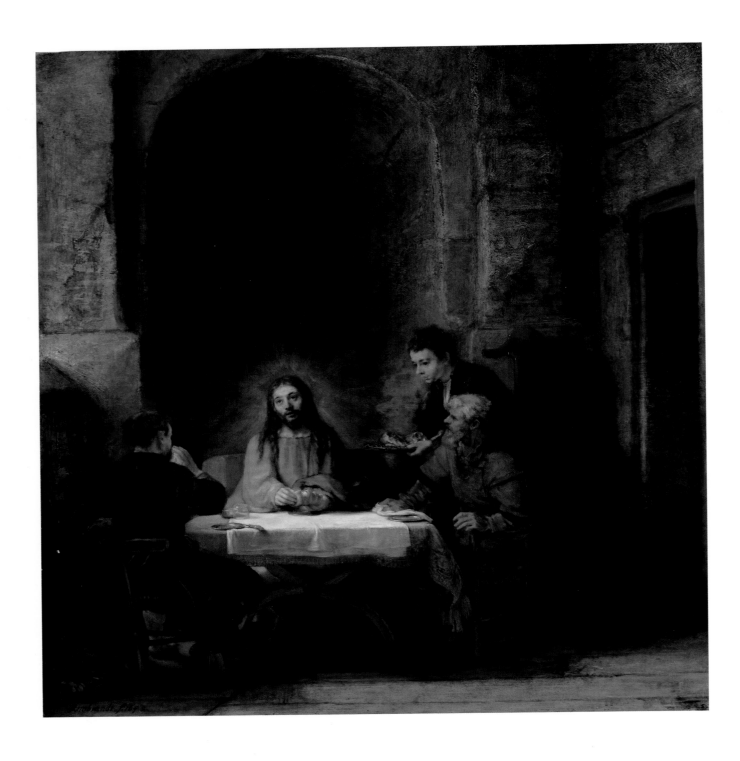

Rembrandt (1606–69)
The Supper at Emmaus, 1648
Oil on wood panel, 68 × 65 cm
(26 ¾ × 25 ⅝ in.)
Department of Paintings, Louis XVI
collection, acquired at the Randon de Boisset
sale in Paris, 1777

Rembrandt's rendition of Christ meeting his
disciples at Emmaus and revealing himself
to them during the meal has a poignant
realism. The visage of Christ, an image that
long preoccupied the artist, is based on a
contemporary model. Here, it is surrounded
by a halo of light.

The itinerary continues in the Grande Galerie, which was also rearranged in 1997, and
then in the Salle des États, where the remodeling was awarded by competition to Lorenzo
Piqueras in 1999. The room was inaugurated in 2005 to showcase the *Gioconda*, sur-
rounded by Venetian Renaissance paintings. In 2019, the color of the walls was changed
into a deep midnight blue for the Leonardo exhibition. The other works by Leonardo,
notably the *Saint Anne*, which was restored in 2011, preside over the Grande Galerie, where
Italian art through the seventeenth century is displayed chronologically. The last part of
the Italian art itinerary was opened to the public in 1999 in the Pavillon des Sessions, fol-
lowing renovations by the architects Yves Lion and Alain Levitt that completely trans-
formed the former Van Dyck and Rubens rooms, where the neoclassical stuccowork of
the 1900s was removed. Lion and Levitt also designed another entrance to the museum, the
monumental Porte des Lions, which allows access to the Italian paintings rooms, a new
room with Greek and Russian icons, and the large Spanish paintings room.

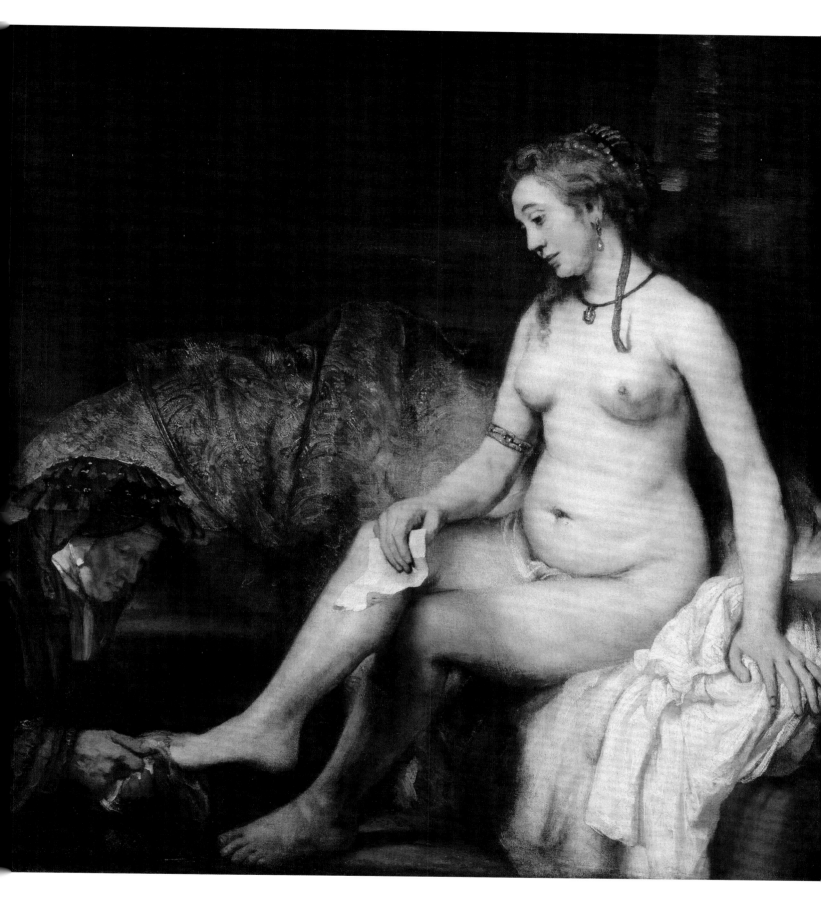

Rembrandt (1606–69)
Bathsheba at Her Bath Holding David's Letter, 1654
Oil on canvas, 142 × 142 cm (55 ⅞ × 55 ⅞ in.)
Department of Paintings, bequest of Dr. Louis
La Caze, 1869

Bathsheba, whose beautiful nude figure was
modeled on Hendrickje Stoffels, the painter's
mistress, seems to meditate on her fate while
she holds the crumpled letter from King David
asking for her favors.

Johannes Vermeer (1632–75)
The Lacemaker, ca. 1669–70
Oil on canvas mounted on wood, 24 × 21 cm
(9 ½ × 8 ¼ in.)
Department of Paintings, acquired at the
Vis Blokhuyzen sale in Paris, 1870

The closely cropped framing draws attention
to the lacemaker's meticulous work and invites
the viewer to also bend toward this absorbed
figure, captured in the moment and modeled
by light.

Opposite
Samuel van Hoogstraten (1627–78)
The Slippers
Oil on canvas, 103 × 70 cm (40 ½ × 27 ½ in.)
Department of Paintings, collection of Count
Oscar de l'Espine; gift with usufruct reserved
from his daughter Hortense (1867–1932),
Princess Louise de Croÿ, 1930; entered the
Louvre in 1932

The perspective brings out the quiet space
where the abandoned book, slippers, and
broom suggest that domestic occupations
have been cast aside for some guilty activity.
This moralizing story is told through strong
illusionism and rigorous geometry.

Albrecht Dürer (1471–1528)
Self-Portrait with Thistle, 1493
Parchment mounted on canvas, 56 × 44 cm
(22 × 17 ⅜ in.)
Department of Paintings, acquired in 1922

One of the earliest independent self-portraits
in Western painting, it was produced when
the artist was twenty-two years old, probably
in Strasbourg, during his first trip there.
The thistle has been the object of numerous
interpretations, from Goethe, who saw it as
a symbol of love and Dürer's engagement to
his future bride, to others who relate it to the
crown of thorns and the Passion of Christ.

Opposite
Lucas Cranach the Elder (1472–1553)
The Three Graces, 1531
Oil on wood panel, 36 × 24 cm (14 ⅛ × 9 ½ in.)
Department of Paintings, acquired through
an appeal for donations in 2011

Spanish paintings have left the Pavillon de Flore, where they had been so wonderfully displayed in 1969. Relatively small in number, they could be sparsely hung there, and again in their new room. Flemish and Italian influences converge in works by late medieval Catalan and Castilian masters such as Bernat Martorell and Jaume Hughet. The strange, overwhelming, and tortuous Mannerism of El Greco, who came from Crete by way of Venice and settled in Toledo during the reign of Philip II, is on full display in his *Christ on the Cross Adored by Two Donors* and *Portrait of Diego de Covarrubias*. The collection includes a number of very large paintings from the Spanish Golden Age, such as *The Mass for the Founding of the Trinitarian Order* by Juan Carreño de Miranda; José de Ribera's *Adoration of the Shepherds*; the cycle of the *Life of Saint Bonaventure* by Francisco de Zurbarán, from Seville; and Bartolomé Esteban Murillo's *Angels' Kitchen*. Realism is forcefully expressed in the young boys by Ribera and

Domenikos Theotokopoulos,
known as El Greco (1541–1614)
Christ on the Cross Adored by Two Donors, ca. 1580
Oil on canvas, 248 × 180 cm (97 ⅝ × 70 ⅞ in.)
Department of Paintings, acquired in 1908

Painted for the Hieronymite monks of Toledo, this is the only work from Louis-Philippe's Spanish gallery to enter the Louvre.

Opposite
Francisco de Zurbarán (1598–1664)
Saint Bonaventure's Body Lying in State, 1629
Oil on canvas, 245 × 220 cm
(96 ½ × 86 ⅝ in.)
From the cycle *Life of Saint Bonaventure* (minster general of the Franciscan order) for the Franciscan College of Seville
Department of Paintings, acquired in 1858

D. LUIS MARIA DE CISTUE Y MARTINEZ. A LOS
DOS AÑOS Y OCHO MESES D SU ED.

F. GOYA

Francisco de Goya y Lucientes (1746–1828)
Portrait of Luis María de Cistué y Martínez,
April–May 1791
Oil on canvas, 118 × 86 cm (46 ½ × 33 ⅞ in.)
Department of Paintings, formerly in the
Rockefeller collection and collection of Yves
Saint Laurent and Pierre Bergé, gift of Pierre
Bergé, 2009

The godson of King Charles IV and the queen
of Spain is seen here in the full innocence of
childhood, with his favorite pet.

Opposite
Francisco de Goya y Lucientes (1746–1828)
Ferdinand Guillemardet ca. 1799
Oil on canvas, 186 × 124 cm (73 ¼ × 48 ⅞ in.)
Department of Paintings, bequeathed by Louis
Guillemardet, the sitter's son, 1865

Murillo (*The Clubfoot*) and in the sober elegance of Zurbarán's *Saint Apollonia*, painted as a
young, contemporary woman. Lastly, there are eight works by Goya, all strong portraits where
color is used to express character, such as the tricolor sash in *Ferdinand Guillemardet*, or the
delicate rose sash in the *Portrait of Luis María de Cistué y Martínez*, a gift to the museum from
Pierre Bergé.

In 1999, the Cabinet of Graphic Arts, and the Edmond de Rothschild collection of prints
and drawings, were completely remodeled. With a new access through the Porte des Lions,
the Department of Graphic Arts received new spaces for conservation, documentation, and
restoration while retaining the study room in the Escalier des Souverains, which it has held
since 1969. For rotating and temporary exhibitions, the department now has a room in the
Pavillon des Sessions, which had been added on to the large rooms of the Mollien Wing,
connecting the Grande Galerie with the Mollien staircase. The department also has second-
ary spaces within the French paintings rooms on the Cour Carrée for temporary exhibitions
of drawings and pastels.

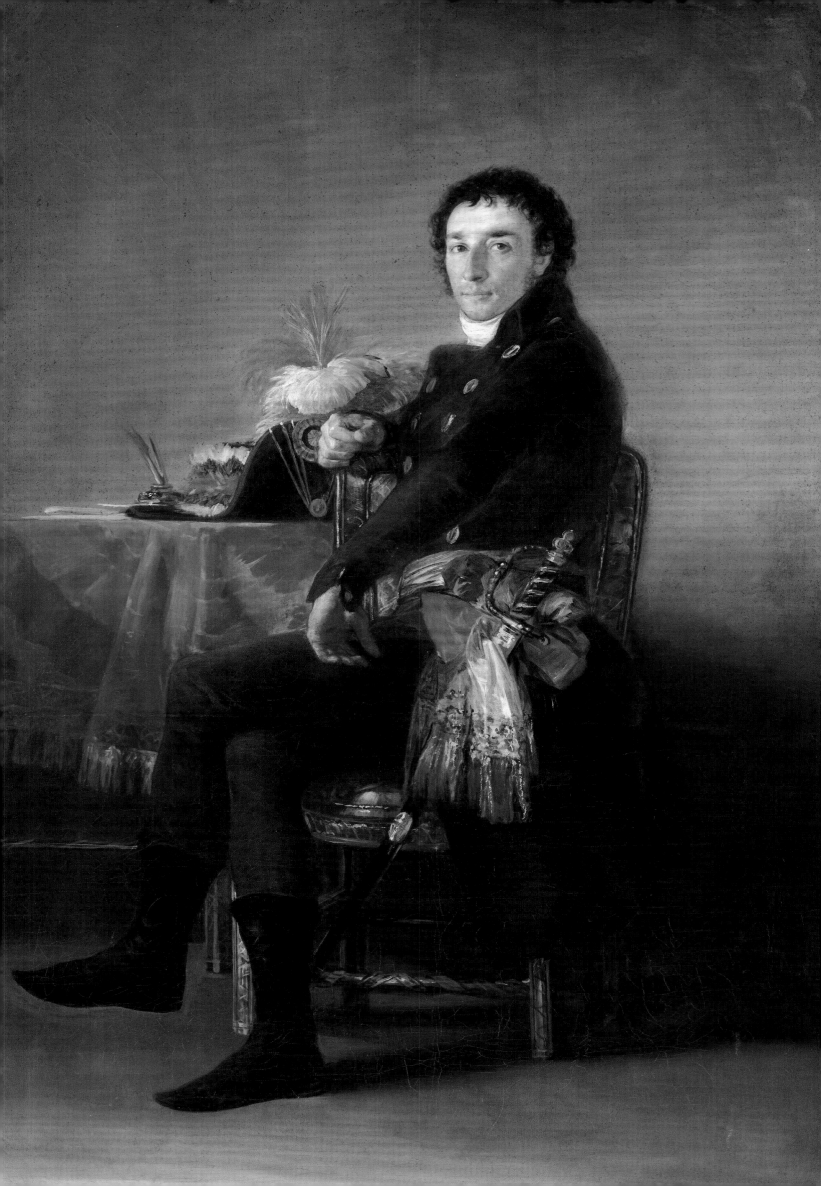

In the Pavillon des Sessions:
The Oceanic and Pre-Columbian Art Collections,
and the Musée des Arts Premiers

Let's now go to the Porte des Lions, formerly the south entrance to the Tuileries Palace. It leads to the museum of African, Asian, Oceanic art, and art of the Americas, opened in 2000, six years prior to the inauguration of the Musée du Quai Branly. The decision to create this branch in the Louvre was political, taken personally by President Jacques Chirac, who wanted the so-called "first" arts to stand symbolically on equal footing with the more traditional treasures of classical civilizations. The Louvre made a very strict selection from its collections, and great care was taken with the aesthetics of the installation, making it striking to the viewer, but without the sociological and archaeological framework developed at the Musée du Quai Branly. Magnificent, representative examples of important cultural periods have been spectacularly staged on the ground floor of the Pavillon des Sessions, in display cases designed by Jean-Michel Wilmotte.

Sub-Saharan Africa's oldest civilizations, in particular from Nigeria, are presented —Nok male statuettes, Ife terra-cotta heads, Benin bronze plaques—and the time-immemorial art of the Dogon and Zulu peoples. With art from the major Asian civilizations (e.g., China, India, Japan, Khmer) having been moved to the Musée Guimet in 1945, Asian art at the Louvre focuses on the smaller cultures of highland and maritime southeast Asia, including the islands of the Philippines, Sumatra, and Indonesia. Their art is close to that of Oceania, which is well represented in the Pavillon des Sessions. A Maori head from Easter Island, a group of Kanak sculptures from New Caledonia and Hawaii, a shield from the Solomon Islands—they all illustrate the inventiveness of the Pacific archipelagos. The art of the Americas is largely pre-Columbian, from Guatemala, Mexico, and the Andes. There are several sculptures from Maya, pre-Aztec, and Aztec civilizations, such as a Chupícuaro terra-cotta statuette (700–200 B.C.) and a fifteenth-century Teotihuacán mask. There are also spaces devoted to Caribbean cultures, with pieces such as a Taíno ceremonial chair, and indigenous North American art, such as masks from British Columbia and Alaska.

Some of these objects fit into the historical concept of the Louvre as a universal museum. The idea of creating a museum of faraway peoples—from Asia, Oceania, Africa, and the Americas—at the Louvre dates back to 1825 and began to take form the following year, with the acquisition of pre-Columbian and Oceanic objects from the sale of the collection of the Louvre's former director Dominique Vivant Denon. Sadly, the project failed to develop further, and the existing objects filled vitrines of the Musée de la Marine, where officers of the navy were placing finds from "faraway seas." The few pre-Columbian objects collected by Denon and others—and brought back to France by travelers in Mexico and Peru—were the seeds of a true, methodical museum of pre-Columbian antiquities at the Louvre, where they were not merely "curiosities" but genuine testaments to the civilizations they exemplify and illuminate. The Musée des Antiquités Américaines opened in 1851 and gave that field new energy, official recognition, and public visibility. A debate had already begun on whether the Louvre was a fine arts museum and repository reserved for academic beauty, or a museum of civilizations grounded in archaeological research that would endeavor to explain the history of the world.

The creation of this museum encouraged donors—such as Victor Schoelcher, who had at that time just signed the decree in favor of the abolition of slavery—and Victor Place, who, prior to his discoveries in Khorsabad, was the consul in Haiti, where he found fragments of terra-cotta figures that were to become the first Taíno objects in French public collections. Enthusiasm waned after an initial euphoria, but this opened up a great opportunity for the new Musée d'Ethnographie du Trocadéro, created in 1878. Despite the protestations of the curator of antiquities, the ethnographic museum prevailed, and in its intention to present these civilizations in the long term, received the transfer of 1,452 pre-Columbian objects in 1887. Meanwhile, those earlier collected

Ife head
Nigeria, 12th–14th century
Terra-cotta with traces of polychrome,
H. 15.5 cm (6 ⅛ in.)
Pavillon des Sessions (collection of the Musée du Quai Branly), formerly the Barbier-Mueller collection

The art of the Benin Kingdom has always fascinated Europe, for its great simplicity, strong volumes, and naturalism.

Opposite
Male coming-of-age ritual statue
Malo Island, Vanuatu, early 19th century
Natora wood, pigments (including blue washing powder), H. 300 cm (118 ⅛ in.)

Pavillon des Sessions (collection of the Musée du Quai Branly), found by the *Korrigane* expedition, 1935, gift of M. Desgranges, 1938

Benin sculpture
Nigeria, 16th–17th century
Brass, H. 40 cm (15 ¾ in.)
Pavillon des Sessions (collection of the Musée
du Quai Branly), formerly in the collections
of George W. Neville, Ernest Ascher, Joseph
Mueller, and the Musée Barbier-Mueller

Opposite
Fragment of a Maori statue
Easter Island, 11th–15th century
Basalt tuff, H. 170 cm (66 ⅞ in.)
Pavillon des Sessions (collection of the Musée
du Quai Branly), collected by the
Métraux-Lavachery mission, 1934–35,
gift of the government of Chile, 1935

objects from "faraway seas" were scattered about various institutions, with some remaining at the Musée de la Marine, and others sent to the Trocadéro or the room of comparative archaeology at the museum in Saint-Germain-en-Laye.

The museum of "arts premiers" that became the Musée du Quai Branly (now Jacques Chirac) was founded on the collections of the Musée de l'Homme du Trocadéro and the Musée des Arts Africains et Océaniens de la Porte Dorée, and represents the symbolic return of the civilizations that had left the Louvre many years ago.

The Carrousel and Tuileries Gardens

The Department of Islamic Art, courtyard space, architecture by Rudy Ricciotti and Mario Bellini, 2012

Previous spread
The Marsan Wing and Carrousel Garden, seen from the roof of the Flora Wing

The digging of the tunnel between the Pont Royal and the Place des Pyramides, as well as under the Carrousel area, also entailed a complete reorganization of the Carrousel and Tuileries Gardens, including the terrace where the old château once stood. A number of early projects failed, due to lack of will and financing. In 1984, Jean Nouvel proposed to reproduce Le Nôtre's parterre and to plant new groves where contemporary installations could be placed (Poirier, Ipoustéguy, Arman, Kienholz). Michel Corajoud and Michel Serres, and even Laurent Guinamard (in 1985), made other proposals, including a rose garden.

Ultimately, the Ministry of Culture launched a competition in 1990 to redesign the Carrousel and Tuileries Gardens. Eight teams of landscapists were consulted, and they produced designs and mock-ups for the whole area. Pei was given the terrace, while Jacques Wirtz and his son Peter designed the rows of topiaries and labyrinths for the Carrousel Garden. To conceal the required safety exits from the underground areas, they created mounds planted with trees and bordered by yew hedges. The long rows of topiary are like rays of sunlight issuing from the Carrousel Arch. The subtle undulations of the green grass against the dark yew create an abstract world appropriate for Maillol's sculptures.

In their plan for the Tuileries Garden, Pascal Cribier, Louis Benech, and François Roubaud renewed the vegetation and completely remodeled what they called the "*grand carré*," or large square, joining the old reserved gardens with the outline of the parterre designed by Le Nôtre. The only aspects of the Napoleon III garden they left visible were a slim ditch and a few century-old trees. They created new perspectives, redesigned the parterres, and planted dense flower beds with pleasant walkways for easy maintenance.

After the Grand Louvre

The Grand Louvre was just one stage in the history of the Louvre. After the EPGL was dissolved, the Établissement Public du Musée du Louvre had to lead the museum's renaissance on its own, and with the help of donors. The restoration of the palace culminated in the Galerie d'Apollon (2004), where the luxuriously painted and sculpted decorations recovered its youthful glow after three years of work. Restoration of the roofing, facades, and painted ceilings continues to this day.

Little by little, the spaces that had not been touched by the Grand Louvre program were transformed. These include the rooms of the *Code of Hammurabi* (2003), the Salle du Manège (2004), and the Salle des États (2005). In 2010, Greek sculptures were reinstalled in dialogue with ceramic wares and bronzes around the Venus de Milo. Islamic and Roman-era art of the eastern Mediterranean were reinstalled in 2012, and the eighteenth-century decorative arts rooms and Roman art rooms in 2014. Over time, a renovation with a new hanging made it possible to showcase seventeenth- and eighteenth-century French painting in 2015 and northern European painting in 2017. The increasing success of the museum, with ever-larger numbers of visitors—reaching ten million in 2018—and the proliferation of functions, exhibitions, and restaurants, forced another reorganization of the spaces created under the Grand Louvre project. The Napoleon Hall and its annexes for group tours, a bookstore, and restaurants were remodeled. The rooms on the history of the Louvre became spaces for temporary exhibitions of the Department of Graphic Arts, as well as a permanent room explaining drawings techniques (2018), called "Rotonde Sully." The historical collection about the palaces was transferred to the area of the Pavillon de l'Horloge, on three floors.

The Louvre also began to have control over its acquisitions policy, funded in part by museum admissions fees, but also by new tax benefits. Large companies could be approached to finance the acquisition of "national treasures," since they are allowed a 90 percent tax credit on the purchase price of the work. This was how the Louvre acquired,

The museographic spaces of the Department of Islamic Art in the Cour Visconti

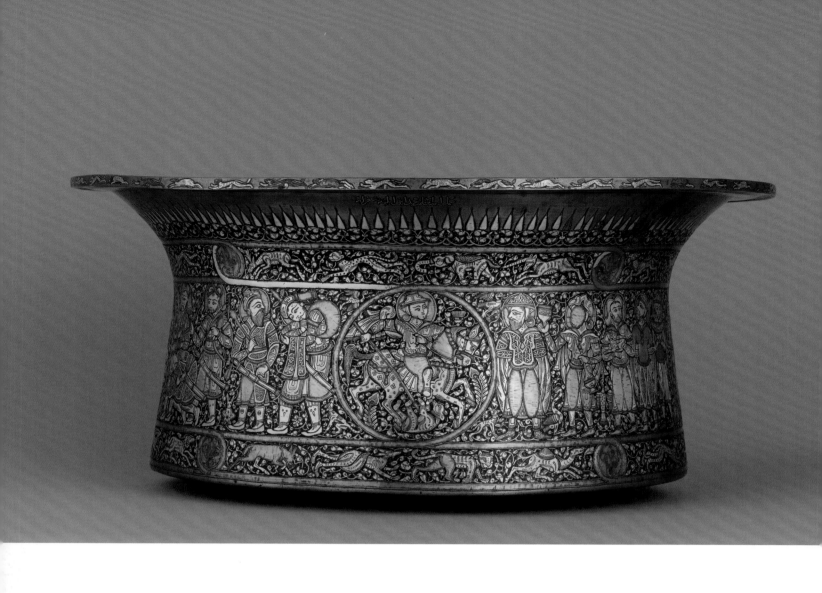

Baptismal basin of Saint Louis
Signed by de Muhammad Ibn al-Zain
Syria or Egypt, ca. 1330–40, copper alloy, cast
and then hammered, gold and silver inlay,
H. 23.2 cm (9 ⅛ in.), D. 50.5 cm (19 ⅞ in.)
Department of Islamic Art, used for the
baptism of Louis XIII at Fontainebleau in
1601; associated with the figure of the king
Saint Louis between 1742 and 1791; seized
under the Revolution from the Sainte-Chapelle
of Vincennes castle in 1793 and turned over to
the Muséum Central des Arts

This masterpiece of Mamluk copperware
depicts princes on horseback within round
medallions, interposed along a cortège of high
dignitaries, illustrating the power of the ruler.
It is signed by the coppersmith Muhammad ibn
al-Zain.

Opposite
Barada Panel
Rendering of the mosaics from the Umayyad
mosque in Damascus (Syria) by Fehmi
Kabbani, Kamal Kallass, and Nazmi Khayr
in 1928–29
Watercolor and gold on marouflé paper affixed
to canvas, 330 × 297 cm (130 × 117 in.)
Department of Islamic Art, acquired in 2010

This full-scale rendering of the exceptional
mosaics from the courtyard portico (705–15)
was done at the initiative of Eustache de Lorey.
It documents how the mosaic looked before
later restorations.

among other gems, an Egyptian papyrus on medicine, Malouel's *Pietà*, important portraits by Ingres (of the duke of Orléans and the comte Molé), Houdon's sculpted *Vestal*, and a medallion from the decoration of the Place des Victoires.

Islamic Art

Since September 2012, a wavy glass veil over the Cour Visconti shelters the Louvre's impressive Islamic art collection, with thousands of objects from various continents covering a broad chronology that begins in the eighth century. Some items had been in the museum since its inception, such as the so-called baptismal basin of Saint Louis from the Sainte-Chapelle of Vincennes Castle, a superb gold- and silver-inlaid copper basin signed by Muhammad Ibn al-Zain (ca. 1330–40) from the period of the Mamluk sultanate, and the carved rock-crystal objects made in Fatimid, from the treasury of the abbey of Saint-Denis.

For quite some time, Islamic antiquities were part of the Department of Decorative Arts, until they were given their own section within the Department of Oriental Antiquities. In the years after World War I, they were in a large space in the Sully Pavilion, which was drastically reduced after World War II. In the Grand Louvre project, Islamic antiquities were assigned rooms that had been built under the Richelieu Wing, inaugurated in 1993.

In 2004, the Department of Islamic Art was created when it split off from the Department of Oriental Antiquities, and it received Islamic objects on deposit from the Musée des Arts Décoratifs. As a result, new spaces were needed to showcase examples from this rich collection of more than ten thousand objects. The only available option was the Cour Visconti, provided that a new space could be built down into the ground of the courtyard and then covered. The architectural team of Rudy Ricciotti and Mario Bellini won the project competition in 2005 and designed a very nonlinear tented glass building to fit into the courtyard.

Renaud Piérard's installation of the Islamic art collection is on two floors, using elements of surprise and playing on the transparency of the large vitrines. The chronological and geographical itinerary in four stages (eighth to tenth centuries, 1200–50, 1250–1500,

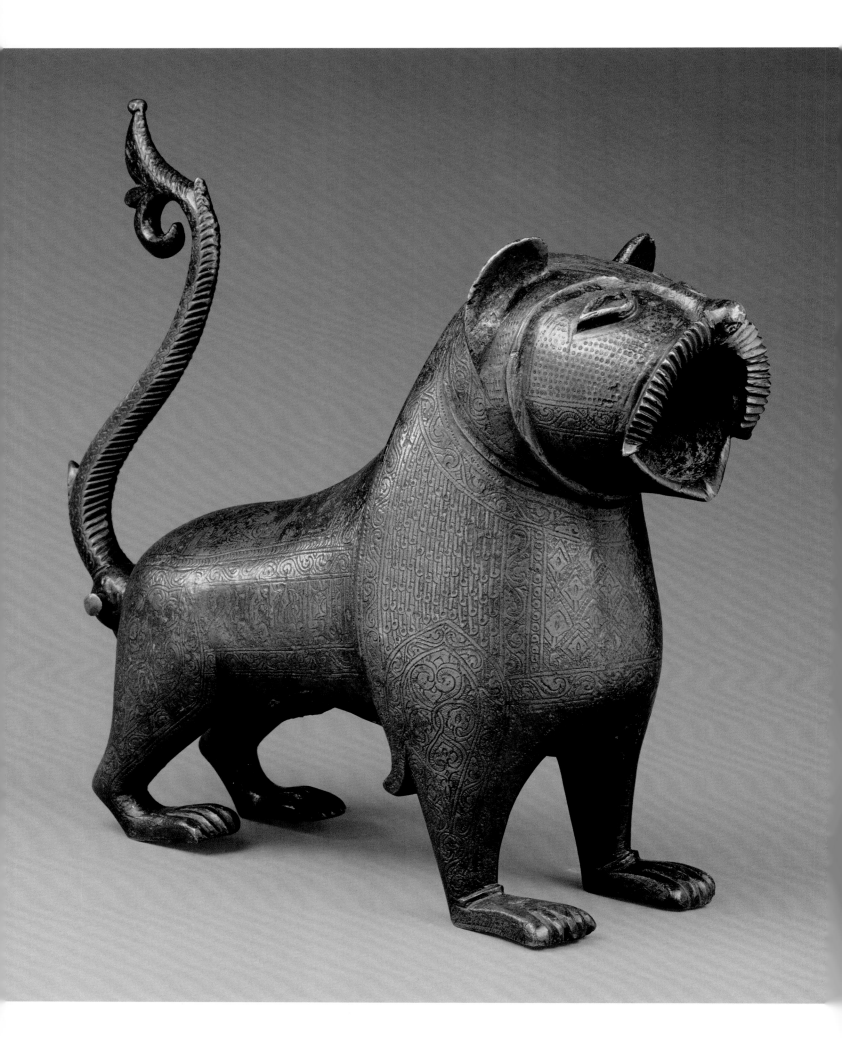

and 1500–1800) begins at top, with full-scale renderings of the mosaics from the Umayyad mosque in Damascus. The Louvre's collection is particularly strong in ninth-century Islamic art. The large vitrines display ceramics from the Abbasid period onward, and Egyptian Tulunid and Fatimid carved wood and ivory objects. Spain is also well represented, with works such as the beautiful ivory pyxis of al-Mughira, made in 968 in the workshops of the caliphate of Córdoba, and bronze objects such as the peacock aquamanile and the Monzón lion. The chronological display features ceramics from Iran; Syrian glass; mosque lamps and bottles; and encrusted metalwork such as the "Barberini vase," made for an Ayyubid sultan who reigned in Aleppo and later belonging to Pope Urban VIII. After passing through the carved stone porch from a fifteenth-century Mamluk palace in Cairo, visitors are treated to Marinid art from Morocco, and Mughal art from Iran. One then arrives at the opulence of the three great modern empires: Mughal India, Persian

Perfume burner in the shape of a falcon
Khorasan, Iran, 9th century
Cast bronze with openwork, incised decoration, encrustations in glass,
H. 22.5 cm (8 ⅞ in.)
Department of Islamic Art, acquired in 1897

Opposite
Fountain lion
Spain, 11th–12th century
Cast bronze, incised decoration,
H. 31.5 cm (12 ⅜ in.)
Department of Islamic Art, formerly in the collections of the painter Mariano Fortuny y Marsal, Eugène Piot, and Louis Stern; bequest of Mme Louis Stern, 1926

Ewer in the shape of a rooster
Iran, 13th century
Fritware, reticulated, engraved, and painted
decoration under transparent colored glaze,
H. 39.5 cm (15 ½ in.)
Department of Islamic Art, gift of the Société
des Amis du Louvre, 1970

Opposite
Ottoman ceramic wall (detail), reconstructed
in the rooms devoted to art in Turkey,
ca. 1560–1600
Ceramic, painted under glaze,
total H. of wall: 350 cm (137 ⅞ in.)
Department of Islamic Art

Iran, and Ottoman Turkey. A 16-meter-long (52 1/2 ft.) wall of Ottoman tiles reflects the ceramists' vivacious sense of color. Mughal metalware reached its heights with precious stone ornaments, used to decorate even the handles on daggers. Rugs are displayed on a rotational basis, as are books, miniatures, and calligraphy. The Louvre's acquisitions policy has evolved toward areas that were underrepresented in the past, such as miniatures, stone-carved *jali* from India, rugs, and more.

Near Eastern Art from the Roman and Byzantine Periods

The rooms devoted to Near Eastern art opened in 2012, around the same time as the new Islamic art rooms. This project was not new, and had, in fact, been partly executed in 1997: in the Grand Louvre project, the works of late antiquity, which were distributed among three different departments (Egyptian, Oriental, and Roman) would be exhibited in contiguous rooms around the Cour Visconti, instead of the École du Louvre, which had been transferred to the Flora Wing. There, only two spaces were remodeled by François Pin and Catherine Bizouard, to exhibit works of Egyptian origin: that of the Copts and that of Roman Egypt. The remains of the Coptic Basilica of Bawit were given a space appropriate to their scale, in what had been the amphitheater of the École du Louvre. Cloth and wood

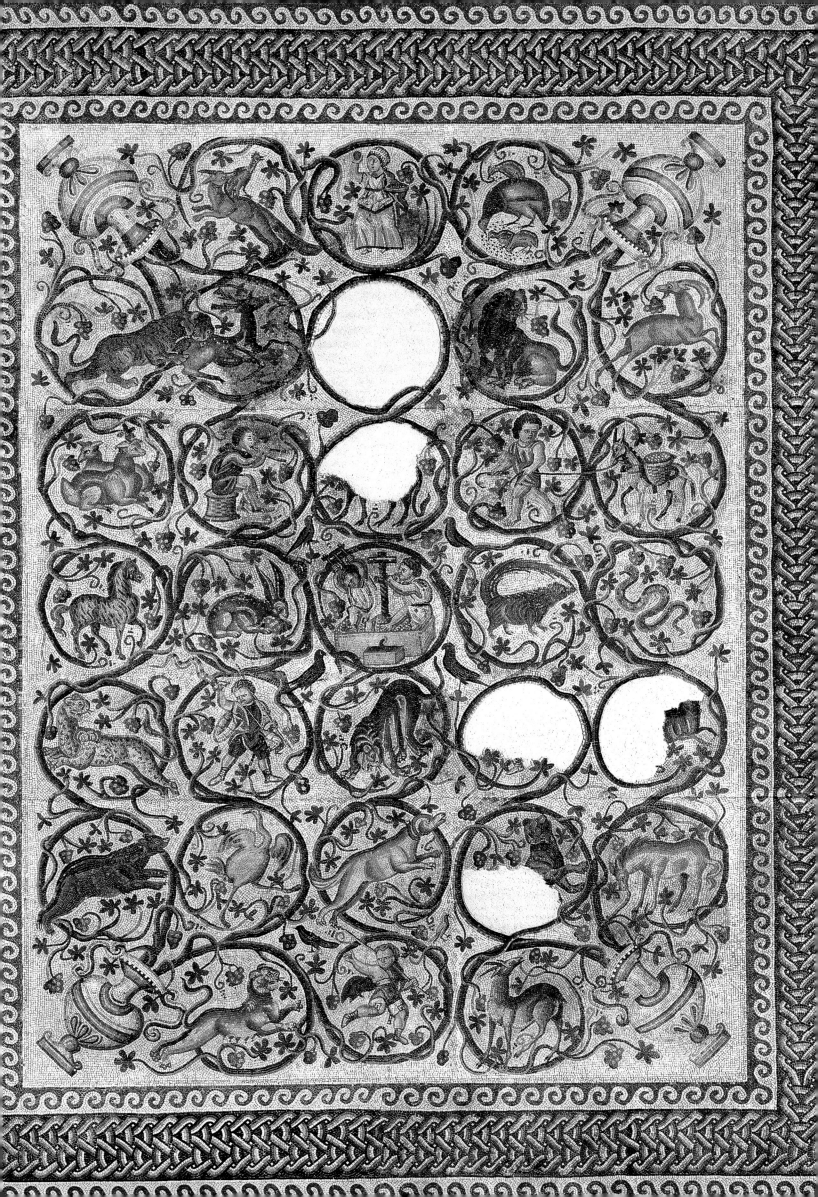

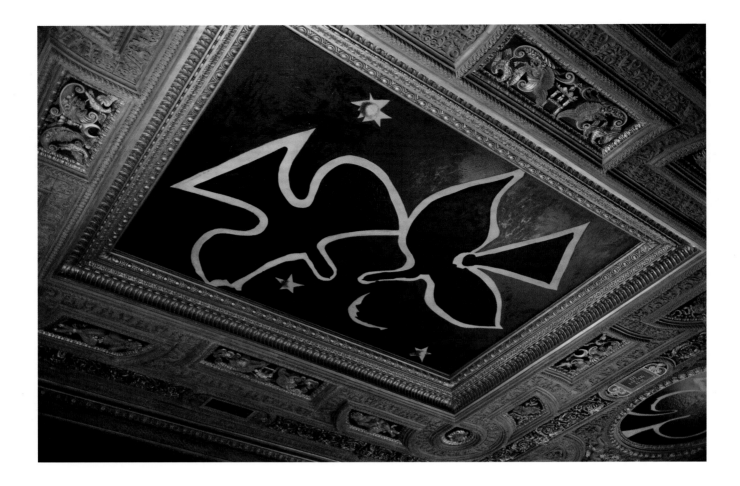

Georges Braque (1882–1963)
The Birds
Commissioned in 1953
Oil on canvas, 346 × 505 cm (136 ¼ × 198 ¾ in.)
Department of Paintings

This work replaced the paintings by Blondel in the ceiling compartments of the king's antechamber. Braque's *The Birds* were the first works of contemporary art to be inserted in the historical decoration of the Louvre.

objects, which form the core of the collections, were exhibited in large display cases on the ground floor next to the Cour Visconti. To the west of this courtyard, beneath the Salle du Manège, large glass panels were installed along the recesses in the cellars to protect the Roman Egypt works. Fayum funerary portraits, sarcophagi, burial objects, and the like could be presented in adapted circumstances that in a sense also evoke their functional context, with the advantage of superb lighting.

The next step in 2012 was to take over the ground floor under the Grande Galerie, to connect the two spaces of this collection and to build down into the ground of the Cour Visconti in order to install the large mosaic floor from the Basilica of Qabr Hiram (close to Tyre, Lebanon), discovered in 1861. Dating to 575, this mosaic was from a small church but measures as much as 120 square meters (1,291 sq ft.). At center are large medallions surrounded by foliated scrolls with pastoral and hunting scenes and animal combats. The medallions along the edges of the floor contain bust-length personifications of the months, the seasons, and the winds, as well as birds and animals.

The decision to devote the Cour Visconti to these collections, dig down into the courtyard, and cover it was a game changer. It allowed for a new visitor itinerary of the Roman and Byzantine antiquities from Egypt and the Near East on two levels, in what had been the artists' workshops under the Grande Galerie. The works from various parts of the Mediterranean dialogue with one another and illustrate the particular eclecticism and diversity of Eastern cults. One room is also devoted to Nubia and Sudan.

On the lower level, partly underground, the mosaic floor was installed and surrounded by a beautiful series of late antique mosaics, mainly from excavations at Antioch, such as the "Phoenix mosaic." The mezzanine of the new rooms offers a plunging view onto these mosaics. To either side, rooms that were remodeled after the Cour Visconti are devoted to Roman and Coptic Egypt, and complete the panorama of art at the end of the era of antiquity and the beginning of the Byzantine period.

The Louvre
and Contemporary Art

Contemporary Art: A Permanent Décor

In the nineteenth century, the Louvre was still a museum with contemporary art. Decorations were commissioned from great artists, as the Delacroix ceiling in the Galerie d'Apollon reminds us. After Napoleon III, however, commissions for large-scale decorations subsided, and the last painted ceilings date to the 1880s. The insertion of twentieth-century decorations in historical spaces began in 1953, with the replacement of canvases by Merry-Joseph Blondel with a work by Georges Braque, in the compartments of the Renaissance ceiling of the king's antechamber. These large blue birds by a well-recognized Cubist painter were the target of criticism at the time, but are now viewed as largely classical, as a sign of the continuation of creativity at the palace, and as the first attempt to marry old and new—a marriage André Malraux effected again ten years later at the Opéra Garnier and the Odéon theater.

Later plans to inject contemporary art into the Louvre were abandoned. These included projects for a new staircase in the Pavillon de Flore in 1968 and for the historic rooms of the Louvre. In 1984, Martial Raysse was approached to work on the paneling of the Galerie d'Apollon; in 1985, the Délégation aux Arts Plastiques were in talks with Riopelle, Hantaï, and Gérard Fromanger to paint the ceiling of the Royal Sessions Room. But these efforts and others ended nowhere. Likewise, when the Pyramid was under construction, all the proposals to place a work on the central pillar failed, regardless of whether they were more recent works by Jean Tinguely or Eduardo Chillida, or older works such as Brancusi's *Rooster*, vying for the spot against Rodin's *Thinker*, and even the *Fountain of Diana*.

Pierre Rosenberg, the Louvre's president and director at the time, took stock of the locations that could be given a permanent contemporary decoration. Henri Loyrette, who succeeded Rosenberg in 2001, assembled a committee of experts and placed the issue in the hands of a curator of contemporary art. Three locations were identified: the north staircase of the Colonnade, the Lefuel staircase, and the Royal Sessions Room. In 2007,

Anselm Kiefer (b. 1945)
Athanor
Commissioned in 2007
Emulsion, shellac, oil, chalk, lead, silver, and gold on linen, 1,000 × 430 cm (393 ¾ × 169 ¼ in.)
North staircase landing, Sully Wing

Anselm Kiefer (b. 1945)
Hortus Conclusus
Commissioned in 2007
Plaster, shellac, wood, resin
North staircase landing, Sully Wing

Anselm Kiefer, a German artist living in France, made a monumental painting for an arch of the Percier and Fontaine Colonnade staircase: *Athanor* (the furnace from which alchemists extract the philosopher's stone). In this work, a reclining figure—a symbolic self-portrait—is surrounded by a vast starry sky. The human form, a microcosm of the universe, is tied to the macrocosm, and art is the link between the world below and the world above. Two sculptures by Kiefer were also placed in empty niches, one from classical mythology and the other from Christian history: *Danae*, whom Jupiter seduced in the form of a golden shower, and *Hortus Conclusus*, the enclosed garden, a symbol of the Immaculate Conception.

François Morellet was commissioned to make the eleven stained-glass windows on the Lefuel staircase. Starting from the existing partitions of the oval windows, he created black-and-white geometric forms that fit perfectly into the space. This work was inaugurated in 2010, as was Cy Twombly's *Ceiling* for the Royal Sessions Room: a great blue sky filled with circles with the names of the major Greek sculptors, evoking the spirit of the place.

Contemporary Artists in Exhibitions at the Louvre

Michel Laclotte, then curator of paintings at the Louvre from 1966 to 1987, was the first to invite contemporary artists to dialogue with older art, in connection with temporary exhibitions. The first of these was a special exhibition devoted to Ingres's *Turkish Bath*, when Laclotte also showed works on the same theme by artists such as Picasso, Man Ray, Labisse, and Rauschenberg (1971). After becoming director of the Louvre, he began holding exhibitions in the Napoleon Hall, with the theme of continuity between past and present. The first of these exhibitions, *Polyptych*, was followed by *Copy/Create*, *After the Antique*, and *The Empire of Time*, all of which included works commissioned from contemporary artists.

Under the direction of Françoise Viatte, the Department of Graphic Arts developed another type of exhibition for the Napoleon Hall. For these *Carte Blanche* exhibitions, figures such as Peter Greenaway, Julia Kristeva, and Jacques Derrida chose a theme (clouds, blindness, etc.) to be illustrated with works from the Louvre and by contemporary artists. Along these same lines, the exhibitions *On Possession and Destruction* and *Painting as Crime* explored graphic arts in history. The department's attention to contemporary art has now led to an annual print commission for the Louvre's collection.

The *Carte Blanche* series ended, but it was soon followed by the *Illustrious Guests* series, which has featured Toni Morrison, Robert Badinter, Pierre Boulez, Patrice Chéreau, Umberto Eco, Bob Wilson, and Le Clézio, each of whom were invited to program lectures, exhibitions, and dance and theater performances.

Artists Invited to the Louvre

The Louvre's contemporary art programming expanded and even came to include exhibitions exclusively on contemporary art. This was not an entirely new development. In 1947, Picasso exhibited ten paintings together with works by Zurbarán, Delacroix, and Courbet, though the show was not treated to much fanfare. André Malraux was truly the first to introduce large exhibitions of living artists into the Louvre. It began with the Braque workshop in 1961, followed by Delaunay, Chagall, and Picasso (to celebrate his ninetieth birthday). But this practice died out in 1971.

Contemporary art programming has grown considerably at the Louvre with the appointment of a specialist in contemporary art, and thanks to the support of patrons. Specific, group, and individual presentations have now been added to those dialogues held in conjunction with temporary exhibitions. And so was born *Counterpoint*, a program in which artists are invited to exhibit their work in an area of the collections of their choice. For the first of these shows, Christian Boltanski chose works at the Louvre that came from

François Morellet (1926–2016)
L'Esprit d'escalier
Commissioned in 2008, completed in 2009
Lead, glass
Lefuel staircase, Richelieu Wing

Michelangelo Pistoletto (b. 1933)
Obelisco e Terzo Paradiso, 1976–2013
Mirrors, colored cloth
Department of Sculptures, Cour Marly,
25 April–2 September 2013

Opposite
Wim Delvoye (b. 1965)
Suppo (detail), 2010
Laser-cut stainless steel, H. 1,100 cm (433 in.)
Pyramid entrance, 31 May – 17 September 2012

archaeological excavations; Ange Leccia, Xavier Veilhan, and Jean-Michel Othoniel were among the ten guests who participated in this exhibition. In 2005, the Louvre commissioned the Sèvres Manufactory to make pieces based on designs by artists such as Anne and Patrick Poirier, Jim Dine, and Louise Bourgeois for the museum's decorative arts collection. Sculpture got its turn in 2007, when ten artists exhibited at the Louvre: Richard Deacon drew inspiration from Gregor Erhart's *Mary Magdalene*, Luciano Fabro placed a marble sculpture rolled up like a column in the Cour Marly, Giuseppe Penone planted trees in the Cour Puget, and Anish Kapoor installed a large concave mirror in the Cour Khorsabad.

Contemporary art is no longer limited to a specific exhibition room and can be found throughout the museum, in both permanent collection rooms and emblematic spaces, such as the central pillar in the Pyramid. Contemporary artists also confront the work of past masters: Miquel Barceló and Delacroix (2004); François Rouan and Primaticcio (2005); and Tony Cragg and Messerschmidt (2011), the latter placing sculptures in the courtyards. Concurrent with the *Frans Post* exhibition in 2005, the Brazilian artist Tunga suspended skulls and the heads of statues from a gallows installed under the Pyramid. In conjunction with the *American Artists and the Louvre* exhibition in 2006, Mike Kelley produced a sound video installation. As part of the Year of Armenia, Sarkis was invited to create an installation, and several artists took over the medieval rooms at the Louvre in celebration of the Year of Russia.

Gradually, the correlation to an exhibition transforms into a personal invitation, sometimes resulting in a single work, sometimes more. Examples include Maurizio Cattelan's *Untitled (Drummer Boy)*, installed on a cornice of the Cour Napoleon (2004); Yan Pei-Ming's *Funeral for Mona Lisa*, in the Salon Denon (2009); and Joseph Kossuth's neon sentences on the walls of the medieval Louvre (2009). Some photographers who turned their lens on the Louvre were then exhibited on its walls, including Jean-Christophe Ballot (2003), Patrick Faigenbaum (2005), Candida Höfer (2006), Jean-Luc Moulène (2005), and Christian Milovanoff (2007).

The invitation has even led to full retrospectives. In 2008, Belgian artist Jan Fabre took over the rooms devoted to Northern European painting. Acting upon his interpretation

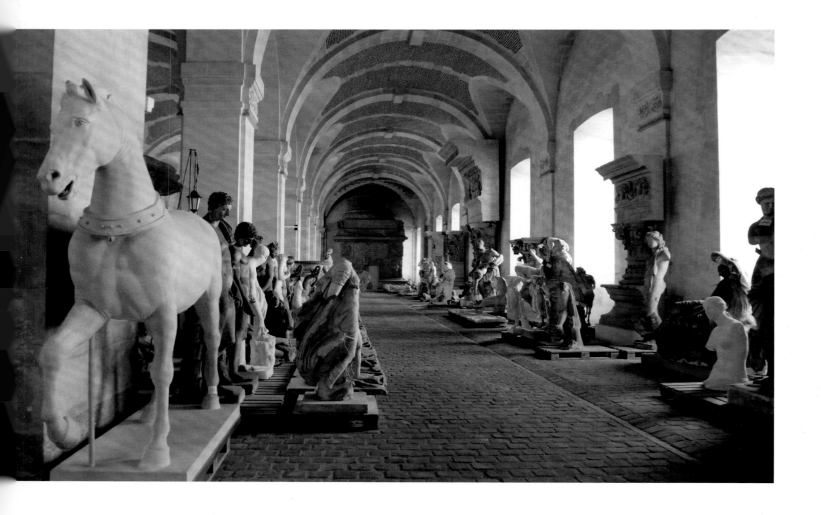

The Louvre's Museum of Casts: Hellenistic
Greece and Rome
Versailles, Petite Écurie du Roi

of early Flemish painting, Fabre elaborated a "mental drama" featuring the larger themes of his own work, combining the grotesque, the macabre, the sublime, money, death, self-portraiture, and the mystic lamb.

In 2011, Israeli artist Michal Rovner built two structures in the Cour Napoléon made of stones from the ruins of houses that had been destroyed and abandoned in Palestine, their bent walls and sham windows like open wounds. On a more playful, ironic note, in 2012, artist Wim Delvoye placed his *Suppo*, a kind of Flamboyant Gothic–inspired stainless-steel arrow, on the pillar under the Pyramid, and installed similarly inspired objects on the furniture in the Napoleon III apartments and rooms devoted to decorative arts, as well as a stained-glass window.

In 2013, Michelangelo Pistoletto presented a retrospective of the major themes of his work. His *Venus of the Rags* consorted with masterpieces of antiquity, and his personal emblem, the "third paradise" (the mathematical symbol of infinity reworked into three consecutive circles instead of two), marked the entrance to the Pyramid and floated above a gigantic mirrored obelisk in the Cour Marly. In one spot, an orator seemed to call on the audience, while in the Grande Galerie, women played lutes, and a mirror invited spectators to participate in the action. Also in 2013, Loris Gréaud installed a work on the central pillar of the Napoleon Hall designed to intrigue the public: he wrapped a copy of one of Michelangelo's *Slaves* in gray cloth, tied it with ropes, and placed it there as if it were waiting for an unveiling that would never come. On that same pillar, Claude Lévêque later installed his jagged neon light (2014–16); JR covered the Pyramid in a gigantic reproduction of the facade of the Louvre, which seemed to optically "erase" the Pyramid (2016); and Japanese artist Kohei Nawa installed a 10-meter-high (32 ¾ ft.) bright gold "throne" as part of a celebration of France's friendship with Japan (2018).

The Louvre Outside the Walls

The Louvre operates at both national and international scales, through works on deposit at many French museums and on loan to exhibitions all over the world. So, for example, 90 percent of the works at the Musée du Petit Palais in Avignon are from the Louvre; mainly early Italian paintings from the Campana collection. For some time now, the Louvre has also managed other museums. Between 1912 and 1970, the Château de Maisons-Laffitte was attached to the Louvre's Department of Sculptures. The Department of Decorative Arts has managed the châteaux of Pau and Azay-le-Rideau, and even the Musée de Cluny and the Musée de la Céramique in Sèvres (1926–64).

The Musée des Moulages Antiques

The one museum that remains and has even grown since it was created is the Musée des Moulages Antiques, a collection of casts in the Petites Écurie at Versailles. Its oldest pieces were made in Rome in the seventeenth century—either for the king or for the Academy of Painting and Sculpture—and include casts of the *Farnese Hercules*, the Column of Trajan, and the *Dying Gaul*. Most of the pieces were brought by various curators of antiquities to the Louvre and placed on the Daru staircase—and later in the Salle du Manège—for pedagogical purposes and to relate the larger history of antique art. Some were transferred from the École Nationale Supérieure des Beaux-Arts, where traditional teaching relied on the great classical models. The collection is uneven, and some pieces are almost as valuable as their originals, when these have been damaged, dismembered, or even lost. And whereas antique sculpture does have wide representation through at least one copy of all the known masterpieces, architecture takes center stage with replicas of the huge columns of the Parthenon, the Caryatid of the Erechtheion, and examples of capitals and entablatures.

Musée National Eugène Delacroix: the garden, remodeled and replanted in 2013, and a corner of the studio

The Musée Delacroix

The Musée National Eugene Delacroix is certainly one site that *is* the Louvre without being *in* the Louvre: surprising, intimate, and moving. Let's take a turn through this studio, where the painter's presence can still be felt. Located on the Place Furstenberg, one of the loveliest areas of the Quartier Latin, the building dates to the seventeenth century, with a studio and garden, all restored (2013). Delacroix settled here in 1857, not far from Saint-Sulpice, where he executed large frescos. "The view onto my small garden and the merry aspect of my studio always give me a feeling of pleasure," the artist wrote in his journal that same year. It is also where he died, in 1863. The apartment was rented by the Association des Amis de Delacroix in 1929, which subsequently repurchased it in 1952 and gifted it to the state two years later. Its became attached administratively to the Établissement Public du Musée du Louvre in 2004 and has been directed by a Louvre curator ever since. The restoration focused entirely on recreating the ambience of an artist's working studio. Paintings, objects brought back from Delacroix's trip to North Africa, prints, and correspondences are either on deposit or have been patiently collected. The atmosphere is less that of a museum than a living place, inhabited by the memory of the painter.

The Louvre-Lens—The Louvre Abu Dhabi

Another adventure has been the creation of a museum in the city of Lens, located at the heart of a mining region that had been heavily affected by closures. The Louvre was searching for a means to relocate its collections, but without copying what the Centre Pompidou had done in Metz. Lens was chosen from among a number of proposed cities. The Louvre wanted a new educational and cultural instrument, armed with innovative approaches, and the Nord-Pas-de-Calais region decided to create a public cultural establishment: the Louvre-Lens. Begun in 2004, this project was both architectural and museographic. A competition attracted 124 candidates, from which seven finalists were drawn, and the project was awarded to the Japanese firm SANAA in September 2005. Architects Kazuyo Sejima and Ryue Nishizawa built five bare, elongated parallelepiped structures whose proportions, softly curving walls, gently sloping floors and ceilings, and light streaming in through the roofs and walls create an impression of sublime beauty. The visitor reception building, a glass square, the polished-aluminum Galerie du Temps, (Time Gallery), and the other exhibition buildings blend into the surrounding nature, a large park extracted from the mine and designed by Catherine Mosbach. The Louvre transferred 250 works to the new facility. Dating from 4,000 B.C. to 1848, they are exhibited chronologically in the 2,000-square-meter (21,527 sq ft.) Galerie du Temps. Civilizations are presented side by side, with their origins and diverse techniques playing off one another. An implicit transversality was built into the display by the museographer Adrien Gardère, where the overall timeline is not truncated but rather hyphenated through space. The works on display are renewed annually.

And then there was the creation of the Louvre Abu Dhabi, a universal art museum. It is the paradigm of the museum's reach, know-how, and collections. The Agence France-Museum, established by the French Ministry of Culture and the Louvre, joined forces with the major French cultural establishments to create its program and rotate the loans of significant works to be displayed together with the United Arab Emirates own acquisitions. The large starry dome designed by Jean Nouvel was inaugurated in 2017, ten years after the project was launched, and houses six hundred works.

Eight hundred years after the Louvre château was built, and 220 years after the museum was created, this place, which during the revolution became the "Muséum des Arts"; under Napoleon III, the "Nouveau Louvre"; and in the twentieth century, the "Grand Louvre," continues its metamorphosis. A source of admiration and controversy, it holds the riches of a nation and makes them accessible to all audiences. Everyone can find something to love here: historical testimony, architectural beauty, works of art from every time and country, and beneath it all, the labor and passion of those who created them.

Opposite
Louvre-Lens: the Galerie du Temps,
section on antiquity
Foreground, at left, statue of a young man from
Cyprus; at right, a kouros from the sanctuary
of Asklepius at Paros (archaic Greek art);
background, from left to right, a Mithraic
relief from the Capitoline in Rome, *Jupiter*
and *Marcus Aurelius*, two marble statues from
the Borghese collection (Roman art)

Louvre-Lens: the Galerie du Temps,
modern section in 2012
Foreground: *D'Alembert* (marble) by Félix
Lecomte; background, *Lion and Snake* (bronze)
by Barye, *Liberty Leading the People* by Delacroix,
The Marquise of Santa Cruz by Goya, *Fantasy
Figure* (formerly identified as Diderot) by
Fragonard

Following spread
View of the Louvre-Lens from the gardens
Design concept by SANAA (Kazuyo Sejima,
Ryue Nishizawa), Imrey Culbert (Celia Imrey,
Tim Culbert), and garden by Catherine
Mosbach, 2012

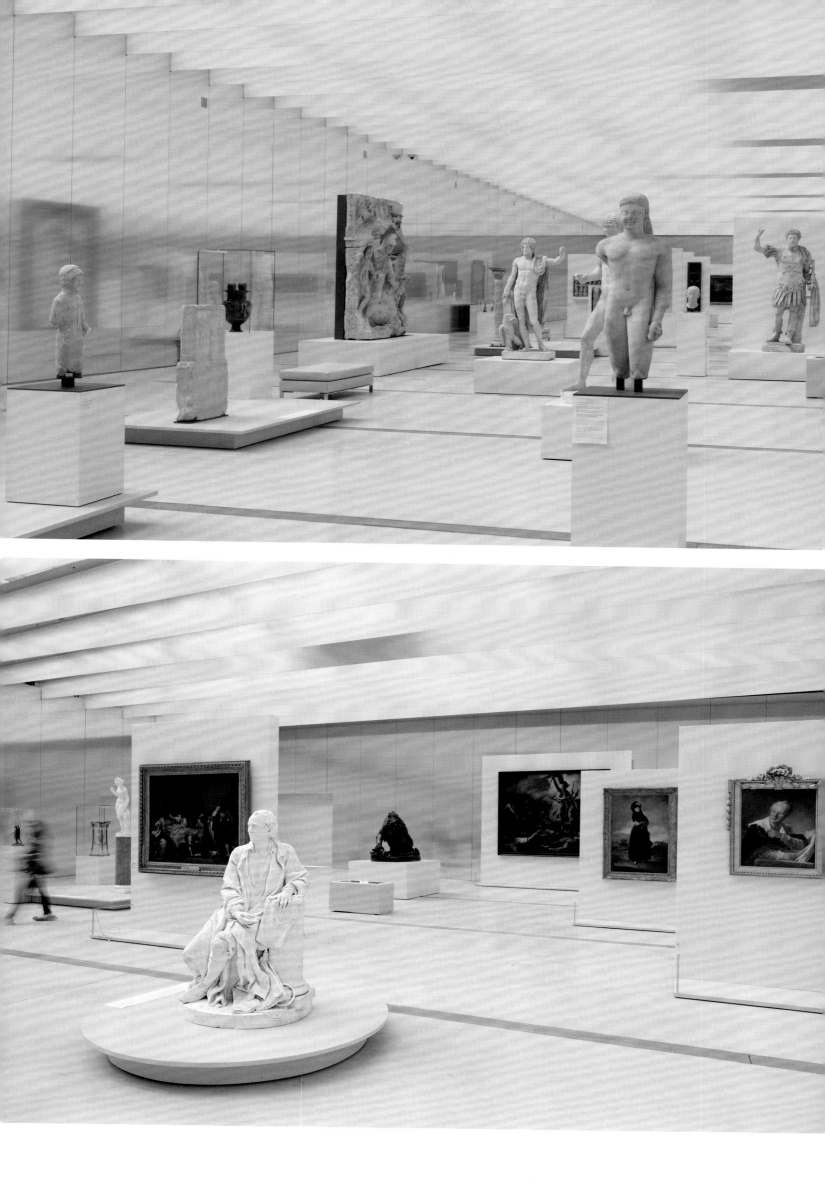

Selected Bibliography

History and Architecture of the Louvre and Tuileries

BRESC-BAUTIER, Geneviève. *Le Louvre, une histoire de palais*. Paris: Musée du Louvre Éditions/Somogy Éditions d'Art, 2008.

BRESC-BAUTIER, Geneviève, ed. *La Galerie d'Apollon au Palais du Louvre*. Paris: Musée du Louvre Éditions/Gallimard, 2004.

BRESC-BAUTIER, Geneviève, Denis CAGET, and Emmanuel JACQUIN. *Jardins du Carrousel et des Tuileries*. Paris: Éditions de la Réunion des Musées Nationaux (RMN), Caisse Nationale des Monuments Historiques et des Sites, 1996.

BRESC-BAUTIER, Geneviève, Yves CARLIER, Bernard CHEVALLIER, Anne DION-TENENBAUM, Guillaume FONKENELL, and Jean-Denis SERENA. *Les Tuileries: Grands décors d'un palais disparu*. Paris: Éditions du Patrimoine, 2016.

BRESC-BAUTIER, Geneviève, Guillaume FONKENELL, Yannick LINTZ, and Françoise MARDRUS eds. *Histoire du Louvre*. Paris: Louvre Éditions/Fayard, 2016, 3 vols.

BRESC-BAUTIER, Geneviève, and Emmanuel JACQUIN. *Le Jardin des Tuileries*. Paris: Musée du Louvre Éditions/Connaissance des Arts, 2008.

CARMONA, Michel. *Le Louvre et les Tuileries: Huit siècles d'histoire*. Paris: Éditions de La Martinière, 2004.

FONKENELL, Guillaume. *Le Palais des Tuileries*. Paris: Éditions Honoré Clair, 2010.

FONKENELL, Guillaume, ed. *Le Louvre pendant la guerre: Regards photographiques 1938–1947*. Paris: Musée du Louvre Éditions/Le Passage, 2009.

GADY, Alexandre. *Le Louvre et les Tuileries: La fabrique d'un chef-d'oeuvre*. Paris: Musée du Louvre Éditions, 2015.

LAVEISSIÈRE, Sylvain, ed. *Napoléon et le Louvre*. Paris: Musée du Louvre Éditions/Fayard, 2004.

Les donateurs du Louvre. Paris: Éditions de la Réunion des Musées Nationaux, 1989.

MONTJOUVENT, Philippe de. *Le Louvre, palais des rois, palais des arts*. Paris: Timée Éditions, 2009.

POISSON, Georges. *La grande histoire du Louvre*. Paris: Perrin, 2013.

QUONIAM, Pierre, and Laurent Guinamard. *Le Palais du Louvre*. Paris: Nathan, 1988.

ROSENBERG, Pierre, and Marie-Anne DUPUY, eds. *Dominique-Vivant Denon: L'oeil de Napoléon*. Exh. cat. Musée du Louvre, 20 October 1999–17 January 2000. Paris: Éditions de la Réunion des Musées Nationaux, 1999.

SOULIÉ, Daniel. *Le Louvre pour les nuls*. Paris: Musée du Louvre Éditions/First Éditions, 2010.

SOULIÉ, Daniel. *Le Louvre secret et insolite*. Paris: Musée du Louvre Éditions/Parigramme, 2011.

The Collections

General Works

GLAMA, Barthélémy, Claude POMMEREAU, and Daniel SOULIÉ. *Tout le Louvre: Les chefs-d'oeuvre, l'histoire du palais, l'architecture*. Paris: Musée du Louvre Éditions/Beaux-Arts Magazine, 2012.

GOETZ, Adrien, and Erich LESSING. *Au Louvre, les arts face à face*. Paris: Musée du Louvre Éditions/Hazan, 2003.

LAMMERHUBER, Loïs, and Daniel SOULIÉ. *Louvre avec vues*. Paris: Musée du Louvre Éditions/Éditions de La Martinière, 2007.

Le Guide du Louvre. Paris: Musée du Louvre Éditions/RMN, 2005.

LESSING, Erich, Daniel SOULIÉ, and Philippe APELOIG. *Louvre*. Paris: Musée du Louvre Éditions/Éditions de La Martinière, 2008.

Louvre, le guide des chefs-d'oeuvre. Paris: Musée du Louvre Éditions/Beaux-Arts Magazine, 2007.

MORVAN, Frédéric. *Louvre, les 300 chefs-d'oeuvre*. Paris: Musée du Louvre Éditions/Hazan, 2006.

MORVAN Frédéric. *Objectif Louvre: Le guide des visites en famille*. Paris: Musée du Louvre Éditions/Actes Sud Junior, 2007.

MORVAN, Frédéric. *Objectif Louvre: Étonnants parcours en famille*. Paris: Musée du Louvre Éditions/Actes Sud Junior, 2009.

Department of Oriental Antiquities

CHEVALIER, Nicole. *Chronique des premières missions archéologiques ançaises à Suse*. Paris: Musée du Louvre Éditions/IFRI, Tehran, 2009.

CLUZAN, Sophie. *De Sumer à Canaan, l'Orient ancien et la Bible*. Paris: Musée du Louvre Éditions/Seuil, 2005.

FONTAN, Élisabeth, ed. *De Khorsabad à Paris: La découverte des Assyriens*. Paris: Éditions de la Réunion des Musées Nationaux, 1994.

LE BRETON, Élisabeth. *Du verbe à l'écrit: La naissance de l'écriture en Mésopotamie*. Paris: Musée du Louvre Éditions/RMN, 2003.

Department of Egyptian Antiquities

ANDREU, Guillemette, ed. *Objets d'Égypte*. Paris: Musée du Louvre Éditions/Le Passage, 2009.

BARBOTIN, Christophe, and Didier DEVAUCHELLE. *La voix des hiéroglyphes*. Paris: Musée du Louvre Éditions/Éditions Khéops, 2006.

SOULIÉ, Daniel. *L'Égypte est au Louvre*. Paris: Musée du Louvre Éditions/Somogy Éditions d'art, 2007.

Department of Greek, Etruscan, and Roman Antiquities

CHATZIEFREMIDOU, Katerina, Françoise GAULTIER, and Laurent HAUMESSER. *L'art étrusque: 100 chefs-d'oeuvre du Musée du Louvre*. Paris: Musée du Louvre Éditions/Somogy, 2013.

DENOYELLE, Martine. *Chefs-d'oeuvre de la céramique grecque dans les collections du Louvre*. Paris: Éditions de la Réunion des Musées Nationaux, 1994.

HAMIAUX, Marianne. *Les sculptures grecques*. 2 vols. Paris: Éditions de la Réunion des Musées Nationaux, 1992.

HAMIAUX, Marianne, Ludovic LAUGIER, and Jean-Luc MARTINEZ. *La Victoire de Samothrace*. Paris: Louvre Éditions/Somogy, 2015.

KERSAUSON, Kate de. *Catalogue des portraits romains*. 2 vols. Paris: Éditions de la Réunion des Musées Nationaux, 1996.

MARTINEZ, Jean-Luc, ed. *Les antiques du Louvre: Une histoire du goût d'Henri IV à Napoléon*. Paris: Musée du Louvre Éditions/Hazan, 2004.

MARTINEZ, Jean-Luc, and Alain PASQUIER. *100 chefs-d'oeuvre de la sculpture grecque au Louvre*. Paris: Musée du Louvre Éditions/Somogy Éditions d'Art, 2007.

Department of Islamic Art

MAKARIOU, Sophie, ed. *Les arts de l'Islam au Musée du Louvre*. Paris: Musée du Louvre Éditions/Hazan, 2012.

Department of Paintings

ALLARD, Sébastien. *Le Louvre à l'époque romantique: Les décors du palais (1815–1835)*. Paris: Musée du Louvre Éditions/Fage Éditions, 2006.

FAROULT, Guillaume, Élisabeth FOUCART-WALTER, and Olivier MESLAY. *Catalogue des peintures britanniques, espagnoles, germaniques, scandinaves et diverses du Musée du Louvre.* Paris: Musée du Louvre Éditions/Gallimard, 2013.

FOUCART, Jacques. *Catalogue des peintures flamandes et hollandaises du Musée du Louvre.* Paris: Musée du Louvre Éditions/Gallimard, 2009.

GOETZ, Adrien. *La Grande Galerie des peintures.* Paris: Musée du Louvre Éditions/Centre Pompidou, 2003.

HABERT, Jean, Stéphane LOIRE, Cécile SCAILLIÉREZ, and Dominique THIÉBAUT. *Catalogue des peintures italiennes du Musée du Louvre.* Paris: Musée du Louvre Éditions/Gallimard, 2007.

LOIRE, Stéphane. *École italienne, XVII^e siècle, 1. Bologne, 2. Lombardie, Naples, Rome et Venise.* Paris: Éditions de la Réunion des Musées Nationaux, 1996.

LOIRE, Stéphane. *Peinture italienne du XVII^e siècle au Musée du Louvre: Florence, Gênes, Lombardie, Naples, Rome et Venise.* Paris: Louvre Éditions/Gallimard, 2006.

LOIRE, Stéphane. *Peinture italienne du XVIII^e siècle au Musée du Louvre.* Paris: Louvre Éditions/Gallimard, 2017.

POMARÈDE, Vincent, ed. *1001 peintures au Louvre, de l'Antiquité au XIX^e siècle.* Paris: Musée du Louvre Éditions/5 Continents, 2005.

POMARÈDE, Vincent, Anja GREBE, and Erich LESSING. *Le Louvre: Toutes les peintures.* Paris: Musée du Louvre Éditions/Skira-Flammarion, 2012.

Department of Sculptures

BARON, Françoise. *Sculpture française (I), Moyen Âge.* Paris: Éditions de la Réunion des Musées Nationaux, 1996.

BRESC-BAUTIER, Geneviève, ed. *Les sculptures européennes du Musée du Louvre.* Paris: Musée du Louvre Éditions/Somogy Éditions d'Art, 2006.

DUFRÊNE, Thierry. *La Grande Galerie des sculptures.* Paris: Musée du Louvre Éditions/Musée d'Orsay/Centre Pompidou, 2005.

GABORIT, Jean-René. *Sculpture française (II), Renaissance et temps modernes.* 2 vols. Paris: Éditions de la Réunion des Musées Nationaux, 1998.

LE POGAM, Pierre-Yves. *La sculpture à la lettre: Promenade épigraphique au Département des Sculptures du Musée du Louvre.* Paris: Musée du Louvre Éditions/Officina Libraria, 2008.

Department of Decorative Arts

ALCOUFFE, Daniel. *Les gemmes de la couronne.* Paris: Éditions de la Réunion des Musées Nationaux, 2001.

BASCOU, Marc, Michèle BIMBENET-PRIVAT, Frédéric DASSAS, and Jannic DURAND, eds. *Décors et objets d'art du XVIII^e siècle au Musée du Louvre.* Paris: Louvre Éditions/Somogy, 2014.

DION-TENENBAUM, Anne. *Les appartements Napoléon III.* Paris: Musée du Louvre Éditions/Beaux-Arts Magazine, 2008.

DION-TENENBAUM, Anne. *L'orfèvrerie française du XIX^e siècle: La collection du Musée du Louvre.* Paris: Musée du Louvre Éditions/Somogy, 2011.

GABORIT-CHOPIN, Danielle. *Ivoires médiévaux, V^e–XV^e siècle.* Paris: Éditions de la Réunion des Musées Nationaux, 2003.

MALGOUYRES, Philippe. *Ivoires du Musée du Louvre du XV^e au XIX^e siècle.* Paris: Musée du Louvre Éditions/Gourcu Gradenigo, 2010.

Department of Graphic Arts

SÉRULLAZ, Arlette. *100 chefs-d'oeuvre du dessin du Musée du Louvre.* Paris: Éditions de La Martinière, 2012.

"Cabinet des Dessins" Collection: 24 titles, Paris-Milan: Musée du Louvre Éditions/5 Continents Éditions; 3 titles, Paris: Musée du Louvre Éditions/Le Passage.

"Inventaire général des dessins du musée du Louvre": 10 published volumes of the catalogue raisonné.

Musée Eugène Delacroix

SÉRULLAZ, Arlette. *Le Musée Eugène Delacroix.* Paris: Musée du Louvre Éditions/Beaux-Arts Magazine, 2006.

Pavillon des Sessions

Guide du Musée du Quai Branly. Paris: Musée du Quai Branly, 2006.

The Louvre Magazine

Grande Galerie is a quarterly journal published by the Louvre since 2007, on issues relating to its collections. It provides current museum news (acquisitions, restorations, temporary exhibitions) and looks at the history of the palace and its collections, with articles by well-known guest writers. For more information, go to www.louvre.fr and grandegalerie@louvre.fr.

Websites and Databases

The Louvre's official website (www.louvre.fr) provides a great deal of practical information to prepare a visit to the museum. It also gives a history of the palace and an introduction to the museum's departments, as well as current information (temporary exhibitions, acquisitions) and thematic itineraries of the collections.

From the Louvre's website, one can access the Atlas database, where all the works exhibited permanently at the museum (thirty-five thousand) can be searched. Most are illustrated.

The Louvre's website also provides access to the online database of the Department of Graphic Arts, where one can search the 140,000 drawings at the Louvre and Orsay Museums.

The Ministry of Culture and Communication makes available to the public the Joconde database, where close to four hundred thousand objects in French museums can be searched (www.culture.gouv.fr/documentation/joconde).

The website of the photography agency of the Réunion des Musées Nationaux provides access to tens of thousands of images of works in French and foreign museums (www.photo.rmn.fr).

Acknowledgments

The author, photographer, and editors thank the following for their precious help: Caporal Frédéric Alibert, Cécile Barthes, Elisabetta Bartoli, Hélène Bendejacq, Djamella Berri, Malika Berri, Caporal-chef Ludovic Bevalot, Caroline Biro, Catherine Bridonneau, Pauline Carlier, Joëlle Cinq-Fraix, Anne-Laure Charrier-Ranoux, Laurent Creuzet, Alain Dajoux, Isabelle Deborne, Anne Dion-Tenenbaum, Virginie Fabre, Adjudant-chef Cédric Herbay, Aurélien Gaborit, Camille Godin, Clarine Guillou, Christine Finance, Sabine de La Rochefoucauld, Alain Lasne, Élisabeth Le Breton, Isabelle Luche, Sophie Makariou, Jean-Pascal Martin, Anne Mettetal-Brand, Fanny Meurisse, Caporal-chef Raphaël Osawa, Céline Rebière-Plé, Marie-Pierre Salé, Daniel Soulié, Camille Sourisse, Carole Treton.

Edition directed by: Geneviève Rudolf
French edition: Clémentine de la Féronnière
Translation by: Art in Translation, Madrid
English edition coordinated by: Jennifer Duardo (Rizzoli Electa),
Félix Andrada (Ediciones El Viso)
Production manager: Gonzalo Saavedra (Ediciones El Viso)
Graphic design: Ursula Held
Layout: Ana Martín
Copy editing: Philomena Mariani
Proofreading: Jeannine Ng
Manufacturing: Luc Martin
Photoengraving: Nord Compo, Villeneuve-d'Ascq
Printing and processing: Printer Trento, Trento, Italy

Printed in Italy